COMPUTER AIDED ARCHITECTURAL DESIGN FUTURES 2005

Computer Aided Architectural Design Futures 2005

Proceedings of the 11th International CAAD Futures Conference held at the Vienna University of Technology, Vienna, Austria, on June 20–22, 2005

Edited by

BOB MARTENS

Vienna University of Technology,
Vienna, Austria

and

ANDRE BROWN

University of Liverpool,
Liverpool, U.K.

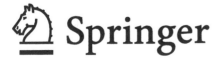 Springer

A C.I.P. Catalogue record for this book is available from the Library of Congress.

ISBN-13 978-90-481-6872-9 (PB)
ISBN-13 978-1-4020-3698-9 (e-book)

Published by Springer,
P.O. Box 17, 3300 AA Dordrecht, The Netherlands.

www.springeronline.com

Printed on acid-free paper

Table of Contents

Foreword

MARTENS Bob and BROWN Andre
Co-conference Chairs, CAAD Futures 2005

Computer Aided Architectural Design is a particularly dynamic field that is developing through the actions of architects, software developers, researchers, technologists, users, and society alike. CAAD tools in the architectural office are no longer prominent outsiders, but have become ubiquitous tools for all professionals in the design disciplines. At the same time, techniques and tools from other fields and uses, are entering the field of architectural design. This is exemplified by the tendency to speak of Information and Communication Technology as a field in which CAAD is embedded. Exciting new combinations are possible for those, who are firmly grounded in an understanding of architectural design and who have a clear vision of the potential use of ICT.

CAAD Futures 2005 called for innovative and original papers in the field of Computer Aided Architectural Design, that present rigorous, high-quality research and development work. Papers should point towards the future, but be based on a thorough understanding of the past and present. This book contains a selection of papers presented at the 11th CAAD Futures conference which took place at Vienna University of Technology; the following categories of double-blind peer-reviewed papers are included:

- Building Information Modelling and Construction Management;

- Design Methods, process and creativity;

- Digital Design, Representation and Visualization;

- Form and Fabric: Computer Integrated Construction and Manufacturing;

- Human-machine Interaction: Connecting the Physical and the Virtual;

- Knowledge Based Design and Generative Systems;

- Linking Education, Research and Practice;

- Virtual Heritage, Reconstruction and Histories

Over recent years the grouping of papers under headings of Virtual Environments, and Collaboration (or cooperation) has been common, but we have deliberately resisted the temptation to use these categories. These days the topics of virtual

environments and collaboration are so common to much of the research undertaken that we need to be more specific in order to produce helpful classifications. We hope that the headings listed above do that.

Two decades of CAAD Futures conferences can be regarded as a quest for "Learning from the Past" (in line with the conference theme!). Up to the 2001 conference, paper-based proceedings were published in collaboration with renowned publishing houses. Since 2001, a limited number of CD-Roms were distributed to the conference participants. There are hardly any individual teachers, researchers, librarians, etc., who can claim to have a complete set of CAAD Futures proceedings, since some of the earlier works are out of stock. Making nearly two decades of teaching and research work in this specialized field of CAAD available would therefore be of great importance (approx. 5.500 pages) and allow the identification of a more tangible historical and developmental record. For authors this would encourage and enable wider dissemination of their published papers. eCAADe ("education and research in CAAD in europe" - www.ecaade.org) served as a collaborating partner with the CAAD Futures foundation to get this idea put into practice and took over the financial risk for the cost of digitisation. As soon as the complete "rough material" was available in the pdf-format the next step was to create two different final versions. The wider availability of CAAD Futures Proceedings for the period 1985 to 2003 has been accomplished on one hand by means of an off-line-version (CD-Rom) and on the other hand by an on-line-version in CUMINCAD (Cumulative Index on CAD - www.cumincad.scix.net). Considering the effort involved it could have been rather tempting only to scan-in the total package without separate text recordis, But this would have meant that a full-text search would not have been possible. In this aspect the Digital Proceedings differ considerably from their paper-based originals. Doubtless, a digital publication can be designed according to specific appearance requirements from the very beginning provided the paper-based form is only to act as a mere by-product.

ACKNOWLEDGEMENTS

We are indebted to Henri Achten, Urs Hirschberg and Ardeshir Mahdavi for their support to this conference as program Chairs. Hannu Penttilä provided boundless efforts concerning the maintenance of the web-based reviewing interface, which allowed us to stay within the tight deadlines.

Keynote Papers

Digitally Sponsored Convergence of Design Education, Research and Practice

BURRY Mark
Spatial Information Architecture Laboratory, RMIT University, Australia

Keywords: transdisciplinary design, convergence, design practice, collaboration, post digital design

Abstract: This paper looks at examples of successful transdisciplinary design projects that oblige a departure from the typical assertion of sub-discipline distinctions. In doing so a case is made for a new convergence between architectural design education, research and practice. A case for post digital design will also be made, defined here as the comprehensive assimilation of the computer within traditional modes of design practice, offering a more natural and productive state of affairs than the exclusively digital office promulgated especially during the previous decade. The paper concludes with a demonstration of transdisciplinary design teaching and practice, offering a post digital design framework that require radical new approaches to education and practice. It is contended here that only when CAAD research is undertaken conjointly within teaching and practice can the links be properly formed between the two.

1 BACKGROUND

The history of computer-aided architectural design is now more than a generation in length. Given how far CAAD has come in this time, it is perhaps surprising that CAAD still means 'CAD' to many, and its presence in the architectural course is tolerated only through its apparent usefulness as CAD in the contemporary office. The status of CAAD has been primarily one attuned to the fortunes of early adopters on the quest for digital equivalents to traditional practice paradigms. Implicitly at least, the emphasis has been on extending the architects' range of commercial opportunity: increased efficiency as the prime motivator over the quest for design excellence in itself. For much of this period CAAD education has therefore been located at the program fringe with varying levels of interest from each academic community, but seldom touching the curriculum core. The critics of CA(A)D in the academy regard its insinuation into the program as an inexorable thief of time better devoted to other more valuable intellectual engagements.

Where CAAD is synonymous with design experimentation – the *"exciting new combinations"* referred to in the 'Conference Theme'- it runs contrary to the desires of conservative members of the teaching and practicing fraternity. These are often

B. Martens and A. Brown (eds.), Computer Aided Architectural Design Futures 2005, 3-22.
© 2005 *Springer. Printed in the Netherlands.*

senior colleagues with a tighter grasp on the reins of power. Their misgivings become manifestly obvious during design reviews, for instance. A major unexpected challenge to the proselytising of those committed to progressing the work of the first generation CAAD pioneers is a younger set of reactionaries more inclined to oppose than progress the cause. 'Younger', in this context, refers to a significant cohort of potential movers and shakers who, whilst only in their thirties now, are unlucky enough to have just missed the easy access to more sophisticated software running on cheaper and considerably more powerful computers currently available to students – unless they have made strenuous counter-current steps gain access. In other words, not having been able to get their hands dirty in the way that 'studio' traditionally allows, can force designers with an otherwise reasonable disposition to tend towards a corner. It is one thing to accept a water colourist making a better go of it than oneself: at least we can judge our worth through our personal experience of a relatively familiar task. When the work is not only rather difficult to interpret against conventional composition, but has also emerged from a process that is quite foreign to the critic, special difficulties arise. We can see that our schools today are in a mode change that has no historical precedent for the practice of architecture, at least since the Industrial Revolution.

"Learning from the past" as a means to set *"a foundation for the future"* is thus a more loaded conference theme than might first appear. Through making a case in this brief paper for a digitally sponsored convergence of design education, research and practice, I shall try and sidestep any trite reverence for what has gone before, even that sufficiently robust to survive or thrive in today's context. Alignment with a trajectory of foregrounding the role and status of architectural rendering, faster and ever more accurate costing, tighter project management with the great strides in ICT (Information and Communication Technology) is a manifestly positive benchmark. But *only* to focus on ICT would risk missing some of the great benefits that we are beginning to derive from other shifts in thinking and action. The entry of *"techniques and tools from other fields and uses"* into our repertoire, as the conference theme notes, is surely the true stuff of innovation? This desire to borrow tools and techniques from elsewhere can only be satisfied effectively when we fracture inviolable discipline boundaries, a change requiring a significant cultural shift. This definition of innovation – the lifting of a skill set or tools from one discipline and applying it within another, is especially effective when one foot is kept in the past. This allows for the rediscovery of previously highly valued, latterly overlooked, transdisciplinary relationships whose worth has been judged irrelevant in a recent context. Moving forwards needs to be complemented by looking quizzically over our shoulders at what is being left behind.

Three case studies are offered here as examples of transdisciplinary advantage. Details of one historically grounded research project (Gaudí's Sagrada Família Church) are compared with two recent case studies (urban sculpture and student collaborative work). In all three examples I shall identify where the academy <-> practice <-> design research convergence emerges as a new enterprise, not merely a continuation of what we assume always to have been in place. In doing so, a shift in thinking and action is provoked, offering an essential new link between practice and the classroom – through the addition of CAAD 'research' into the traditional mix.

2. HISTORY

The history of the Sagrada Família Church in Barcelona, the architect Antoni Gaudí's *magnum* opus hardly needs to be told here. The building commenced in 1882 and was inherited by the young Gaudí a year later when the original architect, del Villar resigned on a point of principle: the client had asked the architect to build in a particular way in order to save money, which he regarded as unacceptable interference. Del Villar's proposal was for a relatively modest Gothic Revival church, whereas the young Gaudí quickly persuaded his client to be more ambitious.

Gaudí worked on this project for 43 years until his accidental death in 1926: he was mortally injured by a passing tram. In terms of Gaudí's ambition, the project was inadequately funded from the beginning, and as the project made at times very slow progress, he had the unusual luxury of being able to focus on aspects of the design that ordinarily would not be possible. In a way, notions of rapid process at that time were self-defeating. The complexity of Gaudí's design made the cost go up relative to del Villar's original design, placing increased demands on the limited funds available. Rather than simplify the design to meet the budget constraints, Gaudí used the time to seek means to rationalise the description of the building without compromising the plastic expression. Ironically, what he was proposing for his time was never practically achievable, which more or less remained the case until the arrival of the computer. The direction the project took during his last twelve years – the period when he had eschewed all secular commissions, devoting himself entirely to the project, was one of rigorous application of geometry. All the surfaces of the building from that point onwards were based on second order geometry, more commonly referred to as ruled-surfaces. The surfaces themselves are easy to describe and comprehend: the helicoids, the hyperboloid of revolution, and the hyperbolic paraboloid. Their articulation as a community of intersected forms is far more problematic from a representational viewpoint.

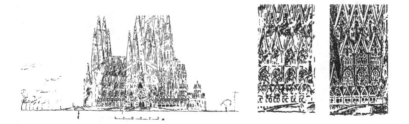

Figure 1 The first drawing to appear of the whole of the Sagrada Família Church, drawn by Gaudí's assistant Rubió in 1906: Gaudí died in 1926. Twenty years later we can see that the Gothic Revival moulding has been replaced by a more plastic surface treatment. In fact, Gaudí had spent the last twelve years of his life exploring second-order (ruled) surfaces, from aesthetic, philosophical, and practical points of advantage

Figures 1 show the project and the migration from freeform to rational geometry. On the left hand side is the first definitive drawing of the project by Gaudí produced by his assistant Rubió under his direction in 1906 – 23 years after his commission, that is, approximately half way through his work on the church. The drawing went through a series of iterative changes but remained the definitive statement of the overall composition right up to Gaudí's death in 1926. It is when we compare details of the first and last version of the sketch that we can see subtle changes, which are in fact the transition from freeform to ruled-surfaces, shown in the two excerpts that are side by side. This can be seen most clearly when we compare the clerestory window (the uppermost row); the window shown in the photograph of the 1:10 scale plaster of Paris model made by Gaudí (Figure 2) has been incorporated into the design. This photograph was taken before Gaudí's death, and is especially important as the models were subsequently smashed during the occupation of the incomplete church during the Spanish Civil War.

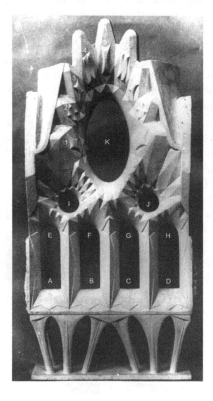

Figure 3 Hyperboloid of revolution showing the 9 parameters that can alter its relationship between neighbours. These are 3 Cartesian coordinates, three axes of rotation about each Cartesian axis, two constants th at determine the 'waist' (collar) dimensions, and a third that defines the asymptote that determines the hyperbolic curvature

Figure 2 Sagrada Família Church clerestory window made at a scale of 1:10 during the years immediately preceding Gaudí's death in 1926. Each letter refers to the Boolean subtraction of a series of hyperboloids of revolution from a notional solid

Overlaid in the photograph are a series of letters referring to hyperboloids of revolution: ruled-surfaces which have been subtracted from the notional wall mass as a Boolean operation. The formal description of a hyperboloid of revolution is shown in Figure 3. Each hyperboloid of revolution has nine constituent parameters that govern its relationship to neighbouring hyperboloids in a geometrical array. When the values of these parameters change *inter alia*, not only is there an extraordinarily detailed disguising the underlying rationalist composition, there is also and extraordinary range of possibilities. The nine parameters are shown in Figure 3.

What makes this project transdisciplinary, a research project, and why would a university be involved?

3. PRE-DIGITAL INTERVENTION

I have worked as consultant architect to the Sagrada Família Church since 1979, commencing as a 'year out' student. During this time I worked on most of the nave construction which has been developed with archaeologically derived geometrical precision from the surviving fragments of plaster of Paris model such as the clerestory window shown in Figure 2. Gaudí had a highly original working method whereby he personally intervened with the craftspeople working with him. In interpreting his design for the nave his successors did not have the advantage of actually composing the building with all the possibilities of direct engagement with the model makers and a slow timeframe within which to cogitate – the latter-day task was essentially one of reverse engineering. My role was to attempt to speed-up the process from one of haptic engagement with rapidly setting plaster of Paris to the cleaner process of descriptive geometry analysed on paper. Predating any thoughts of computers, solid geometry, Boolean operations, or even wire frame representations, the work was fundamentally a mapping exercise. Intersecting these forms in space graphically was a challenge only when interpreting the task from a purely architectural focus. Indeed, while in that mindset, and having only just emerged from my late Modernist chrysalis, my resolution of the task was proceeding nowhere until the quantum leap into cartography. Only when each form was conceived as a terrain with contours could an effective method of intersecting adjacent geometries be derived. Figure 4 shows the side view of a hyperboloid of revolution raised typically to meet the source of natural light thereby distinguishing the exterior (left hand side) and making for richer architectonic expression. Combining inclination of forms with elliptical rather than circular inducing parameters no doubt enlivened the composition; it also has to be admitted that this confounded the cartographical quest many times over.

Figure 5 shows the notional area view of the hyperbolic terrain, effectively the façade. The map shows the positions of each hyperboloid of revolution collar or throat relative to each other, the curves of intersection between the adjacent forms, and more acutely, the points of intersection between any three such curves known as *triple points*. As the composition was based on a system of proportion relatively

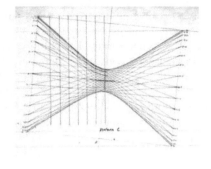

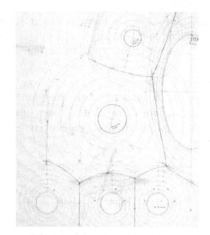

Figure 4 Graphical representation of the parameters

Figure 5 Contours are derived in order to find the intersections

easily derived from the surviving photographs, the fact that the models were in fragments was not the same problem that the team would have been faced with if, say, we were confronted with a similar scenario for the *Casa Milá (La Pedrera)*, the nearby freeform Gaudí apartment block, that mercifully was completed in Gaudí's time. As in any genetic puzzle, with sufficient triple points providing an x, y, and z coordinates common to three intersecting hyperboloids of revolution, the task of reverse engineering was rendered 'not impossible'… but relatively impossible if we continued working using graphical analysis and cartographical constructs.

4. DIGITAL INTERVENTION

In 1989 the first real application of Gaudí's sophisticated ruled-surface geometry was nearing a point of being programmed for building and we were obliged to look at the computer as an aid to speed-up an otherwise unremittingly slow process. At that time it was not clear how these digital explorations might take place, still less where. The investment at that time into an emerging technology without any clear idea of which, if any software would be able to adequately advance the task appeared to be too great, so the opportunity of taking the work into the academic research environment appeared to be a good first move. Within three months it became clear that there was no proprietary software package dedicated for architectural use anywhere in the market capable of doing the tasks, despite many confident assurances to the contrary by the manufacturers concerned. In fact today, whilst the architectural software has come along very significantly, there is no single package that we are aware of that can perform all the tasks required, which is why a significant proportion of the research work undertaken to advance the project takes place in the academy. And it is this essential paradox that makes the Sagrada Família Church such an interesting subject in the debate that connects the fortunes of the future with the experiences of the past.

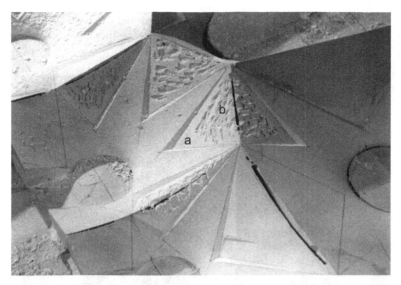

Figure 6 Gaudí probably derived all his large scale models from an iterative hands-on process working more with plaster of Paris than with a pencil

Figure 6 reveals the 3D translation in plaster of Paris from the 2D drawn abstractions, typified by the drawing shown in Figure 5. The curves of intersection and associated triple points can be seen, and the system of decoration allied to the ruled-surfaces' rulings are clear. The translation from Gaudí's hand-making research techniques, through the descriptive geometry to the computer was not an obvious one. Where the relatively weak demands of the architect on 3D spatial modelling had failed to stimulate a market for sophisticated product, the demands of the aero, auto, and marine designers had. Software directed to all three sectors revealed just how sophisticated their needs for complex surface and spatial representation were in comparison. Their software, which quickly revealed its usefulness, was and remains in a cost structure far beyond the reach of most of the construction sector, and today we are still waiting for such product to emerge at an industry appropriate price point. This point is rapidly being reached, fortunately. Fifteen years earlier than the time of writing, software with the capacity to make a series of progressive Boolean operations was esoteric within the architects' world to the point of obscurity. Figure 7, being read from top left to bottom right, however, reveals the power of such operations in the production of Gaudinian form. It is fascinating that the use of software at the time of its first contribution at the Sagrada Família Church was as atypical then as the intellectual and conceptual processes that Gaudí was able to apply to his work in his time. It seems very apposite that he proposed a design methodology initially perceived as quirky by most of those I demonstrated it to in the early days of its use. Yet it appears highly contemporary now.

Figure 7 shows but one iteration in the search for a precision version of the clerestory window that was needed to match the original. While the process was far more rapid than my earlier pursuit by hand drawing, and quicker still than the modelling from Gaudí's time, it was clear from the beginning that we were only

making minimal use of the softwares' potential, which led to Project Architect Jordi Fauli's suggestion that we engage directly with the mathematics underlying the ruled-surface geometry.

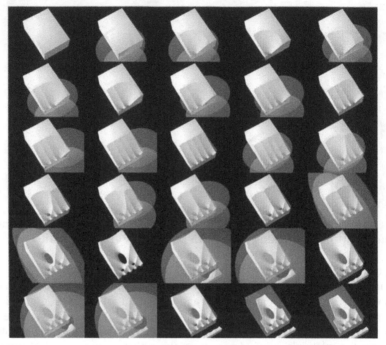

Figure 7 series of Boolean subtractions echoing through the use of the computer an analogue process. The process reads from top left to bottom right

Figure 11 (LHS) shows a detail of a restored fragment of Gaudí's 1:10 model of the clerestory (Figure 2). The surviving fragments of the exterior and interior faces of this window together offer over five hundred points in space. With painstaking care, all these were measured using homemade equipment giving us a series of data files with the 3D coordinates relating to each hyperboloids of revolution. It took twelve person weeks to take these measurements and record them in 1992, this being a year or two ahead of the office of Gehry Partners and their access to medical measuring kit. As a point of interest, in 2003 this work was repeated using a laser scanner returning a point cloud of coordinates in the millions for the same surfaces, such have been the advances during the last decade.

5. BESPOKE SOFTWARE

To find the combination of hyperboloids of revolutions that would match the data extracted from the models, each data file was read into a program *xhyper* written by Peter Wood at Victoria University of Wellington in 1994.

Figure 8 (LHS) The Program *xhyper* written by Peter Wood. Figure 9 (RHS): The data coming from *xhyper* is then post processed by another program *script_gen* written for the purpose of generating an executable script

The data files (Figure 8) identified the points as being crucial, such as the triple points and points around the throat (collar). The next level of importance were the points on the intersection curves while the points on the surfaces (around the borders of the facetted decoration, for example) were regarded as the least accurate, especially as we suspected most of the surfaces to be from elliptical hyperboloids of revolution, and therefore manually interpolated rather than specifically 'found' in space. The points that are listed in the upper window of Figure 8 show the distinction: the letter commencing each descriptor identifies whether the point is exterior or interior, and the sequence that follows identifies the weighting for each point along with its unique identifier. The program Xhyper then used one of two algorithms 'Simplex' or 'Hill Climbing' (depending on the number of variables and/or unknowns in terms of the 9 parameters shown in Figure 3).

At that time the only opportunities that existed for this level of number crunching was to use the Unix platform and x windows – we had tried a very primitive prototype using Basic with DOS, and again it seems that little details like this remind us just how far we have come in a relatively short time.

Having produced a program that was able to match hypothetical but accurate hyperboloids of revolution to the data sets gathered from the laboratory measurements of the surviving models, the next logical step was to tie the output directly to a 3D digital model. This we did by writing an executable script *Script_gen* which output a CSV text that would make each hyperboloid in space for subsequent Boolean operations (Figure 7). A further script performed the sequence of subtractions, labelled and dimensioned the model. The whole operation took just one hour to run for each iteration which was the equivalent of several months of 'cartography' with further months of plaster modelling. Having said this, ninety six iterations were required: the rotation parameter only had to change by 0.25° for a substantial change to result in the curves of intersection, and more importantly the triple points. Just at the time when we felt that as a team we could congratulate ourselves on the finesse we had brought to the task, we would pull ourselves up short as we realised that Gaudí managed this finesse in his head, without the need for ninety six variations. In fact, we know of only two.

Figure 10 compares the trimmed hypothetical surfaces resulting from *xhyper* with the points and connecting lines measured in space on the original models, and the close match can be appreciated.

11

Figure 10 Comparison of trimmed ruled-surfaces as intersected 'optimised' hyperboloids of revolution shown against the wireframe of actual data

Figure 11 Final computed and digitally represented outcome

Figure 12 Digitally modelled exterior to the Sagrada Família nave clerestory

Finding the parent surfaces was actually just the beginning; the decoration and other embellishment contingent on the abilities of the software at that time in being able to trim surfaces, and ultimately build competent solids. Figure 12 shows the 3D digital model completed in 1994, and can be compared with the photograph (Figure 2), which we suspect dates from 1922.

For the last decade we have been experimenting with parametric design, the first instance of its direct application to the Sagrada Família Church being the row of columns that form the triforium below the clerestory. This detailed account for the design of the now constructed window along the length of the central nave is to provide insight into how a diverse team first had to be formed in order to accommodate Gaudí's unique way of working, provoking a resident expertise in ways to get the best out of collaboration with the computer.

An assertion that the Sagrada Família Church is one of the world's most progressive projects, and not the anachronism that so many have presumed, requires some justification. Rather than posit the analysis, interpretation, and resolution of the models, followed by the synthesis and ultimately the application of the ruled-surfaces described above as being the main innovation, I believe that there are other more fundamental values being established through the project. Principally, it is the actual teamwork behind the project that offers an alternative model of practice. The way the digital opportunities have been approached, and what this represents in a context extending far beyond the particular idiosyncrasies and needs of the Sagrada Família Church offers some new foundations firmly rooted in the past. The project has embraced a dialogue with research groups at several universities, and stimulated (almost) a generation of students on that basis.

6. TRANSDISCIPLINARY DESIGN COLLABORATION

The following table delineates the contribution from the transdisciplinary design team, outlining their contribution and the phases of the project that they contributed to.

Table 1 Transdisciplinary design collaboration (Sagrada Família Church)

Discipline	Contribution	Phase of project
Architects (prior to 1989)	Conceptual design – Gaudí died in 1926 leaving the design for the remaining two transepts based on the almost completed Nativity Façade, the nave fully modelled at scales of 1:25 and 1:10, the whole composition sketched (Figure 1) as a plan, section and elevation, and models for the sacristies designed to be prototypes for the remaining towers (other than the transepts).	The client regards the building as 'Gaudí's project', and Gaudí is referred to today as the Sagrada Família Church's architect.
Archaeologist	The models were severely damaged with the fragments dispersed around site such that they are still being recovered. These have	From 2000 the project has moved to the central crossing and apse area that was documented by Gaudí only

	had to be looked for, then identified, catalogued and stored.	as sketches. Vital pieces of his known experimental work that can be seen in photographs are still sought and profited on when found.
Archivist	All Gaudí's drawings and models were burnt during the Spanish Civil War. The handful of surviving drawings and photographs had to be looked for and assessed for their usefulness	This role has been essential and maintained on site since Gaudí's death.
Draftspersons	Basic information needed to be extracted from the model fragments, initially as measured drawings, more recently as 3D scans	Essential in Gaudí's day, now increasingly irrelevant as the direct modelling to production opportunities increase
Model makers	The surviving fragments of model had to be reassembled into as close an approximation of the original model as possible. The model makers have also had to invent machinery and techniques to allow Gaudí's haptic experimentation to continue. Ultimately the model makes need to make the precision versions of the applied geometry at scales of 1:25 and 1:10 to 'test' the proposals prior to actual building. Rapid prototyping contributes to this process but has not replaced it.	Despite the heavy use of rapid prototyping on site via 3D printers, the number of model makers has risen on site indicating their prominent role, not just as scale modellers but as production modellers for 1:1 moulds etc.
Historian	Because of the cultural significance of this building, and the many mysteries that surround it, almost all moves have to be qualified by an historical perspective. Significant material continues to turn-up such as the urban plan for the 'star-shaped plaza' surrounding the building, lodged with the Town Council in the 1910s, and only just located during recent years.	The building's historical context manifestly becomes more complex with the passage of time
Cartographer / descriptive geometers	All the surfaces are based on a rational geometry, principally ruled-surfaces. Their interrelationships are not in the typical province of the architect although it is noted here that the School of Architecture in Barcelona retains a Department of Descriptive Geometry (recently renamed to fit the times).	Always important, the arrival of 3D laser measuring and other scanning techniques makes the topographers' role evermore prominent
Mathematicians	To rely on graphical analysis alone, while substantially speeding-up the process, is not enough, especially once digital assistance is sought. In order to enter the geometry into the computer, while possible through mimicking the hand drawn techniques, it is far more efficient to do so as mathematical formulae. While recognising that this task is relatively trivial for the mathematician, it is well beyond the skill set of a typical architect	Mathematicians have only entered the project once it became clear that efficiency through the use of software depended substantially on direct mathematical input
Programmers	If we are going to work with formulae, it is not enough to rely on proprietary software	Once mathematics became a core component to software use,

	interfaces, and necessarily programmers are required to adapt such packages to the particular needs of the project.	programming was required to make full use of their contribution given the potential of any given package was significantly enhanced beyond 'out-of-the-box' capability.
Structural engineers	Every move made at the Sagrada Família Church has to be qualified structurally as Gaudí has setup the whole building as a piece of equilibrated design.	As the building becomes higher, and regarding making use of existing foundations, the role of the structural designer becomes more significant, especially in the pursuit of increased material strength and performance.
Architects (after 1989)	The role of the Sagrada Família Church architects since 1989 have necessarily encompassed the use of the computer, and with it necessarily are quite different from any that went before. Points of commonality remain the sketch pad and the gesture. In all other respects the working practice is entirely different, as are the relationships between the architects and collaborators which are probably far less hierarchical than used to be the case.	The shifts in the role of the architects and the particularities of the construction evolution seem to be intimately tied and co-dependent. The role of the architect is changing significantly, with the emergence of specialist 'project design architects' and 'detailed design architects'
Boat builders	Much of the building needs to be prototyped at full-scale for the purpose of testing the design visually or making moulds. He architects have relied on the nautical industry for many of the techniques, just as Gaudí himself used boat builders for the structure of his 'La Pedrera' apartment building.	It is clear that Gaudí has relied on peripheral and improbably connected skill-bases outwith the construction industry from the first, as much as he drew deeply from the oldest traditions.
Topographers	The nature of the design requires topographers to measure the building as much in the air as on the ground, and connect almost on a daily basis with the architects.	This role has evolved from surveying to 'spatial collaboration', and is expected to become more so as the project becomes more complex.
CAD/CAM Auto engineers	All work that can be practically undertaken by CNC techniques is done so using a skill base imported directly from the auto and aero industry.	Once the shift to manufacturing processes has been made it is assumed that the new processes will acquire their own AEC identity.
Stonemasons	It is impossible to work on this project without engaging the stonemasons from the moment of inception. All aspects today push the use of stone to new limits both in terms of production and performance, which has been the case since Gaudí first led the building project.	Towards the end of his involvement Gaudí himself experimented in composite materials, notably with the design and execution of the Nativity Façade belltower finials. At this point the history of the project shows new materials and techniques being added to the mix rather than replacing any.

7. POST DIGITAL TRANSDISCIPLINARY DESIGN COLLABORATION: 'SHOAL FLY BY'

Table 1 shows the various core disciplines, the role their members played, and the stages of the project that they contributed to. If the story ended there it would be an interesting piece of history. However, the project that follows shows that the methodologies and new research relationships with the academy are as potent for contemporary projects, and that they do not have to be 'cathedral scale'.

In 2002 two architects / artists from a small town outside Melbourne Australia contacted our research facility based at RMIT University. They had heard of our work with the Sagrada Família Church and wondered if we could provide some assistance with building a competition piece that they had won. When they visited the brought with them a maquette of the piece 'Shoal Fly By' – one of five intended pieces to adorn the new waterfront of the Docklands urban renewal project in Melbourne (Figure 13). The pieces, inspired by the idea of engaging the passer by with a shoal of fish, at the scale of the maquette, were relatively miniature delicate assemblies of twisted wire with the odd pink 'shape' being held aloft.

Our first step, under project leadership of Andrew Maher, was to engage the tube benders and fabricators at the beginning, and in every conversation involving ways and means to construct the pieces with the designers. This was a direct lesson from the Sagrada Família Church, and one that yielded immediate dividends.

Figure 13 Post digital teamwork: artists Michael Bellemo and Cat Macleod discuss their maquette for a 90 metre long sculpture 'Shoal Fly By'	Figure 14 The maquettes were scanned in 3D producing a cloud formed from millions of points in space

We scanned the model (Figures 13 and 14), and took the point cloud into a parametric modelling environment, with which we produced a 3D digital model for the designers to sign off. From this point, the 3D digital representation of the model held no further interest to us. Each strand of the model was extracted as a tube following a nurbs curve.

There being no facility in Melbourne remotely capable of bending a nurbs curve, we had to find a way of working in a series of cotangent arcs (Figure 15). Peter Wood in Wellington was again the computer programmer who provided an interface between us and our instrument.

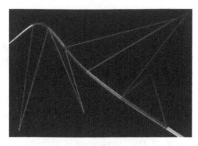

Figure 15 Each strand has to be rationalised as a series of cotangent arcs that seamlessly join

Figure 16 Using more arcs per strand raises the cost but closes the gap between the original and its rationalised equivalent

We worked with a model of each strand, and in discussion with the tube benders and the fabricators, were able to establish a 'so many arcs per strand' agreement. If we had a large number of arcs with which to engage, we could seamlessly approximate the original nurbs curve very closely, but the cost would be relatively high. Figure 16 shows that by reducing the number of cotangent arcs lowered the overall cost but downgraded the degree of match. Our program allowed us to tinker in the presence of the builders and architects / artists resolving the project to acceptable margins to all concerned. The characteristics and kinks of each strand that were important to the projects authors survived their digital translation perfectly. Figure 17 is a view of the digital project.

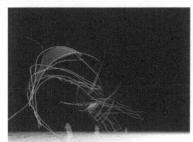

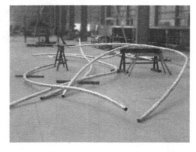

Figure 17 Digital rendering

Figure 18 The arcs become strands

Three other innovations added value to this project. The first was the absence of any drawings. Once the strands had been resolved into arcs using our program, their detailing was entirely by spreadsheet. The tube benders and fabricators worked entirely from this source, the columns providing respectively the radius, length and curvature of the arcs, and the positions in space and relative rotation.

The second innovation was inadvertently hitting upon the escape route of the bread and salami approach to 'blob solving'. It seems that one of the greatest digital triumphs today is fabrication based on the digital resolution of sufficient 2D profiles to provide a structural solution to any weird shaped building. With the method described above, the structural layout may be considered as 3D curves based on any criteria and not solely on a slicing routine within the software. The isoparms on the

surface, for example, can be extracted and be used as the guides for appropriately sized structural members composed of cotangent arcs. Although we have since discovered two other teams hitting upon this method for solving the 3D curved edge to a spatial element, we believe that this the first structure of its kind conceding completely to the spatial design, and not the more typical *vice versa*.

Finally, the third innovation was to involve two senior students in this project firstly as an elective study during semester, and then as summer scholars. Rather than simply being on the payroll (which of course they were), the emphasis was on co-ownership. And in working in this way, the power of the analogue balanced very well the digital intervention, providing a powerful post digital experience for all.

The project has two of the intended five pieces built along the new waterfront (Figures 19 and 20). The longest will be approximately 90 metres, somewhat larger than the model that came in a shoebox, the essential analogue constituent to what was otherwise a purely digital progression to completed artefact.

Figure 19 The sculpture was made and first erected in an industrial building

Figure 20 The first of five 'Shoal Fly By' sculptures in place

Table 2 Transdisciplinary design collaboration ('Shoal Fly By')

Discipline	Contribution	Phase of project
Architects / artists	Conceptual design – the project was fully developed from the outset as an analogue physical model.	The project originators were fully involved through the entire project.
Draftspersons (research assistants)	Basic information needed to be extracted from the model fragments as 3D scans	Skills in scanning required for the initial digital design phases only

Model makers	A dummy model had to be made initially top perfect the scanning techniques given the combination of the original model's fragility, and the fact that the authors wanted it to remain intact	Despite the heavy use of rapid prototyping on site via 3D printers, the number of model makers has risen on site indicating their prominent role, not just as scale modellers but as production modellers for 1:1 moulds etc.
Tube benders	The tube bender needed to be consulted from the beginning to reach a common position on hows and when	Crucial at the early stages they were nevertheless fully involved right up until fabrication
Fabricators	The fabricators were consulted from the beginning to reach a common position on the ways the project would be built. The dialogue with the fabricator remained steady and crucial throughout the project.	
Mathematicians	To rely on graphical analysis alone, while substantially speeding-up the process, is not enough, especially once digital assistance is sought. In order to enter the geometry into the computer, while possible through mimicking the hand drawn techniques, it is far more efficient to do so as mathematical formulae. While recognising that this task is relatively trivial for the mathematician, it is well beyond the skill set of a typical architect	Mathematicians entered the project at the commencement since we realised from the Sagrada Família Church project that efficiency through the use of software depended substantially on direct mathematical input.
Programmers	As with the Sagrada Família Church, if we are going to work with formulae, it is not enough to rely on proprietary software interfaces, and necessarily programmers are required to adapt such packages to the particular needs of the project.	Mathematics was a core component to software use from the outset, programming was required to make full use of their contribution given the potential of any given package was significantly enhanced beyond 'out-of-the-box' capability.
Structural engineers	Involved from the commencement with a certain amount of risk taking being undertaken, given the desired slenderness of the tubes selected.	More involved at the outset with the project originators, and not especially involved with the digital design development at all, as far as we could discern.
Design development architects (after the conceptual design phase)	The role of the design development architects commenced after the conclusion of the conceptual design. This would on paper appear not to be ideal, but in fact worked fine in that there were no discernable tangled egos or vanities throughout the project, the biggest killer to post digital design shared authorship projects such as these.	The design development architects came in after the competition had been won, so there was never any competing agenda: the design, as a winning concept, belongs to the competition winners.
Topographers	The nature of the design requires 'topographers' to measure the structure as much in the air as on the ground, and connect almost on a daily basis with the architects.	This role has evolved from surveying to 'spatial collaboration', and is expected to become more so as complex projects such as this place far greater demands on the spatial 'fixer'.

8. POST DIGITAL TRANSDISCIPLINARY DESIGN COLLABORATION: 'THE POLITICS OF WATER'

The final transdisciplinary post digital project to be described here, the *Politics of Water*, is one of the outcomes from a studio we ran last year with a mixture of architecture and industrial design students. Features of the studio were derived from the very positive experience we had with the *Shoal Fly By* project the year before.

The *Politics of Water* studio was conceived as a semester long project in three stages – two research-through-design focused and one more conventionally applied research. In t he first stage the class worked individually coming to terms with the designer's opportunities to express the physical and political attributes of water. There were no expectations of difference in approach anticipated between the architects and the industrial designers. In the second phase, however, a distinction was expected as each student worked on a project based on or around water at any scale that suited them. An architecture student Tatu Parsinnen, for instance, proposed a grid-shelled concrete swimming baths on the water where the tide movement outside manifested itself inside (Figure 21 LHS). Industrial designers worked on projects such as a new kind of umbrella to objects of a far more esoteric nature.

Figure 21 Original proposal for a public baths (LHS); modified with window opening sizes are determined by the activities within the swimming pool (RHS)

For the final phase, the students formed into groups from both disciplines, each working on a project that did not come from any of the group members – the role of author and the concept of authorship was questioned through the detailed design development of someone else's baby. Figure 21 RHS shows the effects of the major conceptual leap the inheritors made to Tatu's project, ultimately blessed by the original author, I hasten to point out. Why, they asked, given the various levels of privacy required in the different areas of the pool, were all the windows the same size?

This question was dealt with using *Photoshop* where the group did nothing apart from coaxing the grid into more generous areas of glass, and others into tighter areas. Stung (perhaps) by the criticism that they had locked the 'developer' into a project requiring umpteen unique pieces of glass, they set about resolving this challenge parametrically. This they achieved through an analogue parametric model shown in Figure 22. The theory runs thus: each exterior opening is set by the expanding and contracting distortion of the original grid. Using a range of only 5 rectilinear sheets of glass, these would be moved in space until a workable opening

to the interior of the space was found through experimentation – shown in the model through the rubber band quadrilaterals stretched by the parametrically alterable positions for the edges to the reveals. Figure 22 LHS and centre show two solutions to the exterior opening, and RHS shows them both superimposed. In seeking to provide evidence for a digitally sponsored convergence of design education, research and practice, I believe that this project along with the other four companion projects from the studio provides a compelling case for fusing architecture and industrial design students and their respective design sensibilities.

Figure 22 There are five sizes of glass proposed for the swimming pool, but many more variants for the actual opening sizes can be found using this analogue parametric model

9. CONCLUDING COMMENTS

Motivated by the observable practice uptake (predominantly 3D rendered images and animations, 2D drafting and associated text management), investigations into the extent to which the computer actually assists in the design process have been secondary to more pragmatic goals in most schools and practices. 'Design' software development has been progressively providing a more persuasive exposition of the design outcome – such as the precise 2D drafting that describes the building to the builder, and a broad range of value added services including virtual 3D modelling, model rendering, image manipulation, animation, and production management. Software dedicated to each or several of these tasks continues to dominate in practice, which is less inclined to take up the design exploratory tools favoured by some sectors of the academy.

Much is made of the ongoing debate in which the possible augmentation of design process through digital intervention is pitted against the presumed ability of the computer to take an eventual lead in design synthesis. The dilemmas about the desirability and viability of CSAD (*computer sponsored architectural design*) have perhaps masked tendencies that are becoming ever more manifest, which represent quite different opportunities for architectural designers regardless of individual software development strategies: convergence between design education, research and practice. This convergence not only offers fluency across all three areas of activity within the discipline, it also erodes the preciously guarded delimitation of architecture as a discrete and professionally protected discipline.

Software that crosses traditional discipline boundaries through its generic spatiality, for instance, provides those with the most appropriate training and experience with a greatly broadened career path. The architects' role may be expanding in scope but so too is the risk that others from a different discipline base and training have arrived in a better position to challenge the traditionally exclusive roles of the architect. Sophisticated software in the uneducated hands may merely enfranchise the amateur to do a less than professional job.

To conclude, *Learning from the Past - a Foundation for the Future*, is a perfectly valid proposition, so long as we expel a lot of the baggage that can come with holding onto the past. As Gaudí showed us, we might complement the best of the old with learning to love informed risk-taking (again), and welcome radical but testable new departures within our contemporary design process, digitally inspired or otherwise. I believe that this is still the cultural shift that is required in both practice and the academy as an *a priori* to focusing on the 'digital shift' for itself.

ACKNOWLEDGEMENTS

Sagrada Família Church: The research reported here has been part funded by the Australian Research Council. I acknowledge their support and that of the Junta Constructora of the Sagrada Família church in Barcelona for the opportunities they provide for extending the work of Gaudí into contemporary architectural practice and research [Team: Mark Burry (Architect), Peter Wood (computer programming), Jordi Cussó, Josep Talledes, (model makers) Jordi Bonet (Architect Director and Coordinator), Jordi Faulí (Project Architect)].

'Shoal Fly By' (public art for the Melbourne Docklands precinct): Michaels Bellemo, Cat Macleod (commissioned architects / artists). Mark Burry, Andrew Maher, (Architects), Peter Wood (computer programming), Rebecca Naughtin, Lee-Anne Khor (Summer Scholars), BENDTECH Industries (Tube Bending), Olivetti Engineering (Fabrication)

Politics of Water: Tatu Parssinen (concept) Sheree Danli Lai, Tony Josendal, Jakob Lange, Stephen Wallace (developed design), Mark Burry, Dominik Holzer, Malte Wagenfeld, Mark Taylor (studio directors).

Space, Time, Mind:

Toward an Architecture of Sentient Buildings

MAHDAVI Ardeshir
Department of Building Physics and Building Ecology, Vienna University of Technology, Austria

Keywords: sentient buildings, computational models, environmental controls

Abstract: This paper describes a specific vision of a sentient building and a specific path to its realization. A sentient building is defined here as one that possesses a representation of its own context, components, systems, and processes. It can autonomously maintain and update this representation, and it can use this representation toward real-time self-regulatory determination of its own state.

1 MOTIVATION

In the history of architecture, there have been persistent tendencies to project onto buildings more than "mere" inanimate matter. Occasionally, symbolic and theatrical means have been deployed to create buildings that appear to be alive and spirited. The industrial age provided the machine as an alternative paradigm for the negation of the kind of inertia typically associated with buildings. While mechanical constructs were soon seen to be too primitive a model for life and sentience, a certain process of convergence in the ontology of the mental and the machine-like has continued to the present time. This process reached a new quality as a result of advances in computer science and speculations regarding the alleged computational underpinnings of mind. The computational paradigm has provided a new kind of program to transcend the inertness of built objects, involving the projection of computationally-based intelligence and sentience onto buildings.

The present contribution describes a specific vision of a sentient building and a specific path to its realization (Mahdavi 2004a). As such, it may be situated in the general context of computational approaches toward the processes of conception, construction, and operation of buildings. However, it must be stated clearly at the outset, that here the use of the term "sentience" is not metaphysically loaded. Rather, sentience denotes here merely the presence of a kind of computational second-order mapping (or meta-mapping) in building systems operation. This requires that the flow of raw information collected around and in a building is supplied to a building's continuously self-updating model of its own constitution and state. Thus, a sentient building may be defined as one that possesses a representation of its own context,

B. Martens and A. Brown (eds.), Computer Aided Architectural Design Futures 2005, 23-40.
© 2005 *Springer. Printed in the Netherlands.*

structure, components, systems, and processes. Ideally, it can autonomously maintain and update this representation, and it can – based on objective functions and within limits set by occupants – use this representation toward real-time self-regulatory determination of its own state.

To understand why the embodiment of representational sentience may be advantageous, one only needs to take a brief look at the operational processes in complex buildings. Buildings are complex not only because they require the integration of multiple spatial functions and multiple environmental and operational systems, but also because they must satisfy multiple (sometimes conflicting) requirements. Specifically, multiple environmental systems (e.g. for heating, cooling, ventilation, lighting, security) must operate in a manner that is occupationally desirable, energy-effective, environmentally sustainable, and economically feasible. A considerable number of buildings fail to meet these requirements. This failure is, in part, due to insufficiently integrated operation of multiple building systems across multiple levels of spatial hierarchy.

The approach elucidated in the present contribution is motivated by the assumption that a building's operational system can benefit from the presence of an explicit, comprehensive, and dynamic (ideally self-actualizing) model of its composition, status, and context. Representational sentience arises, for example, when this model is used by a control instance to assess a building's past behavior or to perform exploratory behavioral predictions of the future states of the building as a consequence of alternative operational scenarios. Such predictions can be appraised by the building's control system to determine the preferable operational regime for the building and its systems.

Section 2 of the paper defines building sentience and describes its elements. Section 3 deals with the representational foundations of sentient buildings. It covers the nature of entities and processes to be considered in a sentient building model (section 3.1) and describes how a structured template for such a model can be generated (section 3.2) and autonomously actualized (section 3.3). Section 4 concerns the embodiment of control semantics for building operation in the in a dynamic sentient building model. Section 5 includes the paper's concluding remarks.

2 ELEMENTS

Put simply, building sentience involves: *i)* the building with its processes, occupancy, and context as the source of information; *ii)* the representation of this information in terms of a dynamic model; *iii)* building operation support applications that make use of this model (see Figure 1).

Information toward the construction of a sentient building's representation can stem from various sources: *a)* physical building components with associated geometric, topological, and semantic attributes; *b)* technical building systems and their status; *c)* indoor conditions (thermal, air quality, visual, acoustical, etc.); *d)* presence and actions of building occupants; *e)* building context (site and surroundings, weather conditions).

As captured in a self-updating building model, such information can support the workings of multiple applications such as: *i)* building memory (information repository on the buildings past states and performance); *ii)* facility management; *iii)* information services for user query and request processing; *iv)* building systems for indoor environmental control.

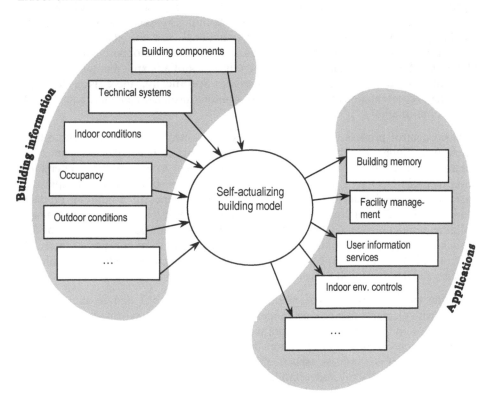

Figure 1 Elements of sentient buildings

25

3 REPRESENTATION

The underlying representation of a sentient building must capture both product and process aspects. It must represent the elements, features, and systems of the building as a physical artifact. But it must also cater for the dynamic processes in and around building. Of particular interest is in the context of the present paper the class of control actions pertaining to the operation of the environmental systems of the building.

3.1 Product and Process

As far as the representation of the building as an artifact is concerned, numerous representational schemes (product models) have been proposed to describe building elements and components in a standardized fashion (see, for example, IAI 2005). Thereby, one of the main motivations has been to facilitate hi-fidelity information exchange between agents involved in the building delivery process (architects, engineers, construction people, manufacturers, facility managers, users). The representational stance of building product models is commonly static (see Figure 2 as a – schematically illustrated – example of a building product model). In contrast, building control processes require representational systems that can capture procedural sequences of events, decisions, and actions. As opposed to abundant literature in building product modeling, there is a lack of an explicit ontology for the representation of building control processes. Specifically, there is a lack of consistent representations that would unify building product, behavior, and control process information.

A basic control process involves a controller, a control device, and a controlled entity (see Figure 3). An example of such a process is when the occupant (the controller) of a room opens a window (control device) to change the temperature (control parameter) in a room (controlled entity). Now, how can one couple the basic process model depicted in Figure 3 with an instance of a building product model (Figure 2)? Figure 4 illustrates a high-level version of such a combined building product and control model (Mahdavi 2004b). While certain instances of the product model such as building, section, space and enclosure constitute the set of controlled entities in the process view, other instances such as aperture or technical systems and devices fulfill the role of control devices.

Both the basic control process model depicted in Figure 3 and its embellished version with elements of a product model (Figure 4) are rather schematic. They must be extended and augmented to capture the details of realistic control processes. To achieve a more detailed and operationally effective representational integration of building product and process aspects, this scheme must be realized within the context a two-fold hierarchy, one pertaining to the building product classes and the other pertaining to controller classes. Key to the communication between the two hierarchies is the Janus-faced notion of the "controlled entity" (or "control zone"). From the product model view point, a control zone corresponds either directly to a product model entity (such as space) or to an entity derived by partition or

aggregation of product model entities (e.g. a workstation within a room, a collection of windows in a facade). From the control model point of view, a zone is a control object (a controlled entity), whose control-relevant attribute (control parameter) is monitored via corresponding sensors. From this perspective, thus, a control zone is defined in terms of the association of a control device and a sensor. As Figure 5 illustrates, zones can be viewed as fluid and reconfigurable entities, which represent the target of control operations and whose spatial extension may be mapped back to (properly partitioned or aggregated) components of a building product model. Devices and sensors can also be mapped back to a product model in terms of physical objects (cp. Figure 2).

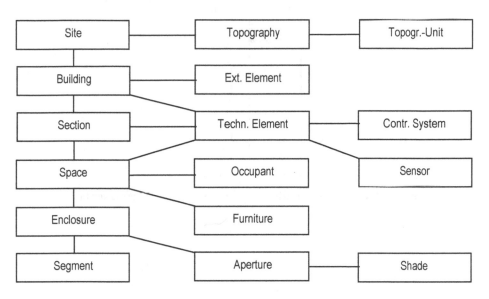

Figure 2 The building product model SOM (Mahdavi 1999, Mahdavi et al. 2002)

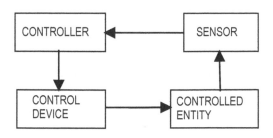

Figure 3 Schematic illustration of a typical control process

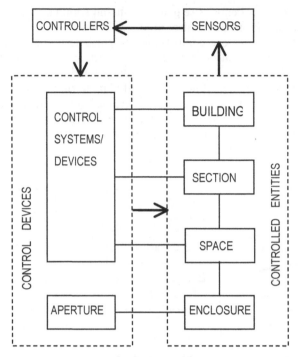

Figure 4 A combined building product and process representation

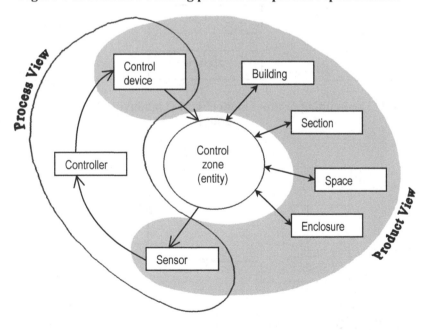

Figure 5 Control zone (entity) as the link between product and process aspects in building representation

3.2 Generation of the Representation

Whilst the building product modeling community is quite experienced in dealing with complex hierarchies of product model components, explicit hierarchical schemes for the representation of control processes are far less developed. Strictly speaking, the "controller" entity, as shown in the basic schemes of Figure 3 to 5, applies only to a "device controller" (DC), i.e. the dedicated controller of a specific device. These schemes stipulate that a DC receives state information of a controlled entity directly from a sensor, and, utilizing a decision-making functionality (e.g. a rule or an algorithm that encapsulates the relationship between the device state and its sensory implication), sets the state of the device. Real world building control problems are, however, much more complex, as they involve the operation of multiple devices – and associated distribution networks – for each environmental system domain and multiple environmental system domains (e.g., lighting, heating, cooling, ventilation). An appropriate representation of control processes must thus capture the relationships between primary device controllers and various layers of higher-level controllers (or meta-controllers). Moreover, it must be created based on a logical and coherent method, ideally allowing for the automated generation of the control process model (Mahdavi 2004a, 2004b).

Generally speaking, the complexity of building systems control could be substantially reduced, if distinct processes could be assigned to distinct control loops. However, controllers for various systems and components are often interdependent. A controller may need the information from another controller in order to devise and execute proper control actions. For example, the building lighting system may need information on the building's thermal status (e.g. heating versus cooling mode) in order to identify the most desirable combination of natural and electrical lighting options. Moreover, two different controllers may affect the same control parameter of the same impact zone. For example, the operation of the window and the operation of the heating system can both affect the temperature in a room. In such cases, controllers of individual systems cannot identify the preferable course of action independently. Instead, they must rely on a higher-level controller instance (i.e., a "meta-controller"), which can process information from both systems toward a properly integrated control response.

Thus, the multitude of controllers in a complex building control system must be coupled appropriately to facilitate an effective building operation regime. This requires control system features to integrate and coordinate the operation of multiple devices and their controllers. Toward this end, control functionalities must be distributed among multiple higher-level controllers or "meta-controllers" (MCs) in a structured fashion. The nodes in the network of device controllers (DCs) and meta-controllers (MCs) constitute points of information processing and decision making. The manner in which the control system functionality is distributed among the controllers must be explicitly configured. The control process model must be created using a logical, coherent, and reproducible method, so that it can be used for a diverse set of building control applications. Ideally, the procedure for the generation of such a control process scheme should be formalized and automated, given its complexity, and given the required flexibility to dynamically accommodate changes

over time in the configuration of the controlled entities, control devices, and their respective controllers.

Previous work has demonstrated the potential of a rule-based approach toward the automated generation of the control system model (Mahdavi 2001a, 2004b). Such a model can provide a syntactic template (or framework) of distributed nodes which can, in a next step, accommodate control semantics, i.e. the various methods and algorithms for control decision making. To generate the syntactic control framework, model generation rules are applied successively, resulting in a unique configuration of nodes that constitute the representational framework for a given control context. To start the process of control scheme generation, first the set of sensors and device controllers (DCs) are specified and the associations between them are established. Subsequently, the generation of the control node hierarchy can proceed as follows:

i. The layer of first-order MC_1s is derived as needed. A MC_1 is necessary, if a sensor is affected by more than one DC.

ii. The layer of second-order MC_2s is derived as needed. A MC_2 is necessary, if a DC is affected by more than one MC_1.

iii. Successive layers of higher-order Meta-controllers (MC_is) are derived as needed. A MC_i is necessary, if a MC_{i-2} is affected by more than one MC_{i-1}.

The following example illustrates the application of these rules. The scenario includes two adjacent rooms, each with two luminaires ($L_{1.1}$, $L_{1.2}$, $L_{2.1}$, $L_{2.2}$), two windows ($W_{1.1}$, $W_{1.2}$, $W_{2.1}$, $W_{2.2}$), a radiator (R_1, R_2) and a shared external moveable shading device (S) for daylight and insolation control (see Figure 6). In each space, illuminance and air temperature are to be maintained within the set-point range. Corresponding indicators are monitored via four illuminance sensors ($E_{1.1}$, $E_{1.2}$, $E_{2.1}$, $E_{2.2}$) and two temperature sensors (θ_1, θ_2). Once the associations of the devices and sensors have been determined, generation rules can be applied to the control problem, resulting in the scheme of Figure 7. In this case, 6 first-order MCs ($M1_1$ to $M1_6$) are generated to account for those instances, where a control zone (as represented by a sensor) is affected by more than a control device. For example, sensor $E_{1.1}$ is affected by devices $L_{1.1}$, $L_{1.2}$, and S, implying the need for $M1_1$. Analogously, three second-order MCs are generated to account for those cases, where a control device is affected by more than a first-order MC. For example, device $L_{1.1}$ is connected to both $M1_1$ and $M1_3$, implying the need for $M2_1$. Finally, a third-order MC (M3) is resulted, due to the circumstance that some first-order MCs (i.e., $M1_1$, $M1_3$, $M1_4$, and $M1_6$) are affected by more than one second-order MC. Using this methodology, a unique scheme of distributed, hierarchical control nodes can be constructed. This model generation approach can be automated and enables, thus, the control system to effectively respond to changes in spatial organization, control zone configuration, and control components. Moreover, the systematic and explicit definition of sensors, zones, devices, controllers, and their relationships, together with the aforementioned generative rules provide a control systems design environment that is advantageous in terms of scalability and robustness.

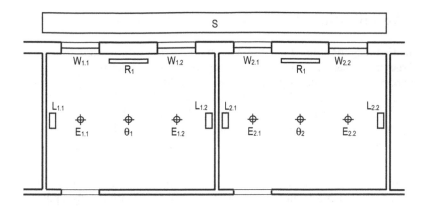

Figure 6 An illustrative test space configuration for the generation of control syntax scheme (see text)

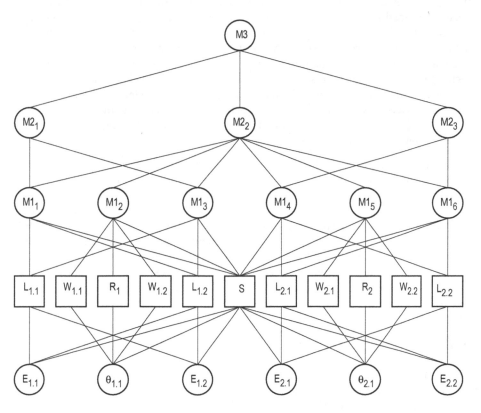

Figure 7 A hierarchical control node scheme generated for the configuration shown in Figure 6 based on a set of rules

3.3 Actualization of the Representation

Subsequent to the generation of a building model with information on building context, structure, systems, processes, and occupancy (see Section 3.2), it can be used to support the real-time building operation (building systems control, facility management, etc.). However, given the complexity of such a model, it needs to be self-actualizing, i.e. it must maintain and update itself fairly autonomously. Otherwise, the bottleneck involved in a manual model updating scenario would represent an insurmountable problem for the practical feasibility of building sentience.

Depending on the type and the nature of the entity, system, or process to be monitored, various sensing technologies can be applied to continuously update the status of a building model. For example, required sensors and data collection, storage, and processing tools for the continuous monitoring of the outdoor and indoor environmental conditions are widely available. However, further progress in this area regarding cost reduction and technical interoperability is both possible and necessary. Section 3.3.1 describes, as a case in point, recent advances in low-cost real-time sky luminance mapping toward supporting applications in daylight and solar radiation control domains. As to the presence and activities of building occupants, relevant information may be gained via existing motion detection technologies (based on ultrasound or infrared sensing) as well as machine vision. Likewise, the status of moveable building control components (windows, doors, shading devices, etc.) and systems (e.g. actuators of heating, cooling, ventilation, and lighting systems) can be monitored based on existing technologies (e.g. contact and position sensing, machine vision).

Tracking the changes in the location and orientation of building components such as partitions and furniture (due, for example, to building renovation or layout reconfiguration) is a more formidable challenge. Different technologies are being developed and tested based on wireless ultrasound location detection, radio frequency identification, and image processing. Moreover, methods and routines for the recognition of the geometric (and semantic) features of complex built environments are being explored toward automated generation and continuous updating of as-is building models. Section 3.3.2 illustrates, as an example, ongoing research pertaining to an optically-based location sensing strategy in built environments.

3.3.1 Sensing the Context: The Case of Sky Scanning

The availability and quality of daylight in indoor environments is amongst the primary concerns of indoor environmental performance. Daylight simulation can assist model-based building systems control applications (Mahdavi 2004a, 2001b). Reliable prediction of daylight availability in indoor environments via computational simulation requires reasonably detailed and accurate sky luminance models. As past research has demonstrated (Roy et al. 1998), relatively low-cost sky luminance mapping via digital imaging could provide an alternative to high-end research-level

sky scanners and thus support the provision of information on sky luminance distribution patterns on a more pervasive basis.

To examine the reliability of camera-driven sky luminance maps, we placed a digital camera, equipped with a fisheye converter and pointing toward the sky zenith, on the roof of a building of the Vienna University of Technology (Austria). A total of 170 images were collected (see Figure 8 for an example) under varying sky conditions. Simultaneously, the luminance due to sky was measured using a photometric sky monitoring device. Additionally, the illuminance due to the entire sky dome was measured using a precision illuminance meter. To further calibrate the process, a correction factor was applied to the digitally gained luminance values. This correction factor was derived as the ratio of the optically measured horizontal illuminance due to the entire sky dome to the horizontal illuminance of the sky as derived from digital images (Mahdavi and Spasojevic 2004). Figure 9 shows the relationship between photometrically measured (vertical axis) and the corrected camera-based luminance values (horizontal axis). The correlation coefficient (r^2) of the corresponding linear regression amounts to 0.83.

Figure 8 A sky image taken with a digital camera equipped with a fisheye lens

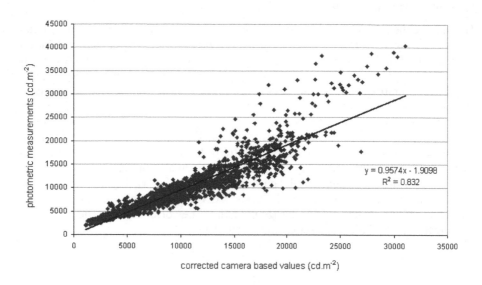

Figure 9 Photometrically measured versus corrected camera-based luminance values

To illustrate the potential of this sky luminance mapping approach toward improved indoor light level simulation, a comparison was made between two sets of light simulations for a test space in Vienna University of Technology (Figure 10). The first set of simulations was conducted using the CIE standard overcast sky (Hopkinson et al. 1966) as the underlying sky model. In the second set, camera-based sky luminance data were used. In both cases, sky luminance data were normalized based on the measured global illuminance level due to the sky hemisphere. All other simulation model assumptions (e.g. room, surface reflectance, glazing transmittance, room furniture, measurement points) were identical. Simulations were performed using the lighting simulation program LUMINA (Pal and Mahdavi 1999), for ten measurement points and five different times. Corresponding indoor illuminance measurements (for the same measurement points and time instances) were performed using a set of 10 illuminance sensors.

The comparison results are shown in Figure 11. The analysis of the relationship (linear regression) between simulations based on the CIE standard overcast sky and the measurements revealed a correlation coefficient (r^2) of 0.65. The comparison between the simulation results with the application of the camera-based sky luminance mapping and simultaneously measured indoor illuminance values (see Figure 11) resulted in a significantly higher correlation coefficient of 0.89 for the corresponding linear regression.

These results imply that digital sky imaging, calibrated with parallel measurements of overall horizontal illuminance levels, can provide an efficient basis for the real-

time generation of detailed sky luminance models. The application of such sky luminance models increases the predictive accuracy of the computational daylight prediction tools. Thus, the reliability of daylight simulation can be increased toward supporting the operation of daylighting systems in sentient buildings.

Figure 10 Illustration of the test space at the Vienna University of Technology with measurement points

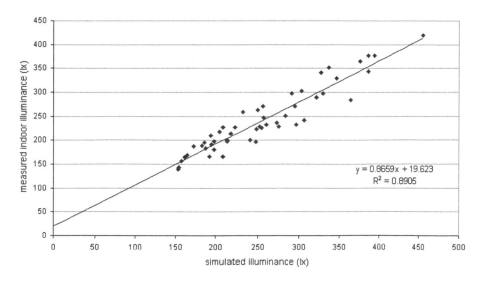

Figure 11 Measured versus simulated indoor illuminance values (sky luminance data based on digital imaging)

3.3.2 Location Sensing

Location sensing (tracking the position and orientation of objects in rooms) is critical for constructing and updating models of buildings as dynamic environments. As buildings and rooms are not static entities but change in multiple ways over time, the ability to track such changes automatically is necessary for the viability of sentient building models and the requirements of simulation-based building control applications. After examining a range of existing technologies from the building automation perspective, we considered a specific location sensing system to obtain real-time context information for the generation of a dynamic space model. This location sensing system uses a vision-based technology and scans scenes for distinctive optical markers. It exploits a combination of cameras and visual markers (low-cost black-and-white tags). Using optimized image processing methods, it obtains in real-time the identification and location (both position and orientation data) of an object to which the visual tag is attached (Icoglu and Mahdavi 2004). The overall system architecture is schematically depicted in Figure 12.

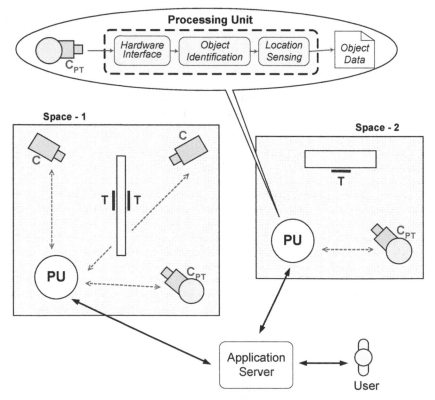

Figure 12 Schematic illustration of the overall structure of a location sensing system for sentient buildings (C: network camera; C$_{PT}$ network pan-tilt camera unit; T: optical tag; PU processing unit)

Network cameras (netcams) are used as visual sensors, reinforced with pan-tilt units that effectively increase the range of these devices. Netcams are specifically designed for built environments and make use of the existing network installation without requiring additional infrastructure. Software implementation of the overall system needs to be low-cost, low-maintenance, and scalable. Thus, the system is designed as a distributed framework, whereby hardware and software components are tied together via Internet. Netcams and pan-tilts constitute the hardware part of the system whereas Processing Units (PUs) form the distributed software components. PUs are programs that extract the context information by using optimized image processing and computer vision methods. They are the consumers of the hardware resources. PUs, implemented on different computers scattered across the facility, convey the location data to the central Application Server where incoming pieces of information are combined, stored in the system database, and displayed to the operator. The distributed structure of the framework supports scalability and incremental growth. It also enhances performance through parallel operations. An additional function of the Application Server is to control the status of the components and dynamically assign active netcams to active PUs in such a manner that the workload is constantly balanced within the system. This arrangement provides a self-organizing capability and minimizes operator overhead. The resulting flexible and adaptive structure is offers a suitable response to the requirements of control applications for sentient buildings.

Ongoing work has demonstrated the possibility to apply spatial reasoning to derive from the tag information provided by a location sensing system – together with the associate object information in facility databases – comprehensive three-dimensional building models with information on space boundaries, openings, and infrastructure objects.

4 CONTROL SEMANTICS

The previously introduced representational scheme of control devices and controllers (see Section 3.2) is syntactic in nature. It does not provide specific solutions to address issues of control semantics. Rather, it provides a framework (or a template) for implementing different kinds of control semantics. Given its systematic hierarchical structure, the representation is specially suited for the implementation of distributed and modular control logic routines. Such routines include also the class of so-called model-based control methods (Mahdavi 2004). These methods aim at the behavioral description of the reaction of controlled entities to alternative states of relevant control devices given a set of contextual conditions (i.e. climate, occupancy).

Both rules and simulations can be applied to capture (and predict) system behavior. In rule-based control, if-then statements provide the basis for the control logic. As implemented within a DC node, a rule can capture the relationship between the state of a device and the state of the sensor monitoring the associated controlled entity. Rules can be developed, for example, based the knowledge and experience of the

technical experts and facility managers or using the collected sensory data from the zone to be controlled.

Simulation-based control methods (Mahdavi 2001b) can also be implemented within the proposed representational framework (see Figure 13 for a simplified illustration). Toward this end, the following procedure may be followed: *i)* Multiple potential control device states are considered in a DC node; *ii)* The resulting device state space is mapped to the corresponding control zone state space via multiple real-time simulation runs; *iii)* Simulation results (predicted control zone states) are evaluated and ranked according to applicable objective functions; *iv)* DC implements the most desirable device state (or it reports the ranked device options to the next higher MC).

a b c d

Figure 13 Simplified illustration of a simulation-based control process as implemented in a DC: *i)* system control state at time t_i; *ii)* candidate control options for time t_{i+1} (i.e. alternative DC states); *iii)* computational prediction and evaluation (ranking) of the performance implications (zone states) of alternative DC states; *iv)* transition to the new control state

Rule-based and simulation-based control algorithms and methods can "animate" the previously discussed control system representation syntax (see Section 3.2, Figure 7) resulting in a versatile systems control environment. Such an environment has the potential to simultaneously address: *i)* the effects of control actions on multiple zone performance indicators (control parameter), *ii)* the influences of devices in multiple domains (heating, cooling, lighting, etc.), *iii)* conflicts amongst devices used to control multiple zones, *iv)* cooperation between local and central systems, *v)* multiple control objective functions.

A number of prototypical implementations of model-based methods for thermal and visual control have demonstrated their potential (see, for example, Mahdavi 2004). Ongoing research in this area is likely to improve the efficiency and scalability of such methods in the near future.

5. CONCLUSION

Buildings are subject to dynamic changes of different kinds and cycles. Environmental conditions around building as well as the organizational and indoor-environmental requirements of building occupants change continuously. Buildings provide the stage for a host of dynamic processes and activities. Building parts and components age over time, and are thus modified or replaced repeatedly. Increasingly, buildings include more flexible, moveable, and reconfigurable components in their structures, enclosures and systems. Buildings sometimes receive additions and are frequently overhauled and adapted in view of new services and requirements. Under these dynamically changing conditions, provision of functionally, environmentally, and economically desirable services represent a formidable control and management problem.

Building sentience provides a basis to tackle certain aspects of this problem. As conceived here, sentience involves three requirements. First, a comprehensive facility model is generated, including information on building as artifact as well as on building's context, occupancy, and processes. Second, this model is actualized continuously and autonomously. Third, the model is called upon to envision, test, evaluate, and enact regulatory and organizational options in building operation and management.

These requirements may be met, in essence, through a creative combination of information modeling techniques, environmental monitoring and location sensing, spatial reasoning, performance simulation, and model-based control logic. Toward this end, much more development and implementation work is needed. Nonetheless, as far as the prerequisite knowledge and technologies are involved, the realization of building sentience is within reach.

ACKNOWLEDGMENT

The research presented in this paper is supported, in part, by a grant from the Austrian Science Foundation (FWF), project number P15998-N07. Members of the research team include, besides the author, G. Suter, K. Brunner, B. Spasojevic, O. Icoglu and J. Lechleitner.

REFERENCES

Hopkinson, R.G., Peterbridge, P. and Longmore, J. 1966. *Daylighting*. London: Heinemann,.

IAI 2005. *International Alliance for Interoperability* (online). Website: http://www.iai-international.org/iai_international/ [site visited February 2005]

Icoglu, O. and Mahdavi, A. 2004. Location sensing for self-updating building models. In *eWork and eBusiness in Architecture, Engineering and Construction: Proceedings of the 5th ECPPM conference*, eds. A. Dkbas and R. Scherer: 103-108. Rotterdam: A.A. Balkema Publishers.

Mahdavi, A. 2004a. Self-organizing models for sentient buildings. *In Advanced Building Simulation*, eds. A.M. Malkawi and G. Augenbroe: 159-188. Oxon: Spon Press.

Mahdavi, A. 2004b. A combined product-process model for building systems control. In *eWork and eBusiness in Architecture, Engineering and Construction: Proceedings of the 5th ECPPM conference*, eds. A. Dkbas and R. Scherer: 127-134. Rotterdam: A.A. Balkema Publishers.

Mahdavi, A. 2001a. Aspects of self-aware buildings. *International Journal of Design Sciences and Technology* 9(1): 35-52.

Mahdavi, A. 2001b. Simulation-based control of building systems operation. *Building and Environment* 36(6): 789-796.

Mahdavi, A. 1999. A comprehensive computational environment for performance based reasoning in building design and evaluation. *Automation in Construction* 8(4): 427-435.

Mahdavi, A. and Spasojevic, B. 2004. Sky luminance mapping for daylight-responsive illumination systems control in buildings. In *Proceedings of the 35th congress on air-conditioning, heating, refrigerating*, eds. SMEITS, "AMD Sistern": 311-317.

Mahdavi, A., Suter, G. and Ries, R. 2002. A Representation Scheme for Integrated Building Performance Analysis. In: *Proceedings of the 6th International Conference: Design and Decision Support Systems in Architecture*, ed. H. Timmermans: 301-316. Ellecom, The Netherlands.

Pal, V. and Mahdavi, A. 1999. A comprehensive approach to modeling and evaluating the visual environment in buildings. In *Proceedings of Building Simulation '99. Sixth International IBPSA Conference* [Vol. II], eds. N. Nakahara, H. Yoshida, M. Udagawa, and J. Hensen: 579-586. Kyoto, Japan.

Roy, G.G., Hayman, S. and Julian, W. 1998. *Sky modeling from Digital Imagery* [ARC Project A89530177, Final Report]. Sydney: The University of Sydney, Murdoch University.

Constructing Complexity

MITCHELL William J.
School of Architecture and Planning, MIT, USA

Keywords: assembly, complexity, construction, fabrication, uniformity, variety

Abstract: Buildings were once materialized drawings, but now, increasingly, they are materialized digital information – designed and documented on computer-aided design systems, fabricated with digitally controlled machinery, and assembled on site with the assistance of digital positioning and placement equipment. Within the framework of digitally mediated design and construction we can precisely quantify the *design content* and the *construction content* of a project, and go on to define *complexity* as the ratio of added design content to added construction content. This paper develops the definitions of design content, construction content, and complexity, and explores the formal, functional, and economic consequences of varying the levels of complexity of projects. It argues that the emerging architecture of the digital era is characterized by high levels of complexity, and that this enables more sensitive and inflected response to the exigencies of site, program, and expressive intention than was generally possible within the framework of industrial modernism.

Perhaps you have wondered why the shapes of buildings seem to be getting more complex. Conceivably, it could be nothing more profound than an arbitrary flicker of architectural fashion. But it is worth asking whether the difference between, say, Frank Gehry's Bilbao Guggenheim and the characteristically rectangular slabs and towers of the late twentieth century is due to something more fundamental? Does the curved shape of London's Swiss Re Building, the twisted profile of New York's proposed Freedom Tower, or the non-repetitive roof structure of the British Museum courtyard represent some significant change in the conditions of production of architecture?

The shift, I suggest, is a direct outcome of new conditions created by the digital revolution. Buildings were once materialized drawings, but now, increasingly, they are materialized digital information – designed with the help of computer-aided design systems, fabricated by means of digitally controlled machinery, put together on site with the assistance of digital layout and positioning devices, and generally inseparable from flows of information through global computer networks. Many architects have simply exploited digital technology to reduce the time and cost of

B. Martens and A. Brown (eds.), Computer Aided Architectural Design Futures 2005, 41-50.

producing buildings in the conventionally modernist mode, much as architects of the early industrial revolution took advantage of mass-production to inexpensively proliferate the ornament that had previously been created by craftsmen. But others have recognized that the digital revolution has opened up new domains of architectural form for exploration, and they have seized the opportunity to produce projects that break the old rules.

To see precisely how new formal possibilities emerge from the interplay of information and materiality, we need to do some numbers. It will be helpful to begin with a homely example that should be familiar to anyone who has ever operated a computer graphics or computer-aided design system. Consider the task of inputting a circle. You need to give a *circle* command and specify three numbers – usually an *x-coordinate*, a *y-coordinate*, and a *radius*, though Euclid tells us that there are other, equivalent ways to convey the same information. You can enter the circle's three parameter values by typing the numbers, or by graphically selecting and sizing a circle with a mouse, but the result is the same in any case. Now consider the task of inputting an irregular, jagged polygon with, say, fifty vertices. It is a lot more work. You need to explicitly enter the *x-coordinate* and the *y-coordinate* for each vertex – a *polygon* command, plus a total of one hundred parameter values. Let us say, then, that the *design content* of a shape entered and stored in the system is the number of discrete items of information (that is, command words and parameter values) required to specify it. (A little more strictly, it is the number of bits in the input stream.) It is easy to see that design content of the circular shape is approximately three percent of that of the irregular, jagged shape.

The difference is not just a technicality. The higher the design content of a shape, the more opportunities it provides for adaptation to a specific context. If a designer needs to fit a circular shape into a tight space, for example, she can only shift its center point and vary its radius. But if she needs to fit the jagged shape, she can shift any combination of vertices to accommodate arbitrary nooks and crannies. This added flexibility comes at a price, however. There are more decisions to make with the jagged shape – more for the designer to think about.

To refine this definition of design content a little further, we can establish it relative to particular computer-aided design systems. Any such system has a set of input commands – enabling the user to specify a straight line, a circle, a rectangular box, a spline, and so on. Some systems have more specialized commands to facilitate the entry of objects like columns, walls, doors, windows, and the like. In interpreting a command, the system makes use of built-in design content – knowledge, expressed in computer code, of how to display a straight line defined by its end points, how to display a circle specified by three parameters, how to display a column proportioned as desired, and in general how to display anything in the system's shape vocabulary. Some systems encode very little predefined design content in this way, and have correspondingly restricted sets of input commands, while others encode a great deal, and provide extensive repertoires of commands for users to learn and utilize. Thus, when a designer inputs a shape using the commands of a particular system, the input that she provides is the *added* design content. This can be defined as the *smallest* number of discrete items of information (shortest string of bits, if you want to be

precise) required to specify the shape fully. This modified definition allows for the fact that there will usually be efficient and inefficient ways to enter the same geometric information, and stipulates that we are only concerned here with the most efficient.

Designers can re-use not only content that they find pre-encoded in a system at the start of a design process, but also content that they have input themselves, at some earlier stage in that process. A common strategy in design of office towers, for example, is to lay out a standard floor then repeatedly translate vertically and copy to describe the entire building. Depending upon the specific circumstances, we might regard this either as elegant economy of means or as lazy self-plagiarism.

A fully displayed design, then, is the joint product of the information already encoded in the system and the information added, in response to particular conditions and requirements of the context at hand, by the designer. The system automatically does the work of expanding the added design content into a complete display.

Another way to express this point, using more traditional terminology, is to say that any computer-aided design system encodes stylistic conventions. Many systems support a style derived directly from Euclid's *Elements* – one characterized by straight lines, arcs of circles, parallels, perpendiculars, and tangents. Some encode the vocabularies and layout rules of particular industrialized component building systems. It would be a provocative but technically trivial exercise to implement a neoclassical system that encoded the vocabulary and syntax of the style specified by, say, Palladio's *Four Books*, or Durand's *Précis*. A designer working within the established intellectual framework of a strong tradition, as expressed in the commands of a computer-aided design system, needs to add only a small amount of content to specify a complete design, while a designer working within a more general tradition typically needs to add more. A designer who is content to operate within the bounds of encoded tradition needs to add relatively little, while a designer who wants to break radically with tradition needs to work harder. In design innovation, as in other domains, there are no free lunches.

Investment in computer-aided design software privileges the associated style. Early computer-aided architectural design systems mostly privileged a very conventional style of walls, columns, doors, windows, extruded floor plans, floor slabs, and so on, laid out with the help of grids, construction planes, and skeletons of construction lines. In the 1980s and 1990s, though, the software industry invested in computer-aided design systems that encoded knowledge about the calculation and display of free-form curved shapes specified by a few parameters. As a result, these became widely and inexpensively available. They were mostly intended for use in the automobile, aerospace, and animation industries, but were quickly appropriated by architects. They established and enforced the rules of a new style – one of splines, blobs and twisted surfaces. Before these systems, creation and display of an architectural composition consisting of free-form curved surfaces would have required a huge amount of added design content – impractically large in most practical contexts. After these systems, the same composition could be specified with a much smaller amount of added design content. Under these new conditions, it

was hardly surprising that schools and avant-garde practices happily embraced curved surfaces – much as the schools, in previous eras, had followed Palladio and Durand. It was a matter of the shifting economics of information work.

But it is one thing to specify and render a curved-surface shape on a computer-aided design system, and quite another to materialize it, at large scale, on a construction site. Successful materialization requires some sort of construction machine that can efficiently translate the digital description of the shape into a tangible realization. (The process is analogous to that of performing a digitally encoded score on an electronic musical instrument.) It might, in principle, be a sophisticated CAD/CAM fabrication device such as a laser cutter or a multi-axis milling machine, or it might be an organized team of construction workers with the skills and tools needed to do the job. Let us, for the moment, make the simplifying assumption that it is just a black box that accepts a digital description as input and produces a material realization as output.

Now, like a computer-aided design system, a construction machine will have some set of commands that it can execute. A simple laser cutter, for example, might execute commands to *move* the laser from one specified point to another, and to *cut* from one point to another. To connect to such a device, a computer-aided design system needs driver software that translates an internally stored description of a shape into a corresponding sequence of *move* and *cut* commands. The *construction content* of a shape may be defined as the length of this sequence. (More strictly, it is the number of bits in the sequence.) A rectangle, for example, has little construction content; it can be generated by one *move* command followed by four *cut* commands. But a fifty-sided polygon requires a *move* command followed by fifty *cut* commands, so it has much greater construction content. In each case, an additional *locate* command must be executed – by fingers, a robot, or a construction crane – to place the fabricated piece within an assembly of pieces.

The translation of a shape description into a sequence of commands to a construction machine is one of converting a *state description*, which specifies a desired end condition, into a *process description*, which tells how get there. The translation task may be quite trivial, as in generation of *move* and *cut* commands for a laser cutter. The translation of a complex three-dimensional shape into tool paths for a multi-axis milling machine is, however, much less trivial. In general, state-to-process translation algorithms encode knowledge of construction materials and processes.

There are, however, supply chains for construction elements, and the definition of construction content should be established relative to position within a supply chain. If, for example, a designer has at her disposal a pre-cut rectangle of the right size for use in her project, then no further cutting operations are required; the only construction operation is to *locate* it in the desired position. This *locate* operation represents the *added* construction content at this step in the supply chain. In general, construction machines that start with elementary raw materials add a lot of construction content in the process of realizing elaborate designs, while construction machines that assemble sophisticated, highly finished, prefabricated components add relatively little. This, of course, relates closely to the economist's concept of added value at each step in a supply chain.

44

Generally, construction operations can usefully be subdivided into *fabrication* operations (cutting, milling, stamping, etc.) that produce discrete elements and *assembly* operations that combine discrete elements to produce systems. Since ancient times, for example, builders have fabricated discrete bricks by shaping and drying or firing clay, and then assembled bricks into walls, arches, and other structures. Similarly, in modern electronics, solid-state devices – very sophisticated building blocks – are fabricated in expensive and technologically sophisticated plants, and then robotically assembled into devices. A designer may assume prefabricated elements, or even pre-assembled complete subsystems. In doing so, she not only establishes a starting point for addition of construction content, she also inherits design content. This inherited design content may be represented explicitly and in detail in a computer-aided design system, as when selection of a component from a menu results in insertion of a detailed description of that element into the design, or it may be represented by an abstraction, as when an element is represented simply by its outline.

Figure 1 The Bush Building at MIT, designed by Walter Netsch in the early 1960s – an elegant example of industrial modernism. The design content is low, since the entire form is generated by a few key decisions. Construction economies were achieved through extensive repetition.

The ratio of fabrication operations to assembly operations may shift from project to project. When a cave is carved directly out of the living rock, or an adobe building is created from mud, the task is entirely one of in-situ fabrication. Conversely, when a

factory is assembled from precast concrete elements, or when a child creates a composition of Lego blocks, the task is entirely one of assembly. A standard strategy of industrial modernism has been to minimize in-situ fabrication, and to do as much pre-fabrication and pre-assembly as possible, under controlled factory conditions.

Execution of a command by a construction machine has an associated time and a cost. Obviously the total time to fabricate a component is the sum of the times for the individual commands in the sequence, while the total cost is given by the cost of raw materials plus the sum of the costs for the individual commands. Similarly, the total time to assemble a subsystem is the sum of the times for the individual assembly steps, and the total cost is the sum of the individual costs. Thus the times and costs of executing a design rise with construction content, but can be reduced by machines that execute commands quickly and inexpensively.

In practice, this analysis is complicated by the fact that errors occur in fabrication and assembly processes. They must, therefore, incorporate strategies for error detection and correction. Net efficiency depends upon reducing error rates, and upon effective detection and correction.

It follows from all this that fast, reliable, efficient construction machines allow designers more construction content within the same schedule and budget constraints. Industrial-era machinery typically achieved such efficiency through repetition, mass-production, and economies of scale. In the digital era, numerically controlled machines have allowed similar efficiencies with *non-repetitive* operations.

With the concepts of design content and construction content in hand, we can now formalize the intuitive idea of the *complexity* of a designed and constructed shape, an assembly of shapes, or a complete architectural project. Roughly speaking, it is the number of design decisions relative to the scale of the project. We can measure it as the *ratio of added design content to added construction content*. If the entry of a few command words and parameter values to a computer-aided design system suffices to generate a great deal of construction content, then the project is of low complexity. If many parameter values are required, as in the case of a fifty-sided irregular polygon to be produced by a laser cutter, the complexity approaches one hundred percent. Differences in complexity arise because a command given to a computer-aided design system may imply more construction content than immediately meets the eye.

The difference between building designs of low complexity and those of higher complexity is economically and culturally significant, and its implications have played out differently in different eras. This can conveniently be demonstrated by means of the following two-by-two table.

Table 1 Interrelationship between type of construction and level of complexity

	Repetitive construction	Non-repetitive
Low complexity	Industrialized component building systems	British Museum roof Swiss Re
High complexity	Habitat, Montreal	Craft construction Stata Center, MIT

Along one axis there is a distinction between projects of low complexity and those of high complexity, and along the other the distinction is between repetitive construction and non-repetitive. The entries list examples of each combination.

The condition of low-complexity, repetitive design and construction is illustrated by the industrialized component building systems that were popular in Postwar Europe. These radically reduced the time and cost of construction through efficient mass-production of standardized elements. Architects working within the frameworks of such systems could select and specify the positions of standard elements – adding relatively little design content as they did so. If the elements were available from stock at construction time, there was also little added construction content. So large buildings could be designed and built very quickly and economically, but the process provided little opportunity to adapt buildings sensitively to local site and climatic conditions, programmatic requirements, and cultures.

Mainstream architectural modernism more generally – particularly in its developer-driven manifestations – has frequently served as a strategy for simultaneously meeting challenges of scale, budget, and schedule by reducing complexity. A typical modern office tower, for example, might have a modular layout, symmetry about one or more axes, a repetitive structural frame and curtain wall, and a standard floor plan that repeats vertically. An urban complex might even be composed of repeating towers, as in the case of the ill-fated World Trade Center. At the design stage, replication of a floor or an entire tower by a *translate-and-copy* command is an operation that adds very little design content, but eventually generates a great deal of construction content. But you get what you pay for; this simplification of design (typically under budget and time pressure) reduces an architect's ability to respond thoughtfully to the exigencies of particular moments and spaces.

Typically, modernists have minimized complexity not only by standardizing components and subassemblies, but also by standardizing the spatial relationships

among them – laying them out in repetitive arrays and grids. An alternative strategy was famously demonstrated by Moshe Safdie's Habitat in Montreal, where the box-like units were highly standardized, but the spaces and masses that they produced were varied. The efficiencies of mass production could still be achieved, but the resulting level of complexity was higher.

Figure 2 The roof of the British Museum courtyard, London, by Norman Foster. Non-repetitive construction is enabled by efficient numerically controlled fabrication, but design content remains fairly low, since the varied shapes of the roof panels, structural members, and joints are controlled by simple rules and a few parameter values.

Norman Foster's designs for the British Museum courtyard and the Swiss Re tower in London illustrate the condition of non-repetitive geometry with relatively low complexity. In each case, the structural frame and skin system is topologically uniform but geometrically varied. The metal structural members are connected together in a standardized way, but the lengths of the members, the joint angles, and the dimensions of the glass panels that they support are varied. The variation is controlled by simple formulas and a few parameters, so the added design content is not much higher than for fully repetitive designs. This is variety, cleverly achieved through exploitation of numerically controlled fabrication, but without resulting in great complexity.

Habitat and the British Museum courtyard combine standardization and variability in different ways – putting the capacity for responsive variation in different places.

In Habitat it is in the spatial relationships among standard physical elements, while in the British Museum roof it is in the lengths and connection angles of the physical elements themselves.

Under conditions of craft production, the versatility of craft workers makes it possible to produce buildings that contain very little repetition anywhere. But the operations performed by craft workers tend to be slow and expensive, so craft production does not scale – as illustrated by projects like Gaudi's Sagrada Familia, which has been in construction, at great cost, for many decades. Non-repetitive construction at large scale requires digitally controlled fabrication, positioning, and placement machinery that combines versatility approaching that of craft workers with efficiency approaching that of mass-production techniques.

Figure 3 The Bilbao Guggenheim, by Frank Gehry. The forms are non-repetitive, and they are not controlled by simple rules. Design content is high, since the architect made many explicit choices.

Frank Gehry's projects for the Bilbao Guggenheim, the Disney Concert Hall in Los Angeles, and the Stata Center at MIT, vividly demonstrate this new possibility of scaling up variety. Both the shapes of the material components and their spatial relationships are non-uniform. Efficient construction required both numerically controlled fabrication and use of advanced electronic surveying and positioning techniques to assemble fabricated elements on site. Added design content is very high, since each space, element, and detail had to be considered individually. This gave the architect enormous scope to respond to the demands of complex programs

and surrounding urban conditions, and provided a great deal of expressive freedom. The result is correspondingly complex form, at large scale, achieved through clever exploitation of the possibilities of non-repetitive but efficient construction.

It does not follow that buildings with very high design content, produced under conditions that allow varied construction at large scale, will always be spectacularly irregular in their forms. It is logically possible for many carefully considered design decisions to add up to an elegantly minimal, tightly disciplined response. But this is now a deliberate design choice, not a side effect of industrial-era construction technology and inherited design content.

Figure 4 The Stata Center at MIT, designed by Frank Gehry. The architect made many explicit choices in response to the demands of a very complex program and urban context, so the form has a corresponding level of complexity. Form follows function in a new sense.

New technological capabilities are not always wisely used. Our new capacity for digitally enabled variety and construction of strange and irregular shapes has sometimes been deployed merely for its sensational effect. But thoughtful architects are beginning to see beyond the short-lived seduction of the surprising, and to find new ways of responding – without the compromise of Procrustean simplification – to the demands of the complex conditions they engage. As they do so, an authentic architecture of the digital era is emerging.

Virtual Heritage, Reconstruction and Histories

Labyrinthine Digital Histories
Interpretive, Extensible and Referential

DAVE Bharat
Faculty of Architecture, Building and Planning, University of Melbourne, Australia

Keywords: historic reconstruction, relativism, data reuse, semantic representation

Abstract: Interactive and media-rich digital representations are being increasingly used to offer passages through time and space, a role that was traditionally supported by travels and travelogues, maps, sketches, books and oral histories. In the last two decades, a number of projects have been implemented using digital media with the aim of recording past and extant artefacts and environments. However, the future of such digital past remains as fragile as the memories and moments it tries to capture. There is a need to go beyond creating introverted and closed historical reconstruction projects. This paper surveys significant issues and describes our ongoing work in developing an interpretive, extensible and referential framework toward virtual reconstruction projects.

1 INTRODUCTION

Viewing the Chartres cathedral from a distance with its twin towers and the green roof soaring above the corn-fields, or walking along its rows of flying buttresses or viewing the interior columns soaring up toward the vaulted ceiling, one soon realises that this is a place where architecture transcends a mere act of building. The apparent stability of architectural elements and masses plays against the changing light and sound creating a moving experience. Since architecture as tangible and measurable shapes is accessible through geometric representations, it is only too tempting to use it as scaffolding for representing architecture. That is, in fact, how we initially began work on a project on digital representation of the Chartres cathedral.

Based on selected literature on the cathedral and published drawings, work on a detailed three dimensional model was initiated. The model is an approximation of proportionally correct architectural elements at various levels of details (Figure 1).

While the work on the three-dimensional model is progressing, it has become increasingly clear that such geometric representations though useful may actually convey a misleading degree of completeness and finality that hides many discontinuities and fragmentary knowledge about the cathedral. For example, the cathedral building program lasted over thirty years. About nine separate teams of masons with up to 300 people each worked on the project, carrying out works that

B. Martens and A. Brown (eds.), Computer Aided Architectural Design Futures 2005, 53-62.
© 2005 *Springer. Printed in the Netherlands.*

lasted for varying durations from a few months to a couple of years. The spire of the second tower flanking the main façade was built 350 years later than the rest of the structure. There are competing arguments that suggest different sequences of construction. The conjectures about the lower level crypt await further resolution. Whereas the modern gaze roams almost unobtrusively over, around and inside the cathedral, it was not always the case. The cathedral was used and experienced differently by the people of Chartres depending on their social status.

Figure 1 Digital model of the Chartres cathedral

As Favier (1990) noted: "A cathedral is quite different from a well-defined painting, which the painter can varnish once he has completed it. Because it is alive, the cathedral – and Chartres more than most – is never complete (...)" As a result, the material, temporal, typological and historical aspects of architecture do not lend themselves to traditional and isolated geometric representations using digital media. These observations motivate a research program on historical architectural reconstruction outlined in this paper. Briefly described, we seek to develop digital representations in reconstruction projects that suggest *evolving commentary of arguments* or *interpretations* rather than *conclusive documents*. That, in turn, requires an *extensible* and *referential* framework of information. Extensible so that information can be added to it over time. Referential so that information can be reused and referenced using pointers to relevant internal and external information and sources. To investigate how we might develop extensible and referential interpretations, the following section begins with a survey of key ideas and developments that have guided recent digital reconstruction projects.

2 THE PAST RECLAIMED

As Woodwark (1991) recounts, some of the earliest experiments in digitally supported historic reconstruction work originated as early as 1983 at the University of Bath. The work on modelling Roman Baths in that project represented the first known documented application of solid modeling and computer graphics for reconstructive purposes. The project involved an archaeologist and a team of

researchers in computational geometry. The model they developed used only one solid primitive – the planar half space – and did not include any facility for real-time interaction or animation. Since then over the last few decades, increasingly more complex and ambitious virtual reconstruction projects have been realised. Examples of such projects abound and they include historic sites from cultures and civilizations around the globe. Representative examples of such virtual reconstruction projects include the Dunhuang caves and the Xian terracotta soldiers in China, the Indus Valley cities of Harappa and the Mughal city of Fatehpur Sikri in India, the Egyptian pyramids and temples, the Mesopotamian stone tablets and palaces, the Greek agoras, the Roman forums and theatres, the Mayan and Aztec cities, the European cathedrals and the temples of Angkor Wat in Cambodia, and many more. Brief surveys of many of these projects are available in Forte and Siliotti (1996), Addison (2001), Barcelo et. al. (2000), and in the proceedings of a number of conferences in virtual reality, archaeology, and cultural heritage.

Interactive and media-rich digital representations are being increasingly used to offer passages through time and space. These projects in virtual reconstruction extend earlier traditions that relied upon travels and travelogues, maps, sketches, books and oral histories to analyse, record, reconstruct and communicate the past, present and future spatial environments (Figure 2). For example, Giambattista Piranesi, an Italian draftsman in the 18th century, drew not only the existing ruins of Rome but turned them into fantastic, visionary spaces populated with fragments of disparate elements from many archaeological sites. Piranesi's etchings are the hallmarks of historic and imaginary reconstructions. Subsequently, people such as Austin Henry Layard in 1840's established the modern tradition of graphic reconstructions in his work on the Mesopotamian archaeological investigations (Gilkes 2001). Luigi Canina in the 1850's further extended this tradition in studies of the Appian Way in which he created 'before' and 'after' drawings of the ruins and reconstructions. It was not until this century that a different sensibility appears in the discourse on such reconstructions, one which emphasises evidence, veracity of detail and *relativist* interpretations in place of a singular history marking a shift in how reconstructions are undertaken, understood and communicated.

Figure 2 Reconstruction of an ancient temple by Piranesi

The introduction of digital media in historic reconstruction studies in the early 80's is marked by a shift to the visual of a different kind. The developments in digital technologies have led to virtual reconstructions that range from 'manufactured deficiencies' to 'manufactured intensities' (Gillings, 2002). The availability of powerful hardware and software enable development of three dimensional reconstructions with details of a higher order of magnitude than was ever possible before. The ability to interact with such information in real-time anywhere anytime opens many new opportunities to reprise the past.

3 FUTURE OF THE DIGITAL PAST

However, what is the future of such digital past? In most cases, it remains as fragile as the memories and moments it tries to capture. Some of the most problematic issues with digital reconstruction projects include the following.

- *Multiple interpretive perspectives*: In the quest for sensually recreating a historical context supported by digital multimedia, virtual reconstruction projects often lose sight of the fact that what they portray are often provisional and competing perspectives. The discipline of archaeology emerged gradually from the 18th century obsession with collecting and categorising objects on the basis of stylistic logic, finally taking root in the 19th century as a modern discipline. The subsequent "processual archaeology" was a reaction against the preceding methodological apparatus of cataloguing and timelines. As Lewis Binford (1965), one of the champions of the new phase in archaeology, noted: "The archaeologist's task... lies in abstracting from cultural products the normative concepts extant in the minds of men now dead." It is also not just a coincidence that museums have increasingly come to adopt an interpretive role instead of just being the modern-day *kunstkammer* (cabinets of natural curiosities). This, of course, opens up the problematic issue of which version of description and explanation is being communicated in any reconstruction project. The implicit and explicit choices made in any virtual reconstruction are thus inextricably linked with specific worldviews and theoretical agendas.

- *Source data, representations and uses*: Due to the need to accommodate multiple perspectives, it is essential to record and communicate provenance of data in virtual reconstruction projects. Further, spatial reconstruction projects of natural and manmade artefacts including buildings, involve use of multiple representations such as text, drawings, images, sounds, etc. Consequently such projects demand substantial resources to develop and hence evolve as one-off, hand-crafted initiatives centred on a mass of data that are rarely available or useful to any but the original and highly specific objectives. For example, most 3D datasets developed in such projects create and follow their own data schemes that are unique to those projects. In order to gain real-time performance increases, many datasets are also optimised for specific applications. As a result, most work remains one-off and rarely usable in other projects except at the level of the lowest common denominator, namely

geometric primitives or triangulated faces. Except perhaps for such geometric representations, it is usually not possible to access, extend or reuse such information outside of original project goals. Such problems of creating reusable data standards, semantic structures and databases are not unique to the virtual reconstruction community. The AEC sector is still grappling with development of data exchange standards. These issues are also faced by the professionals involved with cultural heritage information management (see for example the Getty Centre data standards and guidelines, online at http://www.getty.edu/research/conducting_research/standards/).

- *Evaluation*: While significant efforts are directed at developing virtual reconstruction projects, there is a lack of critical methodologies for and results describing post-implementation evaluation or assessment. Unlike written documents, there is yet no tradition of critique and scholarship among virtual reconstruction community. An unfortunate outcome of this neglect is that it is difficult to abstract valuable higher level principles from isolated projects.

The implications of the above problematic issues are that many virtual reconstruction projects powered by the advanced hardware and software succumb to the 'software fog' (Niccolucci 2002) in which remaking history one pixel at a time hides the connection between concepts and representation. Thus projects become vehicles for displaying the technological virtuosity which no doubt dazzles even the most sceptical viewers but many of these projects become consigned to bit-rust no sooner than they are developed. Of the problematic issues discussed above, we have explored elsewhere why and how we might evaluate virtual environments in another project (Champion Dave and Bishop, 2003). In the following are discussed how we plan to investigate the other two issues.

4 INTERPRETIVE DIGITAL RECONSTRUCTIONS

We face a paradoxical situation in which the technologies to capture and generate data for use in virtual reconstructions are leaping forward (see IEEE, 2000 for a good review) but modelling such data in an extensible and reusable way while also supporting different perspectives on them is not advancing at the same pace.

We explore these issues through a prototype project using the Chartres cathedral as historical context, a fascinating example of architecture as book and a complex building project that is at once an institution but also a commentary on social and cultural values. In this project, we consider all digital representations of the Chartres cathedral as *evolving commentary of arguments* or *interpretations* rather than *conclusive documents*. That, in turn, requires such representations to be *extensible* and *referential* information. Extensible so that information can be added to it over time. Referential so that information can be reused and referenced using pointers to relevant internal and external information and sources.

To this end, we first identified the following set of features and operations that are essential to support interpretive engagement with information in this project. In this

57

stage, we focus not on the means (how these features will be achieved) but on the ends (what is to be enabled and why). The project should support:

* ***temporal sequence of assembly and interrogation of parts***: It will enable us to understand not just structural implications of elements like buttresses of the cathedral but also the very making of these elements and associated changes in labour and how continuities in construction emerged even when teams of masons and workers kept moving frequently from site to site.

* ***representations that support multiple levels of details at various scales***: It will, for example, help show the readability of iconographic program of Chartres as a text that can be read progressively from different vantage points.

Figure 3 Examples of analytical representations

* ***Objects with parametric attributes***: It will support exploration of elements such as the curiously different towers flanking the main portal and their geometries, or how the modular ratios unite horizontal and vertical planes in the cathedral (Figure 3).

* ***Compositional hierarchy of spaces and objects***: It will help exploration of spaces of inclusion and exclusion, of rituals and social hierarchy, and how these are materially translated in the cathedral.

* ***Substitution and addition of objects***: The cathedral was the site of two separate fires and the main building program that lasted over 30 years. Similarly, much debate surrounds the illuminated windows some of which have undergone restoration at different points in time.

* ***Typologies and diffusion of concepts***: While the burgers of Chartres may have viewed their cathedral as the epitome of the Gothic expression, there are different versions of that Gothic that traversed along the cross-roads on which Chartres was located. This shows up as regional variations of Gothic not only in France but in Germany and England. Similarly there is a family of buttress designs that unites cathedrals dispersed in space and time in France.

* ***Accretion of information and authorship***: Almost all the information about the cathedral reflects serendipitous ways in which the cathedral has been reconceptualised as additional information was unearthed by different researchers. This process reflects not just a history of the cathedral but also the world views of those who added to this knowledge and their contemporaries.

- *Multiple viewpoints and interpretations*: The views of the cathedral as it is today do not reveal the fact that most worshippers sat on the cold hard stones on the floor or on bales of hay. Neither does it reveal that unless one paid at the gate (no longer existing), one would see only the spires of the cathedral from outside the main wall. The viewpoints thus become a critical vehicle for understanding social hierarchy.

- *Environmental conditions*: Some of the most interesting elements of the Chartres cathedral are illuminated windows which can be appreciated fully only with dynamic atmosphere and light simulation. Similarly sound plays equally important role in the cathedral. On a macro scale, the cathedral building boom in the 12th century saw the biggest deforestation and stone quarrying in French history. Thus the material history of these institutions is intimately tied with implications that went beyond the grounds they occupied in space.

- *Objects with behaviours*: Dynamically scriptable objects and characters will help represent social codes and hierarchies for example by limiting and allowing access to various spaces of the cathedral. These will help with understanding cathedrals as social institutions that are different from contemporary conceptions. For example, ball games were played in the side aisles of the Cathedral when it was not occupied with religious service.

- *Presence of multiple readers/visitors*: It will acknowledge other viewpoints, activities and interests thus supporting exchanges that were the accidental by-product of pilgrimages and festivals associated with the Chartres Cathedral.

- *Extensible information structure*: It should be possible for this information to grow and for visitors to deposit additional information over time. This is quite similar to what the travellers and researchers do: create their own accounts that, in turn, inform and guide the others.

- *Referential information structure*: It should be possible to retrieve the underlying structure of objects and their source data including authorship in the project so that such data can be commented upon, provided with an alternative, or referenced to other objects outside this project, for example, soil studies that explain why particular French clay used in the stained glass manufacture resulted in the peculiar *blooming* blues and reds.

4.1 Conceptual Framework

The preceding wish-list or building blocks of the ongoing project are currently being developed using small test bed examples in the first instance. As stated earlier, the intention is to identify a rich set of operations or features that will support interactive exploration of alternative viewpoints and information, and allow extension of the project information over time.

If this project description begins to vaguely resemble a *multidimensional Wiki*, it is closer to the spirit of the project than any other description we could envisage. The original design principles of Wiki include *open, incremental, organic, mundane,*

universal, overt, unified, precise, tolerant, observable and convergent (Cunningham, 2004). We extend these principles with a few additional ones to embrace Binford's call to *abstract from cultural products the normative concepts extant in the minds of men* by developing digital infrastructure that supports open annotated commentaries instead of isolated documents. Some of the ideas outlined above are implemented in various degrees in our work and others (see for example Kensek, Dodd and Cipolla, 2002; Snyder and Paley, 2001; Champion, Dave and Bishop, 2003).

Conceptually, we view virtual reconstructions as revolving around the three axes of spatial, temporal and knowledge-based annotations (Figure 4).

Figure 4 Reconstruction as accretion of understanding

In response, we draw upon ideas first promulgated in gIBIS (Conklin and Begeman, 1988), Wiki (Cunningham, 2004) and XML-based multimedia databases to develop a computational architecture (Figure 5).

Figure 5 Framework components

The computational framework to support the above objectives separates data from the description of what they contain, and further both these are separated from how they can be composed in multiple presentation or display structures. Such a separation between data, their meanings, and presentation enables the possibility for reuse, extensibility and serving multiple compositional needs in the context of virtual reconstruction information. This framework is currently being implemented using data related to the Chartres cathedral documents.

5 CONCLUSION

Virtual reconstruction projects can become richer through labyrinthine narratives since histories are never complete and are continuously re-created and re-written as ongoing projects. To go beyond creating one-off and closed historical reconstruction projects, this paper outlined significant issues and described our ongoing work in developing an interpretive, extensible and referential framework toward virtual reconstruction projects. The framework suggested here offers a set of high-level requirements and a generic conceptual framework for virtual reconstruction projects using digital technologies.

ACKNOWLEDGEMENTS

I would like to thank Prof. Stephen Clancy, Ithaca College, who first introduced me to the mysteries of the Chartres cathedral.

REFERENCES

Addison, A. 2001. Virtual heritage: technology in the service of culture. *Virtual reality, archaeology, and cultural heritage: Proceedings of the 2001 conference on Virtual reality, archaeology, and cultural heritage*, Glyfada, Greece, 343-354, New York: ACM Press.

Barcelo, J.A., M. Forte, and D.H. Sanders (eds.). 2000. *Virtual Reality in Archaeology*. Oxford: Archeopress.

Binford, L. 1965. Archaeological systematics and the study of culture process. In *Contemporary Archaeology*, ed. M. Leone: 125-132. Carbondale: Southern Illinois University.

Champion, E., B. Dave, and I. Bishop. 2003. Interaction, Agency and Artefacts. In *Digital Design: Research and Practice, Proceedings of the 10th International Conference on CAAD Futures'2003*, eds. M. Chiu, J. Tsou, T. Kvan, M. Morozumi, and T. Jeng: 249-258. Dordrecht: Kluwer.

Conklin, J., and Begeman, M. L. 1988. gIBIS: a hypertext tool for policy discussion. *Proceedings of the 1988 ACM Conference on Computer-Supported Cooperative Work* [Portland]: 140-152, New York: ACM Press.

Cunningham, W. 2004. Design Principles of Wiki. http://c2.com/cgi/wiki?WikiDesignPrinciples, accessed 30 November 2004.

Favier, Jean. 1990. *The World of Chartres*, New York: Harry N. Abrams.

Forte, M., and A. Siliotti (eds.). 1996. *Virtual Archaeology: great discoveries brought to life through virtual reality.* London: Thames and Hudson.

Gillings, M. 2002. Virtual Archaeologies and the hyper-real. In *Virtual Reality in Geography*, eds. P. Fisher and D. Unwin: 17-34. London: Taylor and Francis.

Gilkes, O.J. 2001. Wag the dog? Archaeology, reality and virtual reality in a virtual country. In *Virtual reality, archaeology, and cultural heritage: Proceedings of the 2001 conference on Virtual reality, archaeology, and cultural heritage*, Glyfada, Greece, 169-178, New York: ACM Press.

IEEE, 2000. Virtual Heritage. *IEEE Multimedia.* 7(2).

Kensek, K., L.S. Dodd, and N. Cipolla. 2002. Fantastic reconstructions or reconstructions of the fantastic? Tracking and presenting ambiguity, alternatives and documentation in virtual worlds. In *Thresholds – Design, Research, Education and Practice, in the space between the Physical and the Real, Proceedings of the 22nd Annual Conference of the Association for Computer-Aided Design in* Architecture, ed. George Proctor: 293-306. Cal Poly: ACADIA.

Niccolucci, F. 2002. XML and the future of humanities computing. *ACM SIGAPP Applied Computing Review*, 10(1), Spring 43-47, New York: ACM Press.

Snyder, A.B., and S.M. Paley. 2001. Experiencing an ancient Assyrian palace: methods for a reconstruction. In *Reinventing the Discourse, Proceedings of the 21st Annual Conference of the Association for Computer-Aided Design in Architecture*, ed. Wassim Jabi: 62-75. Buffalo: ACADIA.

Woodwark, J. 1991. Reconstructing History with Computer Graphics. *IEEE Computer Graphics and Applications*, 11(1): 18- 20.

A 3D Model of the Inner City of Beijing

The Application of Data Interrogation Techniques

CHAN Chiu-Shui[1], DANG Anrong[2] and TONG Ziyu[3]
[1] *Department of Architecture / VRAC, Iowa State University, USA*
[2] *School of Architecture, Tsinghua University, China*
[3] *Department of Architecture, Southeast University, China*

Keywords: 3D city modeling, GIS, remote sensing, virtual environments

Abstract: This study has two major concentrations: 1) exploring methods of creating a digital city model, and 2) applying the model to study urban spatial structure, an issue of particular interest and importance to urban planners. Based on existing studies that primarily address two-dimensional (2D) urban structure, this paper focuses on the three-dimensional (3D) structure relating to the 3D urban form. Given their greater clarity and possibilities for quantitative analysis, both 3D digital urban models and GIS spatial overlay analysis methods hold tremendous potential for analysing and predicting future urban form. In this project, the Xidan Business District in Beijing's Inner City was the area selected to implement the digital-city application. Under the hypothesis that the existing urban spatial structure is determined by the city's urban planning scheme and current urban marketing forces, it is found that actual urban development does not follow the planning restrictions on zoning and building height regulations. Some contradictions and conflicts, such as building location and height, appeared in the studied district. The specific reasons for the discrepancies need to be further studied.

1 INTRODUCTION

For 800 years, the city of Beijing has been designed to function as the capital of China. The original urban planning concepts were guided by certain aspects of Chinese culture and philosophy, reflected in the urban forms preserved in the Inner City. Throughout its historical evolution, the area's urban form has been affected dramatically by socio-cultural, economic and political changes; furthermore, urban problems and conflicts have emerged. For example, the Inner City district is facing challenges due to issues of modernization and alterations in skyline shapes, landmark images, traffic patterns, and land-use allocations.

For urban planners, design practitioners and planning scholars, appropriate tools to aid urban study and the decision-making processes are needed, but these ideas have not been fully explored. A three-dimensional (3D) digital city would be such a tool; however, a digital city that can be virtually displayed and viewed in full scale would be more useful for this purpose. This paper depicts 3D visualization of a digital city,

B. Martens and A. Brown (eds.), Computer Aided Architectural Design Futures 2005, 63-72.
© 2005 *Springer. Printed in the Netherlands.*

the methods used for geometric modelling, the results of the virtual models and generational processes, and one exercise in applying the model to evaluate the urban spatial structure.

2 URBAN SPATIAL STRUCTURE

Urban spatial structure is defined as an organizational representation that includes both 2D urban patterns and 3D urban forms. Since the 1960s, urban spatial structure has been one of the many foci in research exploring factors that affect the evolution of urban growth—for instance, how urban economic development would affect the functional characteristics of a city and its optimal size (Capello and Camagni 2000); how economic, housing and land reform have changed Chinese cities (Wu and Yeh 1999); and the impact of urban patterns on ecological conditions. These studies showed the significance of analyzing a city's urban spatial structure.

From the 1980s onward, cellular automata has been one of the computer-simulation methods used widely for describing urban spatial evolution and for explaining how and why cities grow (Couclelis 1997; Batty, Xie, and Sun 1999; Barredo et al. 2003). Other studies have applied information technology to construct a digital city (Blundell, Williams, and Lintonbon 1999; Pietsch, Radford, and Woodbury 2001) for visualization and urban study purposes. This research intends to develop a digital model based on virtual reality technology (Langendorf 1995; Chan, Dang, and Tong 2004) to provide an interactive simulation and analysis environment for studying the urban spatial structure. This virtual city model includes volumetric city blocks and related urban data for study. The Inner City of Beijing has been selected as the subject of study.

3 3D MODEL OF AN URBAN SPATIAL STRUCTURE

Beijing is a dynamic city that combines traditional housing, historical palaces, and modern skyscrapers together in a metropolitan environment. Currently undergoing a process of rapid growth, the city faces various urban issues that challenge planners and policy makers. Thus, it is critical to explore new possibilities and new tools that would aid urban decision making. This is the purpose of this project.

Methods for developing a digital city model have been well explored in many projects done at universities in Europe, America and Asia through the use of various geometric modeling systems (Jepson and Friedman 1998). Other methods include applying computer vision, graphic technologies, and 3D laser scanners to digitally archive historical monuments and restore cultural heritage objects (Ikeuchi 2004). Some of these projects have generated beautiful models in the virtual reality environment. However, few projects have been designed to be a full-scale display in an immersive setting. This project intends to concentrate on the digital study of urban spatial structure; thus, two models were constructed—a volumetric model

implementing building height regulations and a detailed urban model displaying existing conditions with realistic building heights and appearances. Each model has both a PC and virtual-reality version.

3.1 Data Acquisition

The most interesting issues in modeling a city relate to the problems of gathering and maintaining tremendous amounts of urban data, and the accuracy of building data. The methods used to create a volumetric city model to show the planned urban volume were based on the information given on the building-height regulation map issued by the Beijing Urban Planning Commission in 1990. Figure 1 shows the map with 14 different colours representing different land-use and height restrictions. However, creating a model that represents the current city is more difficult. Particularly, the technological limitations and mobility issues of 3D laser scanners yield difficulties for scanning buildings in a large-scale urban environment, and the inaccessibility of accurate, detailed drawings from government authorities makes the data acquisition process more challenging. Fortunately, various data-acquisition methods have been tested on the city maps provided by associates at the Beijing University of Technology and on satellite photos purchased from the DigitalGlobe Company. Different algorithms were applied to the sets of building drawings provided by the Beijing Urban Planning Commission. Extra algorithms were developed in this project to serve specific purposes.

Figure 1 Building-height regulation map and satellite photo of the Inner City

One algorithm applied techniques available in remote sensing (RS) and geographic information systems (GIS) to fetch 3D information from satellite photos obtained on October 18, 2001 (see Figure 1). The satellite photos consisted of a 61-centimeter panchromatic black-and-white image (Figure 2a) and a 2.44-meter multi-spectral colour image (Figure 2b). Manipulated through the ERDAS image-processing software package, these two images were fused into a clear and colourful city image (Figure 2c). The second algorithm was to export the image into GIS to draw the 2D geometry of each building (Figure 3a) and apply the topology function to create a database including the building's ID number, area square footage, perimeter,

existing height, and related city regulations (Figure 3b). The third algorithm was to calculate the existing building height of each building from the formula of H = 0.648855 * BC (Figure 3c), where BC is the distance length of building shadows measured in the satellite photos. The formula was derived from the relations among parameters of solar elevation, solar azimuth, satellite elevation and satellite azimuth. Particularly, the satellite elevation determines the length of the building's oblique projection, and satellite azimuth determines the direction of the building's oblique projection (Chan, Dang, and Tong 2004).

Figure 2 (a) Panchromatic Image (b) Multi-spectral image (c) Fusion image

Record	AREA	PERIMETER	HEIGHT	BUILD ID
2	977.094	137.004	18	52102
3	1074.844	181.600	24	52101
4	532.969	95.532	18	52103
5	322.359	87.688	12	52104
6	1159.125	173.500	18	52002
7	1119.938	145.813	18	52106
8	465.625	99.500	4	52105
9	445.266	89.188	24	52110
10	864.969	172.563	18	52003
11	245.766	68.063	4	52109
12	727.531	108.938	18	52004
13	462.891	99.063	4	52107
14	145.031	51.125	4	52108
15	360.375	77.500	18	52112
16	447.375	98.563	4	52111

Figure 3 (3a) 2D geometry in GIS (3b) 2D data in GIS (3c) 3D information

Table 1 Examples of building-height calculation results (Unit=Meter)

Building Name	Shadow Length *(BC)*	Transform Coefficient	Calculated Height *(H)*	Actual Height	Errors
Power Building	67.207681		43.61	44.00	-0.39
Time Square	91.738757	0.648855	59.53	60.00	-0.47
Wujing Building	79.992469		51.90	52.00	-0.10
Book Store	67.857083		44.03	44.00	0.03

After the length of each building's shadow (BC) was measured from the photo image, the formula could calculate its existing height (H), which was used to convert its 2D shape to a 3D solid in GIS. Results of this method generated a digital city model with individual buildings reflected existing heights. This method was tested on four existing buildings located in the Xidan Business District. The actual values of these four building compounds' height were given by the city. Results of the eight measurements (Table 1 lists only four values) indicated that the possible errors ran

from 0.03 to -0.47 meters. Thus, it is concluded that the methodology applied in this algorithm is valid and reliable.

3.2 Modeling Process

The volumetric city model was generated via this process: (1) scanning the building-height regulation map, (2) scaling it up to full scale in ACAD, creating 2D in ACAD, (3) exporting the 2D to GIS, (4) extruding it to 3D with the regulated building heights in GIS, and (5) converting the model to VRML for visual display. This model serves as an abstract representation (or a graphic representation of urban text codes) of the city (Figure 4). In the model, different colours represent the regulated building height of each block.

Figure 4 Volumetric model of the Inner City of Beijing in VRML format

Figure 5 Detailed MAX model and combined model

The existing city model was constructed by measuring buildings' shadow length to achieve accurate measurements of height. In order to show a more realistic city vista, detailed models were constructed using digital photographs through texture mapping in 3D MAX. A photograph of every façade was taken on site and exported to AutoCAD to obtain accurate dimensions before being applied in 3D MAX to achieve a realistic appearance. Results of combining the existing city model and detailed model are shown as an example in Figure 5. This final PC model has the

potential to be used as a tool or a base for studying urban design.

In terms of showing the model in virtual full scale, the PC models were converted into VRML models using OpenSG as the graphic scene generator for the virtual reality display. The VR Juggler program controls the OpenSG package to create immersive 3D graphics in the CAVE virtual environment. Combining 3D projectors, 3D goggles and a wireless tracker, a digital model can be viewed and accessed interactively in the immersive CAVE environment.

3.3 Modelling Results

The modelling processes are extremely time consuming, due to the extensive collections of photographs, maps, drawings, site surveys and building measurements needed to construct the model. The key issue, however, is balancing the various systems to obtain the maximum level of realism when the model is displayed in the CAVE (Figure 6a). This project has run numerous trials to find the optimal solution for digitizing the model accurately and showing details of the city vista realistically, to allow for the display of digital culture. A wireframe model was also created in C6 (six-sided CAVE facilities) for easy navigation (Figure 6).

Figure 6 Temple of Heaven (left) and the wire frame of the Inner City (right)

4 APPLICATIONS OF THE DIGITAL MODEL

The applications of the two digital city models were tested in the following. For example, the Xidan Business District has an area of 2.85 square kilometres (4.5% of Beijing's Inner City area). Figure 7 shows a 2D building-height regulation map and a 3D model of the regulated form of this area. Figures 8 contains detailed 2D map and 3D model views of existing urban conditions. Images in the regulated model (Figure 7) show that the main street is wide and straight while the secondary streets are well-organized. Buildings are not very high, leaving the skyline relatively flat. Generally speaking, tall buildings are located along the main street, and low buildings are mostly on the secondary streets.

Figure 7 2D and 3D models of the regulated urban form

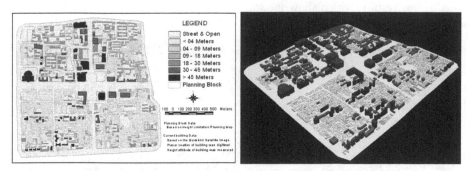

Figure 8 2D and 3D models of the existing urban form

Table 2 Statistical analysis of building-height regulations in Xidan Business District

Planning Land-use	Height (M)	Count	Sum_Area (M²)	Percentage (%)
Green space	0	12	71406.01	4.02
Preserved	4	2	31734.65	1.78
09 M	9	5	92149.48	5.18
12 M	12	15	191196.11	10.75
18 M	18	30	629277.19	35.39
24 M	24	9	77472.97	4.36
30 M	30	22	405661.22	22.81
45 M	45	15	279438.68	15.71
Total / Average		110	1778336.3	100

Data shown in Table 2 are results obtained from the GIS database. The most prevalent item is the 18-meter block height, which occupies 35.39% of the entire district. The 30- and 45-meter heights are the second and third most common. Together, these three categories account for 73.91% of the district, making this district slightly taller than others in the Inner City of Beijing. For the Inner City as a whole, the most common regulation is the 18-meter height limit. Although these

building-height regulations have been set up as planning guidelines, urban development may or may not follow such strategies. Figures 7 and 8 do show that the current spatial structure in Xidan Business District is more complex than intended. Other issues are discussed in the following sections.

4.1 Spatial-structure Analysis

Other than checking conformity to regulations and codes, digital city models can also be used to analyze the character of the urban form. For instance, although most of the buildings are low-rise, the district as a whole is not as flat as the planning scheme would suggest. This can be seen by combining the two models together to visualize the results, which show the locations of high-rise buildings are scattered, and some of them exceed the maximum regulation of 45 meters (see Figure 9).

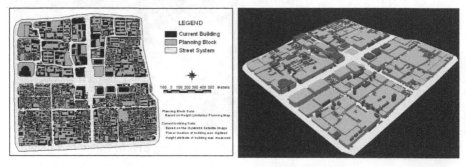

Figure 9 2D and 3D views combining the regulated and existing urban forms

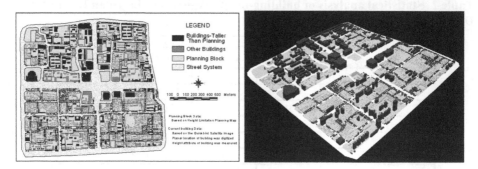

Figure 10 2D and 3D view of the buildings that are taller than planned

4.2 Contradictions

After extensive study of the GIS data sets and VR models, several contradictions between the planning regulation scheme and current situations could also be discovered. For instance, some buildings exceed the maximum building height indicated by their assigned value (Figure 10), some buildings are located outside the planned street, and some are even on green space, etc. In sum, after the urban

ordinances are graphically displayed three dimensionally, the contradiction and conflict can be accurately identified. By the same token, expected outcomes could be easily visualized, evaluated, and modified.

4.3 Future Prediction

Courtyard housing is a traditional Chinese dwelling typology in Beijing. Most of the courtyard houses are located in the south part of the Xidan Business District and have a low building height of 4 meters (Figure 11). According to the planning scheme, many low-rise houses in this area (around 78% of residential in this district) will be torn down and replaced by high-rise apartments or commercial buildings. This indicates that courtyard housing will gradually disappear in some areas of the Inner City of Beijing. Based on the study, it is suggested that some historical preservation strategies should be imposed in this area for maintaining cultural heritage.

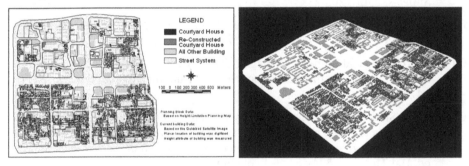

Figure 11 2D and 3D views of courtyard houses in Xidan Business District

5 CONCLUSION

The methods of creating a VR model by combining GIS and RS have shown a number of advantages for studying urban spatial structures. The model created in the GIS provides a clear database with functions for quantitative analysis on various urban issues that cannot be easily identified without the aid of a digital model. For the Xidan Business District, the urban spatial structure has been determined mainly by the urban planning scheme with a number of issues involved. It is found that the current urban development does not conform to planning restrictions on zoning and building height. Some contradictions on building location and height occurred in the studied district. The specific reasons behind the discrepancies between the urban planning scheme and the current development need to be further studied.

6 ACKNOWLEDGEMENT

This project is funded by the National Science Foundation, #0089884. Any opinions, conclusions, or recommendations expressed in this article are those of the authors and do not necessarily reflect the views of the National Science Foundation.

REFERENCES

Barredo, Jose I, Marjo Kasanko, Niall McCormick, and Carlo Lavalle. 2003. Modeling dynamic spatial processes: simulation of urban future scenarios through cellular automata. *Landscape and Urban Planning,* 64(3): 145-160.

Batty, Michael, Yichun Xie, and Zhanli Sun. 1999. Modeling urban dynamics through GIS-based cellular automata. *Computers, Environment and Urban Systems,* 23(3): 205-233.

Blundell, Peter Jones, Alan Williams, and Jo Lintonbon. 1999. The Sheffield Urban Study Project. *Architectural Research Quarterly* 3(3): 235-244.

Capello, Roberta, and Roberto Camagni. 2000. Beyond Optimal City Size: An Evaluation of Alternative Urban Growth Patterns, *Urban Studies,* 37(9): 1479–1496.

Chan, Chiu-Shui, Anrong Dang and Ziyu Tong. 2004. Utilizing RS and GIS techniques to create a VR model of the Inner City of Beijing. In *Proceedings of the Tenth International Conference on Virtual Systems and MultiMedia,* ed. Hal Thwaites: 574-583. Tokyo: Ohmsha.

Couclelis, Helen. 1997. From cellular automata to urban models: new principles for model development and implementation. *Environment and Planning B: Planning & Design,* 24: 165-174.

Jepson, William, and Scott Friedman. 1998. Virtual L.A.: Urban Simulation in Los Angeles. *Planning Magazine, the Journal of the Amercian Planning Association,* 4-7.

Ikeuchi, Katsushi. 2004. Digitally Archiving Cultural Heritage. In *Proceedings of the Tenth International Conference on Virtual Systems and MultiMedia,* ed. Hal Thwaites: 13-17. Tokyo: Ohmsha.

Langendorf, Richard. 1995. Visualization in Urban Planning and Design. *Environment and Planning B: Planning and Design,* 22: 343-358.

Pietsch, Susan, Antony Radford, and Robert Woodbury. 2001 Making and Using a City Model: Adelaide, Australia. In *Proceedings of the 19th eCAADe Conference,* 442-447.

Wu, Fulong, and Anthony G.O. Yeh. 1999. Urban Spatial Structure in a Transitional Economy: The Case of Guangzhou. *Journal of the American Planning Association,* 65(4): 377-394.

A Method Proposed for Adoption of Digital Technology in Architectural Heritage Documentation

KEPCZYNSKA-WALCZAK Anetta
Institute of Architecture and Urban Planning, Technical University of Lodz, Poland

Keywords: ICT, architectural heritage, database systems

Abstract: This paper aims to present results of a research focused on defining guidelines for creation of a comprehensive digital archive and improvement of the procedures of filing, documentation, popularisation, management and protection of architectural heritage. The research presents a clear vision of the potential use of ICT in this field. The study focuses on the employment of the latest technologies in cultivating the architectural past, bringing this past to life and thus making the connection to the present and future.

1 INTRODUCTION

There were cases of sensitivity to the past in Europe as early as the 12th century (Boulting 1976); those reflected only the need for continuity, typical in the traditional society of that time. A sense of history was fundamental for the origins of heritage, and this did not fully develop until the Renaissance when people widely started to understand the dimension of historic time. The deliberate care and study of important historical documents, as well as other significant material works which, as a whole, depict the life of the past generations, has been part of the European civilisation since then. This preoccupation with the past was not immediately transformed into a sense of heritage. But the change came soon, and by the 1520s there appeared the first pictures showing ancient ruins for consciously emotional effect. This seems an important change as once people become emotionally committed to their built legacy they are motivated to preserve it. Generations of Europeans lived in an environment which integral part was built by their ancestors. The approach towards these structures fluctuated over centuries from hostility through pragmatism to sensitivity. The latter led to the modern concept of heritage formed during the 19th and 20th centuries. The term 'heritage' itself is, however, rather a new concept, which emerged and has been formulated since the 1970s. Earlier the terms 'cultural property' and 'historical monument' were applied more often to historical and cultural assets. It was the UNESCO's World Heritage Convention that gave birth to the term 'cultural heritage' international recognition. The formation of united Europe during the late 20th century has had an immense

B. Martens and A. Brown (eds.), Computer Aided Architectural Design Futures 2005, 73-82.
© 2005 *Springer. Printed in the Netherlands.*

impact on the field of cultural heritage. With this process, heritage received new meaning and importance. Traditionally, cultural heritage was often seen as a source of national unity arising from the recognition of great architecture, monuments or achievements. For some thirty years, cultural heritage has been increasingly seen as a much broader phenomenon that can contribute to political ideals, to economic prosperity and to social cohesion. Especially, cultural heritage has been widely recognised as a vehicle of cultural identity. It became generally accepted that discovery of a common heritage, all the richer for its diversity, would be a platform for mutual recognition, understanding and acceptance of cultural diversity across Europe. In this light, architectural heritage is one of the most visible, tangible symbols of a European collective civilisation and culture.

2 BACKGROUND

It is assumed that the introduction of the personal computer (PC) in the early 1980s was the most significant change since the industrial revolution two centuries before (Currie 2000). The global information infrastructure (GII) which emerged in the 1990s is central to what is now referred to as the "information age" or "information society". The advent of the Information Society is creating unprecedented conditions for access to and exploitation of public sector information including architectural heritage collections. Information and communication technologies (ICT) play a major role in creation and delivery of the new digital contents, which goes far beyond the traditional providing access to information about cultural heritage objects. For example, deeply immersive environments may make museum visitors dwell on in amazement in view of virtual worlds they could not experience anywhere than in the digital realm (Mulrenin 2002).

Europe's cultural and memory institutions are, therefore, facing very rapid and dramatic transformations. These transformations are due not only to the use of increasingly sophisticated technologies, which become obsolete more and more rapidly, but also due to the re-examination of the role of modern public institutions in today's society and the related fast changing user demands. These trends affect all functions of modern cultural institutions, from collection management and scholarly study through restoration and preservation to providing new forms of universal and dynamic access to their holdings. Being digital for many European archives, libraries and museums is no longer an option but a necessity (Mulrenin 2002).

2.1 Previous Research Dealing with the Subject

The use of computerised systems for built heritage documentation is not a novelty. The first methodical research in this field was conducted as early as the late 1970s. Results of one of the early research projects, published by Sykes in 1984, revealed that of eleven analysed built heritage institutions from the whole world, only three did not use computer database systems and among these were Poland and – surprisingly – Japan (Sykes 1985). With the development of a networked

environment, the issues related to data exchange and standardisation emerged. Fundamental work was done in the early 1990s in the USA by the Society of American Archivists (Walch 1995). Attempts leading to standardisation and deployment of digital technologies in the built heritage documentation were undertaken also in Europe on both academic and governmental levels (Council of Europe 1993, 1995). The advent of the Internet created unprecedented conditions for access to, and exploitation of, public sector information including architectural heritage collections. This resulted in a real explosion of researches and implementations of computerised systems addressed not only to the specialists but to a wider audience with the new aims of increased awareness and education. Since the mid 1990s, a number of projects have been developed and implemented by universities, museums and heritage documentation institutions across Europe. The international initiatives devoted to issues related to the impact of digital technology on the methods of heritage documentation emerged, such as MINERVA (http://www.minervaeurope.org/) or DigiCULT (http://www.digicult.info/pages/ index.php). By the early 2000s the subject had become mainstream in the field of built heritage research activities, which may be exemplified by the UNESCO conference "World Heritage in the Digital Age" in 2002 (URL: http://www.virtualworldheritage.org/).

Concurrently, the major interest of research activities in the EU Member States is a development of a user-friendly information society. Research, stimulated by the Research, Technology and Development (RTD) Framework Programmes, focuses on the development of information technology and its various implementations. It is not surprising then, that there is a growing interest in employing the latest technologies in the field of cultural heritage. Also, architectural heritage is the subject of Information Technology (IT) projects aiming at improving its recording, protection, conservation and accessibility. The studies on common standards for digitising and archiving virtual collections are underway. Among other researches it is worth to mention these indicating the impact on the efficiency and effectiveness of conservation planning through the implementation and use of Internet multimedia database information systems (Angelides and Angelides 2000), or even going further and proposing three-dimensional interactive applications leading to creative, collaborative environments – such concepts are, however, beyond the scope of this research.

2.2 Recording of Architectural Heritage in Poland

In Poland the subjects related to the application of digital technologies for the built heritage remained relatively unexplored until the mid and late 1990s, when a few minor research projects were done at various academic institutions. There were also attempts at co-operation with foreign universities and research centres (Blaise and Dudek 1999). However, none of these scholarly activities went beyond experimentation.

The need for international co-operation in the field of digital technology deployment in the built heritage documentation had been, however, long recognised by the

Polish institutions responsible for such activities. Until late 1980s the information exchange was, however, limited to other communist countries (Lenard 1987). More recently, the international project called HerO (Heritage Observatory) was planned by the National Centre for Historical Monument Studies and Documentation in co-operation with similar bodies from other European countries. Unfortunately, this ceased at the preliminary stage due to the lack of financing and insufficient involvement of European partners applying for the financial support from the Culture 2000 programme in 2003.

The current built heritage documentation practice in Poland does not fit to the present needs. The existing system of heritage recording and protection is based on a database of paper fiches. The database verification and upgrade is usually delayed, and moreover, the records do not include some information crucial for successful protection and regeneration of historical buildings, e.g. the urban context, urban planning regulations, etc. The lack of computerised heritage documentation system causes situations like this described below: In the late 2003 the Department for the Heritage Protection of the Ministry of Culture ordered an inventory of built heritage in Poland to be done by the State Conservation Offices in all provinces. The major purpose was to verify a number of historic buildings and complexes listed within the register, their present state, use and ownership. Special forms were prepared in the Microsoft Word format to be filled out by inspectors. Ministerial officers ordered, additionally, statistic reports which had to be done considering various criteria. As a result inspectors had to abstract required information from the above-mentioned forms. Then the occurrence of particular features was counted manually and put into other tabular forms, which along with written comments had to be printed and sent by post to the Ministry in Warsaw. The whole inventory took a few months (sic!) and the achieved results have been unreliable due to the high risk of human errors.

There are also other problems related to the successful recording. First, there is no legally binding standard for the built heritage recording. The historical buildings usually have documentation in form of so-called "white card", Their use is widespread but limited to the monuments from the "register". The same template is binding in a case of architectural complexes with exclusion of cemeteries for which separate recordings are used. The movable monuments are recorded using different template. As a result, heritage listings maintained by various responsible bodies may not be compatible, which in consequence may affect their merge in one comprehensive system. Secondly, the existing documentation of built heritage ("white cards") lacks reference marks to the corresponding documentation on urban complexes, archaeology, or movable heritage. Thirdly, there is a lack of reference to urban planning, and other regulations affecting heritage protection. Fourthly, the information on built heritage is dispersed, as at present a number of various institutions, including museums, libraries, and universities, gather and process data concerning built heritage. Fifthly, persons requiring information on particular buildings have a limited access to the information on their heritage status, and related data. Finally, there is no link between the guidelines of international conventions ratified by Poland and the heritage legislation.

It was rather unfortunate coincidence than a lack of foreseeing that records do not exist in digital version nor there is any comprehensive computer database, and it is important to stress that authors of the "white card" had the IT in their minds. This seems to be proved by the existence of the information system for documentation of movable heritage, which has been in use for some twenty years. This system lacks, however, integrity and its efficiency remains below the expectations.

It is, therefore, clear there is an urgent need for new methods of preparation, storage and distribution of information about a historic environment. Particularly, as Poland has accessed European Union that regards rising awareness of heritage as one of key activities towards the strengthening local identities and diversity within Europe.

3 PROJECT DESCRIPTION

All the above evidence reveals that Poland is not fully exploiting the potential of the new economy based on the ICT. The country is not moving fast enough into the digital age as compared with other European countries.

The use of the ICT for the heritage documentation would be an important step forward in solving most of the problems indicated in the previous section. What is more, an integrated information system on the built heritage would facilitate a creation of material for use in urban planning, education, promotion, tourism, and other related areas. It would also contribute to the community involvement in this process. Especially as the new Heritage Act introduced provisions for so-called Community Curators of Built Heritage (these may be either individuals or organisations), sharing the responsibility for the heritage protection with governmental and local authorities. This may be done through a number of publications, both printed and available on-line, promoting built heritage and related issues. This in consequence, requires the access to the resources in digitised form.

3.1 Project Principles

The above facts demonstrate the need for an Internet-accessed multimedia database holding information on the architectural heritage of Poland. Such a comprehensive set of data on built heritage gathered in one place would become particularly convenient resource (on-hand compendium) for variety of users, including: conservation officers; researchers; participants in building process – investors, architects / urban designers, officers responsible for issuing building consents, etc.; educational community; promotion market and tourism sectors.

Central to the research methodology was the belief that a computer aided documentation system for built heritage in Poland should be compatible and harmonised with similar European projects as a response to the needs of the emerging Information Society. To achieve that, standards and best practices in Europe were identified, analysed and compared with the current Polish system of heritage protection and management.

Adoption of Digital Technology in Architectural Heritage Documentation

The principal aim of the research was, therefore, to investigate and adopt knowledge, proven methods and tools. In other words this project aimed at outlining a framework for creation of a database, which scope may be broadly defined as: all primary material relating to built heritage in Poland; all secondary (interpretative) data, where the geographical coverage focuses on Poland. This remit covers an extremely diverse range of information types (described below). The core of the proposed database would be formed by the resources held by the Provincial Conservation Offices and National Centre for Historical Monument Studies and Documentation – principally record cards with necessary modifications imposed by the compatibility with European standards and requirements of proposed extended documentation system. This collection may be extended by a number of other digitised resources. Figure 1. shows the scheme of proposed database.

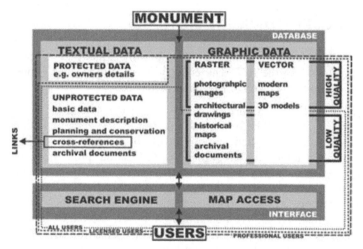

Figure 1 Scheme of proposed database

The database would be addressed to all types of users potentially interested in the built heritage in Poland. There are three levels of access proposed:

- All users (everybody can search general textual data on buildings and small, low quality, nonprintable images – "thumbnails");

- Licensed users (those who bought access to images of higher quality, but still below the requirement of commercial use);

- Professional users (staff of Conservation Offices and Documentation Centres who have access to all resources including secured, password-protected data, such as: owners details, detailed description of valuable equipment or fittings, etc.).

All the users, despite their status, would have access to the database through the Internet via a search engine and, alternatively, via map (GIS search facility). It is worth mentioning here that the use of GIS may be beneficial in a number of ways, going far beyond providing access to the collections, e.g.: analysis of heritage in the

geographical space; interpretation of heritage data in a wider environmental context (spatial relationships among heritage objects, relationships to the natural environment, relationships to land-use, etc); decision support to the conservation procedures, and many more.

3.2 Addressed Issues

In the vision of general access to architectural heritage information on-line, mechanisms are needed for users to be able to find specific information in the open network environment by using electronic directories, for owners of information to be able to protect their Intellectual Property Rights (IPR), for charges to be made, for electronic publications to be able to make effective external references and linkages to information objects, to ensure that the user actually gets access to the information he/she asked for. Therefore, in order to realise this vision, the following issues had to be addressed: standards adoption; content; digitisation; metadata; database solution; accessibility and data retrieval (thesauri, multilingualism, IPR, etc.); digital preservation – longevity – sustainability of digital archives; e-commerce.

The most commonly used and officially accepted standards in Europe essential to adopt in Poland were analysed here and confronted with those already existing in Polish architectural heritage recording practice. It was revealed that the Polish recording system is far more extensive and detailed than that proposed by the Council of Europe in Core Data Index standard. Though there are also some mandatory Core Data Index data not included in the Polish record file. Therefore the mandatory built heritage recording system in Poland should be modified to comply with Core Data Index recommendations. In addition, other useful information should be provided, such as for example link to the local urban planning, or information on inventorial measurements and their availability (or optionally their digital surrogates). The modified record should, however, maintain its specific information, including a historic outline and extensive description.

Almost the entire resources on the built heritage in Poland need to be digitised. Thus, it would be unrealistic to expect the whole scope of material available on the built heritage in Poland to be digitised. As a consequence the priorities and criteria were also evaluated and prioritised, including such issues as: user-focused selection of material (the most often consulted material should be digitised first); future conservation requirements and preservation needs; public access and future use; appropriateness of content for digitisation and privileged domains (some collections are not suitable to be digitised, for example due to their fragility); the requirement of scalability (allowing an organisation to quickly and easily scale any application, from tens to tens of thousands of online users).

For data to be meaningfully processed, metadata associated with it must be present and accessible. It provides the information required to identify data of interest based on content, validity, sources, physical material, pre-processing, legal aspects or other selected criteria. With the growing number of on-line collections providing information on heritage, there is an urgent requirement for definition and use of common metadata standards among a large number of institutions as a means to

facilitate synergy and information interchange. Although the discussion is still open and there is no uniform metadata standard adopted in Europe, there are indications that the Dublin Core Metadata Element Set may become the compromise solutions. What is more, its popularity is constantly growing, and it has already been officially adopted by some governments, including the UK, Denmark, and Australia.

A number of major issues should be addressed during the database system selection due to the nature of the project, including: ability to handle a wide variety of media types; scalable and accurate query and delivery capabilities; continuous data retrieval by multiple, concurrent users; simple, common access from various platforms and operational systems; the highest data security. Taking above into the consideration it was suggested that the database should be of the object-relational type. The systems inheriting relational model have been by far the most common types of databases today. Therefore, following experiences of European best practices, the Oracle Database system is proposed as an optimal solution for its extensive functionality, scalability, data security and other outstanding features. The system supports the requirements of the most demanding Internet-based applications, as well as the highest availability requirements. It is capable of handling all types of information for all types of applications.

Controlled vocabulary should be deployed in the proposed database for two major purposes: reduction of terminological confusion by controlling synonyms and near-synonyms and by "separating" homographs, and subsequently bringing related items together and separating unrelated items; facilitation of comprehensive searches by linking (through hierarchy or cross-references) terms with related meanings. The thesauri should be harmonised with widely recognised controlled vocabularies, such as Art and Architecture Thesaurus (AAT). This is also crucial for providing multilingual access to the resources.

To manage the IPR effectively, it is necessary to introduce licensing scheme. Special technologies for copyright management and protection as well as access control should be adopted to reduce a risk of unauthorised use and possible misuse of data. The latter is also necessary for the personal data protection and the most sensitive information should be available only to the narrowest class of users.

Technical discontinuity and obsolescence is a major problem particularly for institutions whose core business is the archiving and long-term preservation of digital cultural resources. The most important is to ensure continued access to electronic resources, through addressing issues related to the lifespan of the medium on which the file is stored, and the obsolescence of the format in which the file is stored. Therefore digital preservation methods should be adopted. The adoption of a sustainable approach to the digital technology is of crucial importance as the proposed system would be financed from public funds.

Hence, it is clear the issues involved in creating a digital resource are very much inter-related and a holistic approach is required. As a result of the research a comprehensive concept covering all stages of the adoption of digital technology in the architectural heritage documentation in Poland was developed (Figure 2).

Organisational policies for digitisation and related issues should be directed and co-ordinated nationally to set priorities and avoid the duplication of work. The adoption of centralised approach is important also for another reason: according to recent surveys 95 per cent of all cultural heritage institutions in Europe are not in the position to participate in any kind of digital cultural heritage venture, since they not only lack the financial resources, but also have a shortage of staff, essential skills, and the necessary technologies (Mulrenin 2002). The situation in Poland is without doubt similar or even worse. There is, therefore, a need for supportive infrastructure organisation managing the digital resources of many cultural heritage institutions similar to those analysed in the PhD research, SCRAN and RCAHMS in particular.

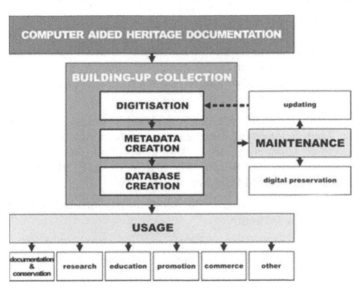

Figure 2 **Proposed approach towards the adoption of digital technology in the architectural heritage documentation in Poland**

4 CONCLUSIONS

The above-described concept is intended as a starting point for implementation of digital technology in recording and management of architectural heritage of Poland. It is believed that the research outcomes may become useful not only for the architectural heritage documentation and management, but also in the wider cultural heritage sector in Poland.

It is necessary to point out that during the work on this project it was tried to avoid common mistakes related to the deployment of IT in architecture, identified by Tom Maver (1995): "(...) it is almost impossible to find a PhD thesis which claims anything less than an all-singing, all-dancing, fully integrated, multi-disciplinary (design) decision support system which does the business as soon as you press the

start button". Author believes that she managed to keep away from such naive claims in this research – on the contrary, the study reveals that the proposed solution requires a multidisciplinary expert team including not only architects but also historians, IT programmers, lawyers, and even linguists. The study indicates, what is more, that the validity of any guidelines related to the digital technology has a limited lifespan, and therefore the proposed model for digitisation and recording data on architectural heritage in Poland, to be successful, requires constant, diligent review of the technology development.

REFERENCES

Angelides M., and M.C. Angelides. 2000. Using multimedia database information systems over the Internet for enhancing the planning processes for dealing with the built heritage. *Information Journal of Information Management* 20: 349-367.

Blaise, J.-Y., and I. Dudek. 1999. SOL: Spatial and historical web-based interface for On Line architectural documentation of Krakow's Rynek Glowny. In Architectural Computing: from Turing to 2000 [eCAADe Conference Proceedings]. eds. A. Brown, M. Knight, and P. Berridge: 700-707. Liverpool: eCAADe and University of Liverpool.

Boulting, N. 1976. The law's delay. *The Future of the Past*, ed. J. Fawcett: 9-34 London: Thames & Hudson.

Council of Europe. 1993. *Architectural Heritage: Inventory and Documentation Methods in Europe*. Strasbourg: Council of Europe.

Council of Europe. 1995. *Recommendation No. R (95) 3 of the Committee of Ministers to Member States*. Council of Europe.

Currie, W. 2000. *The global information society*. Chichester, NY: John Wiley & Sons.

Lenard, B. 1987. Metody i technika ewidencji zabytkow, Banska Bystrzyca, 22-26 wrzesnia 1986 r. *Ochrona Zabytkow*. 3 (158): 215-216.

Maver, T.W. 1995. CAAD's Seven Deadly Sins. in *Sixth International Conference on Computer-Aided Architectural Design Futures*, 21-22. Singapore: CASA.

Mulrenin, A. (ed.). 2002. *The DigiCULT Report: Technological landscapes for tomorrow's cultural economy. Unlocking the value of cultural heritage*. Luxembourg: Office for Official Publications of the European Communities.

Sykes, M.H. 1985. *Manual on Systems of Inventorying Immovable Cultural Property* [Museums and Monuments vol.19]. Lanham: Unipub.

Walch, V.I., and M. Matters. 1995. *Standards for Archival Description: A Handbook*. Chicago: Society of American Archivists.

From Architectural Intent to Physical Model
Representing the Chiostro della Carità *by Andrea Palladio with New Technologies*

SDEGNO Alberto
Department of Architectural Design, University IUAV of Venice, Italy

Keywords: laser scanner, digital modelling, rapid prototyping, 3D representation

Abstract: The research presented here addresses the subject of the analysis of partially executed architecture. Information for such analyses has been gathered with the use of laser instruments. The paper aims to show a method for processing the laser-surveyed data using geometric modelling software to construct the physical model of the structure through the use of prototypes created with a variety of materials. The laser technology is is interpreted using an additive system (*referred to as physical polymerization*).

1 INTRODUCTION

The aim of our research has been to analyze the possibility of transforming the data acquired during an instrumental survey of an historical building into a physical model. During the phase of data acquisition we have employed both traditional, photogrammetric techniques and a 3D laser scanner. The points and the surfaces in the digital model have been post-processed so that they could be utilized for the automatic construction of the model. Laser technology is always employed in the process.

The focus is an architectural structure designed by Andrea Palladio, located in Venice where the present day *Museo delle Gallerie dell'Accademia* resides. It deals with the *Convento della Carità*, which possesses several base materials and which presents itself as a work of great interest. Also of interest is that it is the author's sole work to redesign a *Casa degli antichi* – a Roman Domus – even though dictated by the needs of a religious community.

Among materials available for consideration, we have, first of all, the designs presented in Palladio's treatise (Palladio 1570) – in which the author makes explicit reference to his site, Venice. Secondly there are the well conserved executed sections of three designed sites: the façade of the interior courtyard, the *tablinum*, where the ancients displayed images of their ancestors – and the oval staircase. The latter is an extraordinary helicoidal staircase, which is of significant importance as it is the first Renaissance staircase of its kind. Due to this fact, it will be not be

B. Martens and A. Brown (eds.), Computer Aided Architectural Design Futures 2005, 83-92.

discussed in detail here. In addition to the Palladian designs and the constructed sections aforementioned, we have some other sources of information. These include a few graphic sources O. Bertotti Scamozzi's designs, F. Muttoni etchings, G. Leoni's interpretations and a few textual materials, such as those conserved in the Archives of the State of Venice. Moreover, Canal, said Canaletto, created an interesting painting in the mid 1700's that depicts the cloister in question. This painting has already been investigated and studied (Sdgeno 2004).

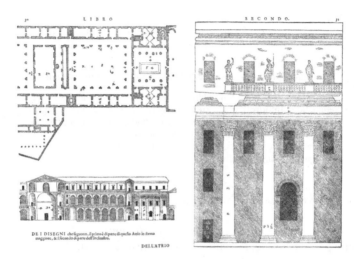

Figure 1-2 Palladian drawings from the 'Quattro Libri dell'Architettura'

Figure 3-4 Photographs of the 'Chiostro della Carità' in Venice

The work is structured around a central cloister on which a vitruvian elevation appears that is subdivided in three orders: Doric, Ionic, and Corinthian. The central cloister is the true focus of this investigation. The executed elevation corresponds

almost perfectly to the Palladian design, with variations in the dimensions of the orders. To the side of this, the *atrium* was planned and constructed, while in 1630 was destroyed by fire and never rebuilt. Then, the *tablina* – two small vaulted spaces, symmetrical with respect to the longitudinal axis of the structure – were planned for, but only one of these was realized. Finally a series of stairs lead to the upper levels, one of which is the oval set mentioned previously.

2 LASER SCANNING

In addition to the initial investigation of documentary sources consisting of Palladian texts and designs, a 3D laser scan was executed using a 3D Laser Scanner (Mensi GS 200). The main scanning was done from a position in the centre of the courtyard, placing markers on significant architectural points in order to mount two secondary scans. This work was supported by an agreement between the Faculty of Architecture at the IUAV University of Venice and the Gamsau centre of research in Marseille.

Figure 5-7 3D Laser scanning

In order to compensate for the areas that were not covered by the principal scans, two partial scans were added to the main one. Moreover, other scans taken at a superior height were made so that further detailed information on the architectural orders, and a greater amount of reference points, would be available for consideration. The second phase of the work dealt with the treatment of the points cloud so as to be able to select profiles necessary for the geometric reconstruction of the elements. The cloud has 4.273.839 points and was made in one day (8 hours) with a group of four users. The vertical section of the points cloud took place on the axis of the first order on the left, while the horizontal ones took place at varying levels. In particular, the dimensions of reference were 1, 2, 3, 4, 5 meters. From the

sections we proceeded to the geometric modelling of surfaces. The handling of the points cloud occurred using *RealWorks Survey* software. Specific software for the treatment of 3D numerical data is being developed under the direction of the Gamsau centre.

Figure 8-9 Points' clouds of the 'Chiostro della Carità'

3 GEOMETRIC MODELING

The most delicate part of this project was the geometric modelling of surfaces and of volumes. In particular, the Doric order was constructed as a surface of simple extrusion in the case of the plinth, as an angular extrusion in the case of the superior abacus, and as a surface of revolution for the *tora* and the inferior *scotia*, the shaft, the superior *echinus* and the lower cinctures. In any case, the arch and the cornices can be built either as simple extrusions or as extrusions along shaped directrixes.

Figure 10 The treatment of points' cloud from profiles

The entablature was realized as a simple linear extrusion, on which an automatic triangularisation of a few particulars was superimposed, such as the *bucrania* and round bas-reliefs. In fact, bas-relief elements are directly managed by the software that provides creation of the mesh.

With the exception of the capital, the superior level was executed implementing the same method as was used for the Doric order. Moreover, the Ionic volute – an object rather complex to construct – demanded a different approach. As a point of departure, it was decided to verify the *voluta*'s stereometry using the classical geometric construction, provided in the two-dimensional drawing of the spiral that generates the form. Therefore, the channel would be constructed as an extrusion of a significant section along a spiraliform directrix. The 3D volute was nevertheless executed via mathematics and was compared with the numeric one. The latter had been derived from the points cloud, as the information was not sufficient enough for modelling.

Figure 11 The construction of Doric, Ionic and Corinthian Orders

Finally, the last level showed the construction of the Corinthian pilaster and that of the cornices of the openings. In this case an ulterior problem occurred. In a way it is partly similar to the preceding one, with the difference that while the profile of the pilaster's shaft could be individuated rather well, the Corinthian capital was all but impossible to construct with the collected points. In this case, the density of the acanthus leaves, and the distance from the pick-up point, did not allow for the acquisition of a quantity of information sufficient for 3D modelling. In spite of this, we proceeded by acquiring a series of photographic images, digitalizing them, and comparing them with the designs of the orders as they are presented in Palladio's treatise.

Subsequent altimetrical verification took place using photogrammetric procedures to acquire perspective restitution from photographs. The first order on the ground floor,

in particular, was obtained from a vertically planed photograph. Noted is the planimetric form obtained thanks to direct acquisition using basic metric instruments. As for the superior orders, perspective restitution was taken from a photograph at an inclined plane, with individuation of three vanishing points towards which all lines concur. In order to obtain the best results it was decided to photograph the angle between Palladio's building and the existing brickwork side of the cloister.

Figure 12 Perspective restitution from photograph

Palladio's designs, the points cloud, and traditional photogrammetric procedures have all aided in the construction of one 3D element. From this one solid model, a digital yet exact copy of the actual state of the convent was constructed. Using this model as a point of departure it was possible to analyze some of the convent's geometric structures. These include the barrel vaults on the *peristilium* pathway. Having constructed the main part of the façade, it was then possible to reconstruct the entire cloister, as it had been devised by Palladio, replicating the model on all four sides. The final model of the cloister has 1.254.832 faces, and we used 370 objects.

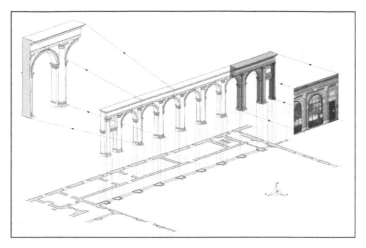

Figure 13 The digital model of the Doric colonnade

4 RAPID PROTOTYPING

The last stage of research was the execution of a physical prototype of the perceived façade, making use of electronic technology for the construction of models. Before executing the task of construction through numerical control, a selection of technology was made, analyzing various types of materials and techniques. A Palladian Doric capital was used as a model for this study. It was to be realized at a scale of 1:500 with respect to the actual capital of the *Convento della Carità*. It was also decided to reconstruct the entire stereometry rather than just half of it, as it is presented in the realized façade (in the form of a semi-column). Many different materials and techniques were used.

The first instrument implemented was the numerically controlled machine that permits a procedure known as *Laminated Object Manufacturing* (LOM). This technique allows for the construction of a volume beginning with very thin layers of thermo adhesive paper that are cut with a laser and glued automatically. These layers of paper are 0.066 mm thick. The model required finishing by hand, taking manually away the parts external to the central volume. The LOM technique was often used a few years ago, while rapid prototyping is now preferred. Rapid prototyping executes a single component much more quickly and is an automatic process that does not require refinishing on the part of the user. The appearance of the piece is of particular interest, since the presence of lines, similar to wood grain, gives it a woody quality. Even its consistency is woody, as compressed paper renders this final result. However, this technology was considered less appropriate since it can only be used for simple forms and curves, but not for complex surfaces such as acanthus leaves.

Figure 14 LOM Techniques for the construction of the Doric Capital

The second technique used was *resin polymerization*, which involves a laser solidification procedure. Two types of resin were used. Results were quite different from the qualitative point of view. With a good density of solidification a compact and almost opaque compound was achieved, while air bubbles were present with the use of a lower quality resin rendering the object less precise, even though more pleasing aesthetically. The colours of the materials can vary and the consistency is rubbery.

Figure 15 RP Techniques with resin for the construction of the Doric Capital

The third technique involved the implementation of *rapid prototyping* (RP) with the use of powders. Such a technique proved to be very interesting as production time was short, yet the precision of the final physical model was high. Furthermore, it was possible to use different materials. These included grey coloured aluminium powder, nylon and glass powders with each of the latter being white. Most recently attention has been turned to ceramic powder, which is especially useful in architecture because it gives a greater physical weight compared to nylon, not to mention a different chromatism. The use of this material is still in the experimental stage, and we have produced the entire project with it.

Figure 16 RP techniques with nylon powder for the Doric Capital

The scale of representation has been defined at 1:500. This three-dimensional model will help surpass the limitations of an exclusively virtual representation of the project.

5 CONCLUSIONS AND POSSIBLE DEVELOPMENTS

The findings in this paper demonstrate how advanced research institutes and private partners can work together effectively to study the representation of architecture using new computer instruments. Through the use of geometric data, point cloud information can be applied to the modelling of solids in such a way that execution can be achieved using new physical construction technologies (LOM, RP, etc.).

As far as possible developments regarding numerical input are concerned, the following are desirable: the improvement of acquiring points, particularly for defining architectonic details; the moderation of numerical data in line with the requirements of specific software, and the integration with other representation techniques, (photogrammetrical morphing, photomodelling, etc.). On the other hand, experiments for output technologies should necessarily deal with the problems faced in the use of new materials; for example, calcareous sand has already been investigated. Also, a useful area of investigation could be that of trying to use artificial compounds that integrate different materials, such as the technique required for the colouring of powders. However, verifying the durability and the physical behaviour of any new material is always required.

ACKNOWLEDGMENTS

The author wishes to thank: Michel Florenzano, Michel Berthelot, Livio De Luca, from the Research Centre *UMR 694 MAP – Gamsau* in *Marseille*, for the collaboration with their 3D Laser Scanner; Cesare Zanetti from *Protoservice*, for the physical modelling with RP techniques; Anna Sgrosso from the Università degli Studi di Napoli "Federico II" and Agostino De Rosa from the Università IUAV di Venezia, for the support on the application of Descriptive Geometry techniques.

REFERENCES

Dokonal, W., B. Martens, and R. Plösch. 2000. Architectural Education: Students Creating a City Model, Eternity, Infinity and Virtuality in Architecture. *Proceedings of the 22nd Annual Conference of the ACADIA*: 219-221.

Gatermann, Harald. 2004. The Didactic Triangle - Using CAD, Photography and Descriptive Geometry as Educating Tools with Mutual Influence. In

Architecture in the Network Society [eCAADe 2004 proceedings], eds. B. Rüdiger, B. Tournay, and H. Orbak: 558-562. Copenhagen: eCAADe.

Gatto A., and L. Iuliano. 1998. *Prototipazione rapida*, Milano: Tecniche nuove.

Gibson, Ian, Thomas Kvan and Wai Ming Ling. 2002. Rapid Prototyping of Architectural Models. Journal of Rapid Prototyping 8(2): 91-99.

Migliari, R. (ed.). 2001. *Frontiere del rilievo. Dalla matita alle scansioni 3D*, Roma: Gangemi.

Palladio, Andrea. 1570. *I Quattro Libri dell'Architettura*, Venice: Dominico de' Franceschi.

Schmitt, G. 2004. The Impact of Computer Aided Architectural Design on Physical Reality. *International Journal of Architectural Computing* 2(1): 31-42.

Sdegno, A. 2004. 3D Reconstruction of Canaletto Painting. In *Architecture in the Network Society* [eCAADe 2004 proceedings], eds. B. Rüdiger, B. Tournay, and H. Orbak: 342-348. Copenhagen: eCAADe.

Sdegno, A. 2004. Modelli di luce artificiale. Immagini digitali e modellistica laser per la rappresentazione dell'architettura. In *Tecnologie per comunicare l'architettura* [Proceedings of E-ArCom], ed. E.S. Malinverni: 523-528. Ancona.

Shih, Naai-Jung. 2003. Digital Architecture - What Would 6000 Points Turn Out To Be? In *Connecting Crossroads of Digital Discourse* [Proceedings of the 2003 Annual Conference of the ACADIA], ed. K. Klinger: 67-73. Indianapolis, IN: ACADIA.

Shih, Naai-Jung. 2003. The Application of Color-image-mapped Rapid Prototyping in Architectural 3D Modeling. In *Digital Design* [21th eCAADe Conference Proceedings], eds. W. Dokonal, and U. Hirschberg: 347-350. Graz: eCAADe.

Tchou, C., J. Stumpfel, P. Einarsson, M. Fajardo and P. Debevec. 2004. Unlight the Parthenon. In *Proceedings of Siggraph 2004*.

Yu, Y., P. Debevec, J. Malik, and T. Hawkins. 1999. Inverse Global Illumination: Recovering Reflectance Models of Real Scenes From Photographs. In *Computer Graphics Proceedings* [Annual Conference Series], 215-224. New York: ACM Siggraph.

Ucelli, G., G. Conti, M. Lindsay, and G. Ryder. 2000. From "Soft" to "Hard" Prototyping: A Unique Combination of VR and RP for Design In, Proceedings of the Seventh UK Virtual Reality Special Interest Group Conference, ed. Robin Hollands: 1-9. Glasgow: University of Strathclyde.

Van den Heuvel, F.A. 2000. Trends in CAD-based photogrammetric measurement, *International Archives of Photogrammetry and Remote Sensing* 33(5/2): 852-863.

Xi, F., and B. Shu. 1999. CAD-based path planning for 3-D line laser scanning. *Computer-Aided Design* 31(7): 473-479.

Interactive Visualization of Large-Scale Architectural Models over the Grid

Strolling in Tang Chang'an City

XU Shuhong[1], HENG Chye Kiang[2], SUBRAMANIAM Ganesan[1], HO Quoc Thuan[1], KHOO Boon Tat[1] and HUANG Yan[2]

[1] *Institute of High Performance Computing, Singapore*
[2] *Department of Architecture, National University of Singapore*

Keywords: remote visualization, grid-enabled visualization, large-scale architectural models, virtual heritage

Abstract: Virtual reconstruction of the ancient Chinese Chang'an city has been continued for ten years at the National University of Singapore. Motivated by sharing this grand city with people who are geographically distant and equipped with normal personal computers, this paper presents a practical Grid-enabled visualization infrastructure that is suitable for interactive visualization of large-scale architectural models. The underlying Grid services, such as information service, visualization planner and execution container etc, are developed according to the OGSA standard. To tackle the critical problem of Grid visualization, i.e. data size and network bandwidth, a multi-stage data compression approach is deployed and the corresponding data pre-processing, rendering and remote display issues are systematically addressed.

1 INTRODUCTION

Chang'an, meaning long-lasting peace, was the capital of China's Tang dynasty from 618 to 907 AD. At its peak, it had a population of about one million. Measuring 9.7 by 8.6 kilometres, the city's architecture inspired the planning of many capital cities in East Asia such as Heijo-kyo and Heian-kyo in Japan in the 8th century, and imperial Chinese cities like Beijing of the Ming and Qing dynasties. To bring this architectural miracle back to life, a team led by Professor Heng Chye Kiang at the National University of Singapore (NUS) has conducted extensive research since the middle of 90s. Hundreds of full-scaled buildings and architectural landmarks, such as 55-meter Mingde Gate at the city's main entrance, Zhuque Avenue which was as wide as a 45-lane highway, Buddha Hall and Hanyuan Hall etc, have been digitally reconstructed (Heng 1999). How to enable users, especially remote users with normal personal computers, to access and interactively explore this splendid city becomes a very attractive research topic. The promise of Grid computing is a transparent, interconnected fabric to link data sources, computing (visualization) resources, and users into widely distributed virtual organizations

B. Martens and A. Brown (eds.), Computer Aided Architectural Design Futures 2005, 93-102.
© 2005 *Springer. Printed in the Netherlands.*

(Shalf and Bethel 2003). Lots of research and development efforts have been conducted on Grid computing issues (www.globus.org). However, Grid-enabled visualization, particularly interactive visualization of large-scale data, has not been well addressed and a wide gulf exists between current visualization technologies and the vision of global, Grid-enabled visualization capabilities. In this paper, we present a practical visualization infrastructure over the Grid for interactive visualization of large-scale architectural models. A multi-stage data compression approach, which happens in data pre-processing, rendering, and remote display stages, is deployed to tackle the critical problem of Grid-based visualization, i.e. data size and network bandwidth. The underlying Grid services, such as information service to enquire available data and visualization resources, visualization planner and execution container etc, are developed according to the OGSA standard (Foster 2001, 2003). Compared with other Grid-enabled visualization infrastructures, ours is specially designed to provide efficient services to the interactive visualization of large-scale architectural models and easy to implement. The related visualization issues have been systematically studied and integrated with the Grid services.

The reminder of this paper is organized as follows: Section 2 reviews the related remote visualization technologies and other Grid-enabled visualization approaches. A new infrastructure, A-VizGrid, is presented in Section 3. Section 4 introduces a multi-stage data compression approach and the corresponding techniques adopted. The development of a prototype system based on A-VizGrid is covered in Section 5 and conclusion is given in Section 6.

2 RELATED WORK

Grid-enabled visualization is a relative new area that originates from remote visualization and Grid services. Typically there are four approaches for remote visualization: (1) do everything on the remote server, (2) do everything but the rendering on the remote server, (3) use a local proxy for the rendering, and (4) do everything at the local site. SGI Vizserver (www.sgi.com/products/software/vizserver/) and VIRTUALE3D vCollab (www.virtuale3d.com) are two examples that use approach (1) and (4), respectively. In SGI Vizserver, rendering is executed at the server site. Rendered results are then captured from the server's frame buffer and sent to remote clients. To speed-up image transmission, users can interactively choose different compression ratio (up-to 1:32) to compress images. According to our test, the default image compression algorithm provided by Vizserver is inefficient and network latency is another problem. Using a different approach, vCollab copies the whole dataset to each of the collaborators. Rendering is carried out locally. This can reduce network latency but system rendering ability is heavily limited.

The advent of Grid computing has inspired people to explore Grid-enabled visualization technologies. In UK, researchers have been developing visualization middleware for e-science (www.visulization.leeds.ac.uk/gViz). They intend to develop a fully Grid-enabled extension of IRIS Explorer, to allow an e-scientist to

run Grid applications through the IRIS Explorer user interface. Much of the Grid complexity will thus be hidden from the end-user. Among the few existing Grid related visualization systems, the Access Grid (www.accessgrid.org) has been widely used. It is an open-source remote video conference tool that integrates various resources including multimedia large-format displays, presentation and interactive environments, and interfaces to Grid middleware and to visualization environments. Kong et al. developed a collaborative visualization system over the Access Grid using the ICENI Grid middleware (Kong et al. 2003). Karonis et al. (2003) built a prototype visualization system using the Globus Toolkit, MPICH-G2, and the Access Grid. However, by nature Access Grid is designed for group-group remote video conferences. Even though digital cameras and print-screen stream can be used to share rendered results, the Access Grid system itself does not deal with rendering work directly. Heinzlreiter and Kranzlmuller (2003) introduced a Grid visualization kernel GVK based on the concept of visualization pipe and aimed to develop a universal Grid visualization service. Visualization pipe programming is usually not the best choice for interactive rendering of large-scale architectural models. Furthermore, in their prototype system, only one sided communication is considered and users cannot interact with the visualization process. Another infrastructure, RAVE, introduced by Grimstead et al. (2004) intended to make use of available resources, either local or remote, and react to changes in these resources. Their services connect to the data service, and request a copy of the latest data. This has the same limitations as the vCollab. In summary, Grid-based visualization technology is far from mature till today. How to efficiently make use of distant visualization resources and overcome network bandwidth limitations, especially for large-scale data, is still a research challenge.

3 A NEW GRID-ENABLED VISUALIZATION INFRASTRUCTURE

The Chang'an city is composed of hundreds of detailed 3D models. Hundreds of millions of polygons and numerous high-resolution textures have been used to model these 3D buildings that go far beyond the rendering capability of a single computer. Even though numerous software techniques have been developed to counterbalance the insufficiency of rendering hardware and enable game players to experience a relatively large virtual word using normal Personal Computers (PC), interactively visualizing Chang'an city with fidelity is still far beyond the capability of a normal PC. In general, software approaches improve rendering speed at the sacrifice of accuracy. For any visualization hardware, the number of triangles and texture size that can be handled is fixed. To "squeeze" the Chang'an city into the narrow graphics pipe of a PC graphics card, lots of the charming details of this splendid city will be lost. Thus, sharing the visualization burden over the Grid and making use of remote powerful rendering hardware becomes a natural choice for PC users who want to explore the Chang'an city and experience ancient Chinese architectural beauties. In an idea grid environment, data and visualization resources should be transparent to end users. Visualization tasks can be distributed and

balanced among distant heterogeneous resources (visualization supercomputers, clusters, normal PCs, and laptops). However, heavily limited by current network bandwidth and internet technologies, it is obviously impractical to distribute a big real-time visualization task to remote resources which are linked by low speed networks and the internet. To achieve real-time rendering speed with acceptable latency, the networks among the distributed rendering resources have to be fast enough. For interactive visualization of large-scale architectural models like Chang'an city, a practical solution is to distribute the task to a limited number of powerful rendering facilities (visualization supercomputers and clusters) connected by high-speed networks to reduce data communications over networks. Data sources might be kept remotely. A data resource server can be used to coordinate data transmission. Based on these considerations, a grid-enabled visualization infrastructure A-VizGrid (Architectural Visualization Grid) is proposed as follows (Figure 1).

Figure 1 Infrastructure of A-VizGrid

Grid resources are used to do computation and handle data. On top of a resource, a visualization or data service can be deployed. These services are registered into a centralized information service so that they can be located by a visualization planner. A visualization or data service runs within its execution service container which deals with communications over the Grid using Grid-compliant protocols. The following steps are performed to deploy and utilize this Grid-enabled system:

1) The user sends a visualization request to Portal Server. The contents of this request include the districts and buildings that the user wants to navigate, the rendering quality that the user prefers, and what kind of visualization software installed in the user's machine etc.

2) The Portal Server authorizes and forwards the visualization request to the Visualization Planner.

3) The Visualization Planner sends a data resource information request to Information Service. The replied information, including the location, data file size, number of triangles and texture size etc of each available data resource, is returned to the Visualization Planner and used to estimate the visualization resources required to handle these data in real time. Then, the Visualization Planner sends a visualization resource information request to the Information Service and gets the information on available visualization resources.

4) The Visualization Planner allocates the corresponding data resources and visualization resources based on user requirements and the reply from the Information Service. As data transfer speed over networks is usually much slower than that between cluster nodes or using computer system bus, an important criterion of choosing visualization resources is to minimize large data communications over networks.

5) The allocated data are sent to the Visualization Service site using GridFTP. For distributed data files, a data service server is usually used to consolidate and merge them. Data processing and transfer applications are launched by the Visualization Planner through the corresponding execution container at Data Service site.

6) Once data transfer is completed, the Visualization Planner launches the rendering application at Visualization Service site through its execution container. In case a rendering task cannot be handled by a visualization supercomputer/cluster and needs to be distributed among a few rendering facilities, a visualization service master is used to synchronize rendering jobs and handle user interactions.

7) Meanwhile, the Visualization Planner launches the remote visualization application. The rendered results at Visualization Service site are captured and transferred to the user continually. To overcome network bandwidth limit, the rendered results are compressed first before being sent out and the UDP protocol is used. For a detailed analysis of different communication protocols for remote visualization, see (Renambot et al. 2003).

8) At the user site, the compressed images are decompressed and displayed. The user can interact with the remote rendering application using keyboard and mouse commands.

4 MULTI-STAGE DATA COMPRESSION

Grid services provide a mechanism for sharing a heavy computing or visualization burden with distant resources. Compared with the narrow graphics pipe of a single computer, this virtually combined graphics pipe provided by the Grid is much broad. Unfortunately, due to the limitations of current network bandwidth, the capability of this virtual graphics pipe is not unlimited. Especially for interactive visualization of large-scale data, we are unable to implement a pure hardware approach, simply chop a big visualization task and throw the sub-tasks into the virtual pipe. In many cases we still need software techniques as complements.

4.1 Data Pre-Processing

Original models of ancient Chinese buildings designed by commercial architectural software are usually not suitable for interactive rendering. They are composed of too many redundant polygons. 3D model simplification, as a data pre-processing step, is necessary. Surface simplification techniques have been extensively investigated. Hoppe's progressive meshes (Hoppe 1996) and Garland's quadric error metrics method (Garland and Heckbert 1997) have been widely used. Figure 2 shows an example of the Dayan tower simplification. In the picture, we can see that the original 18,756 triangles have been reduced to 9,378 without much visual difference. According to user requirements, 3D models can be simplified into different resolution levels. In our system, three versions of the city, i.e. high, medium and low resolution, are pre-obtained and saved in data source machines. The whole city is divided into several districts for user selection and fast rendering.

(a) Original Model with 18,756 Triangles (b) Simplified Model with 9,378 Triangles

Figure 2 Surface Simplification Applied to the Dayan Tower Model

4.2　　Rendering Stage

Parallel rendering is necessary for large-scale data visualization. In a multiple CPU visualization supercomputer, the rendering pipe can be divided into three functional stages, i.e. APP, CULL and DRAW. Each stage can be a separate process. Cluster-based parallel rendering can be categorized into sort-first, sort-middle, sort-last, and hybrid approaches (Molnar et al. 1994). In a typical master-slave system, each rendering node (master and slaves) has a copy of the whole dataset to reduce data communication burden. The master node is used to synchronize the applications running at each rendering node. The rendered results can be collected from their frame buffers and assembled for remote display. According to the experiments done by Staadt et al. (2003), for interactive cluster-based rendering, this deployment is most effective. In a distributed visualization system that is composed of supercomputers and clusters linked by high-speed networks, a similar approach can be deployed. To fit large-scale data into the system memory of each rendering node, data paging technique can be used.

Level of Detail (LOD) is a widely used technique for interactive rendering of large models. Traditional LOD techniques are based on pre-built models at different detail levels. Applications automatically choose a level to draw based on the model's distance from viewpoint. These level models increase system memory request. Another problem is the distracting "popping" effect when the application switches between detail levels. To avoid these problems, view-dependent continuous LOD methods for real-time rendering can be used. The basic idea is to dynamically generate the simplification model according to viewpoint, object and screen resolution. Here we introduce a simple and fast dynamic LOD algorithm based on vertex clustering operations. Before rendering, each vertex is weighted according to its relative curvature value. These values are used to measure the relative importance of each vertex. During rendering, the radius of a bounding sphere centred at vertex P is online calculated using the following formula.

$$R = \sqrt{\frac{K \times W \times H}{SW \times SH}} \times \frac{\|OP\|}{\|OP'\|} \times \left(\frac{90^o}{90^o - \theta}\right)^2 \qquad (1)$$

Where the size of near clipping plane is $W \times H$, screen window resolution is $SW \times SH$, rendering error is within K pixels, the projection of vertex P on near clipping plane is P', O is viewpoint, $\|OP\|$ and $\|OP'\|$ are the lengths of line segments and θ is the angle between line OP and the central viewing line (viewing direction). All the vertices inside this bounding sphere are clustered into a single vertex. After vertex clustering, a simplified mesh is obtained. To further improve rendering speed, before vertex clustering process, visibility culling and back-facing culling calculations are carried out to filter out invisible vertices.

4.3 Remote Display Stage

To make use of remote visualization resources, one of the biggest challenges is how to send the rendered results over limited network bandwidth with acceptable latency. When we use Grid services to search for available visualization resources, an important consideration is the network bandwidth and physical distance between the user and visualization resources. We use UDP protocol to transfer rendered results (images). A wavelet-based image compression and decompression algorithm is also integrated with the A-VizGrid system. This algorithm is much efficient than that provided by SGI Vizserver. Figure 3 shows a comparison result. Picture 3(a) is the result using the default image compression algorithm provided by Vizserver. The compression ratio is 1:32. Compared with the result using wavelet compression (Figure 3(b)), its visual quality is obviously worse, even if the wavelet algorithm used a much higher compression ratio 1:128.

(a) 1:32 Compressed by Vizserver (b) 1:128 Compressed by wavelets

Figure 3 Image Compression using Different Algorithms

5 PROTOTYPE DEVELOPMENT

Based on the A-VizGrid infrastructure, a prototype system is being developed. The data resources are located at NUS. Available visualization resources include a SGI Onxy2 with four InfiniteReality Graphics pipes at the Institute of High Performance Computing (IHPC), a 5-node Linux cluster with 10 AMD64 CUPs and Nvidia Quadro FX3000G graphics cards at IHPC, and a SGI Onyx3000 at the Nanyang Technological University. The information service, visualization planner and execution container etc, are OGSA-based Grid services. Execution containers and the portal server have been implemented using Java (Ho and Khoo 2004). In the SGI supercomputers, we use OpenGL Performer with enhanced culling and view-dependent continuous LOD algorithms to handle large-scale architectural models. The rendered results are remotely displayed using Vizserver integrated with a wavelet-based image compression/decompression algorithm. In the visualization cluster system, we use Chromium to run OpenGL applications (Humphreys et al. 2002). We also use the CAVELib to control and synchronize OpenGL Performer applications. Figure 4 and 5 are two screen snapshots of the Chang'an city.

Figure 4 Bird's-Eye View of the City **Figure 5 Navigation in the Linde Hall**

6 CONCLUSION

A practical Grid-enabled visualization infrastructure has been presented in this paper. It intends to provide efficient services for interactive visualization of large-scale architectural models, such as Tang Chang'an city. It is easy to implement and the underlying Grid services are developed according to the OGSA standard. To tackle the critical problem of Grid visualization, i.e. data size and network bandwidth, a multi-stage data compression approach has been deployed and the corresponding data pre-processing, rendering and remote display issues have been systematically addressed.

ACKNOWLEDGEMENTS

We would like to thank the members of the Grid team at IHPC for valuable discussions and sharing of information with respect to the proposed grid-enabled visualization infrastructure. We also thank the Centre for Industrial Mathematics of NUS for use of their patented image compression algorithm. This research is supported by the Academic Research Fund of NUS under contract number R-295-000-037-112.

REFERENCES

Foster, I., C. Kesselman, and S. Tuecke. 2001. The anatomy of the Grid: enabling scalable virtual organizations. *The International Journal of High Performance Computing Applications* 15(Fall): 200-222.

Foster, I., and I. Kesselman. 2003. *The Grid 2: blueprint for a new computing infrastructure* [2nd ed.]. Morgan Kaufmannn.

Garland, M., and P.S. Heckbert. 1997. Surface simplification using quadric error metrics. In *ACM SIGGRAPH Proceedings*, 209-216. New York: ACM Press.

Grimstead, I.J., N.J. Avis, and D.W. Walker. 2004. RAVE: resource-aware visualization environment. In *Proceedings of the UK e-Science All-Hands Meeting*, ed. Simon Cox: 137-140. Nottingham.

Heinzlreiter, P., and D. Kranzlmuller. 2003. Visualization services on the Grid: the Grid visualization kernel. *Parallel Processing Letters* 13(June): 135-148.

Heng, Chye Kiang. 1999. *Cities of aristocrats and bureaucrats: the development of medieval Chinese cities*. Honolulu: University of Hawai'i Press.

Ho, Q.T., and B. Khoo. 2004. *Development of execution containers for Grid-based visualization*. Technical report (IHPC/SNC/Grid-04-11), Institute of High Performance Computing, Singapore

Hoppe, Hugues. 1996. Progressive meshes. In *ACM SIGGRAPH Proceedings*, 99-108.

Humphreys, G., M. Houston, R. Ng, and R. Frank. 2002. Chromium: a stream-processing framework for interactive rendering on clusters. In *ACM SIGGRAPH Proceedings*, 693-702. New York: ACM Press.

Karonis, N.T., M.E. Papka, J. Binns, and J. Bresnahan. 2003. High-resolution remote rendering of large datasets in a collaborative environment. *Future generation Computer Systems* 19(August): 909-917.

Kong, G., J. Stanton, S. Newhouse, and J. Darlington. 2003. Collaborative visualisation over the Access Grid using the ICENI Grid middleware. In *Proceedings of the UK e-Science All Hands Meeting*, ed. Simmon Cox: 393-396. Nottingham.

Molnar, S., M. Cox, D. Ellsworth, and H. Fuchs. 1994. A sorting classification of parallel rendering. *IEEE Computer Graphics and Applications* 14(July): 23-32.

Renambot L., T. Schaaf, H. Bal, D. Germans, and H. Spoelder. 2003. Griz: experience with remote visualization over an optical grid. *Future Generation Computer Systems* 19(August): 871-881.

Shalf, J., and E.W. Bethel. 2003. The Grid and future visualization architectures. *IEEE Computer Graphics and Applications* 23(March/April): 6-10.

Staadt, O.G., J. Walker, C. Nuber, and B. Hamann. 2003. A survey and performance analysis of software platforms for interactive cluster-based multi-screen rendering. In *Eurographics Workshop on Virtual Environments*, ed. Joachim Deisinger, and Andreas Kunz: 261-270. Zurich.

Digital Design, Representation and Visualization

Townscaping: Development of Dynamic Virtual City Augmented 3D Sketch Design Tools

PENG Chengzhi
School of Architecture, University of Sheffield, UK

Keywords: virtual city, 3D sketch design, interactive urban visualisation, web-based design

Abstract: The paper presents the development of an experimental Web-based design environment called Townscaping to be used at the conceptual stage of architectural and urban design. Inspired by Gordon Cullen's seminal work on Townscape (1960's-1970's), the idea of Townscaping is to explore how 3D digital sketch design tools could be developed to operate in connection with a dynamic virtual city system under a user's direct control. A prototype of Townscaping has been designed and implemented on the basis of an existing dynamic virtual city system. In Townscaping, a set of tools is provided for users to create and edit 3D graphic elements to be positioned directly onto the user-specified virtual city models. One of the key features of Townscaping is to enable sketching while navigation: designers can perform sketch design and gain immediate visual feedback while navigating the 3D virtual city models to any viewpoint at any moment. The current study suggests that it is feasible for virtual city models to serve as interactive urban contexts for 3D sketch design. Townscaping is considered primarily a research platform with which we are interested in investigating if designers' engaging in 3D space conceptions may be enhanced through interacting and sketching with virtual townscapes.

1 INTRODUCTION

Digital 3D sketch design has been an active area of research and development in various domains of design such as architecture, industrial design, engineering design etc. With different choices of operating platforms, novel tools have been built to explore interesting issues concerning how the experiences and processes of intuitive (freehand) drawing or sketching can be recreated through digital means. This paper reports on our current research that explores the potential of linking 3D sketch design to interactive urban visualisation modelling. The research hypothesis to be tested is twofold: (1) New possibilities of engaging in 3D sketch design can be identified if the sketching tools can be enacted within contexts of designing; (2) Architectural and urban design at the inception stage could be better supported and to some extent enhanced by sketch design tools augmented by 3D interactive urban contextual visualisation modelling.

B. Martens and A. Brown (eds.), Computer Aided Architectural Design Futures 2005, 105-114.
© 2005 *Springer. Printed in the Netherlands.*

Townscaping: Dynamic Virtual City Augmented 3D Sketch Design Tools

The Townscaping project started with the idea of bringing two common practices closer to one another: on one hand, 3D graphic modelling of urban context, and on the other hand, sketch design in architecture and urban design. For various purposes, there is a growing interest in the construction of 3D models of urban and built environment for which a wide array of digital modelling and rendering techniques have been developed (see, for instance, Pietsch et al. 2001; Shiode 2001). In architecture and urban design, sketch design remains an essential process in which strategic and schematic ideas are played out by designers in an episodic manner (Rowe 1987). Given that these are two commonly seen activities, it seems reasonable to ask if we could consider 3D urban models as a kind of backdrop or canvas for digital sketch design to take place directly within it.

Using any conventional CAD package such as AutoCAD or MicroStation, one can build a 3D urban site and use it as a basis to develop 3D designs. Yet, most designers would consider site modelling and actual designing two separate activities; designs are mostly developed on their own and then tried to 'fit' or 'import' into the site model. In setting up the Townscaping experiment, we have worked the other way around. An interactive urban visualisation system together with information content about a real historical city were first developed, allowing users to select and retrieve any area of 3D urban models in the VRML format. A set of tools for spawning and manipulating 3D basic graphic elements was then built into the urban visualisation system. In Townscaping, users (designers) can therefore activate the tools at anytime to perform sketch design while navigating the 3D virtual urban site. At the end of a sketch design session, the result can be saved and then imported to a CAD system for further design elaboration if the designer so wishes.

Townscaping is considered primarily a research prototype with which we are particularly interested in investigating if designers' engaging in space conceptions may be enhanced through virtual city augmented 3D sketch design. The remainder of the paper is organised as follows. In Section 2, the SUCoD platform developed through previous research is introduced briefly as the basis for developing the Townscaping environment. Section 3 describes the six key component functions that constitute the present design of Townscaping. More technical details of the current implementation of Townscaping together with a worked example of using the sketch design tools are presented in Section 4. Finally, in Section 5, an initial evaluation of the usability of Townscaping is reported, pointing to a number of issues to be further explored in building the next version of Townscaping.

2 SUCOD: A WEB-BASED PLATFORM FOR GENERATING USER-DEFINED 3D CITY MODELS

The *Sheffield Urban Contextual Databank* (SUCoD) system was developed through previous research that looked into how the usability and reusability of urban models and associated datasets could be significantly improved by adopting a Web-based multi-tiered framework (Peng et al. 2001, 2002). Central to the design of SUCoD is a set of facilities for allowing users to freely retrieve 3D city models (in VRML 2),

images of historical maps, and web links to other associated urban resources according to user-specified spatial-temporal attributes. In so doing, the restriction on end-user retrieval as pre-determined by how the urban models and other datasets were built in the first place by the model developers can be removed.

Figure 1 shows a snap shot of current implementation of SUCoD (accessible online http://sucod.shef.ac.uk). Based on ILOG JViews, a Java applet was built to display an interactive city map of historical Sheffield containing multiple layers of selectable graphic objects that depict the city's terrain, streets and buildings etc. Secondly, extra functions were built into the applet for users to perform resource retrievals including Get Historical Map for retrieving scanned historical maps, and Get VRML for retrieving user-specifiable city model sets in the VRML 2 format. These two retrieval functions were designed to communicate with corresponding CGI Perl scripts over HTTP. Intended as intelligent agents operating on the middle tier, the Perl scripts were designed to accomplish a number of tasks in real-time: processing user selections, accessing relevant urban data repository stored on the back-end tier, and constructing well-formed maps, models and other associated datasets ready for user browsing.

Figure 1 Current implementation of SUCoD's user front end

Another two user interaction functions were also attempted. Upload VRML was designed to allow users to submit their own VRML worlds that can be further combined with the city models they retrieve from SUCoD. List VRML was designed for the user to generate an on-demand HTML table that lists the history of city model retrieval and/or user model upload. List VRML can be invoked at anytime during a single live session, and the history of user interaction is formatted as a simple HTML form page containing checkboxes for all VRML worlds registered through either Get VRML or Upload VRML. With records generated by the listing function, users can go on selecting any of the VRML worlds from the list and creating their own personal virtual worlds, which may well be syntheses of urban contexts and user proposed designs.

The SUCoD prototype has been developed to explore how 3D city modelling might shift from developer-centered to user-driven. We have learned that the usability of 3D city models could not be significantly improved if users of the city models were not allowed to perform interactions at a higher level leading to the generation of personal virtual worlds pertinent to their own purposes. We have since considered SUCoD an open extensible platform for experimenting further interactive functions beyond those of retrieving, uploading and listing. In the next section, I describe our development of the Townscaping 3D sketch design tools on the basis of SUCoD.

3 TOWNSCAPING: DYNAMIC VIRTUAL CITY AUGMENTED 3D SKETCH DESIGN

Townscaping was developed along Cullen's principle of *sketching while navigation* to provide designers with an intuitive 3D contextual sketch design environment. Sketching while navigation allows users to freely navigate to any position in a virtual city model and to perform 3D sketch design activities. Unlike conventional CAD systems, switching between navigation and sketch design in Townscaping is easier without users going through complicated mode change on the user interface. The Townscaping environment is envisaged to support early conceptual design by (a) aiding visual understanding of the design context, (b) making a set of 3D graphic editing tools applicable directly onto the design context as represented by a VR model, and (c) enabling immediate feedback on sketch design via VR-enabled navigation. Conceptually, the current design of Townscaping is composed of the following component functions:

Select, Access and Define. As seen in SUCoD, interactive maps of a city are provided for users to select an area of interest and access the VR models of that area. Users define 3D city contexts in terms of spatial boundary and information content that they consider appropriate to their tasks at hand.

Navigation. Once a 3D urban context is defined and generated as a virtual world, the user can freely navigate the world through various modes such as Walk, Fly Through, Pan, Look etc. as commonly seen in VR-based viewers.

Viewpoints. Similar to book marking Web pages when people find their favourite websites, viewpoints can be set up by users freely during navigation. These may be the viewing points where the users consider the scenes captured are of special interests or importance that can be quickly revisited if needed.

Generation. Instances from a range of 3D graphic elements can be specified and generated into the virtual city model. Depending on the computer graphic language chosen in the implementation, the types of graphic elements and the scopes of their attributes may vary from one language to another.

3D Editing. Graphic objects generated in the VR model can be manipulated individually (or, as a group defined by the users) to enable changes in spatial positions, dimensions, appearances, or even behaviours.

World Save. At anyone time, users may decide to leave Townscaping and save whatever has been produced during the session including the urban contexts specified. Users can reload their saved worlds later to resume design editing.

4 CURRENT IMPLEMENTATION AND A WORKED EXAMPLE

The current Townscaping prototype is implemented as a Java™ Web Start application that can be accessed directly from the existing SUCoD web server (http://sucod.shef.ac.uk/townscaping). Once set up, it can be launched from a user's desktop shortcut. Java, Java3D and Perl were used to implement the key functionalities for accessing urban contextual models and sketching while navigation. The VRML97Loader class in Java3D was used to load the original Sheffield urban model datasets in VRML 2, and this opens up the use of a great deal of Java3D capabilities in Townscaping such as allowing users' adding new viewpoints into the contextual models. Several panels were built for users to access various tools and functions such as Navigation, Views, Buildings, Designer (see Figure 4). In addition, a collection of CGI scripts written in Perl is deployed on the server to process user requests for selected urban contextual resources such as maps and models. Finally, when leaving Townscaping, users can save locally their sketch design results as XML files, containing both the city contextual models and their sketch designs which can be reloaded at later sessions.

Figure 2 SUCoD's city map is first displayed for user selection of a general area of interest for retrieving an IVL map for accessing Townscaping

When accessing Townscaping, the city's index map is first displayed for the user to specify a general area of interest by selecting one or more 200m square tiles, and

then the Get IVL Map for Townscaping function can be activated for building the final 3D urban context (see Figure 2). The green-shaded area on the index map indicates the current scope of 3D VR models currently available from the SUCoD server, which will be extended as more contextual datasets are built into the system.

As soon as the Get IVL Map for Townscaping function is activated, the user is shown another interactive city map in a separate window (Figure 3). Created in ILOG's IVL format, this is a much more detailed map containing 20 layers that depict the 2D layouts of urban features gathered through an urban study survey. With this interactive map, the user can further define a more exact area of interest by fine tuning the content selection down to individual buildings and street blocks if considered appropriate.

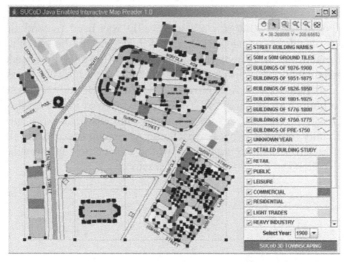

Figure 3 An IVL map is displayed following user selection on the index map

When the user is satisfied with her content selection on the IVL map and activates the SUCoD 3D Townscaping function, a virtual city model is displayed in a new window with the Townscaping toolset provided on the left (Figure 4). The 3D city model is initially shown at the viewpoint (view 0) that is at the top of the Views list containing all the viewpoints preset by the urban model developers. On the Navigation panel, the user can move around the model via MOVE, PAN or LOOK with Align to reset the sky-ground of the city model into horizontal. Direction of navigation or where to look is controlled by the user's moving and pressing the mouse cursor into a position relative to the centre of the field of vision. As mentioned earlier, the user can add new viewpoints at anytime by navigating to the intended locations, adjusting the views and then entering names of the new viewpoints through the Views panel (Figure 5). The marking up of new viewpoints can be a valuable exercise in setting up how a sketch design may be approached.

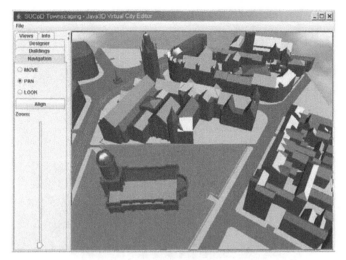

Figure 4 A 3D city model is generated following user selection on the IVL map and the Townscaping toolset is provided on the left

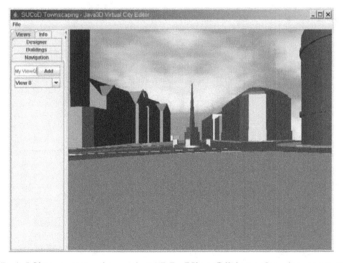

Figure 5 Adding a new viewpoint "My ViewQ" into the city context model

On the Designer panel, the user is provided with a set of graphic elements including Cube, Cone, Cylinder and Sphere. This should be seen as the initial toolset, which will be extended to afford other types of 3D elements/tools. Selecting the Cube tool, for instance, a Cube-Properties pad is shown prompting the designer to enter the name, dimensions and colours of a cube element (see Figure 6). As the Apply button is pressed, an instance of Cube is generated into the virtual world at a preset location and orientation. The cube object can then be manipulated through the ten spatial operations on the Buildings panel until a desirable status is reached.

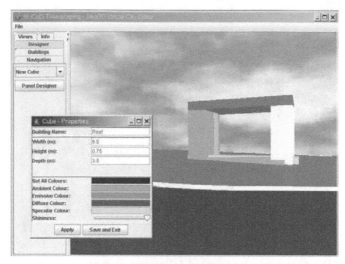

Figure 6 3D editing with the spatial operations on the Buildings panel and an element properties sheet for editing elements' names, dimensions and colours

Figure 7 Sketch design of a street performance stage in front of a monument

As a worked example to illustrate Townscaping (Figures 6-8), a hypothetic street performance stage is conceived in relation to a city monument site, the Jubilee Monument in Barkers Pool back in 1900. Instances of Cube and Cylinder of various properties were generated and manipulated into the intended positions and orientations. It is worth mentioning that defining new viewpoints can play a very useful role in the process of sketch design because it allows the designer to move around those bookmarked views quickly while deliberating the design composition.

Figure 8 Navigate to the viewpoint "My Stage" for another contextual check

5 INITIAL FEEDBACK ON TOWNSCAPING AND TOPICS FOR FURTHER RESEARCH

A group of architect students were invited to use Townscaping soon after the first prototype was deployed and tested on SUCoD. During the evaluation, no specific design tasks were given, but each student was asked to complete a simple questionnaire regarding their experiences, impressions and suggestions of the sketch design tools. Although the initial feedback received was generally positive and encouraging, there remain usability issues to be further resolved:

1) Manipulating a cylinder element is particularly problematic as it can be difficult for users to predict the net effect of combined move, rotate and tilt. The current spatial operations are command-driven and can be fine tuned with a sensitivity sliding bar. However, the lack of direct manipulation such as "point-and-drag" can often hinder the flow of fluency in sketch design.

2) The current range of 3D graphic tools is limited and, strictly speaking, they are not really for 'sketching' as in freehand sketch but more for 3D conceptual design. More work is needed to incorporate perhaps some of the features seen in HoloSketch (Deering 1996), FreeDrawer (Wesche and Seidel 2001) and Space Pen (Jung et al. 2002). But Townscaping is open to experimenting with novel 3D graphic constructs, free-form or otherwise, as potential catalysts for space conception in architectural and urban design.

3) It was suggested that users should have the option to save their sketch design results into files containing only their design schemes that can be further imported into a CAD system for further design development. More work is needed to enable further processing of the current saved world in XML into a CAD-compatible format such as the DXF.

4) The current urban contextual models retrieved from SUCoD do not contain aspects of urban landscapes other than buildings and streets. Some kind of *urban design props* could be introduced as auxiliary resources for sketch design. Especially, user placement of 3D human figures in virtual urban spaces could perhaps help engender a sense of human proportion.

The Townscaping environment is presented as a follow-up development of SUCoD. It shows that the urban contextual resources developed for a city can be exploited to realise dynamic virtual city augmented 3D sketch design tools. The development of the Townscaping toolset is still at an early stage, but we believe that the underlying principle and methodology as demonstrated through SUCoD-Townscaping can be applicable to other cities and towns.

REFERENCES

Cullen, Gordon. 1971. *The Concise Townscape* [New edition]. London: Architectural Press.

Deering, M.F. 1996. The HoloSketch VR sketching system. *Communications of the ACM* 39(5): 54-61.

Jung, T., M.D. Gross and E. Do. 2002. Annotating and sketching on 3D web models. In *Proceedings of the 7th International Conference on Intelligent User Interfaces*: 95-102. New york: ACM Press.

Peng, C., D. Chang, P. Blundell Jones, and B. Lawson. 2001. Dynamic Retrievals in an Urban Contextual Databank System using Java-CGI Communications. In *Proceedings of Computer Aided Architectural Design Futures 2001,* eds. B. de Vries, J. van Leeuwen, and H. Achten: 89-102. Dordrecht: Kluwer.

Peng, C., D. Chang, P. Blundell, and B. Lawson. 2002. On an Alternative Framework for Building Virtual Cities: Supporting Urban Contextual Modelling On Demand. *Environment and Planning B: Planning and Design* 29(1): 87-103.

Pietsch, S., A. Radford, and R. Woodbury. 2001. Making and Using a City Model: Adelaide, Australia. In *Proceedings of the 19th eCAADe Conference,* ed. Hannu Penttilä: 442-447. Espoo: Otamedia

Rowe, Peter G. 1987. *Design Thinking*. Cambridge, MA: MIT Press.

Shiode, Narushige. 2001. 3D urban models: recent developments in the digital modelling of urban environments in three-dimensions. *GeoJournal* 52(3): 263-269.

Wesche, G., and H.P. Seidel. 2001. FreeDrawer: a free-form sketching system on the responsive workbench. In *Proceedings of the ACM symposium on virtual reality software and technology*, eds. C. Shaw, W. Wang, and M. Green: 167-174. New York: ACM Press.

Towards a Virtual Reality Tool for Lighting
Communication and Analysis in Urban Environments

TAHRANI Souha[1], JALLOULI Jihen[1], MOREAU Guillaume[2] and WOLOSZYN Philippe[1]
[1]CERMA UMR CNRS 1563, [2]Ecole d'Architecture de Nantes, Nantes, France

Keywords: virtual reality, 3D city modelling, environmental simulation, visual perception

Abstract: The objective of this paper is to evaluate the use of virtual reality as a potential decision-making tool to cognitively evaluate urban daylighting ambiences. This paper evaluates the *solar effects* visual perception in a real urban path in comparison to a virtual urban path in order to extract the characteristics of these effects and use them to figure out the necessary conditions for generating a physical and sensitive phenomena simulation. The comparison is based on questionnaires and interviews with participants on their judgements on sunlight during their walk through the chosen path. Our results highlight the relation between perception and the context of the urban environment, and prove that -in spite of its limits- virtual reality is able to simulate a large part of real *solar effects*.

1 INTRODUCTION

Studying the urban environment is a complex procedure that is heavily influenced by the multi-layered interaction and dynamics between the built environment (the mixture of volumes, shapes and materials that form the cities), the physical factors (wind, light, sound, pollution etc.), and their physical and cognitive representation by the human sense, what we might call the architectural and urban ambiance. The study of this multi-layered interaction is processed through an interdisciplinary approach, that complements classical ones with the use of Virtual Reality (VR) technologies as study tools.

There are many urban studies that primarily focus on visual perception analysis and its relation to movement in the urban space. These studies generally show a sensitive examination of the city (Lynch 1960, Cullen 1971), but don't look into the physical factors that play a very important role in controlling the urban pedestrian movement. A few studies focus on the interaction between the physical and psychological factors in immersive environments (Woloszyn 2003).

Our aim is to develop a dynamic immersive tool that uses visual perception as an analysis method to study the impact of the *solar effect* on space acknowledgement.

B. Martens and A. Brown (eds.), Computer Aided Architectural Design Futures 2005, 115-124.

To do that, the following questions are asked: How can the spatial factors influence our visual perception? Is it possible to measure the perceptive impact? What are the requirements for representing this impact?

In this paper, we will present an experimental study that compares the perception of *solar effects* in real and virtual environment. The first part will be devoted to a theoretical study. The two later sections will concentrate on describing the experimental study, the adopted methods and the obtained results.

2 BACKGROUND

Our study is based on two tools: *solar effects* and *VR technology*. This part will focus on a study of "solar effects" concept, as well as an overview of VR and its applications in the architectural and urban field.

2.1 Solar Effects

Human vision is conditioned by the existence of light, producing physical and psychological effects. In this logic, the concept of lighting ambience is defined by the position of human beings in the space and their visual perception of environmental daylight.

Several studies described the "effect of light" on architecture (Jungman 1995) by studying the way to visualize light in the architectural image. Other studies treated the notion of "ambiance effects" by using these effects as an ambiance analysis and design tool. This concept was initiated by the "sonic effects" - *effets sonores*-proposed by J.F. Augoyard and H. Torgue who defined this notion as: "*the interaction between the transmitting source, the elements of built space and the perception of the receiver*" (Augoyard 1998). Furthermore, some studies attend the notion of "effect of light" leading to "visual and luminous effect" (Thibaud 2001a). Although this work is not yet complete, there are several experiments that are based on this double sided concept "visual and luminous effects" and "sonic effects" (Follut 2000).

This perspective introduces the interaction between light and space through "solar effects" concept that is generated by combining the three following factors: observer (visual perception), space (architectural and urban forms), and daylight. In our work, we approach the "solar effect" as a tool for phenomenal interpretation of the public space. It is an essential component in building the urban scene (Figure1). Figure 2 shows an example of some "solar effects" used in this paper, such as the effect of "*Attraction*": an effect that attracts the attention in an uncontrolled or conscious way. "*Repulsion*": an effect implying a solar phenomenon into a rejection attitude and "*Opening*": effect highlights the opening of space, related to the position of the observer.

Figure 1 The same view of the Barillerie Street in Nantes, with and without light, shows how "solar effects" play a crucial part in our space comprehension

Figure 2 Solar effects demonstration: Attraction, Repulsion and Opening

2.2 Virtual reality in architectural and urban field

According to Fuchs (Fuchs and Moreau 2003), VR is a set of multi-disciplinary tools and techniques that allow the immersion of an user in an artificial world permitting him to change of place, time and interaction type. VR interacts with the human senses by introducing the concept of immersion (perception) and real-time interaction (action). These are studied on three levels: the physical realism of the model, the behaviour and the experience of performing a specific task in the virtual world.

Four classes of interaction primitives can be distinguished: observing, moving in, acting in and communicating with the world. Our study is limited to the 2 first categories, where the user will observe the daylight during his walk in the real-time 3D environment. Despite the latest evolution of VR, there remain several constraints. In our work, we were confronted by some difficulties related to visual representation:

- Immersion limitations: screen resolution, weak projector contrast and triangle/texture limits in real time rendering. Moreover, the limited field of view may reduce the immersion feeling and we shall not forget that perception is here exclusively visual.

- Interfacing problem: How to locate and direct the user's movement in the real-time 3D environment while maintaining a high degree of freedom? Inspired by Azpiazu (Azpiazu et al. 2004) we are looking at the "guide" metaphor: liking the user's motion to a guide that he can stop whenever he wants. During stops, he can wander about.

For many years, research has been more focused on improving VR systems (free navigation, better rendering, better colour representation, etc.) than on studying perception, especially in outdoor environments. This is why our work tries to evaluate daylight in the urban space through the way it is perceived by using VR tools.

Bishop (Bishop et al. 2000) described the rationale for using virtual environments by taking an experimental approach to explore aspects of landscape perception. That experiment was encouraging for the further use of virtual environments. The quality of indoor daylighting was examined by comparing different types of images: real space, photography and computer-generated images (Charton 2001). The results showed some disagreement between perceiving light in real space and in images and confirm that movement is essential in having a better light perception. A similar study (Billger and Heldal 2002) tried to investigate the issue of colours, lights and size perception in architectural models and showed that neither the desktop model nor the VR model sufficiently represented light and colours, thus disqualifying models from being a design tool for buildings.

3 EXPERIMENTAL STUDY

Throughout the study, we investigated the way people evaluate urban daylighting by studying their behaviour and personal classification of real and virtual space lighting (both physical and cognitive).

We used two tools in the experiment: the subjective acknowledgement of the "solar effects", and the objective characterization offered by VR technology. The objectives of the experiment are to validate our methods by cognitively evaluating urban daylighting ambiences and to explore the "solar effects" characteristics as cognitive descriptors of the urban space. This paper is looking into the subjective way that the observer perceives real or represented "solar effects" - *perceived solar effect*- further than entering deep into the technical aspect of producing these effects in real time digital environment (which could become further research if required).

Two urban paths, *in situ* and *in vitro,* were studied throughout our experiment. The experimental process consists first of "solar effects" observation in the real urban path, to formulate our questionnaire. Then, we tested subjects in both real and virtual path by using *"the commented circuit"* method (Thibaud 2001b) before completing a brief questionnaire. The last stage is devoted to the analysis of subjects' commentaries and questionnaires answering.

3.1 Experiment Study Area

The study site is the downtown of the city of Nantes – France; a pedestrian axis of the city with an approximate length of 500 meters. This is a varying space that contains different urban types from three different architectural periods. It starts by *"Pilori square"* (Middle Aged) and finish by *"Royal square"* (19th Century), going through a contemporary avenue called *"Cours des Cinquantes Otages"* (figure 3). This vivid variety generates an extensive collection of "solar effects" throughout this path.

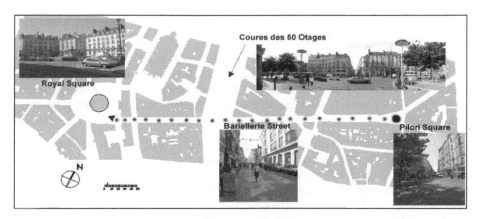

Figure 3 The chosen urban path

The 3D digital urban path was built with AutoCAD. Textures and light computation were made with 3D VIZ4 under the following conditions: *Elevations textures*, as photographs of real path elevations, computed for simulating light at (April 1st - 2002 at 1:30pm). *Daylight simulation* was carried out according to Nantes location (Latitude: 47°15', longitude:1°33') and at the same date that photographs were taken. The computation daylight integrates sunlight, skylight, as well as radiosity, to simulate the way that light interacts in the selected environment (Figure 4). In order to export the model with its light and shadows to VRML file, the *"Render to textures"* technology was applied with 3D MAX5, that allows to create a texture maps based on objects' appearance in the rendered scene.

Since, due to technical limitations, we couldn't yet simulate free movement in the virtual world, we used a walkthrough camera in the model to symbolize the user's field of view during his walk through the virtual path. The camera was placed 165 cm higher than the model ground, with 61.6°of field of view, that corresponds to a user positioned 150 cm away from a 238 X 190 cm screen. These settings allowed the user to forget virtuality and to concentrate on space light perception. The digital model has then been exported to a VRML file to be projected in the immersive room. The room is equipped with a powerful workstation, a large rear-projecting screen to visualize the VRML model on 1/1 scale (Figure 4).

119

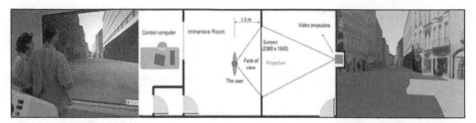

Figure 4 Plan of the immersive room and Simulated viewpoint of *Pilori square*

3.2 Procedure and Tasks

This exploratory study was leaded with 18 participants in the real path and 11 participants in the virtual one. The participants were males and females, mainly students between 20-35 years old. 39% of the participants are used to the selected urban path, 34% have a knowledge of the bath and 27% were their first travelling through.

We asked the participants about their judgements on sunlight during their walk through the chosen path by using the "*commented circuit*" method. This method allows them to interact with public space by performing 3 interaction modes: "walk, observe and describe" so as to characterize their light perception in space. The participants spent about 12-15 minutes to walk through the real path, between 11:30am-2:30pm. Their impressions and daylight evaluation for each space were collected via a Dictaphone. They were then asked to complete a questionnaire, and then evaluate their experience in each world. In order to study the collected data, we analysed, first the recorded statements of the subjects to extract the description of the perceived (*in situ*) and the represented (*in vitro*) "solar effects". Then the questionnaires to get the memorable properties of the "solar effects". that highlights the most remarkable "solar effects" in the urban path. The results of each experience were studied on three levels to facilitate the interpretation:

- Preparing "Evaluation lists" that regroup the synonym subjects' commentaries to extract the characterization of perceived "solar effects".

- Determining the conditions that generate each type of "solar effects" by studying a part each space of the path as described in the subjects' commentaries.

- Studying the different stages in the paths as categorized by the participants light evaluation on the closed questions. The analysis of split spaces is inspired by "Régnier's Abacus" method (Régnier 1989). The method allows a simple, fast and precise systematisation of the opinions expressed in a group. It is particularly adapted to the collection and the treatment of qualitative information by employing a technique of coloured votes. The decision is taken by choosing a colour code from a grid of 5-7 colours that express the degree of agreement or not of each item in the closed list (between 5-15 item by list). White colour indicate a neutral opinion.

4 RESULTS

Through comparing those two urban paths, the results are split into three levels as mentioned on (3.3): subjects' judgements of subjective splitting of the paths, evaluation listing (*in situ, in vitro*) and emergence conditions of the "solar effects".

4.1 Subjects' Judgements Space Division

There were different subdivisions of the urban path in the two worlds- 5 urban spaces on the real world and 4 urban spaces on the virtual one-. For example, the majority of participants didn't distinguish the beginning of the path -"*Pilori square*"- in the virtual world. This was due to the predefined field of view of the walkthrough camera. For that, "*Pilori square*" isn't included in our comparison. Comparing users' daylight judgements is done through the "Régnier's Abacus" method, which proposes a choice between opposite qualification items: (luminous-dark), (opening-closing), etc. (Figure 5). The collection of subjects' choices gives a coloured diagram. That allows to evaluate the daylight in each stage of the bath, then to reveal qualifications of several "solar effects" in the chosen context.

Figure 5 illustrates as example of "*Royal square*". It shows similarities between some items, such as size, reflecting, and opening. The (rhythmic- random) item was judged differently. Consequently, that common qualifications allow to isolate some effects such as "*Attraction*" and "*Opening*". This confirms that theses effects are perceived the same way in both environments.

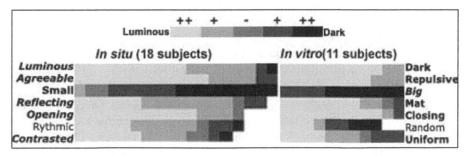

Figure 5 Subjects judgment results of Royal square through Régnier's Abacus

4.2 Evaluation Listing

This level is based on the comparison between evaluation lists made for each world in order to evaluate the way that subjects express their visual perception in each world. Do they have the same perception of the same effect in the two worlds? The evaluation list of "solar effects" *in situ* is richer than the *in vitro* one. In the real path, subjects' perception varies during the walk through the path, whereas in the virtual world, perception sometimes stays fixed although space changes. That is

121

because the real world is far more complex since it is more animated, it contains pedestrians, cars, urban furniture etc.; a lot of stimuli that influence visual perception and make it richer. However, we have found many similarities in the participants' comments on the two paths in terms of visual perception. Table 1 shows an example of the users' comments on the effect of "Attraction/Repulsion" and "Opening".

Table 1 Comparison between the evaluation *in situ* and *in vitro* grids

Solar effect	Users' comments		Analysis
	In situ	*In vitro*	
Attraction/ Repulsion	Attracted by, looking at there, want to go, not to like, to accelerate, turn, slow down ...	That gives desire, disagreeable, ugly., pick up the attention, not okay here, doesn't interest me, We aren't attracted.	The lack of free movement in the virtual world makes the perception of these effects as a wish, contrary to reality
Opening	A big, large, wide, spacious space, there is more of light	A sensation of space, illuminated space, It's big, space around me.	The same perception in the two worlds.

4.3 Conditions of Solar Effects Generation

This level compares between generated conditions of each effect type in the both urban paths. It allows to evaluate the characteristic of each effect in a specific urban space real or virtual. This asks the following question: in the same specific space (real and virtual), which phenomena are perceived similarly, and which aren't, and why? Which elements permit the emergence of some effects in one world and not in the other?

For example, at the "*Barillerie street*" (*in situ* and *in vitro*), "Attraction" and "Opening" effects aren't perceived by everybody *in situ* because the contrast in the virtual world highlights the opening on the "*Cours des 50 Otages*". On the other hand, the "Opening" effects in the "*Royal square*" is perceived similarly in both worlds. The example shows that perceiving "Opening" effect is changed from world to other although preceding results demonstrate that this effect has same perception in the two worlds. In this case the context (morphology, human presence, etc.) play an essential role in perceiving effects.

4.4 Discussion

Comparisons between the two environments allow us to determine the effects that are perceived similarly or differently in both worlds, as well as which effects disappear or appear in the each world. We claim that perception of the "solar effects" in the virtual world depends on the limitations imposed by the VR system:

- *Motion restrictions*: Predetermined walk through the path allows immersion but not total interaction within the space;
- *Sun presence*: Several real "solar effects" related to the direct presence of the sun which is absent in the virtual world;
- *Model quality*: "Solar effects" dependence of the quality of the virtual model (the texture, the resolution, the relief, etc.);
- *Urban ambiances*: "Solar effects" interaction with the other urban ambiances that are absent in the virtual world as well as pedestrians and urban furniture.

Visual perception of urban daylight varies between the real and the virtual world due to the particular conditions of each experiment. So we can conclude that visual perception in both real and virtual worlds largely depends on the urban context.

5 CONCLUSION

In this paper we have validated our methodology based on cognitive evaluation of the urban daylighting ambiences. However, it remains unable to completely extract the characteristics of "solar effects". Analysing visual perception of urban daylight through "solar effects" by using VR techniques shows that visual perception depends on: User's movement in the space, stimuli that occur during his walk through the path and ambiances which result from the combination of urban phenomenon (such as thermal and sound ambiances).

As in other design field application (such as design for manufacturing) where VR techniques allow to integrate the user earlier in the process and to detect major design flaws earlier in the process (Moreau and Fuchs 2001), VR has proved to be potentially of use in urban design. Future working directions include two research fields to set up VR as an assisting tool for the urban planning process but also as a complementary design tool:

- improving experimental conditions: it has been shown that motion is major cue in perception, we aim to use free movement in the virtual world by implementing the concept of "*guided visits*" navigation (Azpiazu et al. 2004). Additionally, the introduction of stereoscopic vision that should enhance visual perception of the roofs and their shape versus the background.
- Validating the whole methodology: a comparison between two urban paths with different identities, will be carried out in order to determine the "solar effects" role in space construction.

REFERENCES

Augoyard, Jean François. 1998. The cricket effect. Which tools for the research on sonic urban ambiences? In *Stockholm, Hey Listen!*. 1-8. Stockholm: The Royal Swedish Academy of Music and the Authors.

Azpiazu, A., C. Pedrinaci, and A. Garcìa-Alonso. 2004. A new paradigm for virtual reality: The guided visit trough a virtual world. In *IEEE VRIC 2004 Proceedings,* ed. Simon Richir, and Bernard Tavarel: 181-186. Laval: ISTIA.

Billger, Monica and Ilona Heldal. 2003. Virtual Environments versus a Full-Scale model for examining colours and space. In *Proceedings of Virtual Concept 2003,* ed. D. Couteillers et al.: 249-256. Biarritz: ESTIA.

Bishop, Ian D., JoAnna R. Wherrett, and David R. Miller. 2001. Assessment of path choices on a country walk using a virtual environment. *Landscape and urban planning 52:* 225 – 237.

Charton, Virgil. 2002. *Etude comparative de la perception d'ambiances lumineuses en milieu réel et en milieu virtuel.* Ph.D. Thesis, Ecole Nationale des Travaux Publics de l'Etat.

Cullen, Gordon. 1961. *The Concise Townscape.* London: the Architectural Press.

Follut, Dominique and Dominique Groleau. 2000. "Ambianscope" an immersion method to analyse urban environments. In *Proceedings of Greenwich 2000 International Digital Creativity Symposium: Architecture, Landscape, Design,* ed. C. Teeling: 139-148. London: University of Greenwich.

Fuchs, Philippe, and Guillaume Moreau. 2003. *Le traité de la réalité virtuelle.* vol. 1. 2nd ed. Paris: Les Presses de l'Ecole des Mines de Paris.

Jungman, Jean Paul. 1995. *Ombre et Lumière: un manuel de tracé et de rendu qui considère.* Paris: La Villette.

Lynch, Kevin. 1960. *The Image of the City.* Cambridge: MIT Press.

Moreau, Guillaume, and Philippe Fuchs. 2001. Virtual Reality in the design process: From design review to ergonomic studies. In *ESS 2001: Simulation in Industry*, ed. Norbert Giambiasi, and Claudia Frydman: 123-130. Marseille: SCS Europe.

Régnier, François. 1989. *Annoncer la couleur.* Nancy: IMQ.

Thibaud, Jean Paul. 2001a. Frames of visibility in public places. *Awards for design, research and planning* 14(1): 42-47.

Thibaud, Jean Paul. 2001b. La méthode des parcours commentés. In *L'espace urbain en méthodes*, eds. M. Grosjean, and J.P. Thibaud: 79–99. Marseille: Editions parenthèses.

Woloszyn, Philippe. 2003. Virtual Reality as an Ambience Production Tool. In *Proceedings of IEPM' 03* [CD-Rom]. Porto: FUCAM.

A Visual Landscape Assessment Approach for High-density Urban Development
A GIS-based Index

HE Jie[1], TSOU Jin Yeu[1], XUE Yucai[2] and CHOW Benny[1]
[1] Department of Architecture, The Chinese University of Hong Kong, Hong Kong
[2] Department of Geography and Resource Management, The Chinese University of Hong Kong, Hong Kong

Keywords: visual perception, visual quality assessment, urban planning, GIS

Abstract: The rapid developments of economy and urbanization bring great pressure to natural environment and resources, which contribute big challenge to sustainable urban development in high-density urban areas like Hong Kong, China and many other Eastern Asia cities. In these areas, protecting natural landscape resources and enhancing visibility to urban spaces and residential zones has become significant in improving the livability of human settlement. This paper presents a new approach in assessing the visual quality in high-density urban environment. The principal methodology is to quantitatively integrate human visual perception parameters with the visible landscape resources' characteristics. GIS is employed as the database and technical platform. A residential development in Hong Kong was used as a case study. The approach provides decision making support to urban planning, site layout design, and estate management during the early stage of the schematic design/planning process.

1 INTRODUCTION

The rapid developments of economy and urbanization not only bring great changes to the form and style of the urban sphere, but also challenge the natural environment and resources which support sustainable urban development in high-density urban areas like Hong Kong, China and many other Eastern Asia cities. Consider that for most people, natural landscape is usually more visually preferable than man-made constructions in urban environments (Kaplan 1983), beauty of urban natural landscape has the potential to improve the liveability of human settlement, or even enhance the estate value in market (Oh and Lee 2002). However, for years, the urban visual contexts of both Hong Kong and Chinese cities have been left ambiguous by the planning, design, management and real estate sectors. On the other hand, with the high urban density and its complicated construction patterns, new constructions usually yield fragmental views to landscape sceneries.

B. Martens and A. Brown (eds.), Computer Aided Architectural Design Futures 2005, 125-134.
© 2005 Springer. Printed in the Netherlands.

Many approaches intend to integrate urban landscape description, visual analysis and visual impact assessment have been developed to support planning decision making. For example, the frameworks for professionals by Blair (1986) and Moughtin et al (2003). However, several insufficiencies can be found in the decision making process in most of the current planning applications. Firstly, there is vagueness in the criteria of identifying the valuable landscapes that deserved to be protected. Secondly, there is no scientific tool which can provide satisfactory accuracy, efficiency, reliability, and validity to analyze and visualize relevant data. Therefore, the visual landscape protection premises, analysis and implementations are only based on personal experiences and manual operations, or even guessing and casual drawings.

To deal with these problems, a number of scientific landscape evaluation (LE) methodologies have been developed to provide quantitative description of natural landscape visual quality or impact prediction, and consequently, support the management of visual landscape resources in urban environment (Pogačnik 1979, Anderson and Schroeder 1983, etc.). There are also scientific systems established for development assessment which aims at achieving predefined subjective criteria like protecting important natural landscape resources. (Oh 2001). In these approaches, information technology (IT) and geographic information system (GIS) support are indispensable (Ervin and Steinitz 2003, Llobera 2003). However, most of these approaches are inadequate in terms of human perception (Llobera 2003). Oppositely, other research trends, such as the isovist studies (Batty 2001, Turner et al. 2001) applied in the urban visual study, are more concentrated on visibility and disregard the landscape resources which could be seen. The situation in high-density urban area is even more complicated. New construction not only changes the site's own configuration, but also possibly affects other area's visual perception, causes scenery blocking or disturbance. That is, the impact involves both the resource and perception qualities, which requires comprehensive consideration of urban visual resource and perception. However, efficient and accurate urban visual protection strategy is often difficult to be conducted in the very beginning stage of the schematic planning, so as design process based on recent urban visual assessment capabilities. An innovative GIS-based approach is therefore suggested. This paper presents its principal methodology and an implementation in a housing development.

2　　CONCEPT OF THE METHODOLOGY

The principal methodology of this approach is to quantitatively integrate human visual perception characteristics with visible landscape resources to develop a visual quality assessment algorithm in order to evaluate the visual quality of urban vision. In the algorithm, the urban visual resources (R) are weighted by perception parameters through a model calculate the visual quality index (V) of a certain viewpoint.

$$P(R) = V \tag{1}$$

2.1 Visual Perception and Recourse Qualities

The research firstly investigates the perception parameters. The visual perception description is based on visibility (Ervin and Steinitz 2003). The resource quality, which means the kind of scenery which can be observed, is calculated based on an established LE model (Brown, Keane and Kaplan 1986). Then a combined visual quality value of a particular viewpoint is calculated to depict the comprehensive perception quality. The calculation is done through weighing the resource quality value within the visible scopes by relevant human visual structure parameters, such as visual distance, view angles, and so on (Higuchi, 1983),

In the proposed approach, this algorithm is introduced to build up an evaluation model which is based on the visual quality inventory of individual urban viewpoints. A single value is assigned to each viewpoint to interpret its visual perception quality. The value then forms an index of visual perception performance. Variations in indices of affected viewpoints or urban spaces can then be quantitatively compared to indicate the level of impacts in urban development. The same model is also used to predict the post-development visual perception.

2.2 GIS Support

GIS, coupled with computer technologies, has already led to great advances and become indispensable support in visual landscape analysis (Ervin and Steinitz 2003, Llobera 2003). In this research, GIS is introduced as a database as well as a technical platform. The following calculation and analysis is achieved through GIS operation.

- Viewshed: The viewshed of the studied viewpoints are calculated through 3D analysis. Several visual-related human engineering parameters are adopted in a GIS-based 360° panoramic visibility calculation (He, 2001).

- Landscape resource quality inventory: Landform (including the absolute value on the slope relative relief of a study cell and its spatial diversity relief contrasting the adjacent eight cells) and landuse (including the naturalism compatibility of a cell and its height contrasting internal variety by comparing with adjacent cells) (Brown, Keane and Kaplan 1986) are calculated and classified through spatial analysis.

- Assessment model implementation: Spatial analysis of GIS is employed in visibility calculation and model implementation. This analysis is applied in every study cell (size of 1m x 1m in most of the application) within the studied scopes. Visual quality of individual viewpoint or viewpoint groups in different selection strategies is counted into an index through cell statistics.

The data generated through the above-mentioned analyses are input in statistical procedures to evaluate the visual quality performance of viewpoint(s). Furthermore, GIS also generate maps for resource quality inventory, perception quality and visual quality indices distribution for each individual viewpoint or viewpoint group.

3 THE FIRST CASE STUDY

Through a case study collaborated with the Housing Department of HKSAR government, the research team conducted the first experiment of the proposed approach and explored the potential of this methodology. The case, Lam Tin Phase 7 Project, is a public housing development located between mountain and harbour sceneries. The objective of the case study is to assess the scenery blocking impacts of the proposed development to its neighbours, and then provide scientific data and visualization support for decision making of planners and architects.

3.1 Visual Quality Assessment

The methodology applied in this case study is illustrated in Figure 1. First, viewshed of specific study viewpoints is calculated with GIS software. The result is illustrated in an individual raster map in binary visibility (1 = visible; 0 = invisible) for each viewpoints. In this case, we only introduce visual distance, which is one of the most important visual perception parameters, and LE models (Higuchi 1983, Patsfall et al. 1984, Bishop and Hulse 1994; Batty 2001, etc) to interpret visual perception quality. The score of perception of each visible cell (denoted by P in the following equation) is assigned according to the classification of visual distance.

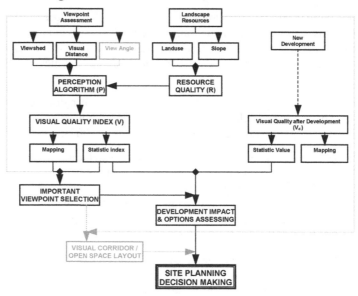

Figure 1 System Framework of the Case Study

$$\begin{cases} Visibility = 0, P\ (cell\ n) = 0 \\ Visibility = 1, P\ (cell\ n) = classification\ by\ visual\ distance \end{cases} \qquad (2)$$

Simultaneously, the visual resource quality of the entire study area is recorded and classified based on landuse and landform (Brown, Keane and Kaplan 1986). The inventory is calculated from the data derived from aerial photos and land-band information, and classified into five categories (Figure 2). The scores of perception and resource quality are then combined through overlaying the calculation in each studied cell. In this case study, we equally weight the perception quality and resource quality in the algorithm (equation (3)). Therefore, every study cell which is visible from a certain viewpoint has its own integrated visual quality value from this viewpoint. These values can be mapped into a visual quality distributions (Figure 3) or counted into an index (expressed by statistical values in sum, average, or standard derivation) to interpret the visual quality of this viewpoint (Figure 4).

$$V \; (cell \; i) \; = R \; (cell \; i) + P \; (cell \; i) \qquad\qquad (3)$$

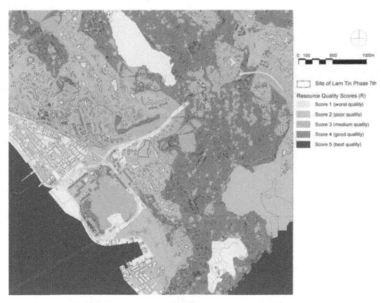

Figure 2 Map of the Resource Quality Inventory

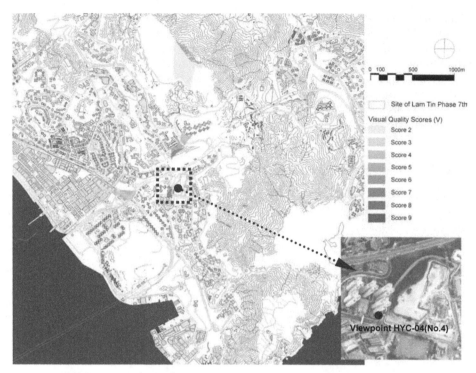

Figure 3 Map of Visual Quality Distribution of Viewpoint HYC-04

Figure 4 Current Perception Quality Indices of the Studied Viewpoints (left: viewpoints on the ground/ podium level; right: viewpoints on 5/F, 15/F and 30/F of buildings)

According to these indices, the studied viewpoints can be classified. Hence, planners, designers and managers can make further judgments on selecting significant viewpoints which deserves to be respected in future urban development (Figure 4).

3.2 Evaluation of Impacts to Surrounding Environment

Pursuing low negative visual perception quality impacts of the proposed development's neighbours is one of the key objectives in site planning. In this case

study, four different site layout options are provided by the planners and architects. The research team compared their visual impact performance and illustrated the results through indices and charts. Planners and architects could also rely on this scientific data whenever the scheme selection requires balancing visual quality performance in multi-disciplinary aspects. In this study, we selected several key viewpoints which are either: 1. important spatial nodes of surrounding urban and/ or estate open spaces; or 2. typical viewpoints from flats at low (the 5th floor), medium (the 15th floor) and high level (the 30th floor) of the surrounding high-rise residential blocks. Each viewpoint's visual quality performance indices in the initial condition (without development) and those four layout options are calculated based on the above-mentioned methodology. On the other hand, a single visual performance value is also calculated for each design option, through summing up the visual perception indices of the surrounding studied viewpoints. The impact on the visual quality is then assessed by comparing either the sensitivity of individual index to the proposed development or the statistical value of viewpoint group before and after the proposed development. The visual quality value decline is illustrated by charts (Figure 5) or overlaid with thematic maps.

Figure 5 Visual Quality Deteriorations with the Four Proposed Development (Expressed as Total Value of Studied Viewpoints on Ground Level (top left) and Building Levels of 5/F (top right), 15/F (bottom left) and 30/F (bottom right)

From the comparison of visual quality deterioration trajectory, the layout plan with the minimum visual quality decline from the site's initial situation, i.e. lowest visual impact, is identified. In this case, the layout plan option 1 keeps a stable position of the least decline in order to sustain the visual quality. Furthermore, it can be seen

131

that the visual quality deterioration trend in each diagram mostly coincides with each other. This also indicates the potential of validity to be applied in practical visual analysis (Tsou et al. 2004).

4 DISCUSSION AND FUTURE RESEARCH

The research in this case study is only the first experiment of the proposed approach. The aim is to explore the implementation potential in planning application. There are still spaces for further development in both the methodology and application aspects.

4.1 Methodological Improvement

The algorithm of perception is still far from mature in the current stage. Besides visual distance, other important parameters, such as incident angle, atmosphere perspective, physical intervening of land uses and elements (Higuchi 1983, Ervin and Steinitz 2003), should also be considered. Meanwhile, a more rigorous mathematical model should be developed in the upcoming studies. Future researches should introduce interviewers' measure in visual perception and regression analysis to verify the weighing of each variable in the equation. Field survey should also be conducted for validation. Another enhancement on the methodology relates to the viewpoint sampling. In this study, due to the limitation of computing resources, sample points are selected based on professional experiences of researchers. If there is enough number of viewpoints, a relatively more steady output could be generated. How to effectively locate the viewpoints for calculation is thus an important question to certify the evaluation results. One possible resolution is to locate the viewpoints in regular interval within the study region. Another approach is to define the scope in which the presumable development has significant impacts based on the principle of intervisibility.

4.2 Potential Fields of Application

There are also other potential application scopes for this methodology, for example, locating the visual corridors. Visual corridors which have potential to be maintained in future urban development can be mapped with high visual perception quality viewpoint(s) and high quality landscape resource(s). Moreover, the index can also be introduced to interpret the quality of flat views. The research team will simulate the mountains and sea sceneries of the living room window of every flat of the proposed residential development. The visual quality distribution on building façade will be surface-draped to a 3D model for visualization. Meanwhile, table and charts of these visual quality indices will also be employed as reference, which always only can be recorded after the construction in previous time. These data can provide more scientific and precise quantitative support for efficient decision making in design and estate management.

5 CONCLUSION

This paper describes a new approach of assessing visual quality that integrates visual resource and perception based on GIS operation. Its potential of managing visual resources for urban development and site planning is demonstrated. One thing should be pointed out is that we present the very earliest results of the implementation of this method and it have yet to be validated through further experiments and exploration.

The study and findings in this project have been reported to the government as well as the relevant professionals of this project including planners, architects and urban managers. We already received valuable comments, in which the sensibility and utility of the assessment method and index has been highly appreciated. On the other hand, incorporating more enriched considerations into the model algorithm was also suggested.

REFERENCES

Anderson, L.M., and Herbert W. Schroeder. 1983. Application of wildland scenic assessment methods to the urban landscape. *Landscape Planning* 10: 219-37.

Batty, Michael. 2001. Exploring isovist fields: space and shape in architectural and morphology. *Environment and Planning B: Planning and Design* 28: 123-50.

Bishop, Ian D., and David W. Hulse. 1994. Prediction of scenic beauty using mapped data and geographic information systems. *Landscape and Urban Planning* 30: 59-70.

Blair, William G.E. 1986. Visual impact assessment in urban environments. In *Foundations for Visual Project Analysis*, eds. Richard C. Smardon, James F. Palmer ,and John P. Felleman: 223-44. New York: John Willey and Sons.

Brown, Terry, Tim Keane, and Stephen Kaplan. 1986. Aesthetics and management: bridging the gap. *Landscape and Urban Planning* 13: 1-10.

Ervin, Stephen, and Carl Steinitz. 2003. Landscape visibility computation: necessary, but not sufficient. *Environment and Planning B: Planning and Design* 30: 757-66.

He, Jie. 2001. *CAD Study in Visual Analysis of the Visual Sustainability for China Urban Natural Landscape Planning*. M.Phil. diss., The Chinese University of Hong Kong.

Higuchi, Tadahiko. 1983. *The Visual and Spatial Structure of Landscapes*. Cambridge: The MIT Press.

Kaplan, Rachel. 1983. The role of nature in the urban context. In *Behavior and the Natural Environment*, eds. Irwin Altman, and Joachim F. Wohlwill: 127-62. New York: Plenum Press.

Llobera, M. 2003. Extending GIS-based visual analysis: The concept of visualscapes. *International Journal of Geographical Information Science* 17(1): 25-48.

Moughtin, Cliff, Rafael Cuesta, Christine Sarris, and Paola Signoretta. 2003. *Urban Design: Method and Techniques*. Oxford: Architectural Press.

Oh, Kyushik. 2001. LandScape Information System: A GIS approach to managing urban development. *Landscape and Urban Planning* 54: 79-89.

Oh, Kyushik, and Wangkey Lee. 2002. Estimating the value of landscape visibility in apartment housing prices. *Journal of Architectural and Planning Research* 19, 1-11.

Patsfall, Michael R., Nickolaus R. Feimer, Gregory J. Buhyoff, and J. Douglas Wellman. 1984. The prediction of scenic beauty from landscape content and composition. *Journal of Environmental Psychology* 4: 7-26.

Pogačnik, Andrej. 1979. A visual information system and its use in urban planning. *Urban Ecology* 4: 29-43.

Tsou, Jin Yeu, Yucai Xue, Jie He, Benny Chow, and Stephen Yim, 2004. Potential of Developing GIS-based Open System for Visual Analysis of Urban Natural Landscape in Environmentally Responsive Urban Design. Paper for the *3rd Great Asian Streets Symposium (GASS'04)*. Singapore: Department of Architecture, National University of Singapore.

Turner, Alasdair, Maria Doxa, David O'Sullivan, and Alan Penn. 2001. From isovists to visibility graphs: a methodology for the analysis of architectural space. *Environment and Planning B: Planning and Design* 28: 103-21.

Architectural Cinematographer: An Initial Approach to Experiential Design in Virtual Worlds

CALDERON Carlos[1], WORLEY Nicholas[1] and NYMAN Karl[2]
[1] *School of Architecture, Planning and Landscape, University of Newcastle Upon Tyne, UK*
[2] *Northfield, New Hampshire, USA*

Keywords: virtual environments, navigation, camera engine, cinematography, experiential design

Abstract: This paper presents a paradigm for the generation of camera placements for architectural virtual environments as a method of enhancing the user's experience and as a way of facilitating the understanding of architectural designs. This paper reports on an initial prototype of a real-time cinematic control camera engine which enables the creation of architectural walkthroughs with a narrative structure. Currently, there is neither software nor a structured approach which facilitates this in architectural visualisations. The paper discusses the potential of our approach; analyses the technical and application domain challenges; examines its current limitations using well known architectural design concepts such as rhythm.

1 INTRODUCTION

Manipulating the viewpoint or the camera control problem is fundamental to any interface which must deal with a three dimensional environment. This problem has been extensively researched in the computer science domain and a number of articles have discussed different aspects of the problem in detail (Ware and Osborne 1990).

In general, users often have problems comprehending and navigating virtual 3D worlds, (He et al. 1996) and they fail to recognise meaningful aspects of 3D models (Referees 2004). In particular and based on our experience (Calderon et al. 2000), participants struggle to perceive and understand the architectural concepts embedded in a design. For example, to experience rhythm in architecture is to observe "variations on a theme within a rectilinear pattern" (Rasmussen 1962) and, thereby, when you feel that a line is rhythmic means that by following with your eyes you have an experience that can be compared with the experience of rhythmic dancing. We are accustomed to perceiving architectural rhythm at a human perspective, that is, at walking pace and eye-level height. We believe that within a VE (virtual environment) the limitation of having to navigate from "standard" camera modes

B. Martens and A. Brown (eds.), Computer Aided Architectural Design Futures 2005, 135-144.
© 2005 Springer. Printed in the Netherlands.

(first person point of view; a particular character's point of view or from a free roaming mode) makes architectural concepts, such as rhythm, more difficult to comprehend and communicate (see Figure 1). A VE allows us to perform actions that aren't possible as part of real-life. We argue that, with this advantage, experiencing architecture is not limited to a first-person perspective – we are able to view ourselves in relation to our surroundings. In fact, similar types of "communication" problems have been faced by cinematographers for over a century. Over the years, filmmakers have developed a set of rules and conventions that allow actions to be communicated comprehensibly and effectively. This paper addresses the problem of communicating architectural designs in 3D real-time virtual environments by proposing a camera mode which incorporates cinematic principles. Basically, what we are trying to create with a new camera paradigm for walkthroughs is similar to what we are trying to create in an actual movie. We are trying to give the viewer/audience better understanding about the scene we are in and in order to achieve this we are developing a real-time cinematic control camera engine for dynamic virtual environments in the architectural domain. It is important, however, that if the user wishes he should be able to control the camera from a first person perspective and a free roaming perspective too – thus ridding himself of the cinematic aspect and intended viewpoints of the camera. We have therefore established 3 modes of camera use which can be freely selected by simply typing a console command at any time during the walkthrough: a) architectural mode (see Figure 1); b) first person point of view and c) free roaming mode in which the user is granted the ability to fly and go through any geometry (no collision detection). It is the architectural mode which is the subject of this paper since the other two are already implemented in the real time engine used: Unreal TM (UnrealEngine2 2004).

In this paper, we discuss an initial implementation of a real-time camera engine in virtual environments as a method of communicating architectural designs in virtual 3D environments in real-time. The paper is structured as follows: in the first section we introduce the principles and related work in camera engines; in the next section, we justify our selection of cinematography as an initial set of rules and conventions for an architectural camera mode and architectural concepts as a way of describing designs from an experiential standpoint. We then describe how the system works and how to create an architectural walkthrough with a narrative structure. We conclude the paper with some observations and future directions.

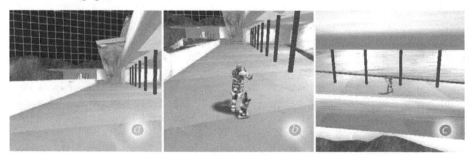

Figure 1 Standard modes: first (a) and third person (b). Architectural camera mode(c) using cinematographic techniques: a tracking shot

2 RELATED WORK

Recent advancements in computer science have explored paradigms for automatically generating complete camera specifications in virtual 3D environments. Karp and Feiner (1990) developed an animation-planning system that can customise computer-generated presentations for a particular viewer or situation. Christianson et al. (1996) presented an interactive system which plans a camera sequence based on a simulated 3D animation script. All these techniques use an off-line planning approach to select the sequence of camera positions. Off-line planning techniques take a pre-existing animation path and calculate the best camera placements. In this investigation, by contrast, we are concerned with real-time camera placement as the interactively controlled action proceeds. That is, systems which concentrate on finding the best camera placement when interactive tasks are performed. These type of systems were pioneered by Drucker and Zeltzer (1995), they show how to set up optimal camera positions for individual shots. In our case, we are not only interested in real-time camera control system but also in incorporating cinematographic expertise for camera placement. He et al (1996) were the first ones to present a paradigm for automatic real-time camera control which incorporated cinematic knowledge which be used across application domains. We used their implementation as the starting point for the framework presented in Section 4.

Finally, it must be said that in the architectural realm initial steps have been taken to investigate ways in which filmmaking can be used for the development of *off-line* architectural animations (Temkin 2003) (Alvarado and Castillo 2003). They argue that if we are to evolve beyond the average fly-through animation new ways of seeing and composing in time, which can be used to inform the process of architectural design, ought to be developed (Temkin 2003). Furthermore, Stappers et al (Stappers, Saakes, and Adriaaanse 2001) proposed narrative enhancements aim at improving experiential quality of walkthroughs in a CAVE [TM]. They realised the importance of incorporating narrative elements in the development process of architectural presentations and put forward a "number of solutions none of which involve much technical effort, but try to improve the fit between the simulation and the users' needs on the basis of existing technology". As previously explained, this investigation is concerned with finding new camera modes which enables the creation of architectural walkthroughs with a narrative structure in 3D real-time virtual environments. This, in turn, poses a series of new challenges.

3 ARCHITECTURAL CONCEPTS AND CINEMATOGRAPHY

When trying to solve the problem of communicating architectural designs in 3D real-time virtual environments using a new paradigm for the automatic generation of camera placements, we are faced with a series of challenges: is there a set of rules and conventions that allow architectural designs to be communicated comprehensibly and effectively and can be translated into camera placements? Is

there an ontology to define an architectural design and which, in turn, can be linked to our set of rules and conventions?

3.1 Encoding Cinematography

As explained in the previous section, various architectural scholars (Temkin, 2003) (Alvarado and Castillo 2003) (Stappers et al. 2001) have already identified the potential of film theory in the early stages of architectural design. From the perspective of designing a new camera mode, there is, however, a more important aspect about cinematography which other possible set of conventions (i.e. viewing modes in computer games) lack: the existence of grammars and languages (i.e. Arijon 1976) which have been translated into a (film) vocabulary and a series of well known (cinematographic) techniques. Hence, existing collections of cinematographic conventions provide an initial path to map low level specifications for the camera placements to high level construction of narratives. However, any attempt to automate cinematography, in our case the creation of a new camera mode, faces a difficulty not faced by real-world filmmaking or storytelling: a description of the rules of cinematography which is explicit enough to be directly encoded as a formal language (He et al. 1996).

In our case, we have solved this problem by creating goal-oriented programmes (scripts) which enable the recreation of well known camera shots by simple assigning values to certain variables in the programme. These programmes provide camera movement along all Cartesian world-space axes (see right top corner in figure 2), plus an Avatar-centred rotational capability. This rotational capability includes manipulations on all Euler angles (see right top corner in Figure 2) except roll which corresponds to the viewpoint's line-of-sight axis or the traditional camera's optical axis. However, some "special effects" like camera shake do require a roll component. Due to the limitations in the graphical engine, those effects are achieved by assigning values rather than modifying the specific "roll" function which is handled natively (i.e. C++ code) by the graphics engine.

For instance, imagine that we want to recreate a tracking shot: a tracking shot sets the camera along a perpendicular from the line of interest and then moves with the actor maintaining the same orientation (see Figure 2). The tracking shot module allows us to modify parameters such as the speed at which the camera moves away from the actor (CamDistAdjust), the maximum distance that the camera can reach (CamDistAdjust), the speed at which the camera rotates to reach its perpendicular vector (CamRotFactor), and the direction of rotation (CamRotFlag; see Figure2).

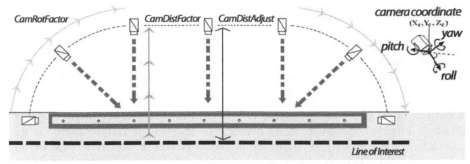

Figure 2 Camera path in a tracking shot; variables (CamRotFactor, CamDistFactor, CamDistAdjust) to recreate a camera shot and camera DOF.

In similar fashion and using the appropriate module, the following descriptions of camera shots are also recreated in the example explained in Section 4.2: establishing and releasing shot, canted framing and angle of framing (see Table 1 for a more detailed description). This subset of camera shots was selected to demonstrate the generalisation of the approach through all six degrees-of-freedom (DOF).

Table 1 List of camera shots and camera movements. A complete description of camera shots can be found in (Yale, 2004)

Camera shot	Camera movements
Tracking shot	Transitional movement occurs either solely in the x or y or z axis while the camera yaw is altered.
Canted framing	Canted framing is a shot where the camera is positioned off centre and at an oblique angle. The camera utilises all three camera rotations: pitch, yaw and roll and a translational movement.
Establishing/Releasing shot	This shot is used to introduce the locale for a scene. It is achieved by a combination of translational movement accompanied by modification of the pitch of the camera.
Angle Framing	This shot can be a stationary shot which is cut to, remains stationary, and cuts away to a different shot. There is no movement in any axis and no rotation involved

In this section we have shown that our system is recreating a representative subset of camera shots. These can then be combined to create walkthroughs with a narrative structure as we described in the example Section 4.2.

3.2 Architectural Concepts

We shall take it, for our purposes here, that the form of a building is its internal physical structure, as described under some appropriate conceptualization. Many aspects of internal physical structure might be considered and described, but the conceptualization always describes the scope of our interest.

Alexander, Ishikawa and Silverstein (1977) provide us with a pattern language which is extremely practical in its nature. For instance, it can be used for the generation (construction) of architectural elements (i.e. a porch) by combining different patterns. This, in turn, would create a language of, for example, a porch. Whilst Alexander's language is extremely useful to describe buildings from a technological or even functional standpoint, it is not particularly well suited for the conceptualization of buildings from an experiential point of view. Wilenski (Wilenski 1927) insisted that an architect's "business as artist" was with "the definition, organization and completion of his formal experience by creating a concrete object". He went on to propose that "the architect experiences, synthesizes, and creates; *he experiences proportion, balance, line, recession and so on,* he coordinates and organizes his experience, and he gives it definite form in a building... He is concerned from first to last with problems of formal relations". We felt, therefore, that experiential issues are more closely related to aesthetics than to technology and opted for selecting Rasmussen (Rasmussen 1962) conceptualization of architecture because, as he put it, "art should not be explained; it must be experienced". Rasmussen description of architectural concepts is an attempt to, by means of words, help others to experience architecture which is precisely our objective. The architectural concepts used in the example in Section 4.2 consist of rhythm, proportion, symmetry/asymmetry, and composition. This set of architectural concepts provides a representative sample of Rasmussen's description and a way of testing the generalisation of cinematographic techniques.

4 ARCHITECTURAL CINEMATOGRAPHER

In this section, we first explain how the system works and then a full example is presented.

4.1 System

Our system is "on-line system" camera system in which cinematographic techniques are encapsulated in modules (scripts) and related to the architectural concepts by an event-model. In other words, the system generates camera placements in real-time as the interactively controlled action proceeds according to the cinematographic technique encoded in the modules and, taking advantage of the event-model embedded in the graphical engine, these modules are assigned to specific architectural concepts of the design using volumes (a mechanism specific of UnrealTM). For

instance, let us assume the modeller/designer wants to show the rhythm embedded in the colonnade using a tracking shot technique. He/she creates a "volume", where he/she wants to create the effect –i.e. inside the colonnade- and links it to the tracking shot script via the event-model. That is, links the tracking shot script's (event) tag to the colonnade's volume.

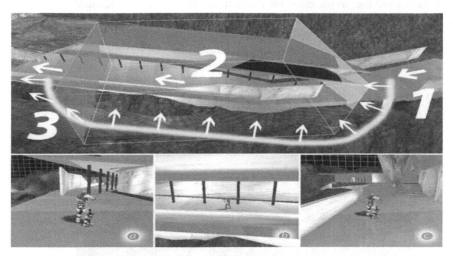

Figure 3 User approaches the colonnade, upon entering an event is triggered in the VE which is recognised by the system and the camera module takes over

When running the environment and the user approaches the colonnade, upon entering, an event is triggered in the VE which is recognised by the system and the camera module (tracking shot) takes over. Figure 3 demonstrates this graphically from the user's standpoint. As the user approaches position 1 in Figure 3 the act of the user entering the volume (the wire frame box in Figure 3) is recognised by the system as an event. Window (a) in Figure 3 depicts the user's approaching the colonnade from a "standard" camera view: a third person point of view. Once the event has been identified, the camera moves into the tracking position shot (yellow line in Figure 3 indicates the camera path and window (b) what the user sees once the camera is in position) whilst the user remains within the volume boundaries (see position 2 in Figure 3). Finally, the user's action of leaving the volume (see position3 in Figure 3) is recognised by the system as an event and the system, in turn, responds by returning the camera to a third person point of view (window (c)).

4.2 Example

The narrative model used in the example follows the principles laid by Brenda and it can be found in (Laurel 1993; see Figure 4 narrative stages). Point (a) on the narrative scale introduces the first architectural concept (composition) through the use of the 'establishing shot' (cinematographic technique). The user remains relatively calm while progressing through the environment and gets a sense of the

composition of the architecture at hand. As he nears the built form (b), his experience heightens as he is introduced to more concepts at more of a regular pace. As he reaches (c), (d), and (e) he experiences rhythm, scale, and symmetry – this area is where the experience of the environment is most enveloping. Reaching points (f) and towards (g) the user is given a slow release from the environment, finally to look back over the architecture once again, taking in the architectural composition from another perspective. The correspondence between different narrative stages; architectural concepts and cinematographic techniques used is shown in Figure 4. Figure 5 shows a series of film strips detailing each architectural concept with its partnered cinematographic technique as it used in the architectural walkthrough. The sequential nature of the camera positions exists as a vehicle for providing the structured, experiential narrative. Deviating from this 'path' finds the user out-of-narrative but able to experience the environment, and thus the architecture, along an undetermined path.

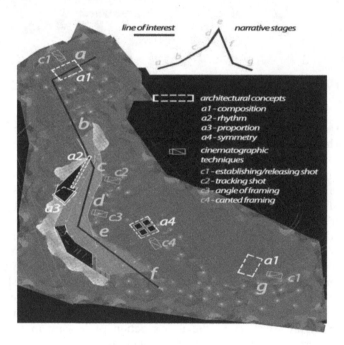

Fig. 4 Correspondance between different narrative stages; Architectural concepts and cinematographic techniques

5 CONCLUSIONS

In this paper we have presented an initial prototype of a real-time cinematic control camera engine which enables the creation of architectural walkthroughs with a narrative structure. Basically, our prototype can be seen as a method of encap-

sulating camera tasks, which follow the rules the cinematography (i.e. tracking shot), into will defined units called "camera modules" (i.e. tracking shot module) which are then combined to create walkthroughs with narrative structure. We therefore have presented the initial steps for a camera mode which we believe could give the viewer a better understanding of the architectural design concepts in a virtual environment.

Figure 5 Architectural concepts with its partnered cinematographic techniques as it used in the architectural walkthrough

REFERENCES

Alexander, C., Ishikawa, S., and Silverstein, M. 1977. *A Pattern Language*. Oxford: University Press.

Alvarado, Rodrigo García, and Castillo, Gino Alvarez. 2003. Técnicas cinematográficas para las animaciones arquitectónicas. In *Proceedings of SIGraDi 2003*, 10-12.

Arijon, D. 1976. *Grammar of the Film Language*. New York: Communication Arts Books.

Calderon, C., van Schaik, P., and Hobbs, B. 2000. Is VR an effective communication medium for building design? *In Proceedings Virtual Reality International Conference* 2000, 46-55. Laval, France.

Christianson, D.B., S.E. Anderson, L. He, M.F. Cohen, D.H. Salesin, and D.S. Weld. 1996. Declarative Camera Control For Automatic Cinematography. In *Proceedings of AAAI '96*, 148-155.

Drucker, S., and D. Zeltzer. 1995. CamDroid: A system for implementing intelligent camera control. In *Proceedings of the 1995 Symposium on Interactive 3D Graphics, 139-144.*

He, L.M. Cohen, and D. Salesin. 1996. The virtual cinematographer: A paradigm for automatic real-time camera control and directing. In *Proceedings of the ACM SIGGRAPH'96,* 217-224.

Karp, P., and S.K. Feiner. 1990. *Issues in the automated generation of animated presentations. Graphics Interface '90.*

Laurel, B. 1993. *Computers as theatre.* Reading: Addison Wesley.

Rasmussen, S.E. 1962. *Experiencing Architecture*, Cambridge: MIT Press

Stappers, Pieter Jan, Saakes, Daniel, and Adriaanse, Jorrit. 2001. On the narrative structure of Virtual Reality walkthroughs. In *CAAD Futures 2001,* eds. B. de Vries, J. van Leeuwen, and H. Achten: 125-138. Dordrecht: Kluwer.

Temkin, A. 2003. Seeing Architecture with a Filmaker's Eyes. In *Proceedings of ACADIA 2003: Connecting-crossroads of digital discourse*, 227-233.

UnrealEngine2. 2004. Internet. Available from http://udn.epicgames.com/Two/WebHome; accessed 17th of August 2004.

Ware, C., and Osborne, S. 1990. Exploration and Virtual Camera Control in Virtual Three Dimensional Environments. In *Proceedings of the 1990 Symposium on Interactive 3D Graphics.* Snowbird, Utah.

Wilenski, Reginal Howard. 1927. *The Modern Movement in Art*. London: Faber and Faber.

Yale, 2004. *Film Analysis Guide.* Internet. Available from http://classes.yale.edu/film-analysis; accessed 28th November 2004.

Virtual Environments in Design and Evaluation:
An Aid for Accessible Design of Home and Work Settings for People with Physical Disabilities

PALMON Orit[1], OXMAN Rivka[2], SHAHAR Meir[1] and WEISS Patrice L.[1]
[1] *Laboratory for Innovations in Rehabilitation Technology, Department of Occupational Therapy, University of Haifa, Israel*
[2] *Faculty of Architecture and Town Planning, Technion, Haifa, Israel*

Keywords: accessibility, environmental-modifications, 3D simulation, barrier-free design

Abstract: One of the major challenges facing the professionals involved in the home modification process is to succeed in adapting the environments in a way that enables an optimal fit between the individual and the setting in which he or she operates. The challenge originates primarily from the fundamental characteristic of design - one can see and test the final result of home modifications only after they have been completed. The goal of this study was to address this problem by developing and evaluating an interactive living environments model, HabiTest, which will facilitate the planning, design and assessment of optimal home and work settings for people with physical disabilities. This paper describes the HabiTest tool, an interactive model that has been implemented via an immersive virtual reality system which displays three-dimensional renderings of specific environments, and which responds to user-driven manipulations such as navigation within the environment and alteration of its design. Initial results of a usability evaluation of this interactive environment by users are described.

1 INTRODUCTION

Analyzing and evaluating the suitability of built environments to human activities is typically performed only after the construction phase has been completed. The major challenges facing professionals originate from the fundamental characteristic of design – one can test the suitability of a designed environment only after it has been completed. The study described in this paper presents a different approach wherein a virtual reality (VR) environment serves as an alternative environment to carry out analysis and evaluation before the final realization of the construction phase. Our study related to the research framework of VR and environmental modification.

B. Martens and A. Brown (eds.), Computer Aided Architectural Design Futures 2005, 145-154.
© 2005 Springer. Printed in the Netherlands.

1.1 Home Modification Process

People with disabilities are often severely limited in their ability to function independently in their homes or at work as a result of physical, cognitive or sensory environmental barriers (Iwarsson, Isacsson and Lanke 1998). Successful environmental modifications to an existing structure can eliminate these barriers by accommodating age and health related disability thereby turning an environment from one that is disabling into one that is enabling. Such modifications aim to achieve an accessible environment that can be fully utilized by the user for its intended purposes (Nielsen and Ambrose 1999); the goal is to achieve an environment that facilitates the individual's ability to perform every day activities and occupations by providing a compensation for their functional loss. Environmental modifications are an inseparable part of the rehabilitation process in the western world (Gitlin 1998).

Yet, despite 30 years of experience and research, the gap between client needs and successful environmental modification remains large since adaptations to home or public settings present a number of major challenges, starting from the need of achieving an optimal fit between the individual and the setting in which he or she operates (Gitlin 1998). Other challenges relate to the modifications of a private home that require having sufficient knowledge and funds or, in contrast, to modifications of public areas where successful adaptations have to meet the needs of a broad range of disabilities (Palmon et al. 2004). Limited success of environmental modifications are also related to the lack of reliable and valid assessment tools and the lack of common conceptual definitions between the professional parties involved in the modification process (Gitlin 1998).

1.2 Virtual Reality and Environmental Modification

Only recently, virtual reality has begun to be applied to environmental modification and to designing and testing the accessibility of an environment for people with disability (Eriksson, Ek and Johansson 2000, Maver, Harrison and Grant 2001). Eriksson, Ek and Johansson (2000) have developed an immersive, desktop simulation program for the design of barrier free home and work environments. Users view a typical living environment and are able to manipulate objects (e.g., furniture) within the environment. It was found to be a useful planning tool in encouraging communication and participation of all the people involved in the design process. The users of the system enjoyed the opportunity to make modifications and to implement their own ideas for barrier-free design, but participants with physical disabilities had difficulty in adopting a user-centered viewpoint while using it. Maver, Harrison and Grant (2001) developed a wheelchair motion platform that was designed to allow wheelchair users to navigate and explore a virtual representation of buildings. Their aim was to develop a tool that would enable the evaluation of wheelchair accessibility of a building in the early stages of building design or redevelopment of old buildings.

The overall goal of this study was to address the problem of assessing accessibility by developing and evaluating an interactive living environments model that will facilitate the planning, design and assessment of optimal home and work settings for people with physical disabilities. The first objective of this paper is to describe a tool that we have used to develop interactive environments that can be used to tests users' abilities to identify and modify accessibility barriers. This interactive model is implemented via an immersive VR system which displays three-dimensional renderings of specific environments, and which responds to user-driven manipulations such as navigation within the environment and alteration of its design. A second objective is to present the initial results of a usability evaluation of this interactive environment by users.

2 HABITEST – DESIGN AND INPLEMENTATION

We aimed to construct and evaluate a tool, known as HabiTest, which overcomes the inherent limitation of a posteriori design by providing a priori opportunities to verify the suitability of a proposed design for a particular user, using the option of virtual reality platform. This tool has been designed to address the needs of the environmental modification intervention process as well as the needs of a newly designed rendering.

2.1 Selection of the Simulation Platform

The construction and simulation of these environments was carried out using EON Reality's (www.eonreality.com) tools, considered to be among the leading tools in the field of VR simulation. An environment used for our initial feasibility testing is shown in Figure 1. In the figure are shown the three alternate points of view that are available to the user. These include a first person view, a third person view, and a bird's eye view. EON Reality's tools enable a rapid development of interactive 3D environments that are easy to navigate in real time while performing accurate collision detection. Accurate collision detection (which was until recently available primarily in mechanical, non-interactive simulations) enhances the user's ability to gather relevant data from the simulation process. EON Reality software also records all collision occurrences into a database. Moreover, auditory, visual and haptic feedback to the user prevents the attainment of positions that are physically invalid. That is, a user cannot navigate to a position where any part of his body nor an item associated with him (e.g., a wheelchair) is allowed to overlap with another object (e.g., wall, door, stair, table leg). The ecological validity of this simulation allows the user to identify corners or narrow passages that, although passable, would be difficult and inconvenient to navigate on a daily basis due to the number of moves and collisions they would necessitate. Figure 1 below, illustrates a typical HabiTest environment. The larger central view is the main view and is "first Person" (ego-centric). The other two auxiliary views are "bird's eye" view (upper left corner) and "third person" side view (upper right corner).

Figure 1 A typical HabiTest environment from EON Reality

2.2 HabiTest: Designing the Key-Features

The team that designed and programmed the HabiTest consisted of two occupational therapists with expertise in environmental modification, assistive technology and virtual reality applications, two architects with expertise in spatial design and in three dimensional (3D) modelling and a programmer with expertise in virtual reality platform programming.

HabiTest must enable users to navigate independently within realistic virtual environments while allowing them to identify any barrier that blocks their ability to navigate or to perform tasks in these environments. HabiTest supports layered presentation; since each object is associated with a particular layer, the display and elimination of any object is simple. Thus, an environment can be rapidly de-cluttered so that 'what-if' testing is supported. For example, it is easy to query how navigation and obstacle identification are affected if any given object is added or removed. Removing layers of objects allows a user to perceive the effect this has on accessibility. It also allows users with cognitive or visual limitation to study the environment in an easier manner prior to testing it.

A number of key features were considered to be essential for this tool. These include: Real time rendering; accurate collision detection of objects and walls; low cost portable tool that could be readily implemented in clinical and home settings; navigation that is easy and intuitive; an avatar representing the user within the environment having realistic characteristics (i.e., seated in a wheelchair with anthropometric measurement similar to an actual user).

In addition to the design requirements of ease of use and intuitiveness, the selection of a navigation tool was based on considerations of what would be the most appropriate hardware for use by people who drive an electric wheelchair since they are the initial targeted population for HabiTest. Since most electric wheelchairs are operated with joysticks we selected a force feedback joystick, specifically Logitech's Wingman and Microsoft's SideWinder. Both of these devices provide vibratory collision feedback to the user, enhancing the realism of the environment when the user collides into a wall or furniture while navigating.

The size of the field of view (FOV) people need to navigate comfortably in an environment has certainly presented a challenge since healthy users who pilot tested HabiTest on a 17 inch monitor found the FOV presented to them to be too narrow for realistic and effective navigation. More recently we have improved the FOV in two different ways. The HabiTest environments may be projected onto a large surface using a video projector and several of the joystick buttons have been programmed to enable users to look around in a similar way people would turn their head to the right, left, and up while exploring a new environment. This "looking around" option is available to users both while standing in one place and while navigating within the environment. A benefit of large scale projection is the ability of engaging a group of people in the design and testing process (Knight and Brown 1999).

The final design consideration is the provision of a means to perform tasks, and specifically to touch objects within the virtual environments. We have elected to provide a virtual hand which is controlled by the user. The hand may be seen in the environment at any time and it has several levels of control. The first level of control is achieved by putting the hand at a fixed distance in front of the user's eyes; when users wish to perform any manipulation with the hand, they may move the hand separately from head movements. In order to simplify interaction with the system, and reduce the different number of devices required (keyboard, joystick, mouse etc.), this offset is also controlled by the joystick. The user must press and hold one of the joystick's buttons in order to activate this specific manipulation. After pressing the button, moving the joystick will affect this offset. To reset this offset, another button has to be pressed (Palmon et al. 2004).

3 INITIAL EVALUATION OF "HABITEST" BY USERS

The purpose of the initial usability testing was to verify the ease with which users are able to navigate within HabiTest. A group of eight female occupational therapists, all graduate students at the University of Haifa participated in the initial usability testing. All participants had worked clinically for a minimum of two years in different therapeutic settings dealing with developmental and learning disabilities of children. None of the participants had had any experience with environmental modifications, nor were they experienced in the playing of computer games that required navigation.

3.1 Initial Usability Testing

The participants navigated within HabiTest for 30 minutes while sitting in a computer lab, each at her own personal computer. The simulation environment was first presented to the participants by enslaving their monitors to the researcher's monitor. Each of the tool's features was demonstrated. A model of a one bedroom apartment with an open kitchen area, supplied by the EON interactive software (see Figure 1) was modified to be used as a HabiTest environment for demonstration and

testing. Following this short demonstration, each participant was given a trial period of ten minutes, to navigate within the environment freely using a mouse. During the trial period, participants were encouraged to request assistance when any operation was unclear or difficult. Upon completion of the trial period, the participants were asked to locate the bathroom, to drive into it and to exit it. They were given up to 20 minutes to perform this task from a starting point at the center of the living room. This task was purposely selected as typical of a difficult navigation task since the location of the bathroom door together with its narrow opening made the navigation task demanding one. Similarly, given the small size of the bathroom, the need to turn around within it in order to exit was also difficult. Although this navigation task is difficult, it is possible to complete. Note that the collision detection feature was activated during the test, so that the participants were made aware of any "impossible" routes.

Despite the fact that the participants had used the same environment during the practice trial, none of them were able to locate the bathroom within the first five minutes of the test. They appeared to be stymied by the narrow FOV and they expressed great frustration. The researcher then simplified the task by giving them instructions how to locate the bathroom but they were still required to enter and exit it without help. All participants were then able to enter the bathroom but only five out of the eight were able to exit it within the 20 minute time limit. All participants experienced difficulty when trying to navigate within the narrow space of the bathroom. This was not surprising since the room was accessible for a wheelchair user but only with great difficulty. The greatest concern expressed by the participants throughout the trial was their lack of awareness of their current location with respect to the apartment.

Similar difficulties were reported when a group of participants viewing the same HabiTest environment at a showcase of VR equipment navigated within it using the joystick. As a result of the FOV difficulties observed during these two initial pilot tests we decided to expand the FOV via the two options described above, projection onto a large surface using a video projector and programming of several of the joystick buttons to enable users to look around in a way similar to how people turn their heads to the right, left, up and down while exploring a new environment (Palmon et al. 2004).

3.2 Ongoing Usability Testing of the HabiTest

The objective of following pilot study was to further test users' abilities to navigate within the new virtual environment when using a joystick. Ten healthy volunteers participated in this study. Three were high school students, two were university students, and five were people with academic positions. Their age ranged from 13 to 46 years (mean = 26.6, standard deviation (SD) = 10.7). Three of the participants were females, five had experience in navigating in virtual reality through computer gaming and six had experience using a joystick in the past. The participants' general experience in using a computer ranged from five hours to 40 plus hours per week.

3.2.1 Procedure

A new setting was created for the purpose of this testing, a rendered model representing the inner area of the main section of the University's Dean of Students office. This setting was selected since the physical premises have been made available to us for testing purposes. As shown in Figure 2, this area contains a large central office and three additional small offices, all of which have doors leading to the central office. The area contains a lot of furniture making it difficult to navigate. Some locations are not accessible for a person who uses a wheelchair. Indeed, some of the furniture must be removed when students who use a wheelchair enter the premises. The rendered model of the Dean of Students central area is shown in Figure 2 (left: a "first person" view of the central area / right: a blueprint of the entire area used for testing). Participants were shown how to use the joystick to navigate within HabiTest and given a trial period of 20 minutes (including explanation time) to practice its various functions. During the trial period participants used the model of a one bedroom apartment and an open kitchen area described above (see Figure 1). Following the trial period participants were asked whether they needed any extra time to practice the use of the joystick and none of them did. The Dean of Student's office virtual model was used during the test period. One clearly visible virtual object (plant, plate with fruit, toy train and a red phone) was placed in each of the four rooms. Participants were requested to navigate within the virtual world to each object and "touch" it with a blue "hand" that appears on the screen. The moment the hand touched the required object, the hand turned red and the object reacted in a distinctive manner -- the plant grew bigger, the train started moving, the phone rang and one of the pieces of fruit jumped up and down. A chair located along the navigation pathway was also a selectable virtual object and the participants had to "touch" it with the virtual hand in order to make it move closer to the table enabling access to that room. In order to be able to touch the objects with the virtual hand, participants had to get within a preset distance from the objects. Thus, they were forced to travel to regions that were difficult to navigate. During this test, participants were represented within the virtual environment as if they were sitting in a wheel chair (first person viewpoint). All actions were performed using the joystick's programmed buttons. All tests were timed, all collisions incurred by the participants were counted and the path length in virtual meters of each participant was recorded. The x-y coordinates of each subject's pathway was stored for subsequent analysis by Matlab, a tool for performing numerical computations with matrices and vectors. Following testing, participants completed a usability questionnaire that included 27 statements that they ranked on a 7-point scale from 1 = "totally disagree" to 7 = "totally agree". The statements queried participants' views on various aspects of HabiTest including the clarity of the pre-test explanation and practice session, operating the joystick, navigating within the virtual environment, and performing the tasks. There was also a general feedback statement on the whole system.

Figure 2 View of the Dean of Students area: HabiTest Environment

Figure 2 illustrates a view of the Dean of the Students area. The figure on the left illustrates a "first person" view of one of the rooms showing its furniture. The figure on the right illustrates the blue print of the entire area used for testing (marked by dots).

3.2.2 Results of the Navigation within HabiTest

The pathway traversed by the participants was divided into six sections (S0-S5). For example, S0 was measured from the moment the participant started navigating in the virtual environment until the moment that the first object was touched. S5 was measured from the moment the participant finished touching the last object until exit from the Students' Dean Office.

Means and standard deviations of the three variables (time, path length and number of collisions) were calculated for each of the six sections. These results showed that there is a large variability in performance between different sections reflecting differences in difficulty in the navigational path (e.g., corners) or in accessibility (e.g., narrow doorway) between sections. For example, in section S2 that was relatively easy from a navigational point of view, the mean number of collisions incurred by participants was 13.3 (SD = 10.5). In contrast, in section S4, the most difficult section to navigate, the mean number of collisions was 96 (SD = 54.5).

Time to navigate and path length could not be compared directly across sections due to differences in their actual path length. Rather, the data from the three variables from each section were compared between subjects. The results show a large within subject variability pointing to typical differences in ability. For example, one of the participants navigated section S3 in 4.6 virtual meters while another navigated the same section in 31.3 virtual meters (see Figure 3). This difference was due to the numerous "back and forth" movements that the latter participant made. Perusal of the trajectory maps of all participants demonstrated that the participants with poorer navigational ability tended to make excessive "back and forth" movements to correct themselves and to place themselves at the correct angle or the correct distance from the doorway or the furniture in order to progress. Even those participants who were

good navigators made at least one or two "back and forth" movements in the more difficult navigational areas as shown in the right panel in Figure 3.

Figure 3 "Back and forth" movements

The left panel of Figure 3, illustrates that the participant has performed many "back and forth" movements to enter the room while the participant shown in the right panel entered the room easily, yet still performed a few back and forth movements.

3.2.3 Results of the Feedback Questionnaire

The means and SDs were calculated for each of the 27 questions completed by the 10 participants, providing information about their subjective responses to the usability characteristics of the virtual environment. For example, participants had high agreement on the sufficiency of time to practice before the actual study (mean = 6.6; SD = 0.5) and the important role that the bird's eye view window played in facilitating navigation (mean=7.0; SD=0). In contrast, participants were not satisfied with the third person view point window (mean = 2.5; SD=2.12). The questionnaire responses also revealed that the participants found the haptic feedback from the joystick even more helpful than the visual feedback (Haptic feedback: mean = 6.0, SD=0.8; Visual feedback: mean = 5.5, SD= 1.2).

4 CONCLUSIONS

We have developed a system that overcomes the possibility of evaluating an environment only after completion of its final construction. By doing so, we have followed the change in the VR paradigm suggested by Maver, Harrison and Grant (2001) to move from simulating mainly VR environments that are distant, dangerous or imaginary into simulating ordinary real environments in order to evaluate their accessibility for people with disabilities. This entailed the implementation of several unique features into HabiTest and the testing of whether a virtual environment is valid as an evaluation tool of an accessibility of a real environment. To date, after the initial testing phase, we suggest that HabiTest, with its unique features (FOV,

Hand, Joystick, Avatar in wheelchair) is a system that is likely able to distinguish between areas of living environment that vary in their accessibility and in their navigational difficulty. It thus appears to provide users with an opportunity to test accessibility and navigation of a wheelchair in a virtual environment. Future plans include comparing performance within the HabiTest to that within an identical real environment in terms of navigation from one point to another and identifying accessibility barriers. Results of this testing will demonstrate the validity of making wider use of virtual accessibility evaluation.

References

Eriksson, Joakim, Asa Ek, and Gerd Johansson. 2000. Design and evaluation of a software prototype for participatory planning of environmental adaptations. *Transactions on Rehabilitation Engineering* 8: 94-106.

Gitlin, Laura, N. 1998. Testing home modification interventions: Issues of theory measurement, design and implementation. *Annual Review of Gerontology and Geriatrics* 18: 191-246

Iwarsson, Sussane, Ake Isacsson, and Jan Lanke. 1998. ADL Independence in the elderly population living in the community: The influence of functional limitations and physical environment demands. *OT International* 3: 52-61.

Knight, Michael, and Andre Brown. 1999. Working in virtual environments through appropriate physical interfaces. In *Architectural Computing: from Turing to 2000* [eCAADe Conference Proceedings]. eds. A. Brown, M. Knight, and P. Berridge: 431-436. Liverpool: eCAADe and University of Liverpool.

Maver, Tom, Colin Harrison, and Mike Grant 2001. Virtual environments for special needs. Changing the VR paradigm. In *CAAD Futures 2001* [Proceedings of the ninth international conference held at the Eindhoven University of Technology], eds. B. de Vries, J. van Leeuwen, and H. Achten: 151-159. Dordrecht: Kluwer.

Nielsen, W. Christian, and Ivor, Ambrose. 1999. Lifetime adaptable housing in Europe. *Technology & Disability* 10: 11-19.

Palmon, Orit, Rivka Oxman, Meir Shahar and Patrice L. Weiss. 2004. Virtual environments as an aid to the design and evaluation of home and work settings for people with physical disabilities. In *Proceedings of the 5th ICDVRAT*, ed. Paul, Sharkey, Rachel McCrindle, and David Brown: 119-124. Oxford, UK.

Do We Need CAD during Conceptual Design?

BILDA Zafer and GERO John S.
Key Centre of Design Computing and Cognition, University of Sydney, Australia

Keywords: representations, protocol studies, conceptual design

Abstract: This paper presents the results of experiments to test whether a designer necessarily needs to produce and utilize external representations in the very early phases of conceptual design. Three architects are engaged in two separate design processes, one is the experiment condition where they were not allowed sketch, and the other, the control condition where they were allowed to sketch. In the experiment condition, architects were required to put on a blindfold and think aloud while designing. The results show that in both conditions the design outcomes fit in the given dimensions of the site, accommodate the space requirements and allow an effective use for the clients. Thus, when the participants were blindfolded, they were able to produce designs by using their cognitive resources to create and hold an internal representation of the design rather than by sketching, or using a CAD tool. We finally raise the question: do architects need CAD representations during the conceptual phase of the design activity?

1 INTRODUCTION

In the early phases of designing architects often redefine their design space by reviewing the design requirements and consequently formulate a tentative solution. The tentative proposal is usually based on one or more concept(s). Then the design ideas are usually tested and evaluated around a stronger concept. Thus the early phase of designing is called the conceptual design phase. Architects often prefer sketching to externalize/represent their thoughts and concepts in this phase and it becomes the medium where they set out their thoughts on the fly. Relatively recently studies attempted to reveal why sketches have been an effective medium for conceptual designing. Some studies proposed that ambiguity is one of the key factors because it allows the seeing of new possibilities in the representations, thus it allows re-interpretations (Goel 1995, Suwa, Purcell and Gero 1998). The debates about designers' use of CAD emphasize that CAD environments do not provide the ambiguous medium designers need for conceptual designing.

In this paper we question if externalization is an essential requirement for conceptual designing, i.e. whether a designer necessarily needs to produce and utilize external representations in the very early phases of conceptual design. This research focuses on "externalizations" in general and whether they are central or peripheral in

B. Martens and A. Brown (eds.), Computer Aided Architectural Design Futures 2005, 155-164.
© 2005 *Springer. Printed in the Netherlands.*

designing, rather than testing the impact of computer mediation on the conceptual design process. However, the initial motivation of this study was based on a search for effective computer mediation in conceptual design. A previous study focused on comparison of traditional versus digital media in terms of differences in cognitive activities (Bilda and Demirkan, 2003). In the current study we attempt to measure the changes in the outcomes when designers can and cannot externalize, rather than comparing the outcomes with the use of different externalization media, such as sketches versus CAD. The implications of the study pose questions on how to develop CAD systems for conceptual design.

2 THE NEED FOR EXTERNAL REPRESENTATIONS

What purpose do external representations serve? In order to explore this question we have to consider design thinking within a time factor that is the timeline of the design activity. Through this timeline there are sequential design actions such that previous actions inform and change the next one. Thus the design features are constructed sequentially and in a situated way. Externalizations serve not only to store the record of this activity, but also serve as a tool to support reasoning between these sequential acts.

In the early phases of the design process architects read and try to understand the design brief, they might visit the site, meet the clients, review the requirements, etc. (Lawson 1997). Then the next stage is not usually starting to draw. There often exists an initial thinking period, and the length of this period varies for every designer. It can be extended without touching pen and paper i.e. without the need to externalize the ideas.

Do architects necessarily start designing with external representations in the early stages of design? Anecdotal examples are often quoted of major architects such as Frank Lloyd Wright who could conceive of and develop a design entirely using imagery with an external representation of the design only being produced at the end of the process (Weisberg 1993). Then it should be possible for some designers to develop and maintain an internal designing activity for a prolonged time. We refer to this activity as the use of imagery alone in designing.

How are the initial design concepts and proposals formed? Before a designer starts to draw we assume s/he is engaged in a thinking process that might occur during their daily activities; whether sitting at a desk, while having a shower or driving. We presume that this thinking is of a visual type; studies in cognitive psychology found evidence that this thinking is visual, not in the sense of "seeing" but a mechanism resembling perception (Kosslyn 1980, Psylyshn 1984). It is possible that this visual thinking process produces design concepts, abstractions and eventually a mental design model which evolves through the timeline of an internal design activity. Consequently effective designing may be possible with this thinking process.

Most empirical studies of design problem solving have been based on an examination of design protocols collecting both graphical and verbal data,

emphasizing either verbal content (Akin 1986) or analysis of the drawings (Do 1995). Consequently, the analysis of cognitive activities in design has focused on the sketching process (Goldschmidt 1994, Goel 1995, Suwa and Tversky 1997, Suwa Purcell and Gero 1998) where the designer externalizes his/her thoughts using pen and paper. Although sketching studies emphasized the use of imagery with sketching (Kavakli and Gero 2002), the issue of how design is carried out using mental imagery alone has not been adequately studied. Athavankar (1997) conducted an experiment where an industrial designer was required to design a product in his imagery (with an eye mask on), so that the he had no access to sketching, and the visual feedback it provides. The study claimed that the designer was able to evolve the shape of the object, manipulate it, evaluate alternative modifications, and add details, and colour as well. Thus, expert designers should be able to use only imagery in the conceptual design phase, before externalizing their design thoughts. A similar study to Athavankar's has been conducted at Sydney University with the think-aloud method where an architect wears a blindfold and commences designing using his/her imagery. S/he is allowed to externalize only when the design is mentally finalized. The protocol analysis of the videotaped sessions showed that common imagistic actions are linked together to create and maintain an internal design representation (Bilda and Purcell 2003).

Reviewing the literature in design studies and cognitive psychology, we can present two views on imagery and sketching activities in design, which also make a distinction between them. 1. Sketching directly produces images, and ideas externalized on paper, and then the designer starts to have a dialogue with them via their perceptual mechanisms. In this way, the design problem space is explored, and restructured through this dialogue (Schon and Wiggins 1992, Goldschmidt 1994, Suwa Purcell and Gero 1998). 2. In contrast during the use of imagery alone for designing, a designer has to accumulate considerable amount of knowledge/meaning before an image is generated (Bilda and Purcell 2003), which suggests concept formation without drawings, and thus, without direct perceptual input. As with sketching activity, there is the dialogue with the images to restructure the design space; this probably is constrained within working memory capacities (Logie 1995).

The first view emphasizes the necessity of externalizing ideas during designing. The second view suggests a thinking process via use of imagery alone. This type of visual thinking has some features/mechanisms different to a thinking process which uses drawings, so that other cognitive mechanisms could take over and shape the thinking process. This visual thinking could encourage designers to a "take your time" approach, so that they conceptually explore the problem space well before producing any tentative proposals or design images.

3 METHOD

This paper presents design outcomes from architects' design sessions conducted under two different conditions: the experiment condition, in which they do not have access to sketching and the control condition where they are given access to

sketching. The design outcomes from the experiment and control conditions are compared to observe whether there are significant differences between them.

The three the architects who participated in the study (two female and one male) have each been practicing for more than 10 years. Architects A1 and A2 have been awarded prizes for their designs in Australia; they have been running their own offices, and also teaching part-time at the University of Sydney. Architect A3 is a senior designer in a well-known architectural firm, and has been teaching part-time at the University of Technology, Sydney. We had preliminary meetings with nine potential architect participants where we asked whether they think they would be capable of using their imagery alone to come up with a design solution. They all gave positive responses, however, we selected three architects based on their statements that they easily can think-aloud when they are designing.

3.1 Experimental Conditions

Design brief 01, given for the experiment condition requires designing a house for two artists: a painter and a dancer, and includes two art studios, an observatory, a sculpture garden and the living, eating, sleeping areas. Design brief 02 for the control condition requires designing a house for a couple with five children aged from 3 to 17, that would accommodate children and parent sleeping areas, family space, study, guest room, eating and outdoor recreation spaces. Each design brief requires a different approach to the site and neighbouring environment.

The set-up of the study, Figure 1, involves a digital video recorder with a built-in or lapel microphone, directed at the designer to capture his/her verbalizations, gestures or sketching activity. The experiment condition of the study involves testing if architects are able to design without having access to sketching. We used a similar approach to that taken by Athavankar (1997); we had the designers engage in the design process while wearing a blindfold. At the start of the session they were told that they were to engage in a design activity but that they would do it while wearing a blindfold. In the beginning of the sessions the participants were given design brief 01 for the project, asked to read through it and then asked to recite it without reference to the written document. This process was repeated until they could recite the brief without mistakes. The aim of this procedure was to ensure that they would have similar access to the brief as an architect who could consult a written brief during the design process. They were then shown a montage of photographs of the site and allowed to examine them and ask questions if necessary. They were also instructed that they are required to come up with an initial sketch design to show the clients with the following criteria: the design should fit in the given dimensions of the site, accommodate the space requirements and allow an effective use based on the clients' requirements.

The participants were also given training in the think-aloud method. When this section of the experiment was completed they were asked to put on the blindfold and to start designing. During the blindfolded designing, they were free to ask about specific aspects of the design brief when they felt the need to do so. Five minutes before the end of the 45 minutes session participants were told that this was the

amount of time remaining. They were expected to produce an initial design for the house and at the end of the session, after the blindfold had been removed, they were asked to represent the design by drawing it as rapidly as possible and without any changes being permitted. If they are able to spend a particular amount of time designing without having an access to sketching and are able to end up with a reasonable design solution then that would be the evidence for the possibility of using imagery alone during designing.

Figure 1 Set-up of the study

In the control condition of the study, the same architects were required to sketch their ideas for design brief 02 while thinking aloud for 45 minutes. Sketching sessions were conducted at least one month after the blindfolded sessions. Participants were asked to memorize the design brief, they were shown the same montage of the site photos and they were given the training session in the think-aloud method. They were given the same site layout to work with. They were asked to number each new sheet of tracing paper. Table 1 shows a summary of the methodological considerations for the experiment and control conditions.

Table 1 Summary of methods

	Experiment Condition	**Control Condition**
Activity	Blindfolded designing, only externalizing at the end of the session.	Sketching
Design Brief	Design a residential house for a painter and a dancer	Design a residential house for a family with five children
Method of data collection	Time-stamped video recording	Time-stamped video recording
Reporting Method	Think-Aloud	Think-Aloud
Coding Scheme	Imagery Coding Scheme	Sketch Coding Scheme

3.2 Assessment of the Design Outcome

In this paper we focus on the results from the assessment of the sketches that are produced at the end of the sketching versus blindfolded sessions. The resulting

sketches by the three architects were double-blind judged by three judges who have been practicing and teaching architectural design for more than 15 years. The judges were provided with the two versions of the design briefs, the collage of photos of the site, as well as the site layout. After inspecting the design brief materials, they inspected the photocopies of the sketches produced in both phases of the study. The judges were provided with one sketch layout for each session which is the final sketch produced in each condition. Additionally section drawings were included if there were any in the related session. The sketches did not have indication of which session they belonged to (either sketching or blindfolded) and the judges were unaware that some of the designs had been produced by blindfolded designers. The criteria for the assessment of sketches were as follows where each item was graded out of 10:

- How creative the sketched design is: defined as seeing opportunities for a design solution that is not the "norm";

- How well the sketched design satisfies the design brief: in terms of design solution meeting the client requirements;

- Practicality.

4 RESULTS

The three architects were able to satisfy the space and client requirements in both design briefs, and in experiment and control conditions in their designs (Figures 2, 3, and 4). Table 2 shows the results of the assessment of the sketches by the three judges. The grades being out of 10 are calculated as the average of three judges' assessments. The end columns in each condition show the average grade of the three architects for each item.

Table 2 Grades for the design outcomes

Criteria	Blindfolded Sessions				Sketching Sessions			
	A1	A2	A3	Aver	A1	A2	A3	Aver
How Creative	5.3	6.0	6.3	**5.9**	5.0	5.7	7.3	**6.0**
How well it satisfies the design brief	7.7	6.3	7.7	**7.2**	6.3	6.3	6.3	**6.3**
Practicality	7.7	7.0	7.0	**7.2**	6.0	5.7	5.3	**5.7**
Average score	**6.9**	**6.4**	**7.0**		**5.8**	**5.9**	**6.3**	

Architect A1 produced similar layouts for the two design briefs in terms of using the site, and the relations between outdoor and indoor spaces even though the briefs were different. Figure 2 shows A1's sketches for the sketching (left-hand side) and blindfolded sessions (right-hand side). A1's blindfolded session design outcome has

higher scores in terms of satisfying the design brief (7.7 versus 6.0) and practicality of the design solution (7.7 versus 6.0). The two design outcomes have closer scores (5.3 and 5.0) for assessment of creativity (Table 2).

Figure 2 Architect 01 sketches (left: sketching; right: blindfolded)

Architect A2 produced different layouts for the two conditions in terms of typology and the relationship of the building to the site. Figure 3 shows A2's sketches for the sketching and blindfolded sessions. A2's blindfolded design session outcome and sketching session outcome have the same scores in terms of satisfying the design brief (6.3 and 6.3) and close scores for creativity assessment (6.0 and 5.7). On the other hand the practicality assessment of the blindfolded session outcome is higher than the sketching session outcome (7.0 versus 5.7).

Figure 3 Architect 02 sketches (left: sketching; right: blindfolded session)

A3 produced quite different layouts for the two conditions, in terms of typology and the relationship of the building to the outdoor areas. Figure 4 shows A3's sketches for the sketching and blindfolded sessions. A3's blindfolded design session outcome has higher scores in terms of satisfying the design brief (7.7 versus 6.3) and practicality of the design solution (7.0 versus 5.3). However, the design outcome of the sketching session has a higher score (6.3 versus 7.3) in creativity assessment.

Average scores of the three architects showed that the blindfolded session design outcomes scored higher than sketching outcomes in terms of two assessment criteria; satisfying the design brief and practicality of the design solution. However, the

average creativity assessment scores are same. Two of the three architects' (A1 and A3) average overall design outcome scores are higher for blindfolded sessions. These results are based on a small number of participants and cannot be generalized, however, they point to one important issue in this study: it is possible for expert designers to produce satisfactory designs through the use of imagery alone i.e. without the use of externalizations during designing.

Figure 4 Architect 03 sketches (left: sketching; right: blindfolded session)

5 IMPLICATIONS FOR CAAD

Research on how designers think can provide clues on how to achieve effective computer mediation. Studies on sketching have been a major part of this research focusing on the designers' interactions with sketches. The development of conceptual CAAD tools is based on insights from sketching studies. In this paper, we have demonstrated that externalizing a design is not the only way to design visually. Sketches and in general externalizations are central to designing; they represent the development of designs, they have an interactive role and a crucial effect in the mechanics of the design activity. However, based on our results from these experiments, we propose that "externalizing" is not necessary for a satisfying and reasonable outcome at the conceptual stage of designing. There is anecdotal evidence in architectural practice that architects sometimes skip the early sketching process and start with a CAD representation of the initial design. This representation is usually worked out with a massing study that involves synthesizing volumetric shapes in a 3D CAD environment. In a collaborative work environment, senior architects might complain that those digital designers are too focused on how the volumes look together, rather than being able to see parts or details synthesized together vertically. Senior architects often use elevation drawings to explore and evaluate these 3D aspects of the design and they consider drawing an elevation as adequate for that. The reason for why such senior architects effectively use elevations is possibly that they developed a skill to see those 3D aspects elevating out of the paper space via drawing lines on a paper. Thus, it is the use of imagery in this case which enables these architects to understand the 3D volumetrics of the environment. Consequently every line on a drawing modifies or adds to the understanding of the 3D model. This supports the idea that architects externalize their designs interactively with the use of imagery, sometimes called interactive imagery (Goldschmidt 1994).

Design practice and design education continue to change, driven in part by the available technology. In design education, students are encouraged to start off designing using a digital medium, and then produce physical models from these digital models. Does this require a different style of thinking? As a consequence, does the initial thinking process or the skill for developing an internal mental representation gain more importance? And if so, what are the cognitive resources needed for this type of activity and further how can they be improved?

At the beginning of this paper we raised the question "Do we need CAD for conceptual designing", and this question was the trigger for exploring a more general question, "Do we need externalizations". Sketching in architectural design is still a central concern which shapes our understanding of the design process and the development of new tools. In this study we attempted to bring another view, questioning whether externalization is the only way to design. Our aim here was to indicate that constructing internal representations could be a strong tool for designing. We presented results from the sketching versus non-sketching experiments which supported this claim. The answer to the initial question is: we may not need sketching for the generation of designs during the conceptual phase. However, externalizations appear to serve other purposes than the simple dialectic suggested by Schon and Wiggins (1992) and confirmed by others. Externalizations whether they are sketches, CAD tools or models, serve other communicative roles. However, it is possible to extend our current understanding of CAAD by developing systems that take into consideration the strength of mental imagery in designing. As we develop a deeper understanding of the visual reasoning and imagistic capacities of the mind it is likely that future CAAD tools for conceptual design may look very different to the current CAAD tools used for detail design.

REFERENCES

Akin, Omer. 1986. *Psychology of architectural design.* London: Pion.

Athavankar, Uday A. 1997. Mental imagery as a design tool. *Cybernetics and Systems* 28(1): 25-47.

Bilda, Zafer, and Terry A. Purcell. 2003. Imagery in the architectural design process. In *Proceedings of the 9th European Workshop on Imagery and Cognition (EWIC 9)*, 41. Universita di Pavia, Dipartimento di Psicologia

Bilda, Zafer, and Halime Demirkan. 2003. An insight on designers' sketching activities in traditional versus digital media. *Design Studies* 24(1): 27-50.

Do, Ellen. Y.-L. 1995. What's in a diagram that a computer should understand. In *Global Design Studio: Proceedings of CAAD Futures 95 International Conference*, ed. Milton Tan, and Robert The: 469-482. Singapore: National University of Singapore.

Goel, Vinod. 1995. *Sketches of thought.* Cambridge: MIT Press.

Goldschmidt, Gabriella 1994. On visual design thinking: The vis kids of architecture. *Design Studies* 15(4): 158-174.

Gross, Mark D. 1996. The Electronic Cocktail Napkin - working with diagrams. *Design Studies* 17(1): 53-69.

Kavakli, Manolya, and John S. Gero, 2001. Sketching as mental imagery processing. *Design Studies* 22(7): 347-364.

Kosslyn, Stephen M. 1980. *Image and mind*. Cambridge, MA: Harvard University Press.

Lawson, Bryan. 1997. How designers think: The design process demystified. Oxford: Architectural Press.

Logie, Robert H. 1995. *Visuo-spatial working memory*. Hove: Erlbaum Associates.

Pylyshyn Zenon W. 1984. *Computation and cognition: Toward a foundation for cognitive science*. Cambridge: MIT Press.

Schon, Donald A., and Glenn Wiggins. 1992. Kinds of seeing and their functions in designing. *Design Studies*, 13(4): 135-156.

Suwa, Masaki, Terry Purcell, and John S. Gero, 1998. Macroscopic analysis of design processes based on a scheme for coding designers' cognitive actions. *Design Studies* 19(10): 455-483.

Weisberg, Robert W. 1993. *Creativity: Beyond the myth of genius*. New York: W.H. Freeman.

Contemporary Digital Techniques in the Early Stages of Design

The Effect of Representation Differences in Current Systems

KNIGHT Michael[1], DOKONAL Wolfgang[2], BROWN Andre[1] and HANNIBAL Claire[1]

[1] *School of Architecture, The University of Liverpool, Liverpool, UK*
[2] *Department of Urban Planning, Graz University of Technology, Austria*

Keywords: design methodology, sketch, traditional, practice

Abstract: This paper reviews the role that computers can play in the early design stages and considers how far recent developments in commercial software have enabled designers to improve design performance through interaction with a CAAD system. An experimental approach is reported on.

1 INTRODUCTION

Studies, reported some years ago that looked at using the computer early in the design process frequently reported on substantial constraining effects that CAAD systems imposed. The hardware and software was relatively expensive but it was also relatively user-unfriendly (Richens 1988, 1992). Early systems were developed in a way that emulated the drawing processes evident in conventional ways of working in the later stages of the design. The computer was simply an electronic drawing board and in some ways it has been difficult for CAAD software to break free from that heritage and embody the enhancements that digital systems can offer over conventional tools.

One of the strands of development that has attempted to aid the idea of breaking free from the heritage and employing the computer as a more creative aid has been work, over the past ten years or more, on accomplishing the goal of the computer as effective digital sketching device. Brown and Horton (1990) reported on the different kinds of drawing associated with different stages of design activity, analysed sketching techniques and showed how contemporary software could be

B. Martens and A. Brown (eds.), Computer Aided Architectural Design Futures 2005, 165-174.
© 2005 *Springer. Printed in the Netherlands.*

modified to accomplish sketching more efficiently. Early in this strand of evolution Daru (1991) stated that "Sketching plays a manifold role in design and design education now as much as it did in the computerless days. Design sketching is indispensable during the early phases of the architectural design process".

In terms of actually implementing sketching tools and interfaces there have been, more recently, interesting developments such as the Electronic Cocktail Napkin project and subsequent developments (Gross and Do 1996) or Digital Clay. (Schweikardt and Gross 1998) and Mase's (2000) very interesting work on the Moderato system. All of these programs and environments take the approach of trying to give designers digital replications of traditional tools (pen or pencil and paper) to use in a manner that mirrors the traditional way of design; but with the assistance of the computer to enhance and augment the process. However, if we ask architects and design tutors alike how digital techniques are being applied in the design process, the notion of originating ideas or sketching of ideas is still alien to many. This is probably because the typical contemporary CAAD system still fails to offer an adequately design-oriented environment for design sketching. Recent software developments and more powerful computers have started to change this, but there still appears to be a long an ingrained perception in the profession, brought about by years of production orientated software, that it is not possible to 'design' in the computer. Today the picture is changing. Many, if not most, architectural students start their earliest design investigations quite naturally using the computer.

This still leaves many questions unanswered and poses many others concerning the relationship between architectural design and the computer. Why do we always have to sketch when we start thinking of a design? Is it because it's the 'natural' thing to do or is it because we are taught to design using pen and paper? Some architectural schools only introduce students to computers in the second year of their studies, and those that do introduce it earlier are often not using it in the early design stages. So what would happen if we started to teach our students from the outset to design with the computer? Will it increase their design capabilities, or might it hinder their ability to generate design ideas: might the change to digital sketching be an unnatural one that ends up constraining rather than freeing ideas? Is there not also a case for quite naturally starting with the computer when it is omnipresent in every aspect of both work and daily life?

This paper looks at the application of current design software in a contemporary design environment. The methodology of the study is based on a structured design problem based activity that investigated the effects of the use of CAAD early in the design process. We were interested to see whether designing wholly on the computer would produce substantially different results to those produced via a more traditional design process. Rauhala, (2003) stated that "It seems impossible to use computers as a creative adviser or as a generator of totally new design solutions. Likewise using computers for generating new and creative associations seems to be in principle infeasible." We were interested in challenging this assertion. In addition it is interesting to note that researchers such as Abdelhameed et al. (2003) have looked at the issue of assessing the impact of media on the design capabilities of architects.

Part of the issue is to do with effectiveness of the software, and its mode of operation or interface. But part of the problem is to do with perception. If a designer has a preconceived antipathy towards digital sketching, and is resistant to the idea that a digital sketching environment can be helpful and productive, then clearly an objective view will be difficult to obtain. So, in addition to the structured design problem a perception study has been undertaken to gauge the response of different groups such as architect and non-architect, student and graduate, to the kind of representation and interface that the kind of software described offers.

2 THE PROJECT

The work in this aspect of the paper is based primarily on two collaborative exercises that took place between two European University Schools of Architecture. An initial exercise took place in February 2004 with students of the Department for Urban Design, Technical University of Graz and the School of Architecture, University of Liverpool. The promising initial findings have prompted a more detailed study. The premise of the exercise is to use the same design problem with two different groups of first year students from, one designing wholly in a 3D CAAD environment, the other working mainly, and initially with traditional tools, but with a CAAD presentation requirement in the later stages of the process.

The software used was Sketchup, which has a feature of user-defined settings for the appearance so that digital representations can be made to look similar to manual sketches. Added to that the mode of operation and geometry definition is relatively free and immediate, with lines, shape and form defined directly by hand movement (via a digital pen or mouse) rather than by keyboard entry of coordinates. As such we can categorise this as a *sketching* interface. But clearly there will be different views (Chastain et al. 2002), both on whether the digital sketch has to look like the manual sketch, and on what the associated qualities are that give a particular environment the facility to act as a supportive visible counterpart to the creative mental processes in early stage design.

2.1 Initial Study

The initial exercise involved two groups of first year architectural students working on a common site and design problem, one working wholly in CAAD, the other working wholly manually. The CAAD students worked in pairs in an intensive studio starting with introductory tutorials in SketchUp and culminating five days later in wholly computer based presentations. Students worked intensively every day on the project. They were encouraged to experiment with the program using mistakes, correction and unintentional events as design generators and parts of the design process; in other word mimicking the affordances that conventional media support (Tweed 2001).

Contemporary Digital Techniques in the Early Stages of Design

The brief called for a house for an artist on a small, urban corner site in Graz. A detailed brief was not established; the house had to be able to provide suitable spaces to live, work and present work. The students could choose their artist (client) and describe the artists's requirements first and develop their own brief in discussion with the tutors. The site was adjacent to a party wall and was set on a small slope and a large single tree, all of which presented quite a demanding task for inexperienced first year students.

The 36 students who worked only with digital techniques took part in a five day intensive workshop, working in pairs. They had five days to both learn a new piece of software (SketchUp) and produce a wholly computer-based presentation. Students worked intensively every day on the project. A problem with this kind of study is clearly that for those working in the digital environment a new skill has to be learned, whereas traditional skills such as drawing and model-making are familiar to students. One the one hand the novelty of a new approach to representation might appeal, and bias views towards that environment. On the other learning a new skill means that the flow of information between medium and mind is likely not to be smooth.

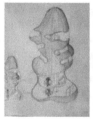

Figure 1 (left) Traditional and Figure 2 (right) digital-supported design

The students working traditionally worked in a different way to the digital group; a study tour introduced the city and the site. The project was five weeks in duration, but with only two studio days per week dedicated solely to it. Students worked traditionally through sketches, drawings and models, but a SketchUp model was a prerequisite of the final presentation. The computer was not used as a counterpart to the design process, but simply as a modelling and representation tool at the end of the process.

Whilst it was not possible to have identical presentation requirements, to demonstrate an understanding of the resulting internal spaces, the students working in wholly digital environments were required to create a walkthrough from street to the major space in the design, whilst those working traditionally were required to produce a serial vision walkthrough from the street level through to a major space in their building.

There were some interesting observations made during the initial phase of the workshop. Firstly, some of the students resented starting from scratch with the computer; they hunted around to try to find a piece of paper to sketch their first ideas. Subsequently it was found that these were mainly the students who already

gained some design experience earlier in their previous education. The second interesting point relating to the digital group was that the students who had experience in other more traditional CAD packages such as AutoCAD, had significant problems using SketchUp. They tried to work in a similar way to the way that they had learned with the program that they were familiar with. This turned out to be a significant hindrance, and the CAAD experience proved to be a handicap to developing a design in a wholly digital environment, rather than a help.

These observations are in line with those made much earlier by Richens (1988, 1992). As we know skill in CAAD software is not universally transferable. Like spoken languages, in some cases, knowledge of one does not guarantee rapid assimilation of another. But this is not unique to working in a digital environment. The ability to produce good quality line drawings with ink drafting pen on tracing paper, does not guarantee an adeptness to produce high quality charcoal on paper drawings.

The heritage mentioned earlier still continues to influence the language of CAAD, and issues such as those relating to Human Computer Interface are still very significant in terms of the introduction of software that attempts to take on the role of counterpart to the design process in the early stages of design. It seems that there is still a widespread expectation that new software will work in ways, and look like that body of established tools.

In order to test this view and to establish if there were identifiable differences across a range of groups with different characteristics a parallel study has been undertaken. This study has taken a large number of respondents and is aimed at obtaining views on the reaction to different representational types.

One matter that we are concerned with is the perception of, and reaction to, digital representations that emulate the physical sketch and sketch model. Respondent data for a number of comparator groups has been collected and analysed. Amongst other things this data allows us to comment on the differences in reaction to *sketchy* interfaces between pairs of groups such as architect and non-architect, architecture student early in their education and at the end, and male-female differences.

2.2 Linked Study

In the study described above we considered how the nature of the architectural representation changed the perception of the user in terms of their reaction to the architectural object being depicted. We used a Semantic Differential Scale from 1 to 7 to collect and analyse the responses. 1 and 7 represented bi-polar adjectives at extreme ends of a spectrum (such as boring to exciting) with 4 measuring a neutral response. The study groups were divided into architects and non-architects, with subdivisions within each group so that we could make finer distinctions. In the study three principal rendering types were used; sketchy line, non-photorealistic and near photorealistic. One line of questions asked about the character of spaces represented, in particular how real or abstract the participant felt them to be. What was interesting for a sketchy line representation is that there was a noticeable difference between

male and female respondents. In Figure 3 male responses are shown in grey bars and female in black. Females appear to regard the sketchy representation as relatively realistic, whereas males interpret it more as an abstraction.

Figure 3 Effect of gender on perception of sketchy line scheme

Another line of questioning looked at how expressive the different representations were felt to be. The graphs for the sketchy representation and the near photorealistic representation are shown in Figures 4 and 5.

The possibly surprising result here is that near photorealistic representations are regarded as 'expressive' by a significant proportion of the survey group. In the physical equivalent a sketchy representation tends to be regarded as expressive, whereas more geometrically accurate representations tend to be regarded as lifeless and uninspiring.

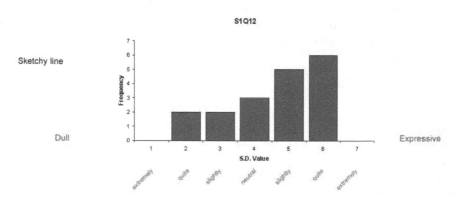

Figure 4 Description of *character* (range from dull to expressive) for sketchy line scheme

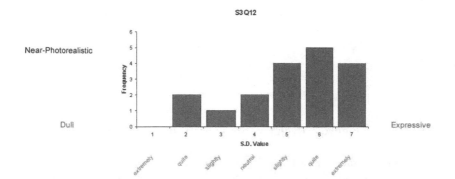

Near-Photorealistic

Dull

Expressive

extremely quite slightly neutral slightly quite extremely

Figure 5 Description of *character* for non-photorealistic scheme

The perception studies outlined above have been extended and the group sizes increased to ensure that the data is statistically significant (Hannibal et al. 2005), especially given that some of the findings are counter to what was expected from the results of previous studies such as those conducted by van Bakergem and Obata (1991), and Bassanino (1999). But what this work shows is that care is needed in drawing conclusions from future studies of designing in what we might contrast as sketchy and non-sketchy environments.

2.3 Second Study

A second digital versus traditional study has been undertaken using a similar premise as before; two groups of 16 students each, one working digitally and the other traditionally on the same scheme on the same site. Both worked on the problem simultaneously in an environment that allowed a much more controlled analysis. However, in order to minimise cultural and pedagogic differences, students from each institution were paired and worked with tutors from both institutions. The digital group were not be allowed to use any analogue means in the initial design phase and the analogue group was not allowed to use the computer. Both groups of students were again, first year level who had similar levels of both CAD and traditional skills.

Figure 6 Evolution of a wholly manual scheme

Figure 7 Evolution of a wholly digital scheme

Figures 6 and 7 show how two typical schemes developed when students used wholly traditional and wholly digital techniques respectively. The evolutions show a number of contrasting features that can be summarised as follows.

In the manual scheme much of the development was through 2D sketches (e.g. Figure 6 left) and exploration in drawn 3D (e.g. Figure 6 centre) are rarer events. A 3D model may be produced, typically only once or twice in the life of the design (Figure 6 right). Changing to focus on a detail at a larger scale is easy and relatively common. In the wholly digital scheme the majority of the evolution is in 3D and begins with a more complete description of the site (Figure 7 left). This is to some extent necessary, but could be a virtue that the CAAD system directs the user towards. Design alternatives are tested in 2D rather than 3D (Figure 7 centre left and centre right). Alternatives are usually tested in the context of the site and building rather than in isolation.

3 CONCLUSIONS

We posed some questions early in this paper. Why do we always have to sketch when we start thinking of a design? Is it because it's the 'natural' thing to do or is it because we are taught to design using pen and paper? Researchers have debated these issues and the answers are still equivocal. So, devising CAAD systems that best support the initial, creative phase of design is a difficult task. The specification is vague. Not only that, there may be more than one ideal specification.

The results of the perception studies reported here indicate that there are gender differences in the value and interpretation placed on different architectural representations. The results of perception studies also tentatively indicate that there is an increased willingness to value the digital representation; and that the elevated value placed on hand rendered, conventional representations evident in studies some years ago no longer necessarily hold. This has significant consequences for the application of digital processes early in the creative 'sketching' phase of design.

Daru (1991) posed four criteria for the assessment of computer based sketching:

- *Is computer based sketch designing didactically correct?* The aim of both methods is to further design education and not just produce aesthetically pleasing or challenging images.

- *Is it useful?* If use of computer tools either gives additional possibilities or shortens the design learning period then the answer is positive.

- *Is it sufficient?* Can computer-based sketching replace traditional hand methods?

- *Is it harmful?* Are such design methods detrimental to the traditional sketching experience?

Given the reservation it is possible to make some general observations from the studies described in Section 2.1 and 2.3. It would appear that the stronger CAAD based students produced designs which they might not have been capable of working through a wholly traditional design methodology and that the CAAD students had a better grasp of the quality of internal spaces. The stronger students who were working traditionally produced designs that would have been very difficult or impossible to produce with their limited CAAD knowledge.

It has been said (Schon and Wiggins 1992, Bailey 2001) that sketching is about the iterative, reflective conversation that occurs with that act of drawing, and that understanding this conversation is the key to understanding. The observations that we have made during the initial part of this research lead us believe that, with new students at least, sketch designing with current software tools is becoming more accepted and useful.

Established software has created an environment in which it is difficult to break free from the shackles of expectation that new software will work in ways, and look like that body of tools. Like the horseless carriage (Chastain 2002) the vehicle is still not the right shape and the driver is still not in the best position to take charge of a design that is powered by a digital engine, but an evolution appears to be happening.

REFERENCES

Abdelhameed, W., F. Ozel, M. Addelatiff, and A. Daef. 2002. Assessment of the Impact of Digital-Manual Media Types on the Basic Design Capabilities of Architects: A Proposed Framework and Directive Measures. In *SIGraDi 2002* [Proceedings of the 6th Iberoamerican Congress of Digital Graphics, Caracas Venezuela], 275-276. Caracas: SIGraDi.

Bailey, Rohan O. 2001. A digital design coach for young designers, in *CAADRIA 2001* [Proceedings of the Sixth Conference on Computer Aided Architectural Design Research in Asia], eds. J.S. Gero, S. Chase, and M. Rosenman: 311-314. Sydney: CAADRIA.

Bassanino, M.N. 1999. *The Perception of Computer Generated Architectural Images* PhD Thesis, University of Liverpool, UK.

Brown A.G.P., and F.F. Horton. 1990. Computer aids for design development. In *Computers in Architecture: Tools for Design,* ed. F. Penz: 15-24. London: Longman.

Chastain, T., Y.E. Kalay, and C. Peri. 2002. Square peg in a round hole or horseless carriage? Reflections on the use of computing in architecture. *Automation in Construction* 11(2): 237-248.

Daru, R. 1991. Sketch as Sketch Can - Design Sketching with Imperfect Aids and Sketchpads of the Future. In *Experiences with CAAD in Education and Practice* [Proceedings eCAADe Conference - Munich], 162-182.

Gross, M.D., and E.Y.-L. Do. 1996. Demonstrating the Electronic Cocktail Napkin: a paperlike interface for early design. In *CHI 96, Conference on Human Factors in Computing Systems*, 5-6. Vancouver: ACM Conference Companion.

Mase, J. 2000. Moderato: 3D Sketch CAD with Quick Positioned Working Plane and Texture Modelling. In *Promise and Reality: State of the Art versus State of Practice in Computing for the Design and Planning Process* [18th eCAADe Conference Proceedings], 269-272. Weimar: eCAADe.

Rauhala, Kari. 2003. Playing Games: the Role of Computers in Sketching. In *Digital Design* [21st eCAADe Conference Proceedings], eds. W. Dokonal, and U. Hirschberg: 347-350. Graz: eCAADe.

Richens, P. 1988. Automation of Drafting and Building Modelling. Historical Review of Commercial Development since the Seventies In *CIB-W78 Conference*. Lund.

Richens, P. 1992. *The Next Ten Years.* In F. Penz (Ed.), Computers in Architecture, Longman.

Schon, Donald A., and Glen Wigging. 1988. Kinds of Seeing and Their Functions in Designing. *Design Studies* 13(2): 135-156.

Schweikardt, E. and M.D. Gross. 1998. Digital Clay: Deriving Digital Models from Freehand Sketches. In *ACADIA 98* Proceedings, eds. T. Seebohm and S. van Wyk: 202-211. Quebec City, Canada, ACADIA.

Tweed, Christopher. 2001. Highlighting the affordances of designs. Mutual realities and vicarious environments. In *Proceedings of Computer Aided Architectural Design Futures 2001,* eds. B. de Vries, J. van Leeuwen, and H. Achten: 681-696. Dordrecht: Kluwer.

Van Bakergem, W.D., and G. Obata. 1991. Free Hand Plotting Is it Live or Is It Digital? In *CAAD Futures' 91* [International Conferences for Computer Aided Design], ed. G.N. Schmitt: 567-82. Braunschweig: Vieweg.

Optimizing Architectural Layout Design via Mixed Integer Programming

KEATRUANGKAMALA Kamol[1] and SINAPIROMSARAN Krung[2]
[1] *Faculty of Architecture, Rangsit University, Thailand*
[2] *Faculty of Science, Chulalongkorn University, Thailand*

Keywords: layout design, linear programming, mixed integer programming, optimization

Abstract: For many decades, solving the optimal architectural layout design is unattainable for the reasonable problem sizes. Architects have to settle for acceptable layouts instead of the favourable optimal solution. With today technologies, various optimization techniques have been used to alleviate the optimal search according to diversified goals. This paper formulates the optimal architectural layout design as the multiobjective mixed integer programming model solved by the MIP solver. The main idea is to capture functional constraints, dimensional constraints and the objective function using only linear formulae with binary variables. Functional constraints are the connectivities, the unused grid cells, the fixed room location, the boundary and the fixed border location while dimension constraints are the non-intersecting, the overlapping, the length and the ratio constraints. The objective function is designed to minimize the absolute distance among rooms and maximize room spaces. Due to the nonlinearity of area computation, the linear approximation of width and height constraints have been utilized. Architects can control these different objectives within the model. By specifying the rigid restriction and the time limits, the problem can be solved within a reasonable amount of time.

1 INTRODUCTION

Finding the optimum architectural layout design is a challenging problem to many architects and researchers from the past decade. The problem involves both quantifiable and qualifiable goals, preferences, and constraints. Particularly, aesthetic and other subjective aspects of design are difficult to describe using the logical expression or the mathematical formulae. Many attempts have been used to deal with this problem such as the wall representation (Flemming 1978), non-linear programming (Imam and Mir 1989) and the evolutionary approach (Michalek and Papalambros 2002). There are various difficulties with each approach. The wall representation uses the special data structure to generate the linear programming subproblem which requires a specific algorithm. The nonlinear programming approach guarantees only local optimal. The evolutionary method can only guarantee the convergence with a long running time (Jo and Gero 1998).

B. Martens and A. Brown (eds.), Computer Aided Architectural Design Futures 2005, 175-184.
© 2005 *Springer. Printed in the Netherlands.*

Optimizing Architectural Layout Design via Mixed Integer Programming

We propose the use of the mixed integer programming model (MIP) (Linderoth and Savelsbergh 1999) to find the optimal architectural layout design. Our approach guarantee the global optimal solution if the MIP solver stops normally. Even though, the architectural space layout design problem is considered to be ill-defined (Yoon 1992). The automated architectural layout planning must deal with a large set of possible solutions (Scott and Donald 1999) that cannot be solved exhaustively for reasonably-sized problems. Therefore, we reduce the search space by allowing architect to specify additional reduction constraints such as the fixed room location, the unused grid cells, the fixed border location and the favorable choice of the nearest room to the top left corner. Furthermore, the requirement of rectangular boundary has not been imposed.

We implement the software that utilizes the graphic user interface (GUI) running on the Windows operating system. The GNU Linear Programming Kit (GLPK) solver is hooked up to automatically solve the given architectural layout model. Architects can request the drawing presentation of the global optimal solution or save it as the DXF format file to use with their CAD software. In the next section, we identify the model variables, parameters and constraints together with the objective functions. After the model has been completed, we tested our software with the simulated examples using only 4, 5, 6, 7, 8 and 10 rooms in the experiment section.

2 OPTIMIZATION OF GEOMETRY

The architectural layout design problem in this research is formulated based on the grid system. Thus, coordinates and dimension are used as the design variables of the problem (Li, Frazer and Tang 2000).

2.1 Design Variables and Parameters

For each room i in figure 1(a), four basic variables are formulated as the coordinated system and the origin point is placed on the top left corner.

x_i = X coordinate of the top left corner of the room i.

y_i = Y coordinate of the top left corner of the room i.

w_i = the horizontal width of the room i.

h_i = the vertical height of the room i.

Additionally, two basic parameters are width and height of the boundary area which are represented by W and H, respectively. We control the width and the height of the design variables using the lower and upper limits, $w_{min,i}$, $w_{max,i}$, $h_{min,i}$, $h_{max,i}$, T_{ij} and R where $w_{min,i}$ and $w_{max,i}$ are the minimal and the maximal width of room i while $h_{min,i}$ and $h_{max,i}$ are the minimal and maximal height of room i, respectively. T_{ij} is the minimal contact length between room i and j and R is the room ratio, see Figure 1(b).

Figure 1 (a) Basic design variables and parameters and (b) Minimal and maximal dimension of room geometry

2.2 Objective of Problem

The multiobjective function of the optimization model in this research composes of minimizing the absolute room distance and maximizing room area. In order to calculate the room area, we use the linear approximation by maximizing the minimal width and height of each room. Moreover, each objective functions are controlled by different nonnegative weighted values. In order to generate multiple optimal distance and optimal area, architect can select the i^{th} room to be fixed at the top left corner coordinate. This function is shown below. For fixed i^{th},

$$minimize \ (u_{i,1}(x_i + y_i) + u_{i,2}\sum absolute \ distance - u_{i,3}\sum approximate \ area) \ (1)$$

where $u_{i,1}$ is the weight of the i^{th} room positioned to the nearest top left corner, $u_{i,2}$ is the weight of the total absolute distance and $u_{i,3}$ is the weight of the total approximated area. If the architect prefers the large area then the weighted sum of $u_{i,3}$ is set larger than $u_{i,2}$. Otherwise, if the architect prefers a short distance between rooms then $u_{i,2}$ is set larger than $u_{i,3}$.

2.3 Layout Design Constraints

In this research, two kinds of constraints are considered, the functional constraint and the dimensional constraint. The functional constraint determines the placement of all rooms while the dimensional constraint forces room dimensions.

2.3.1 Functional Constraints

Functional constraints determine the placement location of rooms according to the architectural requirements. They can be described as follows.

Optimizing Architectural Layout Design via Mixed Integer Programming

Connectivity constraint explains the relationship between different rooms (Medjodoub and Yannon 2000). To ensure room attachment for the purpose of the access way, we design two binary variables (p_{ij}, q_{ij}) which are illustrated as follows:

$$x_i + w_i \geq x_j - W^*(p_{ij} + q_{ij}) \qquad \text{i to the left of j,} \quad p_{ij} = 0, q_{ij} = 0 \qquad (2)$$

$$y_j + h_j \geq y_i - H^*(1 + p_{ij} - q_{ij}) \qquad \text{i above j,} \qquad p_{ij} = 0, q_{ij} = 1 \qquad (3)$$

$$x_j + w_j \geq x_i - W^*(1 - p_{ij} + q_{ij}) \qquad \text{i to the right of j,} \quad p_{ij} = 1, q_{ij} = 0 \qquad (4)$$

$$y_i + h_i \geq y_j - H^*(2 - p_{ij} - q_{ij}) \qquad \text{i below j,} \qquad p_{ij} = 1, q_{ij} = 1 \qquad (5)$$

Fixed position constraint determines the room positioning in a space. In practical design, this constraint helps an architect to secure the room location in the design:

$$x_i = \textit{fixed x coordinate}, \quad y_i = \textit{fixed y coordinate} \qquad (6)$$

Unused grid cell constraint determines the area that is unusable. This constraint helps an architect designing various orthogonal boundary shapes. We use two binary variables (s_{ik}, t_{ik}) to identify the location of unused grid cell, k^{th}.

$$x_i \geq x_{u,k} + 1 - W^*(s_{ik} + t_{ik}) \qquad \textit{unused space to left of i} \qquad (7)$$

$$x_{w,k} \geq x_i + w_i - W^*(1 + s_{ik} - t_{ik}) \qquad \textit{unused space to right of i} \qquad (8)$$

$$y_i \geq y_{w,k} + 1 - H^*(1 - s_{ik} + t_{ik}) \qquad \textit{unused space to top of i} \qquad (9)$$

$$y_{w,k} \geq y_i + h_i - H^*(2 - s_{ik} - t_{ik}) \qquad \textit{unused space to bottom of i} \qquad (10)$$

where $x_{u,k}\, y_{u,k}$ are unused positions in x,y coordinate of the unused k^{th} cell.

Boundary constraint forces a room to be inside a boundary:

$$x_i + w_i \leq W, \quad y_i + h_i \leq H \qquad \textit{a room within the boundary} \qquad (11)$$

Fixed border constraint addresses the absolute placement of the room. This constraint is divided into four types: north, south, east and west. For example, a room is positioned to the "absolutely north" if its touch the top border:

$$y_i = 0, \; y_i + h_i = H \qquad \textit{touch the north and the south border} \qquad (12)$$

$$x_i + w_i = W, \; x_i = 0 \qquad \textit{touch the east and west border} \qquad (13)$$

2.3.2 Dimensional Constraints

Dimensional constraints determine the adjustment of room geometry according to the proportional requirements.

Non-intersecting constraint prevents two rooms from occupying the same space (Medjodoub and Yannon 2000). We use the same two binary variables p_{ij} and q_{ij} to protect room collision. These requirements can be illustrated as:

$$x_i + w_i \leq x_j + W^*(p_{ij} + q_{ij}) \qquad i \text{ to the left of } j, \quad p_{ij} = 0, q_{ij} = 0 \quad (14)$$

$$y_j + h_j \leq y_i + H^*(1 + p_{ij} - q_{ij}) \qquad i \text{ above } j, \qquad\quad p_{ij} = 0, q_{ij} = 1 \quad (15)$$

$$x_j + w_j \leq x_i + W^*(1 - p_{ij} + q_{ij}) \qquad i \text{ to the right of } j, \quad p_{ij} = 1, q_{ij} = 0 \quad (16)$$

$$y_i + h_i \leq y_j + H^*(2 - p_{ij} - q_{ij}) \qquad i \text{ below } j, \qquad\quad p_{ij} = 1, q_{ij} = 1 \quad (17)$$

Overlapping constraint forces the minimal contact length between two connected rooms. Two rooms are touching with each other with the minimal contact length defined by the value (T_{ij}). For example, the junction between a room i and room j must be wide enough to accommodate an access way:

$$0.5^*(w_i + w_j) > T_{ij} + (x_j - x_i) - W^*(p_{ij} + q_{ij}) \qquad i \text{ to the left } j \qquad (18)$$

$$0.5^*(h_i + h_j) \geq T_{ij} + (y_j - y_i) - H^*(2 - p_{ij} - q_{ij}) \qquad i \text{ to the top of } j \qquad (19)$$

$$0.5^*(w_i + w_j) \geq T_{ij} + (x_i - x_j) - W^*(1 - p_{ij} + q_{ij}) \qquad i \text{ to the right of } j \qquad (20)$$

$$0.5^*(h_i + h_j) \geq T_{ij} + (y_i - y_j) - H^*(1 + p_{ij} - q_{ij}) \qquad i \text{ to the bottom of } j \qquad (21)$$

Length constraint is a minimal or maximal length of the bounded size of each room. A certain room is limited to suitable dimensions between the horizontal range of $w_{min,i}$, $w_{max,i}$ and the vertical range of $h_{min,i}$, $h_{max,i}$, respectively:

$$w_{min,i} \leq w_i \leq w_{max,i}, \; h_{min,i} \leq h_i \leq h_{max,i} \quad range \; of \; width \; and \; height \; of \; room \; i \; (22)$$

Ratio constraint restricts the length between horizontal and vertical dimension. This constraint prevents the long and narrow shape of a room. A binary variable (r_i) is used to select the constraint satisfying horizontal and vertical ratio:

$$w_i + r_i^*(W + H) \geq R^*h_i , \; h_i + (1 - r_i)^*(W + H) \geq R^*w_i \quad horizontal \; and \; vertical \; ratio \; (23)$$

3 SOFTWARE DEVELOPMENT

The software uses the non-commercial linear programming and mixed integer programming solver, GLPK (GNU Linear Programming Kit) that was developed by Moscow Aviation Institute (Russia). GLPK software can solve a large-scale linear programming problem and mixed integer linear programming based on the branch and bound technique.

We develop a user-friendly interface for this software to help architect identifying the layout requirement graphically. After the architects input a functional diagram via the interface as in Figure 2(a), the problem is then converted to a GNU MathProg model that is supported by GLPK. The result of the computation as in Figure 2(b) can be presented graphically as layout drawings, see Figure 2(c). Furthermore, the solution can be exported as DXF file format that is widely supported by CAD software, see Figure 2(d).

(a) (b)

(c) (d)

Figure 2 Software interface (a) for functional diagram, (b) and (c) for text and graphical output. (d) shows the export DXF file from CAD software

4 EXPERIMENTS

This research presented the experimental results from the GLPK solver. All experiments were carried on a PC computer using Pentium 1 GHz and 256 MB of memories. We used 4, 5, 6, 7, 8 and 10 rooms for our experiments. Each run was performed using 15 configurations. More than 100 examples from six room sizes were tested.

4.1 Computation time of GLPK

In order to measure the performance, we collected computation time and global solutions. Our experiments are divided into three cases and described as follows.

Case 1 composes of 36 configurations with the equal room proportions. Each configuration contains 4 different connection patterns. Each pattern contains 6 experiments. The average time is reported in Figure 3. Case 2 composes of 36 configurations with different room proportions. We perform the same experiment as in the case a. Case 3 composes of 36 configurations with different of room width and height ratios. We perform the same experiment as in the case a.

The details of each pattern are as follows. Pattern A is the consecutive connection from the first room to the last room. Pattern B is the one room connected to the remaining rooms. Pattern C is the consecutive connection among odd-room numbers and the consecutive connection among even-room numbers and pattern D is the same as pattern C except one odd-room is connected to one even-rooms.

Figure 3 shows the faster computation times of the case 2 comparing with the case 1 about 50 percents. For the case 3, the room ratio shows no different computation time with respect to case 1.

Figure 3 An average summation of room sizes 4 to 10 with 90 run in the different connection patterns of A, B, C and D

4.2 Layout Design with Multiobjectives

In practice, the balanced between quantifiable and unquantifiable aspects of architectural goals should be considered. In our model, we allow the architect to select his/her alternatives by using the weight values. $u_{i,1}$ is the weight of the room position, $u_{i,2}$ is the weight of the total room distance and $u_{i,3}$ in the objective function (see Figure 4). Furthermore, architect can select alternative global optimal solutions based on the room positioning to the top left corner which is shown in Figure 5.

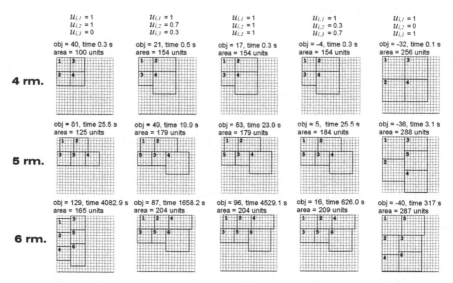

Figure 4 Shows the multiobjectives of 4, 5 and 6 rooms where $u_{i,1}$, $u_{i,2}$ and $u_{i,3}$ is the weight of the total room area for the fixed room i

Figure 5 Five alternative global solutions of 5 room configurations

4.3 Comparison between MIP and Nonlinear Programming

In order to compare the efficient of the MIP and nonlinear model, we select the GLPK solver to solve MIP, the CPLEX solver to solve MIP and the DICOPT solver to solve MINLP (Mixed Integer Nonlinear Programming). Table 1 shows the average comparison with number of variables and objective values.

Table 1 The average comparison between MIP and Non-linear programming

Room	Time (sec.)			Variables (non-zero)			Objective value		
Sized	MIP	MIP	MINLP	MIP	MIP	MINLP	MIP	MIP	MINLP
	GLPK	CPLEX	DICOPT	GLPK	CPLEX	DICOPT	GLPK	CPLEX	DICOPT
4 rm.	1.0	1.0	1.0	594	593	517	32	32	32
5 rm.	69.3	17.4	56.2	856	855	725	80	80	126
6 rm.	430	135	957	1152	1151	935	125	125	183

4.4　　Practical Case Study

A simple practical floor plan was solved by the architect and by our software with the time limit of 1000 seconds. The problem composes of eight rooms in 20x20 m. The detail parameters are shown in Table 2 and the result is shown in Figure 6.

Table 2 Room Dimensional Constraints (Scale in Meter)

Room Name	Min width	Max width	Min height	Max height	Ratio	Connect	Fixed wall
1. Garage x2	5	6	6	6	0.5	2,3	South
2. Living	4	6	5	6	0.5	1,3	None
3. Hall	3	6	3	6	0.5	1,2,4,5,6,7	None
4. Ms Bedroom	5	6	5	6	0.5	3,6	None
5. Bedroom	4	5	4	5	0.5	3	None
6. Bath	2	3	2	3	0.5	3,4	None
7. Dining	5	6	5	6	0.5	3,8	None
8. Kitchen	4	6	4	6	0.5	7	None

(a)

(b)

Figure 6 The comparison shows the similar result between the MIP and the architect where (a) is solved by MIP and (b) is designed by the architect

5 CONCLUSION

From our experiment, the MIP and nonlinear programming solver perform comparatively well with respect to the same architectural designs. For a larger problem size, the fixed position constraints, unused grid cells and the fixed boundary help reduce the computation time considerably. This shows the feasibility of using the MIP model under the constrained space. Moreover, we can select the multiple global solutions by changing the room positioning to the top left corner in the objective function. Our software can be used to generate the optimal architectural layout design alternatives according to architect's preferences. For larger architectural layout design problem, the commercial and parallel MIP solvers are required. Our current use of the MIP solver without the domain expert causes the software to perform very slowly for 10 – 20 room configurations. The machine learning methodology should be adopted to speed up the computational time while the Pareto scheme and Flemming wall's representation should be considered to reduce the possibly search space.

REFERENCES

Flemming, U. 1978. Representation and generation of rectangular dissections. *Annual ACM IEEE Design Automation Conference* 15: 138-144.

Imam, M.H., and M. Mir. 1989. Nonlinear programming approach to automated topology optimization. *Computer-aided Design* 21(2):107-115.

Jo, J.H., and J.S. Gero. 1998. Space layout planning using an evolutionary approach. *Artificial Intelligence in Engineering* 12(3): 149-162.

Li, S.P., J.H. Frazer, and M.X. Tang. 2000. A constraint based generative system for floor layouts. In *CAADRIA 2000* [conference proceedings], eds. Ben-Kiang Tan, Milton Tan and Yunn-Chii Wong: 441-450. Singapore: CASA.

Linderoth, J., and M.W.P. Savelsbergh. 1999. A computational study of search strategies for mixed integer programming. *INFORMS J. on Computing* 11: 173-187.

Medjodoub, B., and B. Yannon. 2000. Separating Topology and Geometry in space planning. *Computer-Aided Design* 32: 39-61.

Michalek, J., and P.Y. Papalambros. 2002. Interactive layout design optimization. *Engineering Optimization* 34(5): 461-184.

Scott, A.A., and D.H. House. 1999. Making Design Come Alive: Using Physically Based Modelling Techniques in Space Layout Planning. In *Computers in Building: Proceedings of the CAADfutures '99 Conference*, eds. G. Augenbroe, and Ch. Eastman: 245-262. Dordrecht: Kluwer.

Design Methods, Process and Creativity

Examining Learning in Multiple Settings
Using a Linkograph to Examine Design Learning

KVAN Thomas and GAO Song
Department of Architecture, The University of Hong Kong, Pokfulam, Hong Kong

Keywords: learning, design process, linkograph

Abstract: We use linkographs as a means to examine single and double loop learning within three designed settings. Two types of learning are dynamic processes related to design process. The linkograph is a technique to examine the inter-connective pattern of design moves. Extending our previous analysis of design communications, we investigate the extent to which Schön's design process consisting of "framing-moving-reflecting" can be identified in communications. The linkographs identify learning loops, the results support prior findings that distal text based communication, although less extensive, is richer in design exchanges; here richer learning is also identified.

1 INTRODUCTION

Face-to-face communication is assumed to be the preferred context for collaborative design. With the introduction of computer and Internet technologies, online remote settings are becoming more broadly adopted. Distal designers cooperate by means of asynchronous, semi asynchronous, or synchronous design and communication tools. Earlier studies on the effects of these new tools on design and learning performance have generally focused on individual learning but we note that collaborative teams must engage group learning as well. Organizational learning has been identified as the process of improving group performance through better knowledge and understanding (Fiol and Lyles 1985). In this paper, we argue that the methodology for understanding learning can be employed as an indicator to examine the impact of different design tools on the process of design teams operation and learning. In this experiment, we asked postgraduate students to use different communicational media in designing and examined the communication protocols recorded during their design activity. These protocols were analysed statistically and the results reported in Kvan and Gao (2004). Here we analyse the same protocols by means of linkographs to identify connectivity in design ideas. We identify measures for the richness of the linkographs and analyze two organizational learning loops (single and double) in the design process.

The impact of collaborative technologies on design practical and educational process improvement have been studied in recent years. Experimental studies show

B. Martens and A. Brown (eds.), Computer Aided Architectural Design Futures 2005, 187-196.

that textual supported distal design environment not only can engage designers in designing, but also improve design performance. Gabriel and Maher (2000) found that designers successfully engaged in design issues using chat-line communication. In an earlier study (Kvan and Gao 2004), the authors noted that the use of text may facilitate reflective thinking during design. We found that the chat-line facilitated students in engaging in more framing activities. The studies conducted in design studio demonstrate semi-asynchronous and asynchronous design tools contribute to better design results and performance. Compared to traditional design studio settings students can produce more design ideas when using Web-board the semi-asynchronous design tool (Kvan, Wong, and Vera 2003). Lahti, Seitamaa-Hakkarainen, and Hakkarainen (2004) identified that an Internet environment could help design team to engage more intensive collaboration and produce better design products in the end. These papers have not, however, examined the nature of the design process in different conditions to understand whether the complexity or richness of the design conversations is influenced by the medium of communication.

2 LEARNING AND THE DESIGN PROCESS

We teach design in the studio context to enable students to learn the tacit knowledge essential to professional work. In the studio, students normally discuss their design ideas with their colleagues and tutors (Cuff 1991). In this research we start with the assumption that practice is a collaborative activity; hence it is important to support team learning in addition to individual learning.

2.1.1 Learning Loops

The purpose of learning is knowledge acquisition and application. There are many ways of learning. Vygotskii (1978) analyses three methods of learning that deal with the interaction between learning and development. In the three methods, the concepts of learning and development are different. The first is that learning is simply to use the product of development. In this approach, "learning is a purely external process that is not actively involved in the development". Development is the degree of mental maturation allowing people to conduct this learning process. The second method is that learning and development occur immediately, or simply saying that learning is development. The process of learning completely interweaves with the process of development. "Learning and development coincide at all points in the same way that two identical geometrical figures coincide when superimposed." The third is that the learning process stimulates and pushes forward the maturation of development. The two processes are inherently different but related. Development is the process of mental maturation; while learning is also a developmental process.

Vygotskii notes that it is this latter aspect that higher education engages. Due to individuality in learning, not every student can master all aspects of learning. Biggs (1999) identifies two levels of learning, academic learning (high-level engagement)

and non-academic learning (low-level engagement). When students engage in the high-level form, they can relate and apply their knowledge, reflecting and theorizing their learning. When students engage in the low-level form, they engage in activities of memorizing, notes taking and recognizing. Biggs indicates that students with high-level engagement need less help from teachers than those students with low-level engagement.

Vygotskii (1978) developed a model called the "zone of proximal development" that addresses differences in learning:

> It is the distance between the actual development level as determined by independent problem solving and the level of potential development as determined through problem solving under adult guidance or in collaborative with more capable peers.

Developing this concept, Doolittle (1997) classifies two stages of learning, early learning and late learning. Early learning relies on assistance and only can use the product of development, while late learning need no assistance and can apply and theorize what has been learnt, thus pushing forward development. The transition from early learning to late learning involves cognitive development through the constructive interaction between teachers and students. Both stages of learning are correlating with Biggs' two levels of engagement.

In the field of organizational learning the learning style is divided into two levels or two cycles (Argyris and Schön 1996; Fiol and Lyles 1985). Low-level learning is identified by Argyris and Schön as single loop learning and high-level learning as double loop learning. The difference between single and double loop learning is located at the degree of inquiry. When people engage in single loop learning, they limit their inquiry between "problem setting" and "problem solving". The strategy they adopt leaves the value of a theory of action unchanged. In this type of activity, professionals engage in routine, repetitive work. By contrast, double loop learning is considered a high level activity that encompasses change the value of theory-in-use.

> "In this type of organizational double-loop learning ... they do so through organizational inquiry that creates new understandings of the conflicting requirements – their sources, conditions, and consequences – and set new priorities and weightings of norms, or reframes the norms themselves, together with their associated strategies and assumptions."

> (Argyris and Schön 1996, 25)

Single loop learning includes action strategy and its consequences, whereas except both elements double loop learning has governing variables, which give direction to other two actions. Figure 1 describes the process of these two learning loops.

Figure 1 The structure of two learning loops

2.1.2 Design Learning and Design Process

The design process has been identified as a learning process (Cross 1980; Schön 1985). Through engaging in designing, designers learn about a design problem and know more about it at the end than in the beginning (Cross 1980). This characteristics of designing is called as "reflective conversation with the situation" consisting of framing, moving and reflecting (Schön 1985). It is through learning-by -doing that students understand and comprehend design problems and abstract theories from the design process. Schön's contribution to design learning and its application in examining design protocols using the three actions has been discussed elsewhere (Kvan and Gao 2004). An important contribution in Schön's work is to identify that we not only need to teach students how to solve design problems but also, more importantly, how to identify problems. The concept of the inquiry of both learning loops therefore is very similar to the idea of framing in that they provide the guidance of designing or learning for further actions. From this, we suggest that a design process that moves from framing through reflection, then on to other activities and then returns to engage in further framing and reflection may correlate to a learning loop. Thus, although we do not claim that learning loops are directly reflected in the encoding, the revisiting of an idea may indicate engagement in learning. Connecting the conclusion made from last paragraph, we adopt the concepts of two learning loops as indicators to examine design learning under different design environments.

3 CODING SCHEMA

Learning loops are tacit and not easily identified; statistical analysis of protocols cannot identify such learning. To identify developmental steps in designing, therefore, we have used the graphing technique of linkographs to track the development of design ideas. Developed by Goldschmidt (1990), the linkograph is a tool to encode design activities by identifying interlinked design moves by way of a systematic triangular web. We then analyze the resulting graph using graph theory to distinguish the graphs. Table 1 illustrates the definition of terms adopted in this paper. These terms are used to measure this triangular web. Some of them are same with the terms used by Goldschmidt; others derive from the domain of graph theory.

Table 1 The definition of terms

Name	Abbr.	Description
Links	L	The number of linked design moves in a component; the larger the diameter of a single component, the more extensive a design thought.
Index	I	A process or a portion of it is the ratio between the number of links and the number of moves that form them (Goldschmidt 1990).
Component	C	One unit in which all design moves are inter-linked; the larger the number of components, the more fragmented the design session.
Diameter	Di	The number of linked design moves in the largest component in one setting; the larger the diameter of a single component, the more extensive a design idea.
Depth	De	The largest number of nodes linking two discrete design actions in a component and hence describes complexity of relationships between design actions.

Table 2 explains the definition of the elements used in a component and their legends. We considered the metric of the index inadequate to compare the complexity and richness of design activity manifest in our protocols. This study therefore introduces the following metrics to describe the results as displayed in a linkograph. Figure 2 illustrates an example of one component. In this component, the number of links is thirteen the number of moves is fifteen, thus the index would be 0.87; the diameter is fourteen and the maximum depth is two.

Table 2 Elements and their legends in a component

Name	Abbr.	Description	Legend
Framing	F	Identify a new design problem; Interpret further from design brief.	●
Moving	M	Proposed explanation of problem solving, a tentative solution.	⊙
Reflecting	R	Evaluate or judge the explanation in Moving.	◎
Node	N	A symbol links two design moves	●

A previous study coded the protocols using Schön's model of framing, moving and reflecting and identified that the number of problem framing activities by using chat-line to communicate is less than the number of communication in face-to-face modes but that remote communication is proportionately richer in framing activities (Kvan and Gao 2004). Statistical analysis shows there is significant difference of design activities when remote setting compared to both co-located settings. Designers seem to transform and reconstruct frames more efficiently in online

remote setting. To examine the implication further, we have represented the encoding using linkograph to examine the connectedness of frames, moves and reflection throughout the design sessions.

Figure 2 An example of a component

3.1 Goldschmidt's Linkograph and Schön's "Framing-moving-reflecting" Model

Goldschmidt developed the linkograph to represent design chunks and test design productivity. Design chunks represent the organization of reasoning and group together moves which are interconnected in the act of design exploration. The design moves in her study are the reasoning actions, which can be compared to Schön's three design activities. Using the protocols in which we have previously encoded designs actions using the F-M-R model, the linkograph reveals the interconnected actions and thus the depth of an idea. In addition to representing connectedness by the graphs, we identify double and single loop learning by way of combining an encoding of the design protocol using Schön's design process and representing the encoding by means of the linkograph. By this technique, the pattern of a design process can be visualized holistically.

3.2 Validation

A significant way of validating the effectiveness of a network on collaborative learning is to ask what effect it has upon the design process (Eason and Olphert 1996). They emphasize usage scenario as an important indicator to analyze the impact of proposed system. One strategy of this scenario is to videotape the iteration process between the interaction of user and proposed system thus the impact on organizational task can be concretely analyzed. The protocol analysis adopted in our experiments belongs to this method. Other ways to evaluate the validity is to discriminate the outcomes and the degree of users' satisfaction (Andriessen 1996). By integrating the above means with the characteristics of our experiments, we selected two methods. One is to measure the satisfaction of users by way of a questionnaire and the other is to measure the validation of coding scheme we adopted from Schön (1985) and Goldschmidt (1990). Schön's coding scheme has been tested in a pilot study and modified to improve its reliability (Kvan and Gao 2004). Previous study demonstrates that using chat-line based communication tools has raised the proportion of problem framing. Thus according to Eason and

Olphert's usage scenario, this data prove the validation of chat-line remote setting in design session. Goldschmidt's technique has been used twice to examine the inter-relation between design activities and finally made a consensus. The results of the questionnaire present most of students agree that they could easily draw and express design ideas through drawing and communication by using different tools.

4 RESULTS AND DISCUSSION

Using Goldschmidt's (1990) index, the description of largest component in each protocol in setting was measured and the mean of these numbers calculated. From this measure, we see that the largest mean index number is obtained for the digital co-located setting. The measure of the index, however, does not inform us of the breadth of the complexity in the design activity. To identify this, we have employed the three standard graph descriptors introduced in the section above, component, diameter and depth.

Table 3 compares the mean value of total number of components and diameters across the three settings; and their ratio. For each metric we have shown the mean of each across the six protocols recorded in each setting. The first column shows the mean value of the number of component in each setting. The mean of component in remote setting is much less (5.8) compared to paper (26.8) and digital based co-located settings (13.5). The next row presents the mean value of the number of link. By comparing the mean value of link among the three settings paper co-located setting contains largest number (238); remote setting has 81; and digital co-located setting has 188.We assume that if fewer components occur while richer links found, then leading to design complexity. In other words, the ratio of link and component (ML/MC) is an indication of the design productivity. The ratio in digital co-located setting is the highest (14.90), next is remote setting (13.96) and the last is paper co-located setting (8.88).

Table 3 Component and diameter among the three settings

	Component		Link		Ratio (ML/MC)
	Mean (MC)	SD	Mean (ML)	SD	
Remote setting	5.8	2.79	81	21.40	13.96
Paper co-located setting	26.8	10.76	238	49.86	8.88
Digital co-located setting	13.5	5.5	188.8	74.01	14.90

Table 4 describes the index metric of the largest components among the three settings and three largest components in each setting. In each design session we choose the largest component, thus totally six components in each setting. The first three columns compare the mean value of total link; mean value of the numbers of

moves; and index. Results indicate the mean value of total link and the mean value of numbers of moves in paper-based co-located setting is the highest (85.7; 121); next is the remote setting (59.7; 61); and in digital based co-located setting the mean value of total link and moves are 87 and 93.3. When comparing the value of index it shows digital co-located setting holds the largest number (1.12); remote setting is the next, which is 1.07; and paper-based co-located setting is 0.71.

By isolating the largest component in the three settings for investigating we find that digital co-located setting contains the largest number of diameter (164); the greatest depth is 5. The remote setting holds the largest number of greatest depth (9) though the diameter of it is less than that of digital face-to-face environment that is 83. The largest component in paper-based setting has 132 diameter and 7 of the greatest depth.

Table 4 Index metric of the largest components among three settings

	Total link		The number of moves		Index		The largest one in each setting	
	Mean	SD	Mean	SD	Mean	SD	The Diameter (Depth) [1]	Greatest Depth (Diameter) [2]
Remote setting	59.7	16.81	61	17.25	1.07	0.32	83 (9)	9 (83)
Paper-based co-located setting	85.7	36.45	121	25.20	0.72	0.32	132 (4)	7 (83)
Digital based co-located setting	87	49.78	93.3	54.73	1.12	0.05	164 (4)	5 (147)

1. The depth in parentheses indicate the depth of the component with largest diameter.
2. The diameters in parentheses indicate the diameter of the component with greatest depth.

As described above, a component is a unit of inter-connected design moves, which represents the process of the development of design ideas. We observe that remote setting has far fewer components, that is, far fewer discrete design threads are developed which then are abandoned and not continued; designers appear to engage in more limited exploration of a problem. In addition, the remote setting exhibits the greatest depth among components. From this, we observe that purposeful design activity is more often engaged in the remote setting. This suggests that initial ideas developed and recorded in the remote setting, where a chat line is employed, are more persistent while in the paper-based setting the idea is developed sequentially. Although digital co-located setting has the largest number of diameter and the highest value of ratio, the depth is only five even less than paper-based co-located setting. This implies that the design ideas raised in digital co-located setting are not re-visited or re-modified as often as those raised in other two settings.

5 CONCLUSION

This paper has introduced the use of linkographs to measure protocols in an effort to characterise the richness and complexity of design activity and represent double and single loop learning. We have applied three new measures, components, diameter and depth, as metrics of richness and adopted the idea of Goldschmidt's index. We have demonstrated that these measures correlate with findings derived in earlier papers using statistical measures. The conclusion is that the discussions of design activity in chat lines can be measured to be richer in design complexity than those taking place face to face. Goldschmidt (1990) notes that "design productivity is related to the generation of a high proportion of design moves rich with links". In her paper, Goldschmidt developed an index as a measure of the percentage of linked moves. She proposed that the higher linkage value is an indicator of greater interconnectedness in design moves. In this figure, we observe that the pattern of design activities in the remote setting are richly interlinked as suggested by the considerable interconnections in the design activities; framing activity in this setting appears to have an impact on later moves. In co-located setting, however, many design moves are isolated and disconnected. Thus, the remote setting seems to support better design productivity than co-located settings.

Argyris and Schön (1996) propose two factors to define single and double loop learning. One factor is the level of aggregation of single loop learning. It is assumed that "single loop learning at one level of aggregation stimulates double-loop learning at all levels." The other factor is to investigate the relationship between learning products and learning processes. They argue that except the product of organizational learning, the values and norms governing process need to be concerned in that those indicators are essential for "improving its (organizational learning) performance and restructuring the values that define improvement." Double loop learning is therefore represented in the form of consistently re-evaluating design values or ideas during design process. In the remote setting the number of components is smallest and depth is the highest implying that double-loop learning is more evident compared to both co-located settings. Remote setting in this experiment is synchronous distributed design environment by adopting the chat-line communication. Chat-line allows designers to record their design process in text format might contribute to design idea maintenance and re-evaluation thus fostering double-loop learning to occur.

REFERENCES

Andriessen, J.H.E. 1996. The why, how and what to evaluate of interaction technology: A review and proposed integration. In *Cscw Requirements and Evaluation*, eds. Peter J. Thomas: 106-124. Berlin: Springer.

Argyris, Chris, and Donald A. Schön. 1996. *Organizational learning ii: Theory, Method and Practice*. Reading, Mass.: Addison-Wesley.

Biggs, John B. 1999. *Teaching for quality learning at university: What the student does*. Buckingham: Society for Research into Higher Education: Open University Press.

Cross, Nigel. 1980. Design methods and learning methods. In *Proceedings of the 1980 Design Research Society Conference*, eds. James A Powell: 281-296. Guilford: Westbury House.

Cuff, Dana. 1991. *Architecture: The story of practice*. Cambridge, Mass.: MIT Press.

Doolittle, Peter E. 1997. Vygotsky's zone of proximal development as a theoretical foundation for cooperative learning. *Journal on Excellence in College Teaching* 8(1): 83-103.

Eason, K., and W. Olphert. 1996. Early evaluation of the organisational implications of cscw systems. In *Cscw Requirements and Evaluation*, eds. Peter J. Thomas: 75-89. Berlin: Springer.

Fiol, C.M., and M.A. Lyles. 1985. Organizational learning. *Academy of Management Review* 10(4): 803-813.

Gabriel, G., and M.L. Maher. 2000. Analysis of design communication with and without computer mediation. In *Collaborative Design: Proceedings of Co-designing 2000*, eds. S.A.R. Scrivener, L.J. Ball and A. Woodcock: 329-337. London: Springer.

Goldschmidt, Gabriela. 1990. Linkography: Assessing design productivity. In *Cybernetics and Systems '90*, eds. R. Trappl: 291-298. Singapore: World Scientific.

Kvan, Thomas, and Song Gao. 2004. Problem framing in multiple settings. *International Journal of Architectural Computing* 2(4): 443-460.

Kvan, Thomas, John T. H. Wong, and Alonso Vera. 2003. The contribution of structural activities to successful design. *International Journal of Computer Applications in Technology* 16(2/3): 122-126.

Lahti, Henna, Pirita Seitamaa-Hakkarainen, and Kai Hakkarainen. 2004. Collaboration patterns in computer supported collaborative designing. *Design Studies* 25(4): 351-371.

Schön, Donald A. 1985. *The design studio: An Exploration of Its Traditions and Potentials*, London: RIBA Publications.

Vygotskii, L. S. 1978. *Mind in society: The Development of Higher Psychological Process, ed. Michael Cole*, Cambridge, Mass.: Harvard University Press.

Using Historical Know-how to Model Design References
A Digital Method for Enhancing Architectural Design Teaching

IORDANOVA Ivanka and TIDAFI Temy
CAD Research Group (GRCAO), School of Architecture, Faculty of Environmental Design, University of Montreal, Canada

Keywords: architectural education, reference modeling, digital design studio

Abstract: The main purpose of this paper is to demonstrate that new computer and communication technology has the potential to change architectural education in a positive way, based on previous experiences and learning from the past. This research is based on two historical aspects that we bring together in order to propose a new didactic method and material for architectural education: the first one consists in finding obsolete architectural training practices and reconsidering them from a modern point of view; the second one proposes using precedents in a new constructive way in situation of teaching architectural conception in studio. This historical approach, combined with architectural design studio observations, has lead to an outline of a prototype of a digital assistant for teaching architectural design. Some aspects of its functioning are here discussed.

1 INTRODUCTION

New tools are proven by history to be able to bring radical novelty to architecture and its communication. This paper supports the idea that new computer and communication technology has the potential to change architectural education in a positive way, even when they are inspired by previous experiences and learning from the past. This research brings together two historical aspects with the purpose of proposing a new didactic method and material for architectural education: the first one, finding out discontinued good practices of architectural training from the past and reconsidering them from a modern point of view; and the second one, using precedents in a new constructive way in situation of teaching architectural conception in the studio. This paper is structured in the following parts: a historical background reviews the methodological foundations of this research and reveals the role of precedents in architectural education and design, so as to highlight problems often encountered in the pedagogy of architecture. Computer approaches addressing this issue are then given. Afterwards, we propose a new method of precedents description that can be used by students in architectural studio. At the end, we discuss some preliminary results and draw directions for future research.

B. Martens and A. Brown (eds.), Computer Aided Architectural Design Futures 2005, 197-206.
© *2005 Springer. Printed in the Netherlands.*

2 BACKGROUND

New computer approaches are usually seen as being the result of pure invention, as is a newly designed building, for example. However, most of the *new* creations are based on past experience, personal or not. That is why we started by looking at the *origins*.

2.1 Historical Study

The goal of this section is to extract historically relevant data that can shed some light on the way ancient architectural methods may be of use for modern design education. In other words, what can we gain from the way architects were educated before the first school of architecture (in the modern sense), the *Académie Royale d'Architecture,* was founded in 1671? Back in Antiquity, architectural orders were created, synthesizing building know-how and aesthetics. In the Middle Ages, building cathedrals was learned directly by working on the construction site, what Schön (1988) would define as 'learning by doing'. Architectural conception and construction were indeed not dissociated until the invention of perspective and the plan-section-elevation representation of buildings during the Italian Renaissance. Thus, architectural and building know-how was passed down directly form masters to "apprentice-architects". Emphasis was put on architectural process rather than only on its final result (Tidafi 1996). Discontinuing this medieval tradition of secret transfer of architectural knowledge, the first architectural schools revived the classical orders, although they had become obsolete in terms of scientific and technical development. This way, the teaching methods focused on the final appearance of the projected building, more-or-less forgetting along the way the process of its making. Thus, *in the modern way of teaching architecture, transfer of know-how has been replaced by learning how to represent a final result of the project; and learning on the site has been substituted by a representation of the final result, that is completely detached from the construction process.* We use these conclusions in the method of modeling of precedents later in this research.

2.2 On the Role of References

Art and architectural precedents are omnipresent in today's architectural education. While in specialized courses they are well analyzed and interpreted by students, this is rarely the case with their use in architectural studio projects. So, we asked the question: "Are precedents important for learning architectural design?"

2.2.1 According to Literature

Bibliographical research on the role of precedents has shown their important role in learning architectural conception. Although this study is not object of the present paper, here are some of the insights we got from it: a person best perceives and understands new things based on analogies with past experiences (Léglise 2000);

references and cases offer holistic knowledge and provide a shortcut to a solution of a complex problem (Kalay 2004); the 'Design World' of architects consists of references and "things to think with", that embody implicitly architectural know-how (Schön 1988); and learning is especially effective when using know-how in a constructionist way (to create something new with it) (Piaget 1970; Schön 1988). The new method of precedents description that we propose is conceived to bring these characteristics to students in architectural design studio.

2.2.2 Based on Experiences in the Architectural Design Studio

Based on some practices in architectural studio and having in mind the visual over-consumption to which students are exposed, we wanted to find out what use do students make of precedents. In other words, beside getting inspiration from precedents, do they actually learn from them, and if yes what and how? Observations held with third year architectural students were quite informative in this regard. From the architectural studio experience, it was possible to come to the conclusion that there are at least two problems arising when students refer to precedents during their exercise-projects. The first one is that, if the reference is represented only by visual material, quite often it is not "understood". In other words, the essential characteristics of a precedent often remain hidden behind the image. For example, in our studio experience the specific form of the Building of the Greater London Authority (Architect Foster & Ass.) was not "understood" (at a 100%) as a product of ecological concerns and architectural know-how (fig. 1). This problem is, in some cases (65% of the students), resolved by the presence of keywords or textual information accompanying the visual support.

Figure 1 The GLA Building

The second problem is that sometimes students can "comprehend" the "essence" of the reference, but are not able to transfer the know-how into their own projects afterwards. A qualitative case study experience in the same third year design studio gave us key evidence on this issue. As shown on Figure 2, the student whose work is shown on the 2-c section of the Figure, has correctly identified the "essence" of the reference seen in Figure 2-a. But the fact that he could "name" it did not mean that he could immediately use it in a new design situation (that implies a new structural function of the form as well). Moreover, it took him much effort even to represent in 3D the hyperbolic paraboloid itself, because the usual CAD tools do not offer this element. In this particular case, a *description of the process generating the form*, or of the essential *chunk(s)* of knowledge used in it, could be of much help.

Figure 2 A structure based on a parabolic hyperboloid: (a) reference, (b) "comprehension", and (c) an effort to use it in a new design situation

We performed another design studio observation with the intent to determine what is the difference (if any) in the comprehension (guessing) of a concept, when represented (1) explicitly, by a geometric drawing, or (2) implicitly, by an expressionist image. Third year architectural students were asked to conceive a 3D model giving a spatial expression of such a concept. The experiment showed that the comprehension is sometimes surprisingly good, even from very "impressionist" visual material. Half of the students working from the "implicit" references could literally name the concept (which was in this case "dynamic equilibrium"). The fact that a geometrical drawing was shown to the group working from "explicit" references, did not considerably enhance their "comprehension" of the concept. However, it increased the precision of the models they designed, but on the other hand, decreased their artistic qualities. Another revelation was that even students who have "guessed" the concept could not "learn" from the references, even when mathematical formulae and geometric drawings were given. They were using previous knowledge for their designs, and this was not enough (in 80%) to give consistent results. *This leads us to the conclusion that knowledge should be implicit, hidden in expressive visual references, but extractable and re-usable.*

The design studio observations, together with the theoretical background from research on use of precedents in design pedagogy (1) shows that precedents are not used with their full potential in design studio projects, and (2) makes us believe that *reusable chunks* of design-process knowledge *extractable from visually represented precedents* could play an important role in teaching architectural design.

3 COMPUTER APPROACHES TO REFERENCES

Recent studies on new computer methods for design education look ways of integrating precedents in the architectural studio in an intelligent and intuitive way.

3.1 Reference Data Bases

Research on reference-based computer-aided design or education (Oxman 2004, Léglise 2000, Heylighen, and Neuckermans 2003, Do and Gross 1996) propose

computer assistance based mainly on visual information on precedents (mainly pictures), combined with manipulation and association of concepts. The use of diagrams instead of keywords (as in *The Electronic Cocktail Napkin* developed by Do and Gross) facilitates the designer and leaves him the opportunity to work with modalities that he is used to: graphical expression and not words. Main concerns of these systems are sophisticated search systems, sharing of the information, and concepts association based on analogy or depending on the design context or situation. The advances in this direction are outstanding. However, comparing with the conclusions from the historical study briefly presented here, one can find an important didactic characteristic *lacking* in these assistants: *the communication of architectural know-how* (hidden behind the pictures and only named by keywords or concepts) *in a way, allowing for its constructive reuse in new designs*. In this way, the proposed research contributes mainly to the *content* of the reference-based assistant, adding a description of essential generating *process(es)* to the already present visual and textual data.

3.2 Case-based Reasoning (CBR) - Case-based Design

If we look at precedent knowledge from a different angle, we can see that there are already quite a few developments considering modeling of precedents for their future re-use in new design situations. This approach is known as Case-based design and is based on the belief that most of the design solutions are developed on the basis of similar, already existent references (Kalay 2004).

Systems based on precedent thinking require very large number of "cases" that are indexed in order to be retrieved during design. Once "found", these cases are modified and adapted to the new design task. This process is often left to the architect, but several computer systems try to assist him/her in this process. Adaptation is possible if the case structure is modifiable. The success of this kind of methods depends on the adaptation of the precedent to the new situation, as well as on the fact if this adaptation will not modify (destruct) the essential characteristics *"that made the case worth emulating in the first place"* (Kalay 2004). This is a problem that our approach tries to resolve by encapsulating only these "essential characteristics" of a given reference in its digital model.

A possible way for solving this problem is the Issue-Concept-Form (ICF) formalism proposed by Rivka Oxman. The *chunking* memory organization is at the basis of her approach for reference representation (Oxman 2004). The information is subdivided into independent semantic fragments. Each « *chunk* » represents only one aspect of the whole case. Thus, a reference is represented by a multitude of *chunks*. Yet, these *chunks* are not "living models" and hence, not reusable in new design situations, a characteristic that we found useful in a learning environment, but missing from reference data bases.

3.3 Prototypes

Some research applications combine CBR with an automatic adaptation of prototypes (Gero 1990). Systems of a similar kind try to generate parametric and even topologic variations of the extracted cases, by combining them with the derived attributes of other similar cases, like in the CADSYN system (Maher, Gomez, and Garza 1996).

The affinity between the case-based reasoning and the design process is proven nowadays, but its potential is far from being realized. It is possible to notice that CBR and prototypes either lead to a rigid model, or the core knowledge is lost during adaptation to the new design situation. Oxman proposes two possible solutions, that we entirely share. The first one is seeing CBR as *only one* of the parts of the "complex hybrid reasoning processes in design". The second possible direction takes into consideration the visual reasoning as a fundamental attribute of design, and suggests that "combining these two research areas may provide significant results for the field" (Oxman 2000).

4 METHODOLOGY

From the study on the history of architectural education, we have concluded that in the modern way of teaching architecture, transfer of know-how was replaced by learning how to represent a final result of the project, and learning on the site was substituted by a representation of the final result, that was completely detached from the construction process. Moreover, design studio experiments proved our hypothesis that precedents hide a non-used potential for design education. On the other hand, computer applications commonly used in practice and in architectural digital studios do not offer possibilities for learning from past experience, nor for reuse of precedent know-how. *Focusing on the final result representation, they do not take into account the process of the object's construction or generation.*

Our general hypothesis is that a reference-based assistant, offering re-usable design knowledge and architectural know-how, could bring positive changes in digital design studio education. This assistant should be flexible and open for new references and modification of the already present ones; it should also provide non-invasive support to design learning and should leave entire creative liberty to the student architect. A specific hypothesis whose validation is an object of this study, is that such an assistant can be conceived and implemented on a computer.

4.1 Modeling the Generating Actions

The didactic method proposed in this work is based on digital three dimensional modeling of valuable (from a didactic point of view) architectural know-how of precedents. The actions modeling approach developed by Tidafi (1996) and inspired by the apprenticeship practice before the Renaissance, allows processes that generate

an object or space to be represented. It enables a systemic approach to modeling both precedents and their organization in the assistant device. This method was successfully implemented by De Paoli and Bogdan (1999) for description of semantic operators that can be geometrically formulated.

4.2 Models of References

The core components of the design assistant are the references. They are either architectural precedents, metaphors, or any other analogue objects that can serve as inspiration and as a source of design knowledge. Together with their three dimensional nature and shape, they offer the know-how used for their creation.

We propose a method for modeling the most meaningful characteristics of the processes that have as result the "objects", that will be manipulated and transformed in the digital "Design World" of the student. The method is inspired by the object-types theory of Schön (1988) explaining the role of references during different phases of design. As problems associated with object libraries are due to the enormous number of precedent cases referred to by architects, we have adopted a non-causal approach based on complex-systems modeling. It enables transformations in space and time, which is the main characteristic of a dynamically organized model.

The models do not simply represent petrified precedent cases, but emphasize their generation processes, expressed by modifiable actions. In this way the final results can be of a great variety and the complexity of the architectural object-types is kept in their models. We join visual representation with a description of the most important characteristics: structural organization, production process, functional organization, spatial composition, etc. These can be either described or modeled by the original author, or interpreted by the precedent's user. Basic components of our model are actions that generate the object-types: formal, functional, structural or normative. These actions are translated into computer language as functions. They can be applied to various kinds of objects, according to the metaphors evoked by the designer. Creativity may result from variations in the variables of the generating function or from a different organization of object-types. The functional method of describing actions allows for object-type determination by explicit characteristics and by derived ones as well. In this way, emergent object-types could be captured.

This approach to object-type modeling is consistent with the paradigm of "situated design". The *chunks* of knowledge (representing object-types' meaningful features) can be combined and structured differently, according to the external conditions (design task or environment); or depending on the designer's experience or inspiration. These higher-order organizations and action definitions (object-types of more complex nature) are stored in memory as well, for future references and use. At least three types of information are recorded: (1) the semantics of the designer's intention, (2) the *chunks* of knowledge entering into a higher-order object-type, together with their organization, and (3) visual representations of these object-types. Functional programming together with a real time 3D visualization is used for the computer implementation of the method.

4.3　　Structure of the Design Pedagogy Assistant

The *digital design-pedagogy assistant* enriches one of the dimensions of the "Design World" of the future architect. It is compatible with the creative work environment and contributes to teaching the design process. The structure of an assistant of this kind should be easy to use and give enough freedom to the teacher and to the student. So it is conceived not as a system taking care of all the process of design, but, on the contrary, as scattered fragments of references in a larger design-learning environment.

Essential is the fact that the design knowledge (the computer program's functional structure) that has generated a given architectural precedent case or "object to think with", is linked to its visual representation. Thus, the visual stimulus of a precedent can be joined with functional characteristics, production procedures and/or semantic meaning of the object. The functional nature of the programming language used for the computer prototype, enables modeling of complex structures, thus simulating real architectural and learning processes. A schematic structure of the assistant is given in Figure 3.

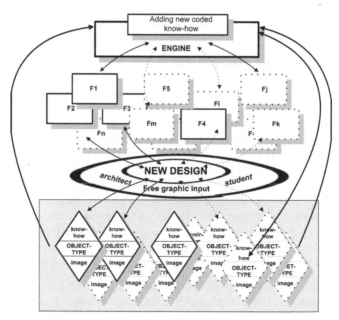

Figure 3 Schematic structure of the proposed Design-Pedagogy Assistant

There are three main parts: (1) The central part is entirely managed by the user and is occupied by the new-design conceived by a student-architect. He/she is free to use or not the references stored in the "surrounding" system. Upon request, a *chunk* of knowledge from one of the precedents can be evoked. It can either modify elements of the design solution already being conceived, or simply visualize a situation-dependent 3-dimensional instance of the coded know-how. (2) The upper part of the

diagram shows the computer functions which encode the architectural know-how and are able to visualize it. New functions can be added to this part of the assistant. Multiple functions of this type can refer to one or many references. Students themselves can be involved in the process of enriching the knowledge "pool" by coding *chunks* of functions. According to Yakeley (2000), programming gives a constructivist approach to learning and improves design method of students architects. (3) The lower part of the figure shows a data base of references (*object-types*). Each of them consists of: (a) visual information (images, drawings, sketches, 3D models, other media), (b) semantic and textual description, and (c) coded structure of the chunks of know-how used in the given reference, and reusable as a higher order model in new situations.

5 VALIDATION AND DISCUSSION

The approach to design education proposed in this paper needs a large platform including a reference data base, compatible with a CAD or modeling environment offering a powerful programming language. As the scripting possibilities offered by some of the commonly used software are ill suited for modeling the structure of the models and their organization in the assistant, experiments are made on a prototype of an assistant, not including all functions yet. The objective is to test the capacities and the flexibility of the modeling engine of the assistant, which is a prerequisite for its successful future use by students. The examples shown in Figure 4 represent: (a) an interactive exploration of the form and the visibility quality of a theatre. The colors above the seats show the level of "comfort" from the respective place; (b) a decorative pattern integrated as a floor mosaic in a Art Deco house. The specific actions of the builder, as found in the architect's instructions, generate the composition; (c) application of a sunlight/shadow and energy optimization *chunks* of knowledge on buildings with different forms of floors, and in different climatic conditions. These three examples are generated with SGDL-script technology, taking advantage of the Scheme programming language, and (d) a screen-shot of one of the folders containing the "visual" part of the design-pedagogy assistant.

Figure 4 (a) theatre form quality exploration; (b) mosaic pattern generation;
(c) taking sunlight into consideration; (d) visual" part of the assistant

We consider these results as a first and promising validation of the reference-based pedagogy assistant prototype. Its integration to a free modeling environment is

forthcoming and will be crucial for the acceptance of the assisting device in architectural design pedagogy practice. However, confident of the important role of precedents in architecture, and aware of their non-realized potential in design studio, we are able to foresee the possible advantages that students can take when referring to the assistant. Future architects will be able to get inspired by references and to learn from past experience, while developing their design approach constructively.

REFERENCES

De Paoli, Giovanni, and Marius Bogdan. 1999. The Front of the Stage of Vitruvius' Roman Theatre. Paper read at *CAAD Futures*, Atlanta, Georgia.

Do, Ellen, and Mark Gross. 1996. Reasoning about Cases with Diagrams. Paper read at *ASCE Third Congress on Computing in Civil Engineering*, Anaheim, California.

Gero, John. 1990. Design Prototypes: A Knowledge Represenations Schema for Design. *AI magazine* 11: 26-36.

Heylighen, Ann, and Herman Neuckermans. 2003. (Learning from Experience)? Promises, Problems and Side-effects of Case-Based Reasoning in Architectural Design. *International Journal of Architectural Computing* 1(1): 60-70.

Kalay, Yehuda. 2004. *Architecture's New Media*. Cambridge: The MIT Press.

Léglise, Michel. 2000. Conception assistée : modélisation et interprétation. In *Modélisation architecturale et outils informatiques entre cultures*, eds. G. De Paoli, and T. Tidafi: 51-66. Montreal: Acfas, Les cahiers scientifiques.

Maher, Mary Lou, Andres Gomez, and Silva Garza. 1996. Developing Case-Based Reasoning for Structural Design. *IEEE*.

Oxman, R. 2000. Visual Reasoning in Case-Based Design. Paper read at *AID'00 Workshop*, Worcester (Mass.).

Oxman, Rivka. 2004. Think-maps: teaching design thinking in design education. *Design studies* 25(1): 63-91.

Piaget, Jean. 1970. *Le structuralisme*. Ed. P. u. d. France, *Que sais-je?* Paris. Original edition, 1968.

Schön, Donald. 1988. Designing: Rules, types and worlds. *Design studies* 9(3): 181-190.

Tidafi, Temy. 1996. *Moyens pour la communication en architecture - Proposition de la modélisation d'actions pour la figuration architecturale*. Ph.D. Thesis, Université de Montréal, Montréal.

Yakeley, Megan. 2000. *Digitally Mediated Design: Using Computer Programming to Develop a Personal Design Process*. Doctoral Thesis, MIT, Boston.

Semantic Roomobjects for Conceptual Design Support
A Knowledge-based Approach

KRAFT Bodo[1] and SCHNEIDER Gerd[2]
[1] *Department of Computer Science III, Aachen University of Technology, Germany*
[2] *Nussbaum GmbH, Germany*

Keywords: conceptual design, semantic modelling, ontology

Abstract: The conceptual design at the beginning of the building construction process is essential for the success of a building project. Even if some CAD tools allow elaborating conceptual sketches, they rather focus on the shape of the building elements and not on their functionality. We introduce semantic roomobjects and roomlinks, by way of example to the CAD tool ArchiCAD. These extensions provide a basis for specifying the organisation and functionality of a building and free architects from being forced to directly produce detailed constructive sketches. Furthermore, we introduce consistency analyses of the conceptual sketch, based on an ontology containing conceptual relevant knowledge, specific to one class of buildings.

1 INTRODUCTION

The building construction process is subdivided into several phases. At the beginning, architects analyse the requirements of the new project and develop a first sketch of the future building. During this early phase, called conceptual design, the functionality and organization of the whole building are more important than exact dimensions and material definitions (Coyne et al. 1990). Usually, architects still use pencil drawings for the conceptual design. After finishing the conceptual design, the sketch has to be manually transferred into a CAD tool. Although the information specified in the conceptual design is essential for all following design phases, current CAD tools are restricted to store only the constructive design information. The semantics, implicitly stored in the pencil drawing, gets lost.

In our project, the research field is to elaborate a new conceptual design support for industrial CAD tools. To give architects more adequate tools for the early design phase, roomobjects and roomlinks with predefined semantics are introduced and implemented by way of example to the CAD software package ArchiCAD. These new construction elements represent the conceptual relevant entities for conceptual design. Furthermore, new functionality is developed, to support architects working with these entities. Integrated with ArchiCAD, the conceptual sketch is checked against conceptual relevant knowledge, dynamically defined by a knowledge

B. Martens and A. Brown (eds.), Computer Aided Architectural Design Futures 2005, 207-216.
© 2005 Springer. Printed in the Netherlands.

engineer using the ontology editor Protégé. The knowledge can be exported and used by the new developed ArchiCAD ConstraintChecker as the basis for the consistency analyses. Restriction violations are visualized inside the architect's sketch without forcing him to modify his sketch.

In this paper we describe how the conceptual design process is supported using semantic roomobjects and roomlinks. Illustrated by the example of the CarSatellite project (Nussbaum 2005), we demonstrate the gain of semantic-oriented design, abstraction mechanisms, and the explicit definition of functional relationships. We further introduce the knowledge specification process using Protégé and the consistency analyses inside ArchiCAD. We finally close with a conclusion.

In literature there are several approaches to support architects in design. Christopher Alexander describes a way to define architectural design patterns (Alexander 1995). Although design patterns are extensively used in computer sciences, in architectural design this approach has never been formalized, implemented and used. The SEED system (Flemming 1994) provides a support for the early phase in architectural building design. In contrast to our approach, the SEED system mainly focuses on the generation of sketches. The importance of knowledge processing for architectural design is comprehensively discussed in (Coyne et al. 1990). In (Schmitt 1993), different new paradigms for a conceptual design support are proposed. Among other things, he introduces the top-down decomposition and modularisation of sketches and the use of object-orientation for architectural design. Even if the work is neither implemented nor integrated into a CAD tool, the ideas are fundamental for our research. The semantic web approach (Berners-Lee, Hendler, and Lassila 2001) tries to improve the quality of information in the World Wide Web. This approach is based on RDF (Powers 2003), a language developed for modelling knowledge. Even if a lot of ontologies have been developed, none of them is applicable for the conceptual design phase. (Bazjanac 1999) demonstrates the benefits of interoperability between different CAD tools. Starting from a conceptual sketch, developed in Nemetschek's Alberti, the sketch is exchanged using the IFC format between CAD tools for constructive and detailed design. The CAD tool Alberti allows defining a bubble diagram as conceptual sketch which is then transferred into a CAD drawing. We follow a similar idea but additionally provide consistency analyses of the conceptual sketch.

2 MOTIVATION FOR SEMANTIC MODELLING

The design support provided by traditional CAD tools is restricted to the simple construction of buildings. The main drawing elements are walls, doors, windows, columns and slabs. Using these construction elements, architects can develop detailed and precise sketches. In Figure 1, a sketch of a CarSatellite garage and the corresponding photo-realistic rendering is depicted. The sketch has already been detailed elaborated; it shows the result of the *constructive design phase*.

The Nussbaum GmbH develops the CarSatellite concept for modular built-up garages. The customer can combine different functional entities to configure a garage

Figure 1 CarSatellite Sketch and Rendering

specific to his needs. He can e.g. specify the number of car diagnostic and car repair places; he can define the size of the storage area, the number of offices and the size of the customer area. The complete garage, composed of different functional entities is then prefabricated including all technical equipment and speedily put up on site.

The executive architect at Nussbaum GmbH uses ArchiCAD for developing the sketches of the CarSatellite projects. Even if ArchiCAD is an adequate tool for the constructive design, as one can see in Figure 1, ArchiCAD does not provide any support while developing the concept of the CarSatellite garages. The development of the conceptual design is a quite challenging task, as design aspects and multiple restrictions from different domains have to be regarded. The architect tries out different combinations of the functional entities to elaborate an optimal sketch; he therefore considers size restrictions, e.g. for a car diagnostic place or workbenches, and needed adjacency relationships between functional entities. The traditional wall structure does not adequately map these functional entities and their relationships. Instead of explicitly expressing the concept of the building, the wall structure just implicitly includes the semantics of the building in the sketch. Without any annotated text, a constructive sketch, like in Figure 1, is not clearly readable.

3 INTEGRATED CONCEPTUAL DESIGN SUPPORT

Looking at Figure 1 again, the garage is composed of a customer area on the left side, including customer toilets, an office room, a dressing room with showers and toilets, and the shop floor area. The shop floor area itself is composed of one car diagnostic and two car repair areas, several workbenches for the wheel balancer, the battery charger, motor diagnostics and mobile workbenches. The storage area is situated in the rear part of the building.

For each of these functional entities, one semantic roomobject is defined; we distinguish between complex and atomic roomobjects. A complex roomobject can be refined into further complex or atomic roomobjets. They allow starting the conceptual sketch in an abstract view which can be stepwise refined. Atomic roomobjects describe simple functional entities that cannot be further detailed; they usually represent a room or a part of a room, as the smallest functional entity occurring in the sketch. In Figure 2, a complex roomobject is depicted as a simple rectangle, an atomic roomobject as a rectangle with rounded edges. The reflexive aggregation

Semantic Roomobjects for Conceptual Design Support

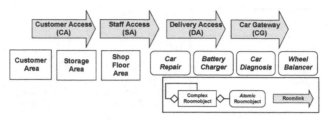

Figure 2 Roomobjects and Roomlinks, specific for Garages

relation between complex roomobjects and the simple aggregation relation between complex and atomic roomobjects is also depicted in Figure 2. To enable architects describing relationships between two roomobjects, we introduce semantic roomlinks. Using roomlinks, the architect can specify functional connections (e.g. access, view, vicinity) between roomobjects that provide a semantic representation containing more information than simple constructive drawing elements (e.g. window, door). The specification of roomlinks helps the architect to explicitly identify the needed relationships between functional entities. As a result, one can clearly recognize the organization of the garage, the semantics of the sketches is explicitly shown. Once defined, the set of roomobjects and roomlinks can be used for each building project of the corresponding class of buildings. In Figure 2 a subset of the roomobjects and roomlinks for the CarSatellite project is depicted. One can identify four different roomlinks to distinguish between the different access relations inside a garage. For a more complete discussion of the dynamic knowledge model definition see (Kraft and Wilhelms 2004).

In Figure 3 three conceptual sketches of the previously introduced CarSatellite garage are depicted, as example of a conceptual design process. The level of abstraction of the conceptual sketch starts with the simple description of the main functional area and its dimension, and ends with a completely elaborated conceptual sketch that can be transferred into a traditional wall structure.

In the first step of the conceptual design process (① in Figure 3), the architect starts with the definition of the building-project's size and shape using the most abstract complex roomobject *CarSatellite-Garage*. The size usually depends on the building site, calculated costs and the wishes of the investor. To formally define how the garage can be accessed by different groups of people, the architect introduces semantic roomlinks to the sketch. In the example in Figure 3, the size of the CarSatellite garage is set to 264 sqm, a customer access (CA) and car gateway (CG) are planned to be situated in the front part, a staff access (SA) and delivery access (DA) in the rear part of the building.

In the next step (② in Figure 3) the architect continues identifying the most important functional areas inside the CarSatellite garage. Here, the architect decides to subdivide the garage into a staff area, a storage area, a costumer area and the garage area. Again, the dimension and size of these areas are continuously calculated and displayed inside the roomobjects to give the architect helpful information. Furthermore, the architect now refines the relationships between the semantic roomobjects. In the example sketch, a customer should only be allowed to access the customer area, while the staff has full access anywhere inside the garage. To formalize these

requirements, the architect specifies only the staff access (SA) between the main areas of the garage and restricts in this way the traffic flow inside the building.

In the last step (③ in Figure 3), the architect further refines the previously defined sketch, up to the level of atomic roomobjects. The garage area is now composed of one car diagnostic place and two car repair places, a wheel balancer, a battery charger, and a generic workbench. Again, the access is restricted to the person group *staff* to avoid customers accessing these areas.

For an integrated conceptual design support, we extend the ArchiCAD product model with new semantic roomobjects and roomlinks, based on the GRAPHISOFT GDL technology and an ArchiCAD programming interface. Each roomobject represents one functional entity inside the conceptual sketch. The roomobjects can easily be imported to ArchiCAD and used like any other drawing object, so that architects are familiar with the usage.

The architect can continuously choose between a detailed and abstract representation of the conceptual sketch. While e.g. elaborating the detailed conceptual design of the staff area using atomic roomobjects, the other areas in the sketch can be displayed in their abstract representation, hiding currently less important details. Using the ArchiCAD rendering features a 3D representation of the conceptual sketch can be generated to help the architect estimating the proportion of volumes. The 3D representation depicts the sketch in the chosen level of abstraction and is available during the whole conceptual design process. The top-down decomposition of the

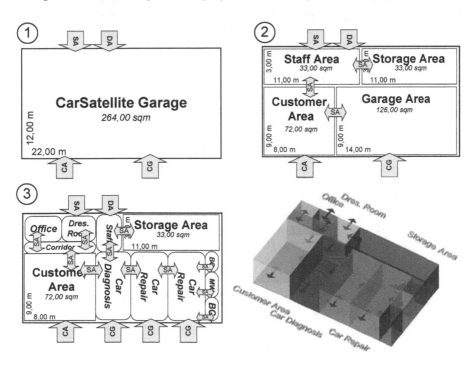

Figure 3 Conceptual Design Sketch with Top-Down Decomposition

sketch helps the architect to reduce the complexity of the sketch, to hide temporarily less important design details and to concentrate on the relevant design tasks. The described functionality is fully integrated in ArchiCAD so that the settling-in period to learn using these tools is minimal. Roomobjects and roomlinks can easily be chosen from a new developed user interface. All functionality to define roomlinks, and to refine or to coarse the level of details can be easily executed. Different editing modes allow a read-only or read-write decomposition of complex areas; the focus is automatically adopted to provide an optimised view on the conceptual design (Schmitt 1993).

4 KNOWLEDGE REPRESENTATION

The complete scenario of the project also consists of a knowledge specification part. In this part, conceptual relevant knowledge, specific to one class of buildings, is being formalized. For knowledge specification and consistency analyses we follow two different approaches. In the graph-based approach, we try to identify the necessary expressive power and the needed structuring elements to develop a visual language for knowledge specification. The consistency between the graph-based knowledge and the conceptual design is calculated using complex analyses based on graph transformations (Kraft and Nagl 2004, Kraft and Wilhelms 2004). In the second approach, we use formal ontologies to classify and define domain specific knowledge. The consistency analyses here are manually implemented in C-code and directly integrated in ArchiCAD. In this paper we concentrate on the second approach.

Using the ontology editor Protégé we initially start with developing an ontology for mapping rules. The ontology is subdivided into a domain unspecific part, which defines the syntax and structure of the rules, and a domain specific part, here specific to CarSatellite garages. Protégé allows a visual definition of the ontology (Figure 4) and the base knowledge (Figure 5).

The domain unspecific part of the ontology consists of four main classes: semantic object, relation, attribute and rule. The class rule is further specialized into attribute, cardinality and relation rules. While the domain unspecific part of the ontology is used as a basis for knowledge specification about any class of buildings, the domain specific part describes the relevant functional entities of one particular class of buildings. The effort, defining knowledge only pays off, if it is reused for several projects of the corresponding class. Therefore, the defined knowledge is on the type level.

Based on the type definition in the ontology, the base knowledge is formalized. Using attribute rules, properties for one roomobject can be demanded or forbidden. A relation rule allows defining demanded or forbidden interrelations between two roomobjects. Attribute rules allow e.g. prescribing a minimal and maximal size for a room-type or define needed equipment to be installed. Relation rules can e.g. demand two rooms to be neighboured or accessible from each other.

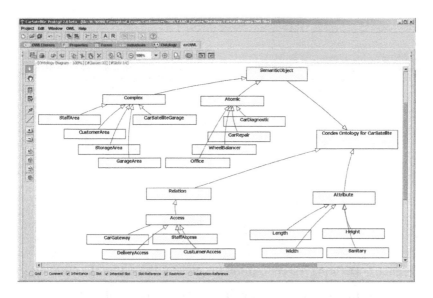

Figure 4 Visual Ontology Specification with Protégé

In the CarSatellite example, we define the relevant functional entities corresponding to the semantics of the previously defined roomobjects and room relations to simplify the consistency analyses, described in section 5. The domain knowledge is currently being developed in cooperation with the Nussbaum GmbH. The merit of focusing on this class of buildings is the well identified set of rules for an extensively elaborated design concept. By restricting ourselves to a highly specialized building project, the development of a closed knowledge base is facilitated.

In Figure 4 a screenshot of the visual ontology definition with Protégé and the ezOWL add-on is displayed. Derived from the class semantic object, the needed complex and atomic functional entities, as well as a set of relations and attributes are created. The classes to represent relation, attribute, and cardinality rules are defined in the same way; the syntax of the rules is specified using associations between the classes. An attribute rule e.g. is composed of three classes: rule, semantic object, and attribute. Using the class hierarchy depicted in Figure 4, all available combinations of semantic objects and attributes can be used for defining rules.

The knowledge definition for CarSatellite comprises e.g. size restrictions for each functional entity. The dimensions of car repair places must be between 9m and 10m depth and 4m width. The depth of the whole CarSatellite garage must be between 10m and 24m depending on the configuration of the garage. It can be composed of just one car repair place, a car repair place and a storage area, two car repair places with or without a storage area in the middle. Furthermore, the knowledge specification prescribes demanded or forbidden relations. The customer lounge e.g. should be situated neighboured to the car diagnostic place. A possibility to view the car should be provided, so that the foreman can show the customer the work to do. To avoid noise pollution, these functional entities should be separated by a wall with a window. The costumer should not have access to the garage area. Finally, the

213

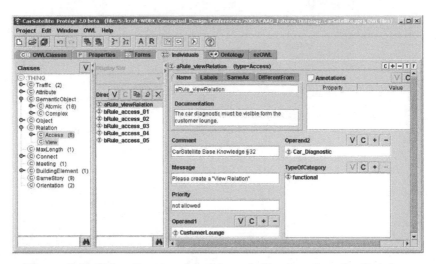

Figure 5 Defining the conceptual knowledge, based on the Ontology

knowledge specification comprises cardinality rules to define the number of allowed occurrences of a room type. It is e.g. a legal restriction to plan a dressing and pause room. Depending on the number of employees separated toilets for women and men have to be installed.

In Figure 5 a screenshot depicts the knowledge specification using Protégé. Based on the previously defined ontology, the so called base knowledge is inserted. Looking at the example, the *view relation* between the customer lounge and the car diagnostic place is depicted. The knowledge specification in Protégé comprises a set of rules. Each rule is composed of a unique identifier, the corresponding semantic objects, attributes or rather relations. Furthermore, two comment fields allow introducing a non formal description and a source of the rule. Finally, an error message containing a hint how to fix the error is stored for each rule. The so defined knowledge is exported using Protégé into an OWL formatted file. As OWL is an adequate data model for ontology storage and exchange, the CarSatellite ontology as well as the corresponding base knowledge can be completely stored and processed as a basis for the consistency analyses in ArchiCAD.

5 CONSISTENCY ANALYSES

To combine the conceptual design using roomobjects and roomlinks with the formally specified knowledge in Protégé, we extend ArchiCAD with new functionality to import and interpret an OWL file to check it against the sketch. We call this extension: ConstraintChecker. The ConstraintChecker allows choosing an OWL file at runtime, depending on the currently used class of rooms (Figure 6).

The ConstraintChecker starts by analysing the attribute rules of all roomobjects, with reference to the length, depth, height and size. The analyses of further attributes, like demanded equipment (sanitary installation, compressed air) is part of

214

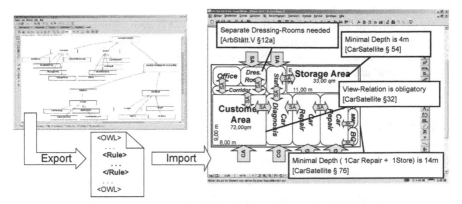

Figure 6 Integrated Consistency Analyses in ArchiCAD

the future work. In case of a restriction violation, the ConstraintChecker displays an error message assigned to the affected roomobject. Analogously, the ConstraintChecker continues analysing all relation and cardinality rules. Obligatory relationships (e.g. staff access anywhere inside the garage) have to be sketched using appropriate roomlinks, forbidden relations must not be sketched. Again, the ConstraintChecker notifies the architect about restriction violations.

Looking at the example sketch in Figure 6, the CarSatellite ontology in Protégé and the conceptual sketch in ArchiCAD are depicted. After importing and interpreting the knowledge specification, the ConstraintChecker identified four restriction violations. In the sketch, e.g. the depth of the storage area remains under the minimal allowed size and the view relation between the customer area and car diagnostic place has not been defined.

The consistency analyses integrated in ArchiCAD works interactively, so that the architect can run the ConstraintChecker anytime during the design process. Thus, the ConstraintChecker is not only used for a final consistency analyses, but also to get continuously more information about the used roomobjects and parts of the sketch.

6 CONCLUSION

Although the conceptual design phase is the basis for the whole design process, none of the traditional CAD tools provide an adequate tool support. We tried to resolve the difficulty supporting the creative elaborating of conceptual sketches by introducing hierarchically processable semantic roomobjects. The abstraction from constructive details to a semantic representation and the possibility to hide temporarily less important cut-outs is conducive to the creativity of the architect. Furthermore, the provided knowledge support aims to help architects avoiding conceptual design errors and to release them keeping plenty of rules and restrictions in mind.

The concepts introduced in this paper are universally applicable for conceptual architectural design. The main idea, to identify important functional entities, relevant

for a specific class of buildings, and relations between them, can be introduced to any CAD tool. Our basic implementation in ArchiCAD demonstrates the feasibility of such an approach. The formal knowledge definition, based on a domain specific ontology, is reusable as well. Nevertheless, supporting creativity keeps an ambiguous goal and the success mainly depends on its acceptance of the architects.

REFERENCES

Alexander, C. 1977. *A Pattern Language: Towns, Buildings, Construction.* Oxford: Oxford University Press.

Bazjanac, V. 1999. *Industry Foundation Classes and Interoperable Commercial Software in Support of Design of Energy-Efficient Buildings.* In *Proceedings of Building Simulation '99*, Volume 2: 661-667. Boston: Addison-Wesley.

Berners-Lee, T., J. Hendler, and O. Lassila. 2001. *The Semantic Web.* In *Scientific American.* Internet. Available from http://www.sciam.com/article.cfm? ArticleID=00048144-10D2-1C70-84A9809EC588EF21; accessed 5 January 2005.

Coyne, R. D., M. A. Rosenman, A. D. Radford, M. Balachandran, and J. S. Gero. 1990. *Knowledge Based Design Systems.* Boston: Addison-Wesley.

Flemming, U. 1994. *Case-Based Design in the SEED System.* In *Knowledge Based Computer Aided Architectural Design*, 69-91. New York: Elsevier.

Kraft, B. and N. Wilhelms. 2004. *Interactive Distributed Knowledge Support for Conceptual Building Design.* In *Proc. of the 10th Intl. Conf. on Computing in Civil and Building Engineering*, eds. K. Beucke, and B. Firmenich: 1-15 [CD-ROM]. Weimar: Bauhaus-Universität Weimar.

Kraft, B. and M. Nagl. 2004. *Parameterized Specification of Conceptual Design Tools in Civil Engineering.* In *Proceedings of the International. Workshop on Applications of Graph Transformation with Industrial Relevance*, eds. M. Nagl,and J. Pfalz: 95-105. Berlin: Springer

Nussbaum. 2005. *Carsatellite, die modulare mobile KFZ Werkstatt von Nussbaum.* Internet. Available from http://www.car-satellite.de; accessed 12 January 2005.

Powers, S. 2003. *Practical RDF.* Cambridge: O'Reilly.

Schmitt, G. 1993. *Architectura et Machina - Architectural Design und virtuelle Architektur.* Wiesbaden: Vieweg.

Stanford Medical Informatics. 2005. *The Protégé Ontology Editor and Knowledge Acquisition System.* Internet. Available from http://protege.stanford.edu; accessed 30 January 2005.

Shared Design Space
The Contribution of Augmented Wiki Hypertext to Design Collaboration

BURRY Jane[1], BURROW Andrew[1], AMOR Robert[2] and BURRY Mark[1]
[1] *Spatial Information Architecture Laboratory, RMIT, Australia*
[2] *Department of Computer Science, University of Auckland, New Zealand*

Keywords: collaborative design, communication, design process, digital media, computer mediated communication

Abstract: Collaborative design activity that involves remote multilateral, multidisciplinary communication has become more commonplace with the electronic means to communicate across any distance in real time. The communication itself can be both an important repository of project information and an important part of the process of conceptualisation and design development. This research has explored the apparent shortcomings inherent in commonly used means of communication and how these impact on the design process. This paper describes research that has taken as a starting point the analysis and observation of actual design communication from the archive of an internationally published collaborative project involving disciplinarily diverse and globally scattered participants. Through the analysis, we have identified characteristics of communication tools or information environments that would address the particular issues found to impede collaboration while fostering those aspects that support it. The findings have been used to inform the design, specification and implementation of collaborative information spaces based on Wiki software.

1 INTRODUCTION

Multilateral communication between designers collaborating remotely poses particular challenges to the design process especially when they are contributing from different discipline backgrounds. Many of the challenges can be seen as more widely applicable to collaboration and communication than just to architecture or design. However the latitude that is afforded to conceptual shifts in the process of design and the many different sets of parameters that are brought to bear in moving towards a shared "solution" or more detailed, better understood model, make this a most demanding subset of collaborative enterprise.

"Design stands midway between content and expression. It is the conceptual side of expression and expression side of conception" (Kress and Van Leeuwen 2001).

B. Martens and A. Brown (eds.), Computer Aided Architectural Design Futures 2005, 217-226.
© 2005 Springer. Printed in the Netherlands.

For this reason, collaboration-in-design places unusually onerous demands on modes and media of communication. For genuinely 'collaborative', as opposed to 'cooperative' , multidisciplinary- design activity the schema must be kept fluid in order for the holistic model or conception to assimilate the different design inputs developing on the basis of different expertise and creative insights. (Kvan 2000) It appears that this fluidity with regard to maintaining an extensive design space and deferral of formal, technical, or architectonic commitment is also manifest in the development and use of terms in design communication.

We analysed the email archive of an internationally published design project with diverse participants and highly speculative ends. Employing a constructionist *participant observation* approach, we observed the development of a sometimes volatile project language (Crotty 1998). It included many evocative metaphorical terms, which once created, had a meaningful role in fostering the collective imagination. They sometimes endured or reappeared through the life of the project, sometimes faded out of communication very quickly and sometimes altered their meaning in the course of use. We also identified significant events in the history of the project through the archive and developed '*thick descriptions*' of the lead up to these (Geertz 1998). The thick description is a history of events complied by a researcher immersed in the process, in this case reconstructed after the events from the record in the emails but by an individual who had had intimate knowledge of the project. These are not objective studies but rather a record drawing inference and constructing meaning from the communications.

Through this process we could generalise two areas of communication that impacted on design collaboration. They are distinct but closely interrelated. The first is structural and the second ontological. This approximates to form and content. (Fairclough 1995). The graph of communication routing and the way in which the communication archive functions as a repository for shared project knowledge and information are both in the structural category. The barriers put up by discipline specific- or skewed- terms and notation and the development of a 'project language' that evolves with the collective conception are examples of ontological issues, that is issues about the things that exist in the communications and the relations between them. There are other phenomena that fit loosely into the ontological category such as misunderstandings caused through over familiar colloquial "empathetic conformity" which is ambiguous out of social context and modal problems, for instance the same information understood differently when presented in different modes, whether these are textual, graphical, mathematical, filmic, sonic etc.

This understanding has formed the basis for developing performance specifications for tools to support communication in collaborative design. These tools are in development based on Wiki software.

2 WIKI

The name Wiki has two principal definitions. "A Wiki or wiki is a website (or other hypertext document collection) that allows a user to add content, as on an Internet

forum, but also allows that content to be edited by any other user. The term Wiki can also refer to the collaborative software used to create such a website" (http://en.wikipedia.org/wiki/Wiki).

Further to the second definition, "Wiki is a piece of software that allows users to freely create and edit Web page content using any Web browser. Wiki supports hyperlinks and has simple text syntax for creating new pages and crosslinks between internal pages on the fly" (http://wiki.org/wiki.cgi?WhatIsWiki 2002).

2.1 Comparison with Web based Threaded Discussion Lists

The open access and edit-ability of Wiki documents distinguishes this hypertext from weblog environments and email list management which, while they archive material for future access do not typically allow open access for deletion, editing or reorganisation of earlier postings. In this sense Wiki does not create an indelible history but a completely dynamic space with potentially negotiated or tacitly developed rules. Mailing lists and list servers tend to be more rigidly ordered and rule bound in this respect. An example is the understanding that postings should stay on topic and that a new topic requires the creation of a new list. Wiki is a genuinely shared environment in which any reader can generally not only post comments but edit, format and restructure existing documents and groups of linked documents. While there is tacit protocol and etiquette as in any shared formal space, the space itself can be used in numerous ways.

2.2 Examples of Possible Ways to Structure Wiki

The principal distinction between these have been dubbed "ThreadMode" which is effectively conversational and generally similar to a collaborative weblog, and "DocumentMode" where a shared page is honed towards a more definitive, well ordered and well formatted state. Threadmode can be difficult to edit and refactor subsequently without losing the threads however it is easy to insert links to other pages that have more document-like quality. To create a new link to a page, whether or not that page has yet been created, it is necessary only to observe the convention of typing a Wiki name in the editor of the current page. This is a word or concatenation containing two uppercase letters. A prosaic example of a Wiki name is "DetailDesign". Typing this name in the hypertext creates a link and the opportunity when the link is followed of creating a page of that name. A page of *this* very generic name might be expected to act as a trailhead to many other pages.

A Wiki hypertext presents as a very versatile collaborative environment. The open and collective authorship of hypertext, was pioneered by Ward Cunningham in the Portland Pattern Repository originally as a means to discuss software engineering strategies (Cunningham 2003). In initial pilot studies with Wikis that have been run for this research, they have been enthusiastically adopted by a range of design-based groups and individuals.

3 ANALYSIS OF EMAIL

The principal method used to explore the archive was participant observation to construct a thick description of the events (Geertz 1998, Ryle 1971). This provided rapid identification of particular difficulties in the design process and the characteristics of the communication leading up to these. The thick descriptions were supported by three other activities. The first was the collection and tabulation of lexical data – the occurrence of terms mapped against time and participants using them. The second was to collate simple quantitative data about the archive from the fields in the email client and the third was to visualise the email route mapping. Email communication provides no single definitive exhaustive archive, there are as many overlapping archives as there are participants. We did not have access to all the communication and it was clear that there were whole areas completely absent. For instance communication between collaborating designers, architects, programmers, mathematicians, mechatronics and pneumatics experts was available; correspondence with the client commissioning body was not. Another fundamental of email communication is that identical content can appear and reappear in many emails. While we eliminated all true duplicates in the amalgamated sample archive that we had, there was no means of eliminating duplicate content that appears in numerous missives through replies containing earlier communication, forwards, ccs etc. The study was also limited to the body text and metadata for the emails without the attachments. An advantage of selecting a highly subjective approach was the opportunity for the observer to read between the lines and detect nuance and inference in the communication. The main issues encountered through observation of the email archive and some of the implications drawn from these for the design of tools to support design collaboration are summarised below.

3.1 Semantic Convergence

People work around disciplinary language barriers by both the use of analogy and by finding shared terms. To some extent the human inclination to invent and use surprising terms to draw attention, help explain aspects of the project and engender a vibrant shared communication space works well for good current communication but challenges the construction and employment of ontologies over terms in the communication for machine reading and explanation to participants. Nevertheless, in a complex process involving many participants, the benefits of being able to reuse information and build on shared understandings that come from using ontologies is very clear (Noy and McGuiness 2001).

3.2 Project Language

The creation and combination of project-specific terms appears to be a very important component of the collaboration. This illustrates the reciprocity between content and expression in design. New terms appear throughout the length of the archive. They cover many stages of the design, prototyping and testing. Some of

them endure; some change their meaning or even disappear quite swiftly. In this last case their function has been fulfilled by moving the process forward at a particular point in time. As the communication is part of the creative process, it is important that tools to support communication and collaboration should be low overhead in both use and administration. For instance the collection of ontological information should not interrupt the natural flow of thought or communication or significantly alter workflow. Ontologies should be able to grow and evolve. While there will be static components, language development is part of design development and any useful project ontology should be able to grow and change with possible provision for retiring redundant terms.

3.3 Empathetic Conformity and Modal Issues

Over-familiar colloquial style in language sometimes creates difficulties in communication in a diverse group the members of which have not all met face to face (Maynard 2002). This is related to the targeting of communication and the routing map established in email. Messages paraphrased by a recipient to a third party in later communication or forwarded mail are prone to creating misunderstanding. An open-access, shared environment with greater opportunities to comment and edit the content could improve this situation.

Information in one mode is poorly understood in another. For example, the implication of a condition communicated through numerical values in the email text is not fully comprehended by some parties. The phenomenon must be experienced visually or aurally. A web interface provides the potential for more multimodal communication.

3.4 Targeting Information: Structural and Ontological Links

The routing of communication manifests as the most fundamental cause of miscommunication, lost information and shortfalls in the collaborative opportunity. Misrouting and inconsistent routing of email or tacit tree hierarchies in the map of communication had a role in most of the communication "crisis points" in the design process. Visualisation of the email routing over time with regard to senders and principal recipients revealed some participants at hubs and others in satellite relation to these hubs. Collaborative enterprise benefits from a collaborative workspace or communication environment. While there is a case for limited or differential access to information and communication within large groups, this can better be managed in a way that is systematic and aligned to the design process.

Structural and ontological issues are not entirely separate. For instance, the email routing map is to some extent a symptom of social grouping occurring in combination with filtered use of language. It may be appropriate to combine ontological and structural tools. Wiki does this in a simple way by creating links based on page names so the structure of the pages and links is to some extent determined by page content. A system of access rules extending the relationship

between content and those sharing access to that content would extend this relationship between structure and content and make the targeting and clustering of documents and participants more explicit.

4 EARLY CASE STUDIES WITH WIKI

In early experiments, Wikis have been created for academic design groups in both research, undergraduate and postgraduate learning. They have also been employed in academic collaborative projects with design practitioners. The medium has been adopted enthusiastically by the student and teaching community, using it to communicate for group assignments including those requiring distant collaboration between institutions, for conversations and sharing research material, dissemination of material by teaching staff and demonstration and presentation of student design work. This has generally occurred in an open Wiki environment. Researchers and research groups have used Wiki to communicate, present project work to client and other groups, post meeting minutes, formulate research proposals, collaborate on publications, and collate research objectives, timelines, references and biographical information, as well as collaborate directly on design and modelling tasks. This latter activity has given rise to a number of project or group specific Wikis that are often password protected. Together these applications have provided a breadth of feedback on the use of Wiki in the design domain.

5 FINDINGS

While Wiki has been found to make a very positive contribution to communication in design based collaborations, there are a range of current operational limitations that have been identified through these testing environments. In the academic/practice Wiki based collaborations there has so far been a clear trend for the academic participants not only to be the initiators but also principal writers, editors and restructurers in the Wiki, a role known colloquially as "Wiki gardeners". Clearly this is partly attributable to the pace of profession life for senior architecture, engineering and design practitioners. Phone calls and face to face meetings are continually given preference over any form of written communication where this has no contractual significance. But no time can be given to a less than user-friendly interface. Formatting can be time consuming, and difficult for a general design population unfamiliar with the rules of structured text using the standard editor. There are also currently frustrating inconsistencies in the way that Wiki appears in different browsers and locations.

There is a word search in Wiki that will find all instances of a term on any page in the Wiki which is very useful for tracking subject material. However, this does not necessarily find similies or Wiki names that are unique but carry the same or very similar meanings.

Comments can be added to a page and files can be attached, a useful means of exchange. However these always appear at the foot of the page and have to be edited manually to thread them with the relevant content on the page. This can be very cumbersome to manage for a long page full of diverse content and it is not uncommon to find a list of orphaned comments and attachments at the foot of the page.

In the structural arena, a Wiki hypertext is typically accessible and editable by all. This removes impediments to collaboration, such as the discretisation and the unmapped and unpredictable routing of communication in electronic mail. However it can also deter participants from exposing creative ideas at an early stage of development and inhibit communication in other ways. For instance it is clear in the email archive that use of terms and notation is tailored by authors to recipients' presumed knowledge so open access could potentially either reduce or bar the use of any discipline specific or exclusive means of expression or allow its unfettered use given the possible anonymity of much of the readership. One solution that has been trialled is to create additional Wikis with restricted (password) access, one Wiki for each small subgroup or project but this is a costly solution: it requires participants to distinguish between and navigate between all the Wikis they personally have access to; it requires administrators to construct Wikis and their access rules; and it does not account for the movement of content from private to public, or in this case from Wiki to Wiki. Thus it reintroduces the hazard of important project knowledge and information being out of sight to those who might benefit from access.

This research has led to a proposal that the hypertext could be augmented in ways that address these current limitations (Burrow 2004).

6 PROPOSALS TO AUGMENT WIKI

The Wiki would be enhanced by a template for the interface that is both portable between browsers and machines and editable. Ideally, this would have a hierarchy of information, at one level determining characteristics for the whole Wiki, while allowing cluster and unique page design adaptation to take place readily and explicitly. In this way particular projects or groups could easily create their own visual and graphical environments within the Wiki, adapted to particular patterns of use and expressive of the users and content.

An editor that closely resembles word processor controls would overcome the difficulties that general users experience in achieving their desired level of control over formatting and presentation of material using structured text protocol in a simple text editor.

A system that automatically creates and maintains access rules in response to browsing and editing of the Wiki hypertext would improve the targeting of documents in the hypertext, and identify significant collections of documents and participants. This is important both for protecting early proposals from open scrutiny

and comment before they are ready for more public airing and for creating communities and groups of documents within the Wiki.

A more sophisticated semantic search tool could identify related content across the Wiki even where non identical names and identifiers have been used. This would make it easy to avoid duplication or near- duplication of content in different parts of the Wiki and build a more robust structure of clusters where closely related material is close in terms of links. This is important in the design context so that each design decision is supported by access to all the relevant information and design history already recorded in the Wiki.

A threaded comment system would make the contribution of comments much more relevant to discussion and document development than having them appended. Similarly, attachments in a side panel or threaded with the text in the editor will make the documents more coherent.

It is proposed that a system of classification could be created for the documents and ontology over document classifications. A single document (Wikipage) could collect multiple classifiers, for instance it could be a 1) design development document that 2) deals with particular aspect of the design 3) it has been authored by a participant from a particular discipline and 4) it is of a type that will no longer be current if it has not been edited for a year. The individual documents within the Wiki can change their significance and role over the life of the Wiki. Some will continue to be added to and edited over a long period and may progress from "brainstorming" status to becoming a formal statement or specification that can be referred to continually. Some will loose their relevance as the discussion or shared activity moves on. Some may be returned to as a source for design development history or presentation. The classification ontology could be used to search the Wiki by different criteria, track changes to classification of documents and to keep the Wiki current and relevant by automatically backgrounding or archiving obsolete pages. The classifier ontology might have both general (design industry) components and project specific components. The classification system ontology should be dynamic and easily edited.

Finally visualisation tools could also give immediate understanding of the evolution of the Wiki itself. Visualisations of the timelines of access rule change and ontology change could give a window onto the current state of the whole design project and a map of its development to date.(Chi et al 1998).

7 CONCLUSIONS

Working together remotely on a collaborative design project within a Wiki is a much more effective way to communicate, develop ideas, create, collect and access shared documents than using electronic mail, mailing lists, web logs, instant messaging or chat. Simple Wiki addresses several of the principal issues found through observing the email archive, in particular, misrouting or poor targeting of information and multimodal presentation of information (Section 3). Some of the

important differences of Wiki compared to email are that a conversation can take place on a single page or series of pages where the sequencing of information is clear and to which all participants have access. In relation to mailing lists or blogs, the information on the pages can be reordered, copied, links added or otherwise edited or formatted by any participant subsequently to keep it readable, current and appropriately connected. In this respect it is much more than a log of communication history. Communication that has been superseded rather than standing alone and possibly being opened after the fact within an email inbox, is seen in the context of what follows, it can be replaced, re-ordered or given a link to more current thinking. Wikis have the advantage over web logs that all the users have access and editing rights. Information that has already been posted can be revisited by the author or collaborators. There is a single record of all the communication that is accessible and can be searched by all. In the prototypical Wikis established for this project it is observed that the creation of Wiki names for pages is much more considered and content-related than many of the subject lines observed in the email archive. Within Wiki there is also the opportunity to change page names and links as part of the ongoing editing of the Wiki. In this way the Wiki is potentially very fluid and analogous to the design process itself. It is also easy to foreground content, for instance by creating additional links to it as its significance increases or becomes better understood.

There are current limitations for using Wiki for collaborative design activity. It is necessary to be able to employ Structured Text rules efficiently to write and format content in the editor. Comments and attachments are uploaded and appended at the foot of the page. These restrictions can be cumbersome and frustrating for users routinely using word processing environments. The Wiki can be too open. While it addresses the vagaries and potential divisiveness of email routing, it may feel too exposed for the development of early ideas, or for sharing all the information pertinent to the design. As the Wiki grows, it is quite possible for similar subject matter to be covered by different 'Wikizens' working in parallel on pages that are distant as measured by links. The identification of these issues has led to current ongoing research and development of augmented Wiki for testing and application in design communication.

REFERENCES

Burrow, Andrew L. 2004. Negotiating Access within Wiki: A System to Construct and Maintain a Taxonomy of Access Rules. In *Proceedings of the fifteenth ACM conference on hypertext and hypermedia*: 77-86. New York: ACM Press.

Chi, E.D., J. Pitkow, J. Mackinlay, P. Piroli, R. Gossweiler, and S.K. Card. 1998. Visualizing the Evolution of Web Ecologies. In *Proceedings of the SIGCHI Conference on Human Factors in Computing systems*, ed. Cl.-M. Karat, A. Lund, J. Coutaz and J. Karat: 400-407. New York:ACM Press.

Crotty, Michael. 1998. *The Foundations of Social Research, Meaning and Perspective in the Research Process*. St. Leonards: Allen & Unwin.

Cunningham, W. 2003. *Wiki design principles. Portland Pattern Repository*, 27 November 2003. Internet, Available from http://c2.com/cgi-bin/wiki?WikiDesignPrinciples; accessed 1st February 2005.

Fairclough, N. 1995. *The Foundations of Social Research, Meaning and Perspective in the Research Process*. London: Longman.

Geertz, C. 1993. *The Interpretation of Cultures: Selected Essays*. London: Fontana.

Gruber, T. 1993. A translation approach to portable ontologies. *Knowledge Acquisition*, 5(2): 199-220.

Kress, G., and T. van Leeuwen. 2001. *Multimodal Discourse, The Modes and Media of Contemporary Communication*, Oxford: Oxford University Press.

Kvan, T. Collaborative design: What is it? *Automation in Construction* 9(4): 409-415

Maynard, Senko J. 2002. *Linguistic Emotivity: centrality of place, the topic-comment dynamic, and an ideology of pathos in Japanese discourse*. Amsterdam: John Benjamins Publishing Company.

Noy, N.F., and McGuinness D.L. 2001. Ontology Development 101: A Guide to Creating Your First Ontology. *Stanford Knowledge Systems Laboratory Technical Report KSL-01-05 and Stanford Medical Informatics Technical Report SMI-2001-0880*

Ryle, G. 1971. *Collected Papers*. Collected Essays. First ed. Vol II, University Lectures No. 18, 1968. The Thinking of Thoughts What is Le Penseur Doing? London: Hutchinson.

What is Wiki? Internet. Available from http://wiki.org/wiki.cgi?WhatIsWiki; accessed 18 February 2005.

Wikipedia: The Free Encyclopedia. Internet. Available from http://en.wikipedia.org/wiki/Wiki; accessed 18 February 2005.

Knowledge Based Design and Generative Systems

Generation of Apparently Irregular Truss Structures

FISCHER Thomas
*School of Design, The Hong Kong Polytechnic University, Hong Kong
and
Spatial Information Architecture Laboratory, RMIT, Australia*

Keywords: apparent irregularity, truss structures, prefabrication, generative design

Abstract: While cheaper mass-customisation technologies are becoming available, architectural design strives for ever more complex and less regular forms. The increasing costs associated with this tendency are difficult to control. Key factors contributing to this cost increase are non-uniform building components. Focusing on space frame construction, this paper examines the possibility of creating apparently irregular structures from relatively small sets of identical parts. Starting with an examination of the cost implications of irregular truss construction, a case study of the Beijing National Swim Center's space frame system and the conflicting natures of bottom-up and top-down generative logic in this context is presented. The paper concludes with the description of the development of a truss system that incorporates various design variables that increase visual irregularity. Learning from the past, this new system draws its basic logic from classic space frame principles but applies present-day computational logic to achieve new aesthetic effects and structural possibilities.

1 INTRODUCTION: IRREGULARITY AND ITS COST

For building simple brick houses, the basic brick can be prefabricated identically in large numbers and used in as many brick houses as one likes. This is highly economical since neither do the bricks within one building require variation of any kind nor is there any variation necessary between individual houses. Contemporary landmark architecture continues to move away from this economic ideal towards increasing numbers of building elements that are unique both to the individual project as well as within that particular project. Due to a number of variables, the cost involved in the use of non-uniform building components can be difficult to calculate in advance. For instance the prototypical character of new landmark projects requires costly research and development efforts and learning from trial and error. Size, granularity and variation of non-uniform building components introduce complexities that affect costs in planning, manufacturing, transport, tracking and assembly (and potentially in building maintenance). Throughout the planning, manufacturing and construction timeline, cost penalties are likely to increase

B. Martens and A. Brown (eds.), Computer Aided Architectural Design Futures 2005, 229-238.
© 2005 Springer. Printed in the Netherlands.

exponentially as a project evolves from ideas and models towards full-scale materials and processes involving skilled labour. It is therefore advisable to resolve and to simplify complex issues in early planning stages in such a way that later stages become less complicated. Different strategies exist to achieve this while allowing apparent or actual irregularity in granular form. A bottom-up generative logic can be applied. One advantage is that great variation in possible outcomes can be achieved to inform the planning process. One disadvantage is that top-down requirements (typically dictated by cost issues and often requiring compromises in form) are difficult to achieve. Alternatively, top-down logic can be applied by defining essential and universal components by means of rationalisation. This strategy is exemplified by the above example of brick buildings and can also be seen in the regular space frames originally developed by Alexander Graham Bell and made popular by Buckminster Fuller as his *octet truss* (Chilton 2000) structures. An example of this type of structure is Biosphere II building in the desert of Arizona. This approach makes it easy to approximate form at a given level of granularity and allows straight-forward industrial mass manufacturing of building components. It will however present a difficult obstacle in achieving visual irregularity in appearance. This paper explores an integration of the described bottom-up and top-down compositional approaches in order to harness the benefits of both. For the sake of completeness, three further strategies should also be mentioned here. Of course, it is always possible to rationalise a non-uniform design to the extent that it becomes uniform enough to allow economical manufacturing. While not truly a solution to the challenge of irregularity, this is nevertheless an option that can still yield interesting outcomes that push the envelope of architectural possibilities. An example of this strategy is the Beijing National Swim Centre by PTW Architects which will be examined in the following section. Alternatively, it is also possible to decide to afford irregularity and to pay for the cost of non-uniform building components. This was the case in the design of the roof structure for the extension of the British Museum by Foster Architects (Barker 2001), which is comprised of almost 5000 individually-made beam units and some 1,500 individual node units. Introducing complexity in the later construction work, this strategy involves more cost than that involved in custom-manufacturing components (see above). Finally, it is also possible to handle or to process granular material in its assembled form in such a fashion that it must physically follow uniformity-breaking rules of some kind. A good example of this strategy is the bending of flat glass panels in the case of the InteractiveCorp Headquarters in Manhattan by Gehry Partners (Lubell 2003). This strategy involves additional cost in geometric planning early in the design process as well as cost implication in the manufacturing and construction phases. It must also be noted that exploiting material elasticity as in the InteractiveCorp building requires a rigid primary structure, which itself must conform to the irregular geometry achieved by the façade. Amongst equal structural members, such as those found inside a typical space frame, elastic deformation would result in cumulative overall deformations that are rather difficult to control. In general it must be noted that irregular structures are highly challenging at the planning, manufacturing and construction phases (and often in building maintenance as well). In the field of space frame design this is corroborated by the small number of irregular space frames that have actually been built. Amongst the numerous case studies examined in Chilton's

discussion of Space Grid Structures (Chilton 2000), only two can be described as irregular. Figure 1 shows a building extension at the Technical University in Lyngby by Tony Robbin and Erik Reitzel (left) and the Atlanta Pavilion by Scogin Elam and Bray (right) (Chilton 2000).

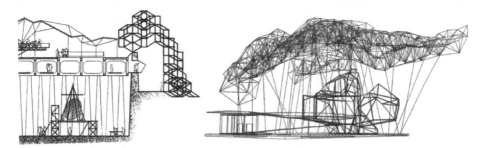

Figure 1 Irregular Truss Structures, reproduced from (Chilton 2000)

The Lyngby project proved to be too expensive to construct at full scale and was therefore built as an indoor sculpture. The Atlanta Pavilion remains unbuilt. A successful and built design for an irregular space frame is the structure of the atrium at Melbourne's Federation Square (Lab Architecture Studio). This project however not only appears highly irregular, it is indeed comprised of individually different components and has been designed manually without an automated generative procedure. It is not the aim of this paper to determine or to deem achievable a measure for apparent irregularity. As a casual measure, this study simply addresses the question: How much does understanding the composition of one part of a structure allow statements about other, unknown parts of the same structure? Interesting measures of irregularity tend to gravitate towards the "edge of chaos" somewhere half-way between regular structures and chaotic structures. Even irregular structures such as that of Federation Square's atrium are not surprisingly chaotic (there are no dramatic changes in density, topological irregularities such as beams penetrating faces do not exist, etc). When knowledge about one part of a structure allows *precise* predictions about other parts, the structure is clearly regular. If *no* predictions are possible, the structure is rather chaotic and probably not what contemporary architecture is aiming for. If *statistical* predictions are possible, the structures are visually irregular and lie within the scope of this investigation. The MERO M12 exhibit system can serve as a benchmark reference. Allowing some "biomorphic" double-curved surfaces, this commercially available system uses 10 different beam lengths and 12 different node units.

2 THE BEIJING SWIMMING CENTRE

The "Water Cube" for the National Swim Centre, which is currently under construction for the 2008 Olympic Games was designed to resemble a transparent box filled with water bubbles (or, more precisely, with a dry foam). The irregular composition of bubbles envisioned for the design competition proved too

complicated and too expensive to build. The ingenious solution developed by Arup Engineers uses a regular structure that to some extent appears to be irregular (Bosse 2004). Regularity is achieved by close-packing identical polyhedra. Figure 2 shows three such compound structures. The left shows rhombic dodecahedra, an alternative representation of close-packed spheres, upon which Fuller's octet truss is also based.

Figure 2 Regular Truss Structures

The middle image shows the so-called Kelvin conjecture, a packing of truncated octahedra proposed 1887 by Lord Kelvin as the most efficient minimal surface circumscribing a space-filling arrangement of polyhedra with equal volume (Bosse 2004). In 1993, Weiare and Phelan proposed a structure with 0.3% more efficiency. This structure is comprised of two different types of polyhedra, one of which is not fully symmetrical and repeated throughout the structure at different rotations. The structure shown on the right of Figure 2 corresponds to the structure used in the Beijing project, it is however not quite the actual Weiare-Phelan structure as is frequently reported. The Weiare-Phelan structure is the basis for this geometry, which is subsequently "evolved" into a more tension-efficient derivation with single-curved edges – a system that would be more difficult to construct physically. In the case of the Beijing project, this geometry has been rotated before "cropping" it into its box shape. Therefore, while the truss structure shows no variation in bubble density, the box surface shows some variance in cell sizes and therefore in density (Figure 3).

Figure 3 Grid surface of the "Water Cube"

3 BOTTOM-UP: VORONOI-BASED FOAMS

A straight-forward approach to computer-generating irregular grids is offered by Voronoi diagrams, for which a set of random points on a plane (or in 3D within a volume) is circumscribed by a network of edges (or faces) so as to maximise the area (or space) of cells around each individual point. The regularity of the initial "seed" points' distribution can be controlled to produce more or less variation in resulting cell sizes. Figure 4 shows a two-dimensional (left) and a three-dimensional (right) result. The 2D example demonstrates the problem of undefined edge conditions. Some vertices of the edge mesh are undefined (or: "at infinity"), leaving edge cells open. In the case of the 3D example, the edge faces have been subjected to further manipulation in the form of "pulling" of numerous peripheral vertex points onto the desired cube surface.

Figure 4 Two- and Three-Dimensional Voronoi Diagrams

The author has undertaken an experiment to determine the possibility of generating irregular foam structures, resembling dry foam (similar to the initial design for the "Water Cube"). The ambition was to minimise surface tension around vertex points in Voronoi structures so as to reduce the number of contained node units to the single one found in dry foam – the so-called caltrop configuration of 4 edges meeting at angles of about 109.5° in space. The most suitable tool available for purposes of this kind is Surface Evolver (Brakke 2004). As illustrated in Figure 5, it allows transforming Voronoi structures into dry foam with its typical node angles.

Figure 5 Surface "Evolution" of a 3D Voronoi Structure

Being useful in reducing the number of node units within a given foam structure, more work is required to determine its possibilities in also minimising the number of contained truss units. Controlling the number of nodes in peripheral areas of a foam also remains a difficult task using this method. An additional challenge is posed by the fact that Voronoi diagrams can only be generated for convex shapes. Hollow spaces and concave surfaces (as those produced by interior architectural spaces) are simply filled with large cells. This requires a separate treatment of individual, non-concave elements of forms such as individual straight walls as well as some way to co-ordinate vertex points where those elements are subsequently re-joined.

4 TOP-DOWN: DERIVATION OF THE OCTET-TRUSS

A useful top-down design process for apparently irregular space frames with a limited number of components can start from the following two suppositions. First, the classic octet truss space frame is a good starting point since it provides a useful system for filling space in a structurally sound way with a minimum number of components. It is necessary, however, to somehow modify the system to appear irregular while minimising the number of required parts and therefore the implied cost consequence. Secondly, it is useful to separate the space-filling system into partitions, which can be broken down fractally into self-similar sub-partitions. In an ideal case, smaller units would have to be rotated at individually different angles to produce a larger unit. This results in a multiplication of visual angles. In 2D this effect can be observed in the fractal decomposition of the pinwheel pattern found on the façade of Federation Square. Figure 6 shows the relationship between close-packed spheres and rhombic dodecahedra (Frazer 1995, Fischer et al. 2004).

Figure 6 Close-Packed Rhombic Dodecahedra and Spheres

Figure 7 Decomposition of Dodecahedra into Self-Similar Rhombic Pyramids

Figure 7 shows how the rhombic dodecahedron can be broken into 12 sub-cells. The 12 faces of the dodecahedron are the bottom faces of 12 rhombic pyramids whose top vertices meet at the centre point of the dodecahedron. The rhombic pyramid can

be broken down fractally into self-similar cells at a volume ratio of 1:8. Sub-units are combined at different rotation angles.

5 INTEGRATING BOTTOM-UP AND TOP-DOWN

In order to make this system useful for achieving irregularity in bottom-up generated structures, it is necessary to identify choices and parameters within the system that provide some controls for this purpose. One possible starting point (not pursued here) is evoked by the fact that, after one level of fractal decomposition, two adjacent pyramids of two dodecahedra produce a rotated dodecahedron at a smaller scale (see left of Figure 8). The remaining three illustrations in Figure 8 show how fractal resolution provides a design parameter and how it can be spatially modulated to produce varying densities for visual or structural purposes for example. Figure 9 shows that the dodecahedron's centre point can be moved in order to achieve greater visual variety. This will dramatically increase the number of required beam lengths and node angles.

Figure 8 Decomposition and Variation in (Local) Density

Figure 9 Search Space for Alternative Midpoints

However, exhaustive searching reveals various interesting local minima in the number of beam lengths. The author's experiments have shown that results of this kind of analysis can depend greatly on the degree of mathematical precision applied. Generous rounding naturally produces smaller numbers of beam lengths. Truss systems in which beams are connected to nodes driving treaded bolts out of the beam end into the nodes provide an elegant means to allow small numbers of beam lengths by compensating for low generative precision. The dodecahedral unit with off-centre mid-point allows up to 8 different orientations within close packing, but at the cost of a steeply increasing number of nodes. The frame of the original

dodecahedral structure itself adds to the number of beams and at the same time emphasizes visual periodicity. Figure 10 shows the structure with shifted centre (left), with variable fractal resolution (centre) and with dodecahedral edges removed.

Figure 10 Variable Density, Moved Midpoint, Removal of Dodecahedral Frame

While counting required beam lengths in irregular space frame systems is a straight-forward task, the counting of required node types is more challenging. Relationships between angles must be compared and matched, and sub- and supersets of matches must be identified. A similar problem is known in spacecraft engineering. In order to continuously correct the rotation of the co-ordinate systems of on-board navigation instruments, a camera captures a view of the celestial sphere and compares it to stored maps of star configurations (see Figure 11). Techniques used in this field suggest that there is little alternative to the obvious and tedious approach of exhausting and comparing possible combinations of all possible rotations.

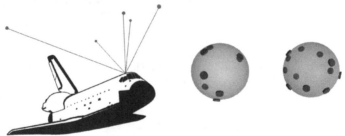

Figure 11 Pattern Matching Between Sets of Points on Spheres

Of the number of different beam lengths that are identified for a particular instance of an irregular space frame, some are small and insignificant enough to be omitted altogether in order to further reduce the number of necessary component groups. A space frame which uses only 1 of 8 possible rotations of a shifted dodecahedron midpoint and a single level of fractal decomposition, and omits two small sets of beam lengths is composed of 176 beams of 9 lengths per dodecahedron. A structure that follows a similar logic with two levels of fractal decomposition is composed of 1380 beams of 18 (two omitted) lengths per dodecahedron. The structure shown in figure 12 has a fractal depth of 2. The density at the higher fractal scale is determined by the "beam-lengths-economy" of respective neighbours leading to a high degree of irregularity at about 251 beams of 11 (8 omitted) beam lengths per dodecahedron. At one level of fractal decomposition a maximum of 50 different nodes is required (not taking into account possibly identical ones), the peripheral

ones being shared according to the dodecahedral close packing. At two levels of fractal decomposition this number grows to a maximum of 354.

Figure 12 Close-up of a Space Frame Based on the Described Procedure

There are three distinct design tasks involved in generating apparently irregular structures: the design of a space-filling frame topology with variable parameters suitable for achieving variation, the design of related generative procedures and software, and the architectural design into which the structure is integrated. The latter task, which has remained ignored in this paper, must take into account two issues. Firstly, the degree of irregularity perceived in the shown structure changes with the observer's viewpoint. (Perspective distortion tends to increase perceived irregularity in space frames.) Some observation angles reveal the lattice of regular vertex locations at which dodecahedra meet. This can be addressed by rotating "revealing" view angles away from typical viewing perspectives. Secondly, the face-centred cubic close packing of dodecahedra produces "jagged" surfaces, which can be treated in different ways in order to approximate flat or curved surfaces. One strategy is to crop larger structures into desired shapes. Another one is to devise additional, gap-filling modules, possibly from beam lengths that are part of the system in use.

6 CONCLUSION

An observer's ability to make only statistical statements when predicting the composition of an unknown part of a structure on the basis of a known part is proposed as a preliminary qualifying criterion for apparent irregularity. The presented procedure allows the generation of space frame structures of different degrees of visual irregularity, based on small numbers of pre-fabricated building components. This was achieved by breaking down a classic and highly regular space-filling structure in a new way that, when integrated with bottom-up generative procedures, provides a number of geometric controls for producing visual

237

irregularity as well as for modulating structural density. It was established that the presented procedure does not fully accomplish but approximates the proposed criterion for apparent irregularity while limiting the number of required prefabricated building components. More work is necessary to transfer the findings to structures other than space frames and to possibly identify further possibilities for increasing apparent irregularity and reducing required component types. To fully utilize computer aid not only to generate possible structures but also to automate their evaluation, a node-counting facility is required.

ACKNOWLEDGEMENTS

I am grateful for the comments I have received from my colleagues at SD (HKPU) and at SIAL (RMIT), Timothy Jachna, John Frazer (in particular for his valuable work and suggestions related to close-packing based structures) as well as Mark Burry, Andrew Maher, and Yamin Tengono (in particular for sharing their valuable initial work on the Beijing swimming pool, and their suggestions related to 3D Voronoi-based structures).

REFERENCES

Barker, D. 2001. Foster and Partners Roof the Great Court. *Architectureweek* 14. February 2001: D1.1

Beijing Olympic Swim Center Designers Chosen. *Architectural Record* 9(2003): 42.

Bosse, C. 2004. Schwimmsporthalle für die Olympischen Spiele 2008, Peking. *Archplus*. 168(2): 33-35.

Brakke, K. 2004. *Surface Evolver v2.24b*. URL: http://www.susqu.edu/facstaff/b/ brakke/evolver; accessed 2 February 2004.

Chilton, J. 2000. *Space Grid Structures*. Oxford: Architectural Press.

Fischer, T., M. Burry, and J. Frazer. 2005. Triangulation of Gen. Form f. Parametric Design and Rapid Protot. *Automation in Construction* 14(2): 233-240.

Frazer, J. 1995. *An Evolutionary Architecture*. London: Architectural Association.

Gibson, L., and M. Ashby. 1988. *Cellular Solids*. Oxford: Pergamon.

Lubell, S. 2003. Gehry to Design InteractiveCorp's Headquarters in Manhattan. *McGraw Hill Construction*. URL: http://www.construction.com/NewsCenter/ Headlines/AR/20031021r.asp; accessed 2 February 2005.

Weaire, D., and S. Hutzler. 1999. *The Physics of Foams*. Oxford: Oxford Univ.Press.

Dynamic Designs of 3D Virtual Worlds Using Generative Design Agents

GU Ning and MAHER Mary Lou
Key Centre of Design Computing and Cognition, University of Sydney, Australia

Keywords: virtual environments, generative design, interactive design, shape grammars

Abstract: 3D virtual worlds are networked environments designed using the metaphor of architecture. Recent developments in 3D virtual worlds focus on interactivity, flexibility and adaptability. Rather than creating virtual environments in which the objects have intelligent behaviours, our research takes a different approach to develop an agent model that is associated with an individual person in the 3D virtual world as a personal design agent. This paper presents a Generative Design Agent (GDA), a kind of rational agent capable of representing a person in a virtual world and designing, implementing and demolishing 3D virtual places based on the occupants' current needs in the virtual world. The core of a GDA's design component is a generative design grammar that is able to capture a style of 3D virtual worlds. 3D virtual worlds designed using the GDA model is another kind of architecture for the "moment".

1 INTRODUCTION: 3D VIRTUAL WORLDS

Virtual worlds, virtual architecture or cyberspace can be understood as networked environments designed using the metaphor of architecture. Through the use of metaphor, we express the concepts in one domain in terms of another (Lakoff and Johnson 1980). The architectural metaphor provides a consistent context for people to browse digital information, interact with the environment and communicate with each other. The purposes of 3D virtual worlds have expanded from the original internet gaming and military simulation to provide support for other activities such as online learning and research, virtual design studios, virtual museums and so on. Virtual worlds have the potential to develop alongside the built environments to be an essential part of our living environments.

Designing virtual worlds has accommodated many different technologies supporting multi-user text-based, 2D graphical and 3D virtual worlds. Nowadays, 3D virtual worlds have become the most common forms. These worlds use 3D models for representing places. A person appears as an avatar (an animated character) which locates the view of the world and provides a sense of awareness of others in the world. Examples of 3D virtual worlds are among those designs implemented with platforms like Active Worlds (www.activeworlds.com), Adobe Atmosphere

B. Martens and A. Brown (eds.), Computer Aided Architectural Design Futures 2005, 239-248.
© 2005 *Springer. Printed in the Netherlands.*

(www.adobe.com/atmosphere), Virtools (www.virtools.com), and SecondLife (www.secondlife.com). Figure 1 illustrates selected designs in 3D virtual worlds from our recent research and teaching.

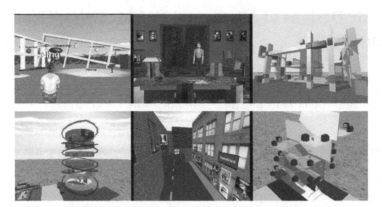

Figure 1 Designs in the 3D Virtual Worlds

An analogy between 3D virtual worlds and the built environments is based on the view that 3D virtual worlds are comprised of functional places. The designer specifies and organises meaningful places and objects, reflecting some social and cultural needs and values in a particular form. Such a view assumes that the concepts of 3D virtual worlds and the built environments have some commonalities as well as some relevant differences. Except for the input and output devices, 3D virtual worlds are implemented entirely in a computer environment. Therefore, the worlds are basically assemblies of computing entities, which can be flexibly programmed and configured. This flexibility makes it possible to consider designing 3D virtual worlds in terms of dynamics and autonomy. However, current examples of 3D virtual worlds are largely static. Like the built environments, the design process is separated in time from its use, and therefore is not directly related to the individual's experience of these virtual places. This paper presents a Generative Design Agent (GDA) model for dynamic designs of 3D virtual worlds. A GDA is a kind of rational agent, on one hand represents a person in the virtual world capable of providing agencies for interacting with other GDAs and the environment, and on the other hand acts as a design agent capable of designing, implementing and demolishing 3D virtual places as needed. The core of a GDA's design component is a generative design grammar that is able to capture a style of 3D virtual worlds.

2 AGENT MODELS FOR 3D VIRTUAL WORLDS

An increased interest in computational agents has been seen recently in the development of internet applications influenced by the concepts of artificial intelligent and artificial life. In the context of computer science, agents as intentional systems operate independently and rationally, seeking to achieve goals by interacting with their environment (Wooldridge and Jennings 1995). Unlike most

computational objects, agents have goals and beliefs and execute actions based on these goals and beliefs (Russell and Norvig, 1995). The increasing interconnection and networking of computers requires agents to interact with each other (Huhns and Stephens 1999). The concept of a multi-agent system is therefore introduced with the applications of distributed artificial intelligence.

Examples such as internet gaming environments usually associate pre-programmed behaviors with 3D objects to integrate interactions to 3D virtual worlds. This allows some components of the environment to be interactive by performing a fixed set of responses. Instead of ascribing fixed behaviours to 3D objects in a virtual world, Maher and Gero (2002) propose a multi-agent system (Figure 2) to represent a 3D virtual world so that each object in the world has agency. With sensors and effectors as the interface to the 3D virtual world, each agent can sense the world, reason about the goals and modify the virtual world to satisfy the goals. 3D virtual worlds developed using this model can adapt their designs to suit different needs.

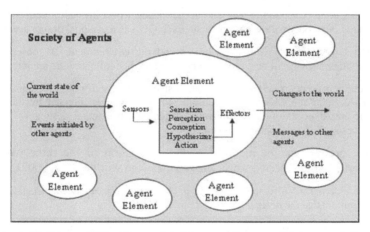

Figure 2 A 3D Virtual World as a Multi-agent System (Maher and Gero 2002)

The typical application of this multi-agent system is to develop object agents in 3D virtual worlds by applying agencies to structural components of a 3D virtual world such as wall, floor and so on, or to spatial components of the world such as room, building and so on. With the specification of relevant domain knowledge, this model has been applied to dynamically control information flows in designing 3D models and to increase the level of interactivity in 3D virtual worlds (Maher et al. 2003).

3 GENERATIVE DESIGN AGENT MODEL

Our study takes a different approach by developing augmented design agents rather than object agent, for 3D virtual worlds. Therefore, the Generative Design Agent (GDA) model is proposed. On one hand, a GDA represents a person in the virtual world by providing this individual with agencies for interacting with other GDAs and the environment. On the other hand, it serves as a design agent that can design,

implement and demolish 3D virtual places as needed. The core of the design component is a generative design grammar that captures a style of 3D virtual worlds, which can be applied to designing virtual places in 3D virtual worlds as needed. Using the GDA model, a multi-user virtual world can be represented by a society of GDAs. Each GDA corresponds to an individual of the virtual community.

As the representation of a person in the virtual world, a GDA is able to interact with other GDAs and the environment. By monitoring these activities, the GDA interprets the person's current needs and automatically designs 3D virtual places to satisfy these needs. With the GDA model, the most significant change to a 3D virtual world is that the design of the world does not need to be pre-defined like the built environment. The 3D virtual world is designed, implemented and demolished, to suit the needs of its inhabitants. The GDA model also allows the design of the world to have influence from its inhabitants, rather than being solely controlled by the designers. The following highlights the characteristics of the GDA approach.

- The agency is applied to a person in the virtual world instead of each structural or spatial component of the environment. Each GDA is a personal design agent.

- The GDA interacts with other GDAs and the environment. By observing these activities, the current needs of the person and his/her collaborators are interpreted.

- Designers do not specify every design. Instead, they specify design grammars for the GDAs. The application of the design grammar then is directed by the currently interpreted needs of the inhabitants, to generate the actual designs of 3D virtual places in the world, for the moment.

The design process can be modeled as the interaction of the three worlds: the external world, the interpreted world and the expected world (Gero, 2002).

- The external world is the world that is composed of external representations of the design outside the designers.

- The interpreted world is the internal representation of the external world that exists inside the designer in terms of the designer's knowledge, experiences and interpretations of the external world.

- The expected world is the world in which the effects of design decisions are predicted based on the designer's current design goals and his/her interpretations of the current state of the world.

The computational processes of the GDA common model are proposed on the base of Maher and Gero's agent model for 3D virtual worlds (2002), where sensors and effectors act as the interface between the agent and the 3D virtual world. There are three computational processes: interpretation, hypothesising and designing. The external world, the GDA's interpreted world and expected world are connected via these three computational processes (Figure 3).

- In interpretation, the GDA uses sensor(s) to retrieve raw data from the 3D virtual world (external world). These data are filtered, focused and transformed to construct the interpreted world, where the current needs of the inhabitants and the current state of the world are interpreted. The types of data from the external world are avatars (A), events (E), attributes of the virtual world such as system time, number of users, object path of the world (W) and 3D objects (O).

- In hypothesising, the GDA constructs the expected world by setting up design goals to reduce or eliminate the mismatches between the currently interpreted needs of the occupants and the state of the world.

- In designing, the GDA applies a design grammar to provide design solutions for satisfying the design goals. The design solutions will be realised in the external world via the GDA's effector(s).

These three computational processes form a recursive loop. Every new generation, modification and demolishment of the design in the external world will trigger a new round of interpretation, hypothesising and designing within the GDA. In this manner, the 3D virtual worlds are dynamically designed as needed.

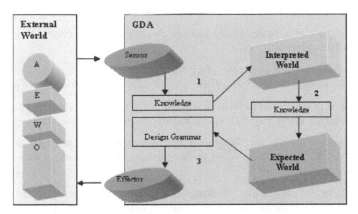

Figure 3 Three Major Computational Processes of the GDA Model: Interpretation (1), Hypothesising (2) and Designing (3)

4 GENERATIVE DESIGN GRAMMAR

The GDA's designing process requires a generative mechanism to produce design solutions for satisfying the design goals. Shape grammars (Stiny and Gips 1972) as design formalism and their applications have been developed in many design domains for over three decades. The core of the GDA's design component is a generative design grammar. The spatial components of this grammar are developed based on the notions of shape grammars.

Knight (2000) summarises the definition and the components of a shape grammar: a shape grammar is a set of shape rules that apply in a step-by-step manner to generate a set, or language of designs. A shape grammar is both descriptive and generative. The shape rules are the description of the spatial forms of the designs. They can also relate to the goals of a design project that may describe anything from functions to meanings to aesthetics and so on. The basic components of the shape rules are shapes. Shapes can be understood as points, lines, planes or volumes. The designs are generated using shape operations. Generally, applications of shape grammars have two purposes. Firstly, shape grammars can be used as design tools to define

design languages and styles. Secondly, shape grammars as design analysis tools, can be used to analyse existing designs in order to better understand the designs.

4.1 Generative Design Grammar Framework

The view of 3D virtual worlds as functional places that support professional activities provides a common ground for designing these worlds. This common ground highlights two key issues: activities and metaphor. Firstly, 3D virtual worlds exist for certain purposes supporting various online activities. Secondly, 3D virtual worlds apply the metaphor of architecture. Based on this understanding, designing 3D virtual worlds can be divided into the following four phases:

- To layout places for designated activities: each place has a volume that corresponds to certain online activities.

- To configure each place: the place then is configured with certain infrastructure, which provides boundary and visual cues for supporting the designated activities.

- To specify navigation methods: navigation in 3D virtual worlds can be facilitated to consider the use of way finding aids and hyper-links among different virtual places.

- To specify interactions: in general this is a process of ascribing behaviours to selected 3D objects in the world, so that the occupants can interact with these objects and each other.

The four phases of designing 3D virtual worlds define the basic structure of a generative design grammar framework that consists of four sets of design rules: layout rules, infrastructure rules, navigation rules and interaction rules (Figure 4). Following the structure of the generative design grammar framework, styles of static virtual architecture can be considered in terms of visualisation (layout of places and visual forms of infrastructure), navigation methods and interactions. They are three inseparable parts for providing an integral experience of 3D virtual worlds. Detailed analysis of styles of 3D virtual worlds can be found in Gu and Maher (2004).

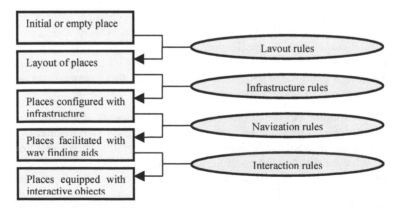

Figure 4 Structure of the Generative Design Grammar and the Firing Sequence of the Design Rules

In shape grammars, state labels are usually applied to separate the shape rules of a grammar into different stages. The generative design grammar framework maintains this usage and further develops special sets of state labels to represent different design contexts. Each design rule is associated with a set of state labels, in order for a rule to be fired, the currently interpreted needs of the occupants and the state of the world need to match the design context represented by the state labels. In this manner, the application of the grammar is directed to generate designs that satisfy the needs of the occupants.

4.1.1 Layout Rules

Layout rules are spatial rules that produce layout of places according to different activities supported in a 3D virtual world. The use of different places for different activities creates a sense of movement for the avatars when changing activities. Because of the use of architectural metaphor, layout problems in 3D virtual worlds can have similar solutions as the ones in the built environments. However, unlike the built environments, 3D virtual worlds do not have to obey physical constraints. Many layout-related issues like adjacency do not need to strictly follow its physical counterpart, which offer designers more freedom in designing. Figure 5 shows two example layout rules that add different virtual gallery spaces to an existing reception space. The state labels of the rules are written above the LHS shape.

Figure 5 Two Example Layout Rules

4.1.2 Infrastructure Rules

Similarly, infrastructure rules are also spatial rules. They further configure each place by defining boundary and deciding objects placements, after the layout is produced. Like layout rules, there are many physical examples and principles to follow, but designers can also gain more freedom in designing as 3D virtual worlds are free from any physical constraints.

4.1.3 Navigation Rules

Navigation rules provide way finding aids such as visual cues or hyperlink portals, to support navigation in 3D virtual worlds. Way finding aids in virtual worlds has been studied with the direct reference to those in the built environments (Darken and Sibert, 1996; Vinson, 1999). There are at least two different types of way finding aids that can be integrated into 3D virtual worlds from the built environments. They are spatial elements and social elements. Spatial elements include paths, openings,

hallways, stairs, intersections, landmarks, maps, signs and so on. Social elements refer to assistance from tour guides or other occupants.

Besides the above references from way finding aids in the built environments, virtual worlds have their unique forms of navigation as virtual places are hyperlinked. Most virtual worlds allow occupants to move directly between any two locations. The left diagram in Figure 6 is an example navigation rule. The LHS of this rule shows that two virtual gallery spaces are separated in a virtual world, without direct access to each other. The RHS of this rule shows that a pair of hyperlinks is created inside these two galleries, which allows visitors to travel back and forwards freely. The right diagram in figure 6 shows the effect of this example navigation rule. The LHS is the interior of one of the virtual gallery spaces. The RHS shows that a hyper-link is created and appears as a colour stone on the floor, which will take the visitor directly to the other gallery space when it is stepped on.

Figure 6 Left: an Example Navigation Rule; Right: the Effect of the Example Navigation Rule

4.1.4 Interaction Rules

Interaction rules ascribe appropriate behaviours to selected 3D objects in different virtual places. Therefore, occupants can interact with these 3D objects by activating their behaviours. In the built environments, the behaviours of a design artefact are causally related to its structure. This is not the case in 3D virtual worlds. Designers ascribe behaviours freely to the 3D objects. Figure 7 shows the effect of an example interaction rule. The LHS is an empty advertisement board outside a virtual building (at the top right corner of the image). The RHS shows the same advertisement board displaying a digital image in an animated sequence, after the interaction rule is fired, which reconfigures the properties of the board using a scripting language to enable the animation to be shown.

Figure 7 The Effect of an Example Interaction Rule

4.2 Generative Design Grammar Application

The four sets of design rules are fired following the order of layout rules, infrastructure rules, navigation rules and interaction rules. By altering the sequence of the design rule application, different designs can be obtained. In this case, the occupants' needs of the moment and the current state of the virtual world are sensed and interpreted by the GDA, to be used to match the state labels, for directing the design grammar application. Therefore, 3D virtual places are generated differently during its use, in order to satisfy the changing needs of the occupants. Figure 8 illustrates a dynamic virtual gallery that changes overtime (from left to right) during its use in one particular session, to suit the needs of different moments.

Figure 8 Example: A Dynamic Virtual Gallery Changes over Time

In the cases when there are more than one design rule that meet the current design context, a control mechanism is needed to resolve the conflict. In general, there are three main methods for controlling the generative design grammar application. They are random selection, human designer interference and evaluation-learning mechanism. The random selection method allow the system to randomly select one design rule from the set of rules that meet the current design context, for firing. The human designer interference method allows the system to turn to human designers or users for instructions once such a conflict occurs. The evaluation-learning mechanism provide a more dynamic but more complicated approach to allow the system to resolve the conflict based on past design experience and feedback. The design example shown in figure 8 uses the human designer interference method.

5 CONCLUSION

The generic GDA model presented in this paper enables 3D virtual worlds to be dynamically designed as needed. As the core of a GDA's design component, the generative design grammar includes the representation of design context of 3D virtual worlds in the forms of state labels, which can be used to match against the GDA's current interpretation for directing the grammar application. Highlighted with the GDA's generative capabilities, this research provides new insights for 3D virtual worlds from the following perspectives:

- The GDA model introduces dynamics and autonomy to the designs of 3D virtual worlds. Virtual worlds designed with the GDA model do not have a static infrastructure like the built environments. It is designed for a particular "moment", and reflects its inhabitants' interests of that "moment".

- The generative design grammar framework serves as a base for developing generative design grammars with different styles that suits different purposes.

247

- The generative design grammar framework also provides a foundation to formally study the styles of 3D virtual worlds. Compared to other novice designs, virtual worlds designed with a specific style in mind will achieve better consistency in terms of visualisation, navigation and interaction, and this consistency provides a strong base to assist its occupants' orientations and interactions in the virtual worlds.

The future extension of this research will be focused on agent communication. The first direction is to study the GDA's interpretation process in a complex multi-GDA 3D virtual world. The second direction is to study the collective design styles of 3D virtual worlds shared by a society of GDAs.

REFERENCES

Darken, Rudolf P., and John L. Sibert. 1996. Way Finding Strategies and Behaviours in Large Virtual Worlds. In *Proceedings of ACM SIGCHI'96*: 142-149. New York: ACM.

Gero, John S. 2002. Computational Models of Creative Designing Based on Situated Cognition. In *Proceedings of Creativity and Cognition 2002*, ed. Tom Hewett, and Terence Kavanagh: 3-10. New York: ACM.

Gu, Ning, and Mary L. Maher. 2004. Generating Virtual Architecture with Style. In *Proceedings of ANZAScA 2004*, ed. Zbigniew Bromberek: 141-147. University of Tasmania.

Huhns, Michael N., and Larry M. Stephen. 1999. Multiagent Systems and Society of Agents. In *Multiagent Systems: A Modern Approach to Distributed Artificial Intelligence*, ed. Gerhard Weiss: 79-120. Cambridge: MIT Press.

Knight, Terry W. 2000. Shape Grammars in Education and Practice: History and Prospects. *International Journal of Design Computing* 2. Available from http://www.arch.usyd.edu.au/kcdc/journal/vol2; accessed 24 January 2005.

Lakoff, George, and Mark Johnson. 1980. *Metaphors We Live by*. Chicago: University of Chicago Press.

Maher, Mary L., and John S. Gero. 2002. Agent Models of Virtual Worlds. In *Proceedings of ACADIA 2002*: 127-138. California State Polytechnic University.

Maher, Mary L., P-S Liew, Ning Gu, and Lan Ding. 2003. An Agent Approach to Supporting Collaborative Design in 3D Virtual Worlds. In *Proceeding of eCAADe 2003*, ed. Wolfgang Dokonal, and Urs Hirschberg: 47-52. Graz University of Technology.

Russell, Stuart, and Peter Norvig. 1995. *Artificial Intelligence: A Modern Approach*. Englewood Cliffs: Prentice Hall.

Stiny, George, and James Gips. 1972. Shape Grammars and the Generative Specification of Painting and Sculpture. In *Proceedings of Information Processing 71*, ed. C.V. Freiman: 1460-1465. Amsterdam: North Holland.

Vinson, Norman G. 1999. Design Guidelines for Landmarks to Support Navigation in Virtual Environments. In *Proceedings of CHI'99*: 278-285. Pittsburgh.

Wooldridge, Michael, and Nicholas R. Jennings. 1995. Intelligent Agents: Theory and Practice. *Knowledge Engineering Review* 10(2): 115–152.

Using Cellular Automata to Generate High-Density Building Form

HERR Christiane M. and KVAN Thomas
Department of Architecture, The University of Hong Kong, Pokfulam, Hong Kong

Keywords: cellular automata, high density architecture, urban morphology, generative design

Abstract: This paper presents an investigation into the use of cellular automata systems for the design of high-density architecture for Asian cities. In this architectural context, urban form is shaped by architectural solutions that are developed in a copy-and-paste manner. To this background, cellular automata are introduced and discussed with respect to the specific potential of cellular systems to support architectural design addressing large projects as well as cost and speed constraints. Previous applications of cellular automata to architectural design have been conceptual and are typically limited by the rigidity of classical automata systems as adopted from other fields. This paper examines the generative design potential of cellular automata by applying them to the re-modelling of an existing architectural project. From this application it is concluded that cellular automata systems for architectural design can benefit from challenging and adapting classic cellular automata features, such as uniform volumetric high-resolution models and globally consistent rule execution. A demonstration example is used to illustrate that dynamic, state-dependent geometries can support an architectural design process.

1 THE CHALLENGE OF VARIETY

Cities characterized by high density living conditions produce distinctive building forms in response to local conditions and needs. Asian cities, in particular, are subjected to ongoing rapid urban growth and increasing urban densities. This often results in mass-production of building form, particularly in the case of residential purposes. In response to high density and spatial limitations, building sizes have continued to grow during the past decades, often accommodating several thousand people per building and frequently more than 100,000 per housing estate. Increased development sizes are typically detrimental to architectural quality since building form is often designed highly repetitively and, under pressure of time and tight budgets, increasingly devoid of individual character. Once developed, building types are often standardised and reproduced in other cities without much architectural rethinking, such that context-insensitive design shortcomings are often also repeated. A building type designed for Hong Kong, for example, may be copied to Singapore, Shanghai or Guangzhou without acknowledgement of climatic,

B. Martens and A. Brown (eds.), Computer Aided Architectural Design Futures 2005, 249-258.
© 2005 *Springer. Printed in the Netherlands.*

economic, contextual or social differences. While efficient in terms of space, the lack of variety in the standard building form leads to monotonous estates. Entire new towns are composed from rigid arrays of identical buildings, regardless of location or the cultural background of the inhabitants (Gutierrez and Portefaix 2004). Monotonous living environments are not only aesthetically challenged but can also have a negative impact on their inhabitants, limiting personal control of living space and forcing inhabitants into conformity with little opportunity for individual expression (Herrenkohl 1981, Evans 2003).

Architectural design for high density urbanism is typically determined by tight economic constraints and building regulations. The latter are typically of a highly prescriptive nature, rigidly determining all aspects of architectural expression from massing to window detailing. With ever-accelerating planning speed and developers' pressure for quick financial return, architects face a design environment that has little concern for variety and architectural quality in the results of their work. Thus, high-density architecture in Asia is dominated by a limited set of building types that closely adhere to the site's so-called *maximum development potential*. It describes the ideal building that will produce the greatest financial benefit to the developer, who in turn bears high economic pressure from competitors. To cope with these requirements, architectural design typically relies on simplified and repetitive standardised solutions, hindering the development of context-sensitive design alternatives and promoting copy-and-paste routines rather than responsive designs.

Figure 1 High-density suburbs of Hong Kong

To deal with the requirements of tight regulations and efficiency while at the same time exploring less rigid and more individual building morphologies, alternative approaches to the design of high-density building form are needed. In response to these demands, this paper proposes the use of cellular automata (CA) as a generative architectural design strategy in particular for high-density residential architecture.

CA can provide an automated approach to the complexity of designing with a large number of similar parts, reducing architects' investment of time and effort spent by architects by replacing top-down controlled design processes with a generative paradigm based on local control. CA also have the potential to assist designers in introducing variety to highly standardised building systems by providing efficient use of already established frameworks of design constraints as well as design and construction processes.

2 GENERATING VARIETY

Dealing with multiple constraints and complex geometrical configurations is a tedious task. To solve this type of design problem, architects need to devote a great deal of time to initially simple initial tasks, which rapidly increase in complexity as they interlink and repeat across large projects. In designing a high-density residential apartment block, architects might for example spend much time in reconciling the spatial layout of an apartment with the maximum permissible length of a fire escape route while considering minimum lighting requirements and restrictions to the site coverage. Once a solution is found, the designer copies this to every floor on the building rather than spending the time to find spatial and structural alternatives at different floor levels. This strategy does not necessarily manifest undesirable outcomes when applied at the scale of a single building, but it very likely results in overbearing monotony if it is applied to an array of 60-storey buildings comprising an entire city quarter or 'new town', as is often the case in recent urban developments in China (Figure 1).

Generative design approaches have emerged from the search for strategies to facilitate the exploration of alternative solutions in design, using computers as variance-producing engines to navigate large solution spaces and to come up with unexpected solutions (Negroponte 1970). In generative design, algorithms are often used to produce an array of alternative solutions based on predefined goals and constraints, which the designer then evaluates to select the most appropriate or interesting. A strength of the computer as a design tool stems from its capability to perform tasks that rely on numerically formalized dimensional or relational constraints. Design decisions that require a more holistic, context-based understanding and judgement are typically left to be decided upon by human designers (Cross 1977). The use of generative approaches in design is motivated in part by the need to manage and express increasing complexity of factors that determine the design processes. In designing contemporary urban environments, a multitude of requirements and constraints have to be observed, that can often overwhelm designers (Negroponte 1970). In this context, CA have received attention from architects as a generative strategy that is characterized by the simplicity of its mechanisms on one hand and the potential complexity of its outcomes on the other (Herr 2003). Driven by local communication between cells over time, behaviour in CA is based on simple rules followed individually by cells arranged within a larger grid. Relying on geometrical neighbourhoods to determine individual cell states, CA are inherently context-sensitive systems. Originally

developed by the mathematicians Ulam and von Neumann, CA have been applied to a wide range of fields to study complex phenomena, ranging from Physics to Geography and have found some application in Architecture as described below. As a generative design tool, cellular CA are typically used in form of volumetric models that transcend traditional types of models in that individual volumetric units are capable of changing their properties according to predefined rules. As with evolutionary approaches to design, CA have been used mainly to explore variations of possible solutions resulting from the tempo-spatial development of initial setups over time. Design constraints are typically implemented in a bottom-up manner in form of simple rules that govern the local behaviour of each cell. The overall outcome of a CA system, however, is often complex and difficult to predict, which results in a design process that emphasises experimentation and exploration of solution spaces. Similarly to shape grammars, CA are characterised by deterministic transformation rules, but dependencies of cell states on adjacent cells provide localized evaluation mechanisms. This characteristic supports local instead of global control models, and is seen as a future opportunity to further generative architectural design (Koutamanis 2000). As a generative design strategy, CA are typically chosen for tasks that involve simple constraints operating on large numbers of elements, where differentiation and variety are sought (Watanabe 2002).

3 CELLULAR AUTOMATA FOR ARCHITECTURE

While CA have been explored in the context of architecture, previous approaches have tended to use existing systems like John H. Conway's *Game of Life*, experimenting with rule sets and interpreting complex spatial results as architectural form. This approach may yield interesting experimental results, but does not address specific requirements of architectural design, which generally involves responding to a design brief, design constraints and to an existing environment. Using CA in architecture further requires an understanding of which types of architectural design tasks can benefit from the application of CA, as opposed to design decisions that require human judgement. Both aspects of CA in design are discussed and illustrated in section 4. Automation of design processes with CA generally relies on numerical descriptions of design constraints or design approaches in which decisions are made according to systematic frameworks. Accordingly, the first architectural design project to bring together a generic understanding of useable space and microcontroller-enhanced building elements is Cedric Price's Generator project (Hardingham 2003). Price approaches architectural space much like a CA system, using volumetric units controlled by both the building's users and by a central computer. In Price's functionalist view of architecture, spaces within a building are generated by and for user needs rather than for their aesthetic values, and the building can change form during usage. A similar interest in form derived from function alone is expressed by Coates et al. (1996), who see their experiments with CA in architecture as the expression of an aesthetic of pure function. Extending Price's generic view of space evident in the Generator project to architectural form in general, Frazer (1995) and his students at the Architectural Association built the

Universal Constructor on an understanding of architecture as logic states in space and time. The system is implemented as a hardware CA system controlled by a host computer that functions also as a human-computer interface. Neither the electronic circuitry nor the cubic geometry of the *Universal Constructor*'s modelling units are designed to directly correspond to architectural concepts other than tempo-spatial logic states. As a generic system, applications of the *Universal Constructor* depend largely on software used in given applications, which maps cubes, their location, their 256 states and neighbouring relationships to built form. Looking for greater differentiation than that achievable with classical two-state automata in their experiments, Coates and his students have also increased the number of possible cell states and emphasise the role of environments and feedback in providing opportunities to develop greater diversity in CA models (Figure 2). Used as form generators without context, CA models tend to produce shapes that display fascinating three-dimensional form but are difficult to adapt to the functional requirements of buildings. Starting the design process with a three-dimensional CA system based on the rules of the *Game of Life*, Krawczyk (2002) deals with this problem by adopting enlarged cells to create contiguous areas in floor plans by overlapping and altering shape edges into curves and by providing vertical supports for cantilevered elements. Post-rationalisation measures of this kind demonstrate that a number of basic premises of classical CA systems may be changed in order to produce meaningful architectural form. While it is possible to use uniform voxel grids at high densities to approximate form, this is rarely useful in architectural design (Mitchell 1990). It can result in the CA system being used to generate form according to only few constraints regarding a particular architectural scale, and requires subsequent manual changes to respond to additional design constraints. This conflict is clearly visible in Watanabe's (2002) 'sun god city I' design, where units of a cellular automaton are arranged according to lighting criteria but many cells lack vertical support as would be required if the model is used for architectural purposes (Figure 2).

Figure 2 Architectural cellular automata by Coates and Watanabe

More design task specific CA systems could also improve computation performance, since CA models at high resolutions can require extensive calculation

time, in particular if less simple rule sets are processed. Using generative CA systems for design tasks further entails the integration of cellular systems with a traditional CAAD environment. As Krawczyk (2002) observes, CA-generated form is likely to be used either in particular aspects or in particular stages of a design project, with the outcomes frequently modified during the design process on the basis of an architect's assessment. Attempting to design rule sets that are sufficiently specific to generate complete buildings defies the characteristic simplicity of rules in CA systems, which is one of the primary reasons to apply CA to design. In summary, CA offer ways to use simple rules in coping with quantifiable constraints, and can handle rather complex geometrical relationships due to transition rules operating according to local cell neighbourhoods. In a generative design tool, these features are well suited to tackle typical design problems in high-density architecture (Herr 2003). Previous research on the subject has tended to focus on developing an abstract and reductionist notion of architecture compatible with theoretical mathematical models. Frazer (1995), for example, has expressed the notion of architecture as 'logic in space'. Instead of attempting to bring architecture closer to mathematical abstraction, however, modifying mathematical paradigms to suit architectural design purposes promises results at a more immediate and practical level. Other generative paradigms have successfully demonstrated their architectural potential by remodelling design precedents, as for example shape grammars have been used to generate Chinese ice ray lattices, Palladian villas and buildings by Frank Lloyd Wright. In the case of CA, implementations have thus far been mainly conceptual studies. To illustrate the generative potential of CA in the context of high-density architecture, we have chosen to remodel an architectural design comprising a group of buildings proposed as a high-density city block in northern Japan (Figure 3).

Figure 3 High-density architecture for Aomori/Japan by Cero9

The implementation is primarily intended to give an example of how a flexible, modular and open-ended use of CA systems can be effective as generative tool in combination with manual design decisions.

4 DESIGNING WITH CELLULAR AUTOMATA: AN EXAMPLE IMPLEMENTATION

The competition entry chosen for remodelling was designed by the Spanish design team Cero9 in 2001. It proposes a high-density urban block for the city of Aomori in northern Japan, developing the given site as a high-density mixed use complex in form of an array of thin, 25-storey 'micro-skyscrapers'. Architecturally, the design is based on a cellular understanding of building form where cells contain single living units and are easily identifiable visually, facilitating a rather straight-forward CA approach. For larger projects such as this one, Cero9 typically use a rationalised design process that aims at generating variety from simple rules, which are applied in successive design stages according to design constraints and project context. As three-dimensional modelling software, AutodeskVIZ was used, with additional scripts that provide CA functionality. To remodel Cero9's design in a generic way, aspects and stages in the design dealing with quantifiable constraints were first identified according to Cero9's (Diaz Moreno and Garcia Grinda 2004) own description. To accommodate both generative and traditional design procedures, the implemented cellular automata may be used in phases, with intermittent stages of manual design interventions. Cell behaviours can be assigned dynamically during the design process, such that elements within the modelling environment can change their behaviour over time. In contrast to classical CA, where cells are uniform and cell states do not affect cell geometry, CA functions can be assigned to any element in the modelling environment, with cells able to change their geometry in response to their states. Compared to a conventional generic high-resolution approach, this non-uniform solution greatly limits the number of cells required in modelling architectural geometries and avoids the restrictions imposed by the compulsory use of additive approximation based on homogeneous grids of elements. To accommodate flexible cell geometries and changing behaviours during the design process, cell neighbourhoods are identified dynamically, depending on the cells and functions in operation.

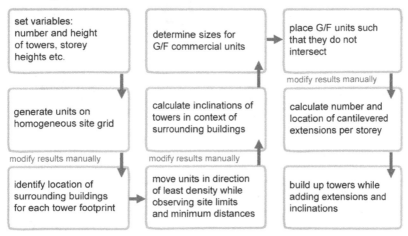

Figure 4 Rule-based sequence of generative design process

Using Cellular Automata to Generate High Density Building Form

The generative sequence in this example begins with rearrangement of two-dimensional building footprints on the site, which grow into three-dimensional plant-like structures at a later stage. Following the design sequence described by Cero9, CA functions of elements in the digital model were found to be useful in a variety of tasks: The arrangement of towers on site constrained by available views and existing buildings surrounding the site, modifications of tower locations to accommodate tower inclinations, finding appropriate locations for commercial and community spaces connected to the towers, and the placement of local extensions to some of the living units (Figure 4). Design decisions not affected during CA execution include the cellular layout, which determines the characteristic tower footprint and the number of buildings on a site, while other variables and the assignment of rules to individual cells are decided upon during human intervention between CA execution phases. Elevated connections between individual towers, for example, were added manually at a later design stage. The modular character of the generative cellular design tool allows modification of the results during the design process without the need to change the design tool, as it would be necessary in a self-contained, deterministic CA environment. The generative functions implemented in this example operate mainly at the level of residential unit 'cells', but they could just as well be applied to similar problems on different levels of scale, depending on the modelling environment they are assigned to.

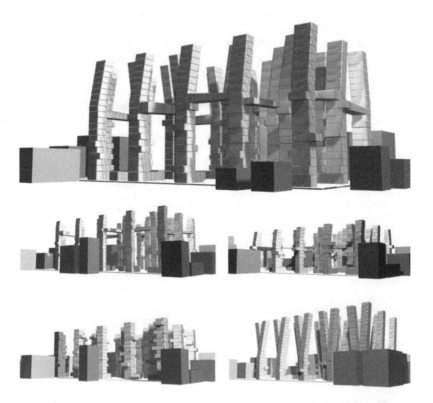

Figure 5 Alternative cellular automata-generated versions of Cero9's design

256

For the purpose of a single project, developing a generative tool such as this example implementation will take longer than traditional design by hand. In the case of large high-density developments, however, repeated use for a variety of solutions (Figure 5) sustains additional time and energy spent in tool development.

5 CONCLUSION

As other authors have previously established, CA offer an effective generative method where architectural projects involve some degree of repetition amongst larger numbers of formal elements. Applying CA to the specific context of high-density housing as shown in the discussed example implementation has resulted in several observations that can be generalised within the context of architectural design. Particularly in the context of Asian high-density architecture, generative CA systems can offer design solutions to large-scale developments and simultaneously meet demands for high speed and efficiency in the design process. The development of a powerful CA system might easily require more resources than the application of traditional design methods to a given design project. Repeated application of a generic CA system to a class of projects, however, potentially yields great economic efficiency while individual designs will show context-sensitive variation. Architectural design projects benefit from looser, more paradigmatic interpretations of classical CA features. In this sense, pragmatic design considerations appear to increase the generative utility of CA systems much more than the strict adherence to features of classical CA systems in their ideal forms. To apply CA to specific problems, classical CA properties are often changed according to their intended use. Such modifiable features include the number of automaton states, the number of rule sets and their change over time. Other options exist, which seem specifically useful in adapting CA systems for increased usefulness in architectural design projects. These include the introduction of human intervention, atypical or dynamically changing definitions of neighbourhoods, variance or omissions in the sequence of automaton execution as well as automata arrangements beyond simple grids and more complex and dynamic cellular geometries. Making use of the latter (mapping automata states to dynamic cellular geometries) in the discussed project has effectively allowed geometric variation and might offer a general alternative to CA-based form finding using high-resolution systems at high computational efficiency.

REFERENCES

Coates, P., N. Healy, C. Lamb, and W.L. Voon. 1996. *The Use of Cellular Automata to Explore Bottom-Up Architectonic Rules*. Paper presented at Eurographics UK Chapter 14th Annual Conference held at Imperial College London, 1996.

Cross, Nigel. 1977. *The Automated Architect*. London: Pion.

Diaz Moreno, Cristina, and Efren Garcia Grinda. 2004. Soft Metropolitanism [Apartments in Micro-Skyscrapers]. In *EL CROQUIS 118: CERO 9, ABALOS & HERREROS, NO.MAD*, ed. F. Marquez Cecilia, and R. Levene: 140-1147. Madrid: El Croquis.

Evans, Gary W. 2003. The Built Environment and Mental Health. *Journal of Urban Health* 80(4): 536-555

Frazer, John Hamilton. 1995. *An Evolutionary Architecture*. London: Architectural Association.

Gutierrez, Laurent, and Valerie Portefaix. 2004. Houses for China. *Architectural Design: Property Development and Progressive Architecture: The New Alliance*, ed. D. Sokol: 81-87. Vol. 74 No. 1 January/February 2004. London: Academy.

Hardingham, Samantha (ed.). 2003. *Cedric Price: opera*. Chichester: Wiley-Academy.

Herr, Christiane M. 2003. Using Cellular Automata to Challenge Cookie-Cutter Architecture. In *The 6th International Conference on Generative Art 2003*, ed. C. Soddu: 72-81. Milano, Italy: Generative Design Lab, DiAP, Politectnico di Milano University.

Herrenkohl, R.C. (ed.). 1981. *Social Effects of the Environment*. Council on Tall Buildings and Urban Habitat: Volume PC Planning and Environmental Criteria Chapter 37.

Koutamanis, Alexander. 2000. Redirecting design generation in architecture. In *The 3rd International Conference on Generative Art 2000*, ed. C. Soddu. Milano, Italy: Generative Design Lab, DiAP, Politectnico di Milano University.

Krawcyk, Robert. 2002. Architectural Interpretation of Cellular Automata. In *The 5th International Conference on Generative Art 2002*, ed. C. Soddu: 7.1-7.8. Milano, Italy: Generative Design Lab, DiAP, Politecnico di Milano University.

Mitchell, William J. 1990. *The logic of architecture: Design, computation, and cognition*. Cambridge, Mass.: MIT Press.

Negroponte, Nicholas. 1970. *The architecture machine: Toward a more human environment*. Cambridge, Mass.: MIT Press.

Silver, Michael. 2003. Traces and Simulations. In *Mapping in the age of digital media: the Yale Symposium*, eds. M. Silver, and D. Balmori: 108-119. Chichester, Wiley-Academy.

Watanabe, Makoto Sei. S. 2002. *Induction design: a method for evolutionary design*. Basel, Birkhäuser.

Dynamic Generative Modelling System for Urban and Regional Design

Background and Case Project

CANEPARO Luca, MASALA Elena and ROBIGLIO Matteo
Department of Architectural Design, Politecnico di Torino, Italy

Keywords: large-scale modelling, participatory design, GIS, software agent, datascape

Abstract: This paper introduces a dynamic generative modelling system for urban and regional design. Through dynamic modelling the system evolves in time according to the interactions of the planners, decision-makers and citizens. On the basis of several synchronous and/or asynchronous user interactions, models are dynamically generated at run time. The models are built by defining the data (datasets) and the actions to perform on that data (tasks). The system reads and correlates data at urban and regional scale from various authorities to generate dynamic datasets. Tasks are especially powerful when they integrate generative procedures in a hierarchical structure. This allows us to model urban and regional dynamics through the interaction of tasks at micro- and macro-scale. Tasks can also implement either Cellular Automata or software agents. We examine the system application to a case project: the simulation of micro- and macro-dynamics in an Alpine valley, with specific challenges to fit competitive and sustainable growth in a landscape quality perspective. The simulation in spatial and temporal dimensions of regional data provided us with the elements to study the territorial evolution over the next twenty years. Four strategies gave as many scenarios highlighting the results of specific policies.

1 INTRODUCTION

The research project brings together two fields: the study of complex dynamic systems through emerging synthesis and the use of participatory design as a pioneering approach to modelling systems.

In the framework of the emerging synthesis, the dialogue and the interaction in urban and regional design are modelled as processes that evolve and change in time. Not only do we have to consider space-place or time events, but urban and regional dynamics are also factors with which to formulate the temporal and spatial emerging of cities and regions. The process notion requires an increased awareness of numerous and simultaneous interrelations among the factors involved in the design: from the individual to the social, from the building to the city and the environment. The emerging synthesis, applied to trans-disciplinary fields, such as physical and natural sciences, has developed new research methods and tools. For the design

B. Martens and A. Brown (eds.), Computer Aided Architectural Design Futures 2005, 259-268.

processes, these experimental methods mark the distance from any positivist mechanism, whose automatic and autonomous assumptions produce specific design results: simulation as the algorithmic automation of a design process. Simulation is used in these practices through an interactive process, across policy, planning and design. The method can be outlined by choice → simulation → evaluation → adaptation / modification → choice → … The design process advances by means of either successive corrections and adaptations or, if needed, by radical changes of strategy. This methodological conception is far from an algorithmic formalisation and is closer to the concept of method as strategy: «a global scheme within which actions must take place» (Gabetti 1983).

To accomplish these goals, we introduce a dynamic generative modelling system for urban and regional design. By dynamic modelling we mean a system that evolves in time according to the interactions of planners and all others involved. In the following sections of the paper, we introduce the project and examine a case study at a regional scale.

2 THE GENERATIVE MODELLING SYSTEM

With CAD systems, models are created at design time. We, on the other hand, are committed to dynamically generating models according to synchronous and/or asynchronous user interactions. Our approach relies on a generative system: a software generating design proposals at run-time. The system implements a generative description – a.k.a. *workflow* – where *datasets* are associated to *tasks* to perform on that data.

2.1 Datasets

Urban and regional datasets, intended as structured data describing a reality, often already exist, but may be spread over different formats, sources and ownerships.

Figure 1 Scheme of the system for generating dynamic datasets from different data owners

We have developed a method and a computer system to read and correlate these data from various authorities (Figure 1). For instance, the available data could be images from aerial or satellite or ground surveys, CAD models of buildings and infrastructures, digital terrain models, regulatory plans, Census, Registry or Local Tax information.

2.2 Tasks

To compute a task, it is necessary to group and relate different datasets, both in input and output. It is possible to have more than one input dataset, which can also be derived from previous output. Tasks are especially powerful when they integrate generative procedures in a hierarchical structure (Figure 2). Several hierarchical structures can coexist, for instance spatial, temporal and scale hierarchies.

Figure 2 The hierarchical structures of the generative procedure

The *spatial hierarchy* influences the morphology of a model. For example several tasks can be structured in order to define these relationships: the plan of a building from GIS or CAD data, the number of its stories from a census database, the terrain elevation from a digital terrain model, the texture of the roof from an aerial photograph. But it can also define how to stack the stories, how they are connected with the roof, or how to map the textures. These tasks can propagate downward in the hierarchy to lower levels and spread over the full urban or regional extent. Datasets, resulting from a task, can also be reiterated in other tasks. In this way, a small number of tasks can usually generate a wide variety of models which, according to our experience, can be fine-tuned to cities and regions in different countries.

In the *temporal hierarchy*, tasks can be defined to model the temporal evolution. This simulation is possible through computing or imaging pre-figuration. For instance, in one case project after we mapped an area on a rectangular grid, we proceeded to associate each cell to a vector by which we defined its status, while the transition rules defined its evolution in time. The results have been useful in representing the consequences of planning decisions.

Concerning the *scale hierarchy*, our present approach is to simulate urban and regional dynamics through the modelling of different interacting processes at various scales: at the macro-scale long term, large scale dynamics of the area are modelled, whereas at the micro-scale individual decision-making is the starting point for urban and regional generation.

2.3 Workflow

Our system defines the relationships between its different datasets and the tasks in the workflow. It is executed at run time to create detailed, generative and dynamic models of large areas. Because the workflow is limited to defining relationships and tasks, the very nature of the system is interactive. It rapidly propagates not only the resulting changes in the datasets or tasks, but also the apposite tasks which represent time dynamics or user interactions at macro- and micro- scales to the model.

3 INTERACTING TASKS

Our approach to model urban and regional dynamics is through the interaction of tasks at different scales.

3.1 Macro-Scale

At macro scale, the urban and regional dynamics are treated in the formal Cellular Automata definition (von Neumann 1963, Wolfram 1994) as cells in a n-dimensional grid-based lattice with n equal to 2 or 3. Hierarchical tasks can easily implement spatial grid structures, i.e. 2- and 3-dimensional lattice. The model space is anisotropic: to each cell is associated a vector representing respectively current use, location, accessibility and zoning status of the area, making it more or less suitable for development. System dynamics are determined by transition rules which map the current state of a cell's neighbourhood at subsequent time steps. Conventionally the task implementation of the dynamic is:

$$s_{i_{t+1}} = f\left(s_i g_{j_t}^n\right) \qquad (1)$$

where s_i is the state of a given cell i at time t + 1, $f()$ determines the "local" (or neighbourhood) function for a finite region g (of neighbourhood size n) in the vicinity of the cell j at time t. The core question is the $f()$ function, that composes the transition rules. Cities and regions do not behave like cells. To be more precise, they mutate in time due to anthropic factors and thropic processes. Furthermore, the hypothesis of autonomy, as is implicit in the paradigm of cities and regions as self-organising systems, is a leading factor to commitment to innovative planning and design practices. From this point of view, a mere cellular automata modelling approach was hardly justified, especially where transition rules exemplify anthropic factors. We have thus opted for the interaction of tasks at different scales: at the socio-economic scale by Cellular Automata and at the morphological scale by human agents and their system representation by software-agents.

3.2 Micro-Scale

At the micro-scale cities and regions are generatively modelled from individuals' decisions. The approach is bottom-up, starting with the decision-making processes. The tasks are assigned to software agents, which can represent the individuals. The agents move and act in the city/region, and interact among themselves socially. During model run time, the agents are requested to make decisions, to establish social relationships and to define the strategies whereby they can achieve personal and/or collective benefits. In their actions there are two recognisable main orders of relationships: 1) *collaborative,* behaviour that concurs to determine the settlement-building of collectives services, e.g. schools, hospitals, bus stops, parks, parking lots; 2) *competitive,* behaviour oriented towards the market, real estate and personal profit on the model of the "Monopoly" game or of stock market simulators.

4 CASE PROJECT

Until now, the methodology and system presented here have been applied to a number of projects at different scales. For instance, it has been used at the urban scale for evaluating the transformation of a central area in the city of Torino, Italy. This project involved the re-functionalising of an old industrial area into a new cultural centrality by changing the infrastructures and building new centres and complexes. Here we present a project on a regional scale: the possible evolution scenarios of an Alpine valley (Val di Susa, Italy), which needs to re-program its future, in search of a competitive and sustainable growth in a landscape quality prospective. Crossed by main road axes, highway, railways and a river, the region is structured in the form of a long corridor compressed along its infrastructures.

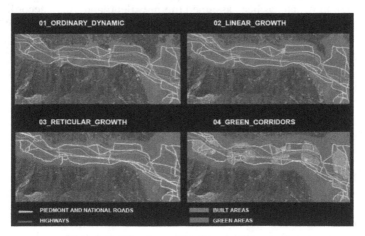

Figure 3 The four ideal/typical scenarios

The study concerns a $1\,000$ km^2 area, where the main unresolved problem is the relationship between the regional infrastructures and the settlements. The generative modelling system was thus directed at creating four ideal/typical scenarios (Figure 3) that were not merely future scenarios, but real projections of development options over a twenty year period.

4.1 Macro-Scale Tasks

Specific instances of the *Tasks* (cf .3) have been defined to implement the general definition of Cellular Automaton (1) in the system: a software agent a relates to an object c that represents the attributes of a cell at time t. In the current project, the attributes of the cell-object c are: Land use L, Zoning Z, Accessibility A and an aggregate value defined as Suitability U. Every agent a implements a set of Transition Rules T, specifying the changes of non-spatial states, i.e. L, Z, A and U.

The agency system for this project has been defined in:

$$A \sim (S, T_S; L, C_L; R, N_R) \tag{2}$$

The first pair denotes a set of states S, associated with the agent, and a set of state transition rules T_S, used to determine how agent states should change over time. The second pair represents the location L of information of object c C_L. R specifies the neighbors of the agent and N_R represents the neighborhood transition rules that govern how agents relate to the other agents in their vicinity. According to this definition (2), state transitions and changes in location for an agent depend on the agent itself and on the input, given by the states of the neighboring agents and objects.

At the macro-scale the region has been mapped on a grid of one hectare cells (100 by 100m side), to which has been assigned the prevalent land use L, according to the revised CORINE land cover (Bossard et al. 2000). Zoning Z is based on 1990-2000 Regulatory Plan of every Commune. Local Accessibility A to cell c is computed considering the kind of the network or the type of link within the network. Finally Suitability U is the geocomputation of the amenities at c as the weighted mean of the local visibility, the desirability of the neighborhood (e.g. parks, recreation etc.) and solar radiation.

4.2 Micro-Scale Tasks

The aim of the Micro-Scale Tasks is to develop a full three-dimensional model of the region at every evolution time step. The system is based on interacting agents to which specific design tasks are assigned and which they are committed to meet. In this case project the agents can be defined as: a) *autonomous*, because they are able to meet autonomously their own design tasks; b) *situated*, because they relate to a specific portion of the region; c) *reactive*, because they perceive the environment through communication with other agents and from its representation, i.e. datasets.

They also react according to their design tasks. The implementation relies on agent roles and *role models* for describing agent systems. Each role describes a position and a set of responsibilities within a specific context or role model. Role models are inspired by the work of Kendall (1999), which formalises the definition of an agent role so that it can be modelled and implemented. The role models and typologies of tasks defined for this case project are:

- *Floor Area Ratio*: for a given cell c is the ratio of useable floor area to the land area from the Property Parcels. The inputs are from both agents a, the Property Parcels and a possible Regulatory Plan dataset. The task is defining a ratio, e.g. 1 suggests that one story building covers the entire site, 2 story building covers half the site and so on.

- *Property Parcels*: trade alternative aggregations of the parcels to define a site. The inputs are from Floor Area Ratio and Building layout. The task is to meet a building layout possibly across several parcels. These parcels have to be cleared because the area of the building footprint must be considered in its number of stories to fit a Floor Area Ratio.

- *Accessibility*: for a given parcel is the local measure according to the typology of transportation means and its proximity. The inputs are from Property Parcels and Infrastructure dataset. The task is the computation of the local accessibility to a parcel.

- *Building design*: generatively modelled from a given library of typologies. The inputs are from the Floor Area Ratio, the Property Parcels, the Accessibility and the Regulatory Plan dataset, if any. The task is to fit a typology to generate a building footprint on one or more adjacent parcels to meet the Floor Area Ratio.

Each of the defined roles is played by an individual agent that can collaborate or compete (cf. 3.2) with other agents to accomplish a common task. Once role models and tasks have been designed, the system automatically translates the role-specific solutions into agent descriptions. From the agent descriptions the Agent Generator can generate an individual agent, assigning to it a situated and specific task, e.g. a specific cell from the macro-model or a property parcel from a tax dataset.

4.2.1 Building Design Agents

A Building design agent sets the relationships: a competitive one with the Floor Area Ratio agents for defining the highest ratio possible, and a collaborative one with both Property Parcel and Accessibility agents to optimise respectively the building plan in a site layout and the access to the infrastructures. An example of working relationships is fitting the ratio of a building Floor Area to Accessibility. To define a building plan the system implements a library of typologies for each instance of the Land Use L. For every building typology the following parameters are defined: a) building width and length, relating to construction technologies; b) the ratio between building footprint and number of stories; c) possible joint at the

corners; d) the span from a front and a side of site. Table 1 illustrates some instances with their symbolic and photo-realistic representations.

Table 1 Land use and library of typologies

Land Use L	Symbolic representation	Photo-realistic representation	Height
Residential continuous dense urban fabric			12m
Residential continuous medium-dense urban fabric			9m
Residential discontinuous urban fabric			7m
Residential discontinuous sparse urban fabric			6m
Industrial areas			6m
Commercial areas			6m
Public or private services			6m

4.3 Ordinary Dynamic Scenario

This is a detailed look at just one of the four ideal-typical scenarios, the one defined as "ordinary dynamic". In this scenario the constraints posed by the Regulatory Plans are relaxed and the dynamics of the region are generated for the next twenty years. The system allows the users to navigate inside the scenario at different time steps. To understand the dynamics better, it is possible to set two windows side-by-side, each on a different time step. Figure 4 shows the same scenario presented at respectively the year 2000 and 2020. The scenario dynamic highlights a large number of new settlements and a sprawling trend along the main longitudinal axes.

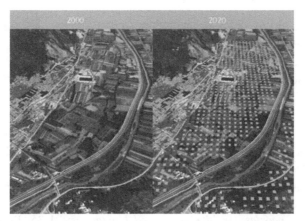

Figure 4 Synchronised views of the Ordinary Dynamic Scenario: 2000 vs. 2020

5 CONCLUSION

Dynamic generative modelling represents an innovative methodology for sharing knowledge through scenarios. In the case project considered, dynamic generative modelling has proven to be an effective metaphor of argument and narrative: our methodological commitment is simulating as a medium for dialoguing with real people (Guhathakurta 2002) about their expectations, projects, interests as well as frustrations in the city/region. To this aim, our experimentation in case projects has been oriented to generating ideal-typical scenarios. This has been pursued to the conscious detriment of realistic representation in the models, because spatial and temporal evidence would extend and encourage public discussion and participation by means of an intuitive, yet rigorous, visual language. Because social systems are so complex and cannot be accurately predicted, we promote interactive modelling to understand the dynamic, as open and transparent decision making processes: not as forecasts, but as one possible future.

Dynamic generative modelling has proven to be a working tool for both communities and decision-makers. The case projects have taught us that complex

social systems can be profoundly influenced by a pervasive access to information. Thus we are considering the sharing of urban and regional "knowledge" through interactive modelling, not just as a communication tool, but also as an integral part of the design and planning processes.

REFERENCES

Batty, M., and Y. Xie. 1994. From cells to cities. In *Environment and planning B*, 21: 31-48.

Bossard, M., J. Feranec, and J. Otahel. 2000. *CORINE land cover technical guide - Addendum 2000*. Bruxelles: European Environment Agency.

Couclelis, H. 1997. From cellular automata to urban models: new principles for model development and implementation. In *Environment and Planning B*, 24: 165-174.

Engelen, G., S. Geertman, P. Smits, and C. Wessels. 1999. Integration of GIS and Dynamic Modelling for Regional Planning. In *Geographical information and planning*, ed. Geertman, S., S. Openshaw, and J. Stillwell: 87-111. Berlin: Springer-Verlag.

Franklin, S., and A. Graesser. 1996. Is it an agent, or just a program?: A taxonomy for autonomous agents. In *Proceedings of the Third International Workshop on Agent Theories, Architectures, and Languages*: 21-35. Berlin: Springer-Verlag.

Gabetti, R. 1983. Progettazione architettonica e ricerca tecnico-scientifica nella costruzione della città. In *Storia e progetto*, ed. Roberto Gabetti et al.: 47-96. Milano: Franco Angeli.

Guhathakurta, S. 2002. Urban Modeling as Storytelling: Using Simulation Models as a Narrative. In *Environment and Planning B*: 985-911.

Kendall, E.A. 1999. Role model designs and implementations with aspect-oriented programming. In *ACM SIGPLAN Notices*, October: 34-10.

Louis, E.A., and A.K. Graham. 1976. *Introduction to urban dynamics*. Cambridge, Mass.: Wright-Allen Press.

von Neumann, J. 1963. The general and logical theory of automata. In *Collected Works, Design of computers, theory of automata and numerical analysis*, ed. von Neumann, J. and A. H. Taub: 288-328. Oxford: Pergamon.

Wolfram, S. 1994. *Cellular Automata and Complexity*. Reading, Mass: Addison-Wesley.

Turning the Design Process Downside-up
Self-organization in Real-world Architecture

SCHEURER Fabian
Chair of CAAD, ETH Zurich, Switzerland

Keywords: self-organization, emergent design, spatial structure, dynamic simulation

Abstract: This paper describes the latest results of an ongoing research project that aims at using the power of self-organization for the design and optimisation of irregular spatial structures in real-world applications. An example is presented, which uses a growing swarm to define the configuration of randomly positioned columns in a large concrete structure. This agent based simulation, developed in cooperation with the building's architects and engineers, was successfully used in the final design stage of a project in the Netherlands to resolve the conflicting structural and functional requirements arising from the initial design.

1 INTRODUCTION

Irregular spatial structures seem to be a rising phenomenon in contemporary architecture. Recent examples include the "bird's nest" hull design for the Chinese National Stadium by Herzog & de Meuron (ARUP 2004) the "foam" structure of the Chinese National Swimming Centre by PTW Architects (Bull 2004) and the "fractal" façade of the Federation Square complex in Melbourne by Lab Architecture Studio (Lab-Architecture 2001). As the descriptive names suggest, the form of those structures is often inspired by natural processes. The design is based on a metaphorical idea and a limited number of components: welded nodes and steel beams in the case of the Beijing stadiums, glass and stone panels at Melbourne's Federation Square. However, they are not – or not at first sight – repetitive in the sense of classical machine production but consist of highly individual parametric parts and pose immense challenges to realization.

Thanks to the advances in computer aided manufacturing (CAM) it is possible to produce large numbers of parametrically shaped parts at reasonable cost. But CAM requires exact production data, and defining the exact location, orientation and geometry of structurally and functionally interdependent components has become a big challenge. This is especially true when the arrangement of those components is important equally for the aesthetic impression and the structural integrity of the building. The complexity of the building process shifts from the production phase towards the design phase.

B. Martens and A. Brown (eds.), Computer Aided Architectural Design Futures 2005, 269-278.

One way to handle this is to reduce complexity by using geometries that are repetitive on a level that is not recognizable at first sight, like in the mentioned examples by Lab and PTW. This paper shows – by example of a real world project – how a design idea based on a naturalistic metaphor, can be realized by using an agent-based approach to deliver exact data of a *non-repetitive* structure.

2 GROWING A FOREST OF COLUMNS

In early 2003 KCAP, the Rotterdam office of architect Kees Christiaanse, approached the chair of CAAD at the ETH Zurich with a request to help them growing a "forest of columns". KCAP had been awarded the contract to design a large semi-underground bicycle parking facility with a pedestrian area on top for the main railway station in the Dutch city of Groningen. The proposed design consisted of a large concrete slab with a number of openings and incisions for ramps and stairs, which was held up by some 150 slender columns. To increase the notion of lightness those columns should not be aligned in a regular pattern but stand in random positions, be of three different diameters and gently lean in arbitrary directions – just like trees in forest (see Figure 1). Since the form of the slab, the position of stairs and ramps, the paths for cycling and walking and the locations of the bike stands had already been more or less defined due to outside conditions, the challenge was now to find the optimal arrangement for the columns.

Figure 1 Design sketches (by permission of KCAP)

2.1 Defining the Task

The architects at KCAP were facing a complex puzzle: they had to exactly define the position, inclination and diameter for over one hundred columns so that the following functional and constructive requirements were fulfilled:

- No column should obstruct a predefined walking or cycling path.

- The diameter (and resulting bearing capacity) of each column had to be sufficient for the portion of the slab it was holding up – depending on the distance to its neighbouring columns.

- The distance of the columns had to be aligned with the spanning and cantilevering capacity of the slab, especially at the edges and nearby expansion joints.

- The columns in the centre part of the structure were required to stand closer together because of glass blocks within the concrete slab (reducing its spanning capacity).

- The number of columns and their diameter should be minimised, saving costs.

Not only were the properties of a single column mutually dependent (changing the inclination would change the positions of the column's head and foot) but every change in a column would directly influence its surrounding (the column's bearing capacity influences the optimum distance to its neighbours). Therefore every change in a single column would propagate through the whole structure and eventually influence every other column.

Knowing full well that the slab design was still subject to slight changes, and that every change in the layout would mean to redefine the properties of every single column, KCAP was looking to automate the placement of the columns. KCAP undertook a parametric approach to the design as they already had experience in the design of irregular structures on another field. In the year 2000 KCAP and the University of Kaiserslautern began the "Kaisersrot" project to develop new methods of urban development based on bottom-up principles. To allow rapid testing of design rules, CAD software tools were programmed which enabled the planners to systematically describe inter-dependencies in urban structures and iteratively generate urban plans according to rules and user interactions. The main focus was on the dispersion of plots within a larger development area following the conflicting demands of the plot owners (Kaisersrot 2004). The similarities to the dispersion of columns under a slab seemed to be obvious.

2.2 Designing a Dynamic Model

The simulation of complex adaptive systems like cellular automata and swarms has been widely used to explore spatial organisation (Coates and Schmid 1999, Frazer 1995, Krause 1997, Miranda, Carranza and Coates 2000). Following the concept of Kaisersrot, the basic idea for the solution of the Groningen project was to create a simulation that takes every column as an autonomous agent that tries to find its place within a habitat, competing with the other agents and governed by the local criteria mentioned above. However there was one important difference: in the Kaisersrot project the number of agents was fixed, here the number of columns should be an outcome of the optimisation process. The agents therefore had to be created "as needed" at run-time of the simulation, demanding for an additional mechanism of birth (and dead). In a first step, an abstract definition of the simulation was defined, closely modelled after the requirements described in Section 2.1.

2.2.1 The Habitat

The habitat is the part of the system that is designed entirely top-down: by the formal and functional requirements of the architects' design:

- The outline of the slab with the incisions for the stairs and ramps;

- The locations and diameters of the holes in the slab;

- The location of two expansion joints cutting through the slab;

- The centre lines of the defined walking and cycling paths;

- The distance between the floor and the slab (the height of the basement).

Also in the habitat the most important global parameters are defined: The spanning and cantilevering capacity in different parts of the slab. The values have been calculated by the engineering partner of the project, the Amsterdam office of Ove Arup and Partners and were translated into two properties:

- The optimum distance of two columns in regard with their diameters;

- The optimum distance of a column to the slab edge or an expansion joint in regard with its diameter.

By translating the constructive real-world requirements into these two "rules of thumb", the state changes of the model could be calculated very quickly and at a sufficient accuracy while also ensuring that whenever it reached a state of equilibrium, it was complying with the constructive needs and therefore "buildable".

2.2.2 The Column Agents

The state of an agent is defined by the locations of its top and bottom end and its diameter, which can be of three different predefined values. It is moving in the habitat according to the following rules:

- Both ends of each agent can move freely within the horizontal planes defining the floor and the slab, but the agent tries to keep its inclination angle below a given threshold value by vertically aligning its ends.

- Each agent tries to keep clear of the walking and cycling paths by moving its bottom end away from the paths' centre lines. In combination with the last rule this also "drags" the top end away.

- The movement of the top ends is confined by the area of the slab outline and the desired distance to the edge is defined by the cantilevering capacity of the slab. The same principle applies at the expansion joints and the holes.

- Each agent tries to hold its neighbouring agents at an optimal distance in regard to the local spanning capacity of the slab and the bearing capacity of the columns. The distances are calculated by a "rule of thumb" that associates a circular part of the slab to the top end of each column, according to its bearing capacity.

Figure 2 Relations between agents and environment

In order to adapt to their environment, the agents are able to change not only their location, but also their internal state using the following mechanism:

- The agents measure the "pressure" which is applied to their top ends by close neighbours and the slab's edges. If it exceeds a certain threshold there are obviously more columns around than needed. It may reduce its diameter and therefore its bearing capacity by one step, allowing its neighbours to come closer (Figure 3 top-right). Conversely, if an agent encounters too little pressure, there are not enough columns around to hold up the slab. It may increase its diameter by one step and therefore its bearing capacity, trying to bear a larger portion of the slab (Figure 3 top-left).

- If the pressure does not drop after the agent reached its smallest state, it may eventually "die" and completely remove itself from the habitat to make room for the others, decreasing the number of columns (Figure 3 bottom-right). If the maximum diameter is reached without generating a sufficient surrounding pressure, the agent "splits" into two agents of the smallest diameter, increasing the number of columns (Figure 3 bottom-left).

Figure 3 Growth and death of column agents

2.3 Programming the Simulation

This abstract model was then used to develop a computer simulation model. The main requirement for the program was to be interactive, e.g. the designer should be

able to directly interfere with the running simulation by changing parameters and positions of single columns. As a result a graphical user interface was required which presented the results of the simulation to the user, preferably in three dimensions, and provided input facilities for the relevant parameters. It also had to be dynamic, and responsive, doing at least 10 simulation steps per second. This was achieved by programming the simulation in Java and using the Java 3D API for real-time rendering.

The definitions for the dynamic behaviour of the agents given in Section 2.2.2 were translated straightforwardly into a particle simulation with springs, attractors and repellers. Particle dynamics are a simple but powerful way of simulating the behaviour of objects that have a mass but no spatial extent (Witkin and Baraff 1997). By connecting particles with damped springs, complex non-rigid structures can be easily simulated, as has been used for example in real time structural analysis (Martini 2001). In computer graphics, Greg Turk (1992) used particle systems to re-tile irregular surfaces by evenly distributing particles on the basis of local repulsion, here it is used to disperse columns. The top and bottom ends of a column are particles connected by a spring, which tries to align them vertically (This spring resembles the actual column, rendered in the 3D view of the simulation). A circular area around the top end marks the virtual bearing capacity of the column, which is dependent on the column diameter. The column tops are repelling each other by force fields which try to keep the distance so that the circles of neighbouring column tops just touch. The edges of the slab and the expansion joints are linear repellers, pushing the column heads away, the centrelines of the paths do the same for the column feet. The openings in the slab are defined as repeller points. The adaptation of the column diameter and the splitting and dying is triggered by changes in the pressure and agent experiences by neighbours and other repellers The pressure is accounted by simply adding up the pushing forces applied to the top of the column. A similar mechanism to adapt the state and number of particles has been used in computer graphics to sample implicit surfaces (Witkin and Heckbert 1994).

2.4 Letting Loose the Columns

Since they are able to multiply, it is sufficient to start with a single column that is thrown randomly into the habitat. It will immediately start growing and eventually it will split into two small columns and so on. Just after twenty cycles (approx. 2 seconds) the whole slab is filled by the bearing circles of the columns (Figure 4). A colour coding in the display of the running simulation is based on the kinetic energy of the column tops, marking the hot spots where still a lot of pushing is happening in red whereas the parts of the slab that already found an equilibrium state are blue. Other colour schemes visualize the distribution of the three column diameters and the inclination angles of the columns to identify problem zones at runtime.

Figure 4 Screenshot of the running simulation

The model can be influenced by changing the various parameters, for example the strength of the repelling forces, the minimum distances from the path lines and a viscous drag that globally slows down the movement of the columns. It is also possible to pick single columns and drag them to desired locations while the simulation is running.

2.5 From Generating to Building

The development of the software was done in close cooperation with the architects and engineers and over a number of iterations the model was gradually refined to a final state. Because the designers were familiar with the development versions of the program, they were able to work with the final version almost immediately. It took only about a day to create a few alternative versions of column placements. These parametric designs were then checked by the engineers using finite element simulations to pick out the best performing design. To our relief only a few minor (and local!) corrections had to be made before the design could be finalized. Construction work on the site started in the autumn of 2004 and the building should be finished by mid 2005.

3 RESULTS

Apart from the physical construction that is materialising at the Groningen main station, much knowledge has been gained through this showcase project. The most important issues are briefly described in the following section.

3.1 Design for Emergence

As in any agent based simulation that is aiming at a certain goal, the fundamental design question is: Given the functional requirements, how should the agents be designed so that their emerging behaviour fulfils the given task? (Pfeifer and Scheier 2000) Although there is currently no general methodology for what is called "design for emergence", it seems in many cases clear how to proceed. Nevertheless, one is easily trapped by preconceived ideas about the desired outcome. The simulation rules should be reduced as far as possible – as Paul Coates put it: "Baroque rule sets are self-defeating, they already specify the majority of the problem solution and anyway, they take too long to program." An example: In a first version, the lower column ends were attracted by polygonal shapes which KCAP had defined as areas for bike stands and the only places where columns were supposed to stand. This resulted in obvious problems because no bike stands were in the central area of the plot and therefore no chance for columns to survive there. The designers simply had thought one step too far by wanting the columns between the bike stands. The actual requirement was that the columns had to get out of the way and not block the paths. After the model was changed accordingly and the paths were introduced as repellers, the columns neatly arranged themselves between the bike stands but also around the roundabout in the middle without obstructing the ways.

3.2 Calming the System

Since the whole simulation is a non-linear *dynamic* system, but the result should be *static* – a structure that can be built from concrete, steel, glass and other rather inflexible materials – the crucial objective is to bring the system to a stable state. In the theory of dynamic systems this is called a *point attractor* in the phase space of the system, e.g. a state where the system converges towards and finally stops changing unless some external influence disturbs the calm. Abrupt changes can easily bring the system into a state of cyclic, quasi-periodic or even chaotic motion from where it never finds to an equilibrium state anymore. In the Groningen example, the growing and shrinking of the columns is a source of significant disturbance, because it is not continuous but happens in three discrete steps. Every time a column grows or shrinks, it adds a lot of kinetic energy to the system which may amplify itself by triggering growth or shrinkage in neighbouring columns. One way of calming a system in a chaotic state is to increase the "viscosity" of the habitat, which slows down the particles and eventually forces the system into a stable state by simply freezing it. But that might then of course not be an optimum state. The important conclusion here is that changes in the system should be continuous wherever possible.

3.3 Finding the Right Parameter Values

According to Kevin Kelly (1997), steering a swarm system resembles the task of a shepherd guiding his herd with gentle interventions and the absence of direct control

could be seen as a disadvantage. Behind the array of sliders that dominate the lower half of the tool's graphical user interface (GUI, see Figure 4) there are 102 different parameters that influence the behaviour of the system. Thus, finding a set of values that leads to a stable and useful state of the system (see Section 3.2) needs quite some sensitivity and knowledge about the interdependencies of the parameters. Interestingly this seemed to be no problem for the designers working with the system – they found out very quickly by just probing around and generated a number of valuable alternative configurations within a few hours. An apparent next step would be to switch from the ontogenetic to the phylogenetic timescale and see a model itself as an agent that can be evolved by the use of genetic algorithms (Frazer 1995; Pfeifer and Scheier 2000). The parameters would be encoded into a virtual genome, so that entire populations of models with different genotypes may be created and compared. Selection on the base of a fitness measure – for example the number of columns, their bearing capacity compared to the load of the slab and the change rate – identifies the best performing genome after a specified simulation period and give it the chance to reproduction. This would then of course eliminate the interaction from the optimisation process, since the number of concurrent simulations is too large for detailed observation.

3.4 Programming Further Simulations

To create a simulation that delivers valuable results the development process requires some knowledge and intuition in the beginning followed by a lot of step by step enhancements based on trial and error. The most time consuming part up to now is the programming of software that simulates the dynamic models and allows for testing and refining of the ideas until the desired results emerge from the system. Implementing the whole simulation in Java has proven to be a realistic approach. To accelerate the development process, the knowledge gained in the Groningen project is currently being used to create a programming toolbox as a base for further simulations. It consists of a number of Java libraries for simulation components (particles, attractors and repellers, springs etc.), GUI components (property editors), renderers (2D and 3D) and import/export interfaces (to and from XML, to VRML etc.). Given the narrow timescales in the architectural process this will be the most important prerequisite for more collaborative work on real-world projects.

4. CONCLUSION

The Groningen project has proven that the simulation of dynamic adaptive systems is a valuable method for creating and optimising irregular spatial structures within the architectural process, and I am very grateful that KCAP and ARUP believed in the approach and made it happen. However there are some important issues to examine further, as briefly discussed in Section 3. New projects are currently being developed at much higher speed by use of the mentioned toolbox, so it will be possible to test different methods to create self-organizing structures more efficiently.

REFERENCES

ARUP. 2004. *Beijing National Stadium, Olympic Green, China. Ove Arup & Partner*. Internet. Available from http://www.arup.com/project.cfm?pageid=2184; accessed 11. August 2004.

Bull, Stewart, Downing, Steve. 2004. Beijing Water Cube - the IT challenge. *The Structural Engineer* 13.07.2004: 23-26.

Coates, Paul, and Claudia Schmid. 1999. Agent Based Modelling. In *Architectural Computing: from Turing to 2000* [eCAADe Conference Proceedings]. eds. A. Brown, M. Knight, and P. Berridge: 652-661. Liverpool: eCAADe and University of Liverpool.

Frazer, John. 1995. *<<An>> evolutionary architecture*. London: Architectural Association.

Kaisersrot. 2004. *Build your own neighbourhood. Kaisersrot*. Internet. Available from http://www.kaisersrot.com; accessed 02. December 2004.

Kelly, Kevin. 1997. Mehr ist anders - zur Topologie des Schwarms. *Arch+*, 138: 25-32.

Krause, Jeffrey. 1997. *Agent Generated Architecture*. In ACADIA '97 Conference Proceedings, eds. J.P. Jordan, B. Mehnert, and A. Harfmann: 63-70. Cincinnati, Ohio: ACADIA

Martini, Kirk. 2001. Non-linear Structural Analysis as Real-Time Animation - Borrowing from the Arcade. In *CAAD Futures 2001* [Proceedings of the ninth international conference held at the Eindhoven University of Technology], eds. B. de Vries, J. van Leeuwen, and H. Achten: 643-656. Dordrecht: Kluwer.

Miranda Carranza, Pablo, and Paul Coates. 2000. Swarm modelling - The use of Swarm Intelligence to generate architectural form. In *Generative Art - Proceedings of the 3rd international conference*, ed. Celestino Soddu. Milano.

Pfeifer, Rolf, and Christian Scheier. 2000. *Understanding intelligence*. Cambridge, MA: MIT Press.

Turk, Greg. 1992. Re-tiling polygonal surfaces. In *Proceedings of the 19th annual conference on Computer graphics and interactive techniques*, 26: 55-64.

Witkin, Andrew P. and David Baraff. 1997. *Physically Based Modeling: Principles and Practice. SIGGRAPH 1997 course notes*. Internet. Available from http://www-2.cs.cmu.edu/~baraff/sigcourse/; accessed 18 February 2005.

Witkin, Andrew P. and Paul S. Heckbert. 1994. Using particles to sample and control implicit surfaces. In Proceedings of the 21st annual conference on Computer graphics and interactive techniques: 269-277: ACM Press.

Human-machine Interaction: Connecting the Physical and the Virtual

iSphere
A Proximity-based 3D Input Interface

LEE Chia-Hsun, HU Yuchang and SELKER Ted
The Media Laboratory, Massachusetts Institute of Technology, USA

Keywords: 3D input device, proximity sensing, parametric modeling, human-computer interaction

Abstract: This paper presents a 24 degree of freedom input device for 3D modeling. iSphere uses the proximity information of pulling-out and pressing-in capacitive sensors to manipulate 12 control points of a 3D surface simultaneously . The iSphere dodecahedron is demonstrated manipulating an analog parametric model with high-level modeling concepts like *push* or *pull* the 3D surfaces. Our pilot experiment shows that iSphere saved many steps of selecting the control point and going through menus. Experts were used to those extra steps and still found themselves doing them but novices saved significant time for surface shaping tasks. 3D systems are benefited to execute high-level modeling commands, but lacking of fidelity is a great issue of analog input device.

1 INTRODUCTION

This paper introduces a realistic way of 3D input and manipulation interfaces. Making 3D models wasn't an easy task for 3D designers. There is a strong need to quickly transform their concepts to certain shapes. Typical 3D modeling systems, like Rhino, 3D Studio MAX or Alias|Wavefront Maya, usually consist of sets of abstract commands. Users are always performing the mediating actions between high-level modeling concepts and low-level manipulation commands. Although the 3D modelling functionality was mature in most 3D systems, the gap between realistic interaction and low-level commands is still left unsolved. To manipulate 3D environments efficiently may be the result of simplifying cognitive behavior to perform mappings and powerful commands intuitively. Designing a system which is aware of user's intention can possibly reduce users' cognitive load.

We argue that an input device which can use a spatial metaphor to map hand actions into modeling commands can improve the processes of 3D modeling. Mapping hand actions into an analog parametric model can eliminate a series of viewing and editing commands. In other words, users can use natural gestures to control the parametric model. Understand hand actions can offload some tasks from the software interface. We also argue that 3D input systems should understand user's behavior to provide interaction directly and meaningfully. Direct mapping of realistic modeling concepts, such as push, pull and twist actions should be easy to learn and remember.

B. Martens and A. Brown (eds.), Computer Aided Architectural Design Futures 2005, 281-290.

iSphere is the dodecahedron with two analog sensing modes per face, as in Figure 1. Hand-position aware mechanism has been equipped into the 3D input device. It also acts like a hand interpreter which maps designer's hand signals into commands. A study was conducted to compare the performance using standard mouse and iSphere.

Figure 1 iSphere is a dodecahedron with capacitive sensors to interpret hand positions into high-level 3D modeling commands

2 RELATED WORK

User interface designers have dealt with 3D input problems for decades. Aish claimed that 3D input systems should be able to create and modify 3D geometry intuitively in order to interpret and evaluate the spatial qualities of a design directly (Aish 1979). But in most 3D modeling systems, command-based input and Graphical User Interfaces (GUIs) still dominate 3D Computer-Aided Design systems and have been optimized for 3D modeling. Keyboards and mice are also essential for users to type in or select commands. 3D manipulations are usually sequential and abstract. Users have to aggregate a serial of simple and abstract commands into a bigger modeling concept. It partially occupied mental resources so that designers are limited to act and think differently. There are always trivial steps before inspecting and editing 3D models that makes 3D modeling complex.

Ishii suggested a new concept to design interfaces integrating both physical and digital systems (Ishii and Ullmer 1997). Designing Tangible User Interfaces (TUIs) is to create seamless interaction across physical interfaces and digital information. Interacting with TUIs can be more meaningful and intuitive than using traditional GUIs. iSphere also extends the concept of TUI with understanding user's hand behavior in order to provide relevant modeling functions at the right time. The orienting approach of a 3D view port into a 3D world-view has been a conceptually important idea since people started creating 3D computer graphics (Van Dam 1984).

A desirable controller for a 3D environment might be a 6 degree of freedom device like a SpaceBall (Zhai et al. 1999). The space ball allows pressure forward aft side to

side and up and down and rotation in X, Y, Z to control modeling. SpaceBall provides an intuitive 3D navigation experience with rotating a physical ball. But it also requires significant work with keyboard and mouse to map it into the control points and other desired function. It still takes time and steps to use physical navigation tool with mouse in order to complete a task like getting the right viewpoint and pulling the surface for 10 units along certain axis.

DataGlove usually works with 3D stereo glasses and positioning sensors. Users have to wear sensors and learn to map hand actions into manipulation commands. The advanced versions of DataGlove can provide 6DOF control and force feedback for users to model 3D under a rich immersive 3D environment. However, lacking physical references is easy to make users get lost. Working with stereo glass and wearable sensors for a long period of time may not yet be a good way. In (Zhai 1998), Zhai concluded that none of the existing 6DOF devices fulfills all aspects of usability requirement for 3D manipulation. When speed and short learning is a primary concern, free moving devices are most suitable. When fatigue, control trajectory quality and coordination are more important, isometric or elastic rate control devices should be selected. In (Zhai 1996), Zhai suggested that designing the affordance of input device (i.e. shape and size) should consider finger actions.

A 3D volume control system using foam resistance sensing techniques was demonstrated in (Murakami, T. et al. 1994). With cubical input channels and pressure-based deformation, it could provide intuitive visual feedback for deforming shapes based on a physical cube.

In (Rekimoto 2002) , SmartSkin introduced a new way of bimanual interaction on the desktop. By using capacitive sensing and embedded sensors, users can naturally control digital information projected on the table by hands. In (Llamas et al. 2003), Twister was presented as a tool of 3D input device using two 6DOF magnetic trackers in both hands to deform a sphere into any shape.

Learn from past experience in order to minimize the complexity of 3D modeling processes, this paper suggests that a physical modeling reference and the capability of using realistic hand interaction will enhance the intuitive experience of 3D modeling. Low-level operations of commands are time-consuming and costing extra efforts to complete a task in a 3D environment. A user does not have direct feedbacks from command-based manipulation and has to break concepts into trivial steps. The fragmented metal views and visual representation should be coupled in order to give designer expressive ways to model intuitively. iSphere is able to simplify the mappings between low-level manipulation commands and modeling concepts, such as pushing and pulling 3D geometries and viewpoints.

3 INTERACTIVE TECHNIQUE

3D users should be expected to consume more cognitive load on designing rather than modeling. We propose iSphere acting as a hand sensor knowing about levels of actions, like hand positions, touching, pushing and twisting actions. In most 3D

modeling systems, keyboards and mice are good for command-executing and mode-switching. However, it still can't allow us to perform an editing command by a single and intuitive action. We claim that making the interaction more realistic can enhance the experience of 3D modeling.

3.1 Realistic Interaction

iSphere has been used with an editing mode for modeling 3D geometries and an inspecting mode for navigating 3D scenes. The natural mapping for an enclosed object is to map the dodecahedron to pulling on and pushing in on the surfaces as though it were clay.. Natural hand actions are mapped to the modeling commands, such as pushing multiple facets to squeeze the 3D model on that direction, as shown in Figure 2(a-d).

**Figure 2 Hand movements as metaphors for editing
and inspecting 3D scenes as realistic interaction**

Visual feedback is provided in 3D software responding the 3D warp effect like playing with virtual clay when a user's hand is attempting to stretch the 3D object. In the inspecting mode, it acts as a proximity sensor which can detect the hand positions around the device. It is connected to the 3D software that rotates the

corresponding camera viewpoint when a hand approaches the surface, as shown in Figure 2 (e-g). The 3D model can automatically get oriented when a user touches anyone of the surfaces. To switch the editing and inspecting mode, a functional button was installed on the desktop which allows users to switch between them by touching it or leaving it.

3.2 Play and Build

Making a 3D model requires visualizing, re-visualizing and acting. But today's CAD system is a complex enough mechanical effort that the review process might come later. Having a design goal and shaping it into 3D objects involves a series of mode-switching activities. The processes are usually trivial, disruptive, and have little relation to design. Designers designed a 3D shape and then switched to the modeling mode. Obviously, designing and decomposing shapes into sequential machinery commands are two totally different cognitive behaviors. This bottom-up approach limits the diversity of design outcomes and the expressiveness of 3D representation during the early design stage. In order to reduce the cognitive load of fragmented design mode and modeling mode, we purpose a top-down 3D modeling approach that allows designers to play and build 3D models and develop their concept directly.

4 IMPLEMENTATION

The hardware consists of 12 facets of capacitive sensors. Each of them is capable of sensing ten degrees within six inches above the surface. Push command will be triggered if hands are closer to the surfaces. Pull commands will be triggered if hands are away from the surfaces. iSphere is a dodecahedron made by acrylic. To create this device, a laser cutter was employed to make a foldable pentagonal surface. This was assembled with fitting pieces that snap it together. A circuit board which is incorporated a PIC microcontroller PIC16F88 and a RS232 serial interface was embedded in the device.

As shown in Figure 1, each side of the dodecahedron is a plastic acrylic piece, designed, with a copper backing and foam. Capacitive sensors are connected in parallel into multiplexers are able to detect the proximity of hands from twelve different directions. For long-distance proximity sensing, we use a transmitter-and-receiver setting in the capacitive sensing circuit. The small capacitance is generated by a surface that is approximately 6 inches per side of the pentagon when a hand is placed over it. A microcontroller is used for getting the digital inputs from the sensor and output the signals to the serial port to a PC.

We utilized the Alias|Wavefront Maya 6.0 C++ API (Application Programming Interface) and implemented the functions into an iSphere Plug-in. It provides us a more flexible environment to design the iSphere system. The plug-in can be loaded automatically in the command prompt in Maya.

iSphere: A Proximity-based 3D Input Interface

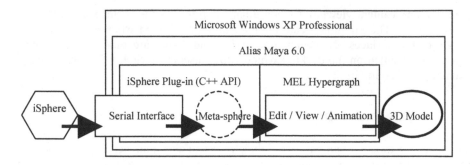

Figure 3 Software Architecture of iSphere

The software architecture can be described as a flowchart, as shown in Figure 3. First, the hardware of iSphere connected to the RS232 Serial Interface (COM1 or COM2 on an IBM PC). Second, a meta-sphere maps raw data into a data structure in order to control any 3D object. MEL (Maya Embedded Language) is handy for describing 3D modification. MEL also takes great advantages in its Hypergraph interface to easily apply 3D modification functions by drawing relationships of data flows.

The software architecture also reserves flexibility to upgrade in the future. New functions can easily be added by insert new codes or nodes into the system. Another advantage is when iSphere provides more commands, switching from different commands can be done easily by connecting the links between different nodes. iSphere is able to manipulate 3D mesh-based model in Alias|Wavefront Maya, 3DS Max or Rhino.

5 PILOT EXPERIMENT

A pilot experiment was conducted to examine potential problems before the formal evaluation. The hypothesis is that iSphere is more intuitive and efficient in modifying clay-like geometry than a general 3D modeling interface. We designed the experiment to study how efficient novices and experts can adapt 3D input techniques in different input device. The experiment contains four 3D modeling tasks and two conditions of user interface.

5.1 Experimental Set-up

A desktop 3D modeling environment was set up in the experiment. It consists of an IBM Graphics Workstation, 19" LCD display monitor, Alias|Wavefront Maya 6.0 with iSphere plug-in software, standard keyboard, mouse, and the iSphere device, as shown in Figure 4. Subjects were asked to sit on a chair where a mental strip attached on the edge providing a harmless reference signal (5Volts-20kHz) which makes the user become an antenna that can greatly improve proximity sensing.

Capacitive sensors can sense hands up to six inches above the surface. The 12 facets are also covered with foam in order to provide feedback when you touch the surface. The iSphere was installed on a soft-foam base to provide arm supports for the user. In order to enhance the 3D visualization, all 3D objects were rendered in shading mode.

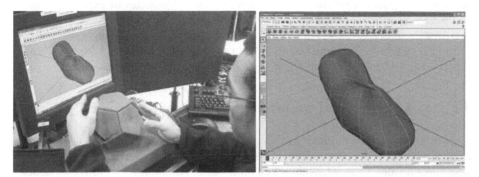

Figure 4 A pilot study of iSphere (left) and a shoe shaped by a subject (right)

5.1.1 Experimental Condition

Two experimental conditions where compared the keyboard-and-mouse desktop environment and the iSphere, were used in this experiment. For novices with no experience in Maya, using standard desktop setting to perform modeling tasks by themselves needs a learning period. Otherwise, we have to provide them more hints to get used to the interface. But for expert users, they can usually perform modeling tasks as routines. We calculated the time expense of each task using KLM-GOMS (Keystroke-Level Model GOMS) which is a model of how experts perform routine tasks (John and Kieras 1996). In this pilot study, subjects were asked to use the iSphere to perform the modeling tasks. We allowed subjects to hold their tasks and re-start again until they felt confident in tasks.

5.1.2 Experimental Task

Four 3D modeling tasks were designed in this study. Each task represents a typical 3D surface shaping procedure involving a series of view and edit commands. Subjects were asked to do four tasks in a sequence. At the beginning of each task, subjects started with a new scene with a default 3D sphere appeared in the middle of the screen. In the first task, subjects were asking to pull the top surface up to 3 units. The second task is to expend the bottom of the sphere to 3 units. In the third test, subjects were asked to make an apple. The final task is to make any shape in five minutes.

5.1.3 Experimental Design

A Two-Group design was used in comparing the performance of novices using iSphere and experts using mice. The tasks for expert users were formulated into a calculable task flowchart. In this experiment, all subjects were asked to perform tasks using iSphere. This condition was given about 15 minutes of exposure, which comprised a pre-test questionnaire, a short demonstration, and four tasks. In the first two tests, subjects were given 3 minutes to finish simple modeling tasks. In the following two tests, subjects had to finish two modeling tasks in 5 minutes. Each subject was asked to fill the post-test questionnaires after four tasks.

5.2 Experimental Results and Discussion

Six volunteers were recruited in this pilot study. Four of them had no previous experience with Maya. Two of them had intermediate level of skills in Maya. Their ages ranged from 17 to 27, with a median of 21.2. All subjects were right handed. All subjects finished the four tasks.

5.2.1 Analysis of the Overall Results

We used KLM-GOMS to analysis subjects who had intermediate experience in Maya and then compared to novice who used iSphere. Expert users used combination of shortcut keys and mouse so that they completed the tests effectively and precisely. In the first two tasks, they presented the same routine to reach the goal state. Before they started moving, they spent 3 to 5 seconds to think over possible solutions. To summarize their actions during the tasks, they spent much time and actions to move the mouse cursor to reach icons or menus on left and top of the screen. Each movement may cost 1 to 1.5 second and all movements cost around 20 to 25 seconds depending on different tasks. The next is selection, they selected corresponding CVs (control Vertex) professionally and move them to appropriate positions that the tasks asked for. The selecting and moving actions cost around 5 to 7 seconds. Clicking mouse buttons cost the shortest time in the experiment, but was the most frequently action. Each click cost around 0.2 second and 10 to 15 times.

Comparing to subjects using keyboard and mouse, the results conducted by subjects using iSphere is relatively simple t. According to our demonstration before the experiment, they all could well know how to reach the goal state by controlling corresponding facets. Therefore, all of them spent less than 2 seconds to think over the solution, before they started. The novice group spent average 8.6 seconds on the first task and average 12.5 seconds on the second task. In the third and fourth task, we weren't able to calculate using KLM-GOMS. Although most of them spent much time to modify the model back and forth, they finished the two tests with shorter than those intermediate Maya users.

The preliminary result shows some important phenomena between using mouse and iSphere. iSphere exposes controls in a spatial way allowing users to directly

manipulate the surface. It takes fewer steps than selection such controls from a tool bar and associations. Using iSphere can also reduce time consuming and actions to make simple models. Furthermore, iSphere allows users to move multiple facets at the same time. Comparing to mouse users, iSphere combines selection, direction and commands. iSphere can measure pressure an pulling at a 4 bits resolution. Currently, iSphere did not have the speed and accuracy of control that a mature analog input device gives. It is not able to perform actions precisely. In the experiment, users spent almost half of the time to move back and forth, because they cannot shape the model exactly as they wanted.

6 DISCUSSION

This paper presents a 3D input device that uses a physical modeling reference and the capability of using natural hand interaction to enhance the intuitive experience of 3D modeling. By using the information collected from its user, the system can simplify 3D modeling user interface. For modeling 3D geometries, iSphere is an input device that allows users to model 3D through hand manipulation. Using proximity of hand positions, designers can map their actions into an analog parametric model. It allows users to manipulate 3D geometries using high-level modeling concepts like push or pull the 3D surfaces. This physical device also doesn't require wearing any sensors. iSphere could change the way 3D designers work with abstract commands into natural hand interaction and intuitive 3D modeling processes, but lacking of fidelity to make detail modification is the main problem for this interface.

Designing new inputs to 12 surfaces is a complex goal. It has to do with choosing, adding and making sensors with enough fidelity, choosing metaphors that match the device, and creating a transfer function that makes sense for what is it being used for. One may argue that iSphere is a specialized device for certain specific modes, while general modelling interface is designed for general input device. Mouse and keyboard are very good at mode-switching tasks. It's not fair to compare them in certain modes of modelling.

Using iSphere, in a sense, limits the ways to model. Users can only interact with this device by hand interaction, however, it can help users to finish specific task quickly. Using mouse and keyboard, on the other hand, has more freedom to perform jobs, but in most actions, it is time consuming. Both of them represent parts of our needs when modelling. Therefore, the next step of making new modelling tools may combine these two concepts. Future work will deal with making mappings robust across shapes, methods of creating models simply and improving algorithms for sensing control. To extend the analog 3D input approach using proximity sensor, we found there are several ways to go. For example, the modeling sequences can be recorded and playback. It can be used as a motion capture device to make 3D animation from realistic interaction.

REFERENCES

Aish, R. 1979. 3D input for CAAD systems. *Computer-Aided Design* 11(2): 66-70.

Ishii, H., and B. Ullmer. 1997. Tangible Bits: Towards Seamless Interfaces between People, Bits, and Atoms. *Proceedings of the CHI 97,* 234-241. New York: ACM Press.

John, B., and D. Kieras. 1996. The GOMS Family of User Interface Analysis Techniques: Comparison and Contrast. *ACM Transactions on Computer-Human Interaction* 3(4): 320-351.

Llamas, I., B. Kim, J. Gargus, J. Rossignac and C.D. Shaw. 2003. Twister: a space-warp operator for the two-handed editing of 3D shapes. *ACM Transactions on Graphics (TOG)* 22(3) 663-668.

Murakami, T., and N. Nakajima. 1994. Direct and Intuitive Input Device for 3-D Shape Deformation. In *Proceedings of the CHI 1994*, 465-470.

Rekimoto, J. 2002. SmartSkin: An Infrastructure for Freehand Manipulation on Interactive Surfaces. In *Proceedings of the CHI 2002*, 113-120. New York: ACM Press.

Van Dam, Andries. 1984. Computer graphics comes of age: an interview with Andries Van Dam. *Communications of the ACM* 27(7): 638-648.

Zhai, S., E. Kandogan, B. Smith, and T. Selker. 1999. In Search of the "Magic Carpet", Design and Experimentation of a 3D Navigation Interface. *Journal of Visual Languages and Computing* 10(1): 3-17.

Zhai, S. 1998. User Performance in Relation to 3D Input Device Design. *In Computer Graphics* 32(4): 50-54.

Zhai, S., P. Milgram, and W. Buxton. 1996. The Influence of Muscle Groups on Performance of Multiple Degree-of-freedom input. In *Proceedings of the CHI 1996*, 308-315. New York: ACM Press.

Learning Design with Digital Sketching:

Copying Graphic Processes from Animations and Storyboards

CHENG Nancy Yen-wen and MCKELVEY Andrew
Department of Architecture, University of Oregon, USA

Keywords: teaching, technology, sketching, pen-based computing

Abstract: This paper examines the effectiveness of animated versus non-animated drawings as teaching tools. Data was collected by comparing how architectural design students given an animation versus those given a static, six-panel storyboard are able to learn processes in a space-planning design problem. All subjects were given an example of an expert design drawing, asked to put the design steps in order, and then to follow those steps in performing a similar design problem. Their responses were recorded with a digital pen-on-paper system that automatically generates vector animations. The animations can then be immediately viewed on a computer for stroke-by-stroke review. Finally, each student's animation was analysed in terms of design process steps and compared with the expert example.

While those given animations performed only marginally better on the survey of steps, they were better able to imitate the order of expert steps. Furthermore, reviewing the examples by computer revealed common errors that students could modify for more successful design strategies. The following discussion examines methods for researching design process with the digital pen, along with shortcomings, advantages and directions for further study.

1 INTRODUCTION, TECHNOLOGY & PRECEDENTS

Teaching design is challenging because experts present processes in large chunks and naturally gloss over subtasks that they find intuitive. Beginners would benefit from seeing projects articulated into explicit subtasks. By recording drawings with a digital pen-on-paper system, we can instantly generate animated sketches that reveal each step in the design process. This paper will discuss the effectiveness of these animated sketches for teaching design.

While stylus-based tablets are a common form of graphic input, mobile digital pens present another level of portability and accessibility. In testing their implications for design teaching, we were inspired by studies that show animations are more effective than static images for teaching physics, that movement helps recall and that picture recall is superior to word recall (Weiss 2000, Sampson 1970). We wanted to see if these results held true for our digital pen animations.

B. Martens and A. Brown (eds.), Computer Aided Architectural Design Futures 2005, 291-300.
© 2005 Springer. Printed in the Netherlands.

Technology: the project uses the commercially available Logitech digital pen-on-paper to record how expert and student designers draw. The pen's camera captures the location of each mark in relationship to Anita Technology's proprietary printed grid pattern, and then the pen's memory stores the sequence of vectors. After downloading the information from the pen through a USB port, one may view the drawings as an interactive animation on a Windows computer. In the Logitech IoReader 1.01 software, the image appears stroke by stroke in bright blue on ghosted light-grey lines of the completed drawing. While this project specifically uses a Logitech mobile pen, its findings can be applied to animations generated by other stylus-based tools.

Precedents: In teaching design, interactive drawing reveals implicit expert knowledge (Schön 1983). To understand how designers use sketching, we looked at work examining how marks relate to design thinking, how marks are used for specific design operations and how to parse drawing marks and connect them to cognitive processes (Goldschmidt 2003, Do 2000, Ullman 1990, Von Sommers 1984).

Papers from both design and developmental psychology show specific methods for analysing the sequence of operations in a group of drawings and for evaluating sequence recall tasks (Dallett 1968). In drawing, we are strongly influenced by our frame of reference – our background and recent memory shape the world we portray. For example, children shown a complex object pulled apart only draw the newly observed details if they have not already formulated a way to draw it whole. In contrast, successful designers use sketching to transform ideas, reframe the problem, and allow creative solutions to break the original problem definition (Cross 1996). Digital pen animations let us easily collect & examine these sequential operations in detail, assisting accurate recall.

Our students have found these animations helpful for revealing expert approaches to sketching and for analysing their own efforts. Teaching with the pen is documented on the Web (http://www.uoregon.edu/~arch/digsketch/) and earlier papers (Cheng 2004a and 2004b). In collecting design drawings for teaching, we had to narrow the task scope to increase comparability between solutions. We devised a design problem composed of 3 short tasks: interior space planning, lobby redesign and façade design. In winter and spring 2004, we collected 31 examples of the space-planning design task from diverse authors and ran pilot studies of how they were perceived. (Cheng 2004b).

1.1 Hypothesis

From these examples, we sought to determine whether interactively viewing the animated process would be more effective than viewing static examples. We guessed that people who interactively viewed an animated design solution would learn the steps in a design process better than people who look only at a static completed image.

2 RESEARCH METHOD

Our most recent experiment tested how well students understood animated versus still drawings. First we showed subjects a completed solution (as a letter-sized laser print) to office space-planning in an existing shell. After viewing the completed drawing, subjects chronologically ordered a randomised list of six possible design operations (a pre-test). This showed their initial design approach. Next they looked at an expert's step-by-step solution to the space-planning problem, either as an interactive animation or a tabloid-size 6-panel storyboard, and attempted to mimic the expert's process on a similar space-planning problem. We asked them to fit a rock-climbing gym into an existing shell using the Logitech pen to record their work. Finally, we asked the students to answer the initial step sequencing again (a post-test) to measure if there was any change in their design approach.

For this trial, our subjects were twenty students with an average 2.5 years of architectural training who had been drawing about 10.5 years. For convenience we will use the names "Animation group" and the "Paper group." We tested them in groups of one to four viewing the same medium, with the same introduction to the pen technology and the project. All subjects were given a text description of an existing rock-climbing gym with a specified list of spaces that had to fit in. We gave subjects 10 minutes to peruse the example and an additional 20 minutes to do the space-planning problem. This procedure yielded subject surveys and digital examples to analyse.

**Figure 1 Still image (left) and storyboard (right) of office layout example:
1 site - 2 program - 3 guidelines (right top)
4 planning - 5 articulation - 6 presentation (right bottom)**

3 DATA

To analyse the drawings, we looked at the subjects' sequence of design steps and developed a colour bar rating system. From the compiled data we were able to compare student's drawings from both the Paper and Animation groups.

3.1　Step-Sequencing Survey

The task of chronologically ordering design steps showed a slightly better performance from the Animation group than the Paper group. Table 1 summarizes how subjects chronologically ordered the design operations in both the pre-test and post-test. We measured how closely the subjects matched the original example by first subtracting the example's score from the average of each group, then summing the absolute value of these differences. A lower number shows a closer match to the original.

Table 1 Step-Sequencing by subjects viewing an animation or paper storyboard

		All		Animation		Paper		
PRE-TEST: Order of design operations after seeing still image	Given Example	Average	variance from given	Ave rate	variance from given	Ave rate	variance from given	Variance: Paper vs. Animation
Draw program clusters	2	2.4	0.4	2.2	0.2	2.8	0.8	greater
Define individual rooms	4	3.8	-0.2	4.1	0.1	3.5	-0.5	greater
Strengthen graphics	6	5.7	-0.3	5.7	-0.3	5.6	-0.4	greater
Label rooms	5	5.2	0.2	5.0	0.0	5.4	0.4	greater
Document existing site	1	1.4	0.4	1.5	0.5	1.3	0.3	less
Define major organizing lines	3	2.5	-0.5	2.5	-0.5	2.5	-0.5	same
Sum of absolute values of variances			**1.9**		**1.5**		**2.8**	greater
POST-TEST Order of design operations after seeing animation or storyboard								
Draw program clusters	2			2.3	0.3	2.4	0.4	greater
Define individual rooms	4			3.8	-0.2	3.9	-0.1	less
Strengthen graphics	6			5.9	-0.1	5.9	-0.1	same
Label rooms	5			5.0	0.0	5.0	0.0	same
Document existing site	1			1.2	0.2	1.5	0.5	greater
Define major organizing lines	3			2.8	-0.3	2.4	-0.6	greater
Sum of absolute values of variances					**0.9**		**1.8**	greater

The pre-test shows that most students were able to guess the actual steps just from looking at the still image. However, the post-test does show that the average answer given by the Animation group was more accurate than the Paper group (post test variance from the actual steps of 0.9 vs. 1.8).

3.2 Design Sequence Colour Bars

To compare subjects' design processes we parsed each drawing into a sequence of colour-coded design operations. We used content categories because they are the most useful for conveying the actual work of design. Suwa and Tversky (1997) support the idea that content information makes a richer protocol analysis. By strictly defining the design steps, we created a reproducible coding scheme that produced consistent labelling by three members of the research team.

SITE INFORMATION lines indicate the given building and the area outside of the building, including columns, site boundaries, dimensions of site and north arrows.

PROGRAM lines show relative sizes of program areas and program adjacency relationships, i.e., abstract box or circle diagrams. They do not place the rooms inside the building envelope.

PARTI lines create simple diagrams defining the overall abstract building order.

GRIDLINES help draw other lines and do not demark physical walls or site boundaries.

PLANNING lines organize the building into physical spaces such as initial wall boundary lines and stairs.

ARTICULATION lines define physical elements beyond walls and stairs, i.e., doors, windows and furnishings.

PRESENTATION lines are non-physical annotations such as text and symbols. Room labels alternated with planning lines are not called out as a separate step.

We recorded the chronological steps in Photoshop as labelled layers to create a verifiable visual record. To reveal the sequential pattern of operations, the steps were then recorded in Excel using conditional formatting to give each operation a distinct colour bar: SITE INFORMATION (black), PROGRAM (green), GRIDLINES (purple), PARTI (grey), PLANNING (light violet), ARTICULATION (light peach), PRESENTATION (light blue).

Figure 2 Macro-steps in original example

3.2.1 Similarity Rating with Macro-step Presence and Order

After coding each drawing into a sequence of steps and generating the corresponding colour bars, we identified macro-steps, or larger organizational patterns of the basic steps.

1. SITE-PROGRAM lines alternately describe the site and program. They may contain traces of planning and gridlines.

2. PLANNING-ARTICULATION lines alternately describe building planning element articulation. They may contain traces of planning and presentation.

3. ARTICULATION-PRESENTATION lines alternately describe element articulation and presentation annotation. They may contain traces of planning.

Figure 3 Macro-steps in student copy

We developed a six-point system to rate drawings according to how similar they were to the parent drawing. Each drawing could earn 3 points for presence of the macro steps and 3 points for order. Each subject drawing was given a point for the *presence* of each macro-step pattern, no matter where or how many times it occurs in the drawing. Also, each drawing was given points for *order* if a step occurred in the right sequence in the drawing process. For example, the expert drawing shows all three macro-steps in order so it gets 3 points for the presence of each step and 3 points for having all the steps in the correct order, yielding a perfect score of 6.

Below, Figure 4 summarizes how the macro-steps recur in the Paper group and the Animation group.

Figure 4 Macro-step scoring – given example patterns on left 4

4 ANALYSIS

From our step sequencing survey, it remains unclear whether an animated or storyboard example increased students' ability to identify and recall a sequence of drawing steps. From our colour bar similarity analysis, we can see that students can better incorporate a series of steps from an animation than from a storyboard into their own drawing process.

4.1 Step-Sequencing Survey Results

While the post-test shows better performance by the Animation group than the Paper group, the difference is not conclusive. The pre-test shows the Animation group had a pre-disposition to seeing the right answers, so it is unclear whether the representation type (animation vs. paper storyboard) made a difference. In considering pre-test versus post-test answers, the Animation group improved 0.6 (from 1.5 to .9), while the Paper group improved more: 1.0 (from 2.8 to 1.8).

4.2 Design Sequence Colour Bar Analysis

Our colour bar analysis shows a distinction between Animation and Paper groups; the Animation group imitated the step sequence of the expert drawing more accurately than the Paper group. Scoring each drawing according to presence and order of the Macro-steps, we found the average score for the Animation group was 1.8 out of a possible 3 points for presence of macro steps, 1.8 out of a possible three points for order of macro-steps, and 3.6 points total. The average score for the Paper group was 1.4 for presence, 1.2 for order, and 2.6 points total.

These data indicate that the difference between the total scores for animated and storyboard drawings is 1.0 point. Given that scores ranged from 0 to 6.0 for a six point maximum range, the 1.0 difference in average score indicates a noticeable separation between the results of the animated and storyboard drawings. The difference in scores indicates that students who viewed animated versions of the expert example were more likely to accurately reproduce the steps of that process.

4.3 Quality Criteria

While quality characteristics generally showed parity between the two groups. specific characteristics reveal that the Animation group stuck to the example more closely.

MULTIPLE SOLUTIONS: The original expert example did not show alternative thumbnail layouts because the office layout problem's simplicity allowed drawing alternate arrangements on top of the existing plan footprint. 39% of the Animation group versus 70% of the Paper group varied from the expert example by creating alternative layout solutions. In this respect, those in the Animation group followed

the example more closely. The subjects seeing the paper storyboard took more freedom to do things independently and may have been less engaged by the example.

Need for mezzanine: Both the original office planning problem and the rock-gym planning problem required fitting program spaces into a given existing building. But whereas the given office design example fit all the spaces onto one floor, program spaces for the rock-gym program would not fit on the footprint and required an additional building level or mezzanine. 84% of Animation group versus 61% of the Paper group correctly created mezzanines for the extra program area. We surmise that those looking at the paper example had to spend more time interpreting the information in the example and had less time to reason about their own design solution. Recording how long each subject examined the expert example could reveal the amount of engagement.

Program area accuracy: While subjects generally included all of the program areas and got the program adjacencies correct, they commonly distorted program area sizes to follow the expert example's strong orthogonal zoning. Beginners often drew spaces too small, trying to squeeze them into a rigid order, rather than modifying the diagram or adjusting dimensions. More of the Animation group (78%) was able to roughly match the required program areas than the Paper group (54%). We again surmise that the clarity of the animation allowed the subjects to be more task-focused.

In short, while the Animation group shows better design performance than the Paper group in specific categories, the difference is not conclusive. More importantly, we see no correlation between quality scores and design sequence colour bar pattern matching. So while an animation can help students follow a pattern of design steps, it does not guarantee the quality of results. An animation provides an engaging way to look at a drawing, but it requires the viewer to make judgments about how to separate a continuous process into cognitive chunks. By contrast, a storyboard provides an interpreted guide, encapsulating key moments of the process in a way that can help beginners. Annotating animations with highlighting marks, text or narration could provide both interactivity and interpretation.

5 CONCLUSIONS

So far, we have used the digital pen to 1) begin a substantial archive of design and drawing processes, 2) develop a methodology to investigate the perception of animated versus still drawings and 3) observe subtle aspects of design and drawing that may lead to better results. Our project showed that students who view an interactive animation of a given drawing example are slightly better able to imitate the sequence of operations than students who view a static storyboard version. By colour coding design operations, we could track patterns of design operations. For a more complete story of each design process, we could refer to the animated drawing record.

While our research is not complete, we have already shown that the digital pen has great potential in researching and teaching design processes. Animated drawings can be used to teach any graphic processes involving a prescribed series of steps. They allow teachers to show how initial steps lead to final results in visual thinking.

REFERENCES

Cheng, N.Y., and S. Lane-Cummings. 2004a. Teaching with Digital Sketching. In *Design Communication Association 2004 Proceedings*, eds. William Bennett and Mark Cabrinha: 61-67. San Luis Obispo, CA: Calpoly.

Cheng, N.Y. 2004b. Stroke Sequence in Digital Sketching. In *Architecture in the Network Society* [eCAADe 2004 proceedings], eds. B. Rüdiger, B. Tournay and H. Orbak: 387-393. Copenhagen: eCAADe.

Cross, N., H. Christiaans, and K. Dorst (eds.). 1996. *Analysing Design Activity*. Chichester: Wiley.

Dallett, K., S.D. Wilcox, and L. D'Andrea. 1968. Picture Memory Experiments. *Journal of Experimental Psychology*. 76(2, PT. 1): 318-326.

Do, E.Y. and M. Gross, and C. Zimring. 2000. Intentions in and relations among design drawings. *Design Studies*, 21(5): 483-503.

Goldschmidt, G. 2003. The Backtalk of Self-Generated Sketches. *Design Issues* 19 (1): 72-88.

Sampson, J.R. 1970. Free recall of verbal and non-verbal stimuli. *Quarterly Journal of Experimental Psychology A*. 22(2): 215-221.

Schön, D.A. 1983. *The Reflective Practitioner*, New York: Basic Books.

Suwa, M., and B. Tversky. 1997. What do architects and students perceive in their design sketches? A protocol analysis. *Design Studies* 18(4): 385-403.

Ullman, David. 1990. The Importance of Drawing in the Mechanical Design Process. *Computer & Graphics*. 14(2): 263-274.

Von Sommers, P. 1984. *Drawing and Cognition*. Cambridge: Cambridge University Press.

Weiss, R.E. 2000. The effect of animation and concreteness of visuals on immediate recall and long-term comprehension when learning the basic principles and laws of motion. *Dissertation Abstracts International*. Vol 60(11-A), 3894, US: University Microfilms International.

Simulating Human Behaviour in Built Environments

YAN Wei and KALAY Yehuda
Department of Architecture, University of California, Berkeley, USA

Keywords: behaviour simulation, behaviour study, human modelling, building modelling

Abstract: This paper addresses the problem of predicting and evaluating the impacts of the built environment on its human inhabitants. It presents a simulation system comprising a usability-based building model and an agent-based virtual user model. The building model represents both geometric information and usability properties of design elements, and is generated automatically from a standard CAD model. Virtual users are modelled as autonomous agents that emulate the appearance, perception, social traits and physical behaviour of real users (walking, sitting, meeting other virtual users, etc.). Their behaviour model is based upon theoretical and practical environment-behaviour studies, real world data from a field study, and Artificial Life research. By inserting the virtual users in the usability-enabled building model, and letting them "explore" it on their own volition, the system reveals the interrelationship between the environment and its users. The environment can then be modified, to see how different arrangements affect user behaviours.

1 INTRODUCTION

Human spatial behaviour, in the context of architectural design, is a term that describes the relationship between the built environment and its human inhabitants. 'Good' spatial behaviour is an indicator of successful architectural design, whereas 'bad' spatial behaviour can be an indicator of wasted resources and the cause for occupants' dissatisfaction. For example, in a study of New York City urban spaces, William Whyte (1980) found that some worked well for people, while most others did not. At lunchtime, a good plaza attracted many people sitting, sunbathing, picnicking, and talking (Figure 1 left). Others were not used much, except walking across (Figure 1 right). If designers of the plazas could predict the ensuing behaviour pattern in advance, they would design spaces that are better suited for their intended use. Simulating future human spatial behaviour is, therefore, an area of great interest to designers and clients.

Most current environmental simulations, however, pay more attention to the physical qualities of built environments, such as lighting, energy use, and thermal comfort, than to human spatial behaviour. Existing human

Figure 1 New York City plazas (Whyte 1980)

B. Martens and A. Brown (eds.), Computer Aided Architectural Design Futures 2005, 301-310.
© 2005 *Springer. Printed in the Netherlands.*

spatial behaviour simulations are often limited to some well-defined areas of human activities, where considerable empirical research helped develop the requisite cognitive models. These include pedestrian traffic simulation (e.g. Helbing et al. 2000; Haklay et al. 2001), and fire egress simulation (e.g. Stahl 1982; Ozel 1993). Such simulations are often aimed at testing the Level of Service—the amount of space people need to conduct certain activities, such as the width of walkways, corridors, and doors, under both normal and emergency situations. General human spatial behaviour simulation models have been developed by Archea (1977), Kaplan & Kaplan (1982) and others. They typically use discrete event simulation methods, where a generalized algorithm tracks minute-by-minute changes, geometry-based approaches, or neural-nets (O'Neill 1992).

Our approach, turning contrast, is general purpose: it is based on an agent-based artificial user model, which can be inserted in any environment. Earlier work by Steinfeld (1992) and Kalay & Irazábal (1995) proposed, but did not implement, the development of artificial—or 'virtual'—users. We have developed simulation methods and implemented both simulation and visualization of human behaviour in a public space. To allow the virtual users to recognize the environment in which they operate, we developed a usability-based building model, which possesses both geometric information and usability properties of design elements. It is generated automatically from a standard CAD model, which saves the need to re-enter a specific model for the simulation. The virtual users are modelled as autonomous agents that emulate the appearance, perception, social traits and physical behaviour of real users. These behaviours are based on a field study using automated video tracking techniques to generate statistics of users' behaviour in a public space (as discussed in Section 2). The conversion of a standard CAD model of the space into a usability-based building model is discussed in Section 3. The agent-based virtual user model is based on environment-behaviour theories, the field study, and Artificial Life algorithms (Section 4). A simulation engine that achieves similar behaviour patterns to those observed in reality is discussed in Section 5.

2 BEHAVIOUR TRACKING AND ANALYSING

To ensure the correspondence of the simulation to reality, our simulation is based on a large amount of quantitative, real-world behaviour data. The data was collected through our automated video tracking system that automatically tracked and analysed the behaviour pattern of users in a public space (Yan and Forsyth 2005). The tracking system consists of an algorithm to detect individual people in single video frames, and a data association technique for tracking people through successive frames. We applied the system to 8 hours of video data, which was recorded in Sproul Plaza at U.C. Berkeley, during 4 days, from 3PM to 5PM on each day, in summer 2003 (Figure 2).

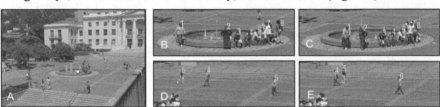

Figure 2 Plaza video (A). Tracking people at the fountain (B & C) and walking (D & E)

The target region is a roughly square space in the centre of the plaza. It contains distinctive paving, a fountain with low seating edge, large area of steps, and a few benches. The plaza is the birth-place of the Free Speech Movement of the 1960s, and has, therefore, been studied extensively by researchers.

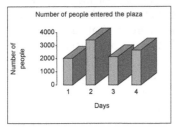

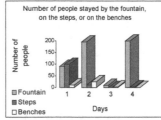

Figure 3 Left: Numbers of people who entered the plaza in different days. Right: Numbers of people sat at different places.

We compared the results obtained from the tracking system with those obtained from manual counting, for a small data set, and found the results to be well-correlated. We then applied the system to the large-scale data set and obtained substantial statistical measurements that include the total number of people who entered the space, the total number of people who sat by a fountain (Figure 3), distributions of duration at the fountain, the benches, and the steps (Figure 4), and people's walking paths (Figure 5). The measurements also include the

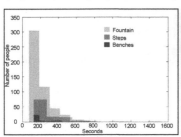

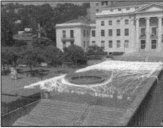

Figure 4 Distributions of duration. Figure 5 Walking paths

probability that a person entering the plaza will choose to sit by the fountain, on the steps, or on the benches, respectively; the distribution of arrival rate per minute (which was found to be close to a Poisson distribution); and the probability of a person entering from one location and exiting at another.

3 USABILITY-BASED BUILDING MODEL

A model of the built environment is, of course, key to behaviour simulations whose goal is to evaluate its effect on human spatial behaviour. However, built environments are relatively complicated, compared with environments of the kind used in Artificial Life simulations, where autonomous life-like agents fly in the sky or swim in the tank with certain motivations and according to certain behaviour rules. For example, Boids environments (Reynolds 1987) focus on simulating interaction among bird-like agents during flight, while avoiding obstacles. Similarly, the Artificial Fish (Tu 1996) environment consists of water current, seaweed and plankton. The fish are able to perceive their environments and act by avoiding collisions and pursuing a moving target. In contrast, built environments consist a large number of design elements, such as walls, doors, windows, stairs, columns, benches, fountains, lawns, paving, etc. A virtual user

needs to perceive and understand them to behave properly, e.g. walk through a door, stand by a fountain, and sit on a bench.

We developed a systematic approach to modelling the environment and created a usability-based building model. Unlike traditional CAD models, our model possesses both graphical/geometric information of design elements and non-graphical information about the usability properties of these elements. The environmental information is structured in a way that makes it perceivable and interpretable by the virtual users. To be more practical, the building model is not created from scratch. Instead, it is built on top of existing CAD models that come from everyday architectural design practices. Such building models already contain complete graphical information but lack the non-graphical information concerning usability of design elements, and therefore cannot be directly understood by virtual users. We have developed a method to automatically convert standard CAD models (e.g. in DXF format), to usability-based models that are ready for the human behaviour simulation.

3.1 Geometry Modelling

We created a model of Sproul Plaza in layer-based DXF format, and converted it into a 3D VRML model (Figure 6). To prepare for the translation from the DXF model to the

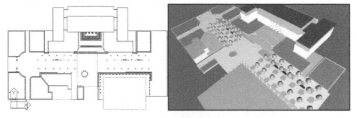

usability-based model, we used a regularized naming convention for the layers, and made sure each design component was placed in its appropriate layer.

Figure 6 The plaza's DXF model (left) and VRML model (right)

For example, LowWall-FountainSide is the name of a design component of type LowWall, and its ID is FountainSide. We also marked the components' z-depths according to their actual spatial relationships, e.g. fountain-side is on top of the ground.

3.2 Usability Modelling

Our modelling tool converts the DXF into Scalable Vector Graphics format (SVG), which is a subset of XML for graphical presentation. SVG is semantically rich: the graphical information is always associated with meaningful textual information. Its element-tree can be traversed to search for a specific node, which can be checked for attributes such as usability. In our approach, as the geometries in the DXF format are converted into SVG elements, their architectural semantics are inserted into the SVG element-tree according to their layer names. Custom tags of the architectural components with their attributes, in extended architectural name-space, appear in the data structure. For example, the fountain-side element is defined by its element type, followed by its geometry element:

```
<arch:LowWall id='FountainSide'/>
<circle cx='85.5' cy='90.75' r='3.75' style='&DesignElementStyle;'/>
```

304

Most of the activities in our simulation take place in the plaza's centre area—the target region. Virtual users must know where they are and what they can do at any given location. For example, a user by the fountain can sit on a small area of the low wall. We subdivide this large space object into many small objects, in the form of a grid of cells. Each cell in the grid is an object that possesses several layers of properties. They can include information such as whether the cell is sittable, whether it is in the sun or in the shade, whether it is occupied by a user, etc. Every user occupies one grid cell at any given time. Given the potentially large number of cells in a plaza, we balanced computational efficiency against the physical reality by using 750mm sized cells, and 1 second time steps.

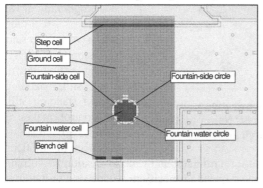

Figure 7 Discrete space model. Cells are marked correctly with colour codes

Each cell can have a number of design element types. For example, it can be fountain-side and ground, at the same time. We applied the Painter algorithm (see Hearn and Baker 1997) to classify cells according to their top-most underlying design element. In the above example, the cell is designated fountain-side, which is the top-most level's type (see Figure 7). Each cell's usability property is then added to the element's attribute list. For example, usability of type 'sit' is defined for a cell of type fountain-side:

```
<arch:LowWall archID='FountainSide' x='9' y='39' id='516' usability='sit'/>
<use xlink:href='#cell_6' transform='translate(84.0,94.5)'/>
```

This discrete space model becomes our usability-based model, which allows virtual users to access and understand the space's properties, beyond mere geometry. It is not tied to any particular CAD software. Rather, it is designed as a reusable tool for working with traditional geometric models and Building Information Models.

4 AGENT-BASED VIRTUAL USER MODEL

The virtual users are modelled as autonomous agents that emulate the appearance, perception, social traits and physical behaviour of real users. User modelling consists of geometry modelling, perception modelling, and behaviour modelling.

4.1 Geometry Modelling

A 3D VRML model is used to represent virtual users as mannequins, with articulated body geometry, texture mapping and animation, and conforms to the international standard of human modelling—Humanoid Animation Specification (H-Anim, 1.1). It is used to represent realistic close-up models of virtual users, their walking and sitting animations (Ballreich 1997, Babski 1998; Figure 8 left).

This model, however, is computationally too expensive for visualizing groups of people. Therefore, we created a simpler human model, based on low-level limb movements that are encapsulated within the H-Anim model, such as the arms' and legs' movements for walking. These stick-figures have the same high-level movements as the close-up models (walking, running, and sitting), without the overhead of fully flashed-out bodies.

By augmenting the VRML model with Java programming, we created real-time motion controls to start or stop walking, running, sitting down, sitting still, standing up, and standing still. The control makes it possible to create a sequence of motions

Figure 8 Left: 'Nancy' and 'Bob' demonstrating walking and standing behaviours respectively. Right: Nancy and Bob finding benches using A* search algorithm

using a script, e.g. walk to location X, sit for n minutes, and walk to location Y. Turning is calculated automatically so that there is no need to specify it: whenever a virtual user starts a journey in a new direction, it will turn along the direction smoothly and go forward, just like a real user. Transitional movements such as sitting down and standing up are inserted into motion sequence automatically. For example, if a virtual user first walks and then sits, a transition of sitting down is inserted between walking and sitting.

4.2 Perception Modelling

Perception modelling defines the users' ability to access and interpret the environment model. It is the combination of four components: (1) "seeing," i.e. accessing the relevant parts of the environment model within a circular area in front of a user in real-time, and translating them into terms that correspond to the virtual user's cognitive model, for such purposes as avoiding collisions and recognizing an acquaintance or an object; (2) "knowing" the entire environment in advance to help make basic decision of what to do and how to behave, much like a frequent visitor has knowledge of the location and orientation of benches, so they can seek them out in order to sit on one; (3) "finding" paths using A* algorithm, which is widely used for searching the shortest path in games (Figure 8 right). We optimised A* in our simulation to reduce the search space from the total number of cells to a subset of cells within a rectangle with a user's starting and target points as corners; and (4) "counting" the duration of a specific behaviour, such as sitting, to make a decision about what to do next: continue sitting or walk away.

4.3 Behaviour Modelling

Behaviour modelling is the most critical issue underlying the simulation because it must mimic closely how humans behave in similar socio/spatial environments, given similar goals. Accordingly, our behaviour modelling is based on three important and firm sources. The first source includes theoretical and practical environment-behaviour

studies, such as those by Lewin (1936), Moore (1987), Stokols (1977), Hall (1966), Whyte (1980), Gehl (1987), etc. The common characteristics of these theories provided us with the basic relationship between environment and behaviour. The relationship can be expressed as: $B = f(G, R, E)$, where G, R, and E stand for the goals, behaviour rules, and the built environment, respectively. Goals are high-level objectives, the results of intra-personal processes. Rules are the results of physiological and psychological processes, influenced by social and cultural dimensions. The built environment is comprised of design elements.

The second source of data was the field study, which provided important and substantial statistical measurements about users' behaviour, e.g. users' goals and overall behaviour patterns. The third source of data is Artificial Life research, which provided primitive group behaviour algorithms. Built from simple behaviour rules for individual users, the group behaviour algorithms are used for simulating spatial interactions among individuals during their movements.

Using these three sources, we developed an agent-based approach, where the behaviour of virtual users (which include walking through the plaza, sitting by the fountain, on the benches, or on the steps, or standing while meeting acquaintances, etc.), is determined through a hierarchical structure of rules, resulted directly from the following aspects:

- **Artificial Life approach.** Primary movement control is inspired by Artificial Life's flocking algorithm (Reynolds 1987). Three simple rules define the heading direction of a so called Boid and result in a complex behaviour pattern that mimics birds' flocking. The three rules are: (1) separation - steering to avoid crowding flockmates; (2) alignment - steering towards the average heading of flockmates; and (3) cohesion - steering to move toward the average position of flockmates. When applied to user simulation, the algorithm is modified with consideration of human social environmental factors.

- **Social spaces.** Environment-behaviour studies helped to apply Artificial Life's flocking algorithm to users' behaviour simulation in public spaces: (1) separation - people tend to keep certain distances from one another (Gehl 1987, Hall 1966; see Figure 9); (2) alignment - pedestrians tend to accelerate or slow down to match the motion of others (Whyte 1980), and align in two-way traffic (Gehl 1987); (3) cohesion - they try to stay in the main pedestrian flow or move into it (Whyte 1980). They gather with and move about with others and seek to place themselves near others (Gehl 1987).

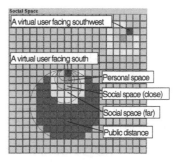

Figure 9 Social spaces

- **Environmental effects.** The field study provided the goals and overall behaviour patterns, including: (1) arrival rates to set up the frequency of inserting virtual users into the plaza from different entrances; (2) target distribution based on users walking paths; (3) probabilities of users choosing to sit; (4) seating preferences based on people's choices among the fountain, the benches, and the steps; and (5) distribution of duration with means and standard deviations of duration at different seating places.

- **Randomisation.** To add more realism to behaviour simulation, we applied random events, including Poisson distribution for arrival rates, normal distribution for duration of sitting and standing, and uniform distribution for meeting acquaintances (standing still), appearance of virtual users, starting and ending points at entrances or exits, etc.

5 SIMULATION AND RESULTS

We built a simulation engine that integrates the building model and the virtual user model into 2D simulation, on top of which we created 3D visualization.

5.1 2D Simulation

The simulation engine first loads the plaza SVG model and parses the model's graphical and usability properties, then creates a virtual user group—a list that allows an unlimited number of users to be added into, and upon completion of a journey removed from the list. The engine runs the simulation step by step, and at each time step (one second) it adds users from the entrances and moves all the users by one step. Adding users from multiple entrances at the same time is a multi-thread process, and it is controlled by the statistics of goals and overall behaviour pattern. The engine passes the environment properties to the virtual users so that the users know, for example, where they can walk and where they can sit. Then the engine starts another thread, which lets the virtual users move following behaviour rules, e.g. shortest path, group movement rules, and social spaces. The simulation engine uses Batik SVG toolkit with Java2D rendering engine, and Document Object Model (DOM) to traverse the element tree (see Watt, A. et al. 2003 for details of Batik).

Figure 10 Left: 2D animation. Right: behaviour data - paths

The simulation results include (1) a 2D animation of virtual users movements, including walking and standing in the plaza, sitting at different places, and meeting other users, etc. (Figure 10 left); and (2) a behaviour data set that records all users' behaviour information associated with their paths, including the coordinates along paths, arrival time, motions, sitting directions, and duration of stay (Figure 10 right).

5.2 3D Visualization

By inserting 3D virtual users to the 3D plaza model and letting the users move following the recorded behaviour data, we realized behaviour visualization—animations in which the virtual users exhibit similar traits to those observed in reality (walking, sitting, meeting other virtual users, etc.; see Figure 11 left).

To experiment how design alternatives affect users' behaviour, we ran a simulation for a new plaza that is similar to Sproul Plaza but missing the fountain (Figure 11 right). As the result turned out, users were just walking across or standing for short time, and no one stayed in the centre of the plaza for very long. The result seems obvious in this

simple experiment. Our point, however, is that the simulation can produce an immediate picture of how environmental settings affect people's behaviour.

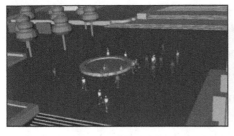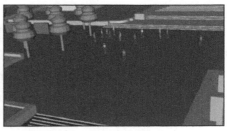

Figure 11 Left: virtual users walking in the plaza and sitting and standing by the fountain. Right: virtual users walking in a plaza without a fountain

6 CONCLUSION

By inserting virtual users in a model of the designed environment, and letting them "explore" it on their own volition, our system reveals the interrelationship between the environment and its users.

The contributions of our approach include: 1) It is more design-oriented than other behaviour simulations. It utilizes CAD models and automates the conversion from CAD models to usability models and therefore requires minimal additional effort in preparing building data for behaviour simulation. 2) The application of computer vision (video tracking) to obtain large amounts of quantitative data for behaviour simulation has proven to be effective. 3) The model places the emphasis on comprehensive environmental behaviour rules, which are derived from solid sources and integrated into the behaviour model. By producing immediate visible results of users' behaviour, the simulation can assist evaluation and comparison of design alternatives, and can help designers gain a better understanding of behaviour and incorporate behaviour knowledge into design process. It can assist architectural education by helping students gain intuition about how different environmental settings impact users' behaviour. 4) While previous behaviour simulations tended to focus on emergency conditions, our model simulates users' daily behaviour and their environmental preferences under normal conditions, which are the main concerns of architects' daily design tasks.

We expect the result of this research to change how architects and environmental behaviour experts will approach the design and evaluation of built environments.

REFERENCES

Archea, J. 1977. The Place of Architectural Factors in Behavioural Theories of Privacy. *Journal of Social Issues* 33: 3.

Babski, C. 1998. Baxter.wrl, LIG/EPFL. http://ligwww.epfl.ch/ ~babski/StandardBody/

Ballreich, C. 1997. nancy.wrl, http://ballreich.net/vrml/h-anim/h-anim-examples.html

Gehl, J. 1987. *Life between buildings: using public space* [English translation]. New York: Van Nostrand Reinhold.

Haklay, M. (et al.) 2001. So go downtown: Simulating Pedestrian Movement in Town Centres. *Environment and Planning B* 28(3): 343-359.

Hall, E.T. 1966. *Hidden Dimension.* New York, Doubleday.

Hearn, D., and Baker, M.P., 1997. Computer Graphics, New Jersey: Prentice Hall.

Helbing, D., Farkas, I., and Vicsek, T., 2000. Simulating dynamical features of escape panic. *Nature* 407(6803): 487-490

Kalay, Y.E., and Irazábal, C. E. 1995. Virtual Users (VUsers): Auto-Animated Human-forms for Representation and Evaluation of Behaviour in Designed Environments, *Technical Report*, Berkeley: University of California.

Kaplan, S. and Kaplan, R. 1982. *Cognition and Environment: Functioning in an Uncertain World.* New York: Prager.

Lewin, K. 1936. *Principles of topological psychology.* McGraw-Hill.

Moore, G.T. 1987. Environment and behaviour research in North America: history, developments, and unresolved issues. *Handbook of environmental psychology.* eds. D. Stokols and I. Altman: 1371-1410. New York, John Wiley & Sons.

O'Neill, M.J. 1992. A Neural Network Simulation as a Computer-Aided Design Tool for Evaluating Building Legibility. *Evaluating and Predicting Design Performance,* ed. Y.E. Kalay: 347-366. New York: John Wiley & Sons.

Ozel, F. 1993. Computer Simulation of Behavior in Spaces. *Environmental Simulation - Research and Policy Issues,* 191-212. New York, Plenum Press.

Reynolds, C.W. 1987. Flocks, Herds, and Schools: A Distributed Behavioural Model, in Computer Graphics, 21(4) 25-34.

Steinfeld, E. 1992. Toward artificial users. *Evaluating and predicting design performance.* ed. Y. E. Kalay: 329-346. New York: John Wiley & Sons.

Stahl, F. 1982. Computer Simulation Modeling for Informed Design Decision Making. In *13th Annual Conference of the Environmental Design Research Association,* eds. P. Bart, A. Chen, and G. Francescato: 105-111. Washington, DC: EDRA.

Stokols, D. 1977. Origins and directions of environment-behavioural research. *Perspectives on environment and behaviour,* 5-36 New York, Plenum Press.

Tu, X. 1996. *Artificial Animals for Computer Animation: Biomechanics, Locomotion, Perception, and Behaviour.* Dissertation, University of Toronto.

Watt, A. et al. 2003. *SVG Unleashed.* Sams Publishing.

Whyte, W. 1980. *The Social Life of Small Urban Spaces.* New York: Project for Public Spaces.

Yan, W., and Forsyth, D. 2005. Learning the Behavior of Users in a Public Space through Video Tracking [forthcoming], In *Proceedings of IEEE WACV.*

Resolving some Ambiguities in Real-time Design Drawing Recognition by means of a Decision Tree for Agents

ACHTEN Henri
Department of Architecture, Building and Planning, Eindhoven University of Technology, The Netherlands

Keywords: multi-agent system, decision tree, pattern recognition, sketch

Abstract: In this paper, we present a theoretical study on automated understanding of the design drawing. This can lead to design support through the natural interface of sketching. In earlier work, 24 plan-based conventions of depiction have been identified, such as grid, zone, axial system, contour, and element vocabulary. These are termed graphic units. Graphic units form a good basis for recognition of drawings as they combine shape with meaning. We present some of the theoretical questions that have to be resolved before an implementation can be made. The contribution of this paper is: (i) identification of domain knowledge which is necessary for recognition; (ii) outlining combined strategy of multi-agent systems and online recognition; (iii) functional structure for agents and their organisation to converge on sketch recognition.

1 GRAPHIC REPRESENTATIONS

During the design process, roughly three classes of graphic representations are utilised: the diagram, the design drawing, and the sketch. The diagram is a clear, well-structured schematic representation of some state of affairs. It is typically used in the early phase of design, very often as an analytical tool. The design drawing is a well-drafted comprehensive drawing applying the techniques of plan, section, and façade. It is typically utilized after concept design, to communicate ideas with the patron or other participants in the design process. The sketch is a quickly produced rough outline of a design idea, typically created in the early phase of design. Within each class there are many differences due to production technique, time constraints, conventions of depiction and encoding, and personal style.

The diagram and sketch are very apt for early design. They enable fast production of numerous ideas, thereby allowing the architect to engage in an iterative process using internal and external memory, reflection, exploration, and test (Goel 1995; Verstijnen 1997). In this work we are concerned with computational interpretation of such drawings. We are motivated from a *design support* and *design research*

B. Martens and A. Brown (eds.), Computer Aided Architectural Design Futures 2005, 311-320.
© 2005 *Springer. Printed in the Netherlands.*

perspective. Much of the output in early design is produced by means of diagrams and sketches. Understanding these drawings supports early design assessment, can provide relevant knowledge, aid in information exchange, and facilitate transfer of information between design phases or applications.

In order to achieve understanding of graphic representations, we need a theory for computational interpretation of drawings. Such a theory is lacking in the design research field (Lawson and Loke 1997, 174-175; Verstijnen et al. 1998, 520; Dahl et al. 2001, 6) and in general recognition research (Tombre 1995, Mundy 1999, 23). An additional complication is the general oversight of context (Song et al. 2002) and annotations (McGown et al. 1998, 432-433), the lack of which leads to unrealistic assumptions about image recognition. As a consequence, we have to draw our foundations, evidence, and intuitions from many disciplines including design research, image and pattern recognition, handwriting recognition, artificial intelligence, and multi-agent systems. The contribution of this paper is: (i) identification of domain knowledge which is necessary for recognition; (ii) outlining combined strategy of multi-agent systems and online recognition; (iii) functional structure for agents and their organisation to converge on sketch recognition.

Design sketches have been subject of much study. Although there is now general agreement that the sketching activity is structured (Kavakli et al. 1998; Scrivener et al. 2000), there is no consensus in terminology and framework how to categorise this structuring. This seems to be mainly caused by the great variety of research questions, design domains, and agendas pursued (compare for example Goel 1995; Purcell and Gero 1998; McGown et al. 1998; Rodgers et al. 2000; Lim et al. 2003; Akin and Moustapha 2004; Tovey et al. 2003). Most authors employ their own categorisation to differentiate between kinds of drawing (e.g. Goel 1995; 128-136, Verstijnen et al. 1998; and McGown et al. 1998).

Applied research on sketch recognition in the engineering areas has focused almost exclusively of the construction or identification of three-dimensional objects based on sketches or line drawings (e.g. Jansen and Krause 1984; Cooper 1997; Tovey 1997; Parodi et al. 1998; Bimber et al. 2000). With regard to formalised content of architectural sketch drawings, most work has been done on the plan representation. (Koutamanis 1990) outlines a computational analysis of space formation in architectural plans. (Cha and Gero 1998) formalise a number of shape configurations that may occur without consideration of design content. (Do et al. 2000) and (Gross 1996) deal with graphic shorthands of for example 'table,' 'chair,' and 'house.' (Koutamanis and Mitossi 2001) focus on local and global co-ordinating devices such as 'door in wall' and 'proportion system' of Palladio. (Leclercq 2001) has implemented a system that takes sketch input and recognises grids, spaces, and functions. In earlier work, we have classified 24 conventions that are used in drawings such as 'grid,' 'zone,' 'contour,' and 'axial system' (Achten 1997).

1.1 Basic Assumptions

Domain knowledge is important for drawing recognition as it informs what should be looked for. Based on the authors above, we can state that the kind of knowledge

we need combines meaning with shape. Such meaning necessarily is based on agreement or convention within a domain: it is not intrinsic to a graphic representation. In our work, we have the following basic assumptions:

- There is nothing inherently ambiguous in graphic representations. Ambiguity through multiple interpretation is what the architect does with the graphic representation, not the graphic representation itself.

- We primarily consider sketches that are made with some care for clarity (and which can thus be verified by an outside observer). Sketches that are purposefully unclear fall outside our scope. Within all possible conventions of depiction, we only look at plan representations.

- Although designers habitually reinterpret sketches, they do so in an orderly fashion and in a limited way. Reinterpretations do not wildly diverge and are relatively close to each other. The question therefore, is not to investigate why sketches are ambiguous, but rather which clues architects employ and which interpretations they allow.

- We limit our definition of computational interpretation of a sketch to instrumental meaning (what do the graphic entities map to the design task), not architectural theoretical meaning or other domains of discourse. Instrumental meaning is domain-specific and context dependent. We take the previously identified 24 graphic units as instrumental meaning in graphic representations.

1.2 Graphic Units

The definition of a graphic unit is: "a specified set of graphic entities and their appearance that has a generally accepted meaning within the design community" (Achten 1997, 22). The appeal to 'generally accepted meaning,' even though it introduces methodological problems, is necessary because meaning is in many cases the only distinguishing factor between otherwise similar shapes (e.g. "is this set of straight lines a grid or a close packing of squares," and "is this rectangle a table or a column?") Graphic units can be divided in structuring and descriptive graphic units.

Structuring graphic units build up and organise the design. Their elements only indirectly map on elements in the built environment, and they are typically left out in final documentation drawings. They are *measurement device, zone, schematic subdivision, modular field, grid, refinement grid, tartan grid, structural tartan grid, schematic axial system, axial system, proportion system*, and *circulation system*.

Descriptive graphic units map to objects in the built environment: *simple contour, contour, specified form, elaborated structural contour, complementary contours, function symbols, element vocabulary, structural element vocabulary, combinatorial element vocabulary, functional space, partitioning system*, and *circulation*.

Sketch recognition therefore, translates in our view to recognition of graphic units in a plan-based diagrammatic drawing or sketch which has been created with some care for clarity.

2 GRAPHIC UNIT RECOGNITION

Image recognition research mainly focuses on photo- or video-like sources, or aims to mimic some functionality of the human visual system. Line art or line drawings are quite distinct from these kind of sources. In particular handwriting recognition has received a lot of attention, but in the area of drawings there has not been much work. Comparatively much effort has been given to automated document management, in particular in the transfer from paper-based maps to the electronic format of GIS and CAD (Ogier et al. 1998). Other work includes the reconstruction of telephone system manhole drawings (Arias et al. 1995), conversion of machine engineering line drawings (Wenyin and Dori 1998), and symbol detection in architectural drawings (Ah-Soon and Tombre 2001). In all cases the processed sources are the precise class of design documentation drawings.

Most approaches in image recognition are built on multiple levels of (similar or mixed) recognisers that incrementally process or reason about information delivered from lower levels. A recent trend is to incorporate statistical techniques (Forsyth 1999), although there is concern to which extent this can link to domain knowledge (Mundy 1999). Questions in this area are about the often manual tuning of the system, incorporation of domain knowledge, and the problem of low performance when variations in the drawings occur. It is to be expected that this latter problem is much larger when the input material is a sketch drawing. This calls for a strategy which can deal with much uncertainty in the recognition process.

We propose to combine two techniques to tackle the question of drawing recognition: (1) multi-agent approach; and (2) online recognition. We discuss these two strategies in the context of a hypothetical drawing system that recognises graphic units. The hypothetical system has the following components: (a) drawing area; (b) drawing pen (similar to the technique reported in Cheng 2004); (c) module for tracking and segmenting strokes made by the pen; (d) multi-agent module for determining which graphic units are present in the drawing; (e) visual display for feedback of d-module.

2.1 Multi-agent Approach

It has become increasingly productive to recast the multiple classifier approach in terms of multi-agent systems. Although the classifiers remain the same (Ng and Singh 1998; Giacinto and Roli 2001 point out the utility of aggregating various classifiers), the approach adds to the conceptual level a more autonomous role to each classifier; it acknowledges explicitly the limited capabilities per classifier; and it realises that classifiers (in the guise of agents) should communicate with other classifiers to settle ambiguities (Vuurpijl and Schomaker 1998; van Erp et al. 2002). The parallelism inherent in multi-agent systems is another major motivation. In particular when multiple interpretations are possible, resolution critically depends on a weighed and balanced exchange of viewpoints. In sequential processing this may lead to long waiting times for a decision-module to gather all relevant evidence.

Earlier, we have established a multi-agent framework that forms the basis for building a drawing recognition system (Achten and Jessurun 2003). The functional behaviour of an agent A_i is described by its properties $\{P_i, G_i, F_i, C_i, S_i\}$, that are informally defined as follows.

The purpose P_i of an agent A_i is to recognise one particular graphic unit. Thus, there is a *Grid-agent, Zone-agent, Circulation System-agent, Simple Contour-agent*, etc.

The goal G_i of an agent A_i is to determine whether the graphic unit P_i is present in the current state of the drawing. Thus, the *Grid-agent* continuously checks for grids.

Each agent A_i employs a set of features F_x to decide if graphic unit P_i occurs. Thus, the *Grid-agent* looks for occurrences of parallel (F_1) aligned (F_2) straight lines (F_3) drawn consecutively (F_4) in the same direction (F_5) of roughly the same length (F_6) in two directions (F_7) in which the parallel lines keep the same distance from each other (F_8), and the lines in two directions overlap each other in an implied grid area (F_9). Obviously, multiple agents can use the same features.

Each agent A_i has a set of criteria C_y which establish a relative measure RM_i of the degree to which graphic unit P_i is detected. Thus, the *Grid-agent* wants to detect at least three consecutive lines that fulfil F_1 - F_9 before it considers the possibility that a grid occurs. If the number of consecutive lines increases that fulfil $F_1 - F_9$, the relative measure also increases according to an S-shaped curve.

Each agent A_i has a set of segmentation measures S_z to determine if it should continue tracking the current sequence of strokes graphic unit P_i. This basically defines the activation window during which the agent considers the current sequence of strokes. Thus, the *Grid-agent* stops tracking a series of consecutive lines when curved lines occur, or when new lines no longer fall within the implied grid area without extending it, and so forth.

2.2 Online Recognition

Online recognition means that computer interpretation takes place while the designer is drawing. In particular in the handwriting recognition area, numerous researchers opt for online recognition of text (Williams 2002 contains many examples), motivated especially by the high efficiency of the stroke direction feature (Liu et al. 2003, 2271). To the best of our knowledge, there is no online computer *interpretation* of sketches applied in architectural design, and only sporadically in engineering design (Dijk and Mayer 1997 and Qin et al. 2001 are notable exceptions). This is an omission since the creation order of strokes and their direction information can only be derived from an online process. Especially in the case of diagrams and sketches, where the appearance of elements shows high degree of variety, these are important clues to derive what is being drawn (e.g. features F_4 and F_5 of the Grid-agent example).

The c-module in the hypothetical sketch system creates a data stream of strokes which forms the input for the multi-agent system in the d-module. The agents continuously parse the stream in the manner described above; this is in fact their

way of 'seeing' the drawing. An agent A_i annotates the drawing by placing four kinds of markers in the stream: M_s, M_h, M_e, and M_c. The start marker M_s designates the first stroke of a sequence that an agent is tracking. A new start marker can only be placed after the agent has placed an end marker or claim marker. The hypothesis marker M_h designates the end of a sequence while the agent is anticipating that in the near future it will be completed (in this manner, interfering non-fitting strokes can be ignored). The end marker M_e designates the last stroke of a sequence that an agent is tracking. A new end marker can only be placed after the agent has placed a start marker. The claim marker M_c is placed once the agent reaches the threshold value and a graphic unit has been identified.

At any point in the stream, any agent can place its own marker; each marker is associated with the agent that has put it there. After parsing and annotating the data stream, the stream is stored for later reference.

2.3 Resolving the Decision Process

Whenever an agent reaches its threshold value and places a claim, all other agents respond by polling their current relative measures RM_i. In order to converge to a decision, we adopt a decision tree developed earlier for architects to decide which graphic unit is present (Achten 2000); see Figure 1.

In the decision tree, the path ABDGK17 is the series of questions that must be answered to determine the graphic unit. These are currently stated in natural language: *A*. Is it a graphic or symbol element; *B*. Is it a closed shape or a set of one or more lines; *D*. Is it a coordinating system or not; *G*. Is it a zone, grid, or proportion system; and *K*. Is it a modular field, grid, refinement grid, tartan grid, or structural tartan grid. The leaves 1-27 are the specific graphic units.

The decision tree essentially divides graphic units in groups: text (A7); multiple shapes on building level (ABCEI); multiple shapes on element level (ABCEJ); single shapes on building level (ABCF); area structuring devices (ABDG and ABDGK); and building structuring devices (ABDH, ABDHL, ABDHM, ABDHN). The groups are distinguished from each other through the nodes *A-N*. The decision in each node to decide between one or the order further branch is made on a specific set of features for that node. Therefore, each graphic unit is characterised by a unique decision cluster of features (the aggregation of the nodes leading to that graphic unit).

At any given point during the online recognition process, it is likely that multiple agents have a relative measure RM_i which is higher than 0. In other words, features are likely not to activate one single agent (restricted to a single path in the decision tree), but multiple agents (distributed over the nodes of the whole tree). So we can view the distribution of the features over the 24 distinct paths as additional evidence for a ranking which can modify a preliminary ranking based on RM_i only. Qualitatively speaking, the path which has the greatest collection of features presents the most likely candidate. We still have to determine a quantitative means of aggregating the features along a path and balancing this measure against RM_i.

Figure 1 Decision Cluster ABDGK For Graphic Unit *Tartan Grid*

3 FUTURE WORK

We have outlined a multi-agent system for online recognition of graphic units in diagrammatic and sketch drawings. Empirical work is still needed to calibrate the stroke segmentation of the c-module. The utility of the decision tree is to separate the major groups, and show near the leaves how ambiguity occurs through alternative interpretations. The different depths of the decision tree give a relative indication which groups are easier to recognise than others. A major step we still have to take is the formalisation into features of the natural language questions in the nodes *A-N*. This also requires an additional revision of the decision tree into truly binary branches per node. Based on the resulting pool of features, we can determine which aggregation policy has the most potential.

A running implementation will provide feedback about the viability of the theoretical work. Supposing that we find some virtue in the current work, further theoretical questions then concern whether an agent should keep a record of its own performance when recognition has to take place; if it is desirable to have each agent segment the input by itself (and how to aggregate over feature activations that are built on different segmentations); and whether an agent should follow multiple tracks in the data stream.

REFERENCES

Achten, H.H. 1997. *Generic Representations*. PhD-diss., Eindhoven University of Technology.

Achten, H.H. 2000. Design case retrieval by generic representations. In *Artificial intelligence in design '00*, ed. J.S. Gero: 373-392. Dordrecht: Kluwer.

Achten, H.H., and J. Jessurun. 2003. Learning from mah jong. In *Digital design: research and practice*, ed. M.L. Chiu et al.: 115-124. Dordrecht: Kluwer.

Ah-Soon, C., and K. Tombre. 2001. Architectural symbol recognition using a network of constraints. *Pattern Recognition Letters* 22: 231-248.

Akin, O., and H. Moustapha 2004. Strategic use of representation in architectural massing. *Design Studies* 25(1): 31-50.

Arias, J.F., Lai, C.P., Surya, S., Kasturi, R., and A. Chhabra. 1995. Interpretation of telephone system manhole drawings. *Pattern Recognition Letters* 16: 355-369.

Bimber, O., Encarnação, L.M., and A. Stork. 2000. A multi-layered architecture for sketch-based interaction within virtual environments. *Computers & Graphics* 24(6): 851-867.

Cha, M.Y., and Gero, J.S. 1998. Shape pattern recognition. In *Artificial intelligence in design'98*, ed. Gero, J.S., and F. Sudweeks: 169-187, Dordrecht: Kluwer.

Cheng, N.Y.-W. 2004. Stroke sequence in digital sketching. In *Architecture in the Network Society* [eCAADe 2004 proceedings], eds. B. Rüdiger, B. Tournay, and H. Orbak: 387-393. Copenhagen: eCAADe.

Cooper, M.C. 1997. Interpreting line drawings of curved objects with tangential edges and surfaces. *Image and Vision Computing* 15: 263-276.

Dahl, D.W., Chattopadhyay, A., and G.J. Gorn. (2001). The importance of visualization in concept design. *Design Studies* 22(1): 5-26.

Dijk, C.G.C. van, and A.A.C. Mayer. 1997. Sketch input for conceptual surface design. *Computers in Industry* 34(1): 125-137.

Do, E., Gross, M.D., Neiman, B., and G. Zimring (2000). Intentions in and relations among design drawings. *Design Studies* 21(5): 483-503.

Erp, M. van, Vuurpijl, L., and L. Schomaker. 2002. An overview and comparison of voting methods for pattern recognition. In *Proceedings of IWFHR'02*, ed. Williams, A.D.: 195-200, Los Alamitos: IEEE Computer Society.

Forsyth, D. 1999. An empirical-statistical agenda for recognition. In *Shape, contour and grouping in computer vision*, ed. Forsyth, D.A., Mundy, J.L., di Gesú, V., and R. Cipolla: 9-21, Berlin: Springer Verlag.

Giacinto, G., and F. Roli. 2001. An approach to the automatic design of multiple classifier systems, *Pattern Recognition Letters* 22: 25-33.

Goel, V. 1995. *Sketches of thought*, Cambridge: The MIT Press.

Gross, M. (1996). The Electronic Cocktail Napkin - a computational environment for working with design diagrams. *Design Studies* 17(1): 53-69.

Jansen, H., and F.-L. Krause. 1984. Interpretation of freehand drawings for mechanical design processes. *Computers & Graphics* 8(4): 351-369.

Kavakli, M., Scrivener, S.A.R. and L.J. Ball 1998. Structure in idea sketching behaviour. *Design Studies* 19(4): 485-517.

Koutamanis, A. (1990). *Development of a computerized handbook of architectural plans*. PhD. diss., Delft University of Technology.

Koutamanis, A., and V. Mitossi (2001). On representation. *Design Research in the Netherlands 2000*, ed. H. Achten, B. de Vries, and J. Hennessey: 105-118, Eindhoven: Eindhoven University of Technology.

Lawson, B. and S.H. Loke 1997. Computers, words and pictures. *Design Studies* 18(2): 171-183.

Leclercq, P.P. 2001. Programming and assisted sketching. In *Computer aided architectural design futures 2001*, ed. B. de Vries and J.P. van Leeuwen, and H.H. Achten:15-31. Dordrecht: Kluwer.

Lim, S., Qin, S.F., Prieto, P., Wright, D., and J. Shackleton. 2003. A study of sketching behaviour to support free-form surface modelling from on-line sketching. *Design Studies* 25(4): 393-413.

Liu, C.L., Nakashima, K., Sako, H.,, and H. Fujisawa 2003. Handwritten digit recognition: benchmarking of state-of-the-art techniques. *Pattern Recognition* 36(10): 2271-2285.

McGown, A., Green, G., and P.A. Rodgers 1998. Visible ideas: information patterns of conceptual sketch activity. *Design Studies* 19(4): 431-453.

Mundy, J. 1999. A formal-physical agenda for recognition. *Shape, contour and grouping in computer Vision*, ed. Forsyth, D.A., Mundy, J.L., di Gesú, V., and R. Cipolla: 22-27, Berlin: Springer Verlag.

Ng, G.S., and H. Singh. 1998. Democracy in pattern classification: combinations of votes in various pattern classifiers, *Artificial Intelligence in Engineering* 12: 189-204.

Ogier, J.M., Mullot, R., Labiche, J., and Y. Lecourtier. 1998. Multilevel approach and distributed consistency for technical map interpretation: Application to cadastral maps. *Computer Vision and Image Understanding* 70(3): 438-451.

Parodi, P., Lancewicki, R., Vijh, A., and J.K. Tsotsos. 1998. Empirically-derived estimates of the complexity of labelling line drawings of polyhedral scenes. *Artificial Intelligence* 105: 47-75.

Purcell, A.T., and J.S. Gero 1998. Drawings and the design process. *Design Studies* 19(4): 389-430.

Qin, S.-F., Wright, D.K., and I.N. Jordanov. 2001. On-line segmentation of freehand sketches by knowledge-based nonlinear thresholding operations, *Pattern Recognition* 34(10): 1885-1893.

Rodgers, P.A., G. Green, and A. McGown. 2000. Using concept sketches to track design progress. *Design Studies* 21(5): 451-464.

Scrivener, S.A.R., Ball, L.J. and W. Tseng. 2000. Uncertainty and sketching behaviour. *Design Studies* 21(5): 465-481.

Song, X.B., Abu-Mostafa, Y., Sill, J., Kasdan, H., and M. Pavel. 2002. Robust image recognition by fusion of contextual information. *Information Fusion* 3(4): 277-287.

Tombre, K. 1995. Graphics recognition – general context and challenges. *Pattern Recognition Letters* 16(9): 883-891.

Tovey, M. 1997. Styling and design: intuition and analysis in industrial design. *Design Studies* 18(1): 5-31.

Tovey, M., Porter, S., and R. Newman. 2003. Sketching, concept development and automotive design. *Design Studies* 24(2): 135-153.

Verstijnen, I.M. 1997. *Sketches of creative discovery*. PhD. diss, Delft University of Technology.

Verstijnen, I.M., J.M. Hennessey, C. van Leeuwen, R. Hamel, and G. Goldschmidt. 1998. Sketching and creative discovery. *Design Studies* 19(4): 519-546.

Vuurpijl, L., and L. Schomaker, L. 1998. Multiple-agent architectures for the classification of handwritten text. In *Proceedings of IWFHR6*, 335-346. Taejon, Korea.

Wenyin, L., and D. Dori. 1998. A generic integrated line detection algorithm and its object-process specification. *Computer Vision and Image Understanding* 70(3): 420-437.

Williams, A.D. (ed.). 2002. *Proceedings Eighth International Workshop on Frontiers in Handwriting Recognition*, Los Alamitos: IEEE Computer Society.

Sketching with Digital Pen and Paper

KOUTAMANIS Alexander
Faculty of Architecture, Delft University of Technology, The Netherlands

Keywords: digital sketching, annotation, information management, digitization, interaction

Abstract: Architectural sketching with the computer has been possible for some time now. Using manual and optical digitizers architects have been able to create images similar in structure and appearance to conventional sketches on paper. Digitized sketches are traditionally associated with early design but are also increasingly linked to interactive interfaces and information management. The paper reports on the application of a new technology (Anoto) that uses a digital pen on specially prepared paper. The focus of the application was feedback from analogue documents to the computer programs used for preparing these documents and on the roles of freehand sketching in later design phases. Sketching with digital pen and paper was found to be useful for the management of annotations made on analogue versions of digital information, especially in multi-actor synchronous and asynchronous situations.

1 SKETCHING AND THE COMPUTER

Architects have been making and processing sketches with computers for some time now, even though in many respects sketching looks like an afterthought in design automation. Freehand sketching with the computer has developed in the margins of CAD hardware. The combination of graphics tablets with pen-like pointing devices has provided the basic means for manually digitizing drawings. Manual digitizers are characterized by low user threshold, as their mechanical and ergonomic properties are similar to these of familiar analogue media (Woessner, Kieferle, and Drosdol 2004, Lim 2003). Arguably more important for the transfer of analogue images to the computer have been optical digitizers (scanners), which produce pixel images. This makes optical digitization less attractive for several applications but in terms of utility scanners provide more flexibility, tolerance and ease. They accept a wider variety of analogue documents and hence allow the user to make full use of analogue skills – as opposed to the weaknesses of manual digitizers in mechanical aspects of sketching, i.e. the interaction of the drawer's anatomy with furniture and drawing materials (Van Sommers 1984). Manual digitizers also exhibit limitations in terms of cognitive ergonomics. For example, sketching with most tablets involves constantly looking away from the hand and frequent interruptions for giving commands. Most attempts to alleviate such problems combine the functionalities of the graphics tablet with those of the monitor (e.g. tablet PC, palmtop).

B. Martens and A. Brown (eds.), Computer Aided Architectural Design Futures 2005, 321-330.
© 2005 *Springer. Printed in the Netherlands.*

Sketching with Digital Pen and Paper

The quality of the digital images produced by either optical or mechanical devices is adequate for most tasks. Digitization is particularly successful in the *paradigmatic* dimension, i.e. the graphic components of a drawing. These are normally registered with an accuracy and precision that allow for high legibility and extensive digital processing. On the other hand, the *syntagmatic* dimension, i.e the sequential creation of the drawing, remains rather elusive. This is less due to technological limitations and more because of the lack of specific, focused requirements. When available the ability to record and play back strokes is frequently neglected as a gimmick.

Sketching is generally associated with early, conceptual design. The development of early design tools has relied heavily on sketching input (Do 2001), while the transfer of a sketch to the computer generally concerns the transformation into measured drawing or 3D model (Jozen, Wang, and Sasada 1999). Consequently, the emphasis has remained on the paradigmatic dimension (Koutamanis 2001), the symbolic content of the sketch and digitization quality. The paradigmatic dimension has also provided inspiration and means for abstract symbols, generative actions and manipulations in interactive interfaces for digital environments (Do 2001, Achten and Jessurun 2002), as well as for visual indexing and retrieval (Do 2002).

In recent years freehand sketches have started receiving attention beyond the early design phases, mostly thanks to new approaches to information integration and collaborative design. These have led to a number of tools and digital environments where sketches play several roles. Internet collaboration environments make extensive use of freehand sketching for annotating digital documents, e.g. in markup and redlining in CAD document viewers or whiteboarding. Some environments go even further and recreate the architect's analogue workplace also with respect to visual information management, including sketches and freehand annotations. Similar transfers of analogue environments also underlie interactive visualization or 3D modelling. In the resulting compound environments freehand sketching is an attractive option for interaction because of its apparent simplicity (Lim 2003): it makes interfaces more compact because of familiarity with the interaction metaphor.

The significance of using sketching beyond the purposes of early generative activities is also acknowledged in cyclical models of visual thinking, such as the ARC (act-reflect-change) cycle and the ETC (express/test cycle) model. Such models stress something that architects and designers already know but possibly do not fully appreciate: reflection, testing and modification of a design are all served by sketches and freehand annotations. In architecture, design and engineering "sketches and drawings are the basic components of communication; words are built around them" (Henderson 1999). The complex, weakly structured or even chaotic "muddling through" in explorations of divergent approaches and solutions that characterize the early phases form a mode that continues to be applicable throughout the design process, especially in analysis and revision. A main difference is that early phases tend to keep precedents implicit and give the impression of starting from scratch, while later phases operate against an explicit background of drawings and decisions: Sketching and drawing are also seen as a neutral way of focusing collaborative activities on common tasks and of mirroring the discussions in a group.

2 DIGITAL PEN AND PAPER

The research described in the present paper aims to: (1) explore roles and forms of freehand sketching throughout the design process and in particular in later phases of the design process; and (2) test and adapt new technologies to architectural purposes with particular emphasis on providing feedback from analogue to digital environments. The second aim derives from the realization that much effort has been put into digitizing analogue documents but little has been done to transfer the structure of digital information back to analogue environments. Still, the main purpose of design automation in practice is the production of analogue hard copy: conventional drawings and other design documents. The evolution of a design takes place mostly by means of such analogue documents, including in group sessions and meetings. Many discussions, suggestions and decisions can be traced back in the annotations that "deface" the computer prints. The transfer of these annotations back to the computer records decisions that may be distorted soon after a design session, as well as facilitates a closer correlation between annotation and design entity.

We focused on mobile tools as a simple, unobtrusive means of achieving our goals (Cheng and Lane-Cumming 2003). Such tools are often dismissed as mere gadgets but this simply reflects the way technologies are marketed. In terms of connectivity mobile tools offer significant advantages through the proliferation of GPRS, Wi-Fi and Bluetooth, while their portability and ergonomics have become acceptable for most practical purposes. Moreover, they are widely, affordable, familiar and available also for professional applications. Our choice of digital sketching technology was the Anoto digital pen and paper (http://www.anoto.com). This technology is an alternative to mechanical and optical digitizers, with characteristics that help bridge the gap between the analogue and the digital image, especially in terms of ergonomics and mobility. Anoto pens can write on any kind of paper form, provided the form is covered with a proprietary dot pattern with a nominal spacing of 0.3 mm. The digital pen is equipped with a tiny infrared LED camera of the CMOS image-sensing type. The camera is positioned beside the ballpoint tip and takes 50-100 digital snapshots of strokes made by the pen on the dot pattern within a 7 mm range from the tip. The snapshots are stored in the pen as a series of map coordinates that correspond to the exact location of the strokes (as continuous curves) on the particular page.

The drawings can be transferred (synchronized) to a computer or smartphone using Bluetooth or a USB connection. The digital image produced by synchronization is a precise and exact copy of the analogue drawings made with the pen. In transferring the images the pen also reports on which piece of paper the drawing has been made (including the exact position on the form). This automatic document management allows users to switch between different documents without having to keep track of the changes. Moreover, different forms or documents can be linked to different computer applications, thereby automating post-processing of the images. Post-processing may also include grouping of strokes into higher-level primitives (e.g. OCR). The digital images are not static but can play back the sequence of strokes as they were made on paper. This provides a representation of syntagmatic aspects that is adequate for the identification and analysis of drawing actions (Cheng 2004).

3 MECHANICAL ASPECTS

Initial explorations of sketching with the digital pen and paper inevitably evolved around mechanical aspects. These tend to dominate acquaintance with a new device and with a new technology. Mechanical aspects relate to the interaction of the drawer's anatomy with furniture and drawing materials. The drawer's movements, actions and choices with respect to making a particular (e.g. the starting position for a circle) guide further actions in one or another direction and may underlie consistencies (e.g. in stroke direction) more than culture or nurture (Van Sommers 1984). The digital pen has few differences with normal ballpoint pens. The most striking difference is the thickness of the digital pen: the holding area has a circumference of approximately 60 mm (compared to 30 mm for a pencil or 45 mm for a thick graphite lead holder). Drawers with a preference for thinner writing implements were particularly unhappy with the digital pen. Otherwise the digital pen exhibited few apparent mechanical differences with conventional ballpoint pens. In order to ensure minimal adaptation costs in time and effort we sought test users accustomed to sketching and doodling with a ballpoint pen. We expected that they would have the appropriate tolerances for the evaluation of mechanical aspects.

Figure 1 Digital ballpoint sketch (left: digital pen version; right: digital paper)

Drawers were given a minimal instruction and practically no training with the digital pen. We assumed that this would help identify problems and conflicts on the basis of user experiences (as opposed to researchers' expectations). Users were encouraged to synchronize their pen with the computer frequently so as to evaluate the interim states of their sketches. Initial trials looked promising: after mastering the operational basics, users quickly started experimenting with line thickness and colour (Figure 1). The next step involved making use of these pen features for expressing aspects of the scene such as depth (Figure 2). This was generally done in several stages, using synchronization and analysis of the digital image before proceeding with a new element, colour or line weight. However, users were soon to discover the limitations of the digital pen, especially with respect to stroke weight and pen orientation: short, light strokes are poorly captured by the LED camera. Moreover, writing at an angle of less than 60° against the paper means that the camera may fail to capture the strokes. As a result, many sketches failed.

Figure 2 Line weight and colour (left: digital pen version; right: digital paper)

Figure 3 Explanatory sketch (top left: underlying grid; top right: design sketch; bottom: use patterns in design)

Rather than extensively instructing and training the drawers we decided to impose artificial constraints that simplified the technical requirements on the sketches. As the initial failures verified, the digital pen is less appropriate for naturalistic imagery than for more abstract graphics such as orthographic projections and diagrams. Consequently we decided to avoid the usual artistic sketching problems by concentrating on more abstract conventional representations and analytical situations. For example, an architect was asked to explain the principles behind one of her designs, a pavilion based on an irregular grid of dynamic lines. The discussion on the derivation of the form from these lines and on the effects of the form on dynamic aspects such as circulation and orientation made extensive use of multi-layered yet very legible sketches (Figure 3).

4 SYNTAGMATIC ASPECTS

Analytical sketches such as Figure 3 also reinforced our expectation that drawing with the digital pen supports extensive parsing of multilayered, complex sketches. This derives partly from the options given to the user concerning line weight and colour but primarily from the ability to record the syntagmatic dimension. In many cases syntagmatic information adds little to the final product but in complex, ambiguous sketches the ability to trace the moment and the actor may help unravel small mysteries. The sequence of strokes and states of the image in Figure 3 correspond to the narration of the designer and the presentation of the explanation of the design. In a design situation the corresponding sequence would depict the registration of apparent design decisions, including backtracking to and revision of earlier decisions. In order to focus on the syntagmatic dimension we chose to concentrate on later design phases, where the specificity of decisions and products combines with the necessity of continuity, clarity and integration. These phases involve multi-actor situations that make intensive use of compound documents in communication, revision and feedback to earlier decisions, thereby providing examples rich in constraints and requirements for visual information management.

The first challenge in the use of digital pen and paper in later design phases was that it should be used against the background of a variety of design documents and not on empty stationery. This meant that the Anoto dot pattern should be combined with the documents of a particular design. Such combinations can be created by:

1. Including the Anoto dot pattern in the digital documents to be printed

2. Printing or copying documents on Anoto stationary

3. Printing the dot pattern on tracing paper for use on top of other documents

The first solution is the most elegant and efficient but unfortunately use of the proprietary dot pattern involves special licensing and fees. Consequently, we made extensive use of the second solution, employing not only commercially available stationery but also forms we printed on a variety of paper sorts using the PDF files included in the software that is supplied with the digital pen. We used standard laser

and inkjet printers with a resolution of 300 and 600 dpi without problems other than that the LED camera of the pen performed poorly in heavily printed areas (Figure 4) where there was insufficient contrast or the dot pattern was obscured by the printed drawing (typically hatched areas). The third solution was welcomed by the drawers because it offered the possibility to use overlay techniques as well as more paper sorts. However, the dot pattern also reduced the transparency of the tracing paper.

Figure 4 Combinations of different aspects in a façade extension study

Even though the pen captures only the new drawing and writing actions, the transfer of the digital sketches to the software used for the production of the drawings simply involved appropriate scaling of the digital images (i.e. reversing the scaling used in printing). The sketches were imported and superimposed on the original documents as overlay pixel images in CAD, as redlining in CAD viewers and as combined background (together with the CAD documents) in whiteboarding. In all cases the alignment of the CAD images and the digital sketches was precise and distortion-free (even though some drawers sketched on their laps or creased the paper while working on a table). We estimated the tolerance of the digital sketches was in the area of 0.5 mm. The high precision of the digital pen also allowed us to combine any number of sketches with the CAD images, which facilitated the analysis of different aspects and the static combination of aspects in multilayered structures (Figure 4).

The analysis of layers and aspects in a sketch refers initially to paradigmatic aspects (form, colour and stroke thickness). However, it came as no surprise that the syntagmatic order largely matched the paradigmatic structure: semantically and visually related graphic components were generally drawn in groups. This simplified distinction between different aspects and permitted a variety of combinations in a

manner similar to overlaying: as aspects tended to occupy different segments in the timeline of a drawing we could combine aspects by omitting segments. Mechanical aspects sometimes complicated segmentation because drawers might cluster graphic elements in a mechanically convenient order (e.g. make all strokes with a particular orientation in one go) rather than enter each design entity separately.

Figure 5 Different states in a conversion study involving three drawers

The last application we explored involved the use of digital pens and paper by small groups (3-5 users) in the analysis and further development of existing designs. By issuing each participant with an own digital pen and asking them to synchronize the pens periodically (ostensibly in order to charge the battery) we managed to record different aspects at different states throughout the process without intruding to a disconcerting degree. The pens were used both synchronously and asynchronously. In synchronous situations we promoted the use of tracing paper so that participants could distinguish visually between their respective input. To our surprise, drawers soon abandoned tracing paper in favour of using multiple copies of the same document and combining their input in the computer, similarly to the asynchronous situations. The compactness of the files and their segmentation into different paper forms, actors and aspects offered interesting overlaying opportunities: by making various file combinations we were able to illustrate or reconstruct a particular point

of view or a discussion on a specific issue (Figure 5). This was enhanced by the dynamic playback of strokes, which meant that we could recreate a series of actions in the computer files. Document management was straightforward, as the files could be identified by pen, paper form and relative time.

Some of the details that were particularly interesting concerned the emergence of shapes that frequently eluded the participants during the session and were considered with some surprise and even suspicion when the products of the session were reviewed. Accidental emergence was mostly a case of erroneous interpretation of overlapping or adjacent but semantically unrelated strokes made by different drawers or at different times. This was primarily due to relationships of continuity and closure that linked the strokes together in compact or familiar forms. For example, a discussion on the orientation of a free-standing L-shaped wall in a foyer produced a rectangular image that puzzled the participants in the discussion, a couple of whom remembered erroneously that the wall was abandoned in favour of a primitive hut-like pavilion. The ability to distinguish between drawers, the corresponding aspects and states of the process in the syntagmatic order generally cleared up misinterpretations. In a similar fashion we were able to analyse issues of common authorship e.g. trace back the derivation and precedence of design constraints that guided design development.

5 UTILITY AND APPLICABILITY

The digital pen is more of a writing than a sketching tool. It offers less expression possibilities than analogue media or sketching software but larger drawing surfaces than other mobile devices (potentially limited only by the size of printing devices and paper sheets). Ergonomically it is inferior to analogue media and pen-line pointing devices but freehand sketching appears to be more forgiving than writing: holding a pen properly is significant for the readability of handwritten text but drawing is less sensitive, especially with more abstract representations. In terms of design information management the technology is a useful addition with respect to the registration and feedback of annotations on analogue versions of digital documents. Combination of sketches with digital documents is straightforward, precise and efficient – to the extent that it can be performed frequently during a design session. The ability to register and analyse the syntagmatic dimension is a useful means to the interpretation of a sketch, especially with respect to emergence and precedence. The recording of syntagmatic information as a sequence of strokes suffices in most cases: there were few instances where a precise time stamp was desirable. The capabilities of the technology are well suited to the support and analysis of multi-actor situations and group processes. Even though the digital pen and paper are no perfect sketching tools, their functionality comes so close to that of conventional analogue media that the group sessions could take place without unnecessary interruptions for technical reasons. Similar applications are possible in construction management, building inspection and facilities management.

REFERENCES

Achten, Henri, and Joran Jessurun. 2002. An agent framework for recognition of graphic units in drawings. In *Connecting the Real and the Virtual - design education* [20th eCAADe Conference Proceedings], eds. K. koszewski and S. Wrona: 246-253. Warsaw: eCAADe.

Cheng, Nancy Yen-wen. 2004. Stroke sequence in digital sketching. In *Architecture in the Network Society* [eCAADe 2004 proceedings], eds. B. Rüdiger, B. Tournay and H. Orbak: 387-393. Copenhagen: eCAADe.

Cheng, Nancy Yen-wen, and Stina Lane-Cumming. 2003. Using mobile digital tools for learning about places. In *CAADRIA 2003 - Proceedings of the 8th International Conference on Computer Aided Architectural Design Research in Asia*, ed. A. Choutgrajank et.al.: 145-155. Bangkok: CAADRIA.

Do, Ellen Yi-Luen. 2001. Graphics Interpreter of Design Actions. The GIDA system of diagram sorting and analysis. In *Computer aided architectural design futures 2001*. eds. B. de Vries, J. van Leeuwen and H. Achten: 271-284. Dordrecht: Kluwer.

―――. 2002. Drawing marks, acts, and reacts: Toward a computational sketching interface for architectural design. *AI EDAM* 16 (3): 149-171.

Henderson, Kathryn. 1999. *On line and on paper: Visual representations, visual culture, and computer graphics in design engineering*. Cambridge, Mass.: MIT Press.

Jozen, T., L. Wang, and T. Sasada. 1999. Sketch VRML - 3D modeling of conception. In *Architectural computing: from Turing to 2000* [eCAADe Conference Proceedings]. eds. A. Brown, M. Knight, and P. Berridge: 557-563. Liverpool: eCAADe and University of Liverpool.

Koutamanis, Alexander. 2001. Prolegomena to the recognition of floor plan sketches: A typology of architectural and graphic primitives in freehand representations. In *Design research in The Netherlands 2000*. eds. H. Achten, B. de Vries, and J. Hennessey. Eindhoven: Faculteit Bouwkunde, TU Eindhoven.

Lim, Chor-Kheng. 2003. Is a pen-based system just another pen or more than a pen? In *Digital Design*. eds. W. Dokonal, and U. Hirschberg: 615-622. Graz: eCAADe and Graz University of Technology.

Van Sommers, Peter. 1984. *Drawing and cognition: Descriptive and experimental studies of graphic production processes*. Cambridge: Cambridge University Press.

Woessner, Uwe, Joachim Kieferle, and Johannes Drosdol. 2004. Interaction methods for architecture in virtual environments. In *Architecture in the Network Society* [22nd eCAADe Conference Proceedings], 66-73. Copenhagen: eCAADe.

Mindstage: Towards a Functional Virtual Architecture

RICHENS Paul[1] and NITSCHE Michael[2]
[1] Digital Research Studio, Department of Architecture, University of Cambridge, UK
[2] School for Literature, Communication, and Culture, Georgia Institute for Technology, USA

Keywords: virtual learning environment, knowledge spatialisation, film design

Abstract: *Mindstage* is a multi-user real-time 3D environment in which is embedded a lecture on film design by Christopher Hobbs. The spatial design follows the structure of the lecture, and is richly illustrated with stills and film clips. The environment, implemented in Virtools, proved to be a visually intriguing combination of architectural, filmic and virtual space, though it was found that co-presence induced some problems with the concept of time.

1 INTRODUCTION

It has for some time been possible to make real-time interactive spatial simulations of architecture using the technology of computer games, but the results tend to be bland and un-engaging compared to computer games themselves (eg Richens and Trinder 1999, Moloney and Amor 2003). The three key pleasure of cyberspace have been well described as *immersion* ('the experience of being transported to an elaborately simulated place'), *agency* ('the satisfying power to take meaningful action') and *transformation* ('countless ways of shape-shifting'), all of which are offered by games (Murray 1997). Purely architectural simulations do not go beyond the first. *Mindstage* is a prototype multi-player real-time 3D virtual environment (RT3DVE) which combines practical intent with all three pleasures by the delivery of teaching material with a strong 3D content, in our case Film Design, but it could just as well be architecture, engineering or physical chemistry.

The project develops one aspect of *Cuthbert Hall* (a virtual Cambridge College) which explored how the integration of narrative and architecture can produce dramatic engagement in an RT3DVE (Nitsche and Roudavski 2002, 2003). Places there are considered as spatial structures which offer Gibsonian *affordances* that is, potentials for action or engagement, which are exploited in the unfolding of dramatic events (Gibson 1979). Some were intended for educational activities, and *Mindstage* elaborates these to become a virtual place affording entry and exploration, the delivery of educational material by speech, text, images and movies, the staging of experiments and demonstrations, and social interaction between students.

B. Martens and A. Brown (eds.), Computer Aided Architectural Design Futures 2005, 331-340.
© 2005 *Springer. Printed in the Netherlands.*

Educational researchers have defined a Virtual Learning Environment (VLE) as a designed information space in which educational interaction occurs, where the information/social space is explicit, and where students are not only active but actors who co-construct the space (Dillenbourg 2000). A VLE does not have to be a 3DVE, but could well include one: we see *Mindstage* as such a component. It will be treated as a place (not a document) and designed architecturally (Kalay et al. 2004). The primary design elements will be layout, surface, navigation and interaction (Gu and Maher 2004).

The subject matter chosen for our prototype is a lecture regularly delivered by Christopher Hobbs to our Master's students studying *Architecture and the Moving Image*. Hobbs is a distinguished production designer whose film credits include *Caravaggio, Edward II* (Jarman 1986, 1991), *The Long Day Closes* (Davies 1992), *Velvet Goldmine* (Haynes 1998) and on television *Cold Lazarus* (1994) and *Gormenghast* (2000). His lecture entitled *Film Design: Illusion and Practice* talks about these, and the wide range of precedents (from the *Bride of Frankenstein* to *Blade Runner*) that he admits as influences. The lecture is richly illustrated with film clips and production stills..

The team assembled for the project had skills in architectural design, texturing, modelling and lighting, sound recording and editing, gameplay development and programming. Implementation was through the *Virtools* 3.0 Game Prototyping software, with modelling in *3D Studio Max* and *Maya*. Hobbs was intrigued by prospect of designing virtual space, and assumed the role of Art Director - which proved to be richly rewarding for the rest of the team. At the time of writing, after about one year's effort, we have a playable prototype which implements three-quarters of the spaces, and delivers about half of the lecture. About two-thirds of the time was spent on technical tests and development, and one third on production.

2 DESIGN

The basic research question to be addressed by *Mindstage*, is whether a RT3DVE can be effective as a learning environment, and if so to develop an approach to the architectural design of virtual space that reinforces that effectiveness, for example by promoting engagement, exploration and memorability. Secondary issues were to find an effective software platform and production workflow, and to locate the boundaries of what is technically possible in a desktop implementation. The starting point was the Hobbs typescript of about 4000 words, which referenced around 40 still images and a similar number of film clips.

2.1 Spatialisation of Knowledge

The first design issue to be confronted was the basic topology of the virtual environment. At one extreme we could make a single space in which the whole action would take place, with all images projected onto a single screen – a virtual

lecture hall. At another, we could spread out the material in a linear fashion, with a succession of screens and delivery points to be visited in strict order. If strict sequencing was not required other topologies might be attractive, such as tree, star, ring or grid. Some of these are familiar forms for galleries and exhibitions.

There is a fair amount of architectural theory and precedent that might be considered. Space syntax (Hiller and Hanson 1984) draws attention to the importance of topology, suggesting for instance that public spaces should form a highly interconnected shallow graph, and private ones deep trees. Richard Owen's 1865 concept for the London Natural History Museum spatialised the taxonomy of the animal kingdom (Stearne 1981). Then there is the long tradition known as the *Art of Memory* (Yates 2001). From classical times orators trained themselves to recall an argument by committing to memory a series of *loci* within a building or city, and visualising mnemonic *imagines agentes* within them. Today's virtual space has a definite affinity to these imagined 'palaces of the mind' and might well be designed on similar principles, eg *loci* should be: not too similar, of moderate size, neither brightly lit nor dark, about thirty feet apart, in deserted places.

In the present case we analysed the structure of the lecture and spatialised that. It consisted of an introduction and a series of themes embracing stylistic and technical material - perspective illusion, gigantism, fantasy, gothic tendencies, fog and smoke, painted illusion, texture, abstraction. The themes fell roughly into three groups, each with internal continuity, but the groups themselves were not strongly ordered. This suggested a topology consisting of a central Hub, where the introduction is presented, with exits to three zones of two or three spaces each (Figure 2). Between zones there is a return to the hub; there is a single route through each zone; the order of zones is suggested but not enforced. We called the central space the Hub, and the three loops the Perspective, the Gothic and the Texture Zones. Later we added an entrance called the Robing Room, and an exit (the Gift Shop?).

Figures 1-3 Aubigny, Topology, *Jubilee Line*

2.2 Look and Feel

Hobbs' script already assumed that it was being delivered in a very special space, an ancient subterranean limestone quarry at Aubigny near Auxerre, France (Figure 1). The network of tunnels and high chambers has a peculiar facetted texture where large blocks of stone have been sawn out. This became a primary visual reference for the project, and an early trial VE was made in *Quake 3 Arena*. The Hub was a

deep square pit, approached at a high level: the main route spiralled down around the walls, with the zones being sequences of caves at the corners, but on successively lower levels.

The trial space was found to be unsatisfactory in several respects. It was too small. The descending progress felt wrong – "onward and upward" would be better. The simple geometry and texture mapping were too literal; there was no necessity for our spaces and textures to be architecturally realistic. Virtual space could be more spare, nebulous or graphic: for example the Stargate sequence in *2001*; the PlayStation game *Rez*, or Tim Hope's exquisite short animation *Jubilee Line*. The latter was adopted as a second visual reference, both for architecture and the treatment of characters (Figure 3).

As the technical trials progressed Hobbs contributed a number of sketches, storyboards and renderings, which did in the end determine much of the environment (Figure 4). The Hub became a deep pit containing a flimsy latticed mast bearing several platforms with bridges to the zones (a familiar 'gothic laboratory' motif found everywhere from *Frankenstein* to *Half-Life*, and an oblique reference to Panorama rotunda (Grau 2003). Its walls are facetted on a large scale like Aubigny, their fine texture is scanned directly from a chalk drawing by Hobbs (Figure 5), and they are dimly lit by radiosity from the scattered projection screens and illuminated signs (Figure 6). The Gothic Zone has an insubstantial white-on-black linear design, with a star-field behind. The Texture Zone uses semi-transparent screens textured with engravings by Gustave Doré of Dickensian London, and leads into a hypostyle hall of Abstract Space with rectangular columns based on Hobbs' design for *Edward II* and textures grabbed from the film itself (Figures 10-12).

Figures 4-5 Hub concept sketches; 6 Hub realisation

2.3 Demonstrations

As well as illustrations, a good lecture will often include demonstrations involving dynamic 3D objects, which in the case of *Mindstage* become interactive simulations affording the pleasures of *agency* and *transformation* (Murray 1997). A reconstruction of the combination of studio set and matte painting used in the *Wizard of Oz* is planned, but not yet executed. The Gothic Zone contains a reconstruction of the skyline models of Los Angeles used in *Blade Runner*, but the most elaborate is a reconstruction of the studio set for the ballroom scene in *Velvet Goldmine*. This was designed by Hobbs in a highly theatrical style – baroque

architecture painted onto cut-out flats - and the demonstration has been realised from his original drawings. The student can interactively move the flats and modify the lighting (Figures 7-9).

Figure 7 *Velvet Goldmine* **drawings; 8 Studio set; 9** *Mindstage* **reconstruction**

2.4 Avatars

The central problem for *Mindstage* was how to represent the lecturer. A character was required to lead the students through the spaces, draw their attention to the clips and demonstrations, and deliver the words of the lecture. Current games use detailed body models, skeleton-based animations derived from motion-capture of actors, photorealistic face textures and detailed lip-synch and expression generation. We did not have the resources to emulate these, and looked for less realistic and cheaper alternatives. Video techniques seemed promising – for example a full length or head and shoulders video sprite. We tested a 'cosmic egg' – a luminous ellipsoid with video of a disembodied face texture-mapped to its surface. Hobbs was not comfortable with the idea of video-recording the full lecture, and eventually, at his suggestion, we simplified the character to a floating Aztec mask. This is devoid of all internal expression, but can react gently by rotating and bobbing, and has proved surprisingly effective.

In a multi-player environment like *Mindstage*, it is necessary to provide avatars for the players (the students), so that they can see and recognise each other. As the motion requirements were very simple, we could have used stock game player-character models and animations, differentiated in the usual way by choice of skin texture map. Instead, we opted for a more abstract representation, inspired by Shelley Fox's fashion models in *Jubilee Line*. Each player is represented by a body-sized bounding box, on the surfaces of which are texture-mapped moving images built from the classical sequential photographs made by the 'father of cinematography' (Muybridge 1901; Figures 10-12).

3 IMPLEMENTATION

Mindstage is implemented in *Virtools 3.0*, a package intended for interactive 3D simulations and game prototyping. An Environment is developed by assembling

resources – 3D models, textures, sounds, animations, developed in other software - in the *Virtools* editor and then adding behaviours, that is, real-time programs that make the objects interactive and intelligent. Behaviours can be implemented at three levels: schematics composed in a visual programming language out of several hundred predefined building blocks; additional building blocks programmed in the lightweight *Virtools Scripting Language*; heavyweight additions programmed in C++. *Mindstage* employed all three techniques, though the visual approach predominates. At run-time, *Virtools* provides a render engine which updates the screen image at around 60 frames per second, and a behaviour engine which similarly allows each intelligent object to process its script incrementally once per frame.

3.1 Static Objects

The following resources are static in that they require little or no intelligence. They are exported directly from a modelling package:

1) Triangle meshes (with *uv* texture coordinates attached) representing the architectural geometry of the environment;

2) Texture maps, often with alpha masks for holes or partial transparency;

3) Lightmaps, additional textures representing the results of a radiosity lighting calculation. Basic lighting can be done at runtime, but high-quality global illumination needs to be pre-calculated;

4) Collision surfaces: some meshes (not necessarily visible) may be designated as walls or floors to constrain the movement of the player;

5) Lights: as we used pre-lighting the usual computer-graphics lights were not needed, though some objects (signs, screens) were made self-luminous;

6) Ambient sounds: these need simple scripts to ensure that they are only heard by players in the relevant spaces.

3.2 Dynamic Objects

These objects involve extensive scripting to develop their interactive behaviour. There is usually a core of static geometry as well. When there are many similar objects (like movie clips or control consoles) they will be created by an initialisation script, usually by copying a common prototype and setting its attributes. Most dynamic objects are also *shared*, meaning that key attributes are automatically synchronized between users of a multi-user environment, so that each user sees the objects in the same position, and performing the same actions.

1) Movie-clip: essentially this is an intelligent texture defined by an *avi* file, with behaviour to start and stop playing itself, and also an associated *wav* file containing the soundtrack. State of play is shared, so each user sees the same frame.

2) Console: each movie screen has an associated control console from which the student can control the display, independently of the lecturer. The script detects the proximity of the student and the use of a *Ctrl* key, then changes colours and activates the film clip.

3) Moving objects such as lifts and the scenery in the *Velvet Goldmine* set require quite elaborate programming. The motion must be shared between users, and transmitted to characters and objects standing on them.

4) Student avatar: each player has control of his own avatar, whose position, orientation and animation state is shared with other players. Four scripts are used: one deals with the animation frame and footfall sounds; one deals with text chat between players; the third detects keyboard and mouse action and uses them to control movement; the fourth prevents collisions with other objects, and makes sure that feet stay on the floor.

5) Lecturer avatar: this has by far the most complicated script, which is driven by a database which associates with each paragraph of speech the place from which it should be delivered and the clips to show. More general behaviour causes the mask to move between positions and to wait for students to be nearby, looking in the right direction, and not chatting among themselves before delivering the next segment. Various 'cut-away' remarks have been recorded to help the avatar attract attention and shepherd students through the space.

Figures 10-12 Gothic, Texture and Abstract Space zones with avatars

4 EVALUATION

Evaluation of the overall pedagogical impact will be delayed until completion; meanwhile preliminary play testing has uncovered a few issues to be addressed on the way: the spatial design is overly linear, the soundscape needs attention, interaction with consoles is clumsy, and the demonstration lacks purpose.

At the technical level, we find that *Virtools* has delivered most of what we required. In particular, we have been surprised at how well we can play several high-resolution movie clips in virtual space simultaneously; something difficult or impossible in most game engines. Most of our problems have been to do with sound. Movie clips are textures, and generate no sound; we have to play the soundtrack

separately, and it soon goes out of sync. We cannot add reverberation effects at run time, and failed to find a way to implement voice chat with spatialised sound. The hardware resources needed are quite heavy – *Mindstage* so far occupies about 650Mb on disk, and needs a 3GHz machine with 1Gb of memory and a good 64Mb graphics card to play smoothly. Parts of the workflow are quite delicate, particularly baking the lightmaps, where we had to patch some of the macros involved. We found that the *Virtools* visual programming approach encourages its own version of "spaghetti code"; it is not properly object oriented and it is going to take further effort to achieve adequate levels of abstraction, encapsulation, information hiding and inheritance. Shared objects, needed in a multiplayer world, unfortunately have a different programming model to normal ones, and are challenging to test and debug.

At the conceptual level, most of our problems have centred on multi-player issues. In a single-player environment, the player's sense of time is personal. Time can be interrupted by leaving the game and coming back later; and it is quite possible to revert to an earlier saved state of play. But in a multi-player world these thing are not possible. If players are to share the state of the lecture, so that they can interact over its contents, then they must operate in the same time frame. If a player leaves the lecture and returns, he will have missed a segment. If he joins later than the first player, he will miss the start.

It turns out that there is quite a wide range of choice over which dynamic objects are shared. If nothing, then the game provides a single-user experience. If the player avatars and film clips are shared but not the lecture sound track, then each player will have a private experience, like visiting an interactive museum with a personal audio-guide. If everything is shared, then you get a synchronized guided tour running every hour or so, rather than an on-demand private visit.

Our tentative resolution is to divide space and time into three chunks, corresponding to the major zones. Each zone has its own instance of the lecturer, running in its own time frame. This has two beneficial effects; waiting time for a segment to start is reduced to a third, and the segments can be taken in any order. The drawback is that it reduces the unity (in Aristotle's sense) of the lecturer character.

5 CONCLUSION AND FURTHER WORK

Although incomplete, it is clear that *Mindstage* succeeds on several levels. That our initial ambition, to enliven a virtual architectural space by placing meaningful activity in it, has succeeded is rather obvious in its current state of incompletion. Empty unlit spaces, though navigable, are not interesting. With radiosity lighting installed they become visually attractive; with film clips and sound tracks added they invite exploration; and when the lecturer is activated they become intellectually rewarding.

Mindstage is, as intended, visually intriguing, sitting at the boundary between architecture, film and virtual reality. Placing Hobbs's thoughts about Hobbs's films in a Hobbsian space delivers a modern virtual *Gesamtkunstwerk*, especially startling

where filmic space of the movie clips achieves a kind of continuity with the virtual architecture on which it is projected (Figure 12).

According to the educationalists, the reason for making a Virtual Learning Environment both spatial and multi-user is that "co-presence promotes shared conversation context, mutual 'tracing' supports mutual modelling of knowledge and implicit co-ordination of problem solving strategy" (Dillenbourg 1999). While *Mindstage* offers these affordances the time-frame conflicts we have unearthed show that they come at the expense of on-demand access. In the multi-user case, Gu's elements of virtual architecture (layout, navigation and interaction) should be expanded to include *characters* and especially *time* (Gu and Maher 2004).

For the future we intend to make some rationalisation of the software structure, and then complete the lecture so that it can be tested on students. Two further lectures – on the filming of *Gormenghast* and the History of Perspective – are being contemplated. Beyond that we intend the software components to contribute to a larger toolkit (the *Cambridge Architectural Game Engine*) which will enable us to implement a wide range of expressive and useful virtual places.

6 ACKNOWLEDGEMENTS

Mindstage was conceived by Michael Nitsche, and implemented by the authors and Jonathan Mackenzie. Christopher Hobbs enthusiastically donated the content for the prototype. We were supported by the staff of the Cambridge University Moving Image Studio, especially Maureen Thomas. The project was funded from a generous grant from Informatix Inc of Tokyo.

The *Mindstage* DVD contains many small excerpts from copyright material. Under fair use provisions we may develop it as an academic research project, and show it at academic meetings. We regret that we do not have the resources to obtain the clearances needed for a wider distribution.

REFERENCES

Dillenbourg, P., P. Mendelsohn, and P. Jermann. 1999 – Why spatial metaphors are relevant to virtual campuses. In *Learning and instruction in multiple contexts and settings* [. Bulletins of the Faculty of Education, 73], eds. Levonen, J., and J. Enkenberg. Finland: University of Joensuu.

Dillenbourg, P. 2000. Virtual Learning Environments. *In Schoolnet Futures: The EUN Millennium Conference and Proceedings*, ed. Guus Wijngaards: 47-65. Brussels: EUN (European Schoolnet).

Gibson, J.J. 1979. *The ecological approach to visual perception.* Boston: Houghton Miflin.

Grau, O. 2003. *Virtual art: from illusion to immersion*. Cambridge, MA: MIT Press.

Gu, N., and M.L. Maher. 2004. Generating Virtual Architecture With Style. In *Proceedings of the Design Computing and Cognition '04 Workshop on Design and Research Issues in Virtual Worlds*. Sydney: Key Centre for Design Computing and Cognition.

Hillier, B., and J. Hanson. 1984. *The social logic of space*. Cambridge: CUP.

Kalay, Y.E., J. Yongwook, K. Seungwook, and L. Jaewook. 2004. Virtual Learning Environments in *CAADRIA 2004: Proceedings of the 9th International Conference on Computer Aided Architectural Design Research, 871-890*. Singapore: CAADRIA.

Moloney, J., and R. Amor. 2003. StringCVE: Advances in a Game Engine-Based Collaborative Virtual Environment for Architectural Design. In *Proceedings of CONVR 2003 Conference on Construction Applications of Virtual Reality*. Blacksburg, USA

Murray, J.H. 1997. *Hamlet on the holodeck: the future of narrative in cyberspace*. Cambridge MA: MIT Press.

Muybridge, E. 1901. *The human figure in motion*. London: Chapman & Hall.

Nitsche, M., and S. Roudavski. 2002. Building Cuthbert Hall virtual college as a dramatically engaging environment. In *PDC '02 Proceedings of the participatory design conference*, eds. T. Binder, J. Gregory, I. Wagner. Palo Alto, CA: CPSR.

Nitsche, M., and S. Roudavski. 2003. Drama and context in real-time virtual environments. In *TIDSE '03 Technologies for interactive digital storytelling and entertainment*, eds. S. Goebel et al. Stuttgart: Fraunhofer IRB Verlag.

Richens, P., and M. Trinder. 1999. Design participation through the Internet: a case study. *Architectural research quarterly* 3(4): 361-374.

Stearne, W.T. 1981. *Natural History Museum at South Kensington*. London: Heinemann.

Yates, F.A. 2001. *The art of memory*. Chicago: UCP.

Advanced Ubiquitous Media for Interactive Space
A Framework

JENG Taysheng
Information Architecture Laboratory, Department of Architecture, National Cheng Kung University, Taiwan

Keywords: ubiquitous media, interactive space, human-computer interaction

Abstract: Developing ubiquitous media for interactive space requires interdisciplinary collaboration in studying ubiquitous computing. This work generalizes the criteria in the many disciplines of ubiquitous computing into a conceptual framework, including interaction interfaces, sensing technologies, application control, and human adaptation. This work presents a novel system architecture based on such a framework, and a research prototype recently developed called *IP++*. Additionally, the design principles and the potential of *IP++* are discussed.

1 INTRODUCTION

The next revolutionary human-computer interaction technology concerns interactions between people, computers and information by developing technologies that naturally reflect human behaviour and support the subtleties of everyday life. Ubiquitous media technologies for off-the-desktop interaction applications have been extensively studied for many years (Abowd and Mynatt 2000). Recent works have proposed integrating physical and digital interactions in the emerging field of interactive space (Winograd 2001, Streitz et al. 2003). This approach requires interdisciplinary collaboration, involving fields such as computing, architecture, industrial design, engineering and cognitive psychology. However, due to the lack of a conceptual framework, the research scope and interactive space design principles have been hard to define. More effort is needed in developing an interdisciplinary framework that articulates various viewpoints on ubiquitous media, while emphasizing the potential application of interactive space to transform our built environments.

To integrate ubiquitous media into interactive space, this work has developed a conceptual framework that addresses general criteria regarding the multiple disciplines of ubiquitous media. These general criteria include *physical-digital interaction interfaces, sensing and perceptual technologies, application and service control,* and *human and environmental adaptations*. Each criterion denotes a distinct functional requirement for developing advanced ubiquitous media for interactive

B. Martens and A. Brown (eds.), Computer Aided Architectural Design Futures 2005, 341-350.

space. After articulating these requirements, the overall system architecture and design principles can be easily realized for different interactive space application domains.

The research prototype presented in this work is part of the *IP*$^{++}$ project most recently developed by our Information Architecture Laboratory. This project focused initially on developing advanced ubiquitous media, and more recently on developing the theory of mapping toward smart environments (Jeng 2004).

2 UBIQUITOUS MEDIA

This work builds on previous studies in structuring the design space of ubiquitous media over several dimensions. One dimension depicts a wide spectrum of *environments*, ranging from real, augmented, augmented virtual, to virtual reality. Another dimension augments *objects* by incorporating sensing and communication capabilities. The computer-augmented objects may be mobile, portable, wearable, tangible, embedded or ambient, such that information and services are provided when and where desired. The third dimension denotes *human activities* involving different situations at home, at school, at work, in the shops or on the move. This design space matrix makes the application domain of ubiquitous media and the different roles of ubiquitous computing technology in interactive space easy to understand. The design space matrix of ubiquitous media is depicted in Figure 1.

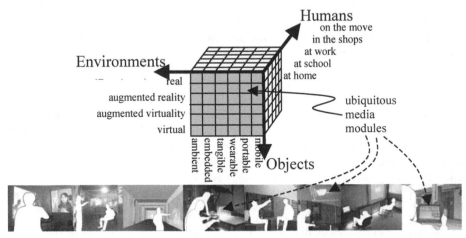

Figure 1 The design space matrix of ubiquitous media

Different research and development have progressed rapidly by augmenting *environments, objects* and *humans* with sensing, computing and communication capabilities. These approaches in different fields converge on the boundary between physical and digital worlds (O'Sullivan and Lgoe 2004). This work proposes a human-centred framework that articulates the various perspectives and major

investigation aspects of ubiquitous media for interactive space. The next section elaborates the core of the proposed conceptual framework.

3 A FRAMEWORK

Figure 2 shows an overview of the conceptual framework. The framework describes four key elements of the kernel- a matrix of the design space. Four key elements of the conceptual framework are: (1) *physical-digital interaction interfaces;* (2) *sensing and perceptual technologies;* (3) *application and service control, and* (4) *human and environmental adaptations*. These elements are described in detail in the following sections.

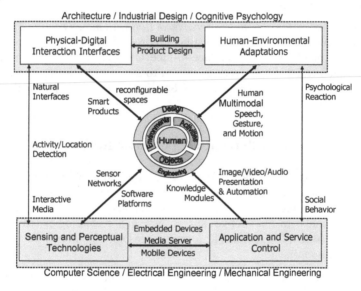

Figure 2 A conceptual framework

3.1 Physical-Digital Interaction Interfaces

When bringing ubiquitous media to interactive space, interaction interfaces include a new set of problems, since interaction interfaces must be constantly present in the real world and support embodied interaction for everyday practices. Several research issues for designing physical-digital interaction interfaces have emerged.

From explicit interaction to implicit interaction: Human-computer interaction is moving from command-based devices (e.g. keyboards and pointing devices) to support natural interaction using gestures, handwriting and speech. The move toward natural interaction poses multiple novel technical, design, and social challenges. For example, stepping on the floor of a room is sufficient to detect a

person's presence there. Therefore, a new interaction model is needed to support several distinct features of *implicit human interaction*, as follows (1). Implicit human input cannot be easily defined in terms of a finite set of modes. (2) The input has no clear boundary (e.g. starting and end points) (3) Implicit human input may be nested and long-lasting. (4) Multiple input activities may operate concurrently. (5) Output can be multi-scaled with ambient displays. (6) Output may be dynamic physical operations distributed in different locations.

From foreground computation to background computation: As computers vanish into the background, human-computer interaction becomes similar to the way humans interact with the physical environment. Researchers increasingly believe that building space should be transformed into a set of interaction interfaces between humans and computers. Buildings would largely integrate computational devices for physical interaction.

From single-user systems to multi-user interaction with mixed reality: People live in a world of mixed reality with two distinct environments: the physical environment where people reside and interact face-to-face and the digital environment where virtual agents interact. Much work is needed to support multi-user interaction in an interactive space, and to articulate and connect events in the physical and digital worlds.

3.2 Sensing and Perceptual Technologies

Sensing technologies are increasingly being used to provide implicit input for natural interaction interfaces. The trend toward sensing-based interactions has imposed a basic requirement on any ubiquitous media to support implicit multimodal inputs in interactive space. Sensing technologies can be briefly classified into three categories: (1) location sensors, (2) mobile sensors, and (3) environmental sensors.

Location sensors: Location sensors are embedded in a room or place to detect human presence. Examples of location sensors are web cameras that use computer vision and recognition technologies that identify behaviour patterns and interpret the signals of human activities. Other commonly used sensing technologies are optical, magnetic and capacitance sensors coupled with radio frequency devices to receive sensed signals. In these experiments, capacitance sensors are used to create smart floors. The aim of a smart floor is to identify a user's presence and provide location-aware information when a person walks into a space. A matrix of capacitance sensors underlying the smart floor triggers the wall-sized display of audio-video projectors in interactive space. Figure 3 shows an example of a smart floor.

Mobile sensors: Mobile sensors are worn in human bodies to detect human motion, gesture and social settings. Examples include sensors that equip handheld devices with perceptual capabilities. Mobile sensors can detect how a device is held and determine how to respond. Radio frequency identity (RFID) is another example of electronic tagging associated with the wide variety of objects tracked by barcodes. Coupling with wireless network connections together, RFID technologies enable

digital annotations of physical objects and locations, which potentially change how people interact with the physical environment.

Environmental sensors: Environmental sensors are conventionally installed in our built environments to measure temperature, humidity, pollution or nerve gas levels to ensure safety and quality. Examples of environmental sensors include the thermostat of a heating system, which switch the heating on when the temperature drops below a certain level, and automatic light switches, which use sensors to detect the presence of humans in public places (e.g. stairways and restrooms) to save energy.

This work identifies two significant facets of sensor-based interactions that are relevant to interactive space design. The first aspect is a sensor network combined with an adaptive software platform to develop ubiquitous media applications. The other aspect refers to creating user experiences in the cognitive process of sensor-based interactions. Creating user experiences stipulates natural cognitive mapping between human actions and sensing effects. Together, sensor-based interactions require a ubiquitous computing infrastructure that maps to the physical space and its corresponding interaction model.

Sensing and perceptual technologies have been increasingly recognized as useful in developing context-aware smart environments. Often, a mixture of location, mobile and environmental sensors can be applied to command control, replacing existing user interfaces and physical switches in the real world. The nature of sensor-based interactions is implicit, continuous and human-centered. Using sensors for implicit input-output interactions has potential to alter the nature of our built environments.

Figure 3 From left to right: the making process of computer-augmented architectural elements with sensor networks

3.3 Application and Service Control

This attempt to support interactive space requires not only linking many sensors and media to locations. Some fundamental conceptual shifts occur in the backend system architecture for application and service control.

Transforming low-level sensor data to high-level application context The first problematic question is, "How is sensor data transformed to application context? How is it interpreted?" In all cases, sensor data derives from low-level device output represented by bits. The low-level sensor data (e.g. "0" or "1" denoting the state of the sensor) has to be translated to high-level application information (e.g. "walking

345

into a space."). When the sensor detects a person in a given context, a particular interpretation of the context can be formalized in a triple *<user_ID, location, event>*: a user identifier, the user's location and the user event. A triple of the context can be extended to environmental features (e.g. temperature and humidity) and the human state (e.g. emotion and psychological reactions).

Triggering context-aware responsive actions: The next question following sensor data context is, "What action is suitable for ubiquitous media in reply to a specified context?" In the example of interactive space, the spatial components such as walls and floor may respond such that an action is triggered in terms of a specific spatial and social context identified by the sensor networks. The responsive action can be multimedia access control (e.g. automatically display of a pre-programmed video), environmental control (e.g. switch lighting on or off), or surveillance monitoring (e.g. start recording, send alert emails).

Application execution and service control: Responsive actions are generally executed in two main stages, service execution and application control. Applications specify and execute services, which include from multimedia access control, environmental control, and surveillance monitoring. In a complicated example such as interactive space, however, services may involve complicated process coordination, stipulating effective management of applications and their corresponding internal events dispatched from sensor networks.

Coordination infrastructure: User activity tracking may involve integrating inputs from many heterogeneous devices and sensors. For example, capacitance sensors are embedded in the floor to provide location information. Other sensors such as cameras are used by programs that identify a user's gesture. Each sensor has its own driver, requiring integration of heterogeneous sensor data. Data integration necessitates a separate layer of system components in the backend to generate an integrated high-level application context related to the interaction.

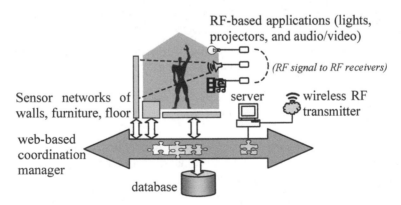

Figure 4 The system architecture

To handle these problems, a system architecture was developed for building ubiquitous media applications. First, the system architecture must decouple sensor

networks from application programs and services. Second, a separate coordination manager layer is required to coordinate activities across system components in the backend. The coordination manager schedules events and monitors the validity state so that the applications and services can be executed in the correct order. The system architecture is depicted in Figure 4.

3.4 Human and Environmental Adaptations

Interactive space is uniquely human-centred design. Ubiquitous media are designed to reduce the cognitive load of human users. Paradoxically, ubiquitous media might turn around and place a considerable demand on humans because they have become part of the physical environment to which people strive to adapt. Even with the most human-centered methodology, ubiquitous media might not be a natural part of the human system. Therefore, researchers need to study how ubiquitous media affect human cognition, and how humans adapt to technological and environmental changes.

Identifying human activities and cognitive processes: Many domains of cognition are relevant to the above aims. One domain focuses on human factors test and evaluation of ubiquitous media to be designed and created for an interactive space, including identifying the human cognitive processes and capturing the reactive and adaptive bahaviors of the human users when they try to interact with ubiquitous media. Activities take two forms. *Efficiency-driven activities* must tightly couple cause and effect, and avoid making mistakes in the interaction. *Exploration-based activities* have more room for ambiguity, enabling users to learn through engaged interactions.

Exploiting natural mapping between actions and perception: The need for adaptation occurs when actions and perception do not match. Observations from this work show that creating new forms of sensor-based interactions often leads to confusion and annoying user experience, but this problem is not due to technology. Rather, the effects of the responsive actions do not match with the desired outcome. People feel comfortable if they can expect what is happening in their environment. Therefore, natural mapping between actions and perception needs to be incorporated into a design, resulting in immediate understanding and compelling user experience.

Creating spatial metaphors to guide user behaviors: What metaphors can be used for ubiquitous media in interactive space? In other words, what is the next "desktop" metaphor? Current experiments are aimed at creating spatial metaphors to guide user behaviors in an interactive space. People like to understand every aspect of their surrounding environments. Users may wander around if they do not know where and how to activate a device, and hesitate to proceed with an action if they cannot predict its effects. In designing interactive space, the set of possible actions and movements needs to be visible to users, and the peripheral information should be moved into the foreground of the user's attention.

4 PUT IT ALL TOGETHER: THE IP^{++} PROJECT

To demonstrate how the framework can be applied to the design of ubiquitous media for interactive space, this work describes a recently developed application called IP^{++}. The IP^{++} project consists of four major components: *smart floor, interactive walls, smart cubes, and information canvas for ambient displays*. The smart floor consists of a set of elevated floor boards, each of which is embedded with capacitance sensors to identify human presence. When the sensor-embedded floor identifies the presence of people, an event (e.g. ambient displays) is triggered over the floor and information canvas. An interactive wall comprises a set of small-sized wall modules, each of which is embedded with an optical sensor to detect when a person passes by. Smart cubes are computer-augmented furniture equipped with capacitance sensors. Parts of the smart cubes are installed with all-in-one computers and monitors. The information canvas is composed of stretchable material for situated ambient displays. Together, smart floor, interactive walls, smart cubes, and information canvas form an interactive space from traditional architectural space.

The IP^{++} project reflects the inherent feature of multi-disciplinary framework. First, a set of composition rules is investigated to design the IP^{++} modules coupling with architectural design. The architectural space comprises physical-digital interaction interfaces. For the purpose of modularization and mobility, all the parts of smart floor, interactive walls, and smart cubes can be reconfigured into varied building modules. Second, the IP^{++} modules are augmented by computer hardware and sensor networks with sensing, computing and communication capabilities. Third, sensor networks are developed in combination with software application execution and web service provision. Finally, cognitive technologies are being developed to examine how humans adapt to ubiquitous media in interactive space.

The IP^{++} project aims to extend the notion of the *Information Portal* (IP) in the physical world, as an analogy to *Internet Protocol* (IP) in the digital world. The IP^{++} project is intended as a dynamic, reconfigurable, and interactive spatial system that provides mixed reality, natural interaction interfaces, and programmable automatic service control. The aims of IP^{++} are to build an interactive space that can link ubiquitous media to physical locations, connect events in the physical and virtual worlds, and create new user experiences through enabling sensing technologies. As the time of writing, the IP^{++} project is under development in conjunction with an interactive media exhibition in digital museum.

5 THE APPLICATION: INTERACTIVE MEDIA EXHIBITION

While the research prototype was being undertaken, the author was invited to demonstrate the IP^{++} research prototype at the Taiwan New Landscape Movement Exhibition 2004. We take this opportunity to demonstrate our ubiquity work in public. The exhibition adapted the original configuration for the IP^{++} project and designed two L shapes to build an interactive exhibition space. Figure 5 shows a

view of the IP^{++} research prototype at the Taiwan New Landscape Exhibition. The IP^{++} prototype has three kinds of sensing-based interactions. First, visitors to the exhibition were invited to walk through the IP^{++} exhibit space, which has three sensor-embedded smart floor boards denoting the *past, present*, and *future* development of Taiwan's landscape. As the visitor moved on to one of the smart floor boards, the floor sensor triggered the display of animations corresponding to the past, present, or future Taiwan landscape. The projected information was determined by the backend IP^{++} system according to the visitor's location on the smart floor boards. A sequence of snapshots of interactive activities is shown in Figure 5.

Secondly, a set of physical icons was designed to be attached to the interactive wall, enabling visitors to interact directly with a computer-generated three-dimensional model, using gestures without wearing any devices. The physical icons were embedded with optical sensors for issuing "rotate", "zoom in" and "zoom out" commands. As the visitor moved one or both hands over the optical sensors, the system issued an implicit command to rotate, zoom in, or zoom out the computer model correspondingly. Therefore, this exhibit was device-free and allowed complex gestures to be performed with a composite command.

The final experiment in this exhibition is a lounge area installed with three computer-augmented cubes. One cube acted as a computer display while the other two sensor-embedded cubes serve as smart seats to sit down. As the visitor sat himself on the cubic box, the sensor inside the box detected the presence and triggered the display of information relevant to the exhibition on the surface of the other cubic box.

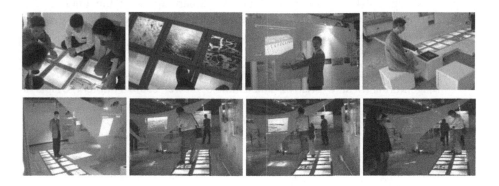

Figure 5 A sequence of snapshots of the IP^{++} interactive media exhibition

6 CONCLUSION

This work developed a framework for ubiquitous media systems and their functional requirements, while simultaneously presenting a research prototype of interactive

space most recent developed called the IP^{++} project. The IP^{++} project starts from technical integrations with advanced ubiquitous media and incrementally moves to interactive space design.

This work gives a brief example from the research prototype to help create new ideas of human-computer interaction, and poses some research ideas for the future. In accordance with this perspective, a large-scale collaborative research consortium spanning multiple disciplines, research institutes, and industries will be formed to develop interactive space. The proposed framework is a basis for the integration of computing across disciplinary boundaries.

ACKNOWLEDGEMENT

The author would like to thank the Taiwan National Science Council for financially supporting this research under Contract No. NSC93-2211-E-006-056.

REFERENCES

Abowd, Gregory D., and Elizabeth D. Mynatt. 2000. Charting Past, Present and Future Research in Ubiquitous Computing, *ACM Transactions on Computer-Human Interaction, Pervasive Computing* [Special issue on HCI in the new Millennium], 7(1): 29-58.

Jeng, Taysheng. 2004. Designing a Ubiquitous Smart Space of the Future: The Principle of Mapping. In *Proceedings of the First International Conference on Design Computing and Cognition (DCC'04)*, ed. John S. Gero: 579-592. Dordrecht: Kluwer.

Streitz, Nobert, Thorsten Prante, Carsten Röcker, Daniel V. Alphen, Carsten Magerkurth, Richard Stenzel, and Daniela Plewe. 2003. Ambient Displays and Mobile Devices for the Creation of Social Architectural Spaces. In *Public and Situated Displays: Social and Interactional Aspects of Shared Display Technologies*, eds. K. O'Hara et al.: 387-409. Dordrecht: Kluwer.

O'Sullivan, Dan, and Tom Lgoe. 2004. *Physical Computing: Sensing and Controlling the Physical World with Computers*. Thomson Course Technology.

Winograd, Terry. 2001. Interaction Spaces for Twenty-First-Century Computing. In *Human-Computer Interaction in the New Millennium*, ed. J. Carroll: 259-276. New York: Addison-Wesley.

Hands Free
A Wearable Surveying System for Building Surveying

PETZOLD Frank[1] and BÜRGY, Christian[2]
[1] *Faculty of Architecture, Bauhaus University Weimar, Germany*
[2] *Wearable Consult, Germany*

Keywords: building surveying, wearable computing, HCI, industrial design, systems engineering

Abstract: Activities in the building industry in Europe concentrate increasingly on a combination of renovation and new-building. A prerequisite for comprehensive IT supported design and planning in the context of existing buildings is both the use of on-site computer-aided surveying techniques and the integration of all professional disciplines in an integrated information and communication system. The starting point is often the building survey on site. An examination of currently available IT tools and hardware shows insufficient support for planning within existing built contexts. Surveying equipment has been derived from other disciplines without being modified to cater for the specific needs of building surveying. This paper describes a concept for computer-aided digital building surveying equipment based upon a wearable computer and AR to close the gap between specialist equipment adapted for use in building surveying and the need for simple straightforward surveying equipment for architects and engineers.

1 BUILDING SURVEYING – THE CURRENT SITUATION

Most of the buildings that Germany will need over the next couple of centuries are already built. More than half of all current building costs are in the renovation sector and this proportion will continue to rise (BMVBW 2001). Planning tasks will therefore increasingly concentrate upon the intelligent use and conversion of existing buildings. In most cases, the building survey is the starting point for all further planning activities.

Current practice-oriented applications in the field of building surveying only provide insular support of specific aspects of the building survey. The majority of available systems deal only with the building survey and in most cases support only specific surveying techniques. Complete solutions aimed at supporting the entire surveying process are not available. As a result different surveying techniques must be combined according to particular constructive approaches.

In most cases the term "building survey" is understood to mean a geometric survey of the physical dimensions of a construction translated into architectural plans, sections and elevations, but this is only one aspect.

B. Martens and A. Brown (eds.), Computer Aided Architectural Design Futures 2005, 351-360.
© 2005 *Springer. Printed in the Netherlands.*

Building surveying involves measuring and documenting a building, usually on site, using a variety of different instruments and technologies ranging from the measuring rule or tape to a camera or tacheometer. On site conditions are usually less than ideal for standard computers, which are usually conceived for desktop use. Surveyors are often to be found climbing ladders or working in cramped attics or damp cellars. Electricity is often not available and direct sunlight can make even the best of displays difficult to read (Figure 1).

Figure 1 On site conditions

The building survey is often undertaken by architects and civil engineers. They require easy-to-use tools for data capture, often coupled with hands-free interaction with a computer. At present the current situation is far removed from this scenario.

2 HANDS FREE – MODULAR WEARABLE COMPUTER SYSTEMS FOR BUILDING SURVEYING

The name "Hands Free" is also the aim of the project – the design of a portable computer tailored to the requirements of building surveying and, with the help of Augmented Reality (AR), to the process of building surveying. The project aim is twofold – the development of a powerful wearable computer and the conceptual development of a modular software solution based upon an analysis of the building surveying process and the needs of the user.

Based upon an analysis of building surveying processes, a conceptual design and an experimental platform (server-client software architecture) for an integrated IT-supported building survey have already been realised. These form the background to this project (Petzold 2001, Weferling et al. 2003, Thurow 2004).

Wearable computers represent a paradigmatic change in the use of portable computers. A wearable computer is worn on the body and typically consists of a variety of components which can be incorporated into clothing and, in contrast to laptops or handhelds, assist the user in their interactions with both real and virtual environments. Wearable computers allow the user to have his or her hands free for other tools and can both accept and provide information whilst working, for instance using transparent displays. Wearable computers open up new interaction

possibilities between the user and his or her work environment both in terms of information capture and storage as well as information provision using AR technologies. The following aspects are relevant for the use of wearable computers in on-site building surveying:

- Ergonomic design of wearable computing hardware

- Interaction techniques for the hands-free use of wearables

- Usability methods for wearables; design and user studies

- Augmented Reality: providing virtual information to the real world

2.1 The Wearable Computer Platform

Our current project takes these investigations one step further and examines the development of a concept for a practical, mobile, digital configuration and system environment – a wearable computer for surveying and planning on-site. Based on the client-server software architecture, we designed hardware systems for physically supporting the surveying process following the same modular concept in order to fit the software concept (Petzold 2001, Weferling et al. 2003, Thurow 2004).

2.1.1 Wearable Ergonomics

Currently available wearable computers, which might serve for the building surveying task, are box-shaped modules to be worn on the user's belt. To be comfortable they are reduced in size and weight. This kind of solution is not very suitable for our purpose because it's coupled with decreased computation power and operational time.

Figure 2 Ergonomic studies using plaster of paris to determine areas of the body least affected by movement and therefore most suited for wearing solid items

Based on the design approach of Gemperle et al. (Gemperle et al. 1998) we devised a concept for a modular system whose shape and arrangement fits the user's body.

Hands free

To examine the ergonomic placement of rigid parts, we plastered a torso and then performed typical movements when surveying buildings (Figure 2). By examining how the plaster of paris creased and ruptured we could identify areas of high motion and dynamic change and areas of relative stability. This enabled use to place computer modules on parts of the body that impede the movement of the user as little as possible (Doppleb et al. 2004).

2.1.2 Hardware Concept

Different work tasks can be identified which depend on the target to be surveyed and site-specific constraints. One possible approach is to provide all possible tools for all kinds of surveys. This, however, means that much of the time redundant equipment is being carried. In order to increase comfort and functionality whilst working, it is more efficient to select the equipment to be worn according to the specific requirements of the next surveying task. As the different tasks require different tools, a concept was devised which follows the analogy of the carpenter and his tool belt. The operator is able to move about with his hands free but has the tools within easy reach whenever he needs them.

The wearable computer system is therefore as modular as the software platform. The ability to interchange computer devices is straightforward and follows the "hot plugging" plug-and-play functionality known from USB-ports. A further important consideration for successful modularity is the ergonomic positioning of interface connectors - in our case VGA, LVDS and USB (Figure 3).

 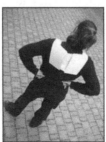 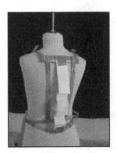

Figure 3 Distribution studies for hardware components

We propose their placement just above the collarbone, in close proximity to the shoulder, from where cables for non-wireless devices (e.g. HMDs) can be routed along the arm or neck/head.

2.1.3 Design Evaluation

A wearable computer for building surveying is not worn everyday, and as such can be expected to accommodate more load than normal clothing and provide more power than a handheld device. A backpack-like arrangement with a comparatively

large computational unit for more powerful demands was devised. This solution is also influenced by working comfort regulations. The straps do not only carry the weight but are also used to route cables to the interface connectors in the area of the collarbone.

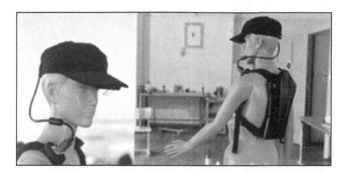

Figure 4 Volumetric model of the backpack housing with HMD plugged in at the collarbone connectors

The 'backpack' contains parts which do not need to be accessed in everyday use: the CPU, the PSU and hard disk (Figure 4). Interactive devices such as the digital pen, laser distance meter, digital camera etc. are located in front of the straps or the tool belt. A chimney-like ventilation channel in the backpack ensures that even high-clocking CPUs do not suffer from thermal difficulties.

Figure 5 Commercially available components used

For additional flexibility, the nine core unit is a cluster of interchangeable units – a scaleable PSU (up to 88W), an interchangeable hard disk (1.8" 40 GB), an embedded PC (up to 1.8 GHz Kontron ETX) and wireless communication modules (WLAN and Bluetooth) (Figure 5 and Figure 6).

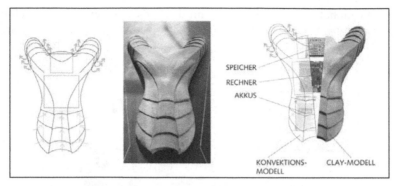

Figure 6 Model of internal hardware architecture, a cluster arrangement of data storage device, CPU and power supply

2.1.4 Prototype

Currently activities focus on the technical realisation of a prototype. The interaction of the individual components has already been tested (Figure 7) and a custom designed PCB complete with electronic components is currently being built (Figure 8). A further aspect is the choice of appropriate materials for the casing or skin. These must be light but also robust and must also dissipate heat effectively.

Figure 7 Test configuration **Figure 8 PCB layout**

2.2 A Software Concept Based upon a Portable Computer and Augmented Reality

The second aspect of the project is the conceptual analysis and envisioning of application scenarios and the development of user interfaces for wearable computers that can be used for building and planning tasks on site. Wearable computers can enhance productivity in the surveying of existing buildings in a number of ways.

The usual process of surveying buildings consists of a series of manual steps. To develop an IT system for this process each stage had to be analysed and delineated. The first step typically employs a sketchbook in which outlines of ground plans and façades are made. The second step is the actual measurement of the building's dimensions (with inch rule, distance meter and tacheometer). Alternative surveying methods and further details can be added subsequently. These provide data for various scale models and provide the basis for further planning. For an optimal evaluation of the working steps for a computer application, the most essential working processes were simulated, analyzed and reconsidered from an ergonomic point of view to support the surveyor with the most viable user interface in the given situation (Bürgy 2004). The following assumptions were made with regard to the functional and qualitative basis for the processes. Augmented Reality, gestures and speech recognition should work sufficiently. Visual tracking is without markers, edges/form recognition work within acceptable tolerance ranges. This project uses a marker-less approach (Vacchetti 2004) allowing to work without obstruction on site. The approach allows the positioning of the user and the superimposition of a virtual model using an "approximate geometric model".

2.2.1 Application Scenarios for Building Surveying – The Sketch Survey

A number of different application scenarios were developed for the implementation of AR technologies. By way of example the following considers the initial sketch survey of a building. The concept enables the user to create 2D sketches using AR. The tool works simply by moving one finger in the air (Figure 9). It is possible to keep the field-of-view almost entirely free of tool buttons and menus by using gesture recognition and speech recognition to enable an intuitive interaction with the computer. An additional menu for alternative control is provided (Figure 10). This application is more than sufficient for the first estimation of a site by an architect and provides all necessary requirements for the further surveying of an object.

Figure 9 2D freehand sketching **Figure 10 Align with reality / possible menu structure**

The 3D sketch was designed to take over the function of a sketch book with 3D abilities. Through the addition of measurements it can be made more precise than the 2D sketch. The process should be fast and does not require many different tools (for instance a distance meter). Further information can be added to the model in the

form of text, texture and pictures. The working process is also based on an AR interface. The laser distance meter results are simultaneously processed into a 3D model. As a result it is necessary to track user and device – the user should be able to move either him or herself or the measuring device without affecting coherence between the real object and 3D model.

Figure 11 Tools which are generally used but refer to special objects like moving a point appear depending upon demand and context.

Additional interfaces such as speech and gesture recognition help keeping the screen free of menus, although these menus can be displayed if required (Figure 11). Tools which are generally used but refer to special objects like moving a point appear depending upon demand and context (i.e. when selected).

Further scenarios have likewise been envisioned and described in detail, for instance, the (head up) display of non-visible information, the display of far-away details (akin to camera zoom), the steering of motorised tacheometers as well as communication with other experts in the planning processes.

2.2.2 Sketching in the Air

The ability to "sketch in the air" is a pre-requisite for the scenario described above. As part of the concept tests this means of interaction was tested in more detail. The first test examined 2D sketching for describing room perimeters, elevations and details without haptic feedback.

Figure 12 Sketching in the air – test equipment and results

The tests were carried out in the office as well as on site. The test equipment included data glasses with camera, a data glove and test software module. The results obtained were of a quality satisfactory for sketching purposes (Figure 12).

Further test series examined typical CAD-like functionality such as selecting a point or drawing a line. Such functionality is necessary in order to determine the current position of the user when an "approximate geometric model" is not yet available.

2.2.3 Visualisation of the User Interface and User Interactions

Initial testing of the user interface and interaction methods was undertaken using an interactive programming environment for games (Quest3D). As the project progresses the user interface can be simulated and the acceptance of the design and menu system evaluated before being implemented as part of the entire system (Figure 13).

Figure 13 Test environment for evaluating the user interface

3 CONCLUSION

The IT support of building surveying and especially the improvement of the underlying processes is a complex task. In approaching this task with an interdisciplinary research team, we developed the concept of a wearable surveying system and AR-based applications.

This software architecture enables the system to be designed according to the analogy of a tool belt offering task-specific tools needed for specific tasks in the surveying process. For this system to be become viable in use, software and hardware design has to be undertaken in parallel. It was therefore most important for us to emphasize the concurrent design process of software developers, architects, IT experts and product designers. Our proof-of-concept implementation of the software architecture already demonstrates that wearable computing is both very practical and also feasible. While it already contains a significant amount of geometrical and structural logic, it is flexible enough to be expanded further. The hardware design is finished and will be implemented in an ongoing proof-of-concept system.

Future project stages will include on-site testing of the wearable computer in real conditions, the integration of AR-tracking and the implementation of the software tools as described. The combination of all of these activities is necessary to be able to assess the practicability of wearable computers for building surveying.

Once the entire system has been tested and optimised its scope could conceivably be widened to cover further associated tasks such as facility management or on-site design and planning.

ACKNOWLEDGEMENTS

The research presented in this paper was supported by Christoph Quiatkowski, Benjamin Peipert, Florian Roth, Jan Doppleb, Norbert Meyer, Alexander Kulik and Nikolaus Steinke from the Bauhaus University Weimar.

REFERENCES

Bürgy, Christian. 2004. Supporting Domain Experts in Determining Viable User Interface Designs for Wearable Computers Used in AEC Work Situations. In *Xth ICCCB* [conference proceedings], ed. Karl Beucke, Berthold Firmenich, Dirk Donath, Renate Fruchter and Kim Roddis: 140-141. Weimar: CD-ROM.

Doppleb, Jan, Nikolaus Steinke, Norbert Meyer, Alexander Kulik, Frank Petzold, Torsten Thurow, and Christian Bürgy. 2004. Wearable Computers for Building Surveying. In *ISWC '04*, accepted paper.

Gemperle, Francine, Chris Kasabach, John Stivoric, Malcolm Bauer, and Richard Martin. 1998. *Design for Wearability*. Internet. Available from http://www.informatik.uni-trier.de/~ley/db/conf/iswc/iswc1998.html; accessed 25.11.2004.

Petzold, Frank. 2001. *Computergestützte Bauaufnahme als Grundlage für die Planung im Bestand - Untersuchungen zur digitalen Modellbildung*. Ph.D. diss., Bauhaus Universität Weimar.

Thurow, Torsten. 2004. A vision of an adaptive geometry model for computer-assisted building surveying. In *Xth ICCCB* [conference proceedings], ed. Karl Beucke, Berthold Firmenich, Dirk Donath, Renate Fruchter and Kim Roddis: 142-143. Weimar: CD-ROM.

Vacchetti, Luca. 2004. *Research at CVLab*. Internet. Available from http://cvlab.epfl.ch/~vacchetti/research.html; accessed 25.11.2004.

Weferling, Ulrich, Dirk Donath, Frank Petzold, and Torsten Thurow. 2003. Neue Techniken in der Bestandserfassung. In *IKM* [conference proceedings], ed. Klaus Gürlebeck, Lorenz Hempel and Carsten Könke, Weimar: CD-ROM.

Responsive Sensate Environments: Past and Future Directions

Designing Space as an Interface with Socio-Spatial Information

BEILHARZ Kirsty
Key Centre of Design Computing and Cognition, University of Sydney, Australia

Keywords: responsive environments, sensate space, sonification, visualisation, gestural controllers

Abstract: This paper looks at ways in which recent developments in sensing technologies and gestural control of data in 3D space provide opportunities to interact with information. Social and spatial data, the utilisation of space, flows of people and dense abstract data lend themselves to visual and auditory representation to enhance our understanding of socio-spatial patterns. Mapping information to visualisation and sonification leads to gestural interaction with information representation, dissolving the visibility and tangibility of traditional computational interfaces and hardware. The purpose of this integration of new technologies is to blur boundaries between computational and spatial interaction and to transform building spaces into responsive, intelligent interfaces for display and information access.

1 INTRODUCTION

Rather than the traditional computer aided architectural design and information communication technology (ICT) integration into architecture, this paper looks designing computer-aided architecture, i.e. spaces and structures enhanced by embedded sensor technologies and responsive (computational) building intelligence. Architecture's responsibility to society could be viewed as designing a sympathetic environment for human experience and interaction. Emerging sensing technologies and intelligence research illuminate interesting opportunities for designing this experience.

2 RESPONSIVE ENVIRONMENTS

Responsive environments include sensate spaces, enabled by spatially- and socially-triggered devices, intelligent and smart houses (utilising video tracking and data capture), networked sensor environments, pervasive mobile computing solutions and ambient visual and auditory displays. This paper briefly reviews the benefits of extant responsive technologies that have developed since last century until the

B. Martens and A. Brown (eds.), Computer Aided Architectural Design Futures 2005, 361-370.
© 2005 *Springer. Printed in the Netherlands.*

present time in order to clarify potential for future directions. Future architectural design requires a re-thinking of the way in which we design spaces that seamlessly integrate people, architectural structures, sensing and interface technologies to dissolve the distinction between human interaction with buildings and computer interaction. Current research mapping human spatial and social behaviour to generative sonification and visualisation for ambient display leads to a second capability of sensate environments: capturing interaction to observe emergent human activity. This goal utilises active and passive sensing technologies to learn more about human interaction, flow and flocking patterns in transitional and social building spaces. Such observant systems can be applied to new spaces to increase the building's awareness.

2.1 Active and Passive Sensing

Active sensors require conscious, deliberate interaction. These include bend, motion, gyroscopic and velocity sensors attached to limbs, pointer devices, 6-degree-of-freedom mice (computer mice or pointers that convey 3D directional movement, rotation and velocity), haptic (i.e. tactile) interfaces, stereo 3D vision or gesture tracking. In an art installation context, these sensors are performative interface devices. Gestural controllers (discussed later) are active sensors and triggers that enable direct spatial human interaction with information representation. For example, gesture controllers allow a person to manipulate, twist, relocate, and transform visual and auditory data using arm and hand gestures. In contrast, inconspicuous, unobtrusive, embedded or *passive* sensing captures data without the user needing to change behaviour or consciously interact with the space, e.g. pressure sensitive floor mats, video tracking, infra-red sensors, temperature, proximity and ultra-sonic sensors. Passive sensing is optimal for sensate environments or intelligent buildings in which people should continue their everyday tasks with the additional advantage of smart feedback, an environment capable of learning (with Artificial Intelligence) and reflexive ambient display.

The difference between active and passive systems lies in the awareness by the user. Commands are extracted from the data stream in exactly the same way for the aforementioned *tactile* active or passive devices. In contrast, gesture recognition and 'interpretative' command extraction is more complex in the case of non-tangible capture technologies such as gesture walls and video tracking. The technical mechanism of command extraction is not the focus of this paper, rather the concern here is the implication of socio-spatial behaviour mapping in sensate spaces that can be both informative and responsive.

2.2 Responsive Environment Design Using Sensors

The methodologies for implementation here are examples from the Key Centre of Design Computing and Cognition (University of Sydney) Sentient Lab design studio (Figure 1). Projects use embedded sensors, Teleo modules to convert digital and analogue signals for computation using the visual object-oriented programming

environment Max/MSP software to interpolate the data and design an output experienced by the user. Output can be a generative design or directly mapped to an auditory, visual or combined display containing social information. *Mapping* is the process of representing non-visual and abstract information (for example, the number of people in a space, motion, temperature, light levels) in the sonification and visualisation display. Mappings between activities and their representation are critical to the understanding (comprehensibility) and social interest of the sonification/visualisation.

Figure 1 The Key Centre of Design Computing and Cognition Sentient Lab showing "invisible" pressure sensitive floor mats embedded underneath the carpet, triggering the visual and auditory sound system and (right) before carpeting the grid of pressure mats laid on the floor, networked to the Teleo (MakingThings 2003) modules for conversion to a USB interface.

Correspondences are constructed between source (activity or trigger behaviour) and its visual and auditory representation in which the mapping (correlation between motion, activity, spatial distribution and intensity) is intended for intuitive perception. Responsive generative ambient auditory display requires: an aesthetic framework that is sustainable and listenable; a generative approach that maintains interest and engagement – invoking interaction and ongoing relevance; and a schema of correspondences between social/spatial activity and sonification that lends immediacy and intuitive understanding (comprehensibility) through its network of mappings.

2.3 Societal Contexts for Responsive Environments

Emergent Energy, developed in the author's Sentient Lab (Figure 2), is an iterative, reflexive system of interaction in which motion, speed, number of users and position in a space determine the growth of a visual design drawn with a Lindenmayer generative algorithm (L-system). The design provides both an informative monitor of social and spatial behaviour and invokes users to interact with their space to influence their artistic surrounds. The design artefact is an embedded history of the movements, interactions and number of people who produced it. Another example, *Obstacle Simulation,* uses spatial sonification to assist obstacle detection and navigation by visually impaired users. Changes in the auditory display communicate information such as proximity to objects and the relative hazard of obstacles in the room using a pressure sensitive floor mat detection system and aesthetic sonification. These two examples were developed using Max/MSP & Jitter (IRCAM

2003), an object-oriented programming environment for real time interaction. Due to the versatile real time capability of this computation method, no significant problems were encountered, though the Lindenmayer algorithmic calculation on a constant data stream is heavy. Gesture/command extraction was not a concern using pressure mat sensors with direct signals to the processor because, unlike video tracking for example, or non-tactile gesture recognition, there is no ambiguity or room for interpretation in the system. The semantics of commands are determined at the mapping stage. Mapping of socio-spatial activity to visualisation and sonification was addressed according to the following criteria (Table 1):

Table 1 Schema of mapping correspondences

Sonification	Visualisation	Activity / Trigger
Pitch (frequency)	Length/scale/scope of graphic display on screen	Distance between activities / motion
Texture/density	Density of events / number of branches or iterations of generative algorithm (embeds history by amount of activity)	Volume of activity, number of users and social threshold
Rhythm/tempo of events	Proximity and rapidity of display (animation)	Speed of actions, punctuation of triggering events, tied to velocity of events
Intensity/dynamic loudness	Heaviness and distinction of on-screen drawing	Intensity/magnitude of triggering events
Timbre (tone colour)	Colour and distribution on visual display (screen)	Region/spatialisation – topology, zoning
Harmony	Design artefact	Multi-user manipulation

Figure 2 L-system generator patch in Max/MSP & Jitter used to create branched visualisations on screen. Different behaviours modify the algorithmic process of design generation. Colour of branches indicates spatial location, heaviness of lines corresponds to the number of room occupants and motion affects the rapidity of branching. In the sonification, the number of people relates to dynamic intensity, position to tone colour and speed to pitch.

Enabling buildings with responsive, "understanding" and feedback capabilities facilitates flexibility and accessibility to assist environmental comfort, navigation for the visually impaired, building awareness, gerontechnology (technologies assisting the elderly), and automated and augmented tasks for the physically disabled.

Nanotechnologies - embedding minute sensor technologies in furnishings, surfaces and pre-fabricated building materials - facilitate localised sensate regions and unobtrusive (wireless) distributed networks for data collection. While beyond the scope of this paper, intelligence and learning capabilities also transform household and commercial products that we use within our everyday spaces (air conditioners, washing machines, coffee machines) contributing to the picture of our increasingly responsive environment.

3 TOWARDS AESTHETIC AND ENGAGING AMBIENT DISPLAY

Scientific sonification or visualisation of abstract data is usually designed for the purpose of illuminating or augmenting our understanding of abstract (non-visual) data. This paper focuses specifically on ambient display (rather than attentive display) due to its purpose: infotainment (aesthetic, informative entertainment). Ambient displays utilise perception that is both peripheral and pre-attentive. For the interactive sonification explained in the later gestural section, participation with the model is integral for information analysis and manipulation in the workplace, i.e. the difference between ambient and interactive sonification is the requirement of attentive concentration in the latter. There are contexts in which sonification is more helpful than visualisation: utilising the human auditory capacity for detecting subtle changes and comprehending dense data; and to avoid overload on visual senses, e.g. during surgery, anaesthesiology, and aircraft control. These applications of visualisation and sonification contribute to our understanding of well-known issues, particularly in regard to sonification: "orthogonality (Ciardi 2004, Neuhoff, Kramer and Wayand 2000) (i.e. changes in one variable that may influence the perception of changes in another variable), reaction times in multimodal presentation (Nesbitt and Barrass 2002), appropriate mapping between data and sound features (Walker and Kramer 1996), and average user sensibility for subtle musical changes (Vickers and Alty 1998)." There is also evidence to suggest that bimodal (visual and auditory) display has synergistic benefits for information representation.

Visualisation and sonification form useful infotainment for monitoring and display in public spaces, designed to augment, enhance and contribute artistically (as well as informatively) to our experience of spaces, e.g. a foyer, sensate space, common room. Aesthetic representation and accessibility (comprehensibility) directly influences the perception and reception of a work. Granularity or magnification (pre-processing, scaling and density of mapping and data sonification) also affects our ability to comprehend the representation (Beilharz 2004; Figure 3).

It might be argued that sound is even more integrally tied to space than light: "in a natural state, any generated sound cannot exist outside its context" (Pottier and Stalla, 2000) – space is a parameter of sound design, just as is pitch or *timbre*. The following examples illustrate the variety of data that can provide informative and engaging sonification to map abstract, non-visual data to auditory display with a range of scientific and artistic motivations.

Figure 3 Four different kinds of data used for visualisation: MIT Aesthetic and Computation Group's *Cubism Reloaded (Simultaneous Perspective in the Digital Realm)* **3D day-planner landscape; Benjamin Fry's** *Website as a Visual Organism* **(2000) using web server as an elegant computational organism defined by communication; Martin Wattenberg's visualisation drawing musical score as a timeline; Jared Schiffman's 3D** *Manipulating a Tree Growing in Real Time*

Ciardi's *sMAX: A Multimodal Toolkit for Stock Market Data Sonification* (Figure 4) sonifies data from stock market environments, in which large numbers of changing variables and temporally complex information must be monitored simultaneously. The auditory system is very useful for task monitoring and analysis of multi-dimensional data. The system is intended to be applicable to any large multi-dimensional data set (Ciardi 2004).

A number of artists and scientists have sonified meteorological data. In *Atmospherics/Weather Works,* Polli uses sonification because it has the potential to convey temporal narrative and time-based experiential and emotional content that enhances perception. Another important consideration is raised, especially with regard to dense data sets, and that is the scope for scaling and pre-processing dense data. Both the data mappings and the scaling or information granularity have significant impact on the efficacy of communication and comprehensibility of the representation. The organized complexity of a hurricane potentially offers rich combinations of patterns and shapes that, when translated into sound, create exciting compositions. Polli also maps the location of data sources to corresponding speaker positions in the auditory display by superimposing the geographical location of data points over a US East Coastal region map.

Figure 4 Hardware configuration and part of sMax visual display

Garth Paine's responsive installation sonifications include *Reeds – A Responsive Sound Installation* and *PLantA,* an installation at the Sydney Opera House during the *Sonify* festival (part of ICAD: International Conference of Auditory Display 2004) using a weather station to capture dynamic non-visual data measurements. Wind velocity, direction, temperature and UV level from outside the installation space conveys that data wirelessly to Paine's (art installation) sonification inside the Sydney Opera House. Direct mappings, such as velocity of musical tempo, directly connect to wind velocity drawing a clear connection to its source.

3.1 Ambient Display and Ambient Devices

Ambient visualisation and sonification in buildings merges informative information display with entertainment (infotainment or informative art) bringing a new versatility and purposefulness to graphical and auditory art in our homes and public spaces. This is where the established practice of installation art works meets domestic infotainment. Ambient display devices include plasma, projection, touch screens and audio amplification systems. These output devices can be used for monitoring environmental characteristics – socio-spatial activities. Ambient information representation is intentionally peripheral and may doubly serve a décor role. Ambient displays normally communicate on the periphery of human perception, requiring minimal attention and cognitive load. As perceptual bandwidth is minimised, users get the gist of the state of the data source through a quick glance, aural refocus, or *gestalt* background ambience. In relation to architecture, ambient representation that responds to the building (lighting, airflow, human traffic, as well as to social elements such as the clustering (flocking) patterns, divergences and task-specific data that are observed adds a dimension of responsiveness to the spatial habitat.

4 USING GESTURAL CONTROLLERS AND SPATIAL INTERACTION TO ENGAGE WITH INFORMATION

Introducing gestural controllers as a mechanism for interacting with the 3D spatial auditory and visual representation of information takes this process one step further. While gesture controllers for performing music are current new technologies and information sonification is used independently, the future approach proposed in this paper brings together these disciplines in which gestural interaction affects change in source data. There is a chain from building/computer – information – visualisation/sonification – human interaction/manipulation in which tactile, gestural and haptic interfaces provide ways to access and manipulate data and displays without the encumbrance of traditional keyboard/mouse interfaces. The barrier between humans and information, between humans and the smart building are disintegrated while computation and sensing are conflated into a single organism: the intelligent building. The science fiction film, Steven Spielberg's *Minority Report* (Maeda, 2004) forecasted a kind of interface that is already now achievable: spatial and gestural manipulation of video and computer data on a transparent screen suspended in 3D space (Figure 5-6). The notion behind gestural information access is an important one: dissolving the hardware and unsightliness of computer interfaces. As computing moves towards people acting in spaces, deviating from our currently sedentary desk-bound lifestyle, the importance of the spatial interaction and experience design, the way in which information is represented, becomes essential. Building architecture and information architecture become one (Figure 7).

5 CONCLUSION

In summary, this paper outlines some ways in which sensate environments can capture three dimensional spatial and social (behavioural) data and realise a representation of patterns, cliques, clusters and eccentricities in real time responsive environments. Designing the responsive experience with increasingly accessible pre-fabricated sensors and retro-fitted sensate technologies allows building design to flow into the realm of experience and interaction design, dissolving barriers between the computation machine and the visualisation/sonification space. Gestural controllers provide a mechanism for spatial interaction with data representation that absolves the need for visible computing interfaces such as the mouse, keyboard and conventional monitors. Seamless integration of spatial experience and computational response is a direction essential to the future of designing spaces. Not only information sonification but auditory displays with which we can interact provide a future direction in spatial design and interpretation.

Figure 5 Justin Manor's *Manipulable Cinematic Landscapes* (Maeda, 2004) is a glove-controlled cinematic landscape interface in 3D space

Figure 6 Haptic (tactile) manipulable cubes in Reed Kram's *Three Dimensions to Three Dimensions* (left) are creative tools for expression while sensors attached to digits and limbs can be used as gestural controllers for music (right) (Choi, 2000; Pottier and Stalla, 2000; Rovan and Hayward, 2000)

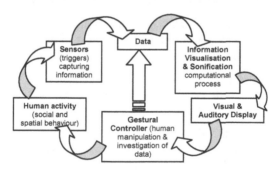

Figure 7 A summary of the flow of knowledge (left) from socio-spatial activities to the capturing sensors to visualisation/sonification in real time and display. The cycle is completed when gestural interaction is used to manipulate or investigate this data: a new and original mode of interaction with information

REFERENCES

Beilharz, K. 2004. (Criteria & Aesthetics for) Mapping Social Behaviour to Real Time Generative Structures for Ambient Auditory Display (Interactive Sonification). In *INTERACTION - Systems, Practice and Theory: A Creativity*

& *Cognition Symposium*, ed. E. Edmonds and R. Gibson: 75-102. Sydney: Creativity and Cognition Press, The Dynamic Design Research Group, UTS.

Choi, I. 2000. Gestural Primitives and the Context for Computational Processing in an Interactive Performance System. In *Trends in Gestural Control of Music* [CD-rom], ed. W.W. Wanderley, and M. Battier. Paris: IRCAM (Institute of Research in Computer and Acoustic Music) Centre Pompidou.

Ciardi, F.C. 2004. sMAX: A Multimodal Toolkit for Stock Market Data Sonification, In *Proceedings of ICAD 04 -Tenth Meeting of the International Conference on Auditory Display*, ed. S. Barrass, and P. Vickers. Sydney, Australia.

IRCAM. 2003. *Max/MSP, Cycling 74: Max/MSP - A graphical environment for music, audio, and multimedia objects-oriented control*. Internet. Available from http://www.cycling74.com/products/maxmsp.html; accessed 18 February 2005.

Maeda, J. 2004. *Creative Code*. Thames and Hudson, London.

MakingThings. 2003. Teleo Modules and Sensor Devices. Internet. Available from http://www.makingthings.com/products/products.htm; accessed 18 February 2005.

Nesbitt, K.V., and S. Barrass. 2002. Evaluation of a Multimodal Sonification and Visualisation of Depth of Market Stock Data. In *International Conference on Auditory Display (ICAD)*, ed. R. Nakatsu, and H. Kawahara. Kyoto, Japan.

Neuhoff, J.G., G. Kramer, and J. Wayand. 2000. Sonification and the Interaction of Perceptual Dimensions: Can the Data Get Lost in the Map? In *International Conference on Auditory Display*, Atlanta, Georgia, USA.

Pottier, L., and O. Stalla. 2000. Interpretation and Space. In *Trends in Gestural Control of Music*, eds. W.W. Wanderley, and M. Battier. Paris: IRCAM - Centre Pompidou.

Rovan, J., and V. Hayward. 2000. Typology of Tactile Sounds and their Synthesis in Gesture-Driven Computer Music Performance. In *Trends in Gestural Control of Music*, eds. W.W. Wanderley, and M. Battier. Paris: IRCAM - Centre Pompidou.

Song, H.J., and K. Beilharz. 2004. Some Strategies for Clear Auditory Differentiation in Information Sonification. In *KCDC Working Paper*. Sydney: University of Sydney.

Vickers, P., and J.L. Alty. 1998. Towards some Organising Principles for Musical Program Auralisations, In *International Conference on Auditory Display (ICAD)*, ed. A. Edwards, and S.A. Brewster. Glasgow, Scotland, U.K.

Walker, B.N., and G. Kramer. 1996. Mappings and Metaphors in Auditory Displays: An Experimental Assessment. In *International Conference on Auditory Display (ICAD)*. Palo Alto, California, USA.

Form and Fabric: Computer Integrated Construction and Manufacturing

The Redefinition of Ornament
Using Programming and CNC Manufacturing

STREHLKE Kai and LOVERIDGE Russell
Department of Architecture, Swiss Federal School of Technology, Switzerland

Keywords: 3D modeling, parametric design, image processing, design education, CAM

Abstract: Architectural ornament, the art of decorative patterning, is commonly perceived as an historical characteristic which declined in the beginning of the 20th century. The lecture of Adolf Loos in 1908 "Ornament and Crime" can certainly be seen as a crucial contribution in the architectural discussion about the exclusion of ornament. Although the modernist emphasis on unadorned form, the upcoming international style and the replacement of craftsmanship by the rise of mass production yielded to a systematic elimination of ornament, we are experiencing its revival in contemporary architecture through experiments using digital technologies. This paper describes our ongoing research and teaching activities in the field of architectural ornamentation, surface modeling and texturing, as well as the related CNC manufacturing processes.

1 INTRODUCTION

In our work, different course environments and research projects have been developed which deal with the production of ornament Using Computer Aided Architectural Design (CAAD) & Computer Aided Architectural Manufacturing (CAAM). In each case the working method focuses on the complete production cycle, from the generation of the digital ornament to its final production. This complete work process is important in our methodology as each of the stages is interdependent.

Digitally generated ornament equates well with the concepts of mass customization and CAAM production in architecture. Ornament declined dramatically in the late 1800s through the standardization of building components, due at first to the industrial revolution, and then subsequently to the rise of the modernist style. This reduction of ornament in architecture can be directly attributed to the intensification of machines in fabrication. It is therefore ironic that a return to ornament may be possible through the use of CAAD/CAAM technology. The creation of varied ornament, especially when it is programmed, is a good test for mass customization from an architectural perspective.

The fundamental principle upon which this work was undertaken is the importance of working at the 1:1 scale. The result of any manufacturing method will leave traces

B. Martens and A. Brown (eds.), Computer Aided Architectural Design Futures 2005, 373-382.
© 2005 *Springer. Printed in the Netherlands.*

of how it was made. If these traces are to be exploited for an aesthetic value then it is important that these "artifacts" be viewed and evaluated at their true scale. Within the university context this goal of working at 1:1 obviously cannot be applied on complete buildings, but only on building components, assemblies, or objects at the furniture scale. This immediacy of scale and fabrication is another reason why we are dealing with the issue of ornament.

This paper is structured in three chapters. The first chapter discusses different approaches to the generation of digital ornament, the second outlines the procedures used in the production process, and the final chapter illustrates the processes with examples from courses and research and actual projects.

2 DIGITAL GENERATION OF SURFACES

In both research and teaching we have developed three ways to create digital surfaces. Different methods allow for varying levels of complexity, both in terms of the skill required to create a surface, and in the intricacy of the final product. Levels of complexity are especially important in the context of teaching. It is essential that students can understand and control the processes in a way that facilitates an expressive and creative output, and likewise more advanced levels of complexity are required for subtle manipulations and sophisticated generation concepts.

2.1 Modeled Surfaces

Modeling of surfaces in 3D CAD software is the easiest approach to creating an ornamented surface topology, and for architecture students also the most intuitive. This work typically begins with manipulation and transformation of a NURBS surface using the digital tools available in the software of the students choice. This process is a direct analogy to "sculpting" a surface into the desired form for output. Although this seems straightforward, it is already important at this digital stage to know and understand which fabrication process will be used for the project output.

Figure 1 Surface modeling and production

Several different types of computer numerically controlled (CNC) machines are available, however most work is done on a 3-axis CNC milling machine. In 3-axis milling it is important to understand the constraints of the mill and how they affect the possible geometry of the piece (ex: undercutting). Other considerations include the selection & order of cutting tools, cutting path algorithms, and their parameters.

The desired surface quality is also an important issue to be considered. The choice of cutting tools and machining parameters will greatly influence the aesthetic quality of the surface. By controlling these parameters it is possible to accentuate and amplify textures that are a result of the machining process. If these textures were to be modeled digitally it would result in massive data files which are tedious to use in production. The resulting designed object is therefore a product of the entire process; the integration of the design with the production, and the output parameters.

2.2 Programmed Surfaces

The second approach uses programming to generate surface topologies and ornament. This method takes advantage of the computer as a numerical environment, and is a novel approach to the idea of contemporary ornament. The working approach to a project, including its requirements for input, output, and the type of geometry, all together determine which programming language and CAAD software package will be used.

The chosen software environment for teaching is MAYA, or specifically MEL (Maya Embedded Language). MAYA is an excellent teaching tool due to the interactive nature between the GUI and the MEL scripting editor. Typical programming techniques such as simple loops, parametric scripts, shape grammars, and genetic algorithms allow for different methods of surface generation.

Programming allows us to employ different mathematical concepts of geometry and topology in the description of surfaces. Considering the machining process, one will notice that the cutter of a mill is essentially sculpting a surface by following a line, or an organized series of lines. In several projects lines have been used as recursive geometric descriptions of a surface.

Figure 2 Surface scripting with Hilbert curve

The Hilbert curve (David Hilbert 1903) is an example of a plane filling curve; a fractal algorithm which fills a given area with a recursive line pattern. The interesting characteristic is that a single line describes a surface, yet it has inherent possibilities for controlled complexity. The Hilbert curve never intersects with itself, but also generates an interesting overall pattern. These features of space filling curves make them ideally suited to computer generated and manufactured ornamentation.

2.3 Image Derived Surfaces

The third method uses digital images as the preliminary data, which a program then analyses and translates into a digital topology or structure. This method has two significant advantages; first it allows us to work in an intuitive way with the images, using existing programs such as Photoshop, and secondly it allows us to use images of ornaments as input. In the book "The Language of Ornament", James Trilling states that "ornament comes from ornament". Historically, styles and ornament were catalogued, and these were used as the basis for most ornamented works. As the art-form of ornament has been in decline (at least in the western world) for the last century, it is then possible to use digital images of ornament (or other images), as if from an artisans catalogue, as the muse for the digital process.

Figure 3 Translation of image into an undulated NURBS topology

It is important to note that this process is not about digitally reproducing an exact copy of the geometry from the image. It is rather about using the graphic impression of an original to translate a 2D representation into a new 3D surface topology. This process is composed of two steps: the digital interpretation of an image, and the translation of this image data into a producible surface.

2.3.1 Digital Interpretation of Images

The goal of this process is to extract a three-dimensional topology from a two-dimensional image of ornamentation. Photogrammetry can calculate and reproduce the exact surface geometry, however, this process is computationally complex and requires multiple images. What is of more concern in our process is not the precise

geometry, but an accurate optical appearance of the ornament. Our methodology therefore uses concepts of photo-interpretation to develop a surface that delivers a similar optical impression. Image recognition is the process in which the brain interprets what is being seen by the eyes. If the image corresponds, or is closely related to a known condition from memory, the brain will interpret the image based on that known condition. When looking at an image of any surface topology, a viewer is therefore interpreting the relative pixel values, and reconstructing an impression of that 3D surface topology in their brain.

In our work we are making an analogous process within a digital process. By analyzing the image in three different ways we can extract different surface characteristics. At the smallest scale the texture of a surface is determined by large differentiation in the contrast of pixels within small areas, the "noise ratio". On a smooth surface this noise ratio is small, and on a rough surface it is large. At a medium scale the overall gradient of pixels determines whether the surface is sloped, flat, high or low. Over the entire image simple optical recognition is looking for repeating patterns of contrast within a given threshold, effectively mapping out edges, tool traces, or other distinct features within the image. By combining the three processes of analysis and setting up logical rules for the relation between height and pixel brightness a topological system of vector lines or a surface can be directly generated.

2.3.2 Generation of Ornament

From the analysis of the image and from the parameters of the program we get a specific data set, this data set is then translated into a digital surface geometry. Knowing that the surfaces will be carved using a specific milling tool we can follow one of two approaches; either we can create a surface or series of surfaces, or we can create one or a set of lines to define the cutting pattern. When lines are used to define a surface there is a much greater aesthetic control over how the final surface will appear. As each line exactly defines the path of the cutter, the spacing and organization of the lines also therefore defines any "artifacting" or texturing. To define a surface topology the series of lines are spaced based upon the size of the cutting tool and the parameters of the machine. The most common method is to create a series of parallel lines and to deviate the cutting path in Z-height so as to define the topology. Other algorithms for defining a surface can also be used, such as progressive contour lining, spiral cutting, or block cutting. As mentioned previously, there are a number of mathematically defined recursive curves, such as the Hilbert, Peano, Wunderlich, and Moore's curve that fulfill this criteria ideally.

3 THE CNC PRODUCTION PROCESS

Production using CAM is divided into two steps; the generation of Numerical Control (NC) machine code, and the manufacturing. In addition at this stage the material qualities in relation to the fabrication process will be an important issue.

3.1 Generation of the NC Machine Code

To physically fabricate a surface its geometry first needs to be defined as NC code for the specific CNC machine. This is often the point at which the students think the design exercise is finished, however the parameters and choices made in creating the NC code also affect the final piece, and should be seen as important design decisions. The creation of NC code is typically done using traditional CAM software such as SurfCAM or MasterCAM. The geometry is imported into the CAM program where the parameters for the cutting paths, the cutting tools, and the specific machine are defined.

The CAM software then outputs an NC-code file which is originally based on an HPGL plotter code, where the main difference is in the inclusion of a controlled Z-height. Because this code is very simple, sometimes this process is omitted and the NC code is generated directly from our scripted programs.

3.2 Computer Controlled Manufacturing

The final step in the process is the fabrication of the ornament on a CNC machine. Each machine has capabilities and constraints, however, constraints can be overcome creatively, and often lead to new techniques and new aesthetic output.

We are working with both a mid-sized model laser cutter, and a large industrial gas assisted laser cutter, however they are restricted to 2D profile cutting or surface etching of a material. A water-jet cutting machine; conceptually identical to the laser cutter, can be used to work with materials that cannot be cut with the laser. In addition we have a 3D-printer, which is not used in the ornament courses. The small 3D-printer does not allow us to work at the 1:1 scale and we are constrained to the plaster powder based material associated with this technology.

Figure 4 CNC machining and different materials

In most projects a 3-axis milling machine is used. For the fabrication of surfaces, and specifically of ornaments, the mill is appropriate as it is analogous to a "sculpting machine". It is a simple, proven, inexpensive, and robust technology. The constraints of a 3-axis mill reside in the fact that it cannot do undercuts. This

limitation, is seen as a positive influence (especially in the teaching) as it forces additional reflection on the fabrication process while in the digital design stages.

CNC milling technology is relatively old, and as a result is more commonly available in industry. Although we are using machines common to other manufacturing industries we are approaching the processes in an unorthodox manner, and as a result the outcome is often novel and atypical.

3.3 Materials

The final consideration in the overall process is the material. Fabrication is a process of controlled stressing of material producing vibrations, internal stresses, and fractures which can cause unexpected damage to the piece while being manufactured. Consequently, it is important that the choice of material is suited to both the design and the fabrication process. The laser cutting machines are limited to materials that will be cut with high intensity energy. The waterjet-cutter can cut most other materials, but will stress or fracture brittle materials.

The CNC mill will cut most materials with sufficient internal rigidity. Typical architectural materials such as foam, plastic, lumber, engineered wood products, and Eternit (fiber reinforced concrete panels) are used for most projects.

4 EXAMPLES IN PRACTICE AND RESEARCH

Experimentation and experience play a key role in the successful fabrication of a piece. Our projects investigate the role of CAAD/CAAM in architectural ornament.

4.1 EternitOrnament

Figure 5 Samples from EternitOrnament

The focus of the course EternitOrnament was to develop programmed ornament that could be manufactured in Eternit so as to provide new expressive possibilities for the

material. Students were encouraged to experiment with the various concepts of ornament from different cultures and histories in architecture. Different digital designs strategies emerged that were then augmented by variations in the manufacturing process. One student created a code for recursive geometries carved into Eternit cladding panels. By mirroring and rotating the pattern the overall wall attains an aesthetic akin to geometric Islamic tiling. A second student programmed variable sized water-jet cut openings in a paravant screen, which created ornamental patterns of shadow and light. The final products ranged from variations of wall cladding systems, to furniture, and signage. Many of the final products were included in the traveling exhibition "Eternit Architektur Preis03: Experiment Eternit".

4.2 The Rustizierer

The experimental project 'Rustizierer' is a reinterpretation of Gottfried Semper's rusticated and ornamented façades. The Rustizierer uses photo-interpretation of the original (manual) tool traces to translate the original stone-working patterns into algorithms. These algorithms were then used to generate the digital surfaces for fabrication using a CNC milling machine. The Rustizierer was part of the exhibition "Gottfried Semper, Architecture and Science" Museum für Gestaltung, in Zurich.

Figure 6 The Rustizierer project 2003

Figure 7 The Rustizierer, details of individual stones

4.3 Historical Building Facade

During the renovation of a historical building in central Zurich two exterior columns required structural work, and in the process the carved ornamented façades were required to be replaced. Due to its historical designation, the façade aesthetic had to be preserved. Our image based process was adapted to generate "wobbling" vertical vectors which vary in depth to recreate the appearance of the ornamental carving. The CNC-mill was used to fabricate a series of plates which were then used for casting in stainless steel. For the casting process it was important that the molten metal could easily "flow" over the complete surface. The foundry specified the minimum sizes for the profile of the ornamental grooves, these parameters were then used to retroactively define the entire design and subsequent production process. The resulting pieces and process received approval and praise from the Zurich Historical Board.

Figure 8 HBF project 2004

5 CONCLUSIONS

Digitally generated ornament is developed here to exemplify the concepts of mass customization within the context of architectural design. Mass customization and individualized fabrication are becoming more common. The inclusion of parametric design in architecture will continue to grow as the architectural role of the computer evolves. The combination of CAAD/CAAM technologies will continue to challenge the traditions of architecture, and engage the architects that play an active role in the entire process.

Contemporary forms of ornament can already be seen to be making a return. The pictorial or narrative surfaces of Herzog & deMeuron and Francis Soler use large appliqué images to enliven the surfaces of their buildings. The printed images remain two dimensional but they act with the same intent as Semper's rustication and ornamentation, to enliven, communicate, and differentiate the façade. The possibilities for integrating the ornament directly into the design and materiality of the architecture can easily be seen as a next step in this development. By adding a

third dimension to the ornament the architecture regains its active play of light, shadow, and optical effects, allowing for direct communication with the viewer in a highly specialized and controlled manner.

The projects presented within this paper seek to engage this advanced technology in both the design and fabrication of a historically significant part of architecture: Ornament. The availability of skilled workers, specifically in the historical restoration and preservation sector continues to diminish. The benefits of this work lie in the ability to generate ornament efficiently, and also to re-generate ornament and styles in some cases only preserved in archival images.

The merits of this research, as well as the software and processes are continuously evolving. This process presents a contemporary approach to a traditional art that has been successfully applied in the restoration of a historic building. The results thus far continue to be positive, and several further projects to push this research further are in progress.

REFERENCES

Cache, B. 1995. *Earth Moves: The furnishing of Territories*. Cambridge: MIT Press.

Deluez, G. 1988. *Le Pli: Leibniz et le Baroque*. Paris: Edition de Minuit.

Imperiale, A. 2000. *New Flatness: Surface Tension in Digital Architecture*. Basel: Birkhaüser.

Kolarevic, B. 2003. *Architecture in the Digital Age: Design and Manufacturing*. London: Spon Press.

Loveridge, R., and Strehlke, K. 2004. The Rustizierer: A dimensional translation of antiquity into technology. In *TransLate*: Trans vol 12. ed. H. Bindl: 52-59. Zurich: GTA Verlag - ETH Press.

Sharples, Holden, Pasquarelli. 2003. Versioning: Evolutionary Techniques in Architecture. *Architectural Design* 72(5). London: Wiley Academy.

Staub, N. 2003. Semper's stronghold of education. In *ETH Life* vol 080103. Zuerich: ETH press.

Strothotte, T. 1997. *Seeing Between the Pixels: Pictures in Interactive Systems*. Berlin: Springer.

Trilling, J. 2001. *The Language of Ornament*. London: Thames and Hudson.

Tufte, E.R. 1990. *Envisioning Information*. Connecticut: Graphic Press.

Wood Frame Grammar:
CAD Scripting a Wood Frame House

SASS Lawrence
Department of Architecture, MIT, USA

Keywords: CNC, shape grammars, scripting

Abstract: This paper demonstrates a novel method to generate house designs completely from 3/4" plywood sheets. A shape grammar routine is employed to divide an initial solid shape into constructible components for fabrication by CNC wood routing. The paper demonstrates programmable functions that can be performed using CAD scripting. Future goals for the grammar are to develop CAD programs for digital fabrication using CNC routers. The programs will automate the fabrication process allowing the designer to focus on the visual aspect of design evaluation at any scale with little concern for constructability.

1 INTRODUCTION

As designers begin using rapid prototyping to build and evaluate high quality physical artefacts (models), new computer programs are needed to make the constructive aspects of process efficient and affordable. New software development used for fabrication will aid the relationship of CAD modeling with rapid prototyping devices by translating 3D geometries to a specific material and geometry for manufacturing. Currently, software used to translate CAD models to tool paths for rapid prototyping machines, known as CAM software, breaks computer models into thin layered plot files for 3D printing or 3D milling. CAM software for CNC devices breaks 3D models into very specific tool paths also in a layered fashion. Here fabrication software refers to a method to break 3D shapes into flat geometries for two dimensional cutting with assembly logic embedded in each component. The novelty of the project is the use of a shape grammar routine that visually describes the process of reduction. The grammar relates to both to materials property and machine processing. To describe the visual aspects of the functions needed to transform an initial shape into functions for CNC cutting a shape grammar is used. This shape grammar is used to generate wood frame housing with studs and internal and external sheet walls. All materials for the walls, wall studs, roofing and flooring are cut from plywood sheets the example at the end of this paper uses 132-4' x 8' x 3/4" sheets of plywood to create a 10' x 15' x 16' room. The functional grammar here is referred to as a *wood frame grammar*.

B. Martens and A. Brown (eds.), Computer Aided Architectural Design Futures 2005, 383-392.
© 2005 *Springer. Printed in the Netherlands.*

The motivation for the *wood frame grammar* is to create housing exclusively of one sheet material. Typical wood frame construction is built with walls of various size construction components such as 2" x 4" studs, ¾" plywood sheets and metal fasteners at corners. Current construction techniques result in inefficient material manufacturing, weak and low quality connections between walls, floor and the roofs structure (Figure 1a). Structurally weak points in current wood frame housing at the corners and connections between panels are caused by manual measurements and manually driven construction tools.

A modern approach is used here to fabricate all parts of a wood framed room by creating friction fit connections from sheet material cut with a highly precise CNC table router. The *wood frame grammar* defines assembly methods and tool cuts for notched studs that connect to friction fit walls and studs. Additional connections are granted with the help of structural dog bones used to attach panels to panels and studs to studs. The grammar yields corners of one precise piece with an angle that can be connected to a flat section or infill single panels (Figure 1b). In contrast to conventional construction the strength is in the corners, this method does not need special fasteners at connections between panels.

(a)	(b)
conventional	precision
panel wall assembly	end wall assembly

Figure 1 Typical wall panel system (a), panels cut using CNC technology (b)

2 GRAMMAR FUNCTIONS AND CAD SCRIPTING

The argument to use shape grammars is a need to visually explore the construction process leading to the automation of CAD. Ultimately a shape grammar interpreter could read the drawings in this paper then translate them to CNC code for the manufacture of each sheet of plywood. With or without an interpreter the process to create connections, wood cuts and assemblies needs a visual context. Shape grammars are best for visual descriptions of shape transformations and operations.

This *wood frame grammar* is a rule based presentation of early stage research results within a longer term goal to write VBA scripts for a solid modeling program. These scripts are functions that will translate an initial shape to plywood parts. The process is divided into two phases; the shape grammar in this paper generates geometries for Phase 1.

Phase 1 is composed of 5 sets of scripts (translated from shape grammar rule sets) that transform a single 3D CAD model to a 3D construction model with specific parts and pieces based on 3/4" plywood sheathing and studs (Figure 2). The first script subdivides the initial shape in the form of a CAD model with 1/2" walls into corners and end walls. The second, third, and fourth scripts build new geometry based on ¾" plywood sheets. Each of the four wall types is a double sided stud wall with notches for friction fit connections between the studs and the sheathing. Results of the first phase of five script sets will generate a CAD model of walls and studs.

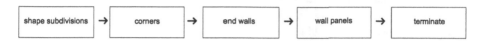

Figure 2 Phase 1 - Rule sets

Phase 2 is composed of script sets for fabrication at 1/12 the scale of reality. The first script translates 3D geometries to a flatten position then cuts that geometry into parts that fit within a 4" x 8" boundary sheet. These boundary sheets are a simulation of a 4' x 8' sheet of plywood. The boundary sheet also has a thickness that is 1/16" scalable to ¾" plywood. For walls larger than a boundary sheet the grammar cuts the part and places a dog-bone between the sheet for a solid connection in construction between inner and outer sheathing (Figure 4). The same process occurs for studs longer than 8"; they are divided and a mini dog bone connection is set at the joining edges. The fourth script checks for a proper tolerance connection between each part assuring a solid friction fit connection. Then the program terminates. The technique used to friction fit wood panels follows past techniques on self assembled building components (Sass 2004).

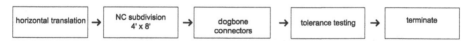

Figure 3 Phase 2 - Rule sets

3 BACKGROUND

There are three past papers on generative fabrication processes using shape grammars or generative computing and CNC manufacturing. The first paper presents a program that generates design artefacts in CAD with models printed in 3D from a shape grammar routine (Wang and Duarte 2002). The program known as *3D shaper* generates shapes with rules based on the relationship of rectangular shapes grouped and organized by the grammar. A shortcoming of this process was that models did not contain a fabrication methodology resulting in physically small shapes for formal evaluation only. Larger models were needed for internal space exploration. The second paper was a shape grammar based computer program used to generate sheet metal panels for the manufacture of lightweight parts (Soman et al. 2002).

Rules for the grammar are based on the material and assembly properties of sheet metal and CAD CAM operations. The grammar is built of rules for notching, bending and punching sheet to fabricate stereo encasings. Last and most recent is a paper (Kilian 2003) presenting a computer program that generates a puzzle connection between two flat or curved CAD surfaces. The program calculates the relationship between surfaces then generates new geometry built of semi circular extensions and subtractions. Each extension fits into the subtraction of the opposing sheet. The program generates zipper joints of varying scales based on the level of curvature between the two surfaces. The three papers are novel generative methods to bridge the relationship between computation, materials and computer controlled machinery. This paper follows the logic of the three by organizing the rules for the design and fabrication of buildings.

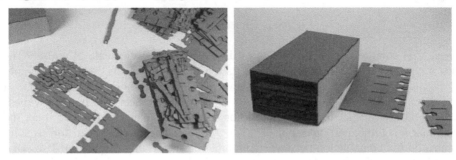

Figure 4 Left, photo of dog bones, studs, and wall panels with notches for dog bone connections cut of 1/16" cardboard stock simulating 3/4" plywood sheets Right, photo of panels, studs and dog bones in one packaged container

4 WOOD FRAME SHAPE GRAMMAR

This *wood frame shape grammar* transforms an initial shape to cut sheets for laser cutting later. Later the same cut sheet can be used for CNC wood router cutting. Shape grammars are typically used to generate shapes based on shape rules (Stiny 1980). Here shape rules transform an initial shape a → b to flat geometries of various formations that reflect a specific material property (3/4" plywood).

Starting with an initial shape in Figure 5, rules 1 – 4 subdivides an initial shape into corners, end walls and panels. The rule assume an initial shape were $t = 1/2$", the thickness of the wall panel at a scale of 1" = 1'-0". Symbols are used to identify the insertion point of each panel type, * is used for corners, • for end walls and ■ for flat panels. There are two corner types depending on base angleθ, if greater than 90° rule 2 is applied. Rules 5 … 10 break typical corners into components and variables. Rule 9 defines variables for notched connections between the panels and studs. The notch in the stud and panel gives the double plywood wall its strength. Rule 11 … 16 are for special shaped corners that join end walls on three sides.

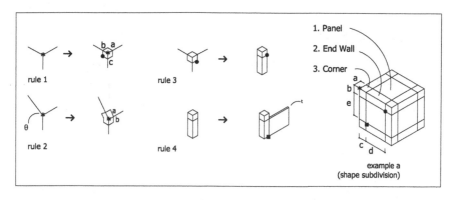

Figure 5 Rules used to subdivide the initial shape and build corners

Wood Frame Grammar

Figure 6 Rules used to define end walls, wall panels, windows and doors

Rules 17-22 define end walls with notched connections between flat panels as well as connections between studs and panels. Notched edges for panels are created using rules 7, 13 and 19. Rules 23-28 define straight walls with notched studs, example e in Figure 6 describes the addition of wall units to create a full infill wall of many studs and panels. Rules 29a-29c erases insertion symbols. Rules 30-33 are used to join panel and studs, for example rule 30 is used to fuse an end wall to a straight wall panel. Rules 34-39 describe the subtraction of wall panels for windows and doors. Variable "t" is the thickness of the wall panel for a smooth connection between doors and walls.

5 GENERATING A ROOM

The *wood frame shape grammar* can be used to create a valid room/house. Figure 7 is a demonstration of a process of operations for a shape grammar routine. If this were a computer program or script the user would be prompted with variables. The first prompt would request the user create an initial 3D shape. For this example the initial shape is a room with a pitched roof. Rules are run on a model scaled to 1" = 1'-0". Rule 1 is applied to the initial shape of 10" x 15" room with a 16" high ceiling, walls "t" are 1/2" thick. This rule is used to generate corners at the bottom and ridgeline of the roof. Rule 2 generates corners for the roof angle while rule 3 and 4 divide the model into end walls and panels. Rules 5-10 transform 1/2" thick walls into 1/16" thick panels with internal studs notched into inner and outer panels. Rules 11-16 divide the corners at the spring of the roof. Rule 17-22 creates end walls with notched corners followed by rules 23-28 that create a straight wall panel of notched studs. This phase of the grammar is terminated by apply 29a-29c to erase symbols used to insert panels. Windows measuring 2" x 2" are applied by placing a • symbol to the left of the window at the bottom of an adjacent notch. Door insertions also use a • to mark the insertion in this case at the bottom of the floor below, 1/2" from the edge "t". Phase 1 of the grammar is terminated with the application of 29a used to remove the window and door symbols.

Phase 2 of the process translates all objects in the 3D model to a horizontal position. Each panel and stud is translated to a flattened position then numbered based on the parts location in the 3D model. Walls are broken into regions north, south, east and west followed by a set of numbers for all parts within each region. After the geometry is flattened and numbered, each part is positioned within a 4" x 8" panel to be cut from 1/16" thick cardboard. In this derivation of a room there are 132 - 4" x 8" panels or (4' x 8' x 3/4") sheets of plywood (Figure 8). Next, wall panels for each side of the room are cut to fit within smaller sheets of plywood then circular subtractions are made for dog bone connectors. Smaller dog bones are used for joining studs. Phase 2 is terminated after test for tolerance connections between parts.

Wood Frame Grammar

$$\theta = 142°$$
$$t = 1/2"$$

$$a = 1' - 6"$$
$$b = 1' - 6"$$
$$c = 1' - 6"$$

$$dx = 13' - 0"$$
$$dy = 8' - 0"$$
$$e = 8' - 0"$$

$$mx = 13' - 0"$$
$$my = 8' - 0"$$
$$n = 1"$$
$$ns = e/4 - n(3)$$
$$ce = \frac{a - 1"}{2}$$

Figure 7 Grammar derivation

Figure 8 132 cut sheets for 4" x 8" panels of 1/16" sheet material used to build the model in Figure 7

6 CONCLUSION

The *wood frame grammar* demonstrates an effective way to generate designs and construct housing of friction fit wood connections using a shape grammar routine. The grammar also demonstrates that working with 1/16" cardboard and laser cutting is scalable to 3/4" plywood (Figure 9). The full process starts with a 3D CAD model, followed by files of parts generate from rules cut on a laser cutter. Next parts are assembled to creating a physical representation of the initial CAD model with embedded assembly logic (Figure 9a).

 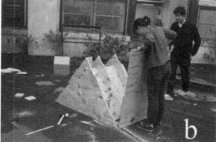

Figure 9 (a) 3D print and a model of cardboard sheets measuring 10" x 15" x 16", (b) student assembling a friction fit full scale plywood section at the roof

Wood Frame Grammar

Having a shape grammar that handles complex building methods will lead to dynamic design shapes for rooms and buildings. The novelty of this process is the precise notching of studs to panels and panels to panels with very solid corners. A shape for a space is presented in figure 10. This shape is far more complex that that of the model in figure 9a. Future research results will demonstrate CAD scripts as functions for each rule set where initial shapes generated in 3D CAD are translated by scripts for subdivisions, corner builders, end wall scripts and wall panel functions. Ultimate goals will lead to a design program for generating wood frame houses from shape models.

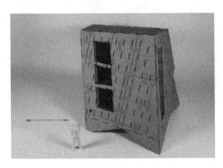

Figure 10 Alternative design of many complex sides

REFERENCES

Kilian, Axel. 2003. Fabrication of partially double-curved surfaces out of flat sheet materials through a 3D puzzle approach, In *Connecting Crossroads of Digital Discourse* [Proceedings of the 2003 Annual Conference of the ACADIA], ed. K. Klinger: 74-81. Indianapolis, IN: ACADIA.

Sass, Lawrence. 2004. Design for Self Assembly of Building Components using Rapid Prototyping. In *Architecture in the Network Society* [eCAADe 2004 proceedings], eds. B. Rüdiger, B. Tournay, and H. Orbak: 95-104. Copenhagen: eCAADe.

Soman Aditya, Swapnil Padhye, and Matthew Campbell. 2003. Toward an automated approach to the design of sheet metal components, *Artificial Intelligence for Engineering Design, Analysis and Manufacturing* 17(3): 187-204.

Stiny, George, 1980. Introduction to shape and shape grammars. *Environment and Planning B* 7: 343-351.

Wang, Yufei, and Jose P. Duarte. 2002. Automatic generation and fabrication of design, *Automation and Construction* 11(3): 291-302.

Transformations on Parametric Design Models
A Case Study on the Sagrada Familia Columns

BARRIOS Carlos
Department of Architecture, Massachusetts Institute of Technology, USA

Keywords: parametric modeling, parametric design, design transformations

Abstract: This paper presents a research in progress in the development of parametric models for generation of complex shapes, and introduces a methodology for exploration of possible designs generated from a single model. The research presents a case study on the designs of the Spanish architect Antonio Gaudi, and takes on the fundamental rules of form generation of the lateral nave columns of the Sagrada Familia temple in Barcelona. A parameterization schema is presented as a fundamental tool for design exploration, which allows the reproduction of the original shapes designed by Gaudi, and the generation of a large set of new designs.

1 INTRODUCTION

Parametric modeling (PM) CAD systems, which until recently were high end commodities in the architectural domain, are becoming standardized tools to aid the design process in academy, practice and research. Initially intended for the aeronautical industry, parametric modeling systems are making their way into the architectural domain since they provide a powerful framework for conception of design, allowing the description of multiple instances and possible designs from a single modeling schema. PM systems are challenging the traditional use computer systems for representation of designs to intelligent models capable of interacting and responding to local and global variables imposed by the environment and by the designer at will. Parametric modeling systems pose a challenge to expand the design process beyond current limitations of traditional CAD systems by:

- Offering more flexibility to design parts and assemblies of complex nature;

- Provide reliable systems to test instances of designs from a single model;

- Expand design exploration of at the initial stages of the process.

PM requires rigorous thought in the process to build a model that is appropriate for the needs of the designer and a very sophisticated structure. Even though this task can be time consuming, a good parametric model has the advantage to provide a solid structure that will act as a container of information of the design history.

B. Martens and A. Brown (eds.), Computer Aided Architectural Design Futures 2005, 393-400.
© 2005 *Springer. Printed in the Netherlands.*

Furthermore, the model can be flexible enough to be constantly evaluated, revised, and updated if different components are added, changed and deleted, within the same structure of the PM.

2 PARAMETRIC MODELS

A parametric model is an abstract representation of a system or event in which some elements of the system have attributes (properties) that are fixed, and some attributes that can vary. The attributes that are fixed are called explicit, and attributes that are subject to change are called variables. Explicit attributes become variables through parameterization, a process that defines which components of the model will vary and how the variation occurs. Variables can also be constraint to a particular range of values. The variables can be independent, were the variable can have any value that is assigned to have, or they can be dependent, in which the value of the variable is related or linked to the value of another entity of the model.

Parametric modeling is the process of making a geometrical representation of a design with components and attributes that have been parameterized. Parametric design is the process of designing with parametric models or in a parametric modeling setting.

2.1 Instances of a Parametric Model

The principal advantage of a parametric model is that it allows a level of flexibility to perform transformations that would result in different configurations of the same geometrical components. The different configurations are called instances of the parametric model. Each instance represents a unique set of transformations based on the values assigned to the parameters. As a result, variations on the design are obtained by assigning different values to the parameters that yield different configurations. In simple terms, a parametric model allows the designer to perform changes and reconfigurations of the geometry without erasing and redrawing

2.2 Scope

The scope, number of design instances that a parametric model can generate, will depend on a balance between the parameterization schema, the constraints and degrees of freedom of the parameterized components, and the geometrical model representation. Together they will determine the size of the design space allowed by a parametric model.

The parameterization schema will determine which are the attributes subject to parametric transformations, in other words which components of the model will vary and which components of the model will be fixed. The step value assigned to the parameters, along with the constraints, will determine the increment in which the parameters can vary.

The representation type of the geometric model will determine if topological transformations are allowed. In the case of a circular shape, unless a different representation is chosen, the shape will always remain a circle. If instead of a circle we had chosen to use four arcs, the resulting shape will have generated all kinds of ovals and ellipses including circles as well.

3 PARAMETRIC MODELS FOR THE COLUMNS OF THE SAGRADA FAMILIA

The singular character of the work of Gaudi is the result of a sophisticated geometrical manipulation of simple forms derived from his own observations of nature. Gaudi's design rules are based on the architects' intuition and interpretation of natural forms rather than scientific knowledge of mathematics and geometry. The geometry of the columns of the nave of the temple is the result of the studies that Gaudi performed between 1915 and 1923.

Gaudi initially proposed a helicoidally shape column, like the salomonic columns from the renaissance. However, Gaudi considered that the single twist was visually inappropriate, since it produced a visual perception of a weak column that could be squashed or deformed. The visual imperfection of the single twist column which bothered Gaudi for a number of years was solved by the use of two rotations. This methodology, which has no know precedents in architecture, is the result of eight years of work and experiments and Gaudi's interpretation of the helicoidally growth present in trees and plants.

3.1 Generation Procedure

Gaudi's novel solution consisted in the use of two opposite rotations of the same shape, once clockwise and another counter-clockwise, much like superimposing two opposite twisted columns on top of each other. The process of double rotation of the columns is better explained graphically, to shows the generation process of a square column, known as *the column of 4*. Figure 1 shows a square shape extruded along a vertical axis with a 22.5 degree rotation. Figure 2 shows the same procedure with a negative rotation, known as a *counter-rotation* of the same square shape. When the two shapes are superimposed and a Boolean intersection is performed, the resulting shape is the actual column of 4 as develop by Gaudi (Figure 3). Even though Gaudi did not have knowledge of how Boolean intersections are done in a computer, the resulting shape from the Boolean intersection is analogous to the actual column originally designed by Gaudi, which simulates the techniques used by the plaster modeling process (Burry 1993, 54).

Figure 1 Rotation Figure 2 Counter-Rotation Figure 3 Intersection

The columns on lateral nave of the Sagrada Familia nave follow the same procedure, where the only variations are the initial shape, the height of the column, and the rotation degrees.

3.2 Reconstruction of the Column Model

The work started by the reconstruction of the columns knots of the lateral nave of the Sagrada Familia. The rectangular knot (Figure 4) was selected as the main model for the parametric exploration. The first challenge was to find a suitable modeling procedure that will yield an accurate representation of the knot. The modeling system we chose did not have the appropriate tools to reconstruct the knot shapes according to the counter rotation procedure prescribed by Gaudi. This initial challenge called for alternate ways to represent the column knot. After a series of experiments it was found that using a bottom (initial) and top (final) shapes of the knot and filling the space in-between with a blend surface algorithm, the resulting form will generate the knot shape that was visually equivalent to the original plaster model by Gaudi. Figures 5 and 6 show the parametric model of the column and the knot and the comparison with the plaster model by Gaudi.

Figure 4 Column Knot Figure 5 Parametric Model Figure 6 Original

Figures 7 through 10 show the sequence for the generation of the parametric model. The first stage was to create the top and bottom figures and locate them in parallel planes at a distance equivalent to the height of the column knot. A pair of top-bottom figures was created for each rotation. This wireframe model is called the parametric skeleton (Figure 7). A surface fitting algorithm was applied to each pair of top-bottom shapes producing both the rotation and counter-rotation shapes (Figures 8 and 9). The two generated shapes were used to perform the Boolean intersection that generates the knot shape (Figure 10). Although this procedure of blending between two shapes was not described by Gaudi, nor any other researchers and scholars, the resulting columns were not only geometrically accurate, but also visually correct when compared to the original Gaudi models.

Figure 7 Skeleton Figure 8 Blend-1 Figure 9 Blend-2 Figure 10 Knot

3.3 Parameterization of the Column Model

The parameterization of the column knot was performed by building a parametric skeleton and implementing surface fitting procedures which generated the shapes for each rotation of the column. This parameterization schema can be subdivided into three parts: The skeleton and primitive shapes, the surface fitting procedure and the resulting shape from the Boolean operation. For the purpose of this paper we will concentrate in the first part of the parametric model, leaving the second and third unvaried.

In the parametric skeleton there are three types of geometrical components: the axis of the column represented by a line, two parallel planes where the top and bottom shapes will be located, and the top and bottom shapes. Each surface procedure is composed of two initial shapes one on the top and one for the bottom, for a total of 4 initial shapes. The parameterization schema only constrains the location of the initial shapes to the top and bottom planes. The planes must be normal to the axis line. The shapes are not constraint and are free to take any kind of geometrical and topological transformations. The parameterized model of the column knot is shown in Figure 11. The same procedure was applied to the column of four shown in Figure 12.

Figure 11 Parameterization of the Knot **Figure 12 Column of Four**

3.4 Transformations of the Parametric Model

The first set of transformations was done to the top and bottom shapes, starting with variations of the proportions of the lower rectangles, to variations on the angles and finally with variations on the four initial shapes. The height of the column, as well as the rest of the parameters remained unchanged through these set of operations. An important discovery was that the topology of the final column would be altered as a result of changing the parameters of the initial shapes, even though the topology of the all the geometrical components of the model remained unchanged. Figure 13 shows different variations of the design obtained from the same parametric model. Other set of transformations included changes in the topology of the primitive shapes. The parametric model allowed topological changes and still maintained the integrity of the surface fitting procedures without breaking the model, or causing geometric problems.

Figure 13 Parametric Variations

4 DISCUSSION

Even though there are four initial shapes, the parametric model does not determine what kinds of shapes are valid. Potentially, there are no limits in which kinds of shapes can the designer use as long as they are closed; therefore the parameterized entities tend to go to infinity, in which case the number of possible designs from this parametric model is infinite. In order to determine a limit number of possible designs it is possible to limit the parameterization of the initial shapes to a certain type. In this case the number of design instances will not only depend on the number of shapes, but the possible combinations among them. This is defined as parametric combinations.

The generation of a parametric model requires a level of thought beyond the representation of a design idea, but provides a very powerful framework for design exploration. In the architectural domain most cases have used applications of parametric models in the context of design development, where most of the design decisions have been made. Which leads to the question of what is parametric design? On the other hand, if it becomes necessary to know in advance what the design is what the role of a parametric model is? Even though the modeling process demands rigorous thinking about the design, the initial assessment of the research proved the potential to use parametric models for design exploration in the initial stages of the design process. Perhaps a well defined parametric model will serve for the purpose of creating designs in a particular language while discarding other that do not fit the criteria.

4.1 Counting New Designs

Since all of the designs obtained were the result of altering only the initial shapes of the parametric model it would be worthwhile to speculate how many possible designs a parametric model can generate. For the column knot, the parametric variations were done exclusively in the initial shapes. Consequently, for the case of the column knot the number of possible designs will depend on the number of shapes and the parameterization of the initial shapes. Additional parameters include, the location of the planes, the direction of the axis, the length of the axis, the surface fitting procedure, which for the set of transformations studied, remain unchanged.

Based on the aforementioned premises, the design space (DS) of the parametric model equals to the sum of number of parameterized entities (PE), and the step value of the parameters (SV), multiplied by the number and type of constraints (CN) which determines the degrees of freedom. The CN is a factor between 0 and 1, where 0 means that the constraints don't allow any transformations, and a factor of 1 allows infinite degrees of freedom. The representation type (RT) and the ability to regenerate the model (RM) are more difficult to be quantified; therefore they will remain as constants of value 1. The following formula can be derived:

$$DS=(PE+SV)*CN*RT*RM \qquad (1)$$

Where the parameterized entities are the four initial shapes; the step value of the parameters is not defined, therefore is zero; and the constraints are not defined, therefore the value is 1. If were to plug-in the values mentioned the formula will be

$$DS=(PE+0)*1*1*1 \qquad (2)$$

Therefore the number of designs generated by the model is directly proportional to the number of parametric entities (PE). The presented model showed that is had the ability to generate infinite instances of design from a single parametric model. Although the robustness of the parametric model was mostly dependent on the sets of relations and procedures, it allowed the designer to

If we were to consider that design representations, such as plans, elevations, and 3D models, are geometrical models in an explicit representation, we must conclude that they are subject to parameterization. This proves that there is a great potential for applications in architectural design that has yet to be explored.

REFERENCES

Burry, Mark. 1993. *Expiatory Church of the Sagrada Familia.* London: Phaidon.

Fischer, T., C.M. Herr, M.C. Burry, and J.H. Frazer. 2003. Tangible Interfaces to Explain Gaudi's Use of Ruled-Surface Geometries: Interactive Systems Design for Haptic, Nonverbal Learning. *Automation in Construction* 12(5): 467-71.

Gomez, Josep (et al). 1996. *La Sagrada Familia: De Gaudi Al Cad.* Barcelona: Edicions UPC, Universitat Politecnica de Catalunya.

Knight, Terry W. 1983. Transformations of Languages of Designs. *Environment and Planning B: Planning and Design* 10(part 1): 125-28; (part 2): 29-54; (part 3) 55-77.

Mitchell, William J. 1977. *Computer-Aided Architectural Design.* New York: Petrocelli/Charter.

Mitchell, William J. 1990. *The Logic of Architecture: Design, Computation, and Cognition.* Cambridge, Mass.: MIT Press.

Mitchell, William J., and Thomas Kvan. 1987. *The Art of Computer Graphics Programming: A Structured Introduction for Architects and Designers.* New York: Van Nostrand Reinhold.

Building Information Modelling and Construction Management

Spatial Reasoning for Building Model Reconstruction Based on Sensed Object Location Information

SUTER Georg, BRUNNER Klaus and MAHDAVI Ardeshir
Department of Building Physics and Building Ecology, Faculty of Architecture and Urban Planning, Vienna University of Technology, Austria

Keywords: location-sensing, spatial reasoning, building information modeling

Abstract: The continuous collection of data on the state of facilities appears increasingly feasible due to advances in sensing technologies. In this context, we explore the application of tag-based location-sensing to reconstruct models of existing buildings. We describe tag-based building representations, which are complete under certain conditions for the automated conversion to boundary-based building representations. The latter have a rich structure and are useful for various construction-related applications. We describe and demonstrate with a system prototype how spatial reasoning methods facilitate the conversion process.

1 INTRODUCTION

There is a growing interest in the continuous data collection of buildings, driven in part by recent advances in sensing technologies. Although commercial solutions are available for monitoring and preventative maintenance of mission-critical HVAC, lighting, security or circulation systems, these cover only a small fraction of the information that may be useful in assessing building performance. What is still lacking is a systematic and comprehensive approach to collecting state information throughout the building life-cycle. If overall facility performance is to be tracked, analyzed, and improved, it appears that 'inert' or 'grey' matter in buildings such as surfaces, furniture, manually operable windows and doors should be included as well. Although generally thought of as static, these entities change considerably over time. For example, studies on churn rates and churn cost in office buildings suggest that significant physical changes can occur in workplace configurations over relatively short time periods (Ryburg 1996). Through appropriate sensing infrastructures, entities affected by such changes could be made available for detailed performance analysis.

Automated reconstruction and recognition of objects or scenes from sensor data has been researched extensively in computer vision and related fields (Hebert 1998). Most work assumes only minimal or no a-priori knowledge about a target scene.

B. Martens and A. Brown (eds.), Computer Aided Architectural Design Futures 2005, 403-412.
© 2005 *Springer. Printed in the Netherlands.*

However, progress with respect to potential applications in the building domain, has been slow. On the other hand, the availability of smart sensing technologies - some of which employ computer vision techniques - suggests the feasibility of scenes enhanced by markers tracked by sensors. Richer models could be derived from such scenes. The work presented in this paper adopts the latter approach and demonstrates how seemingly unrelated object data collected by a tag-based location-sensing system (and possibly other sensor sources) may be enriched through spatial reasoning into comprehensive, three-dimensional building models.

In the following sections, we first describe which objects in a building are marked with tags for location sensing. We assume that each sensed object's identity is known and may be linked with additional information in remote product databases. Key issues include the minimization of the number of tags to mark objects as well as the amount of information required and maintained at the back-end. We use the term tag-based building representation to refer to a building model obtained by a combination of tags and product databases. Such a representation in itself, however, exhibits little explicit structure and is thus of limited immediate use to most applications. We describe a procedure that converts a tag-based into a boundary-based building representation through spatial reasoning. Boundary-based building representations are useful for a variety of potential applications, including quantity surveying, inventory management, building controls, augmented reality, mobile robotics and context-aware computing (see, for example, Mahdavi 2001, Harter et al. 1999).

2 TAG-BASED BUILDING REPRESENTATIONS

Current location-sensing systems often rely on tags, that is, small markers mounted on objects to be tracked. In contrast to tag-less technologies such as laser scanners, one benefit of tags is the encoding of object identification and, sometimes, additional information. We assume that a tag's pose is sensed and represented as a coordinate system transformation. TRIP is a tag-based location sensing system that provides this kind of information (Lopez de Ipina 2002, Icoglu et al. 2004). As TRIP uses computer vision techniques to derive tag locations, only those objects with line-of-sight between tags and sensors can be tracked. We further assume ideal sensor data, that is, there is no deviation between measured and true values.

In the present context, it suffices to define *buildings* as an aggregation of *spaces* (class names are italicized). The concept of architectural space is relevant for a number of construction applications. It is included in emerging building product model standards such as the Industry Foundation Classes (IFC) (IAI 2004). We use and adapt the space object terminology introduced by Bjoerk (1992) because it is more specific than the IFC model for the purpose of this work. Spaces as well as buildings are abstract concepts, but they may be described in terms of their physical or imaginary boundaries. *Physical-envelope-boundaries* or *physical-space-boundaries*, that is, boundaries of enclosing structures such as façades or roofs, and, respectively, floors, walls, and ceilings, may be marked with tags. These are grouped

by space (analogously those for the envelope). There is a one-to-one correspondence between such a tag-set and a space object (Figure 1 upper-left box). For simplicity, we use the term *space-tag-set* to refer to these two related objects. Semi-bounded spaces or spaces with *imaginary-space-boundaries* may be modeled as *holes* in physical-space-boundaries. A hole-tag is placed on the physical-space-boundary in which a hole is contained and otherwise treated as an opening-tag (see below). A *physical-building-boundary* is an aggregation of envelope- and space-boundaries and thus an abstract concept. For the remainder of this paper, we will omit the term 'physical' for convenience.

A space-boundary-tag may be placed anywhere on the interior of a space-boundary (that is, neither on a corner or an edge). Again, there is a one-to-one relationship between a tag and a space-boundary. This facilitates flexible placement and minimizes the number of space-boundary-tags. Flexibility is important as space-boundaries may be partially obstructed and line-of-sight between tag and sensor may be required. Envelope-boundaries are marked similar to spaces. In the following, we will often use the terms envelope and space interchangeably.

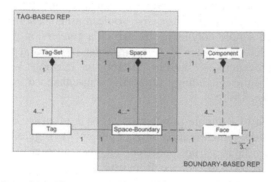

Figure 1 Tag-based and boundary-based space representations (dotted lines indicate derivation by spatial reasoning)

An *opening* such as a *door* or *window* may fill a hole in a space-boundary, implying a containment relation. An *opening-tag* is placed on a pre-defined opening spot. Additional tags may be required if multiple movable opening parts are tracked.

Infrastructure-objects include *tables*, *light-fixtures*, *cabinets*, *blinds* and other movable or fixed objects in a space. Placement of *infrastructure-object-tags* is analogous to opening-tags.

3 CONVERSION FROM TAG-BASED TO BOUNDARY-BASED BUILDING REPRESENTATIONS

This section describes a procedure that converts a tag-based into a boundary-based building representation. The geometry related to a building object is a non-simple

polyhedron, whose *components* are associated with the envelope and spaces (in contrast to a simple polyhedron, a non-simple polyhedron may have holes and multiple components). Similarly, each envelope- or space-boundary has a *face*, which is part of a component. Faces in turn have adjacency relations among themselves (see lower-right box in Figure 1). Once a building-polyhedron is known, opening geometries are generated and matched with component faces. This step gives rise to a space connectivity graph based on openings. Finally, infrastructure-object geometries are generated and associated with spaces.

3.1 Space-boundaries

Space-components are bounded by space-boundary-faces. The shape of these faces is initially unknown and determined by a geometric modeling procedure. Since tag-representations for non-simple polyhedra with a one-to-one correspondence between tags and faces are incomplete (Suter 2004), a divide-and-conquer approach is chosen whereby the boundaries of individual components are evaluated first. In the present context, the number of components is known because space-boundary-tags are grouped by space. The resulting component boundaries are subsequently combined into a single non-simple polyhedron by boolean intersection. Components are treated as flat-faced simple polyhedra, for which a conversion procedure has been developed. A detailed description is given in Suter (2004) and summarized in the following. The procedure is closely related to existing work on sampling representations in solid modeling, especially tag-enhanced ray representations (Menon and Voelcker 1995).

A tag representation of a simple polyhedron A, or tag-rep(A), is converted in two stages into a boundary-representation of A, or Brep(A) (Figure 2). The first stage relies on known procedures from constructive solid geometry (CSG) to derive a disjunctive decomposition of 3-space from the set of half-spaces induced by the position and normal vectors associated with the tags in tag-rep(A) (Shapiro and Vossler 1990). Tag positions are also used in point classification procedures to identify cells in the disjunctive decomposition whose point set represents a subset of A. The result of this procedure may or may not include all cells, which, if merged by boolean union, would be equivalent to A. The success of the first stage is influenced by a combination of factors, including tag placement and the shape of A.

If the first stage does not result in a valid polyhedron, the conversion procedure enters its second stage, which involves a generate-and-test search process. The objective is to incrementally evaluate the boundary of an evolving polyhedron, B, until it is equivalent to that of A, that is, $bB = bA$ (b denotes boundary). Two tests are performed on bB. First, bB is inspected for general polyhedron well-formedness conditions (Requicha 1980). Second, each tag in the tag-rep needs to be matched with exactly one face. This condition enforces the one-to-one correspondence between tags and faces mentioned earlier. Unmatched as well as multiple tags matching a face result in a conflict, in which case a new face alternative is generated and added to B. A vertex-edge graph and constraints on vertices, edges, and faces - all derived from the disjunctive decomposition using known boundary evaluation

algorithms (Requicha 1985) - guide this highly recursive search process to evaluate *bB*.

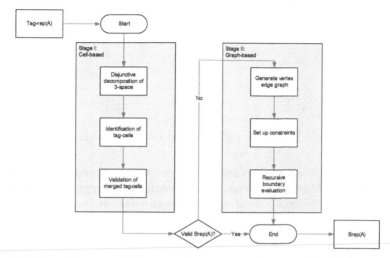

Figure 2 Flow diagram of the procedure converting a tag-rep(A) to a Brep(A)

Note that in most cases neither of the two stages alone would achieve the conversion between tag-rep and Brep. Whereas the first stage may only generate a partial Brep(A), the search space in the second phase would often be unmanageable unless narrowed by the constraints obtained from the first stage.

3.2 Merge of Space-components

As space-tag normals point toward the interior of a space, the space-components obtained by the conversion outlined above are semi-bounded. Thus the combination of space-components occurs by boolean difference operation (Figure 3a). Note that the polyhedron resulting from such an operation is still semi-bounded. The same intersection operation is used when one of the components to be merged is the (bounded) envelope-component (Figure 3b). The result of that operation is a bounded polyhedron. As boolean intersection is commutative, the order in which space- and envelope-components are processed does not matter.

Figure 3 Merge of bounded and semi-bounded components by boolean intersection. a. Merge of two space-components; b. Merge of an envelope-component and a space component

3.3 Openings

Relations of an opening with space-boundaries are not readily derived from a tag-based building representation. However, tests for relations can be performed when space-boundary-faces are known. Assuming that an opening connects two spaces (or a space and the outdoor environment), the relation of a given opening-tag and space-boundary-face pair is determined as follows (Figure 4a). First, tag and face normals are compared. If they are not parallel, there is no relation. Otherwise, the distance between the tag position p and its projection p' on the surface, in which the face is embedded, is computed. If the distance is greater than a certain maximum distance (about 50cm should be sufficient to reliably derive relations even in case of thick walls), then there is no relation. Otherwise, the last test involves point classification of p' with respect to the face. If p' lies on the interior of the face, then there is a relation between tag and face, otherwise there is not. With relations between each opening, its space-boundaries, and hence spaces known, it is possible to derive a space connectivity graph based on openings (Figure 4b, 4c).

The next step in the generation of openings is to actually evaluate an opening shape and integrate it within its space-boundary context. First, the shape is retrieved from the product database by opening-tag ID. This could be a simple two-dimensional profile, a three-dimensional solid, or the latter computed from the former with thickness information. The opening geometry is then transformed from local to global coordinate system based on the opening-tag pose. The level of detail required depends on application needs, therefore we just give examples of common opening representations.

The decision regarding opening representations could have far-reaching consequences for the building geometry and topology. For example, a hole or void-opening, modeled as a profile obtained from the product database, swept by the distance between two related space-boundaries and subtracted from the building-

polyhedron, would connect two previously separated space-components (Figure 4d). On the other hand, simply converting the profile into faces and subtracting these from corresponding space-boundaries would not affect the number of components (Figure 4b, 4c). In either case, it appears desirable to preserve the state of the building-polyhedron prior to the integration of openings because it represents a view of the building that is more abstract and may have different topological properties than the view that includes openings. Simultaneous accommodation of multiple object views or representations has been mentioned frequently as a crucial requirement for building information models (see, for example, Rosenman and Gero 1996).

Figure 4 Opening representations and space connectivity. a. matching of opening-tags and space-boundary-faces; b. opening-faces co-planar with space-boundary-faces. c. recessed opening-faces; d. disjoint opening-solid filling a hole connecting two space-components.

3.4 Infrastructure Objects

Infrastructure-object geometries are evaluated similar to opening-object geometries. The containment relation between an infrastructure-object and a space is of interest here. It may be derived only when at least space-boundaries are known. Consideration of an infrastructure-object-tag position rather than explicit or approximated shapes should be sufficient for most applications. A given infrastructure-object-tag and space-component pair is tested for containment by point classification of the tag position with respect to the space-component. A containment relation exists if the tag position lies outside or on the boundary of the component, that is, in or on the void enclosed by it. There is no containment relation if the tag position lies in the component.

It is possible that an infrastructure-object can not be associated uniquely (e.g. a table geometry extending beyond a single space) or at all (e.g. a chair completely contained by a void opening) with respect to a space-component. In such cases, hole geometries and approximated shapes such as bounding boxes for infrastructure-objects and space-components should be considered to minimize processing overhead.

4 EXAMPLE

A proof-of-concept prototype system was implemented to demonstrate the conversion from tag-based to boundary-based building representations. Envelope- and space-boundary evaluation is currently performed with only a limited set of constraints (the cell-based first stage is skipped altogether). Most of the geometry processing is done in the ACIS API, a commercial solid modeling environment (Spatial 2004). Figure 5 illustrates the conversion from tag-rep to Brep for an F-shaped space that is part of an office environment. The vertex-edge graph (upper-left image) provides the basis for recursive evaluation of face alternatives. There are several intermediate states (states 77 and 165 are shown as examples) of the evolving space-component, most of which result in local failure, which may require backtracking to higher levels in the search tree. In the example, the boundary of the target space is validated after 246 steps. Figure 6 shows two views of the office environment at different abstraction levels. The first is a high-level view of space-boundary-components. The second view includes detailed representations of openings, blinds, and infrastructure-objects. Note the difference in the number of components in the building-polyhedron: seven in the first view, one in the second – that is, envelope- and space-components are merged into a single component. Providing such flexible views or interpretations of a building is relevant with respect to the disparate information needs of various applications.

5 DISCUSSION

We have introduced the concept of tag-based building representations and a procedure to convert these to boundary-based representations. Several issues should be addressed in future work. First, various steps in the conversion involve spatial queries that are computationally expensive. This suggests the exploration of spatial indexing schemes to improve the scalability of tag-based building models. A by-product of such an effort could be the automated derivation of zones or floors. Secondly, in a realistic setting, pre-processing would be required to account for tolerances in location sensing data. In the work presented here, we have assumed ideal sensor data. Deviations between recorded and true sensor values could cause significant problems in evaluating tag-based building models, resulting in global failure in the worst case. For example, deviations in tag positions or normals due to sensor tolerances could cause certain faces not to be included in a Brep derived from a tag-rep (see Hoover, Goldgof and Bowyer 1998 for a description of similar problems in validating face adjacency graphs).

ACKNOWLEDGMENTS

The research presented in this paper was supported by a grant from FWF (Austrian Science Foundation), project number P15998-N07.

Figure 5 Illustration of a conversion procedure from a tag representation to a boundary representation of a space (shaded areas and dotted lines indicate derivation)

Figure 6 Two views of the building representation: space-boundary view (left) and total building model view (right)

REFERENCES

Björk, Bo-Christer. 1992. A conceptual model of spaces, space boundaries and enclosing structures. *Automation in Construction* 1(3): 193-214.

Harter, Andy, Andy Hopper, Pete Steggles, Andy Ward, and Paul Webster. 1999. The anatomy of a context-aware application. *Wireless Networks* 8: 187-197.

Hebert, Martial. 1998. *Shape recognition: recent techniques and applications.* Proceedings of RFIA '98, 15-31. Clermont-Ferrand: Université Blaise Pascal de Clermont-Ferrand.

Hoover, Adam, Dmitry Goldgof, and Kevin Bowyer. 1998. The space envelope: a representation for 3D scenes. *Computer Vision and Image Understanding* 69 (3): 310-329.

Icoglu, Oguz, Klaus Brunner, Ardeshir Mahdavi, and Georg Suter. 2004. *A Distributed Location Sensing Platform for Dynamic Building Models.* In *Second European Symposium on Ambient Intelligence,* eds. P. Markopoulos, B. Eggen, E. Aarts and J.L. Crowley: Vol 3295, 124-135. New York: Springer.

Lopez de Ipina, Diego. 2002. *Visual sensing and middleware support for sentient computing.* Ph.D. diss., University of Cambridge.

Mahdavi, Ardeshir. 2001. Aspects of self-aware buildings, *International Journal of Design Sciences and Technology* 9: 35–52.

Menon, Jai, and Herbert Voelcker. 1995. *On the completeness and conversion of ray representations of arbitrary solids.* Proceedings of the third ACM symposium on Solid modeling and applications, 175-186. Salt Lake City: ACM Press.

Requicha, Aristides. 1980. Representations for rigid solids: theory, methods, and systems, *ACM Computing Surveys* 12: 437-464.

Requicha, Aristides. 1985. Boolean operations in solid modeling: boundary evaluation and merging algorithms. *Proceedings of the IEEE* 73(1): 30-44.

Rosenman, Mike, and John Gero. 1996. Modeling multiple views of design objects in a collaborative CAD environment. *Computer-Aided Design* 28(3): 193–205.

Ryburg, Jon. 1996. *New churn rates: people, walls, and furniture in restructuring companies.* Ann Arbor, MI: Facility Performance Group.

Shapiro, Vadim, and Donald Vossler. 1990. Construction and optimization of CSG representations. *Computer-Aided Design* 23(1): 4-20.

Spatial. 2004. www.spatial.com. Accessed 2 February 2005.

Suter, Georg. 2004. *Tag representations of simple polyhedra* [Technical Report]. Vienna: Vienna University of Technology.

Construction Analysis during the Design Process

DE VRIES Bauke and HARINK Jeroen
Department of Architecture, Building and Planning, Eindhoven University of Technology, The Netherlands

Keywords: 4D CAD, design process, construction analysis, automatic planning

Abstract: 4D CAD systems are used by contractors for visually checking the construction process. To enable simulation of the construction process, the construction planner links building components from a CAD model with the activities from a project planning. In this paper we describe a method to generate a project planning directly from a CAD model using basic construction knowledge. A case study is discussed briefly to show the current results and the shortcomings. Finally an outlook is presented on a more advanced implementation that is (also) useful for designers.

1 INTRODUCTION

Traditionally, construction planning is a critical factor in building management. The construction planner, employed by a building contractor is a person with much experience in building construction that knows how to estimate the required labour and equipment from a building design. Using this knowledge a construction planning is created as the leading schedule for other derived plans such as transport, measurement, safety, etc. Project plans are constructed completely manually or using a specific tool like MS project or Primavera.

Due to its critical factor, many research efforts have been directed to simulation of the building process using the planning, to visually or computationally search for conflicts or errors (Dawood et al. 2003, Mckinney and Fisher 1998). From this research, 4D CAD systems have emerged, like InVizn®, Navisworks® and 4D Suite®. These systems support the planner by relating building components from a 3D CAD system with construction activities from a project planning system, using a graphical interface. The construction process can then be simulated by executing the planning and the user can visually check how the process proceeds. 4D CAD systems can by used for construction analysis and communication. Experiences in practice by Mark Clayton and Marcel Broekmaat have learned that 4D CAD reduces the number of activities on the critical path, distributes the equipment more evenly, allows for more flexibility in time and reduces planning mistakes (Clayton et al. 2002, Vries and Broekmaat 2003).

B. Martens and A. Brown (eds.), Computer Aided Architectural Design Futures 2005, 413-422.

Even when using 4D CAD systems, the planning expert still plays a crucial role. It is him who manually relates building components to construction activities and who visually tests whether problems occur during the construction process. 4D CAD systems don't bear any knowledge about the construction process itself. More advanced systems support collision detection, but there is no mechanism for expressing constraints and dependencies, and to test whether they are violated in the construction process.

In our research project we took up the challenge to automate the planning process, being well aware that a completely automated procedure is probably not feasible. However, this proposition allows us to investigate which construction knowledge can be derived from common sense or physical laws, which knowledge is construction method dependent, which knowledge is building component dependent and which knowledge cannot be described by the previous methods and thus remains. For knowledge representation we initially follow a computational approach to research how far this method can bring us in producing a reliable planning. A limited pilot study is executed to test the results against current planning practice. In this paper we report on the construction algorithms we investigated and how well they performed in the pilot study. Finally we will discuss which deviations were found and how we think we can extend our system to produce a more reliable planning.

2 CONSTRUCTION ALGORITHMS

A construction algorithm encapsulates construction knowledge. Construction knowledge can be divided in knowledge about structural behaviour and knowledge about construction methods. Structural behaviour is determined by physical laws, construction methods are determined by the building products and the construction equipment. For now, we assume that the construction method is fixed, which does not mean that our automated planning can only handle only one construction method. We will come back to this issue in discussion section. Provided the construction method, yet multiple construction processes or in that case, construction orderings are possible. In this section we will discuss which computation methods are available for calculating the construction order of building components and how these methods perform. An excellent overview of ordering methods is presented by Johnson et al. (2004). They discriminate between ordering by element type, by elevation, by joint configuration, and by tracing from foundation. The authors were not able to identify an algorithm that worked in a consistent, generalized manner. The methods flawed for special cases. They conclude that only Finite Element Analyses can solve this problem. Different from their research however, we do not aim at an abstraction for structural analysis, but for construction analysis. Therefore we have researched algorithms that analyze the topology of a building construction. Before that we will briefly discuss the basic principles for 3D geometry representation of building components, since this representation strongly affects the algorithmic approaches.

2.1 3D Representations

In building practice line drawings are still widely used. Recognition of building components from line drawings is in its infantry and is not considered in this research. Increasingly, architectural and engineering offices produce 3D models using surface modelling and/or solid modelling. With solid modelling structural properties like inertia and volume are ready available. CAAD systems typically contain a library of building components that can be adjusted to the designer's needs. Building components (e.g. wall) can provide additional (e.g. material) and derived data (e.g. surface area).

2.2 Object Topology Analysis

Instead of calculating the vertical load distribution to find out which component bears another component, it is also possible to use the geometric data of the model. More specifically the topology of the building can tell which component is on top of or next to another component. Under the assumption that a 3D CAD model is available, we investigated two approaches for topology analysis, namely 3D box representation and 3D solid representation. The results of the analysis should be a directed graph, stored in a log file. In this graph the nodes represent the building components and from each node the edges point at components that are underneath or besides.

2.2.1 3D Box Representation

The original 3D model is subdivided into a 3D grid. Building components represented as boxes, can occupy one or more grid cells. A useful grid size is 20 cm. (Bax 1976), because the dimensions of many structural components as they are delivered on the building site can be approximated without obtaining incorrect results with the ordering algorithm. First, the algorithm will test each component if any of the grid cells is vertically adjacent in one direction to other grid cells of other components. If so, these vertical relationships will be registered in the log file. Secondly, for those components whose grid cells don't have any vertical adjacent neighbours, it will search for horizontal adjacent components in all four directions. These horizontal relationships are also registered in the log file.

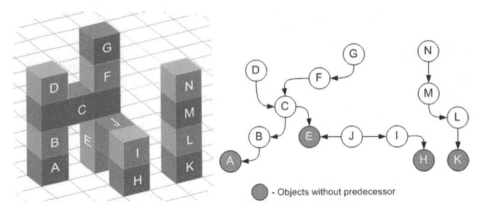

Figure 1 3D grid and Graph schema

Although, this is a very elegant method that can process any 3D CAD model, it causes serious problems in terms of memory management. The minimal data needed are the cell centre coordinates for the occupied grid cells. Even a computer with a big RAM will fall short due to the memory demand of millions of grid cells for an average building model. External storage could solve this problem, but will slow down the computation process dramatically.

2.2.2 3D Solid Representation

The original 3D model is converted into a solid model. First, each solid component is displaced vertically over a short distance (10 cm.) in the negative direction. After a displacement the Constructive Solid Geometry (CSG) intersection operation is used to find out which other component are intersected. Secondly, those components that did not vertically intersect any other component, they are displaced horizontally in all four directions. Again, the intersection operation is executed to find out what the neighbouring components are. From these results, like with the 3D grid, the vertical and horizontal adjacency relationships are stored in a file for each component.

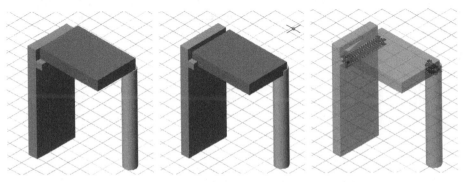

Figure 2 3D solid displacement and intersection

This approach requires significantly less storage capacity and computing power, but is only applicable if a conversion to a CSG model is supported by the CAD program. Unfortunately this is not always true, often even not for all drawing entities within one CAD program.

3 IMPLEMENTATION

The construction analysis is preceded by the creation of a 3D model using a CAD program (e.g. Autocad/ADT). The construction analysis program imports the 3D model and calculates the vertical and horizontal relationship between the building components as described in the previous section. At the same time it must also calculate the duration for the construction of a component. Therefore it uses a database of available equipment and labour, and formulas for the duration calculation expressed in XML. Identification of the construction component type is established in the current implementation by placing a component on a CAD layer with the right component type name. In the generated log we find for each building component, its name, the duration of the construction and a list of components that it is horizontally or vertically related to. A project planning program (e.g. MS project) is used to import the log file and create a planning schema from it, i.e. all components will be ordered subsequently and the appropriate recourses (equipment and labour) will be allocated. The project planning program is also used to create PERT diagrams and for the calculation of the critical path.

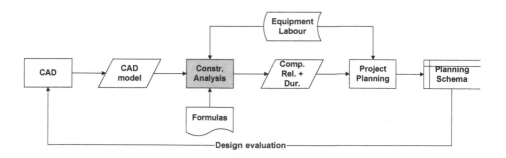

Figure 3 Process model

417

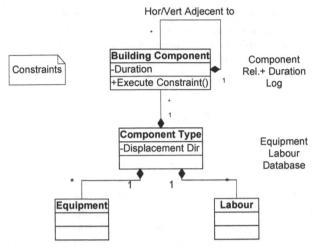

Figure 4 Data model

For the calculation of the construction duration of a component, available literature resources are used that contain reference data about construction time as a function of component volume, applied equipment and applied labour capacity (Misset 2003). The volume is calculated using the CSG function from the CAD system. The calculation formula is described as constraints using XML. External storage of this construction knowledge and reference data allows for adjustment to the needs and experiences of the users.

The construction analysis program (Figure 3), implemented in Autocad-Visual Basic for Applications (VBA), generates horizontal and vertical relationships using the 3D solid representation method in the current implementation as described in Section 2.2.2. A building component can occur in three situations: (i) only vertical relationships (e.g. walls, floors), (ii) only horizontal relationships (e.g. balconies) and (ii) vertical and horizontal relationship (e.g. stairs). To reduce the number of displacements during the construction order analysis, each component type is labelled with a displacement-direction attribute, indicating which displacement is appropriate.

4 PILOT STUDY

The case study (Figure 5) is the construction on an office building for the municipality in Amsterdam. From this project the 3D CAD drawings and the construction planning were available. The construction is combination of prefabricated components (e.g. beam) and in-situ construction components (e.g. the facades).

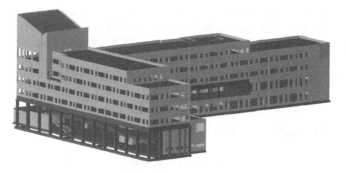

Figure 5 Building for Case Study

4.1 3D CAD Model Preparation

Despite the availability of 3D drawings, created with Autocad - Architectural DeskTop (ADT), the CAD model was not ready for use in our construction analysis system. The ADT component type classification (see Figure 4) is not appropriate for linkage with the equipment and labour reference database. Therefore all ADT components (i.e. Autocad-objects) are transferred to a layer with appropriate component type name (i.e. Autocad-layer). Two additional computer programs were developed for model preparation. The first program converts the ADT components (e.g. wall, floor, etc.) into solids. Objects that are drawn using functions outside the ADT library will be lost. The second program detects clashes between 3D solid components (Figure 6). Inaccurate drawing of building components will produce incorrect results of the construction analysis program. The clash detection program will generate a list of building components that intersect and thus that must be adjusted to prevent this error.

Figure 6 Clash-example

4.2 Planning Generation

After preparation of the CAD model, the generation of the planning is straightforward as described in Section 3. For the case study the equipment and

419

labour database is prepared in XML, listing for each component type the required resources per volume unit. In this test case these data were fixed for each building component. Consequently the system cannot search for construction alternatives. We will come back on this issue in the discussion section. Execution of the Autocad-VBA construction analyses script takes approx. 1 hour for the test case on a standard PC.

4.3 Planning Comparison

For obvious reasons we present here only a small part the whole construction process. A comparison is made between the real planning (Figure 7) and the generated planning (Figure 8) of the concrete construction of the ground floor level.

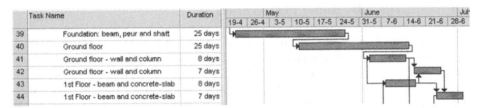

	Task Name	Duration	May						June				Jul
			19-4	26-4	3-5	10-5	17-5	24-5	31-5	7-6	14-6	21-6	28-6
39	Foundation: beam, peur and shaft	25 days											
40	Ground floor	25 days											
41	Ground floor - wall and column	8 days											
42	Ground floor - wall and column	7 days											
43	1st Floor - beam and concrete-slab	8 days											
44	1st Floor - beam and concrete-slab	7 days											

Figure 7 Part of the real planning

First of all we notice that in the generated planning, the construction activities for all individual building components are grouped into bigger tasks. A group is defined as a collection of building components that are constructed subsequently and that share the same resources (equipment and labour). The original, real planning uses a slightly different grouping strategy, based upon experience, to identify the bigger tasks without detailing into subtasks.

	Task Name	Duration	May						June				Jul
			19-4	26-4	3-5	10-5	17-5	24-5	31-5	7-6	14-6	21-6	28-6
1	⊞ Foundation: beam, peur and shaft	4 days											
7	⊞ Ground floor	18,8 days											
53	⊞ Ground floor - wall and column	21,46 days											
149	⊞ 1st Floor -beam and concrete-slab	24,43 days											

Figure 8 Part of the generated planning

There is a striking difference between the generated duration of the foundation task and the really planned duration. This difference can be explained by two factors: (i) in the generated planning all foundation construction activities can be executed concurrently because of unlimited resources, and (ii) the contractor applied a different foundation technique then the one selected from the resources database.

Another interesting result is that in the generated planning, the construction of the walls and columns of the ground floor starts at the same time as the construction of the ground floor slab. The reason is that the floor slabs are supported by the

foundation within the walls and thus a wall component can be put in place before the floor is constructed. Walls and columns construction are completely independent from the floor construction (Figure 9).

Figure 9 Slab position

Finally, we conclude that the construction order is correct. First the foundation is constructed, then the ground floor and the walls and columns. Shortly after the construction of the ground floor walls and columns, the construction of the first floor can start.

5 DISCUSSION

The current system lacks construction knowledge. The construction analysis program will execute a construction activity as soon as this is feasible. There is no knowledge of equipment and labour capacity, equipment and labour availability, costs, material storage capacity and location, temporary constructions, preferences of the contractor, etc. However, we anticipate that much of this additional contractor specific knowledge can be expressed as constraints in XML.

The outcome of the generated planning sometimes raises questions about the traditional construction method, such as the case of the ground floor slab (in the previous section). This result can be a planning flaw because of lack of construction knowledge (e.g. the floor slabs are required for the craftsmen to position the wall and columns) but it can also reveal new options for concurrent building that we have been unaware of (e.g. wall and column positioning by construction cranes or robots).

Most importantly, the proposed system supports the evaluation of alternative construction methods. After a first analysis using the building components layout as designed and default construction capacity values for equipment and labour, the resulting planning schema can be investigated. In the following evaluation runs all variables (building components, equipment, labour) can be varied to study the effect in time, and required resources (equipment, labour). This is represented by the design evaluation loop back cycle in Figure 3. Even one step further this evaluation

process can be extended using optimisation methods from operations research (e.g. linear programming and genetic algorithms). As such the system becomes a construction analysis tool not only for construction planning experts, but for designer also, that want to study the various effects of constructive solutions as part of the design process.

REFERENCES

Bax, M.F.Th. 1976. *Meten met twee maten: Ontwikkeling van een maatstelsel als kader voor een besluitvormingsproces op het gebied van ruimtelijk ordenen* [in Dutch]. Ph.D. thesis, Technische Universiteit Eindhoven.

Clayton, M.J., R.B. Warden, and T.W. Parker. 2002. Virtual construction of architecture using 3D CAD and simulation. *Automation in Construction* 11(2): 227-235.

Dawood, N., E. Sriprasert, Z. Mallasi, and B. Hobbs. 2003. Development of an integrated resource base for 4D/VR construction processes simulation, *Automation in Construction* 12(2): 113-122.

Johnson, S., P. von Buelow, P., and P. Tripeny. 2004. Linking Analysis and Architectural Data: why it's harder than we thought. In *Proceedings ACADIA 2004 conference* [forthcoming].

McKinney, K.,, and M. Fisher. 1998. Generating, evaluating and visualizing construction schedules with CAD tools. *Automation in Construction* 7(6): 433-447.

Misset, 2003. *Bouwkosten* [in Dutch]. Doetichem: Misset.

Vries, de, B., and M. Broekmaat. 2003. Implementation Scenarios for 4D CAD in Practice. In *Proceedings of the 20th International Symposium on Automation and Robotics in Construction*, eds. G. Maas, and F. van Gassel: 393-398. Eindhoven: Technische Universiteit Eindhoven.

A Software Architecture for Self-updating Life-cycle Building Models

BRUNNER Klaus A. and MAHDAVI Ardeshir
Dept. of Building Physics and Building Ecology, Vienna University of Technology, Austria

Keywords: building models, sensors, simulation-based control, life-cycle

Abstract: This paper describes a computational infrastructure for the realization of a self-updating building information model conceived in the design phase and carried over to the operation phase of a building. As such, it illustrates how computational representations of buildings, which typically serve design support, documentation, and communication functions, can be transported into the post-construction phase. Toward this end, we formulate a number of requirements for the conception and maintenance of life-cycle building information models. Moreover, we describe the architecture and the prototypical implementation of such a model.

1 INTRODUCTION

Computational representations of buildings typically serve design support, documentation, and communication functions. A seamless transition from such a representation into the post-construction phase of a building's life-cycle is, however, highly desirable: Such a transition would eliminate – or at least reduce – the redundancy involved in the generation of a high-resolution building model at the outset of the operational phase of a building. However, precise requirements for the conception and maintenance of life-cycle building information models are yet to be formulated. Effective life-cycle models need to be comprehensive, detailed, multi-aspect, and self-updating. They must provide for scalable dispositions to receive and process dynamic (sensor-based) messages regarding changes in buildings' configuration and status. They must also accommodate the informational requirements of operational applications for building control and management (Mahdavi 2004a).

To address these issues, we describe a computational infrastructure for the realization of a self-updating building information model conceived in the design phase and carried over to the operation phase of the building.

B. Martens and A. Brown (eds.), Computer Aided Architectural Design Futures 2005, 423-432.
© 2005 *Springer. Printed in the Netherlands.*

2 PROJECT DESCRIPTION

In the following sections we discuss the main requirements of a building model service and the approaches taken in our prototype's design to meet them.

2.1 Requirements

From the outset, the three main tasks in the operation of a building model service – or any model service, for that matter – can be summarized as follows: 1) data import, 2) model representation and operation, and 3) data retrieval.

2.1.1 Data Import

In the operational phase of the building, its model must be kept up-to-date with current data, preferably collected automatically by sensors placed throughout the building. These may include occupancy sensors, temperature and humidity sensors, inventory tracking sensors, and sensors built into various technical subsystems such as HVAC, shading, and lighting systems to report their current status. The requirements are thus:

Low latency. Sensor readings should be conveyed to the model as quickly as possible. Some control systems (e.g. for lighting) must react within seconds to changes in the building or its environment, requiring an up-to-date model for their control decisions.

Scalability. A large number of sensors – conceivably thousands in a large office building – must be supported.

Adaptability. Sensors use a wide variety of interfaces and protocols to report their readings. It must be possible to convert and import sensor data from these devices with minimal effort.

Low maintenance. Adding or removing sensors should be as simple as possible, with minimal operator effort. This can also be seen as a measure of robustness: a few failing sensors should not disrupt the entire system's operation.

2.1.2 Model Operation

The model service must be able to maintain a consistent state of all available building information and store it efficiently, for access to current and historic data. The main requirements are:

Rich object model. The building object model should be expressive enough to store geometric and semantic information for a wide range of applications.

Concurrency management. The model must be able to maintain a consistent state while allowing, ideally, concurrent read and write access for multiple processes.

Storage management. The service should not just keep current state and allow efficient queries for various attributes, but also store historic model data for later retrieval in an efficient manner.

2.1.3 Data Retrieval

A wide range of client applications may be interested in model data, from end-user visualization to heating control applications. Some need a snapshot of the model in its entirety, others may require selected spatial or temporal portions of the model. The main requirements are thus:

Scalability. Concurrent access by multiple client applications must be possible without disrupting the model service's performance.

Versatility. While some applications may require a simple "snapshot" of the model, others will be interested in specific events (e.g. a sudden drop in temperature, or a change in occupancy of a given space). In some cases, a history of events in a given space can be useful, e.g. to analyze the performance of heating control over the course of a day. The model service must be able to cater for these very different client needs and deliver data in the necessary formats.

2.2 Architecture

In the following subsections we describe the main elements of our prototype's design, based on the tasks outlined in the previous section.

2.2.1 Related Work

Recently, a growing number of publications has been published in research on *sensor networks*. Sensors are envisioned as smart, networked devices embedded into the spaces and objects they are monitoring (Akyildiz 2002). Architectures for transporting sensor readings and querying the sensor network have been proposed (Bonnet, Gehrke, and Seshradi 2001). Sensor networks could serve as a source of building-related data that have been hard to obtain in an automated manner until now.

The work on building product modeling has a relatively long tradition. Specifically, there have been numerous efforts to arrive at systematic and interoperable computational representations for building elements, components, and systems (IAI 2004, ISO 2003, Mahdavi 2004a). However, only recently the concept of real-time sensor-supported self-updating models toward supporting building operation, control, and management activities has emerged (Mahdavi 2004b). In the present contribution, we specifically focus on the integration of sensory networks, building models, and model-based process control applications.

2.2.2 Data Import

To facilitate a simple but powerful communication system between data producers (sensors), the model service, and client applications, a solution based on tuple spaces was chosen. Space-based systems (Carriero, and Gelernter 1989) can accommodate a wide range of interaction patterns in distributed systems, while making the actual details of distribution almost completely transparent.

The JavaSpaces specification (Freeman, Hupfer, and Arnold 1999) describes such a system for the Java programming language. Processes communicate through a simple interface offering two main operations (*write object* and *take object*) on a distributed, logically shared data structure with the characteristics of an associative memory ("bag"). Applications may take objects from the space based on their type and the values of public fields, both synchronously (waiting until an appropriate object appears) and asynchronously (application is notified by means of a call-back mechanism when an object becomes available). As Noble and Zlateva (2001) demonstrate, JavaSpaces are not the fastest way of sending objects between two hosts in a network. The benefits of JavaSpaces lie in their simplicity and the uncoupling of the communicating programs in time and space, taking advantage of which requires a different design approach than other distributed programming methodologies.

One typical application is workload distribution: clients can post work requests into the space, while any number of worker processes can take these requests from the space, process them, and post the results back to the space for clients to take. The remarkable aspects here are the transparency of distribution and the low level of coupling among all the parties: neither clients nor workers need to know anything about each other except the signature of the work request and result objects, and there is no requirement for synchronous operation (as in a normal remote procedure call). Clients may choose to submit a work request, wait for the response, and post the next request; or they may post a batch of work requests at once and come back later to pick up the results. As long as clients and workers are only interested in single objects, concurrency issues are handled transparently by the space.

These characteristics match the requirements for data import very well. Data producers (sensors) can post sensor readings to a space without regard for other data producer and how (or if) the data are actually processed. The space acts as both a buffer and a transport mechanism to one or more data consumers, such as the model service.

At this low level – which deals only with transporting streams of sensor readings, not with semantics and the model context – there is no need to specifically register or de-register new sensors: data producers can appear (start putting objects to the space) and disappear (stop putting objects to the space) any time. Once an object is taken from the space, it is not available to other consumers any more. As there may be multiple unrelated consumers interested in sensor readings, a subscriptions system is used. Groups of equivalent consumers (comprising any number of consumers) can register their interest in sensor readings by writing to a singleton registration object in the space. For each subscribed consumer group, one sensor readings object is written to the space by the data producers (see Figure 1). This evidently means that n copies of each object must be written for n consumer groups,

but saves multiple read and write operations to shared synchronization objects for both senders and receivers as required by other space communication patterns, such as "Channel" (Freeman, Hupfer, and Arnold 1999). The number of consumer groups is assumed to be very small even in large setups; in our prototype, there are only two groups: the model service, and an additional data broker service keeping track of sensor readings mainly for debugging purposes.

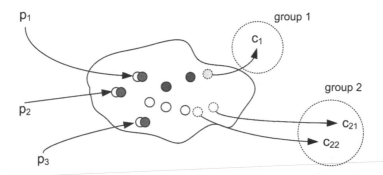

Figure 1 Sensor Data Import. Three consumers in two consumer groups

The space's buffering characteristics implicitly improve the reliability of the system: if one data consumer is offline (e.g. for maintenance, or due to a software crash), data will either be made processed by another consumer from its group if one exists, or it will be buffered transparently for a certain time to be processed as soon as a consumer is online again.

Our current approach to importing data is a *push* model: sensors post information according to their own schedule; data consumers may decide to pick these data up or ignore them. However, the architecture does not preclude a *pull* model, as it is also possible to have sensor adapters listen for requests and post readings in response.

2.2.3 Model Representation and Operation

Model Representation

Our building model is based on the Shared Object Model (SOM), which has been designed to allow the automated derivation of domain-specific models for various applications (Mahdavi, Suter, and Ries 2002; see also Figure 2). In the current implementation, the entire building model's current state is kept in main memory.

A Software Architecture for Self-updating Life-cycle Building Models

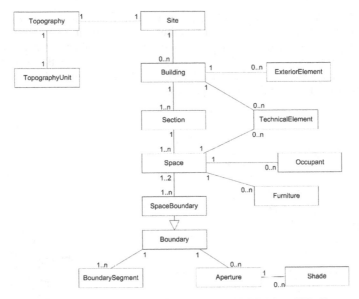

Figure 2 Shared Object Model – SOM (simplified)

Concurrency, Persistent Storage and Retrieval

Each SOM object is tagged with an ID and a ticket obtained from a global, monotonously increasing counter. As soon as an object changes, a new ticket is obtained, and a copy of the object's data is queued for background serialization to the on-disk database. Additionally, a series of updates on more than one object (e.g. when a moving object has to be disassociated from one space and associated to another) can be aggregated into one atomic change operation, in order to prevent inconsistent tree states from becoming visible to other readers. A mapping of tickets to actual time is kept for later queries.

If the state of an object at a given clock time t is requested, first the corresponding ticket value v is retrieved (if there are multiple ticket values for a given time, the highest value will be chosen). The database will then be queried for the object with the given id and the highest ticket value that is less than or equal v. If parent or child objects (e.g. the boundaries of a space) of the retrieved object are requested, the procedure is the same.

This storage and retrieval system is based on the overlapping trees method (Burton et al. 1985) and multi-version database systems. Multi-version databases, as shown by Buckley and Silberschatz (1983), have the potential for drastically reducing concurrency delays caused by locking. The design ensures that a consistent state of the entire object tree can be restored for any given point in transaction time, while keeping storage use low by only storing changed objects.

Sensor Discovery

One of the requirements described under data import is low maintenance. As shown above, new sensors do not have to be registered explicitly to be able to send data. However, the model service must be able to put these new sensor readings in

context: e.g., a source of temperature data must be related to a location to become a meaningful part of the model and to allow queries such as "what is the current temperature in space x?". While it is possible for an operator to enter this relation manually, the model service can also use location information for the given sensor obtained from a location-sensing system (Icoglu et al. 2004). Upon encountering a new source of sensor data, the model service will register its identification and wait until the respective location information for it is received. Once this has occurred, a sensor object is instantiated and linked to the space containing the given coordinates.

2.2.4 Data Retrieval

Simple procedure-call interfaces are not powerful enough to allow for the range of queries that client applications might require. The common alternative approach is to devise a rich query language to express what kind of information is requested from the model. The client thus has to translate its request into the query language, which is in turn parsed by the server and used to select the appropriate objects from the data set and send these to the client. This approach has been used successfully for years in the world of relational databases, namely, as Structured Query Language (SQL). Besides its advantages (e.g. the simple text-based input and output, which eases network transport and integration with all kinds of different client implementations), the intermediate steps of translating query language and converting the server's response to the format required by the client are time-consuming and cumbersome. Additionally, as a pure query language, it does not have the semantic richness of a turing-complete programming language. Complex tasks may have to be performed as a series of queries, increasing the amount of communication necessary between client and server.

In our building model service, we take the alternative approach of allowing clients to submit *agents* to the model service. Agents are submitted as Java objects through the service space and started as separate threads by the model service. They can traverse the model and inspect its objects through a Visitor-style interface. They may also register to be notified of changes in parts of the model: e.g., a lighting control application can submit an agent that monitors a given workplace. It may inspect the relevant SOM objects and derive a suitable representation of the space for a lighting simulation application, whose results in turn will be used by the lighting controller to take the necessary actions. The agent may then register its interest in changes and put its executing thread in "sleep" mode. When as a significant change in the model occurs (e.g. the readings of an illuminance sensor drop sharply, or changes in the workplace geometry are reported by location sensors), the agent is notified by the model service and can now re-inspect the model and inform the control application if necessary. In the terminology of Nwana (1996), our agents are static and not collaborative, although collaboration may be investigated for future applications.

This approach allows complex interactions with the model and reduces network traffic by bringing code and the data it is operating on close together during execution. Developers of client applications can develop their software directly in terms of objects of an expressive model structure, without having to translate into an intermediate language. The service space facilitates loosely coupled communication between system components: tasks that do not involve direct transactions with the

model, or that have to provide a user interface, can still be separated into different processes, possibly on different machines.

2.3 Initial Implementation

Figure 3 shows our experimental implementation. To the left, the *data space* as described earlier is shown. Its main function is to convey sensor information to the model service, but also to send commands to the actuators. In our case, a lighting and shading control system (Luxmate®) is being used to control light fixtures and external shading; indoor sensors for illuminance, temperature, occupancy etc. and outdoor weather station sensors are polled using LabVIEW. Both systems are connected to the data space with specific adapter programs written in Java. All space communication is using standard TCP/IP infrastructure.

To the right, the *service space* mediates requests and responses between the various services and client applications, most prominently the building model service and a lighting controller application. Lumina, an interior lighting simulation application (Pal and Mahdavi 1999) written in C++ and connected to the space through a simple adapter program, is used by the controller to assess the effects of various control actions on the space (e.g. dimming lights, adjusting shades), taking into account the geometry of the space, the states of light fixtures and shades, and exterior lighting conditions. All these data are acquired and converted to Lumina's input format by a software agent submitted to the model service by the controller.

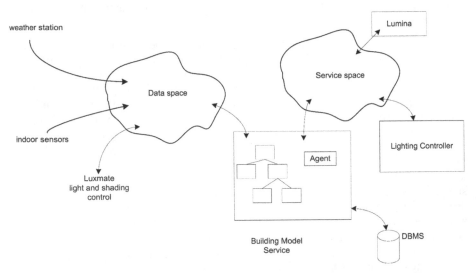

Figure 3 Overview of Experimental Setup. Arrows denote data flow

Our preliminary tests were conducted in an office space containing two desks, four light fixtures and motorized shading for two windows, supplemented with data from an external weather station. A commercial JavaSpaces implementation (GigaSpaces) was used for the data and service spaces. Initial results show that the system is

capable of handling concurrent input from all data sources over the course of months without interruption, storing about 4 Gigabytes of sensor-supplied data. Latency (the interval between the instant of reading a measurement from the sensor by LabVIEW, and the instant it becomes available in the model service) has been consistently less than 0.5 seconds. Model operation and data export have been found to work correctly and reliably.

3 CONCLUSION

We have shown requirements for an architecture for self-updating life-cycle building models and a prototype implementation addressing these requirements. A communication system for sensor readings, actuator commands, and client/server communication based on JavaSpaces has been tested successfully. A model service design based on SOM and software agents was shown to be feasible. We believe that the presented approach would allow for the consideration of complex issues pertaining to the operation and maintenance of sophisticated building service systems already in the design phase of buildings.

There are a number of areas for further research. One of the next tasks will be choosing an appropriate spatial indexing mechanism for large models. Building models contain a large number of mostly static objects that could serve as natural partitioning boundaries for spatial indexing, but also a number of moving objects that tend to move along "paths" that emerge over time. Most spatial indexing schemes, even those optimized towards moving objects, are not suited for this kind of data (Gaede and Günther 1998). Moreover, the current storage and retrieval system's performance should be measured under realistic conditions. The choice of granularity for database storage affects its space- and time-efficiency and should therefore be based on actual usage patterns.

ACKNOWLEDGEMENTS

The research presented in this paper has been supported by a grant from FWF (Austrian Science Foundation), project number P15998-N07.

REFERENCES

Akyildiz, I. F., W. Su, Y. Sankarasubramaniam, and E. Cayirci. 2002. Wireless sensor networks: a survey. *Computer Networks* 38(4): 393–422.

Bonnet, P., J. Gehrke, and P. Seshadri. 2001. Towards sensor database systems. In *MDM '01: Proceedings of the Second International Conference on Mobile Data Management*, Number 1987 in Lecture Notes in Computer Science, 3–14. Berlin: Springer-Verlag.

Buckley, G.N., and A. Silberschatz. 1983. Obtaining progressive protocols for a simple multiversion database model. In *Proceedings of the 9th Int. Conference on Very Large Data Bases*, 74–80. San Francisco: Morgan Kaufmann.

Burton, F.W., J.G. Kollias, D.G. Matsakis, and V.G. Kollias. 1990. Implementation of overlapping B-trees for time and space efficient representation of collections of similar files. *Computer Journal* 33(3): 279–280.

Carriero, N., and D. Gelernter. 1989. Linda in context. *Comm. ACM* 32(4): 444–458.

Freeman, E., S. Hupfer, and K. Arnold. 1999. *Javaspaces Principles, Patterns, and Practice*. Boston: Addision-Wesley.

Gaede, V., and O. Günther. 1998. Multidimensional access methods. *ACM Comput. Surv.* 30(2): 170–231.

International Alliance for Interoperability. 2004. Industry Foundation Classes. Available from http://www.iai-international.org/iai_international/Technical_Documents/iai_documents.html. Internet. Accessed 1 February 2005.

Icoglu, O., K. A. Brunner, A. Mahdavi, and G. Suter. 2004. A distributed location sensing platform for dynamic building models. In *Proceedings of the Second European Symposium on Ambient Intelligence*, Number 3295 in Lecture Notes in Computer Science, 124–135. Berlin: Springer-Verlag.

International Organization for Standardization. 2003. ISO-STEP part standards TC184/SC4.

Mahdavi, A. 2004a. A combined product-process model for building systems control. In *eWork and eBusiness in Architecture, Engineering and Construction: Proceedings of the 5th ECPPM Conference*, 127–134. Leiden: Balkema Publishers.

Mahdavi, A. 2004b. Reflections on computational building models. *Building and Environment* 39(8): 913–925.

Mahdavi, A., G. Suter, and R. Ries. 2002. A representation scheme for integrated building performance analysis. In *Proceedings of the 6th International Conference on Design and Decision Support Systems in Architecture*, ed. H. Timmermans, 301–316. Avegoor: The Netherlands.

Noble, M.S., and S. Zlateva. 2001. Scientific computation with Javaspaces. In *Proceedings of the 9th International Conference on High-Performance Computing and Networking*, 657–666. Berlin: Springer-Verlag.

Nwana, H.S. 1996. Software agents: An overview. *Knowl. Eng. Rev.* 11(3) 1–40.

Pal, V., and A. Mahdavi. 1999. A comprehensive approach to modeling and evaluating the visual environment in buildings. In *Proceedings of Building Simulation 99 – Sixth International IBPSA Conference* [Volume 2], eds. N. Nakahara, H. Yoshida, M. Udagawa, and J. Hensen: 579–586. Kyoto: Japan.

Multidisciplinary Design in Virtual Worlds

ROSENMAN M.A.[1], SMITH G.[1], DING L.[2], MARCHANT D.[3] and MAHER M.L.[1]
[1] *Key Centre of Design Computing, University of Sydney*
[2] *CMIT, Commonwealth Scientific and Industrial Research Organisation, Australia*
[3] *Woods Bagot, Sydney, Australia*

Keywords: collaboration, multiviews, virtual worlds, agents

Abstract: Large design projects, such as those in the AEC domain, involve collaboration among a number of design disciplines, often in separate locations. With the increase in CAD usage in design offices, there has been an increase in the interest in collaboration using the electronic medium, both synchronously and asynchronously. The use of a single shared database representing a single model of a building has been widely put forward but this paper argues that this does not take into account the different representations required by each discipline. This paper puts forward an environment which provides real-time multi-user collaboration in a 3D virtual world for designers in different locations. Agent technology is used to manage the different views, creation and modifications of objects in the 3D virtual world and the necessary relationships with the database(s) belonging to each discipline.

1 INTRODUCTION

Large design projects, such as those in the AEC domain, involve collaboration among a large number of participants from various design disciplines. With the increase in CAD usage in design offices, there has been an increase in the interest in collaboration using the electronic medium (Kvan 1995, Wojtowicz 1995, Maher and Rutherford 1996), together with the advance in electronic representation and standardization of design information. Collaboration among different participants in the design of a building involves both synchronous and asynchronous communication. It involves the ability of the different participants to work on their part of the project using their own particular ways of working yet being able to communicate with the other participants to bring about a common objective, the design of the building. Digital collaboration raises new issues such as keeping track of versions, ownership and ensuring that decisions made are recorded and transmitted to the necessary participants. Shared data models (Yasky 1981, Wong and Sriram 1993, Krishnamurthy and Law, 1997) have been put forward for over twenty years as the answer to many of these problems. Traditionally, the representation of designs has been effected by each discipline producing its own set

B. Martens and A. Brown (eds.), Computer Aided Architectural Design Futures 2005, 433-442.

of drawings i.e. that discipline's representation (or model) of their view of the building. The various sets coexist, may share some commonalities, but are separate representations. The use of a single shared database, as usually proposed, does not take into account these different representations required by each discipline nor does it allow for synchronous real-time multi-user collaboration through electronic collaboration as the amount of information present makes such communication impractical.

This paper presents a collaborative virtual environment for multidisciplinary design based on the need for extending the shared database to take into account the needs of the various views. It focuses on the extensions to a shared model required to address the following issues: different decomposition schema of the model among the collaborators; relationships within and across the different schema; multiple representations and versioning of elements; ownership and access to elements and properties of elements and shared visual representation in a 3D virtual world.

2 COLLABORATIVE VIRTUAL ENVIRONMENTS AND COLLABORATIVE DESIGNING

What is required is an environment that allows real-time multi-user collaboration by designers in different physical locations. This environment must provide 3D visualisation, walkthroughs and rendering to allow communication of the various views of the design as modelled by the different disciplines. This is of special importance at the conceptual stage of the design since much of the early collaborative decision-making is carried out at this stage. A virtual world environment based on an underlying object-oriented representations of the design is put forward here as a necessary environment for synchronous collaboration in the design of buildings. This is in contrast to the decision made by Lee et al. (2003) to use a commercial CAD system or visualisation. One of the main advantages of virtual world environments is that it allows users to be immersed in the environment, allowing for real-time walkthroughs and collaboration (Savioja et al. 2002, Conti et al., 2003). Moreover, CAD models contain a great deal of detail which makes real-time interaction extremely difficult. Agent-based technology will be used to provide the necessary communication between the users, the virtual world views and the object-oriented models.

2.1 Example Problem

This section presents a simple example scenario to illustrate the issues involved in early conceptual design involving architects and structural engineers working both asynchronously and synchronously. The architects create their initial conceptual spatial design (model) of the building (2 storeys, 4 spaces) in own CAD space, Figure 1 a). The architects' model contains a building object as an aggregate of storey objects which are aggregates of space (flats) objects. A bulletin board entry of change to architects' model is made. An email message is sent to all participants as well.

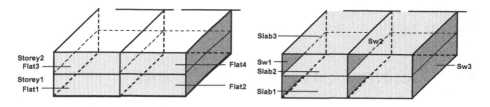

a) Architect's initial design **b) Engineers' initial design**

Figure 1 Initial designs

The engineers view the architects model and, based on their understanding, create their initial conceptual structural system design (model) of the building (3 shear walls and 3 slabs) in own CAD space, Figure 1 b). The engineers' model contains a building object as an aggregation of slabs and shear walls. The engineers add in relationships between their elements and architects' elements, namely that the walls and slabs bound the storeys and flats. A Bulletin board entry of change to engineers' model and relationships is made. An email message is sent to all participants as well.

The architects wish to modify Flats 3 and 4 such that a change in the engineers' Sw2 would occur. This results in a notification of existing relationships between Flats 3 & 4 and walls and slabs in the engineers' model. The architects examine the relationships by viewing the engineers' model and see that they must confer with the engineers. The architects call a meeting with engineers (email message or posting on bulletin board).

A meeting is held in the VW for the discussion of desired changes. The architects' view is presented as a version in the VW and the architects' propose to increase the size of Flat3 and decrease the size of Flat4. The view is switched to the engineers' view in the VW and the ramification of the changes to the structural system are discussed. An agreement is reached to proceed with modification and permission is granted to go ahead with changes.

The architects' version is committed to the 'legal' model, by the agents. A bulletin board notification is made and email messages sent. The engineers make changes to their model (either in the VW or in their CAD system) and update the relationships between their model and the architects model. A bulletin board notification is made and email messages sent.

The above example gives an indication of the objects and relationships required as well as the notifications that would have to be made when working asynchronously. Some relationships may exist either as intra-discipline relationships and/or inter-discipline relationships, whereas others may be just inter-disciplinary. The correspond_to(a, b) relationship, Figure 2 is such an inter-disciplinary relationship. A one-to-many /many-to-one corresponds_to relationship would also be required when the architects may have several wall objects above each other on different floors and the structural engineers would have only one wall object. Little attention has been paid to inter-discipline relationships in modelling. For example, the IFC schema do not have such relationships. Since inter-discipline relationships are an

essential part of multidisciplinary collaboration, and, if IFCs are to be useful in this area, they will require to be extended.

3 MULTIDISCIPLINARY MODELLING

The views and, hence, models of different design disciplines are founded on the functional concerns of those disciplines. In a design context, the view that a person takes depends on the functional concerns of that person. A building may be viewed as a set of activities that take place in it; as a set of spaces; as sculptural form; as an environment modifier or shelter provider; as a set of force resisting elements; as a configuration of physical elements; etc. A building is all of these, and more. A model of an object is a representation of that object resulting from a particular view taken. For each different view of a building there will be a corresponding model. Depending on the view taken, certain objects and their properties become relevant. For the architects, floors, walls, doors and windows, are associated with spatial and environmental functions, whereas structural engineers see the walls and floors as elements capable of bearing loads and resisting forces and moments. Both models must coexist since the two designers will have different uses for their models. According to Bucciarelli (2003) "There is one object of design, but different object worlds." and "No participant has a 'god's eye view' of the design."

A single model approach to representing a design object is insufficient for modelling multiple views to the views taken by the different viewers (Rosenman and Gero 1996). Each viewer may represent an object with different elements and different composition hierarchies. While architects may model walls on different floors as separate elements, the structural engineers may model only a single shear wall. Each discipline model must, however, be consistent vis-a-vis the objects described. While Nederveen (1993), Pierra (1993) and Naja (1999) use the concept of common models to communicate between the discipline models, it is never quite clear who creates the common models and maintains the relationships between them and the discipline models In this project, this consistency will be provided by interrelationships between the various objects in different disciplines modelled by explicit (bidirectional) links from one object to another. Figure 2 shows an example of this approach, with each discipline labeling its objects according to its need. While this approach may have the disadvantage of replicating the same information, it saves the complexities of creating the common concepts and allows each discipline great flexibility in creating its model. The discipline models allow each discipline to work according to its own concepts and representations. The whole model may be seen as the union of the different models.

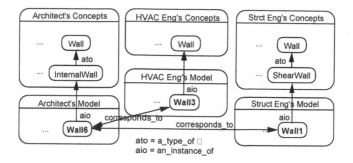

Figure 2 Discipline models and relationships

Two issues of concern, in any collaborative environment, are those of keeping multiple versions of a model and who controls what. In this work, ownership is defined by assigning purpose and functional properties to objects. Thus, an object with both spatial and structural functions, is 'owned' by both the architect and engineer. There is one 'legal' approved version of the total model (i.e. of each discipline), and any modifications to this model require approval by all the 'owners' of the objects which are the subject of modification. Versions are the property of disciplines and thus any 'what if' scenario can be carried out and presented for discussion in the collaborative environment. If approved, the modifications can be committed to the 'legal' version.

4 THE SYSTEM ARCHITECTURE AND PROTOTYPE IMPLEMENTATION

Figure 3 shows the system architecture. The system is comprised of the CAD interfaces, the external and internal databases, the agent society and the virtual world environment.

4.1 The Database and Internal Model

The designers may enter their design through their own CAD systems, thus populating the (external) database with information about the objects and their properties. Notwithstanding the shortcomings of IFC schemas at present, this project uses IFCs as the standard format allowing interoperability between representations. The IFC objects will be stored in an EDM database for persistence. Since the virtual world models do not require all the IFC detailed information, this information is converted into a simpler form and stored in an internal relational database for simple communication with the agent system and the virtual world.

When users request a view in the virtual world, the appropriate agent will query the internal database to extract the necessary objects to display. The one-to-one and one-to-many relationships are stored in the internal model. To date the following

relationships are recognized by the internal model: Aggregates, Composes, CorrespondsTo, Connects, Bounds and Loads.

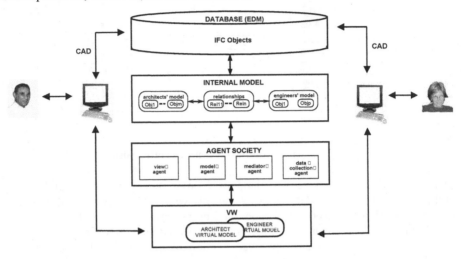

Figure 3 System architecture

Alternatively, the designers may create or modify some objects in the virtual world during a collaborative session. Agents will create the respective objects in the internal database. When committed, the new or modified objects will be translated and transferred to the IFC/EDM database and thus be available to the various CAD systems. Versions of the model reside in the external database. The internal model always holds the current working model.

4.2 The Agent Society

The primary role of the agents is to construct and maintain multiple views of 3D objects instantiated in a virtual world. Agents also provide an interface between the 3D objects from which the 3D virtual worlds are constructed and the database objects that comprise the multiple-views model. Mediator agents associate 3D objects with designers and their 3D world avatars, handle text chat from designers to agents, handle communication between servers and agents, and control the work flow between agents. Data collector agents provide for logging and data collection for later cognitive and data mining analysis or simply as a record of important collaborative sessions.

The internal model shown in Figure 3 contains a set of instances of Component and Association classes, which are instantiated either from a CAD model (via the external database and IFCs) or from the virtual world by an agent. The Component class is specialised by classes Wall, Slab, Beam, Column, Storey and Space. Each Component can also have associations with other Components. The Association class is specialised by classes Corresponds_to, Bounds, Aggregate, and Loads. Components belong to a project, are owned by a citizen (a designer) with a

438

personality (architect, engineer, etc), and are declared to be of one or more functional categories (spatial, structural, aesthetic, etc). Component and Association objects encapsulate tables in a relational database. This relational database both provides persistence for the agents as well as reducing the coupling between the agents and the external database.

The external database contains CAD models from different disciplines and the internal model is populated with Component and Associations accordingly. Maintaining the internal model with respect to changes in the virtual world or changes in the external (EDM) database is the role of the model agent. Views in the virtual world are constructed and reconstructed by view agents through queries on the internal model according to specified personalities, component owners, categories and so on. According to the view required, selected by clicking on a designer view in the web page builder (see section 4.3), the view agent decides which objects are relevant and converts these into AW objects. Because the geometry of the virtual world will be different to that in the external database, view agents maintain a separate set of objects. An opposite process, whereby objects are created in the AW environment, has the agents producing internal model objects which in turn create IFC objects in the EDM database. The Components in the relational database of the internal model can therefore be seen as providing persistence for the agents, reduction of coupling between the agents and the external database, and a simplified intermediate geometry that is accessible from both the external database and the virtual world.

Modifications, such as architects wishing to move a wall, are to be sent via the mediator agent to the model agent who will check whether the modification is permitted. This will be done by checking whether any relationships exist between the object and objects in other disciplines, i.e. whether the object is 'owned' by other disciplines. The model agent may then send back a notification to the mediator agent that this is not permitted and the architects will be notified that they must discuss this with, e.g. the structural engineers. Together with the owner association of a component will be a list of those permitted to make modifications to related objects. Granting permission will mean adding a discipline with the permission to manipulate the objects even though they are owned by another discipline. Alternatively, if no such relationship exists, the model agent will permit the request, update the model accordingly and the view agent will update the view. A discipline may create any number of versions of its own model, since versions are not 'legal' and may make any modifications to its objects within that version model. This version model may be presented in the VW for discussion. If agreement is reached, the version may then be committed as the 'legal' version. Related changes to other discipline models must be made by the discipline concerned.

4.3 The Virtual Collaborative Environment

Figure 4 shows the CRC Collaborative Designer (CCD) in its current form. CCD is a prototype environment that supports collaboration by augmenting the inherently multi user Active Worlds (AW) platform with additional collaboration tools.

Multidisciplinary Design in Virtual Worlds

Designers interact with a virtual world, other designers and agents via the different browser panels. The large 3D panel shows the 3D world, including artefacts being built and the avatars of designers. The panel below the 3D view panel facilitates chat. While streaming audio is also used by CCD, text chat provides persistence and encourages brainstorming-like interaction. The narrow panel at the far left provides for navigation between worlds, teleports, telegrams, contacts, and help pages. The large panel at the far right shows dynamically served web pages that provide more information about the design and runs interactive applications. These applications include a builder (which will be discussed later), a webcam and streaming audio, a distributed sketchpad, and a logging facility for use by cognitive experimenters.

Figure 4 The 3D virtual world collaborative environment

We are using the Active Worlds (AW) platform as a basis for development. This is because the AW server provides a platform for distributed collaboration upon which we can build, and because the virtual world is constructed at runtime from within the world. We enhance the collaborative experience by driving the web panel from the server side off an Apache Tomcat HTTP server. This serves Java Server Pages and Java Servlets from designer actions on the web panel. One reason for choosing Tomcat as the HTTP server is because the agents are implemented in Java, and so agents communicate with the HTTP server using Java Remote Method Invocation. The agents also use a Java Native Interface to the AW software development kit,

enabling agents both to sense the world and to effect changes to it.

Two designers are shown, both as webcam views and as their avatars in the 3D world. The line of buttons at the top of the web panel shows the main applications The Figure shows 'All views'. If 'Architect' was selected; then the view shown would be rebuilt by an agent such that only objects declared to be of interest to architects would be shown.

To create objects in the world, the 'BUILDER' button is selected. A 'list box' appears. This listbox is used to select the personalities of interest and insert objects accordingly. For example a column may be selected from the 'Engineers palette'. Both the list of objects and the palettes are queried from the internal model. To add new objects to the world, the designer moves to a desired location and clicks on the 'INSERT' button. This results in a message being sent to the agents, and a new object being inserted in the world.

5 CONCLUSION

This paper has presented a framework for multidisciplinary collaborative design. It has discussed the need for modelling all the views of the various disciplines and the need for specifying the relationships between the various models. Collaboration takes place in a virtual world environment because of the multi-user and immersive properties of such environments. The paper presented a framework for collaborating in a virtual environment including a database, based on IFCs, containing the various models and relationships between them; a virtual world environment for collaboration and an agent-based society for handling the communication between the users, the virtual world and the database. An internal database simplifies the work of the agents and also decouples the agents from existing (IFC/EDM) technology. If the representation method for representing objects in CAD systems were to change, the agent system would not need to.

The paper has highlighted the need for extending the IFCs to include interdisciplinary relationships as well as extending the scope of IFC objects. Future work includes finalising the mapping from IFC objects to the internal database, including the notification messaging and testing the system more fully.

ACKNOWLEDGEMENTS

The research described was carried out by the Australian Cooperative Research Centre for Construction Innovation. This work is part of the Team Collaboration in High Bandwidth Virtual Environment project.

REFERENCES

Bucciarelli, L.L. 2003. Designing and learning: a disjunction in contexts. *Design Studies* 24(3): 295-311.

Conti, G., G. Ucelli, and R. de Amicis. 2003. JCAD-VR – A multi-user virtual reality design system for conceptual design, in TOPICS. *Reports of the INI-GraphicsNet* 15: 7-9.

Krishnamurthy, K., and K.H. Law. 1997. A data management model for collaborative design in a CAD environment. *Engineering with Computers* 13(2): 65-86.

Kvan, T. 1995. Fruitful exchanges: professional implications for computer-mediated design. In *The Global Design Studio*, eds. M. Tan, and R. The: 24-26. Singapore: University of Singapore.

Lee, K., S. Chin, and J. Kim. 2003. A core system for design information management using Industry Foundation Classes, *Computer-Aided Civil and Infrastructure Engineering*, 18: 286-298.

Maher, M. L., and J. Rutherford. 1996. A model for collaborative design using CAD and database management. *Research in Engineering Design*: 9(2): 85-98.

Naja, H. 1999. Multiview databases for building modelling. *Automation in Construction*, 8: 567-579.

Nederveen, S.V. 1993. View integration in building design. In *Management of Information Technology for Construction*. eds. K.S. Mathur, M.P. Betts, and K.W. Tham: 209-221. Singapore: World Scientific.

Pierra, G. 1993. A multiple perspective object oriented model for engineering design. In *New Advances in Computer Aided Design & Computer Graphics*. ed. X. Zhang: 368-373. Beijing: International Academic Publishers.

Rosenman, M.A., and J.S. Gero. 1996. Modelling multiple views of design objects in a collaborative CAD environment. *CAD Special Issue on AI in Design* 28(3): 207-216.

Savioja, L., M. Mantere, I. Olli, S. Ayravainen, M. Grohn, and J. Iso-Aho. 2003. Utilizing virtual environments in construction projects. *ITCon* 8: 85-99.

Wojtowicz, J. (ed.). 1995. *Virtual Design Studio*. Hong Kong: Hong Kong University Press.

Wong, A., and Sriram, D. 1993. SHARED An information model for cooperative product development. *Research in Engineering Design* 5: 21-39.

Yasky, Y. 1981. *A consistent database for an integrated CAAD system: fundamentals for an automated design assistant*. PhD Thesis, Carnegie-Mellon University.

Linking Education, Research and Practice

A Multi-Disciplinary Design Studio using a Shared IFC Building Model

PLUME Jim and MITCHELL John
Faculty of the Built Environment, University of New South Wales, Australia

Keywords: collaborative design, industry foundation classes, shared building model, building information modelling, design studio

Abstract: This paper reports on a multi-disciplinary building design studio where a shared IFC (Industry Foundation Classes) building model was employed to support a collaborative design process in a studio-teaching environment. This project began with the premise that the efforts over the past decade of the International Alliance for Interoperability (IAI) to develop a genuinely operational building model schema has resulted in a mature technology that is now ready to be applied. This design studio experience sought to test that premise. The paper discusses the background to the idea of design collaboration based on a shared building model, placing this current work within that context. We look at both the nature of design decision-making, as well as the process opportunities afforded by close multi-disciplinary collaboration and rapid feedback from design analysis. Although the work was undertaken in a teaching context, the paper does not discuss the pedagogical issue, but rather concentrates on the operational issues that are encountered when working with a shared building model during a design process. The paper concludes with a statement of the lessons learnt and strategies to be adopted in future projects of this nature.

1 INTRODUCTION

During the past decade, the International Alliance for Interoperability (IAI) has undertaken a worldwide effort to develop a model schema that is able to support a semantically rich representation of a building for use during the life-cycle design and management of a project (IAI 2004). The model schema is defined in the EXPRESS language in accordance with ISO STEP (Standard for the Exchange of Product Data) and has become known as IFC (standing for "Industry Foundation Classes"). In effect, the IFC schema defines a standardised file format that can be used as a mechanism for sharing building information between CAD (computer aided design) systems and an ever-expanding range of design analysis tools. Furthermore, the IFC model schema can be loaded into a STEP model server, providing the opportunity to hold the building model as an object database on a central shared computer and accessible across the Internet as a resource to support collaborative design.

B. Martens and A. Brown (eds.), Computer Aided Architectural Design Futures 2005, 445-454.
© 2005 *Springer. Printed in the Netherlands.*

A Multi-Disciplinary Design Studio using a Shared IFC Building Model

This paper reports on a project in which a shared IFC building model was used as the basis of a multi-disciplinary design studio taught at the University of New South Wales (UNSW), Australia, during the second half of 2004. Our decision to undertake this project was motivated by a recognition that IFC development had reached an important milestone, and it was time to introduce its use into a learning context and begin testing its efficacy as a design support technology. The class was run as a conventional architectural design studio over a 14-week semester (equivalent to 25% of a student's course load) and brought together 23 senior students from a variety of disciplines including architecture, interior architecture, landscape architecture, mechanical and services engineering, statutory planning, environmental sustainability, construction management and design computing.

The aim of this work was to review the efficacy of existing building modelling technology when used in a multi-disciplinary design context. It had three objectives: to examine the impact of using a shared building model in a collaborative design setting; to develop an understanding of the type of information required in a building model in order to support effective design collaboration; and to critique the current IFC standard (Release 2x2), and some of the major applications that support IFC technology. This paper focuses on the last two of those objectives, reporting primarily on the operational issues surrounding the use of a shared building model in a multi-disciplinary design context. Our interest is to consider the scope of the IFC model and to report on our experiences when an attempt was made to use the model to support a design process.

The paper begins with a review of the research context, specifically identifying recent efforts to develop or propose the use of shared building models to support collaborative architectural design processes. It then provides a brief outline of the project sufficient to explain the context of this research. The body of the paper identifies the key issues that emerged from this experience with respect to the nature of the information that can or should be held in a shared building model in order to support effective collaboration within a multi-disciplinary team. The paper concludes with a series of recommendations for further work.

2 RESEARCH CONTEXT

The notion that building design is a multi-disciplinary process involving contributions from an increasingly broad team of specialists is well understood and generally accepted. Thomas Kvan, in a thoughtful discussion of design collaboration, concludes that building design is correctly described as a co-operative process with brief episodes of collaboration where team members come together to resolve issues through negotiation and evaluation (Kvan 2000). He then goes further to argue that it inevitably involves compromise, being very careful to position that as a positive thing since it can often lead to design innovation. In a complementary work, surveying a broad range of research into the nature of design collaboration, Nancy Cheng concludes that "better interfaces for communicating design information and standardized file information and procedures could streamline team

interaction (…) they must integrate visualization with building performance and provide useful functionality throughout the building life cycle" (Cheng 2003). It is the contention of this present work that shared building models provide exactly that, and when combined with appropriate work processes, can lead to effective teamwork and significant improvements in the life-cycle management of facilities.

We can trace the history of building modelling back to the earliest days of CAD development, but it has been during the past decade that significant work has been undertaken to understand how such systems can be effectively used to support building design. Three key examples will serve to illustrate those developments, each providing particular insights into issues of design collaboration. Eastman and Jeng are well known for their EDM-2 project, where the central focus was to address the issue of maintaining multiple disciplinary views of a core building model to allow simultaneous access while still maintaining the integrity of the data (Eastman and Jeng 1999). As we will see later in this paper, this was a key issue for us in our project, and raises one of the most critical issues for the on-going development of shared building model technologies. At about the same time, Yehuda Kalay's P3 project was built around a clearly articulated understanding of design collaboration. He pointed to the fragmented nature of the building industry where each specialist has their own view and set of objectives, arguing that design collaboration works best where those same specialists adopt what he called a "super-paradigm", agreeing to a course of action to achieve a common goal for the whole project, rather than narrowly considering their own objectives in isolation (Kalay 1998). The third example is the ID'EST project reported by (Kim, Liebich and Maver 1997). This project demonstrated that a CAD model could be mapped on to a product database implemented using STEP technology so that the data could be analysed by a variety of evaluation tools as a way of testing its design performance. Although that work has been subsequently overtaken by the development of IFC technology, its remains as a significant example of this approach.

Since that pioneering work of the mid-nineties, we have seen the steady emergence of IFC technology, fostered by an international team of researchers determined to promote a building model approach to facility procurement. Perhaps the most significant demonstration of the efficacy of that technology is given in (Fischer and Kam 2002), a report on the HUT-600 auditorium extension project at Helsinki University of Technology, where IFC technology was used to facilitate data exchange among the major design partners in the project. The benefits observed in this project were summed up in these words, "compared to a conventional approach, these relatively seamless data exchange and technology tools substantially expedited design and improved the quality of interdisciplinary collaboration" (Fischer and Kam 2002, 4). Our approach, working with a small multi-disciplinary team of students, seeks to complement such industry-based studies by focusing on specific operational issues.

We are not aware of any other work that has tested the IFC model in the way that we have attempted, but there are several critiques in the literature of the building modelling approach to support collaboration. These are all useful as they highlight specific issues that need to be considered and addressed. Per Galle's list of 10

desirable features of what he terms CMB (Computer Modelling of Buildings) serves as a very valuable starting point in this discussion (Galle 1995). More recently, (Halfawy and Froese 2002) recommend several specific directions for the IFC development, specifically proposing a strategy to incorporate more "intelligence" into the model. Pham and Dawson, though strongly supportive of building modelling as a design technology, point to the complexity of information transfer that occurs in a typical building project and the need to rigorously understand exactly how that information can be captured effectively (Pham and Dawson 2003). Finally, several authors have recognised the importance of managing the decision-making process when diverse experts have conflicting proposals, each suggesting a computer-based tool to support that process (Kam and Fischer 2004, Kalay 1998, Lee and Gilleard 2002).

3 PROJECT OUTLINE

The design task revolved around a 6 level development with about 38 self-care retirement units and a community hall, located on a busy road in an established part of the city. Due to the time limitations, it was considered impractical to begin with a green field and a brief, so the students began with a preliminary design of the building complex (in the form of an ArchiCAD model) that had already received local government development approval. The professional architect who had core responsibility for the design of the building was involved in the Studio, providing a wealth of detailed knowledge about the site and the planning context of this project. Each student adopted a specific role (with a corresponding area of design focus) to be enacted during the studio. These design foci included things like: statutory planning, site management, thermal design, services engineering, acoustic design, lighting, internal fit out, model management, site access, design for disabled access, code checking, life cycle sustainability, etc.

During the initial phase of the project, the students were required to use their expertise and the tools available to critique the proposed building in terms of their specific area of focus, prepare a design audit report, and then add relevant design information to the shared model. This established what we termed the "reference model", providing a semantically rich representation of the design proposal. The students were then formed into three multi-disciplinary teams and charged with the task of identifying a team design goal, generally centred around a particular part of the project (for example, the community hall, a north-facing apartment, etc). Each team member then had to undertake a design analysis of that part of the proposed building and develop one or more design proposals to be brought back and negotiated with the other team members in order to arrive at an agreed set of design propositions, taking account of the conflicting demands of their individual concerns. These design propositions were then presented in a public forum for the purpose of course assessment. Figure 1 below illustrates all this with one the team's group process model, showing the disciplinary roles represented in that team and the design process envisaged by that team.

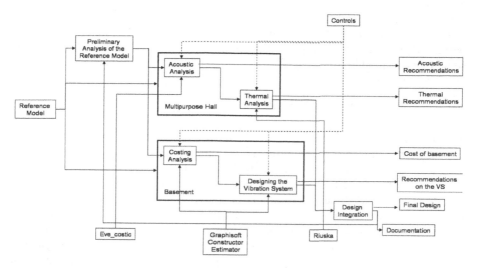

Figure 1 Typical process model developed by a student design team

On a technical level, the studio was supported by an IFC Model Server (provided by EPM Technology). The primary model-editing tool was ArchiCAD. We used a range of IFC viewers in the initial phases to allow the students to visualise the building model, and introduced the Solibri Model Checker (SMC) as a generic tool for doing initial design audits. We negotiated access to a range of design analysis tools covering areas like cost estimation, thermal analysis and services engineering, code checking, life cycle embodied energy calculations, disabled access analysis, lighting and acoustic analysis, and structural analysis (though we have no structural students). A complete list of software contributors is given in the acknowledgements at the end of the paper. Since access was via the Internet, the students had the freedom of working in the studio labs, or from networked laptops within the faculty precinct, or from their homes via standard dial-up or broadband connections.

4 OPERATIONAL ISSUES

While a substantial proportion of architects are apparently now using object model CAD (Geopraxis 2004), the focus of their output is still drawings. Their models are built and optimised for that primary purpose, and are "shared" by traditional 2D layered drawings, while in our multi-disciplinary studio we were sharing the model itself. Therefore, the building model needed to be constructed with collaborative interchange in mind, but more significantly, it was necessary to anticipate the needs of design collaborators. Since our starting point was an ArchiCAD model developed for initial local government development approval, it needed a substantial amount of editing to make it suitable for sharing in a collaborative environment. This process, combined with the need for the students to learn the various applications and become familiar with the concepts of object modelling, took up far more of the

studio time than we might have wished. However, in the midst of those delays, there were many things to be learnt about the use of this type of technology to support design collaboration. The purpose of this section is to report those findings. We do so under two broad headings.

4.1 Building Model Issues

The first major issue was the concept of space or "room" definition. The importance of space data cannot be under-estimated as almost every collaborating application depended on the definition of spaces to identify the functional occupancy of the building. Of the applications used in our studio, only life cycle sustainability ignored the direct use of room data. As our source model had none of this defined, it was necessary to set up an additional studio task to enter this data into a revised model. The reference adopted for space definitions was the Singapore Code checking guidelines (as one of our students was using the online ePlan service in Singapore). This required specific room names, and usage coding, not at all satisfactory for concise construction documentation, but comprehensive and well suited to our Studio needs.

A second major issue was the robustness of the geometric model. It lacked a correct designation of storeys (peculiarly, this was missing in the source model even though it was a multi-storey building), a reference survey datum, correct geographical location, and appropriately accurate building elements. Although the model was generally accurate, several wall junctions were out of alignment: there was some debate about how critical that would be, but the more pedantic of us felt compelled to correct them. This raises a general issue with building modelling and the amount of detail that needs to be accurately represented, balanced against the cost of creating that detail.

A third issue was the consistent usage of building model entities: this relates to the semantic integrity of the model. This is a potentially more complex issue as each application has its own unique mapping to the IFC model entities and in this case, where the architect had never intended to use it for IFC based sharing, many problems arose. For example, the ease of use of ArchiCAD's slab tool meant that ifcSlab entities turned up as kitchen furniture.

A fourth, and probably the most important aspect, was the need for building elements to include property data to support specific analysis by the collaborating applications. A basic requirement was that all building elements should have a material specification to allow thermal, acoustic, sustainability or cost performance calculations. This is handled adequately by the standard IFC model, but more specialised data is generally handled in the IFC definitions through property sets (PSETs). An initial surprise was that the Solibri Model Checker (SMC), which is very good at checking for model consistency and spatial clash detection, could not detect PSET data. As the students were using SMC to assess how complete the model was to support their analytical role, this was a significant set back, and they were obliged to import the IFC model into ArchiCAD to check for such data.

An issue arose with some of the applications that required wall objects to have very specific properties assigned to them in order to carry out the analysis. As the source model was very schematic, the students had to go through and carefully define the layered construction of each wall (which were quite complex for some party walls with both fire and acoustic isolation requirements), expecting that would be enough to allow design analysis. However, two exceptions emerged: the cost estimating application required that each element be assigned a "type" (selected for convenience from the Finnish TALO standard); while for the life-cycle sustainability analysis, each element had to be classified with the application's own classification schema. Contrary to our expectations, those applications were unable to derive that data from the wall construction data in the model, so a level of human judgement and additional entry of property data was needed to support those applications.

4.2 IFC Technology Issues

The most basic issue here was the inconsistency among applications in their support for the current version of IFC: several tools were based on IFC 2.00, two on IFC 2x and the remainder on IFC 2x2. The student version of ArchiCAD had limitations in the export of IFC data, and although since resolved, caused a lot of conversion issues that would have been a major impediment in a real project.

Of greater significance, however, were the mechanisms available for sharing the data using the IFC model server. As a matter of expediency, we decided that our first repository should be the source model divided into sub-models by level. This facilitated the division of the data into more manageable analytical tasks as we were starting to appreciate that it was too large to handle as a complete model (the complete IFC model was 12 Mb, an impediment for students working from home on a dial-up connection, but also surprisingly slow to load in some applications). Breaking it up into separate sub-models also meant that we could update the model concurrently, at least by level, using the small student teams.

The communication with the IFC server was handled by a beta version IFC add-on for ArchiCAD that, in its initial functionality, only permitted the upload and download of complete models. As the Studio developed, a new version was provided to us with increased functionality, providing direct upload and download from the remote repository to ArchiCAD as before, plus new functions to copy both ways between the remote and local repositories. (The local repository is a holding place for each user to manage the native IFC data retrieved from the server.) A major limitation of this interface was that it could not select sub-sets of the data on the fly: although this is a fundamental feature of the server technology, it was not yet implemented in the beta ArchiCAD add-on available to us.

Although the available server technology did not fulfil our expectations, it is that operational concept that offers the greatest promise as well as the most significant development challenges for the future. In such an environment, new data management tasks became paramount: specifically, the need for model access protocols and the versioning of data. This model management requirement is

necessary to ensure models are built according to appropriate model building standards, and to define access and editing rights for users to ensure consistency of data. In our Studio, both of these tasks were beyond the capacity of software functionality available to us and beyond our ability, acting as de-facto model managers. This is the area that offers the most exciting challenges for our ongoing efforts.

5 CONCLUSION AND FUTURE WORK

This paper has reported our experience in running a multi-disciplinary design studio using a shared building model hosted on an IFC server. After putting this work into a research context, we have focused this paper on the operational issues that arose in the studio. To conclude this paper, we wish to identify a few key issues that need to be addressed in the short to long-term future, and to speak briefly of our plans for future developments of this project.

The first key issue is the importance of creating a building model that is suitable to support collaborative design. This may seem fairly obvious, but it was surprising to us just how much the existing model had to be re-oriented towards the applications used in the disciplinary analyses. There is a clear need here to systematically define our understanding of what should be modelled, and to develop good practice guidelines for the use of the various object CAD systems that might be used as model editors. This will be an ongoing task as we see the gradual take up of this technology.

The issue of model management becomes a very vexed one. Almost every writer in the field has drawn attention to this problem, but few, with the possible exception of (Eastman and Jeng 1999), have come up with sound strategies to balance the need for concurrent access with maintaining the semantic integrity of the model. It is instructive to note that Per Galle, writing in 1995, saw this as a major dilemma, to the extent of highlighting the fact that Paul Richens had argued this same need more than a decade earlier, exactly 22 years prior to this present conference (Galle 1995, 203). A very simple example here can be used to highlight the extent of this problem: one application may be used to calculate thermal transmittance based on wall construction properties; the value is uploaded to the model, but then the architect changes the wall construction so that calculated value no longer applies. Clearly, a very clever mechanism is required to track the interdependence of object data. However, just as current work practice manages these processes with adequate rigour, it is not at all clear how intelligent and at what granularity we need to make these model-updating mechanisms. For our part, we will be working further to test this in practice and devise model management processes to handle such contingencies.

Another issue that surfaces in this kind of discussion, and will be a focus of our future projects, is the notion of attaching "intentions" to elements in the project model. In a co-operative design environment, there is a need to find a way to convey the intent behind the decisions that have been taken. This has been addressed by

several authors (Kalay 1998, Maher, Liew and Gero 2003, Lee and Gilleard 2002) and is linked to the need for rigorous tools to support collaborative decision-making.

Our plan is to continue running this studio course at least once each year, gradually refining our processes and testing new technologies and solutions as they become available. It is expected that the feedback generated by this work will continue to inform the on-going development of the IFC model and the growing range of IFC compliant tools. As an extension of this work, we plan to initiate some industry workshops where a multi-disciplinary team of mid-career professionals are brought together over a 5-day period to tackle a focussed design problem using a shared building model in much the same way as this studio. It is anticipated that experienced professionals will have some very useful insights to share, and so this will become an effective way to complement "real-world" case studies such as the HUT-600 project (Fischer and Kam 2002). We are planning the first of those workshops in the first half of 2005, so there may be some interesting things to report at the conference.

ACKNOWLEDGEMENTS

The studio course was funded as part of the Architecture Program at the University of New South Wales. This work was also supported by a grant from the International Alliance for Interoperability – Australasian Chapter (IAI-AC) under the auspices of the CWIC (Collaborative Working in Construction) project. We particularly thank the software vendors who made the whole project possible by donating their products, providing frequent user support and updating us with software improvements during the project: CRC for Innovation/CSIRO – LCA Design & Accessibility Code Checker, *Australia*; CSTB – EVE Acoustic Design, *France*; Data Design Systems – Building Services Partner & IFC Viewer, *Norway*; EPM Technology AS – EDM Database, *Norway*; Graphisoft R&D – ArchiCAD & GS Constructor/Estimator, *Hungary*; TNO – IFC Viewer, *The Netherlands*; Karlsruhe Forschnung Centrum – IFC Viewer, *Germany*; Building Construction Authority and NovaCityNets – ePlan Check, *Singapore*; Olof Granlund – Riuska Thermal Analysis, *Finland*; and Solibri – Model Checker, *Finland*.

REFERENCES

Cheng, Nancy Yen-wen. 2003. Approaches to design collaboration research. *Automation in Construction.* 12(6): 715-723.

Eastman, Charles, and Tay Sheng Jeng. 1999. A database supporting evolutionary product model development for design, *Automation in Construction*, 8(3): 305-323.

Fischer, Martin, and Calvin Kam. 2002. *CIFE Technical Report Number 143: PM4D Final Report*. Stanford: CIFE, Stanford University.

Galle, Per. 1995. Towards integrated, 'intelligent', and compliant computer modeling of buildings. *Automation in Construction* 4(3): 189–211.

GeoPraxis. 2004. *AEC Design Practice Study 2004 - Final Report*, Petaluma, CA: GeoPraxis. Internet. Available from http://www.geopraxis.com/; accessed 30 November 2004.

Halfawy, Mahmoud R. and Thomas Froese. 2002. Modeling and Implementation of Smart AEC Objects: An IFC Perspective. In *Proceedings of the CIB w78 conference: distributing knowledge in building*. Aarhus School of Architecture, 12–14 June 2002. Internet. Available from http://www.cib-w78-2002.dk/papers/papers.htm; accessed 1 February 2005.

IAI – International Alliance for Interoperability. 2004. *IAI International Home Page*. Available from http://www.iai-international.org/iai_international/; accessed 28 November 2004.

Kalay, Yehuda E. 1998. P3: Computational environment to support design collaboration. *Automation in Construction* 8(1): 37-48.

Kam, Calvin and Martin Fischer. 2004. Capitalizing on early project decision-making opportunities to improve facility design, construction, and life-cycle performance--POP, PM4D, and decision dashboard approaches. *Automation in Construction* 13(1): 53-65.

Kim, Inhan, Thomas Liebich, and Tom Maver. 1997. Managing design data in an integrated CAAD environment: a product model approach. *Automation in Construction* 7(1): 35–53.

Kvan, Thomas. 2000. Collaborative design: what is it? *Automation in Construction* 9(4): 409-415.

Lee, Yan-Chuen, and J.D. Gilleard. 2002. Collaborative design: a process model for refurbishment. *Automation in Construction* 11(5): 535-544.

Maher, Mary Lou, Pak-San Liew, and John S. Gero. 2003. An agent approach to data sharing in virtual worlds and CAD. In *Proceedings of the 20th CIB W78 Conference on Information Technology in Construction*. Waiheke Island, Auckland, New Zealand, 23-25 April 2003. Internet. Available from https://www.cs.auckland.ac.nz/w78/; accessed 1 January 2005.

Pham, Nghia, and Anthony Dawson. 2003. Data rich digital architectural environments: Managing rich information flows in architectural practices of Australia. In *Proceedings of the 20th CIB W78 Conference on Information Technology in Construction*. Waiheke Island, Auckland, New Zealand, 23-25 April 2003. Internet. Available from https://www.cs.auckland.ac.nz/w78/; accessed 1 January 2005.

Case Studies of Web-Based Collaborative Design
Empirical Evidence for Design Process

LAEPPLE Eberhard, CLAYTON Mark and JOHNSON Robert
CRS Center, College of Architecture, Texas A&M University, USA

Keywords: collaboration, communications, design management, design process, software

Abstract: Data collected from real-world projects using Web-based communications and project management systems provide quantitative evidence for characterizing the design process. Tens of thousands of records have been analyzed from six cases. The cases are all high-end office and retail building projects, with about 50 members of the design team. The data supports the distinction of multiple stages in the design process as the patterns of usage of the software changes through time. Coordination activities are more frequent in early stages, while collaboration activities are more common in late stages. In planning and design stages, use of the software is focused upon accessing static information, while in construction documentation a relatively greater number of activities include generate and process operations.

1 INTRODUCTION

Web-Based Communication Systems (WBCS) are increasingly used in the architecture, engineering and construction industry. Nonetheless, we do not know how effective they are in supporting successful collaboration and coordination (Alshawi and Ingirige 2003). It is increasingly important to understand the information and communication requirements in the AEC industry to operate successfully (Augenbroe and Eastman 1999). To obtain more confidence in such software, we need to know how they are used in daily operations by architects, engineers, consultants and building owners.

This paper describes an investigation of the communication among members of interdisciplinary teams during the planning and design phases of development and construction projects using WBCS. A typical WBCS provides multiple functions (or channels) for data storage, inspection, and communication, such as posting, accessing posted material, chat communications, email, and broadcast messages. The importance of different channels is based on different capabilities of media richness similar software differentiations are discussed by Jabi (2003). The research examines the frequency of communication among the participants and the change of information patterns over time during the design and planning process. Data has been captured automatically during the use of the WBCS in the form of transaction

B. Martens and A. Brown (eds.), Computer Aided Architectural Design Futures 2005, 455-464.
© 2005 *Springer. Printed in the Netherlands.*

logs, messages and documents. The data has been coded for form and content, documenting quantitatively when, what and which type of information is communicated from whom to whom during a building project. The analysis reveals the balance between coordination information and collaboration related information, a distinction suggested by other researchers (Jeng 2001).

The hypotheses tested are: which type of information is transferred during the project stages; how do participants use WBCS in industry; and which functions are used the most and should be provided or are not used at all.

2 DATA COLLECTION

Three major architecture firms, listed among the top AE firms in Engineering News-Record, provided their WBCS communication repositories from the planning, design and construction documentation stages of building projects for six case projects. Each case consists of up to 20,000 recorded messages or transactions. Each project team has about 50 interdisciplinary members, who perform different roles in the project, such as client, architect, contractor, engineer and consultant. All messages, transactions, and documents that have been posted, submitted or reviewed have been loaded into databases. These databases are then joined into one, by linking the corresponding field names of each project database.

2.1 Software Description

The data has been generated by using mainly two WBCS that are typical of those on the market. Both systems' common functions are file repository, calendar, team directory, and project message board. Members log on and are authenticated, and then the system records each action. Participants have an assigned access level with specified privileges such as administer, change, write, edit or view. The privileges are defined on a function, folder, or file level. However, none of the firms had limited its member's privileges, with the exception of the project client's access rights in Cases 1 and 2. The first system is a proprietary system, developed by an architecture/ engineering firm and used in-house as well as sold to outside clients. It had as an additional function: a threaded discussion board and a link list to outside information. The second system is a commercially available software package and also provided Request for Information (RFI) and Submittal functions of all digital documents. It also had a built in email function, but nobody used this email.

2.2 Case Description

Data was collected for six cases. All cases have in common that they deal with high-end office or retail spaces and that the construction costs are above 10 million US dollars. The complexity of the projects required communication among large teams of participants over a duration of several months. All teams were geographically

distributed. For this paper we limit the discussion based on data including all written or electronically exchanged documentation for each project, such as meeting notes and documents. The information from personal and back-channel and informal communication is being investigated but is beyond the scope of this paper.

Cases 1 and 2 cover the pre-planning phase until the execution phase for office buildings for telecommunication firms. The duration of observation is 50 weeks for each of these cases. Both involved in-depth considerations regarding future operations and flexibility of use. Case 3 covers the planning and design stage for a series of retail and commercial office buildings in a metropolitan setting, which has been investigated for 75 weeks. Case 4 is the design and documentation phases of a corporate headquarter for an insurance company, lasting 38 weeks. Case 5 covers 12 weeks of the design documentation phase for a mixed use high-rise building that includes retail floors and office spaces. Case 6 documents 50 weeks of communication from the design development until construction administration phases of an urban retail building.

One limitation of this research is that not all emails that have been exchanged were available, due to the fact that all members used their corporate Exchange Server, which was not integrated with the WBCS functions. Since verbal communication and face-to-face could not been captured over a long period, written meeting agendas and meeting notes were provided by the firms. In further research that is not yet complete, we will account for the verbal and undocumented exchanges by conducting interviews with key participants.

3 CONTENT ANALYSIS CODING SCHEMAS

We have used content analysis techniques to assign distinct categories to data and complement inferences derived from quantitative observations. The data from the cases has been coded in accordance with the four variables of communication according to Shannon and Weaver (1998): sender, channel, content, and receiver.

The participants have been coded to provide anonymity and to distinguish normalized roles. These roles include six hierarchical levels of personnel per firm corresponding to executive, director, lead engineer or project architect, specialist or architect, and administrative staff. The mapping between person and title to the role has been based primarily through personal discussion with the firms or teams.

Although the software does much of the coding of the transactions automatically, inspection by the researchers is still necessary. The software records the sender, the intended receiver, the channel and the time. The message itself reveals three dimensions of content: data behaviour, coordination/ collaboration tasks and design activity. Data behaviour distinguishes actions of generating, accessing/ reading and then processing information (Baya and Leifer 1996). The discussion of collaboration and coordination is essential to discuss CSCW, because different activities require different tools and means (Kvan 1997, 2000). The coordination dimension is derived from Coordination Theory (Malone and Crowston 1994). Huang (1999) previously

applied this theory to design studies. Messages are coded as either supporting coordination to enable team members to share decisions and manage the workflow or supporting collaboration to produce decisions and solve problems. Coding for design activity uses the categories analysis, synthesis and evaluation to produce a representation of how designers work and think (Purcell et al. 1996). Because the design activity coding is in progress, a report on the results will be presented in a future paper.

The categories are assigned by using data mining/ content analysis software that is trained to find keywords in context; manual coding supplements the automated coding for complex or extended documents and messages. According to best practice for research, samples of computer and manual coding are independently coded by human coders, to check for reliability of coding (Neuendorf 2002).

Our method provides a very rich source for analysis to uncover possible correlations and relations. We are able to characterize usage of the WBCS by participant or role, across phases of a project, and according to multiple models of message purpose. In this report we only describe the quantitative results herein, but further coding of the data could provide evidence in favour or in refutation of various design methodology theories.

Descriptive statistics have been used to produce a first level of analysis. This article presents simple correlations to time and person that have been used to drive inferences about how the WBCS has been used. Future work will present more sophisticated correlation studies.

4 ANALYSIS RESULTS: CHANGES IN COMMUNICATION PATTERNS

The analysis of the data draws a quantitative network of actors in the planning process of building projects. The results at this stage target the work tasks and the information behaviour of the project participants, based upon electronically documented communications and transactions.

4.1 Activity by Location

The use of communication through WBCS is more than twice as frequent among firms as within firms. Some participants were located at central offices, while others occupied branch office facilities. For this study, central offices are considered those that have 10 project members or are part of the corporate headquarters of a participating firm. Similarly, remotely located team members contribute over twice as many transactions than members located in headquarter offices. Cases 1 and 2 involved multiple offices of international firms, consisting of architects, engineers, planners and consultants. Each project member averaged 141 transactions over a 50 week period. Members of remotely located offices that had a small number of team members at the office or were in non-metropolitan settings used the system more

frequent, with up to 310 transactions. This result is not surprising as one might expect that project members who are geographically far from the primary location for the project would rely more on telecommunications, include the WBCS.

4.2 Coordination versus Collaboration

The dimension of coordination versus collaboration provides additional insights. Figures 1 and 2 compare percentage of coordination activities below the line and percentage of collaboration activities above the line for all cases. Since each project was studied for a different duration, the total time for each case has been subdivided into 25 equal "time units". The figures also show a trend line and extremes. The two figures differentiate between cases that were oriented toward the planning and design stage versus cases focused upon construction documentation.

From the graphs, several conclusions can be drawn. Group coordination messages are the most frequently observed category at the project inception and within each project stage itself. They decline in frequency with the progression of the project while the collaboration messages increase (Figure 1 and 2). Progression from coordination to collaboration parallels a change in software functions from "pure messages" to "task assignments" and finally to "documentation and drawings." The appearance of flurries of message of one category type within a phase characterized by another category type needs still more study. Perhaps distinctions of sub-phases or confirmation of a cyclic pattern of design activities will emerge from more detailed analysis.

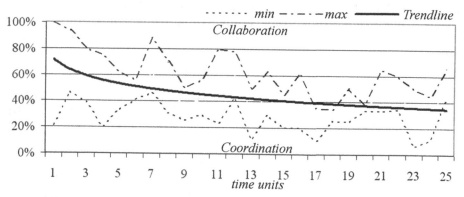

**Figure 1 Planning and Design Stage Ratio between Coordination
and Collaboration over Project Duration**

The figures illustrate a qualitative difference between the two categories of case. In cases that focused upon planning and design, illustrated in Figure 1, the proportion of coordination activities decreased dramatically over time. It starts out at about 70% and then declines to below 40% on average. In the cases focused upon construction documentation, shown in Figure 2, the mix between coordination and

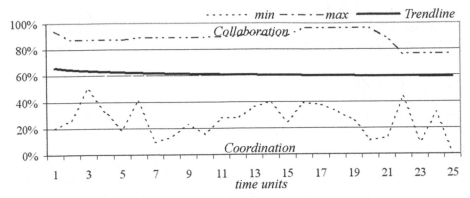

Figure 2 Construction Documentation Stage Ratios between Coordination and Collaboration over Project Duration

collaboration stayed more constant for the duration, declining only about 10%. This difference in shape of these curves suggests that the distinction between early and late design is an accurate model of design processes. Perhaps, in the cases with more coordination, the constructor was already involved. The involvement of new participants probably requires a great effort of coordination prior to collaboration.

4.3 Information Behaviour

The difference between stages is also apparent from analysis of the kind of activity. Figures 3 and 4 show the proportion of activities for each normalized time unit as grouped into classifications of "access", "generate", and "process." Across all cases, 80% of the transactions are only accessing or reading information, while not contributing new information to the information pool:

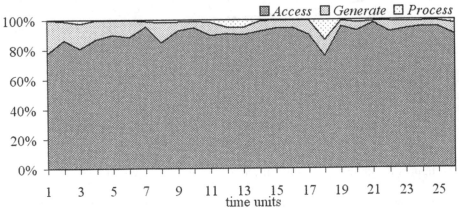

Figure 3 Information Behaviour over Project Duration for Planning and Design Development Stage

Figure 3 shows that 90% of the activities in the early stages are accessing information for reading and assimilation. In construction documentation, only 50% of activities were for accessing information, as visible in Figure 4. Generating new information and processing data account for the remainder of transactions or messages.

With progression of the project, the information type changes from pure messages, review of background information, and negotiations to more output and production oriented information. The study shows that the main production of new issues or documents, such as drawings and detailed descriptions of the building, is accomplished at the later phases of the projects.

An actual tracking of the change in information type over the project life cycle requires longer observation of each case over the whole life cycle. Not all cases have gone through all stages of design, construction and operation. Further study such as the content analysis may allow a more complete picture of which information is used at each stage.

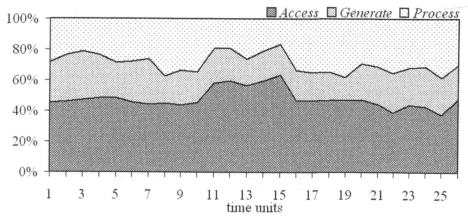

**Figure 4 Information Behaviour over Project Duration
for Construction Documentation**

4.4 Messages According to Organizational Hierarchy

At the beginning of all efforts is the question "who is going to do the work?" One main question this study tries to answer is which who performs which work tasks in the planning and design process. Dividing all messages and transactions based on content analysis into collaboration and coordination tasks, the following picture can be drawn in relation to the hierarchy of authors of each message or transaction.

Coordination is done by participants more in the middle range of hierarchy, such as lead engineers and specialist (Table 1). Collaboration or exchange of information takes place at the specialist and administrative staff level. This can be interpreted as the specialists produce the results, but are coordinated by their leaders and directors.

Although the software supports non-hierarchical interaction among team members, most information is routed along company hierarchy lines rather than directly to the ultimate receiver. In this case the software design does not match the organizational form. Nevertheless it has to be considered that a high ranked employee in the firm usually is assigned to more than one project at a time and might therefore not contribute as many messages to a single project.

Table 1 Task versus Hierarchy of Employee

Tasks	Exec.	Direct	Lead	Speci.	Intern	Staff	
Collaboration	11.9%	15.0%	16.0%	23.8%	0.0%	33.3%	100%
Coordination	6.3%	13.4%	25.7%	35.9%	4.0%	14.6%	100%

Table 2 further indicates that most of the accessing or reading of electronically available information is done on a specialist level. The messages or information is then worked on and presented outside the WBCS to the team leader. The team leader then submits the newly generated information into the system. Based on the log information frequently team members send "new" or "process" information to their staff assistants for submission or distribution into the WBCS. This is similar to the traditional way of doing business by delegating tasks to subordinates who can monitor the flow of information into and out of an executive office, although anybody could directly send information to the intended final receiver.

Table 2 Information Behaviour versus Hierarchy of Employee

Inform.	Exec.	Direct	Lead	Speci.	Intern	Staff	
Access	4.1%	15.8%	20.1%	45.7%	2.5%	11.9%	100%
Generate	7.1%	12.6%	27.3%	23.6%	5.1%	24.3%	100%
Process	6.5%	22.0%	36.2%	15.1%	0.4%	19.8%	100%

5 IMPLICATIONS AND CONCLUSIONS

By inspecting the transactions of WBCS, the traffic flow of information in the design process can be observed. This research draws conclusions about the work tasks and communication behaviour of architects and engineers using digital communication systems by employing large amounts of empirical data that can be subjected to quantitative analysis. This data allows us to assess the adequacy of WBCS with respect to theory. As a by-product, the research has produced evidence for validity of design methods theory. The results will be useful in formulating recommendations for improvements of existing communication software tools, streamlining the exchange process in AEC, and achieving higher user acceptance.

Information flow in design process: The research has produced evidence regarding who participates at various stages of the design process, how they use information, and how they share information throughout the team. The data confirm that a WBCS is most useful in distributed organizations and may be most critical to branch office operations. Coordination efforts are particularly important in the early stages of a project, while collaboration activities dominate at later stages. From the cases studied, one can conclude that the planning and design stage exhibits a high degree of coordination at the beginning and proportionally more collaboration later, while construction documentation exhibits a more consistent split throughout the process. The planning and design stage is overwhelmingly dominated by access operations to the information rather than generate or process operations. Construction documentation is more heavily characterized by generate and process activities. These observations lend credence to design method theory that distinguishes the design process into distinct stages.

The different categories of employee require different functions and support. While high-level employees make relatively small use of the software, the bulk of activities recorded are performed by specialists, lead professionals, and staff. Although executives undertake access, generate and process functions, indicating a range of expertise, there may be opportunities to streamline processes by using non-hierarchical access instead of traditional divisions of authority by status.

Improvements to software design: Both software packages effectively support document repository, calendaring and general project notification. The versioning and the mail function have not been used at all and thus may not be perceived as valuable. Due to storage space and associated cost for the architect, prior versions of documents were always deleted from the WBCS and recovery was difficult. Three cases successfully used the threaded discussion board to solve generic issues. Compared to individual messages that covered the similar topic repeatedly, topics addressed using the threaded discussion did not need to be "renegotiated." A threaded discussion is useful.

Miscellaneous conclusions: The four cases which had buy-in from the senior executive in the architecture firms used WBCS the most, versus the cases when the client was the driving factor for the use of the WBCS. This relates to a required change of mindset in the architecture industry to utilize digital means to increase and smooth the flow of information.

New research method: The use of transaction logs from Web-based software is a new form of design research that produces highly reliable and valid evidence in the design methods.

REFERENCES

Alshawi, Mustafa, and Bingunath Ingirige. 2003. Web-enabled project management: An emerging paradigm in construction. *Automation in Construction* 12(4): 349-364.

Augenbroe, Godfried, and Charles M. Eastman. 1999. *Computers in building: Proceedings of the eight international conference CAADfutures 1999.* Boston: Kluwer.

Baya, Vinod, and Larry J. Leifer. 1996. Understanding information management in conceptual design. In *Analyzing design activity*, ed. Nigel Cross, Henri Christiaans and Kees Dorst:151-168. Chichester, NY: John Wiley.

Huang, Jeffrey. 1999. How do distributed design organizations act together to create meaningful design. In *Computers in building: Proceedings of the eighth international conference CAAD Futures 1999*, ed. Godfried Augenbroe, and Charles M. Eastman: 99-115. Boston: Kluwer Academic.

Jabi, Wassim. 2003. Reflections on computer-supported cooperative design systems. In *10th international conference on CAAD Futures 2003*, ed. Tay-Sheng Jeng, Mao-Lin Chiu, Thomas Kvan, Mitsuo Morozumi, and Jin-Yeu Tsou. Dordrecht: Kluwer.

Jeng, Taysheng. 2001. Coordination of distributed design activities: A rule-driven approach. In *Computer aided architectural design futures 2001*, ed. Bauke de Vries, Jos van Leeuwen, and Henri Achten: 415-426. Dordrecht: Kluwer.

Kvan, Thomas. 1997. But is it collaboration? In *Challenges of the future: 15th ECAADE Conference [CD-Rom]*, ed. Bob Martens, Helena Linzer, and Andreas Voigt. Vienna: Österreichischer Kunst- und Kulturverlag.

_____. 2000. Collaborative design: What is it. *Automation in Construction* 9(4): 409-415.

Malone, Thomas W., and Kevin Crowston. 1994. The interdisciplinary study of coordination. *ACM Computing Surveys* 26(1): 87-119.

Neuendorf, Kimberly A. 2002. *The content analysis guidebook.* Thousand Oaks, CA: Sage.

Purcell, Terry, John Gero, Helen Edwards, and Tom McNeil. 1996. The data in design protocols: The issue of data coding, data analysis in the development of models of the design process. In *Analyzing design activity*, ed. Nigel Cross, Henri Christiaans and Kees Dorst: 225-252. Chichester, NY: John Wiley.

Shannon, Claude Elwood, and Warren Weaver. 1998. *The mathematical theory of communication.* Urbana: University of Illinois Press.

Interdisciplinary Knowledge Modelling for Free-Form Design – An Educational Experiment

KOCATURK, Tuba and VELTKAMP, Martijn
Building Technology Department, Delft University of Technology, The Netherlands

Keywords: collaborative design, constraint based design, design process, digital design education, free-form design

Abstract: The recent advances in digital design media and digital fabrication processes have introduced formal and procedural effects on the conception and production of architecture. In order to bridge the individual concepts and processes of multiple design disciplines, intensive cross-disciplinary communication and information exchange starting from the very early stages of design is necessary. A web-based database for design learning and design teaching named BLIP is introduced. In this framework, cross-disciplinary domain knowledge becomes explicit to be taught and transferred in Free-Form Design research and education. BLIP proposes a conceptual map through which the user can construct structured representations of concepts and their relationships. These concepts are high-level abstractions of formal, structural and production related concepts in Free-Form design development. BLIP is used for formalizing, organizing and representing conceptual maps of the three domains and facilitates information and knowledge sharing in collaborative conceptual design in context. The paper introduces the application together with its application in two educational design experiments.

1 INTRODUCTION

The digital revolution in architectural design and the adoption of CAD/CAM processes in the building industry can be considered as one of the most radical shifts in architectural history concerning their immense formal and procedural implications. Concerning the formal implications, complex CAAD software – at the disposal of almost any designer today – have provided means to create and describe complex juxtapositions of forms. Parametrics and associative geometry provided designers to create customized transformations of forms according to the rules set by the designers, regulating the relationships between geometric properties of their digital model and its performance criteria (structural, constructability, etc). These operations engender a different cognitive model of design as well as a different vocabulary of forms – so called Free-Form, Blob Forms – than was available to designers accustomed to work previously with straight lines, spheres, cubes, cones and cylinders in modelling (Chaszar 2003). As for the procedural implications,

B. Martens and A. Brown (eds.), Computer Aided Architectural Design Futures 2005, 465-474.
© 2005 *Springer. Printed in the Netherlands.*

while digital practices provided a digital continuum between design, engineering and production practices, they also brought about a new set of constraints and dependencies between interdisciplinary design domains.

For conventional design and production processes, designers could manage these iterative processes intuitively, given the experience and familiarity with the standardized building elements and construction methods. Nonetheless, the emerging digital processes, tools and knowledge require a new intuition for the design professionals to cope with the emerging relations and constraints between the domain (in)specific information for the design and realization of Free-Form Architectures. Therefore, how to represent the evolving knowledge, to capture the reasoning process and to manage the constraints during the design process are among the most difficult design issues dealing with Free-Form design in current practice. New tools and techniques are required to capture the emergent relations among evolving material properties, structural morphology, manufacturing technology and the architectural form.

The emergence of new processes, tools and methods have also had significant implications on the design research and education as well as design knowledge in general. As part of the two ongoing projects in the Blob research group of the Architecture Faculty of the Delft University of Technology, we have conducted an extensive case study of the constructed Blob precedents. Within an interdisciplinary framework, the main focus was on the form and the processes employed for its generation and realization (e.g., *design methods, form generation techniques, fabrication technologies, representation tools, structural form development*) as well as various context (in-) dependent dependencies between them throughout the initial design to the final assembly of the Free-Form envelope surface and its supporting structure. BLIP database application has initially been developed as a representational framework to formalize and organize the interdisciplinary design knowledge (explicit and implicit) derived from the Blob precedents, focusing mainly on the dependencies and relations between the formal, structural and production related aspects. The challenge of this study is twofold. Firstly, it is an attempt to explicate experiential knowledge of Free-Form design practice and to structure this information in such a way that it can used as a continuous learning and teaching environment where new knowledge can be added, stored and re-used at any time. Secondly, the knowledge captured is formulated in a new domain (in)dependent taxonomy as generic abstractions of overlapping interdisciplinary concepts and their dependencies. In the following sections, the paper will first introduce the development of the prototype for its specific use in education, and then its application in two educational workshops. The aim of the workshops were mainly to test the usability of the prototype with regard to: how the interdisciplinary abstractions in BLIP facilitate teaching in context, the degree of flexibility it allows concerning the storage of new knowledge and its re-use (learning behaviour), and if it facilitates innovation and creativity.

DESIGN KNOWLEDGE MODELLING AND REPRESENTATION

Design is a complex process that involves a large amount of information with numerous dependencies. This information is commonly represented and communicated in a collection of design documents of various formats. Several researches and approaches have been reported on the formalization of design knowledge. Logan discusses the necessity of formalization of design knowledge models for providing tools for further research (Logan 1985). He refers to the structure of relationships in design activity and claims that design research should focus on understanding these relationships, rather than solving problems. Akin introduces the formalization of knowledge as a system that explicates the behaviour of the problem solver during the design process, which can also be used in design education for the study of uncertainty (Akin 1986). Landsdown defines design as a transformation of an object from an initial, incomplete state to a final complete one. Since the transformation is brought by the application of knowledge, design can be seen as an information processing concept (Landsdown 1986). In this respect, what makes each design unique is in part determined by how the designer(s) bring different items of knowledge together in varying contexts. Creativity can also be defined as combining different items of knowledge in a unique way. Oxman and Oxman propose a structured multi-level model of architectural knowledge and claim that there should be meaningful relationships between levels, or types of knowledge which should facilitate both bottom-up and top-down operations. A formalism is proposed which represents the linkage between concepts in design stories which are structured as a semantic network. (Oxman and Oxman 1990). Maher et al. provide a valuable reference as a comparative portfolio of cased based systems (Maher and Silva Garza 1997). The comparison is based on the complexity of cases and the way generalized knowledge is handled (e.g. heuristic rules, geometric constraints, casual rules). Their problem solving approach is based on analogy from the perspective of memory and they employ concept of memory organization as a guideline for computer representation.

Many document management and knowledge modelling applications exist, but not all are suitable for the early stages of design or support multi-disciplinary knowledge sharing for the conceptual design. The main reasons why a unified cross-disciplinary knowledge representation has not been developed can be outlined as: 1) Theory is specific to a single domain of practice, 2) a neglect of epistemological and ontological concerns in theory making, 3) a lack of agreement about definitions of core concepts and terminology, 4) Poor integration of theories specific to designing and designs with theories from other bodies of knowledge (Eder 1996, Oxman 1995, Pugh 1990, Love 2002).

Although design knowledge grows in part from practice, the practice of design is only one foundation of design knowledge. As Friedman states: "it is not practice but systematic and methodical inquiry into practice—and other issues—that constitute design research, as distinct from practice itself"(Friedman 2003). In this respect, BLIP database proposes a model, an illustration, describing Free-Form design processes by showing its elements (e.g. processes, forms) in relationship to one

another – as different from conventional design processes. These elements are interdisciplinary in nature. The capture and demonstration of their relationships (dependencies, constraints, etc.) is what distinguishes BLIP from a simple catalogue. While offering an interdisciplinary taxonomy, the emerging knowledge is defined mainly as how these elements are brought together in respond to a design problem.

2.1 BLIP

In multidisciplinary knowledge modelling, the task decomposition and integration must be achieved not only through the communication of contents, but also through the communication about the creation and evolution of shared meanings (Lu et al .2001). In other words, design coordination relates to not only the dependency identification among the design decisions, but also the exchange of perspectives between the design stakeholders. Therefore, in a interdisciplinary knowledge model, it is essential to identify, represent and evaluate the influence of one's decision making in a specific domain to others' decision making in different sub-problems. Furthermore, identification of the interdependencies among design activities also plays a key role in solving conflicts.

Building a unified body of knowledge framework and theory across disciplines requires a taxonomy for design participants to declare and share their perspectives. Furthermore, understanding the relationships and dependencies requires clarity about the boundaries between the disciplines, individual terms and concepts, and the design context. For the proposed knowledge model described in the next section, we focus on the experiential knowledge (in the cases) and factual knowledge which are essential source of domain specific, cross-disciplinary and cross-organizational knowledge.

We have developed a methodology that entails the organization of interdisciplinary design knowledge in a web environment, as a decision support and design exploration tool. It establishes a grammar of influences between formal, structural and production related aspects of a free-from development process. These aspects have been conceptualised as a semantic network of keywords by formulating various context independent factors (*features*) that are influential in these processes. Once the *features* are interrelated, documents are entered in the system with reference to these interrelated features (Kocaturk, Tuncer and Veltkamp, 2003). The application is designed to be used for extensive cross-referencing and interactive searches. The links between two or more features also store documents and can also be searched by the user to access more specific information on the relationships between specified features. In the system, users can switch between the documents layer (precedent solutions) and the concept layer (the features and links). In this context, the application provides (Figure 1):

- A high-level multidisciplinary Free-Form design taxonomy (between architectural-structural and manufacturing related processes);

- Structured representations of design concepts and their dynamic relationships in a knowledge-based and precedent-based environment;

- An extensible framework to store/retrieve/share and generate new knowledge (as a conceptual design aid);

- Distinctions of factual/experiential knowledge and different perspectives of stakeholders (in architectural, engineering or manufacturing domains).

Figure 1 Screenshot of BLIP, with on the left the network of keywords and on the right a content document

3 EXPERIMENTAL WORKSHOPS

Two separate workshops were conducted in the design studio in two different semesters, each slightly distinct in their set-up. At the beginning of both workshops, students had first been taught the basic concepts, terminologies, techniques and processes applied in free-form design and construction during which BLIP application was extensively used (for case studies, lectures, etc.). In order to get the students acquainted with the application, they were also asked to analyse precedent Blob design/engineering and production processes and then to extract knowledge to store in BLIP by creating new links between the features which they could use later for their upcoming design task. They were also allowed to add new features into the system as long as they were generic enough to accommodate similar new instances. In the following sections, both workshops will be described and discussed regarding the usability of BLIP concerning how the interdisciplinary abstractions in BLIP facilitated teaching in context, the degree of flexibility it allowed concerning storage of new knowledge and its re-use (learning behaviour), and if it facilitated innovation and creativity.

3.1 First Workshop

The students were asked to generate a double-curved Free-Form roof surface, develop a structural supporting system and alternatives for the fabrication of the structural elements. In this particular design experiment, the students were asked to work as a team in which the team members were all assigned a specific role associated to the three aspects of BLIP: one group responsible for the form-

generation, another for the structural system development and analysis, and the last group to investigate manufacturing alternatives (as three separate domains). Although they were given separate roles in the team, they were asked to develop design alternatives together as a group output. The students had been provided with necessary theoretical background information concerning the scope of their individual tasks in the first half of the workshop.

In addition to their design task, they were also asked to record their collaborative conceptual design process and their design alternatives, concerning what constraints they have encountered posed by which team member, how they solved it, why they abandoned a particular alternative and how they justified their choice for a particular design solution. Later on, they were asked to explicate their design experience and store this in BLIP as new knowledge they discovered by creating new links - if necessary - across each domain.

Figure 2 Conceptual design alternatives generated by the group (Image credit: Chris Kievid)

The students were relatively productive in terms of conceptual solutions and alternatives they produced for the downstream processes, together with their own dependent parameters satisfying all of the constraints set by one or more team members (Figure 2). However, they scored relatively poor on the basis of innovation, judged by their approach of dealing with mutual constraints across domains. They were more solution oriented and rather preferred to choose "easy to deal for all" solutions (even for the conceptual design phase) rather than developing new strategies, or methods to cope with them. This was mainly due to their approach to the problems more locally and their reluctance to switch iteratively between bottom-up and top-down approaches. Thus, they were less efficient in generating new concepts and links although they could manage to generate many documents for the existing links in BLIP.

3.2 Second Workshop

In the second workshop, a new group of students was given a free-form double-curved 3D geometry and were asked to develop the given surface into rational cladding components, design a supporting structure composed of curved elements, and find alternative manufacturing processes for the cladding components and the steel structure. Different from the first workshop, they were given two initial

constraints to start with. Firstly, they were not allowed to make major changes in the geometry. And secondly, all of the surface cladding components and the elements of the structural system should be *developable*. Developability of surfaces is one of the most frequently applied techniques used for constructability modelling of free-form surfaces. These rolled plane configurations have straight lines of ruling on the surface, where the surface normals at any two points on a given line of ruling are in the same plane, so they can be unfolded into a plane.

Although they had to collaborate throughout the whole design process, this time, each student would develop his/her own design alternatives for one task only (complying with the initial constraints), while considering the dependencies of their decisions across domains. Meetings were held to mutually inform the fellow students about the progress, and the conceptual design variables (formal and procedural) developed by each were discussed together with the emerging constraints originating from the structural configuration on the cladding configuration, and vice versa.

form

production structure

Figure 3 This scheme shows the range of variables produced during conceptual design. The distribution of the dots represents the design variables and their degree of dependencies across domains taken into account for their generation. (Image credit: Antonio Pisano)

It has been observed that in this particular experiment the students were more innovative and creative not only in terms of the variety of design solutions, but also the methods and strategies they have invented to deal with particular constraints and dependencies between tasks (Figure 3).

4 DISCUSSION

The experimental setting for both workshops are evaluated within the two philosophical models of experiential learning as outlined by Kolb and Piaget (Kolb 1984, Piaget 1972). Kolb's emphasis is on the experience, followed by reflection. Piaget focuses on knowledge and the ability of its assimilation. This assimilation is related to the students' cognitive schemata which affects the acquisition of new knowledge. During both workshops, students had also been assisted in identifying different types of knowledge – as declarative (what), procedural (how) and contextual (why) – which contributed significantly to their knowledge acquisition and trans-disciplinary knowledge sharing process.

Interdisciplinary Knowledge Modelling for Free-Form Design

Experiential learning is the apparatus in which the learner is subjected to situations where he/she develops and assesses his/her critical thinking abilities, thus allowing for freedom of creative thought. Moreover, it provides students with opportunities to reflect on their own learning, and in particular to monitor and evaluate their own processes of working. One of the challenges of these workshops was to develop the students' abstract thinking ability by which they could conceptualize a particular knowledge as a problem-solution-constraint trio so that they could identify similar problems with that of similar solutions within similar constraints in various other cases. This approach is based on the assumption that design is more of a problem-finding activity (as opposed to problem-solving) especially when the designers are not familiar with the design context and cannot predict what problems they will encounter during the course of a design.

The workshops provided valuable feedback on the usability of the first prototype of BLIP with regard to three evaluation criteria. The first criterion was to test how interdisciplinary abstractions facilitated design teaching in context. BLIP represents design solutions and strategies as an answer to a specific relationship between two or more concepts within one across two or more domains. In this respect, both workshops proved that the framework it provides for interpretation and conceptualisation of design concepts, and to communicate them to students were quite effective. This had been reflected in their collaboration process as well.

Second criterion was the flexibility and extensibility of BLIP for storing new knowledge and its re-use (learning behaviour). Although the functionality of the application allows both, it was rather difficult for the students (as novice designers) to conceptualize their own design actions at a generic level. It has been observed to be rather difficult for the students (as novice designers) to switch between the concept (problem) layer and the information (solution) layer iteratively. This is to be learned in time with gained experience. They needed guidance in this process.

The final criterion was to test if the application could facilitate innovation and creativity. The set-up of each workshop, and the difference in students' cognitive schemata influenced the degree to which this criterion was met. In the first workshop, throughout their design process the students were more focused on problem solution rather than relations between concepts. The only dependency type they interpreted between concepts across domains were *constraints*. Consequently, their problem solution approach was mainly in the form of negotiation and compromise between the groups to satisfy those constraints, and the design alternatives were chosen on a formal basis to the degree to which these forms could be produced and engineered with the most ease, which could also be easily represented in BLIP. However, in the second workshop, the students were not as much concerned about finding a solution but rather referred to high level problems abstractions as guidelines to develop alternative strategies to cope with various dependency types between information across domains. Eventually, they were more innovative and creative in their final solutions. However, it has been observed that the current database is lacking the ability to represent these varying dependency types (relations, links) between features (concepts) across domains. Thus, the knowledge structure should be augmented with relations according to these distinct relationship types. These relationships are not only distinct in meaning (e.g.,

geometric versus non-geometric constraints), but also in form (e.g., uni-directional versus bi-directional relationships). This will allow the system to support the representation of creative and innovative knowledge as well as empower the search function in the system at various levels of abstractions.

5 CONCLUSION

BLIP, as a precedent and knowledge based database, has been developed to categorize, organize and capture the emerging design knowledge in free-form architectural design and production as a teaching and learning tool. As a knowledge and precedent based database, it provides a unified interdisciplinary representational framework in which the emerging relations between three domains can be represented at different levels of abstractions. The major innovation of such environments and tools is the flexibility they provide with respect to the composition and inter-relatedness of the information structure. This flexibility applies when adding new information and relating this to the existing information in the system.

The need for capturing and organizing knowledge has always been an interest in design research. The context of knowledge to be represented proves to be play an essential role on the representational framework for the knowledge structure. Currently, the context of free-form design is still an exception rather than a rule and might well stay as mere formal fantasy unless its full performance is examined and synthesized with innovative structural and fabrication solutions. Therefore, to represent the evolving knowledge, to capture the reasoning process and to manage the emerging relations across domains would be a contribution not only to design education but also to architectural design practice in general. Although it will not require much discussion that master students can not be considered as expert designers, the relatively limited number of precedents, the design complexities and range of disciplines associated with this class of buildings and production processes may require knowledge beyond the direct experience of most practising designers. In this respect, most designers are novices in this context.

ACKNOWLEDGEMENTS

We would like to acknowledge B. Tuncer and J. Beintema for their contribution to the development of BLIP, and D. Lim, M. Cohen de Lara, T. Jaskiewicz, C. Chua, C. Kievid, A. Pisano, J. Hulin and S. Krakhofer who participated in the workshops and provided valuable feedback for this research.

REFERENCES

Akin, Omer. 1986. *Psychology of Architectural Design*. London: Pion

Chaszar, Andre. 2003. Blurring the Lines: An Exploration of Current CAD/CAM Techniques. *Architectural Design* 73(1): 111.

Eder, W.E. 1996. Definitions and Methodologies. In *Design Method*, ed. S. A. Gregory: 19-31. London: Butterworths.

Friedman, Ken. 2003. Theory construction in design research:criteria, approaches and methods. *Design Studies* 24(6): 519.

Kocaturk, Tuba, Bige Tuncer, and Martijn Veltkamp. 2003. Exploration of interrelatonships between digital design and production processes of free-form complex surfaces in a web-based database. In *Computer-Aided Architectural Design Futures*, ed. Mao-Lin Chiu, Jin-Yeu Tsou, Thomas Kvan, Mitsuo Morozumi, and Tay-Sheng Jeng: 445-454. Dordrecht:Kluwer.

Kolb, D.A. 1984. *Experiential Learning: Experience as the Source of Learning and Development*, Englewood Cliffs, NJ:Prentice-Hall.

Landsdown, J. 1986. Requirements for Knowledge Based Bystems in Design. In *Computer-Aided Architectural Design Futures*, ed. Alan Pipes: 120-128. London: Butterworths.

Logan, B.S. 1985. Representing the Structure of Design Problems. In *Computer-Aided Architectural Design Futures*, ed. Alan Pipes: 158-170. London: Butterworths.

Love, Terence. 2002. Constructing a coherent cross-disciplinary body of theory about designing and designs: some philosophical issues. *Design Studies* 23 (3): 346.

Lu, Stephen, and James Jian Chai. 2001. A collaborative design process model in the sociotechnical engineering design framework. *Artificial Intelligence for Engineering Design, Analysis and Manufacturing* 5(1): 3–20.

Maher, Mary Lou and Andres Gomez de Silva Garza. 1997. *Cased-Based Reaasoning in Design. IEEE* 12(2): 34-41.

Oxman, Rivka. 1995. Viewpoint: Observing the observers: research issues in analysing design activity. *Design Studies* 16(2): 275-284.

Oxman, Rivka and Robert Oxman. 1990. Computability of Architectural Knowledge. In *The Electronic Design Studio: Architectural Knowledge and Media in the Computer Era*, ed. Malcolm McCullough, William J. Mitchell, and Patrick Purcell: 171-187. Cambridge: MIT Press.

Piaget, J. 1972. *Psychology and Epistemology: Towards a Theory of Knowledge*, London: Penguin.

Pugh, Stuart. 1990. Engineering Design – unscrambling the research issues. *Research in Engineering Design* 1(1): 65-72.

Reviewers

Thanks are due to the members of the review committee who have served in the refereed double-blind review procedure:

Henri ACHTEN Eindhoven University of Technology (The Netherlands)

Michael BATTY University College London (United Kingdom)

Andy BROWN University of Liverpool(United Kingdom)

Julio BERMUDEZ, University of Utah (USA)

Alan BRIDGES, University of Strathclyde (UK)

Luca CANEPARO, Torino Politechnic (Italy)

Scott CHASE, University of Strathclyde (UK)

Maolin CHIU, National Cheng Kung University (Taiwan)

Richard COYNE, University of Edinburgh (United Kingdom)

Bharat DAVE, University of Melbourne (Australia)

Bauke DE VRIES, Eindhoven University of Technology (Netherlands)

Ellen Yi-Luen DO, University of Washington (USA)

Dirk DONATH, Bauhaus University Weimar (Germany)

Chuck EASTMAN, Georgia Institute of Technology (USA)

Anders EKHOLM, Lund Institute of Technology (Sweden)

Maia ENGELI, University of Plymouth (UK)*

Thomas FISCHER, The Hong Kong Polytechnic University (Hong Kong)

John S GERO, University of Sydney (Australia)

Glenn GOLDMAN, New Jersey Institute of Technology (USA)

Mark GROSS, University of Washington (USA)

Gilles HALIN, CRAI Research Center in Architecture and Engineering (France)

Theodore HALL, Chinese University of Hong Kong (Hong Kong)

Urs HIRSCHBERG, Graz University of Technology (Austria)

Reviewers

Ludger HOVESTADT, Swiss Federal Institute of Technology (Switzerland)

Wassim JABI, New Jersey Institute of Technology (USA)

Brian JOHNSON, University of Washington (USA)

Richard JUNGE, Munich University of Technology (Germany)*

Branko KOLAREVIC, University of Pennsylvania (USA)

Jose KOS, Federal University of Rio de Janeiro (Brazil)

Alexander KOUTAMANIS, Delft University of Technology (The Netherlands)

Thomas KVAN, University of Hong Kong (China)

Jos van LEEUWEN, Eindhoven University of Technology (The Netherlands)

Feng-Tyan LIN, National Taiwan University (Taiwan)

Yu-Tung LIU, National Chiao Tung University (Taiwan)

Ganapathy MAHALINGAM, North Dakota State University (USA)

Ardeshir MAHDAVI, Vienna University of Technology (Austria)

Mary Lou MAHER, Sydney University (Australia)

Bob MARTENS, Vienna University of Technology (Austria)

Tom MAVER, University of Strathclyde (UK)

Mitsuo MOROZUMI, Kumamoto University (Japan)

Herman NEUCKERMANS, University of Leuven (Belgium)

Rivka OXMAN, Technion Israel Institute of Technology (Israel)

Paul RICHENS, Martins Center - University of Cambridge (UK)

Robert RIES, University of Pittsburgh (USA)

Gerhard SCHMITT, Swiss Federal Institute of Technology (Switzerland)

Rudi STOUFFS, Delft University of Technology (Netherlands)

Georg SUTER, Vienna University of Technology (Austria)

Beng-Kiang TAN, National University of Singapore (Singapore)

Jin-yeu TSOU, The Chinese University of Hong Kong (Hong Kong)

Guillermo VASQUEZ DE VELASCO, Texas A&M University (USA)

Jerzy WOJTOWICZ, University of British Columbia (Canada)

Robert WOODBURY, Simon Fraser University (Canada)

*Only first review stage

Author Index

Author Index

Keyword Index

Keyword Index